2010 33RD ANNUAL EDITION

PHOTOGRAPHER'S MARKET ®

From the Editors of Writer's Digest Books

W

WRITER'S DIGEST BOOKS
CINCINNATI, OH

Publisher & Editorial Director, Writing Communities: Jane Friedman
Managing Editor, Writer's Digest Market Books: Alice Pope

Writer's Market Web site: www.writersmarket.com
Writer's Digest Web site: www.writersdigest.com

Distributed in Canada by Fraser Direct
100 Armstrong Avenue
Georgetown, ON, Canada L7G 5S4
Tel: (905) 877-4411

Distributed in the U.K. and Europe by David & Charles
Brunel House, Newton Abbot, Devon, TQ12 4PU, England
Tel: (+44) 1626 323200, Fax: (+44) 1626 323319
E-mail: postmaster@davidandcharles.co.uk

Distributed in Australia by Capricorn Link
P.O. Box 704, Windsor, NSW 2756 Australia
Tel: (02) 4577-3555

ISSN: 0147-247X
ISBN-13: 978-1-58297-584-9
ISBN-10: 1-58297-584-1

Cover design by Claudean Wheeler
Production coordinated by Greg Nock

Attention Booksellers: This is an annual directory of F+W Media, Inc. Return deadline for this edition is December 31, 2010.

fw
media

Contents

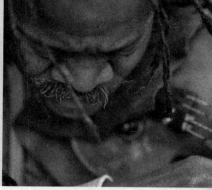

Photo © Todd Heisler/*The New York Times*

BUSINESS BASICS

Photo © Chris Gallow

ARTICLES & INTERVIEWS

Photo © Jason Lindsey

MARKETS

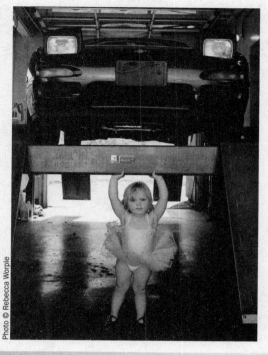

Photo © Rebecca Worple

RESOURCES

INDEXES

How to Use This Book

The first thing you'll notice about most of the listings in this book is the group of symbols that appears before the name of each company. Scanning the listings for symbols can help you quickly locate markets that meet certain criteria. (You'll find a quick-reference key to the symbols on the front and back inside covers of the book.) Here's what each symbol stands for:

N This photo buyer is new to this edition of the book.

↙ This photo buyer is located in Canada.

⊕ This photo buyer is located outside the U.S. and Canada.

A This photo buyer uses only images created on assignment.

S This photo buyer uses only stock images.

▣ This photo buyer accepts submissions in digital format.

▨ This photo buyer uses film or other audiovisual media.

▼ This art fair is a juried event; a juror or committee of jurors views applicants' work and selects those whose work fits within the guidelines of the event.

Complaint Procedure

Important

If you feel you have not been treated fairly by a company listed in *Photographer's Market*, we advise you to take the following steps:

- First, try to contact the listing. Sometimes one phone call, e-mail or letter can quickly clear up the matter.

- Document all your correspondence with the listing. If you write to us with a complaint, provide the details of your submission, the date of your first contact with the listing, and the nature of your subsequent correspondence.

- We will enter your letter into our files.

- The number and severity of complaints will be considered in our decision whether to delete the listing from the next edition.

PAY SCALE

We asked photo buyers to indicate their general pay scale based on what they typically pay for a single image. Their answers are signified by a series of dollar signs before each listing. Scanning for dollar signs can help you quickly identify which markets pay at the top of the scale. However, not every photo buyer answered this question, so don't mistake a missing dollar sign as an indication of low pay rates. Also keep in mind that many photo buyers are willing to negotiate.

$ Pays $1-150

$ $ $151-750

$ $ $ Pays $751-1,500

$ $ $ $ Pays more than $1,500

OPENNESS

We also asked photo buyers to indicate their level of openness to freelance photography. Looking for these symbols can help you identify buyers who are willing to work with newcomers, as well as prestigious buyers who only publish top-notch photography.

☐ Encourages beginning or unpublished photographers to submit work for consideration; publishes new photographers. May pay only in copies or have a low pay rate.

◪ Accepts outstanding work from beginning and established photographers; expects a high level of professionalism from all photographers who make contact.

◕ Hard to break into; publishes mostly previously published photographers.

⊘ May pay at the top of the scale. Closed to unsolicited submissions.

SUBHEADS

Each listing is broken down into sections to make it easier to locate specific information. In the first section of each listing you'll find mailing addresses, phone numbers, e-mail and Website addresses, and the name of the person you should contact. You'll also find general information about photo buyers, including when their business was established and their publishing philosophy. Each listing will include one or more of the following subheads:

Needs. Here you'll find specific subjects each photo buyer is seeking. (You can find an index of these subjects starting on page 507 to help you narrow your search.) You'll also find the average number of freelance photos a buyer uses each year, which will help you gauge your chances of publication.

Audiovisual Needs. If you create images for media such as filmstrips or overhead transparencies, or you shoot videotape or motion picture film, look here for photo buyers' specific needs in these areas.

Specs. Look here to see in what format the photo buyer prefers to receive accepted

Frequently Asked Questions

1 How do companies get listed in the book?

No company pays to be included—all listings are free. Every company has to fill out a detailed questionnaire about their photo needs. All questionnaires are screened to make sure the companies meet our requirements. Each year we contact every company in the book and ask them to update their information.

2 Why aren't other companies I know about listed in this book?

We may have sent these companies a questionnaire, but they never returned it. Or if they did return a questionnaire, we may have decided not to include them based on our requirements.

3 Some publishers say they accept photos with or without a manuscript. What does that mean?

Essentially, the word manuscript means a written article that will be published by a magazine. Some magazines will only consider publishing your photos if they accompany a written article. Other publishers will consider publishing your photos alone, without a manuscript. In previous editions, the word manuscript was abbreviated to ms. In this edition, we spell out the word manuscript whenever it occurs.

4 I sent a CD with large digital files to a photo buyer who said she wanted to see my work. I have not heard from her, and I am afraid that my photos will be used without my permission and without payment. What should I do?

Do not send large, printable files (300 dpi or larger) unless you are sure the photo buyer is going to use them, and you know what you will be paid for their usage and what rights the photo buyer is requesting. If a photo buyer shows interest in seeing your work in digital format, send small JPEGs at first so they can "review" them—i.e., determine if the subject matter and technical quality of your photos meet their requirements. Until you know for sure that the photo buyer is going to license your photos and you have some kind of agreement, do not send high-resolution files. The exception to this rule would be if you have dealt with the photo buyer before or perhaps know someone who has. Some companies receive a large volume of submissions, so sometimes you must be patient. It's a good idea to give any company listed in this book a call before you submit anything and be sure nothing has changed since we contacted them to gather or update information. This is true whether you submit slides, prints or digital images.

5 A company says they want to publish my photographs, but first they will need a fee from me. Is this a standard business practice?

No, it is not a standard business practice. You should never have to pay to have your photos reviewed or to have your photos accepted for publication. If you suspect that a company may not be reputable, do some research before you submit anything or pay their fees. The exception to this rule is contests. It is not unusual for some contests listed in this book to have entry fees (usually minimal—between five and 20 dollars).

images. Many photo buyers will accept both digital and film (slides, transparencies, prints) formats. However, many photo buyers are reporting that they accept digital images only, so make sure you can provide the format the photo buyer requires before you send samples.

Exhibits. This subhead appears only in the Galleries section of the book. Like the Needs subhead, you'll find information here about the specific subjects and types of photography a gallery shows.

Making Contact & Terms. When you're ready to make contact with a photo buyer, look here to find out exactly what they want to see in your submission. You'll also find what the buyer usually pays and what rights they expect in exchange. In the Stock section, this subhead is divided into two parts, Payment & Terms and Making Contact, because this information is often lengthy and complicated.

Handles. This subhead appears only in the Photo Representatives section. Some reps also represent illustrators, fine artists, stylists, make-up artists, etc., in addition to photographers. The term "handles" refers to the various types of "talent" they represent.

Tips. Look here for advice and information directly from photo buyers in their own words.

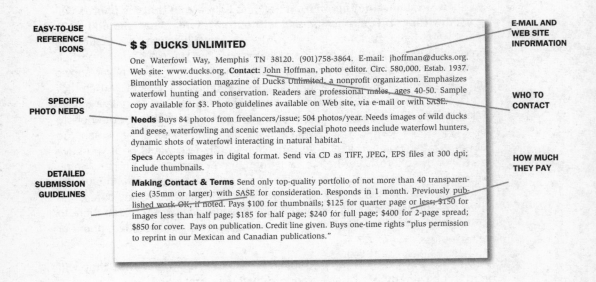

EASY-TO-USE REFERENCE ICONS

E-MAIL AND WEB SITE INFORMATION

$ $ DUCKS UNLIMITED

One Waterfowl Way, Memphis TN 38120. (901)758-3864. E-mail: jhoffman@ducks.org. Web site: www.ducks.org. **Contact:** John Hoffman, photo editor. Circ. 580,000. Estab. 1937. Bimonthly association magazine of Ducks Unlimited, a nonprofit organization. Emphasizes waterfowl hunting and conservation. Readers are professional males, ages 40-50. Sample copy available for $3. Photo guidelines available on Web site, via e-mail or with SASE.

SPECIFIC PHOTO NEEDS

WHO TO CONTACT

Needs Buys 84 photos from freelancers/issue; 504 photos/year. Needs images of wild ducks and geese, waterfowling and scenic wetlands. Special photo needs include waterfowl hunters, dynamic shots of waterfowl interacting in natural habitat.

Specs Accepts images in digital format. Send via CD as TIFF, JPEG, EPS files at 300 dpi; include thumbnails.

HOW MUCH THEY PAY

DETAILED SUBMISSION GUIDELINES

Making Contact & Terms Send only top-quality portfolio of not more than 40 transparencies (35mm or larger) with SASE for consideration. Responds in 1 month. Previously published work OK, if noted. Pays $100 for thumbnails; $125 for quarter page or less; $150 for images less than half page; $185 for half page; $240 for full page; $400 for 2-page spread; $850 for cover. Pays on publication. Credit line given. Buys one-time rights "plus permission to reprint in our Mexican and Canadian publications."

How to Start Selling Your Work

If this is your first edition of *Photographer's Market*, you're probably feeling a little overwhelmed by all the information in this book. Before you start flipping through the listings, read the 11 steps below to learn how to get the most out of this book and your selling efforts.

1. Be honest with yourself. Are the photographs you make of the same quality as those you see published in magazines and newspapers? If the answer is yes, you may be able to sell your photos.

2. Get someone else to be honest with you. Do you know a professional photographer who would critique your work for you? Other ways to get opinions about your work: join a local camera club or other photo organization; attend a stock seminar led by a professional photographer; attend a regional or national photo conference or a workshop where they offer daily critiques.

- You'll find workshop and seminar listings beginning on page 428.
- You'll find a list of photographic organizations on page 465.
- Check your local camera store for information about camera clubs in your area.

3. Get Organized. Create a list of subjects you have photographed and organize your images into subject groups. Make sure you can quickly find specific images and keep track of any sample images you send out. You can use database software on your home computer to help you keep track of your images. (See page 25 for more information.)

Other Resources:

- *Photo Portfolio Success* by John Kaplan, Writer's Digest Books.
- *Sell and Re-Sell Your Photos* by Rohn Engh, Writer's Digest Books.
- *Sellphotos.com* by Rohn Engh, Writer's Digest Books.
- *The Photographer's Travel Guide* by William Manning, Writer's Digest Books.

4. Consider the format. Are your pictures color snapshots, black & white prints, color slides or digital captures? The format of your work will determine, in part, which markets you can approach. Below are some general guidelines for where you can market various photo formats. Always check the listings in this book for specific format information.

- **black & white prints**—galleries, art fairs, private collectors, literary/art magazines, trade magazines, newspapers, some book publishers
- **color prints**—newsletters, very small trade or club magazines
- **large color prints**—galleries, art fairs, private collectors
- **color slides (35mm)**—most magazines, newspapers, some greeting card and calendar publishers, some book publishers, textbook publishers, stock agencies
- **color transparencies (2¼×2¼ and 4×5)**—magazines, book publishers, calendar publishers, ad agencies, stock agencies. Many of these photo buyers have begun to accept only digital photos, especially stock agencies.
- **digital**—newspapers, magazines, stock agencies, ad agencies, book and greeting card publishers. (All listings that accept digital work are marked with a ▣ symbol.)

5. Do you want to sell stock images or accept assignments? A stock image is any photograph you create on your own and then sell to a publisher. An assignment is a photograph created at the request of a specific buyer. Many of the listings in *Photographer's Market* are interested in both stock and assignment work.

- ▣ Listings that are only interested in stock photography are marked with a symbol.
- ▣ Listings that are only interested in assignment photography are marked with a symbol.

6. Start researching. Generate a list of the publishers that might buy your images—check the newsstand, go to the library, search the Web, read the listings in this book. Don't forget to look at greeting cards, stationery, calendars and CD covers. Anything you see with a photograph on it, from a billboard advertisement to a cereal box, is a potential market. See page 1 for instructions about how to read the listings in this book. If you shoot a specific subject, check the Subject Index on page 507 to simplify your search.

7. Check the publisher's guidelines. Do you know exactly how the publisher you choose wants to be approached? Check the listings in this book first. If you don't know the format, subject and number of images a publisher wants in a submission, you should check their website first. Often, guidelines are posted there. Or you can send a short letter with a self-addressed, stamped envelope (SASE) or e-mail asking those questions. A quick call to the receptionist might also yield you the answers.

8. Check out the market. Get in the habit of reading industry magazines. You'll find a list of useful magazines on page 468.

9. Prepare yourself. Before you send your first submission, make sure you know how to respond when a publisher agrees to buy your work.

Pay rates:

Most magazines and newspapers will tell you what they pay, and you can accept or decline. However, you should become familiar with typical pay rates. Ask other photographers what they charge—preferably ones you know well or who are not in direct competition with you. Many will be willing to tell you to prevent you from devaluing the market by undercharging. (See page 15 for more information.)

Other Resources:
 - *Pricing Photography: The Complete Guide to Assignment and Stock Price*, by Michal Heron and David MacTavish, Allworth Press.
 - *fotoQuote*, a software package that is updated each year to list typical stock photo and assignment prices, (800)679-0202, www.cradoc.com.
 - *Negotiating Stock Photo Prices*, by Jim Pickerell, 110 Frederick Ave., Suite A, Rockville MD 20850, (301)251-0720.

Copyright:

You should always include a copyright notice on any slide, print or digital image you send out. While you automatically own the copyright to your work the instant it is created, the notice affords extra protection. The proper format for a copyright notice includes the word or symbol for copyright, the date and your name: © 2009 Donna Poehner. To fully protect your copyright and recover damages from infringers, you must register your copyright with the Copyright Office in Washington, D.C. (See page 26 for more information.)

Rights:

In most cases, you will not actually be selling your photographs, but rather, the rights to publish them. If a publisher wants to buy your images outright, you will lose the right to resell those images in any form or even display them in your portfolio. Most publishers will buy one-time rights and/or first rights. (See page 26 for more information.)
 - Other Resources: *Legal Guide for the Visual Artist*, by Tad Crawford, Allworth Press.

Contracts:

Formal contract or not, you should always agree to any terms of sale in writing. This could be as simple as sending a follow-up letter restating the agreement and asking for confirmation, once you agree to terms over the phone. You should always keep copies of any correspondence in case of a future dispute or misunderstanding. (See page 25 for more information.)
 - Other Resources: *Business and Legal Forms for Photographers*, by Tad Crawford, Allworth Press.

10. Prepare your submission. The number one rule when mailing submissions is: "Follow the directions." Always address letters to specific photo buyers. Always include a SASE of sufficient size and with sufficient postage for your work to be safely returned to you. Never send originals when you are first approaching a potential buyer. Try to include something in your submission that the potential buyer can keep on file, such as a tearsheet and your re'sume'. In fact, photo buyers prefer that you send something they don't have to return to you. Plus, it saves you the time and expense of preparing a SASE. (See page 9 for more information.)
 - Other Resources: *Photo Portfolio Success*, by John Kaplan, Writer's Digest Books.

11. Continue to promote yourself and your work. After you've made that first sale (and even before), it is important to promote yourself. Success in selling your work depends in part on how well and how often you let photo buyers know what you have to offer. This is known as self-promotion. There are several ways to promote yourself and your work. You can send postcards or other printed material through the mail; send an e-mail with an image and a link to your website if you have one; and upload your images to a website that is dedicated to showcasing your work and your photographic services.

Running Your Business

Photography is an art that requires a host of skills, some which can be learned and some which are innate. To make money from your photography, the one skill you can't do without is a knowledge of business. Thankfully, this skill can be learned. What you'll find on the following pages are the basics of running a photography business. We'll cover:

SUBMITTING YOUR WORK

Editors, art directors and other photo buyers are busy people. Many only spend 10 percent of their work time actually choosing photographs for publication. The rest of their time is spent making and returning phone calls, arranging shoots, coordinating production and a host of other unglamorous tasks that make publication possible. They want to discover new talent, and you may even have the exact image they're looking for, but if you don't follow a market's submission instructions to the letter, you have little chance of acceptance.

To learn the dos and don'ts of photography submissions, read each market's listing carefully and make sure to send only what they ask for. Don't send prints if they only want slides. Don't send color if they only want black & white. Check their Website or send for guidelines whenever they are available to get the most complete and up-to-date submission advice. When in doubt, follow these 10 rules when sending your work to a potential buyer:

1. Don't forget your SASE—Always include a self-addressed, stamped envelope whether you want your submission back or not. Make sure your SASE is big enough, has enough packaging, and has enough postage to ensure the safe return of your work.

2. Don't over-package—Never make a submission difficult to open and file. Don't tape down all the loose corners. Don't send anything too large to fit in a standard file.

3. Don't send originals—Try not to send things you must have back. Never, ever send originals unsolicited.

4. Label everything—Put a label directly on the slide mount or print you are submitting. Include your name, address and phone number, as well as the name or number of the image. Your slides and prints will almost certainly get separated from your letter.

5. Do your research—Always research the places to which you want to sell your work. Request sample issues of magazines, visit galleries, examine ads, look at Websites, etc. Make sure your work is appropriate before you send it out. A blind mailing is a waste of postage and a waste of time for both you and the art buyer.

6. Follow directions—Always request submission guidelines. Includea SASE for reply. Follow *all* the directions exactly, even if you think they're silly.

7. Include a business letter—Always include a cover letter, no more than one page, that lets the potential buyer know you are familiar with their company, what your photography background is (briefly), and where you've sold work before (if it pertains to what you're trying to do now). If you send an e-mail, follow the same protocol as you would for a business cover letter and include the same information.

8. Send to a person, not a title—Send submissions to a specific person at a company. When you address a cover letter to Dear Sir or Madam, it shows you know nothing about the company you want to buy your work.

9. Don't forget to follow through—Follow up major submissions with postcard samples several times a year.

10. Have something to leave behind—If you're lucky enough to score a portfolio review, always have a sample of your work to leave with the art director. Make it small enough to fit in a file but big enough not to get lost. Always include your contact information directly on the leave-behind.

DIGITAL SUBMISSION GUIDELINES

Digital images can come from scanned slides, negatives or prints, or from digital cameras. Today, almost every publisher of photographs will accept digital images. Some still accept "analog" images (slides and prints) as well as digital images, but some accept *only* digital images. And, of course, there are those who still do not accept digital images at all, but their number is decreasing.

Previews

Photo buyers need to see a preview of an image before they can decide if it will fit

Starting a Business

For More Info

To learn more about starting a business:

- Take a course at a local college. Many community colleges offer short-term evening and weekend courses on topics like creating a business plan or finding financial assistance to start a small business.

- Contact the Small Business Administration at (800)827-5722 or check out their Website at www.sba.gov. The U.S. Small Business Administration was created by Congress in 1953 to help America's entrepreneurs form successful small enterprises. Today, SBA's program offices in every state offer financing, training and advocacy for small firms."

- Contact the Small Business Development Center at (202)205-6766. The SBDC offers free or low-cost advice, seminars and workshops for small business owners.

- Read a book. Try *The Business of Commercial Photography*, by Ira Wexler (Amphoto Books) or *The Business of Studio Photography*, by Edward R. Lilley (Allworth Press). The business section of your local library will also have many general books about starting a small business.

their needs. In the past, photographers mailed slides or prints to prospective photo buyers so they could review them, determine their quality, and decide whether or not the subject matter was something they could use. Or photographers sent a self-promotion mailer, often a postcard with one or more representative images of their work. Today, preview images can be e-mailed to prospective photo buyers, or they can be viewed on a photographer's website. This eliminates the hassle and expense of sending slides through the mail and wondering if you'll ever get them back.

The important thing about digital preview images is size. They should be no larger than 3 by 5 inches at 72 dpi. E-mailing larger files to someone who just wants a peek at your work could greatly inconvenience them if they have to wait a long time for the files to open or if their e-mail system cannot handle larger files. If photo buyers are interested in using your photographs, they will definitely want a larger, high-resolution file later, but don't overload their systems and their patience in the beginning with large files. Another option is sending a CD with preview images. This is not as efficient as e-mail or a Website since the photo buyer has to put the CD in the computer and view the images one by one. If you send a CD, be sure to include a printout of thumbnail images: If the photo buyer does not have time to put the CD in the computer and view the images, she can at least glance at the printed thumbnails. CDs and DVDs are probably best reserved for high-resolution photos you know the photo buyer wants and has requested from you.

Size & quality

Size and quality might be the two most important aspects of your digital submission. If the quality is not there, photo buyers will not be interested in buying your image regardless of its subject matter. Find out what the photo buyer needs. If you scan your slides or prints, make sure your scanning quality is excellent: no dirt, dust or scratches. If the file size is too small, they will not be able to do much with it either. A resolution of 72 dpi is fine for previews, but if a photo buyer wants to publish your images, they will want larger, high-resolution files. While each photo buyer may have different needs, there are some general guidelines to follow. Often digital images that are destined for print media need to be 300 dpi and the same size as the final, printed image will be (or preferably a little larger). For example, for a full-page photo in a magazine, the digital file might be 8 by 10 inches at 300 dpi. However, always check with the photo buyer who will ultimately be publishing the photo. Many magazines, book publishers, and stock photo agencies post digital submission guidelines on their Websites or will provide copies to photographers if they ask. Photo buyers are usually happy to inform photographers of their digital guidelines since they don't want to receive images they won't be able to use due to poor quality.

Note: Many of the listings in this book that accept digital images state the dpi they require for final submissions. They may also state the size they need in terms of megabytes (MB). See subhead "Specs" in each listing.

Formats

When you know that a photo buyer is definitely going to use your photos, you will then need to submit a high-resolution digital file (as opposed to the low-resolution 72-dpi JPEGs used for previews). Photo buyers often ask for digital images to be saved as JPEGs or TIFFs. Again, make sure you know what format they prefer. Some photo buyers will want you to send them a CD or DVD with the high-resolution images saved on it. Most photo buyers appreciate having a printout of thumbnail images to review in addition to the CD. Some may allow you to e-mail images directly to them, but keep in mind that anything larger than 9 megabytes is usually too large to e-mail. Get the permission of the photo buyer before you attempt to send anything that large via e-mail.

Another option is FTP (file transfer protocol). It allows files to be transferred over the Internet from one computer to another. This option is becoming more prevalent.

Note: Most of the listings in this book that accept digital images state the format they require for final digital submissions. See subhead "Specs" in each listing.

Color space

Another thing you'll need to find out from the photo buyer is what color space they want photos to be saved in. RGB (red, green, blue) is a very common one. You might also encounter CMYK (cyan, magenta, yellow and black). Grayscale is for photos that will be printed without any color (black & white). Again, check with the photo buyer to find out what color space they require.

Forms for Photographers

For More Info

To learn more about forms for photographers, try the following:

- EP (Editorial Photographers), www.editorialphoto.com.

- *Business and Legal Forms for Photographers*, by Tad Crawford (Allworth Press).

- *Legal Guide for the Visual Artist,* by Tad Crawford (Allworth Press).

- *ASMP Professional Business Practices in Photography,* (Allworth Press).

- The American Society of Media Photographers offers traveling business seminars that cover issues from forms to pricing to collecting unpaid bills. Write to them at 14 Washington Rd., Suite 502, Princeton Junction NJ 08550, for a schedule of upcoming business seminars, or visit www.asmp.org.

- The Volunteer Lawyers for the Arts, 1 E. 53rd St., 6th Floor, New York NY 10022, (212)319-2910. The VLA is a nonprofit organization, based in New York City, dedicated to providing all artists, including photographers, with sound legal advice.

USING ESSENTIAL BUSINESS FORMS

Using carefully crafted business forms will not only make you look more professional in the eyes of your clients; it will make bills easier to collect while protecting your copyright. Forms from delivery memos to invoices can be created on a home computer with minimal design skills and printed in duplicate at most quick-print centers. When producing detailed contracts, remember that proper wording is imperative. You want to protect your copyright and, at the same time, be fair to clients. Therefore, it's a good idea to have a lawyer examine your forms before using them.

The following forms are useful when selling stock photography, as well as when shooting on assignment:

Delivery Memo

This document should be mailed to potential clients along with a cover letter when any submission is made. A delivery memo provides an accurate count of the images that are enclosed, and it provides rules for usage. The front of the form should include a description of the images or assignment, the kind of media in which the images can be used, the price for such usage, and the terms and conditions of paying for that usage. Ask clients to sign and return a copy of this form if they agree to the terms you've spelled out.

Terms & conditions

This form often appears on the back of the delivery memo, but be aware that conditions on the front of a form have more legal weight than those on the back. Your terms and conditions should outline in detail all aspects of usage for an assignment or stock image. Include copyright information, client liability, and a sales agreement. Also be sure to include conditions covering the alteration of your images, transfer of rights, and digital storage. The more specific your terms and conditions are to the individual client, the more legally binding they will be. If you create your forms on your computer, seriously consider altering your standard contract to suit each assignment or other photography sale.

Invoice

This is the form you want to send more than any of the others, because mailing it means you have made a sale. The invoice should provide clients with your mailing address, an explanation of usage, and the amount due. Be sure to include a reasonable due date for payment, usually 30 days. You should also include your business tax identification number or social security number.

Model/Property Releases

Get into the habit of obtaining releases from anyone you photograph. They increase the sales potential for images and can protect you from liability. A model release is a short form, signed by the person(s) in a photo, that allows you to sell the image for commercial purposes. The property release does the same thing for photos of personal property. When photographing children, remember that a parent or guardian must sign before the release is legally binding. In exchange for signed releases, some photographers give their subjects copies of the photos; others pay the models. You may choose the system that works best for you, but keep in mind that a legally binding contract must involve consideration, the exchange of something of value. Once you obtain a release, keep it in a permanent file. (You'll find a sample property release on page 15 and a sample model release on page 16.)

You do not need a release if the image is being sold editorially. However, magazines now require such forms in order to protect themselves, especially when an image is used as a photo illustration instead of as a straight documentary shot. You always need a release for advertising purposes or for purposes of trade and promotion. In works of art, you only need a release if the subject is recognizable. When traveling in a foreign country, it is a good idea to carry releases written in that country's language. To translate releases into a foreign language, check with an embassy or a college language professor.

STOCK LIST

Some market listings in this book ask for a stock list, so it is a good idea to have one on hand. Your stock list should be as detailed and specific as possible. Include all the subjects you have in your photo files, breaking them into logical categories

PROPERTY RELEASE

In consideration of $_____$ and/or $_____$
$_____$, receipt of which is acknowledged, I being the legal owner of
or having the right to permit the taking and use of photographs of certain prop-
erty designated as $_____$, do hereby
give $_____$, his/her assigns, licensees, and legal repre-
sentatives the irrevocable right to use this image in all forms and media and in
all manners, including composite or distorted representations, for advertising,
trade, or any other lawful purposes, and I waive any rights to inspect or approve
the finished product, including written copy that may be created in connection
therewith.

Short description of photographs: $_____$
$_____$
$_____$

Additional information: $_____$

I am of full age. I have read this release and fully understand its contents.

Please Print:

Name $_____$

Address $_____$

City $_____$ State $_____$ Zip Code $_____$

Sample property release

and subcategories. On page 17 is a sample stock list that shows how you might
categorize your stock images to create a list that will be easy for photo buyers to
skim. This sample list only hints at what a stock list might include. Create a list that
reflects your unique collection of images.

CHARGING FOR YOUR WORK

No matter how many books you read about what photos are worth and how much
you should charge, no one can set your fees for you. If you let someone try, you'll
be setting yourself up for financial ruin. Figuring out what to charge for your work
is a complex task that will require a lot of time and effort. But the more time you
spend finding out how much you need to charge, the more successful you'll be at
targeting your work to the right markets and getting the money you need to keep
your business, and your life, going.

Keep in mind that what you charge for an image may be completely different

MODEL RELEASE

In consideration of $ _____ and/or _____,
receipt of which is acknowledged, I, _____, do
hereby give _____, his/her assigns, licensees, and
legal representatives the irrevocable right to use my image in all forms and
media and in all manners, including composite or distorted representations, for
advertising, trade, or any other lawful purposes, and I waive any rights to in-
spect or approve the finished product, including written copy that may be cre-
ated in connection therewith. The following name may be used in reference to
these photographs:

My real name, or _____

Short description of photographs: _____

Additional information: _____

Please print:

Name _____

Address _____

City _____ State _____ Zip code _____

Country _____

CONSENT

(If model is under the age of 18) I am the parent or guardian of the minor named
above and have the legal authority to execute the above release. I approve the
foregoing and waive any rights in the premises.

Please print:

Name _____

Address _____

City _____ State _____ Zip code _____

Country _____

Signature _____

Witness _____ Date _____

Sample model release

STOCK LIST

INSECTS
Ants
Aphids
Bees
Beetles
Butterflies
Grasshoppers
Moths
Termites
Wasps

PROFESSIONS
Bee Keeper
Biologist
Firefighter
Nurse
Police Officer
Truck Driver
Waitress
Welder

LANDMARKS
Asia
 Angkor Wat
 Great Wall of China

Europe
 Big Ben
 Eiffel Tower
 Louvre
 Stonehenge

United States
 Empire State Building
 Grand Canyon
 Liberty Bell
 Mt. Rushmore
 Statue of Liberty

TRANSPORTATION
Airplanes and helicopters
Roads
 Country roads
 Dirt roads
 Interstate highways
 Two-lane highways

WEATHER
Clouds
 Cumulus
 Cirrus
 Nimbus
 Stratus
Flooding
Lightning
Snow and Blizzards
Storm Chasers
Rainbows
Tornadoes
Tornado Damage

Sample stock list

from what a photographer down the street charges. There is nothing wrong with this if you've calculated your prices carefully. Perhaps the photographer works in a basement on old equipment and you have a brand new, state-of-the-art studio. You'd better be charging more. Why the disparity? For one thing, you've got a much higher overhead, the continuing costs of running your business. You're also probably delivering a higher-quality product and are more able to meet client requests quickly. So how do you determine just how much you need to charge in order to make ends meet?

Setting your break-even rate

All photographers, before negotiating assignments, should consider their break-even rate—the amount of money they need to make in order to keep their studios open. To arrive at the actual price you'll quote to a client, you should add onto your base rate things like usage, your experience, how quickly you can deliver the image, and what kind of prices the market will bear.

Start by estimating your business expenses. These expenses may include rent (office, studio), gas and electric, insurance (equipment), phone, fax, Internet service, office supplies, postage, stationery, self-promotions/portfolio, photo equipment, computer, staff salaries, taxes. Expenses like film and processing will be charged to your clients.

Next, figure your personal expenses, which will include food, clothing, medical, car and home insurance, gas, repairs and other car expenses, entertainment, retirement savings and investments, etc.

Before you divide your annual expenses by the 365 days in the year, remember you won't be shooting billable assignments every day. A better way to calculate your base fee is by billable weeks. Assume that at least one day a week is going to be spent conducting office business and marketing your work. This amounts to approximately 10 weeks. Add in days for vacation and sick time, perhaps three weeks, and add another week for workshops and seminars. This totals 14 weeks of nonbillable time and 38 billable weeks throughout the year.

Now estimate the number of assignments/sales you expect to complete each week and multiply that number by 38. This will give you a total for your yearly assignments/sales. Finally, divide the total overhead and administrative expenses by the total number of assignments. This will give you an average price per assignment, your break-even or base rate.

As an example, let's say your expenses come to $65,000 per year (this includes $35,000 of personal expenses). If you complete two assignments each week for 38 weeks, your average price per assignment must be about $855. This is what you should charge to break even on each job. But, don't forget, you want to make money.

Establishing usage fees

Too often, photographers shortchange themselves in negotiations because they do not understand how the images in question will be used. Instead, they allow clients to set prices and prefer to accept lower fees rather than lose sales. Unfortunately,

those photographers who shortchange themselves are actually bringing down prices throughout the industry. Clients realize if they shop around they can find photographers willing to shoot assignments at very low rates.

There are ways to combat low prices, however. First, educate yourself about a client's line of work. This type of professionalism helps during negotiations because it shows buyers that you are serious about your work. The added knowledge also gives you an advantage when negotiating fees because photographers are not expected to understand a client's profession.

For example, if most of your clients are in the advertising field, acquire advertising rate cards for magazines so you know what a client pays for ad space. You can also find print ad rates in the Standard Rate and Data Service directory at the library. Knowing what a client is willing to pay for ad space and considering the importance of your image to the ad will give you a better idea of what the image is really worth to the client.

For editorial assignments, fees may be more difficult to negotiate because most magazines have set page rates. They may make exceptions, however, if you have experience or if the assignment is particularly difficult or time-consuming. If a magazine's page rate is still too low to meet your break-even price, consider asking for extra tearsheets and copies of the issue in which your work appears. These pieces can be used in your portfolio and as mailers, and the savings they represent in printing costs may make up for the discrepancy between the page rate and your break-even price.

There are still more ways to negotiate sales. Some clients, such as gift and paper product manufacturers, prefer to pay royalties each time a product is sold. Special markets, such as galleries and stock agencies, typically charge photographers a commission of 20 to 50 percent for displaying or representing their images. In these markets, payment on sales comes from the purchase of prints by gallery patrons, or from fees on the "rental" of photos by clients of stock agencies. Pricing formulas should be developed by looking at your costs and the current price levels in those markets, as well as on the basis of submission fees, commissions and other administrative costs charged to you.

Bidding for jobs

As you build your business, you will likely encounter another aspect of pricing and negotiating that can be very difficult. Like it or not, clients often ask photographers to supply bids for jobs. In some cases, the bidding process is merely procedural and the assignment will go to the photographer who can best complete it. In other instances, the photographer who submits the lowest bid will earn the job. When asked to submit a bid, it is imperative that you find out which bidding process is being used. Putting together an accurate estimate takes time, and you do not want to waste your efforts if your bid is being sought merely to meet some budget quota.

If you decide to bid on a job, it's important to consider your costs carefully. You do not want to bid too much on projects and repeatedly get turned down, but you also don't want to bid too low and forfeit income. When a potential client calls to ask for a bid, consider these dos and don'ts:

1. Always keep a list of questions by the telephone so you can refer to it when bids are requested. The answers to the questions should give you a solid understanding of the project and help you reach a price estimate.

2. Never quote a price during the initial conversation, even if the caller pushes for a "ballpark figure." An on-the-spot estimate can only hurt you in the negotiating process.

3. Immediately find out what the client intends to do with the photos, and ask who will own copyrights to the images after they are produced. It is important to note that many clients believe if they hire you for a job they'll own all the rights to the images you create. If they insist on buying all rights, make sure the price they pay is worth the complete loss of the images.

4. If it is an annual project, ask who completed the job last time, then contact that photographer to see what he or she charged.

5. Find out who you are bidding against and contact those people to make sure you received the same information about the job. While agreeing to charge the same price is illegal, sharing information about reaching a price is not.

6. Talk to photographers not bidding on the project and ask them what they would charge.

7. Finally, consider all aspects of the shoot, including preparation time, fees for assistants and stylists, rental equipment, and other materials costs. Don't leave anything out.

FIGURING SMALL BUSINESS TAXES

Whether you make occasional sales from your work or you derive your entire income from your photography skills, it's a good idea to consult with a tax professional. If you are just starting out, an accountant can give you solid advice about organizing your financial records. If you are an established professional, an accountant can double-check your system and maybe find a few extra deductions. When consulting with a tax professional, it is best to see someone who is familiar with the needs and concerns of small business people, particularly photographers. You can also conduct your own tax research by contacting the Internal Revenue Service.

Self-employment tax

As a freelancer it's important to be aware of tax rates on self-employment income. All income you receive over $400 without taxes being taken out by an employer qualifies as self-employment income. Normally, when you are employed by someone else, the employer shares responsibility for the taxes due. However, when you are self-employed, you must pay the entire amount yourself.

Freelancers frequently overlook self-employment taxes and fail to set aside a sufficient amount of money. They also tend to forget state and local taxes. If the volume of your photo sales reaches a point where it becomes a substantial percentage of your income, then you are required to pay estimated tax on a quarterly

Pricing Information

For More Info

Where to find more information about pricing:

- *Pricing Photography: The Complete Guide to Assignment and Stock Prices*, by Michal Heron and David MacTavish (Allworth Press).

- *ASMP Professional Business Practices in Photography*, (Allworth Press).

- *fotoQuote*, a software package produced by the Cradoc Corporation, is a customizable, annually updated database of stock photo prices for markets from ad agencies to calendar companies. The software also includes negotiating advice and scripted telephone conversations. Call (800)679-0202, or visit www.fotoquote.comfor ordering information.

- Stock Photo Price Calculator, a Website that suggests fees for advertising, corporate and editorial stock, http://photographersindex. com/stockprice.htm.

- EP (Editorial Photographers), www.editorialphoto.com.

basis. This requires you to project the amount of money you expect to generate in a three-month period. However burdensome this may be in the short run, it works to your advantage in that you plan for and stay current with the various taxes you are required to pay. Read IRS publication #505 (Tax Withholding and Estimated Tax).

Deductions

Many deductions can be claimed by self-employed photographers. It's in your best interest to be aware of them. Examples of 100-percent-deductible claims include production costs of résumé, business cards and brochures; photographer's rep commissions; membership dues; costs of purchasing portfolio materials; education/ business-related magazines and books; insurance; and legal and professional services.

Additional deductions can be taken if your office or studio is home-based. The catch here is that your work area must be used only on a professional basis; your office can't double as a family room after hours. The IRS also wants to see evidence that you use the work space on a regular basis via established business hours and proof that you've actively marketed your work. If you can satisfy these criteria, then a percentage of mortgage interests, real estate taxes, rent, maintenance costs, utilities and homeowner's insurance, plus office furniture and equipment, can be claimed on your tax form at year's end.

In the past, to qualify for a home-office deduction, the space you worked in had to

Tax Information

For More Info

To learn more about taxes, contact the IRS. There are free booklets available that provide specific information, such as allowable deductions and tax rate structure:

- Tax Guide for Small Businesses, #334
- Travel, Entertainment, Gift and Car Expenses, #463
- Tax Withholding and Estimated Tax, #505
- Business Expenses, #535
- Accounting Periods and Methods, #538
- Business Use of Your Home, #587

To order any of these booklets, phone the IRS at (800)829-3676. IRS forms and publications, as well as answers to questions and links to help, are available on the Internet at www.irs.gov.

be "the most important, consequential, or influential location" you used to conduct your business. This meant that if you had a separate studio location for shooting but did scheduling, billing and record keeping in your home office, you could not claim a deduction. However, as of 1999, your home office will qualify for a deduction if you "use it exclusively and regularly for administrative or management activities of your trade or business and you have no other fixed location where you conduct substantial administrative or management activities of your trade or business." Read IRS publication #587, Business Use of Your Home, for more details.

If you are working out of your home, keep separate records and bank accounts for personal and business finances, as well as a separate business phone. Since the IRS can audit tax records as far back as seven years, it's vital to keep all paperwork related to your business. This includes invoices, vouchers, expenditures and sales receipts, canceled checks, deposit slips, register tapes and business ledger entries for this period. The burden of proof will be on you if the IRS questions any deductions claimed. To maintain professional status in the eyes of the IRS, you will need to show a profit for three years out of a five-year period.

Sales tax

Sales taxes are complicated and need special consideration. For instance, if you work in more than one state, use models or work with reps in one or more states, or work in one state and store equipment in another, you may be required to pay sales tax in each of the states that apply. In particular, if you work with an out-of-state stock photo agency that has clients over a wide geographic area, you should explore your tax liability with a tax professional.

- As with all taxes, sales taxes must be reported and paid on a timely basis to avoid audits and/or penalties. In regard to sales tax, you should:
- Always register your business at the tax offices with jurisdiction in your city and state.
- Always charge and collect sales tax on the full amount of the invoice, unless an exemption applies.
- If an exemption applies because of resale, you must provide a copy of the customer's resale certificate. If an exemption applies because of other conditions, such as selling one-time reproduction rights or working for a tax-exempt, nonprofit organization, you must also provide documentation.

SELF-PROMOTION

There are basically three ways to acquaint photo buyers with your work: through the mail, over the Internet, or in person. No one way is better or more effective than another. They each serve an individual function and should be used in concert to increase your visibility and, with a little luck, your sales.

Self-promotion mailers

When you are just starting to get your name out there and want to begin generating assignments and stock sales, it's time to design a self-promotion campaign. This is your chance to do your best, most creative work and package it in an unforgettable way to get the attention of busy photo buyers. Self-promotions traditionally are sample images printed on card stock and sent through the mail to potential clients. If the image you choose is strong and you carefully target your mailing, a traditional self-promotion can work.

But don't be afraid to go out on a limb here. You want to show just how amazing and creative you are, and you want the photo buyer to hang onto your sample for

Ideas for Great Self-Promotion

For More Info

Where to find ideas for great self-promotion:

- *HOW* magazine's self-promotion annual (October issue).
- *Self-Promotion Online*, by Ilise Benun (North Light Books).
- *Photo District News*, magazine's self-promotion issue (April).
- *The Photographer's Guide to Marketing & Self-Promotion*, by Maria Piscopo (Allworth Press).
- *Marketing Guidebook for Photographers*, by Mary Virginia Swanson, available at www.mvswanson.com or by calling (520)742-6311.

as long as possible. Why not make it impossible to throw away? Instead of a simple postcard, maybe you could send a small, usable notepad with one of your images at the top, or a calendar the photo buyer can hang up and use all year. If you target your mailing carefully, this kind of special promotion needn't be expensive.

If you're worried that a single image can't do justice to your unique style, you have two options. One way to get multiple images in front of photo buyers without sending an overwhelming package is to design a campaign of promotions that builds from a single image to a small group of related photos. Make the images tell a story and indicate that there are more to follow. If you are computer savvy, the other way to showcase a sampling of your work is to point photo buyers to an online portfolio of your best work. Send a single sample that includes your Internet address, and ask buyers to take a look.

Websites

Websites are steadily becoming more important in the photographer's self-promotion repertory. If you have a good collection of digital photographs—whether they have been scanned from film or are from a digital camera—you should consider creating a Website to showcase samples of your work, provide information about the type of work you do, and display your contact information. The Website does not have to be elaborate or contain every photograph you've ever taken. In fact, it is best if you edit your work very carefully and choose only the best images to display on your Website. The benefit of having a Website is that it makes it so easy for photo buyers to see your work. You can send e-mails to targeted photo buyers and include a link to your Website. Many photo buyers report that this is how they prefer to be contacted. Of course, your URL should also be included on any print materials, such as postcards, brochures, your business cards and stationery. Some photographers even include their URL in their credit line.

Portfolio presentations

Once you've actually made contact with potential buyers and piqued their interest, they'll want to see a larger selection of your work—your portfolio. Once again, there's more than one way to get this sampling of images in front of buyers. Portfolios can be digital—stored on a disk or CD-ROM, or posted on the Internet. They can take the form of a large box or binder and require a special visit and presentation by you. Or they can come in a small binder and be sent through the mail. Whichever way(s) you choose to showcase your best work, you should always have more than one portfolio, and each should be customized for potential clients.

Keep in mind that your portfolios should contain your best work (dupes only). Never put originals in anything that will be out of your hands for more than a few minutes. Also, don't include more than 20 images. If you try to show too many pieces you'll overwhelm the buyer, and any image that is less than your best will detract from the impact of your strongest work. Finally, be sure to show only work a buyer is likely to use. It won't do any good to show a shoe manufacturer your shots of farm animals or a clothing company your food pictures. For more detailed

information on the various types of portfolios and how to select which photos to include and which ones to leave out, see *Photo Portfolio Success*, by John Kaplan (Writer's Digest Books).

Do you need a résumé?

Some of the listings in this book say to submit a résumé with samples. If you are a freelancer, a résumé may not always be necessary. Sometimes a stock list or a list of your clients may suffice, and may be all the photo buyer is really looking for. If you do include a résumé, limit the details to your photographic experience and credits. If you are applying for a position teaching photography or for a full-time photography position at a studio, corporation, newspaper, etc., you will need the résumé. Galleries that want to show your work may also want to see a résumé, but, again, confine the details of your life to significant photographic achievements.

ORGANIZING & LABELING YOUR IMAGES

It will be very difficult for you to make sales of your work if you aren't able to locate a particular image in your files when a buyer needs it. It is imperative that you find a way to organize your images—a way that can adapt to a growing file of images. There are probably as many ways to catalog photographs as there are photographers. However, most photographers begin by placing their photographs into large, general categories such as landscapes, wildlife, countries, cities, etc. They then break these down further into subcategories. If you specialize in a particular subject—birds, for instance—you may want to break the bird category down further into cardinal, eagle, robin, osprey, etc. Find a coding system that works for your particular set of photographs. For example, nature and travel photographer William Manning says, "I might have slide pages for Washington, DC (WDC), Kentucky (KY), or Italy (ITY). I divide my mammal subcategory into African wildlife (AWL), North American wildlife (NAW), zoo animals (ZOO)."

After you figure out a coding system that works for you, find a method for captioning

Image Organization & Storage

To learn more about selecting, organizing, labeling and storing images, see:

For More Info

- *The Photographer's Travel Guide*, by William Manning (Writer's Digest Books).

- *Photo Portfolio Success*, by John Kaplan (Writer's Digest Books).

- *Sell & Re-Sell Your Photos*, by Rohn Engh, 5th edition (Writer's Digest Books).

your slides. Captions with complete information often prompt sales: Photo editors appreciate having as much information as possible. Always remember to include your name and copyright symbol © on each photo. Computer software can make this job a lot easier. Programs such as Emblazon (www.planettools.com), formerly CaptionWriter, allow photographers to easily create and print labels for their slides.

The computer also makes managing your photo files much easier. Programs such as FotoBiz (www.fotobiz.net) and StockView (www.hindsightltd.com) are popular with freelance assignment and stock photographers. FotoBiz has an image log and is capable of creating labels. FotoBiz can also track your images and allows you to create documents such as delivery memos, invoices, etc. StockView (www.hindsightltd.com/stockview/stockview.html) also tracks your images, has labeling options, and can create business documents.

PROTECTING YOUR COPYRIGHT

There is one major misconception about copyright: Many photographers don't realize that once you create a photo it becomes yours. You (or your heirs) own the copyright, regardless of whether you register it for the duration of your lifetime plus 70 years.

The fact that an image is automatically copyrighted does not mean that it shouldn't be registered. Quite the contrary. You cannot even file a copyright infringement suit until you've registered your work. Also, without timely registration of your images, you can only recover actual damages—money lost as a result of sales by the infringer plus any profits the infringer earned. For example, recovering $2,000 for an ad sale can be minimal when weighed against the expense of hiring a copyright attorney. Often this deters photographers from filing lawsuits if they haven't registered their work. They know that the attorney's fees will be more than the actual damages recovered, and, therefore, infringers go unpunished.

Registration allows you to recover certain damages to which you otherwise would not be legally entitled. For instance, attorney fees and court costs can be recovered. So too can statutory damages—awards based on how deliberate and harmful the infringement was. Statutory damages can run as high as $100,000. These are the fees that make registration so important.

In order to recover these fees, there are rules regarding registration that you must follow. The rules have to do with the timeliness of your registration in relation to the infringement:

• **Unpublished images** must be registered before the infringement takes place.

• **Published images** must be registered within three months of the first date of publication or before the infringement began.

The process of registering your work is simple. Contact the Register of Copyrights, Library of Congress, Washington, DC 20559, (202)707-9100, and ask for Form VA (works of visual art). Registration costs $30, but you can register photographs in large quantities for that fee. For bulk registration, your images must be organized under one title, for example, "The works of John Photographer, 1990-1995."

The copyright notice

Another way to protect your copyright is to mark each image with a copyright notice. This informs everyone reviewing your work that you own the copyright. It may seem basic, but in court this can be very important. In a lawsuit, one avenue of defense for an infringer is "innocent infringement"—basically the "I-didn't-know" argument. By placing a copyright notice on your images, you negate this defense for an infringer.

The copyright notice basically consists of three elements: the symbol, the year of first publication, and the copyright holder's name. Here's an example of a copyright notice for an image published in 1999: © 1999 John Q. Photographer. Instead of the symbol ©, you can use the word "Copyright" or simply "Copr." However, most foreign countries prefer © as a common designation.

Also consider adding the notation "All rights reserved" after your copyright notice. This phrase is not necessary in the U.S. since all rights are automatically reserved, but it is recommended in other parts of the world.

Know your rights

The digital era is making copyright protection more difficult. As this technology grows, more and more clients will want digital versions of your photos. Don't be alarmed, just be careful. Your clients don't want to steal your work. When you negotiate the usage of your work, consider adding a phrase to your contract that limits the rights of buyers who want digital versions of your photos. You might want them to guarantee that images will be removed from their computer files once the work appears in print. You might say it's okay to perform limited digital manipulation, and then specify what can be done. The important thing is to discuss what the client intends to do and spell it out in writing.

It's essential not only to know your rights under the Copyright Law, but also to make sure that every photo buyer you deal with understands them. The following list of typical image rights should help you in your dealings with clients:

- **One-time rights.** These photos are "leased" or "licensed" on a one-time basis; one fee is paid for one use.
- **First rights.** This is generally the same as purchase of one-time rights, though the photo buyer is paying a bit more for the privilege of being the first to use the image. He may use it only once unless other rights are negotiated.
- **Serial rights.** The photographer has sold the right to use the photo in a periodical. This shouldn't be confused with using the photo in "installments." Most magazines will want to be sure the photo won't be running in a competing publication.
- **Exclusive rights.** Exclusive rights guarantee the buyer's exclusive right to use the photo in his particular market or for a particular product. A greeting card company, for example, may purchase these rights to an image with the stipulation that it not be sold to a competing company for a certain time period. The photographer, however, may retain rights to sell the image to other markets. Conditions should always be put in writing to avoid any misunderstandings.

- **Electronic rights.** These rights allow a buyer to place your work on electronic media such as CD-ROMs or websites. Often these rights are requested with print rights.

- **Promotion rights.** Such rights allow a publisher to use a photo for promotion of a publication in which the photo appears. The photographer should be paid for promotional use in addition to the rights first sold to reproduce the image. Another form of this—agency promotion rights—is common among stock photo agencies. Likewise, the terms of this need to be negotiated separately.

- **Work for hire.** Under the Copyright Act of 1976, section 101, a "work for hire" is defined as: "(1) a work prepared by an employee within the scope of his or her employment; or (2) a work . . . specially ordered or commissioned for use as a contribution to a collective, as part of a motion picture or audiovisual work or as a supplementary work . . . if the parties expressly agree in a written instrument signed by them that the work shall be considered a work made for hire."

- **All rights.** This involves selling or assigning all rights to a photo for a specified period of time. This differs from work for hire, which always means the photographer permanently surrenders all rights to a photo and any claims to royalties or other future compensation. Terms for all rights—including time period of usage and compensation—should only be negotiated and confirmed in a written agreement with the client.

It is understandable for a client not to want a photo to appear in a competitor's ad. Skillful negotiation usually can result in an agreement between the photographer and the client that says the image(s) will not be sold to a competitor, but could be sold to other industries, possibly offering regional exclusivity for a stated time period.

Protecting Your Copyright

For More Info

How to learn more about protecting your copyright:

- Call the Copyright Office at (202)707-3000 or check out their Website, http://lcweb.loc.gov/copyright, for forms and answers to frequently asked questions.

- ASMP (American Society of Media Photographers), www.asmp.org/commerce/legal/copyright.

- EP (Editorial Photographers), www.editorialphoto.com. *Legal Guide for the Visual Artist*, by Tad Crawford, Allworth Press.

- *SPAR* (Society of Photographers and Artists Representatives), (212)779-7464.

Denny Eilers

The balanced photographer; different ways to market your work

by Kim Andersen

Photographers should continually update their learning," says nationally-known photographer, Denny Eilers. "And work where your passion is."

A seasoned veteran of the photography world, Eilers was a combat journalist for the Army during Viet Nam, worked four years for a publishing company, and worked 15 years for ad agencies in Philadelphia, Atlanta, St. Louis and Kansas City. He also has a degree in Journalism from Iowa State with a minor in Agriculture, and owns Iowa Photo Farm in Luana, Iowa. He specializes in agricultural, hi-tech, business and travel photography, and has completed projects for John Deere and Massey-Ferguson, and has done a shoot for ABC's *Extreme Makeover: Home Edition*. He's also a freelance writer and has done work for *Our Iowa*, the *Wisconsin State Journal*, United Press International, *Encyclopedia Britannica*, Disney, the Associated Press, and several newspapers around the country.

Eilers has the unique perspective of having been on both sides of the camera when it comes to knowing what sells. With his publishing and ad agency experience, he knows what ad departments are looking for and how to deliver. Having started out with 35mm film before making the transition to digital, he also understands the importance of keeping things up-to-date and having a good camera.

"The more you know about your camera," he says, "the less time you'll spend in your office with Photoshop fixing mistakes. It takes good equipment to take good pictures."

TYPES OF PHOTOGRAPHY

Other than portrait photography, there are three main types of photography; editorial, stock and commercial. Eilers handles all three. "Ad agencies have clients who know what they want. Your job is to give them what they want and more,"

KIM ANDERSEN is a freelance writer and photographer, who has written for several daily and weekly newspapers in both Iowa and Wisconsin. A former editor of the *North Iowa Times*, she's an award-winning fiction writer who lives in Platteville, Wisconsin, with her son and mini dachshund.

he says. "For commercial work, pick a specialty area. This should be something you have a passion for and love. Commercial photography is the most competitive and pays the most," says Eilers. "You need better equipment which you can rent, if need be."

Ad agencies

Making a list of businesses which have in-house ad agencies, or businesses that do the majority of their work in-house is important. And photographers need to have the correct contact information. "Don't query ad agencies by e-mail unless you know for sure you can do exactly what they need," Eilers says. Know exactly how to sell their products or make sure you've done that type of work before. "Photo buyers don't buy what they like," says Eilers. "They buy what they need... a photo

Photo © Denny Eilers

Denny Eilers has a large portfolio of livestock images such as this Wisconsin dairy cow.

to help them sell their client's product. Ask yourself how you would take a picture that would sell a product to someone who hasn't used it."

Hire someone to market you, he suggests. Some photographers have a photo representative. They know the business well and if they are good, they will work hard for you. The more work they sell, the more money you both make. Regardless, you need to keep good records.

If photographers choose to go it alone, they need to know what their time is worth, and have an idea what the going rates are at the moment so they can bid appropriately for a job. Updating and replacing out-of-date equipment has to be done periodically to be competitive. Eilers advises photographers who are just out of college and possibly have work already published to get a job in newspapers or small ad agencies to learn how art directors and publishers work and how photos are chosen.

Editorial

Editorial photography is the second way photographers can market their work. This includes magazines, newspapers and websites. They pay less than ad agencies and are usually on a tighter budget. Photographers don't need the same level of equipment they need for commercial work, however. Editorial photograph is usually "people-based," meaning clients are looking for photos of people doing various things.

By capturing the light behind these mature soybean plants, Denny Eilers turned an ordinary crop photo into something special.

"People doing commercial work should also do editorial," says Eilers. "This is where your byline comes from. You don't get a byline from commercial work. This will help you with name recognition and help get the word out about you and your work." He sells "photo/text" packages—written work along with photography.

For editorial work, a clear, written contract should be in place which deals with payment and deadlines. A "kill fee" should be added in the contract in case the article is pulled or doesn't run for some reason. This should cover the photographer's time and the amount is agreed upon by both parties.

Ask yourself: What does the editor of a magazine need for the upcoming issues? Many times future work comes from something you're currently working on. It's important to master the art of query letters when working for the editorial market. Make them as short and concise as possible. Photographers should make sure they're querying the right person as editors can change frequently. If they're only interested in taking photos, photographers should look for a good feature writer with whom to do articles. Even though Eilers is also a writer, he sometimes hires freelance writers to work with him. Things move faster and he can handle more projects that way. "Make sure you take good notes, though," he warns, "if you're going to write the piece yourself." There's nothing worse than not checking your facts because once it's on the page, it's on the page. Even a retraction doesn't totally take away from the mistake and in some circumstances, can end up costing the publication advertising money.

Both commercial and editorial photography have gone almost completely digital. Any photo transparencies or prints you have in your collection will need to be scanned into digital format to send out to clients. "They don't want to see film anymore," says Eilers.

Stock

Stock photography has three categories:

1. Royalty-free—a photo is bought once and used as many times as the purchaser wants.

2. Micro stock—a photographer sells his work himself or through a website

Photo © Denny Eilers

Photo © Denny Eilers

Denny Eilers caught a farmer at work, tractor in sight, as he tends to organic tomato seedlings.

business specializing in micro-stock photography and sells the photo for a set amount many times over.

3. Rights-managed—the photographer retains the rights to the photos. For example, the client may buy the photo and have exclusive use of it for a year. All categories have their merits, but rights-managed gives the photographer control over the use of their photos.

Unlike commercial or editorial work, stock photography takes more time to be financially rewarding. Stock agencies typically want 500-1,000 portfolio-quality photos. Make sure you have their specifications including formatting before submitting your work. Take a look at the agency and see what they *don't* have. Specialize in that if you can; there's less competition that way. Document every picture; when and where it was taken and who's in it. Carry releases with you everywhere you go and don't leave a shoot without making sure they're signed by the people you can see clearly in the shot. If you live in New York, it may be difficult to take the time to go back to Idaho to try and find the person you need to sign it.

Since Eilers specializes in agricultural and hunting and fishing shots, his work is perfect for stock photography. The shots he has in his portfolio are seasonal. If an ad agency is looking for a certain picture of deer hunters in bright orange making their way through the woods, chances are they won't be able to hire someone to take that shot in May for an upcoming issue of their magazine. They will have to turn to stock photography. Specializing in something few other photographers do will increase your chances of selling more pictures. "To really succeed in photography today, you have to be your own coach," says Eilers. "You may not have the best pictures, but you need to have the best marketing plan."

10 Tips for the Balanced Photographer

Tips

1. Hire an assistant to do the digital post-processing. This allows you more time to shoot pictures without having to take time out to process them properly.

2. Understand copyright laws and releases.

3. In your specialty areas, "go deep, go wide." Research as in-depth as you can and know your area well.

4. Keep good, current business records.

5. Learn the business inside and out.

6. Equipment needs to be as up-to-date as possible for you to be competitive.

7. Think about your photography as a business which includes health insurance and retirement plans.

8. Don't ever be caught without a release.

9. Attend major trade shows in the area you've decided to specialize in.

10. Remember to "ready, aim, fire," not "ready, fire, aim." Set up the picture, take a good one, and know where you're going to sell it. Taking a lot of pictures with no idea where to sell them is not a good use of your time.

Articles & Interviews

David Grubbs

A long career of capturing moments

by Crystal Pirri

David Grubbs has been a photojournalist for 27 years. He's worked for three daily newspapers, teaches photography at three universities, and his photos have been published in *Time, Sports Illustrated, Newsweek, Life,* and *The New York Times,* among others. Grubbs has even created his own brand of camera strap, Wapiti Straps, which are used by the White House photographer Pete Souza. You've probably seen his most published photograph—a painting crew standing before the erroneous word "SHCOOL" on the street.

Through high school and the beginning of college, however, Grubbs didn't aspire to be a photographer, but an architect. He was working two low-paying jobs between semesters when a friend recommended him for a staff artist job at the local newspaper, the *Helena Independent Record.*

As fate would have it, Grubbs became friends with the two photographers at the paper, George Lane and Gene Fisher. Their enthusiasm for photography was infectious and soon he bought his first camera, a Pentex K1000. Lane and Fisher mentored him, encouraging his interest in photography and showing him how to develop negatives in the darkroom. It became such a passion for him that he brought his camera to work every day.

Making the front page

During that time the paper had been reporting the efforts of local police to prevent the annual senior keg party. The town was divided, with as many people supporting the party as opposed it. The parents of one graduate defied police by allowing the class to hold the keg party on the fenced grounds of their ranch, intending to sober everyone up before they returned home. Two boys sneaked out of the party with an empty keg, presumably to get more beer. They wrecked on one of Helena's steepest hills, rolling their pickup truck several times. Both occupants, one who had been

CRYSTAL PIRRI is a freelance writer and amateur photographer in Akron, Ohio. She can be reached at crystal@ crystalpirri.com.

"I was sitting on a park bench at Waikiki Beach with my bride of 25 years and my Canon G7," says David Grubbs. "I saw this guy walking toward us and all I had time to do was to raise the camera and shoot."

granted full football scholarships, died in the accident. Grubbs was working at his desk near the newsroom when the word came in of the fatal accident.

It was a heart-wrenching piece of news that had to be covered. Both staff photographers were already out on assignments, shooting the summer wildfires. The editor knew Grubbs had a passion for taking pictures and, more importantly, a camera. He asked Grubbs to shoot the accident.

Grubbs admits he was intimidated when he arrived. He used his artistic eye and shot the scene from every angle. His best picture was published on the front page, a dented keg of beer in the foreground, the mashed truck in the background, and emergency crews working nearby. When he saw that photo on the front page, he says, "I decided right there that I didn't want to be an architect anymore."

Landing newspaper jobs

It wasn't long before a photography position finally opened at the paper, and he was hired. His peers had degrees in photojournalism, and he wanted to follow suit. He found a good program in Oregon and moved with his wife to Corvallis, where he enrolled at OSU. He landed a part-time job at the *Corvallis Gazette-Times* as an ad photographer, which was boring work, he says, but it helped pay the bills.

A semester or two into the program, he moved up to full-time staff photographer. Not long after that, the *Gazette-Times* fired their Chief Photographer. Instead of replacing him, the editor planned to take over the job. Grubbs saw that the workload was too much for an editor, and though he barely qualified for the position he

already had, he wrote a proposal outlining the need for a Chief Photographer and recommended himself for the job. He got it.

Looking back on that move, he says, "I think that (the editor) saw a passion for photography and he knew that I really cared about telling stories, and about giving the readers the whole story in a quick read. So he gave me the opportunity." Grubbs quit school to focus on his job, since he felt the experience he gained was worth more than the degree.

He worked for 10 years as Chief Photographer in Corvallis, when he decided to move his family back to Montana. Billings was the only city with a large enough newspaper to challenge him. He transferred to a staff photographer position with the *Billings Gazette*, which he counts as a promotion, he says, because there were more assignments to shoot and skilled photographers he could learn from.

Finishing school—and then some

Even with his new job, it still bothered him to be without a degree. "College was poking at me and it wouldn't go away. I had to do it." By this time Grubbs was a seasoned photographer, and pursuing a photojournalism degree would no longer benefit him. He enrolled at the local campus of the University of Mary, and earned his Bachelors of Science in Business Management. Encouraged by what he was learning and how he could apply it to his own business, he added two MBAs to his name and is considering returning for the doctorate.

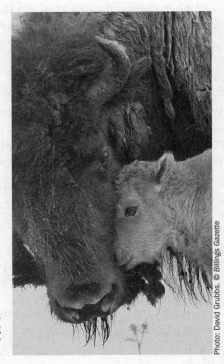

David Grubbs captured this image of a cow bison comforting her calf in Yellowstone park for the *Billings Gazette*.

Photo: David Grubbs. © *Billings Gazette*

For his business degree courses, Grubbs had to come up with a business plan. With a demanding shooting schedule and a job that required him to have camera straps on his shoulders at all times, Grubbs quickly became dissatisfied with the straps that slid off his windbreakers and winter coats. His old pal at the Helena paper, George Lane, had made his own straps for years, citing the same problems. Lane would make extra straps on request for close friends, and Grubbs had become accustomed to using Lane's non-slip, handmade straps. He would order one every time he upgraded his equipment, but eventually Lane stopped making them. Grubbs was forced to make his own.

He started with Lane's design, then changed it and perfected it to a point that satisfied him. Just like he had wanted Lane's, other photographers began asking Grubbs for copies. Making and giving away elk hide camera straps started to get expensive, so he asked for Lane's blessing and started selling them. His college courses walked him through the process, making his business successful while he earned high grades.

He has been selling his straps personally and through his website for ten years now, but it was only recently that he realized how far his product has reached. Pete Souza, the newly appointed White House photographer, can be seen wearing a Wapiti strap in a CBS documentary chronicling his work.

Teaching how to capture the moment

Merely selling his straps and shooting the news didn't satisfy Grubbs, however. He started teaching photography online at MSU, branching out to include Rocky Mountain College and the University of Montana.

"I wanted to teach, because I still just love this medium, I just love it," he says, "and I remember vividly when I first started out with George (Lane) and Gene (Fisher)—they could only teach me so much. I had to just burn film. I don't want anybody else to go through what I went through. I'm not talking about teaching people how to use the cameras. I'm talking about capturing the moment. I want people to stop saying, 'Joey, look up here and smile!' I want that word to go away from our vocabulary when it comes to photography.

"When you take a picture and little Joey's there to blow out the candles on his birthday cake, you tell him to make a wish. You put the camera up to your face and you say 'Joey, look up here! Smile!' Click! You've got this unbelievably horrible picture of this little boy looking at the camera with red eye from the strobe as the candles melt down. Why don't you wait until Joey's bent over the table and his cheeks are full of air and the flames are bent over as he's blowing them out? That's the picture that you're going to hang on your wall. That's a moment.

"I want people to anticipate the moment. And when it happens, be ready to take the picture. That's what I didn't understand for years and years. I just went out and put my camera up to my face and composed it and took the picture. I didn't wait for a moment, I didn't even think about that. Now, the moment is everything. You can have a poorly composed photo with a great moment and you're going to have a great picture."

Collecting accolades

That philosophy has won Grubbs numerous awards and contests. When asked about them, Grubbs downplays their importance, but admits one award meant a lot to him: in 1994 he won first place for the Associated Press Reed Blackburn Memorial award for a documentary on breast cancer.

"I followed this woman around for eight months from the day of diagnosis. I was in the operating room when she had her mastectomy. I was at every doctor appointment; I was there when the doctor told her she had a low chance of survival. I was there when her husband was shaving her head. I was there for every single one of her chemotherapy sessions. She wanted to do [the documentary] because she wanted to help other women, she wanted other women to go get checked, have mammograms." It worked. The paper kept tabs with the local hospitals, and mammograms spiked as much as eighty percent in the weeks that followed. With tears in his eyes, he says, "that helped probably more readers than anything I've ever done."

Embracing new technology

With newspapers closing and the demand for photojournalists waning every year, he stays on top of the game by learning as much as he can about video photography, and adding audio to his still clips. He recalls photography conventions when all the still photographers would go on break during the video presentations, but Grubbs hung around. "That stuff was amazing to me. I really enjoyed the audio part of it. I remember numerous times walking up to a TV photographer and saying, 'The other day I was at this assignment, and this lady said this quote and her voice was so amazing that I wish I had audio.' They'd look at me like what are you, nuts? But it happened all the time and I'd hear these things and the way people said them I'd wish I had audio.

"Now I do! Now I have audio and I can add that to my still pictures or I can shoot video. I like it better just to have audio slideshows. That, to me, is more vivid and it keeps it still. I think still photography is way more powerful than video. Being able to add the audio is an unbelievable addition to our work, to be able to show them these amazing images and then let them hear what people are saying, in their voices."

When teaching new photographers, he teaches "capturing the moment" with this scenario: "When you go to a memorial service or a wake, the picture always happens after everyone leaves. Just be a fly on the wall. Just stand there or you hide yourself, and you wait. Something is going to happen. Mom or sister or girlfriend or boyfriend is going to walk up to that casket and (lay) themselves on it and bawl their eyes out. Or, dad will walk up and do something, make a gesture, say goodbye. Boom, that's the frame, that's the moment. Too many photographers say 'Oh, I have to get back to the paper.' No, you don't have to. You haven't made the picture yet, you gotta stick around. In situations like that, and I'm not saying necessarily just funerals, situations like that people want to be private, and so they wait until everybody else clears out. You'll have an exclusive that nobody else can run. All the other photographers have left." With such determination, drive and passion for photography, you be sure David Grubbs will always be the last photographer standing.

Jason Lindsey

Creating a unique vision on demand

by Donna Poehner

Commercial photographer Jason Lindsey started out as a graphic designer. "I grew up in a small town so the only type of photographers I knew about were senior portrait and wedding photographers, and I knew I didn't want to make a living doing that," says Lindsey. So he studied design in college, took a couple photography courses, and worked as photographer for the college newspaper. It wasn't until he started working as an art director and was hiring photographers himself that he had his "aha" moment: He saw what advertising photography was all about. So after doing graphic design for five years, he transitioned to doing photography full-time.

Of course, he'd been doing his own photography all along. He laughs as he remembers those times. "Since 1993 I've been working close to full-time in terms of how much I was shooting but not in terms of how much money I was making at it," he says. He did stock, nature, and wildlife photography originally, and even published a hardcover coffee table book titled *Windy City Wild: Chicago's Natural Wonders*. He doesn't market the book anymore because his work has changed since then, and the book doesn't reflect what he's doing now.

What Jason Lindsey *is* doing now is work he really enjoys. His client list has grown to include many corporations, advertising agencies, design firms, tourism bureaus, and publications—State Farm, Amazon, PBS, Blue Cross Blue Shield, Caterpillar, National Geographic Books, *Smithsonian Magazine, Conde Nast Traveler, Wall Street Journal,* and *Outside Life* are just a few.

Lindsey's graphic design background has been very helpful in his photography career. He understands that his clients are trying to communicate a very specific message and to convey particular emotions. Being able to understand where creative directors are coming from when he's working with them and being able to speak their language is a great benefit to Lindsey. He can think the way they think—from the client's viewpoint. "It's not always about making the best or most

DONNA POEHNER, a former editor of *Photographer's Market*, is a photographer, writer, and editor living in Cincinnati, Ohio. To see her work, visit www.ziaportraitdesign.com.

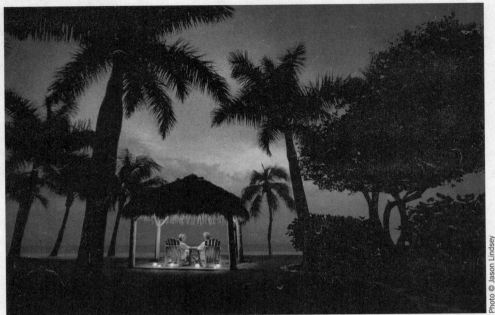

Photo © Jason Lindsey

This striking image of a hut framed by palm trees by Jason Lindsey was used in an ad campaign by Sanibel Tourism. To view more of his work, visit www.jasonlindsey.com.

creative photograph—it's about communicating specific things for clients. Though that doesn't mean that you can't do both. I really push myself to make the most creative image possible at all times. I'm lucky—the kind of work I'm doing now is really the kind of work I set out to do; 90 percent of the work I get is very enjoyable. In the last four to five years, I've been getting hired to shoot for my style. I get quite a bit of freedom as long as I'm meeting the client's needs," he says.

Getting assignments

So how does a photographer go about getting hired for his vision? Lindsey believes it comes from selective marketing—understanding where you want to go and what you want to shoot. "I created the kind of work I wanted to shoot, marketed the kind of work I wanted to shoot, and marketed to the kind of clients I wanted to work with. At a minimum you have to do all three of those things" he says.

In the past year, Lindsey has been working with a photo rep, Melissa Hennessy of Hennessy Represents. Lindsey looks at his association with his rep as a partnership. He looked for a rep for two-and-a-half years, and had four offers but didn't feel that any of them were a good match for him. Melissa Hennessy, on the other hand, felt like a good match: her approach and her attitude were positive. "I didn't want someone who felt like a salesman as much as an advocate. The others felt very salesy and very much about money only. Melissa had been a photographer for a few years so she understood the business from the photographer's side and the creative side. We interviewed each other, and it was probably six months before we came to the decision it was right for us to work together," Lindsey says.

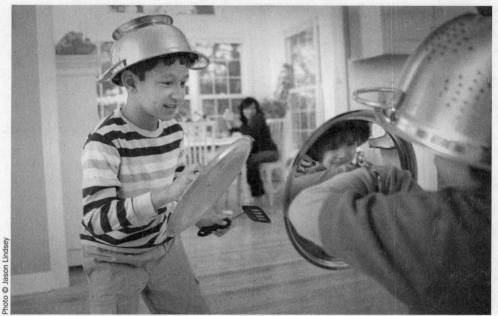

Photo © Jason Lindsey

One of Jason Lindsey's many images featuring children, this shot showing two boys' creative use of kitchen-ware was used by Loyola Medicine. To view more of his work, visit www.jasonlindsey.com.

The past year has been Lindsey's best year ever. He's gotten a lot of work from past clients, his rep is getting him business from new clients, and he believes that once the economy picks up, she'll be able to get even more new business for him. "I think it's easier to get new business when the economy is doing well. When the economy is not good, people tend to stay with people they're familiar with. They don't want to rock the boat with the client if you've done good work for the client in the past. They're more likely to take risks when the economy is better," he says. It's also much better for photographers to look for a rep when they've already got work, Lindsey says. "It was because I was so busy that I didn't have time to do the marketing and portfolio shows and agency visits that I need a rep," he says.

Printed portfolios and electronic marketing

In the age when every photographer has a website, Lindsey says that the printed portfolio book still comes into play—at least in his business. "I've got eight books out right now," he says. The bigger agencies use them in the final stages of their decision-making process. First, they narrow their selection down to three photographers based on their websites and portals like www.workbook.com. Then they call in the three photographers' books, which are shown to the actual client as a final step in the hiring process.

To correspond to the portfolios on his website (www.jasonlindsey.com) such as childhood, lifestyle, work, Lindsey has portfolio books that show more depth of each particular category. For example, he has a lifestyle book with more emphasis on travel, and a lifestyle book that is more general. He also produces customized

Articles & Interviews

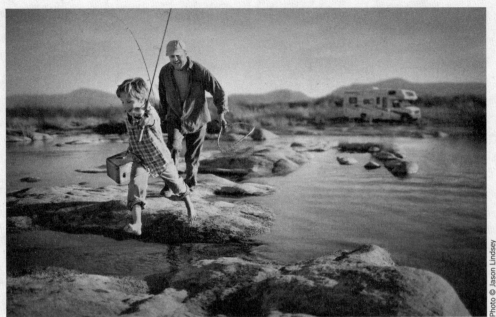

Photo © Jason Lindsey

Jason Lindsey has a number of childhood-themed images in his portfolio. This one was featured in an ad by CITGO. To view more of his work, visit www.jasonlindsey.com.

books based on a client's request. He says, "They may call and say, 'Hey, we love this stuff. Do you have anything more like it?'"

He also e-mails clients PDF books, which are similar to his printed books but in PDF format. These, too, are more in depth than his website in any particular area. "The website is not really a teaser and not really a book—it's not everything. It's important that the photos on my website show that I can shoot with the same vision and similar style, whatever the subject matter may be. A lot of my approach is about pulling out emotions," Lindsey says.

He also uses social media such as Facebook, Twitter, LinkedIn, and his own blog. His blog (www.jasonlindsey.com/blog) serves three purposes. First, it's a creative outlet for Lindsey: He can put up images he's currently working on that don't fit in a particular portfolio. He can also put up just a single image that is fun or images from a personal project. It's a quick way to update people on what he's doing. Second, it gives people a sense of his personality. And third, it seems to be a good way to stay in touch with current clients (most of his visitors are current clients). When he updates his blog, he puts postings on Facebook and Twitter to let people know he's updated it. "A lot of my current clients will go there and comment on something," he says. The informality of Facebook and Twitter allow him to post photos he's taken with his iPhone. "Obviously, it's not something I've done on an assignment, so it's just more fun stuff that I've shot," he says.

The right equipment for the job

Lindsey shoots with Canon equipment: the 35mm 1.2 and the 85mm 1.2 are the two lenses he can't live without. He shoots 70 percent of his work with the 35mm, the 50mm, and the 85mm. He does use zoom lenses for the dynamic action shots, when things are changing a lot. "I'll also use a zoom in the beginning to get sense of what focal length is working best and then switch to a prime lens once I kind of know what's working best," he says.

The biggest change Lindsey sees in technology is the convergence of still and video—and he thinks the two mediums will continue to converge. "We're shooting a lot of HD motion now, and we're ramping up that aspect of our business. Clients have been asking for it for three to four years. I started shooting video about three years ago and then decided not to because the equipment was so different from my still camera equipment, but in the last six months I've started shooting it again because I can shoot with the same equipment and camera as I shoot stills with. I can use my Canon 5D MarkII to shoot 1080p video, and I can use all the equipment and lenses that I already have. The file is shot to a card so it's already digitized, so the process has become physically easier," Lindsey says. He still has assignments where another person shoots video and he shoots stills, but it's becoming more common for him to do both.

Stock agency launch

Lindsey is launching a photographer-owned stock agency, PVstock.com, which his website calls "an eclectic mix of lifestyle and landscape images from leading photographers with new images added monthly. Fresh imagery for your campaign is our specialty." Lindsey's been selling stock on his own for 15 years but has recently signed up other photographers to create PVstock.com. Some of his work on the stock site was created on assignment but a lot was created as stock. "I'm not very good at sitting around, so after a couple days in the office, if we don't have an assignment, we'll go shoot stock. A lot of the stuff we shoot as stock I wouldn't necessarily call stock, but personal exploration, trying new things creatively," he says. PVstock.com will officially launch in fall 2009 with a trip to New York

Advice for Commercial Photographers

- Find your vision
- Market your vision
- Show the kind of work you want to get Have confidence
- Put your personality forward—show your style and vision
- Remember—it's a business

City to attend Picturehouse, an event attended by hundreds of professional stock media buyers. Since the venture is so new, Lindsey doesn't know at this point how successful PVstock.com will be or how it will fit in with the rest of his business. "It's a little tough for me to say now, but three years from now I'll probably make a decision about how much energy and effort we put into it," he says.

Lindsey's advice to up-and-coming commercial shooters: "People are hiring you for your vision and your capabilities, and because they know you're going to get the shot. There are a lot of good photographers out there, but you need to bring something more to the table as far as how you see things. I think it's just going to become more and more about your vision—having a unique vision and being able to create that on demand in the assignment. It's one thing to go out on your own and create great photographs, but it's different when you have to consider things such as location, crew, weather conditions, etc. You've got to make it work, no matter what, at the same quality level that's already in your portfolio."

Chris Gallow

*Telling stories through the angles and
the lights of the links*

by David McPherson

Get seasoned photographer Chris Gallow talking and you're lucky to get one word in for every 20 he utters. An interview with the affable Gallow is more like a one-sided conversation. Even his girlfriend, who joins us for the interview over coffee at Dimitri's on the Danforth in Toronto, jokes she often struggles to enter the conversation. One look at one of his images and you see there is nothing one-sided about the pictures he produces. Gallow is not just an artist with his camera, he's also a storyteller.

Gallow specializes in shooting golf courses, but he is just as adept at resort, celebrity, and travel photography.

"A good golf course image is about telling a story and showing the vision of the designer and the mood," he explains.

Through his golf photography over the past decade, Gallow has told many stories. He has photographed the beauty of nature—and the not so beautiful—from the most spectacular golf holes in the world to naked guys doing handsprings down the fairway (a story for another time).

He's photographed rock stars, actors, astronauts, captains of industry and billionaires; he has watched Ron Joyce, co-founder of Tim Hortons, feed timbits to a fox at Fox Harb'r, Nova Scotia; he has also photographed some pretty spectacular golf courses.

Gallow finds new ways of seeing things; finding that feeling takes time and patience. He has been woken up on the job by many a greenkeeper who find him slumbering in a golf cart, waiting for the right light. If you encounter Gallow on your favorite golf course, you'll find him always wearing his iPod, which gets him focused on the visual at hand. You may see the cameraman up a ladder in the woods, lying on the ground on a tee deck or crouching by a bunker, trying to find

DAVID McPHERSON is a Toronto-based freelance writer with more than 17 years experience writing about music. A graduate of the University of Western Ontario, with a Masters in Journalism, David has published thousands of articles in daily newspapers, consumer magazines, and websites across North America, including *Bluegrass Unlimited, Paste, American Songwriter, Performing Songwriter* to name a few. His website is: www.davidmcpherson.ca.

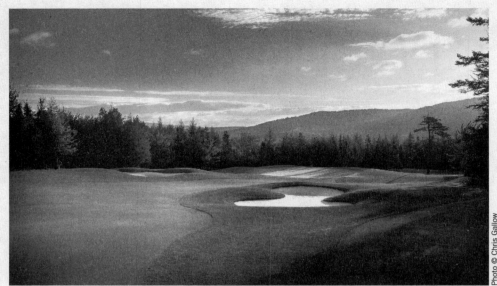

Photo © Chris Gallow

Here Chris Gallow captures the 1st hole of Bell Bay Golf Club, making use of the interesting shadows and light. To view more of his work, visit www.gallowstudios.com.

that perfect angle and capture the essence of a course. Good photography is all about angles, and capturing the mood of that moment he says.

"When you are standing on your favourite tee deck and before taking any images, think to yourself why you like this particular hole," explains Gallow, who is a graduate of the applied photography program at Sheridan College in Toronto. "Do you like the bunkering, do you like the green, do you just like the view, or do you have a memorable moment from a previous round there? Go back and try to capture that moment instead of worrying about doing it technically right."

Capturing that moment like no one else is Gallow's gift. He recalls a time a few years back when the marketing director of Highlands Links in Cape Breton challenged him to "blow him away" with his pictures. He met this challenge, capturing the essence of some of the holes like no other photographers had done.

As that marketing director's compliment attests: "You show me angles of this golf course I've never seen and I know this golf course backwards and forwards."

Angles are the key to great photography, according to Gallow. "If I find a great angle, I will fire off three frames," he says. "I do everything in threes. The reason … one frame, back it up; then back it up again, just in case. As soon as I have three frames, I move inside and outside that frame to see if I can expand on it."

Gallow grew up in Houston, Texas, on a golf course; while golf intrigued him, he was too afraid to try it. He got into golf photography by fluke. A friend put him in touch with the editor of *Ontario Golf* magazine; after a few assignments, he quickly developed a love and appreciation for golf course photography, beginning with a shoot at Cataraqui Golf and Country Club with The Tragically Hip's Paul Langlois and Gord Sinclair. Since, his photography has graced the pages of golf magazines

Golf photography tips

Gallow says photography is a lot harder than people think. "You'll always be learning something new," he says. "I learn new stuff every day."

Here are Gallow's top tips to capture the feel and mood on your next golf outing:

- Stop "taking" pictures and start "making" pictures.

- All about angles. "Never take a photo from a standing position," says Gallow. Put the camera above your head, move around, lie down, etc.

- Don't just take one picture—shoot, shoot, shoot.

- Have fun. "If no one is behind you, put someone in the bunker, someone on top of the bunker, someone holding the pin—don't just put things in the centre and have everyone line up on the tee deck or at the 150 yard marker."

- Don't put sun directly behind your subject. "If the sun is at the back and you are photographing people, you will get a bunch of squinty guys."

- Use a black golf hat to shade sun.

- Get in closer or go wide angle.

- Use a flash to fill the shot with light, or if near a building, bounce the light off the building.

- Shoot early (before 9:30 a.m.) or late (after 6 p.m. until sundown) depending on what part of world you're in.

- Carry a notebook to record all details about the photo you took, frame number, what you did, why you did it, where, time, aperture, f-stop, etc.

- Study the light to see what it does. Understanding light is another key to good golf photography. "Sometimes on a fantastic golf course, there is no shadow in sight or no bump on the fairway, so you have to use the shadows in the trees to break up that flat rhythm and create interest," says Gallow.

- Turn your image upside down; if it looks good upside down, it's probably a successful image when you turn it right-side up.

- Show less sky and more golf course.

- Clouds are key, don't shoot on perfectly clear days.

Articles & Interviews

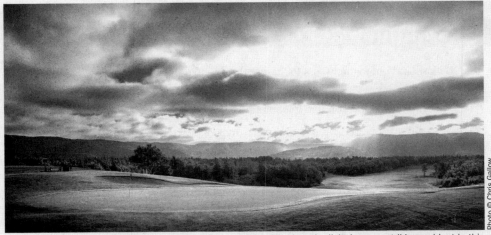

Photo © Chris Gallow

Chris Gallow likes to photograph golf courses at time of the day when the light is more striking, evident in this shot of the 18th hole of Le Portage Golf Club. To see more of his work, visit www.gallowstudios.com.

throughout North America and Europe, including *Golf Illustrated*, *Travel & Leisure Golf* and *Golf Magazine*, to name a few.

There are certain hazards of the golf course photographer's job. He was once on a ladder when a golf ball whizzed between his legs. "I was in the forest when it happened" say Gallow, laughing.

Another not-so-memorable moment for the camera guy, was being on top of a cherry picker and dropping a $3,000 lens 40 feet. He also recalls the time at the PGA Tour event, The Canadian Open, when he smacked a kid in the head and bloodied the poor lad's nose with his 15-pound lens bag.

One of Gallow's favorite spots to shoot golf courses is in the northern U.K.

"There is a quality of light there you don't get anywhere else on the planet," he says.

"I never get bored of taking pictures," he concludes.

Or, talking pictures.

To view some of Gallow's work, visit www.gallowstudios.com

Shooting Celebrities

Check your ego at the door

Chris Gallow says, just like a journalist preparing for an interview, research is important before a photo shoot with a celebrity.

"Find out as much as you can about who you are dealing with such as what their hobbies are," he explains. "Try to talk to their agent ahead of time if you can. You know they are an athlete, but what do they do besides play football? A lot of these guys will talk football, soccer, golf, etc. but they do that all the time. You want to find something you can relate to. If they have kids and you have kids roughly the same age or their kids are younger, you can say, "Your kid is three … 'Oh, that's a great age.' They are still probably into real life, day-to-day family stuff, so treat them as a normal person.

"Generally celebrities have this thing where they are on auto-pilot a lot of the time," Gallow continues. "Their agent or handler is pushing them from meeting to meeting and they will walk in not knowing what they are supposed to be doing. You have to have a briefing moment. Always walk over and shake their hand like any other business situation. If you are shooting Joe Blow down the street or Wayne Gretzky, you have to treat it with the same professionalism.

"Check your ego at the door. They don't want to hear what an amazing photographer you are. Obviously, you are good if you are shooting them."

The control freak

You will run into situations where certain celebrities want total control, says Gallow. He provides a few tips to handle these situations.

"You show them one shot, show them two shots, then you close the laptop and you don't let them disrupt the rest of the shoot," he says. "Try and get them relaxed. The way you get them relaxed is by telling them to be what they want and they will tell you what they will and will not do. If you get them relaxed enough, you might be able to get them to do something off the wall because they will trust you.

"An example for me is Eugene Levy. The art director messed up and shuffled me in with a press junket as part of the Toronto International Film Festival, so he has 15 minutes at this table, 15 minutes at the next table, and I'm sitting in a back courtyard— need to do photo shoot with him, really natural, pouring a water can—something goofy for him. He's a comic, but he's actually very uptight and protective of what he looks like … he doesn't want to be seen like the *American Pie* goofy guy putting his fingers in an apple pie even though that's what he does.

"I did some research and found out he is difficult and his agent is difficult … 'Great, I said, this isn't going to be fun.' But, low and behold after googling images and googling him I discovered he is a golfer. So, he comes over and the handler gives me the 'You have five minutes' and he says 'We have to get this done, I don't want to be here, and I'm tired.' So, I take a few frames, and then I ask him if he has had a chance to get out to the golf course lately. He says, 'No I have not played in a couple weeks.' So, we talked for about four minutes about golf, no frames and no shots. Then, the PR person gives me a tap on the shoulder and says 'You have one minute left.' Levy put his hand up to give me more time. We kept talking golf and I kept shooting; he turned into a different person because he didn't feel threatened."

Articles & Interviews

Sell yourself

"A lot of these people feel like everyone wants something from them, so you have to make them feel relaxed," Gallow advises. "You are doing something very intimate by taking their photo. You are making an image of this person, something that is lasting, so it's very personal. You have to have the ability to sell yourself to them in a way that you gain their trust and they feel you are not going to violate them."

Gallow's final tip for shooting celebrities is to gauge their mood as they enter the room. "Sometimes you can get this from their PR person or handler before they arrive," he explains. "If they are in a bad mood, ask them if they need a few minutes, 'Do you need a coffee? You forget, their lives are scheduled to the minute, so just treat them as a normal human being, not a robot. Make them comfortable.

"Mid-level celebrities tend to have the biggest attitudes and think they are bigger than they are. You need to have thick skin because they can be mean ... don't take it personally. You have to morph your temperament and bring them into your world. Always think how you can get them to respond to what you need."

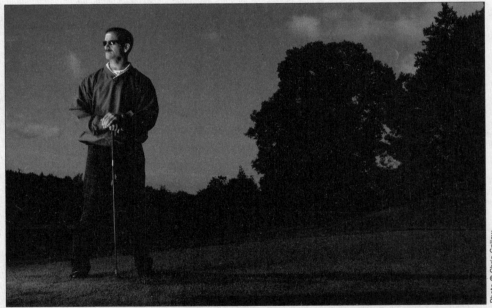

Photo © Chris Gallow

In addition of photographing courses, Chris Gallo also has a portfolio of portraits such as this shot of astronaut Chris Hadfield with club in hand. To see more, visit www.gallowstudios.com.

Todd Heisler

'You owe it to your subject to tell the story'

by Donna Poehner

'm one of the lucky people who has a staff job," says Todd Heisler, Pulitzer Prize-winning photojournalist who currently works for *The New York Times*. The newspaper he worked for before *The New York Times*, the *Rocky Mountain News* in Denver, folded in March 2009. It was at the *Rocky Mountain News* in 2006 that Heisler won the Pulitzer Prize for feature photography for a project called The Final Salute. For almost a year Heisler and reporter Jim Sheeler, who also won a Pulitzer for his writing on the feature, followed Marine Major Steve Beck, whose job was to notify the families when their loved ones died in the Iraq War.

Heisler admits to feeling some survivor's guilt when he talks to close friends and collegues, some of whom are getting out of the business. "But I feel as productive as I ever have," he says. While he acknowledges that he doesn't know where the industry is going, he says, "I do believe that there's always going to be a market for still photography." And while Heisler is a big believer in the still image and its viability in the future, "That doesn't mean that a still photographer doesn't have to pay attention to video and sound," he says. "Photographers are having to learn multi-media technology like sound gathering and sound production. It makes you more marketable in the newsroom, even if you have a staff job, because they know if they send you out, you're going to bring back the content they need." And with newspapers dying and magazine budgets drying up, photojournalists have to think beyond print media and discover other outlets for their work—such as the Internet or television, for example.

Heisler didn't major in photojournalism in college; instead he got a general arts degree. He started with an emphasis in photography, but stopped taking the photography classes altogether when he realized he was getting more out of the other art classes. He didn't abandon photography completely, however, because he was working as a photographer at the college newspaper, which he found fulfilling.

DONNA POEHNER, a former editor of *Photographer's Market*, is a photographer, writer, and editor living in Cincinnati, Ohio. To see her work, visit www.ziaportraitdesign.com.

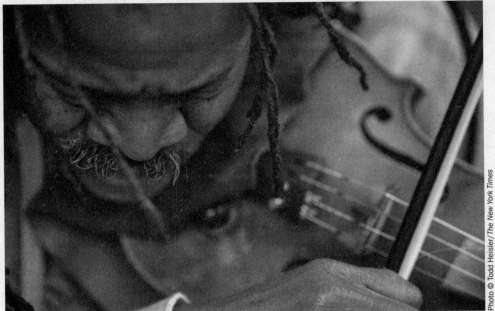

New York Times staff photographer Todd Heisler took this shot of violinist Henrique Prince of The Ebony Hillbil-
lies prior to a Christmas Eve 2008 performance in the Time Square subway station.

Articles & Interviews

After college, Heisler started working at a small newspaper, but, he says, "I
didn't have the chops and was learning on my own." He later joined the staff
of Copley Chicago Newspapers, where he met other photographers, such as Jon
Lowenstein, who inspired him. They turned him on to great photography books
and ground-breaking photographers such as Alex Webb and Josef Koudelka. It was
an eye-opening period for Heisler. "That's when I took off and found my vision,"
he says.

Heisler says it's taken a long time to develop his eye and refine his style. "I realize
it will never completely develop. You should always push yourself to grow. There
are times when you plateau and perfect something, then there comes a time when
you realize you have to push it," he says. "As a photojournalist you're working on
different aspects of the medium at any one given time. At Copley I was working on
light, color, composition, but also story telling because we were doing photo essays
every week. I was lacking the journalism part of it until I went to Denver, a very
news-driven paper, and so I worked on flexing different muscles there. It didn't mean
I was giving up the visual part, but I was trying to grow in other parts of my mind.

"The one mistake that a lot of young photojournalists make is they put too much
emphasis on the aesthetic and not enough emphasis on the content. We've all done
it. I've been guilty of it at certain points in my career. You owe it to your subject to
tell the story," he says.

"It's a really wonderful time to be a photographer at *The New York Times*,"
he says. "It wasn't always the most visual newspaper. They used to call it "The

Gray Lady," but there's a very sophisticated aesthetic they're looking for now. While I was covering the 2009 Presidential campaign, there might be eight to ten photographers I'd be working with, and all of those photographers were probably wire photographers whose work my editors had access to, so I'd have to ask myself everyday, 'Why am I here?' and try to give my editors something different than what they were getting from the wires. That can be pretty challenging. My editors depend on me to give them something different—to go in the other direction. I have to take risks at times. When the AP photographer goes to the left, I try to go to the right. There are times when that backfires—they might get *the* shot and I won't. It can be very nerve wracking."

Winning the Pulitzer Prize, working at *The Times*

Heisler believes that winning the Pulitzer Prize did help in securing his position on the staff of *The New York Times*, but he believes it was a matter of timing as well. He'd been at the *Rocky Mountain News* for five years, and he felt he'd done everything he wanted to do there. Even his editors were encouraging him to move on; while they didn't want to lose him, they also didn't want to hold him back. "When you win a Pulitzer, people start to recognize your name, and friends told me, 'There's actually a small window of opportunity, and if there's something you want to do, you should do it now. Opportunities may go away,'" says Heilser. Moving into the position at *The New York Times* turned out to be a very small window, indeed. Heisler heard there was an opening at *The Times*, which is pretty rare, *and* he was acquainted with Michelle McNally, the assistant managing editor for photography at *The Times*. So, in 2006, Heisler made the move from the *Rocky Mountain News* to *The New York Times*.

What a Good Photojournalist Needs

- Curiosity—the main driving force behind the best journalists.

- A great eye.

- Vision—when you cover a story, have some kind of point of view. Don't be biased or do something that's not true to the story, but point of view is really important.

- Love of people—people are your main subject. Be able to talk to people; put the camera down and share in people's experiences.

- Ability to be in tune with your personality and see how it fits in with the rest of the world.

- To be yourself. Don't be glib.

- Willingness to work odd hours. News doesn't happen on your schedule.

- A good pair of shoes.

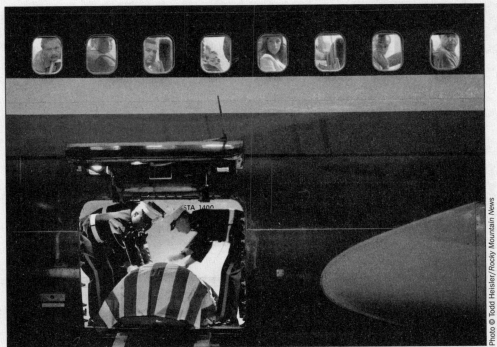

Photo © Todd Heisler/Rocky Mountain News

This photo from Todd Heisler's The Final Salute series captured the arrival of Lt. James Cathey's body to the Reno Airport. Marines climbed into the cargo hold of the plane and draped the flag over his casket as passengers watched the family gather on the tarmac.

Making the transition from the *Rocky Mountain News* to *The New York Times*— and from Denver to New York City—was not as difficult as Heisler thought it might be. "I was pretty familiar with New York, so I knew what I was getting into. *The New York Times* is a very large organization, with a very large newsroom, so that can be a little overwhelming when you start there. But you get to a point in your career when you think, 'Well, what do they see in me? Why are they hiring me?' You have to be true to yourself and do your thing—that's why they hired you. Being a photojournalist, I travel a lot; I'm used to going to strange places; I'm used to meeting new people. It's just one more challenge," says Heisler.

He checks in with the office every morning via e-mail, where he usually finds an assignment waiting for him. He then goes straight to what he's covering and transmits the images to the newspaper from his location. As far as equipment, Heisler says he travels light, carrying two different kits. For breaking news and politics, he employs a digital camera body with either a 70-200mm f/2.8 or a 24-70mm lens. For everything else, he uses a digital camera body with a 50mm, a 135mm, or a 35mm f/1.4, which is the lens he uses the most.

Heisler usually goes into the office a couple times a week and makes the rounds to visit the editors he frequently works with to see what they're working on and if they have any assignments or stories coming up. Some of the photo editors Heisler works with have photography experience while others don't; it's good to

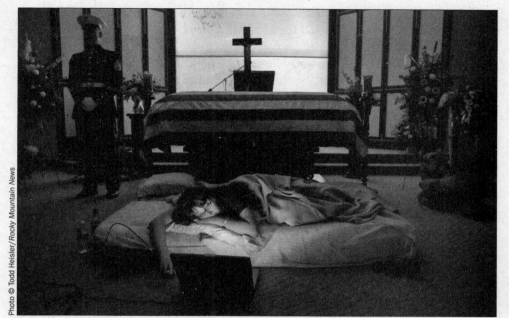

Photo © Todd Heisler/Rocky Mountain News

This photo by Todd Heisler, part of the Pulitzer Prize winning series The Final Salute, depicts Katherine Cathey the night before the burial of her husband's body. She refused to leave the casket, asking to sleep next to his body for the last time. The Marines made a bed for her, tucking in the sheets below the flag. Before she fell asleep, she opened her laptop computer and played songs that reminded her of "Cat," and one of the Marines asked if she wanted them to continue standing watch as she slept. "I think it would be kind of nice if you kept doing it," she said. "I think that's what he would have wanted."

have a balance, Heisler believes. The ones who have been photographers want to say how *they* would have done the assignment. But Heisler believes that the newspaper needs editors who've been photographers because they know what's possible—they understand the technical aspect of it, they know what works. "On big assignments, I'll sit down with the editor and we'll edit together—either on the phone or in person. If it's something I can go back to and shoot more images, I will. Most editors I work with are open to my input. They like to know what we photographers like."

The Final Salute

When Heisler started collaborating on the project that would win both him and reporter Jim Sheeler the Pulitzer Prize, Sheeler had recently met Major Beck, the central subject of the story. "Spending a lot of time with a subject is very important because you get a better perspective of what their reality is. You have to step outside of your own biases. And I'm not talking political biases; I'm just talking about your point of view. That's what's really important, especially in a story like this. It took a long time for Major Beck to let us in, and if he didn't let us in, then the families wouldn't let us in, because they trusted him. And that was a lot of trust," says Heisler. "Major Beck actually encouraged us to *not* publish the story right away. Editors would ask us, 'What's going on with that story? Can you run it?' And we'd

say, 'No, it's not done yet.'" Six months into their coverage of Major Beck, their editors asked again to look at what they had, and they realized they still didn't have it yet—at least not in terms of the photography.

A few months later, Heisler and Sheeler got the call from Major Beck that he had just notified Katherine Cathey, the pregnant wife of Second Lieutenant James Cathey, who had just been killed in Iraq. Cathey allowed Heisler and Sheeler to spend four days with her. "That's when we knew that the story was done," says Heisler. Most of the main images from the piece came from Cathey's experience. She allowed them the kind of access that none of the other families had. He believes that all of his experiences covering this story contributed to his ability to see and create the very intimate images of Cathey that would become the cornerstone of the whole project. He calls it "emotional research": the time spent talking with Major Beck, learning about the military's burial rituals, meeting all the grieving families.

Heisler says he realizes that it sounds cliché, but winning the Pulitzer was "surreal"—and also bittersweet, given the nature of what he and Sheeler covered in The Final Salute. But he's also pleased, not only because of the attention it's brought him, but he says, "It extends the life of the work and gives it a place in history."

"It was one of the hardest experiences of my life," Heisler says. "It was really tough, but it was rewarding. It could have gone the other way, and that's why it was so tough, because the whole time I was thinking—this may go nowhere. It was rewarding not just because of the awards and accolades, but because of the relationships I formed with the families and Major Beck and the response we got from the public. That's why we do what we do—so that people will stop and pay attention to something. In that moment we succeeded."

Becca Worple

Photographing the joy and freedom of childhood

by Donna Poehner

Contemporary children's photographer Becca Worple thinks kids have a lot to teach us. "When you're a kid anything's possible. When you get older you don't do all those things that were so fun as a kid—playing hide-n-seek, playing kick the can, skipping." says Worple. "I skip into Target with my kids, and people stop and look, and they smile. What I'm photographing is the joy and freedom of being a kid. I had a great childhood, and I love capturing that,"

Although Worple studied photography all through high school and college, learning darkroom skills and even winning awards for her work, no one ever suggested that photography could be a career. She even had an aunt, Lois Teegarden, who was a professional photographer, but still Worple didn't foresee having her own photography business. Her major in college was English, and after graduating, she worked in advertising, then sales, and then became a sales trainer. One day she saw a photo contest in *Cottage Life Magazine.* "I got my camera out and said, 'I'm going to win that thing,'" she says. And she did win in one of the categories. When she spoke to *Cottage Life* on the phone they stressed that professional photographers were not allowed to win the contest. She thought to herself: *I wish I was a professional photographer! I'd love nothing more than to be a professional photographer!* Says Worple, "When I picked up my camera and started shooting actively again, I felt like a part of me had been found again. I felt complete."

Worple, who lives in Terrace Park, Ohio, is now the owner of OwenEmma Photography (named for her own two children), a boutique portrait business offering contemporary children's photography—images that focus on emotion, relationships, and storytelling. Kids have always been her passion. Even in high school, her pictures were of people, especially children. "I like capturing people's stories," she says. Never posed or contrived, Worple's images reflect the true character of each child and family and often the nature of childhood itself. Worple calls her time spent photographing the client the "experience" rather than the session or appointment, and she's pleased that her clients have also started using that terminology. Each experience is unique and customized for each particular client. Most important to Worple is the emotional connection—the images she creates must capture some

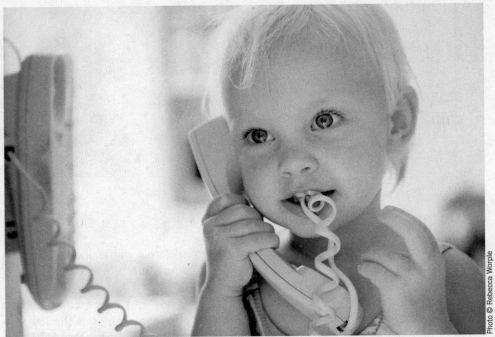

Photo © Rebecca Worple

Becca Worple's portraits such as this one are never staged or contrived. She captures life as it happens and tries to evoke emotional responses that will take her clients back to a special time in their lives. To see more of her work, visit http://owenemma.com.

kind of emotion and evoke potent memories for her clients. "A lot of photography doesn't do that, it might capture the beautiful face and the sweet smile, but it's not as engaging as I would want to have it," she says.

"My clients know that when I come, they don't need to be dressed up perfectly," says Worple whose website (http://owenemma.com) features lively images of children swinging, wearing swim suits, hanging from trees, having pillow fights, playing with their dogs. "Often the kids will dictate what the experience is going to be. I'll talk to my client ahead of time and find out what their kids are like, what they're interested in. I'll have families brainstorm every fleeting thought they have about their families, and I'll have them put that into words—just words, not even cohesive sentences. When I look at their lists, things will come up, like 'the curls in his hair,' 'the nape of his neck,' 'her fingers'... the little things I might not even think of photographing. They might say, 'The kids just love digging in the dirt.' That's what we should do then; let's plan a whole experience around digging in the dirt and see what happens. So we're setting the stage for success," says Worple.

On location, setting the stage

Although Worple says she toys with the idea of having her own studio space, she says, "If I really had a space, I wouldn't use it all that much." She photographs entirely on location, in the client's home or outdoors. Her style is formed by her

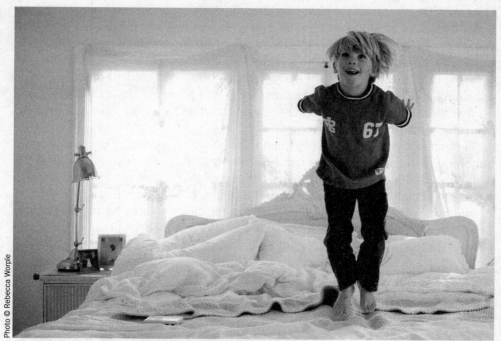

Photo © Rebecca Worple

Becca Worple likes to photograph kids in their natural environment, doing the kinds of activities they love to do. To see more of her work, visit http://owenemma.com.

belief that "kids are most real and pure and honest in environments that they're familiar with. The minute you bring them into a studio, it turns into something different than what I want to capture. I think studio art is beautiful, but it's a different art, I think, than what I'm doing. My photography borders on very candid captures. I also believe that the core of people photography doesn't have to do with your camera; it has to do with genuinely connecting with people—'genuine' being the main word. And kids know genuine."

When shooting, Worple always looks for different vantage points and perspectives that have energy. She's been run over by sleds, hit with swings, and found herself lying on the floor between two beds. Her camera lens has been licked by a dog more than a few times. Worple photographs using only natural light, whether she is outdoors or indoors, and she knows how to make the most of it. Although she has fixed-focal-length lenses, she mainly uses fast zoom lenses because she feels the lenses with fixed focal lengths stifle her creativity. Her favorite lens is the 24-70mm because it's versatile enough that she can zoom in or back away. She calls the 70-200mm lens her "her paparazzi lens" because she can totally back off from her subjects, leaving them free to play naturally. She also loves her fisheye lens because of the crazy captures she can get with it—for example, kids jumping on a bed. She also uses it in her underwater photography.

Worple has a consultation with clients before they have their experience with her because she wants to identify what they want from the session: do they want

large canvases to hang in their home; do they want a customized book of images? Collections start at $1800 and a $750 deposit is required when a client books their experience ($400-500 of that goes toward their final image purchase). Worple likes to identify what the clients really want before the experience so she can shoot for it during the experience. But she says, "I shoot for myself first and foremost. If I'm not shooting for what I want, then I'm not going to be producing images I'm proud of, and then I'm not going to have a business. And I'm really doing this for my heart, for me first."

She used to get calls asking her to photograph a newborn baby or a single child, but she now turns down those requests. She will only photograph children with their parents. "Because to me parents are part of that whole picture, and families are so incredibly important. Families embrace it now," she says.

One family that Worple photographed always drew in chalk on their driveway. Of course, the family photo Worple created for them is their family laying in chalk outlines on the driveway. Worple got up on ladder to shoot down on them as they lay inside their chalk outlines. "It's all about capturing life the way it really is. A family portrait to me is not just the family sitting there smiling," says Worple. She says that clients do want shots where they can see the faces, and then if their budget allows, they go for the more fine-art type photographs.

This is an image Worple created for herself. She was driving past a Jiffy Lube and loved the way the light looked, so she stopped to take some photographs. Since she likes to play with contrasts, it was fun to have the little girl in the ballerina costume (who was the manager's daughter) appear to be holding up the car. The little girl's family loved the image. To see more of her work, visit http://owenemma.com.

Photo © Rebecca Worple

Photographer as sales person

Since Worple used to be in sales herself, she knows that the best sales people don't just call and ask for business. They extend a personal touch: remembering a birthday, asking the client how the family is doing, etc. She likes to collect the birthdays of all her clients and their children and send birthday cards with personalized notes. Her marketing is almost completely word of mouth. When she does send out a promotional piece, she wants it to reflect who she is and what she does; and she wants it to look rich. Her whimsical sense of humor shines through in all her marketing efforts—from the birthday cards she sends to clients to her website.

Worple has learned the importance of knowing how to price her work. She had booked a client, and then they called to cancel, saying they had hired a photographer who was flying in from Los Angeles. He charged $600 for the session alone—no prints, no books, no tangible end product for the client: all that would be extra. In their minds he must be great because of the high session fee he charged. The client called her again: They hated the images the Los Angeles photographer had created, and they wanted to hire her. Worple says, "I realized my prices were way too low. Prices can often be perception—but you have to deliver on that." As a result of this experience, Worple raised all her prices. "It was a great lesson, and I'm grateful for it. Now I have no regret when I tell people my prices," she says. "Considering all we photographers invest in our equipment, workshops to keep learning, new software, the time devoted to working with clients, we're all undercharging," she says.

Working strictly from her home, Worple has "premieres" where clients come to her home to view about 40 images from their experience projected on a screen with a digital projector. She uses ProSelect, the presentation, sales, and workflow software that allows her to show the clients how their images will look at various sizes. Since Worple wants clients to see the products she offers, she definitely wants to meet with them in person, but the down side is that so much time goes into preparing her house and hosting the premiere. If a client is scheduled to view their premiere between 10 and 11 o'clock, she's not the kind of person to show them the door when the hour is up. They bring their kids, and their kids start playing with her kids, and one thing leads to another. She loves what she does and loves the personal connection with the clients, but it is very time-intensive way to conduct her business. She admits that she struggles with this part of the business and that enforcing policies is not her strong suit. "I want to be the artist. I don't want to be the person saying 'If you do this, you get that,'" she says.

Fall is her busiest time, and last year she hired an assistant to work for about 30 hours a week. The assistant was doing just about everything—packaging and delivering, presenting to clients, going to the grocery store. Worple is not sure, however, that this is the type of business she wants to have, because her business is not a totally full-time endeavor. For one thing, she goes away for the summer and does not schedule any experiences with clients during those months. Having flexibility is key to making it all work.

She thinks about shifting into commercial work, but she knows that with that type of work she'd have a boss, a graphic designer, who would be there watching here.

She saw a commercial photo shoot being done in her neighborhood—a girl on a bike with people holding reflectors around her. Worple realized that she already had many shots like that. But she wonders if she'd do well with a crew of people standing around while she worked. She also would like to get her work published more in photojournalistic magazines, and that's a goal she's currently working toward.

For now Worple continues doing what she loves best: photographing kids and their families in their natural environments. Worple realizes that her own children remind her of what's most important in life: the simplicity of living life. "We're so lucky to be given the gift that our clients give us, which is an invitation to their world," she says. "They open their hearts to us and allow us to just be there with them, and it's magical."

Making the Most of Fine Art & Craft Shows

by Paul Grecian

For photographer whose primary interest is in selling works for people's homes or offices, fine art and craft shows offer many opportunities. There are many things to consider, however, if shows are to become a serious and profitable endeavor for a photographer. A successful show requires a strong body of work, a professional display, and a photographer with a proper state of mind and people skills. A lot can be learned about what makes for a successful show by visiting good shows. Then, unobtrusively watching the way experienced photographers work at shows, you may get a sense of what needs to be in place before you participate in your own first show.

Why do shows?

Shows as a means of selling your artwork have many challenges and rewards. Fine art and craft shows offer the photographer direct access and interaction with many kinds of buyers of art. There are people who are looking for works for their homes, offices, or as gifts for family, friends, or co-workers. Ideally, people will just respond emotionally to your work and want to make it a part of their lives even if they did not specifically come to the show for new artwork. There are also other types of professional people walking through shows who may find your work appropriate for annual reports, company holiday cards, advertising, and a myriad of other business applications. The truth is, you do not know who may see your work when you exhibit at a public venue like an art or fine craft show.

One benefit of doing shows is you can exhibit your work in a way you feel best represents who you are as an photographer. This is not something most photographers can do when working with editors, businesses, stock agencies, or galleries. It can be both totally fulfilling and daunting to have this control on how your work is presented to the public. In addition, you will receive direct feedback from those who see your work. This communication between you and the customer is highly valuable marketing research that costs nothing additional beyond your show fees.

Being able to bring your work directly to the public in different locations allows an elevated level of exposure to your work not typically experienced with a gallery.

Shows exist throughout the United States. Even exhibiting in several locations within your own state, you may access potential buyers whom you would never have found otherwise. There are many resources both in print and on the Internet which provide information about shows. Important contact information for show promoters, attendance figures, jurying processes, and fees are all listed in these sources so you can decide whether a specific show is appropriate for you and your work.

Which shows are right for you?

One of the most difficult decisions to make is determining in which shows to exhibit and sell your work. This requires a level of self-honesty about where you fit into the variety of show types that exist. The quality of a show will be of paramount interest to you. Show quality will determine who else will be selling their work at the show and often what kind of customer will attend. Here again, visiting a show before deciding to apply to it will provide additional information to help determine if it is the right venue for you. The highest quality shows are usually juried events. This means applicants need to submit photographic slides or digital images of their work for consideration by a panel of judges. These judges will select appropriate participants for the show which they are jurying. The type of work you do and the quality of it and of your jurying images will determine if your application is successful.

It is generally the case that sales are better at quality juried shows than at lower-end non-juried shows. However, sales success can be dependent on many things, such as the price of your work, geographic location of the show, and what the competition at the show is offering. It is entirely possible to have very good sales at a non-juried show (which also usually have lower entry fees) and to have mediocre or poor sales at a very well-regarded juried show. Finding profitable shows for your work is part of the learning curve in this kind of business.

Another thing to consider when choosing a venue for your work is whether the show has a theme. Shows may be restricted to specific genres (e.g., western, wildlife, nautical), may have "originals only" requirements, or may allow only hand-made crafts, any of which could make it the wrong venue for your work. Promoters provide this information in their listings, so read them carefully. You do not want to go through the time and expense of applying to a show for which your work is inappropriate.

Some may find that their work is best offered at shows during certain times of year. If your work is themed to the holidays, or is most often purchased as holiday gifts, then fall and winter shows may be your best bet. The geographic location of the show may also be a determining factor as to whether it is advantageous for you to apply. Tourist spots where buyers are looking to bring home something of the location they visited will likely want work with a local flavor. Shows in areas which have a robust economy or shows which have a history of strong show sales will have the most competition for available spaces.

Of course, the cost of the show itself may be a driving factor for many applicants. The fees both for application and for the show itself vary widely. And, as with show quality, higher show fees do not necessarily equate with higher show earnings. As in all things related to this business, research and an honest evaluation of your goals

is necessary. Speaking of money, some shows also offer awards to their exhibitors. These awards may be in several categories and can sometimes be for quite a bit of money. Indeed, applicants who think they have a good chance to win an award may apply to such a show for just that reason. In addition to the monetary prizes, award winners gain prestige and sometimes media coverage.

Are shows right for you?

The show life is not for everyone. There are significant physical, emotional, and time demands upon the photographer who engages in shows. Doing shows can be quite physically demanding. Carrying work to and from a show may mean dealing with boxes of substantial weight. The act of setting up a display may require carrying heavy display walls and regular bending and lifting. If the show is an outdoor event, there is the additional task of carrying and setting up a canopy. Good quality canopies are usually heavy and may be complex to set up.

Shows are time consuming events, both in their duration and in the time required to prepare for them. In addition, a show which is not close to where you live may require substantial driving time to and from the venue. A weekend event may require a commitment of at least the day before and the day after if you need to travel.

Emotionally, shows can be inspiring and joyful, but also draining. You will need to be prepared for rejection as most customers attending a show will not likely be interested in your work. At large shows thousands of people may walk past your booth without even looking to see the work you have created. Remember, your target customers are those few who connect with your imagery and to whom your work speaks directly.

Beyond dealing with rejection, be prepared to deal with every sort of personality that may engage you at a show. Some folks will seem rude, some a bit odd, and some overly enthusiastic about your work; some will even want to tell you all about their own photographic or artistic endeavors. Keeping these few guidelines in mind will get you through most situations: (1) never escalate a disagreement, (2) never discuss religion, politics, or any other subject that may become uncomfortable, and (3) always try to keep the discussion focused on your work. Shows are a place of business, and when you establish this understanding with your patrons, they will respect you. Some patrons may become great fans of your work. These customers will come back to you on a regular basis to add work to their collection or to buy gifts for others. Some of these buyers will even become friends and help promote your work. Friendships will also be made with photographers and artists who offer their work at the same shows as you do. These relationships can be long lasting and result in important professional alliances.

A personality trait required to succeed in this business is patience. Sometimes a show just does not work out for you. Variables such as the weather, the economy, competing local events, or even the location of your booth on the show floor can all work against you. Evaluate your results after each show to determine whether you could have controlled some negative aspect, improved some part of your own effort, or it just was not the right venue for your work.

Shows are physically and emotionally draining but also can be very rewarding. If you can evaluate the positives and negatives, commit to a reasonable time period to test

the waters, and be honest with yourself about all that is required for success, you may find shows the most gratifying and enjoyable work in which you have ever engaged.

It's all about the presentation

Presentation of your work, and your physical appearance, can be as important as the art which you are offering for sale. Your display setup will need to fulfill the requirements laid down by the show and should serve to draw people into your booth. Attractive display walls, a clean and organized space, a floor covering, and sufficient lighting are all necessary components of an effective display. The work itself should be placed in sturdy and attractive bins and placed on the walls neatly and in an uncluttered arrangement. Matting and framing should be clean, defect-free, and not compete for attention with your imagery. People are going to connect with your work if they feel comfortable in your space and are able to concentrate on your creations.

To further connect with patrons, provide easy-to-read signs informing them of prices and the forms of payment you accept. Do not forget to display information about you as a photographer. People are interested in the way you create and the motivation behind your work. They want to know your creative approach from both a technical and an aesthetic perspective. The more you can tell them about your methods and artistic philosophy, the more likely they will become engaged.

Your personal appearance will tell potential buyers as much about you as does your artwork. Dressing appropriately in clean, respectful attire will communicate to others that you are a serious person and respect yourself and what you do. Some shows have specific dress requirements (e.g., themed events where historic period clothing is needed), but most do not. Dressing professionally and comfortably should be your goal. That does not mean you cannot express your style or wear jeans, but consider the impact of how you dress on the way people will evaluate you and your work.

Another aspect of personal appearance is your posture and position in your booth. If you are able to stand during the show, this is the preferable way to present yourself. If sitting is a requirement for you, find a seat which enables you to sit high enough to be at eye-level with patrons. Remember to allow for your chair when you design your booth space, as most shows will not allow a chair outside of the specific dimensions of your allotted booth. Eating in front of patrons is a frowned-upon practice, and you certainly do not want to be caught talking with your mouth full. A friendly greeting, eye contact, and the ability to speak about your work freely will get your interaction with potential customers off to a good start.

Follow through

Doing shows can be immediately rewarding, or they can require some time before people who enjoy your work find you. A commitment of several years may be necessary to truly evaluate whether shows are right for you and your work. Be prepared to offer business cards, biographical sheets, and postcards to upcoming shows to maximize your future sales. Having a website, a blog, and a professional presence on social networks can all be useful in establishing a following of customers who will want to see you and buy your work at an upcoming show.

Consumer Publications

Research is the key to selling any kind of photography. If you want your work to appear in a consumer publication, you're in luck. Magazines are the easiest market to research because they're available on newsstands and at the library and at your doctor's office and . . . you get the picture. So, do your homework. Before you send your query or cover letter and samples, and before you drop off your portfolio on the prescribed day, look at a copy of the magazine. The library is a good place to see sample copies because they're free, and there will be at least a year's worth of back issues right on the shelf.

Once you've read a few issues and feel confident your work is appropriate for a particular magazine, it's time to hit the keyboard. Most first submissions take the form of a query or cover letter and samples. So what kind of letter do you send? That depends on what kind of work you're selling. If you simply want to let an editor know you're available for assignments or have a list of stock images appropriate for the publication, send a cover letter, a short business letter that introduces you and your work and tells the editor why your photos are right for the magazine. If you have an idea for a photo essay or plan to provide the text and photos for an article, you should send a query letter, a 1- to 1 ½ -page letter explaining your story or essay idea and why you're qualified to shoot it. You can send your query letter through the U.S. postal system, or you can e-mail it along with a few JPEG samples of your work. Check the listing for the magazine to see how they prefer to be contacted initially. (You'll find a sample query letter on the next page.)

Both kinds of letters can include a brief list of publication credits and any other relevant information about yourself. Both also should include a sample of your work—a tearsheet, a slide or a printed piece, but never an original negative. Be sure your sample photo is of something the magazine might publish. It will be difficult for the editor of a biking magazine to appreciate your skills if you send a sample of your fashion work.

If your letter piques the interest of an editor, he or she may want to see more. If you live near the editorial office, you might be able to schedule an appointment to show your portfolio in person. Or you can inquire about the drop-off policy—many magazines have a day or two each week when artists can leave their portfolios for

Sample Query Letter

February 6, 2009

You may also include your Web site in your contact information.

Alicia Pope
2984 Hall Avenue
Cincinnati, OH 45206
e-mail: amp@shoot.net

Make sure to address letter to the current photo contact.

Connie Albright
Coastal Life
1234 Main Street
Cape Hatteras, NC 27954

Dear Ms. Albright:

Show that you are familiar with the magazine.

I enjoy reading *Coastal Life*, and I'm always impressed with the originality of the articles and photography. The feature on restored lighthouses in the June 2004 edition was spectacular.

Briefly explain your reason for querying.

Enclose copies of relevant work or direct them to your Web site. Never send originals.

I have traveled to many regions along the eastern seaboard and have photographed in several locations along the coast. I have enclosed samples of my work, including 20 slides of lighthouses, sea gulls, sand castles, as well as people enjoying the seaside at all times of the year. I have included vertical shots that would lend themselves to use on the cover. I have also included tearsheets from past assignments with *Nature Photographer*. You may keep the tearsheets on file, but I have enclosed a SASE for the return of the slides when you are done reviewing them.

Always include a self-addressed, stamped envelope for the magazine's reply.

If you feel any of these images would be appropriate for an upcoming issue of *Coastal Life*, please contact me by phone or e-mail. If you would like to see more of my coast life images, I will be happy to send more.

I look forward to hearing from you in the near future.

Sincerely,

Alicia Pope

art directors to review. If you're in Wichita and the magazine is in New York, you'll have to send your portfolio through the mail. Consider using FedEx or UPS; both have tracking services that can locate your book if it gets waylaid on its journey. If the publication accepts images in a digital format (most do these days), you can send more samples of your work via e-mail or on a CD—whatever the publication prefers. Make sure you ask first. Better yet, if you have a Website, you can provide the photo buyer with the link.

To make your search for markets easier, consult the Subject Index on page 507. The index is divided into topics, and markets are listed according to the types of photographs they want to see.

🖵 ⑤ $ ◪ AAA MIDWEST TRAVELER

Auto Club of Missouri, 12901 N. Forty Dr., St. Louis MO 63141. (314)523-7350. Fax: (314)523-6982. E-mail: dreinhardt@aaamissouri.com. Website: www.aaa.com/traveler. **Contact:** Deborah Reinhardt, managing editor. Circ. 500,000. Bimonthly. Emphasizes travel and driving safety. Readers are members of the Auto Club of Missouri. Sample copy and photo guidelines free with SASE (use large manila envelope) or on Website.

Needs Buys 3-5 photos/issue. "We use four-color photos inside to accompany specific articles. Our magazine covers topics of general interest, historical (of Midwest regional interest), profile, travel, car care and driving tips. Our covers are full-color photos mainly corresponding to an article inside. Except for cover shots, we use freelance photos only to accompany specific articles." Model release preferred. Photo captions required.

Specs Accepts images in digital format. Send via Zip as TIFF files at minimum of 300 dpi.

Making Contact & Terms Send query letter with résumé of credits and list of stock photo subjects. Does not keep samples on file; include SASE for return of material. Responds in 1 month. Simultaneous submissions and previously published work OK. Pays $400 for color cover; $75-200 for color inside. **Pays on acceptance.** Credit line given. Buys first, second and electronic rights.

Tips "Send an 8½ × 11 SASE for sample copies and study the type of covers and inside work we use. Photo needs driven by an editoral calendar/schedule. Write to request a copy and include SASE."

ADVENTURE CYCLIST

P.O. Box 8308, Missoula MT 59807. (406)721-1776, ext. 222. Fax: (406)721-8754. E-mail: editor@adventurecycling.org. Website: www.adventurecycling.org/mag. **Contact:** Mike Deme, editor. Circ. 44,000. Estab. 1974. Publication of Adventure Cycling Association. Magazine published 9 times/year. Emphasizes bicycle touring and travel. Sample copy and photo guidelines free with 9 × 12 SAE and 4 first-class stamps. Guidelines also available on Website.

Needs Cover and inside photos. Model release preferred. Photo captions required.

Making Contact & Terms Query first by e-mail to obtain permission to submit samples or portfolio for review. Responds in 6-9 weeks. Simultaneous submissions and previously published work OK. Payment negotiable. Pays on publication. Credit line given. Buys one-time rights.

Ⓝ ▣ $ ⊘ ALABAMA LIVING

P.O. Box 244014, Montgomery AL 36124. (334)215-2732. Fax: (334)215-2733. E-mail: dgates@areapower.com. Website: www.alabamaliving.com. **Contact:** Darryl Gates, editor. Circ. 375,000. Estab. 1948. Monthly publication of the Alabama Rural Electric Association. Emphasizes culture, lifestyles, history and events. Readers are older males and females living in small towns and suburban areas. Sample copy free with 9 × 12 SAE and 4 first-class stamps.

Needs Buys 1-3 photos from freelancers/issue; 12-36 photos/year. Needs photos of Alabama specific scenes, particularly seasonal. Special photo needs include vertical scenic cover shots. Photo captions preferred; include place and date.

Specs Accepts images in digital format. Send via CD, Zip as EPS, JPEG files at 400 dpi.

Making Contact & Terms Send query letter with stock list or transparencies ("dupes are fine") in negative sleeves. Keeps samples on file; include SASE for return of material. Responds in 1 month. Simultaneous submissions and previously published work OK "if previously published out-of-state." Pays $100 for color cover; $50 for color inside; $60-75 for photo/text package. **Pays on acceptance.** Credit line given. Buys one-time rights for publication and website; negotiable.

▣ $ $ ALASKA: Exploring Life on the Last Frontier

301 Arctic Slope Ave., Suite 300, Anchorage AK 99518. (907)272-6070. Website: www. alaskamagazine.com. **Contact**: Rachel Steer, assistant director. Circ. 140,000. Estab. 1935. Monthly magazine. Readers are people interested in Alaska. Sample copy available for $4. Photo guidelines free with SASE or on Website.

Needs Buys 500 photos/year, supplied mainly by freelancers. Photo captions required.

Making Contact & Terms Send carefully edited, captioned submission of 35mm, 2¼ × 2¼ or 4 × 5 transparencies. Include SASE for return of material. Also accepts images in digital format; check guidelines before submitting. Responds in 1 month. Pays $50 maximum for b&w photos; $75-500 for color photos; $300 maximum/day; $2,000 maximum/complete job; $300 maximum/full page; $500 maximum/cover. Buys limited rights, first North American serial rights and electronic rights.

Tips "Each issue of Alaska features a 4- to 6-page photo feature. We're looking for themes and photos to show the best of Alaska. We want sharp, artistically composed pictures. Cover photo always relates to stories inside the issue."

Ⓝ ▣ ALTERNATIVES JOURNAL

Faculty of Environmental Studies, University of Waterloo, Waterloo ON N2L 3G1 Canada. (519)888-4 442. Fax: (519)746-0292. E-mail: mruby@fes.uwaterloo.ca. Website: www. alternativesjournal.ca. **Contact:** Marcia Ruby, production coordinator. Circ. 5,000. Estab. 1971. Bimonthly magazine. Emphasizes environmental issues. Readers are activists, academics, professionals, policy makers. Sample copy free with 9 × 12 SAE and 2 first-class stamps.

- "*Alternatives* is a nonprofit organization whose contributors are all volunteer. We are able to give a small honorarium to artists and photographers. This in no way should reflect the value of the work. It symbolizes our thanks for their contribution to *Alternatives*."

Needs Buys 4-8 photos from freelancers/issue; 48-96 photos/year. Subjects vary widely depending on theme of each issue. "We need action shots of people involved in environmental issues." Check website for upcoming themes. Reviews photos with or without a manuscript. Photo captions preferred; include who, when, where, environmental significance of shot.

Specs Accepts images in digital format. Send via CD, e-mail as JPEG files at 300 dpi.

Making Contact & Terms "E-mail your Web address/electronic portfolio." Simultaneous submissions and previously published work OK. Pays on publication. Buys one-time rights; negotiable.

Tips "*Alternatives* covers Canadian and global environmental issues. Strong action photos or topical environmental issues are needed—preferably with people. We also print animal shots. We look for positive solutions to problems and prefer to illustrate the solutions rather than the problems. Freelancers need a good background understanding of environmental issues. You need to know the significance of your subject before you can powerfully present its visual perspective."

▨ ▣ $ ◻ AMC OUTDOORS

Appalachian Mountain Club, 5 Joy St., Boston MA 02108. (617)523-0655. Fax: (617)523-0722. E-mail: amcpublications@outdoors.org. Website: www.outdoors.org. **Contact:** Photo Editor. Circ. 70,000. Estab. 1908. Magazine published 6 times/year. "Our 94,000 members do more than just read about the outdoors; they get out and play. More than just another regional magazine, *AMC Outdoors* provides information on hundreds of AMC-sponsored adventure and education programs. With award-winning editorial, advice on Northeast destinations and trip planning, recommendations and reviews of the latest gear, AMC chapter news and more, *AMC Outdoors* is the primary source of information about the Northeast outdoors for most of our members." Photo guidelines free with SASE.

Needs Buys 6-12 photos from freelancers/issue; 100 photos/year. Needs photos of adventure, environmental, landscapes/scenics, wildlife, health/fitness/beauty, sports, travel. Other specific photo needs: people, including older adults (50+ years), being active outdoors. "We seek powerful outdoor images from the Northeast U.S., or non-location-specific action shots (hiking, skiing, snowshoeing, paddling, etc.) Our needs vary from issue to issue, based on content, but are often tied to the season."

Specs Uses color prints or 35mm slides. Prefers images in digital format. Send via CD, Zip, e-mail as TIFF, JPEG files at 300 dpi. Lower resolution OK for review of digital photos.

Making Contact & Terms Previously published work OK. Pays $300 (negotiable) for color cover; $50-100 (negotiable) for color inside. Pays on publication. Credit line given.

Tips "We do not run images from other parts of the U.S. or from outside the U.S. unless the landscape background is 'generic.' Most of our readers live and play in the Northeast, are intimately familiar with the region in which they live, and enjoy seeing the area and activities reflected in living color in the pages of their magazines."

▣ AMERICAN ARCHAEOLOGY MAGAZINE

The Archaeological Conservancy, 5301 Central NE #902, Albuquerque NM 87108. (505)266-9668. Fax: (505)266-0311. E-mail: tacmag@nm.net. Website: www.americanarchaeology. org. **Contact:** Vicki Singer, art director. Circ. 35,000. Estab. 1997. Quarterly consumer magazine. Sample copies available.

Specs Uses 35mm, 2¼ × 2¼, 4 × 5 transparencies. Accepts images in digital format. Send via CD at 300 dpi or higher.

Making Contact & Terms Send query letter with résumé, photocopies and tearsheets. Provide résumé, business card, self-promotion piece to be kept on file for possible future assignments. Responds in 2 months to queries. Previously published work OK. Pays $50 and up for occasional stock images; assigns work by project (pay varies); negotiable. **Pays on acceptance.** Credit line given. Buys one-time rights.

Tips "Read our magazine. Include accurate and detailed captions."

▣ $$ ☑ AMERICAN FORESTS MAGAZINE

734 15th St. NW, 8th Floor, Washington DC 20005. (202)737-1944, ext. 203. Fax: (202)737-2457. E-mail: mrobbins@amfor.org. Website: www.americanforests.org. **Contact:** Katrina Marland, editorial assistant. Circ. 25,000. Estab. 1895. Quarterly publication of American Forests. Emphasizes use, enjoyment and management of forests and other natural resources. Readers are "people from all walks of life, from rural to urban settings, whose main common denominator is an abiding love for trees, forests or forestry." Sample copy and photo guidelines free with magazine-sized envelope and 7 first-class stamps.

Needs Buys 32 photos from freelancers/issue; 128 photos/year. Needs woods scenics, wildlife, woods use/management, and urban forestry shots. "Also shots of national champion trees; contact editor for details." Photo captions required; include who, what, where, when and why.

Specs Uses 35mm or larger. Prefers images in digital format. Send link to viewing platform, or send via CD or FTP as TIFF files at 300 dpi.

Making Contact & Terms "We regularly review portfolios from photographers to look for potential images for upcoming issues or to find new photographers to work with." Send query letter with résumé of credits. Include SASE for return of material. Responds in 4 months. Pays $500 for color cover; $90-200 for color inside; $75-100 for b&w inside; $250-2,000 for text/photo package. **Pays on acceptance.** Credit line given. Buys one-time rights and rights for use in online version of magazine.

Tips "Please identify species in tree shots if possible."

▣ Ⓢ $ THE AMERICAN GARDENER

American Horticultural Society, 7931 E. Boulevard Dr., Alexandria VA 22308-1300. (703)768-5700. Fax: (703)768-7533. E-mail: editor@ahs.org. Website: www.ahs.org. **Contact:** Mary Yee, art director/managing editor. Circ. 20,000. Estab. 1922. Bimonthly magazine. Sample copy available for $5. Photo guidelines free with SASE or via e-mail request.

Needs Uses 35-50 photos/issue. Needs photos of plants, gardens, landscapes. Reviews photos with or without a manuscript. Photo captions required; include complete botanical names of plants including genus, species and botanical variety or cultivar.

Specs Prefers color, 35mm slides and larger transparencies or high-res JPEG or TIFF files with a minimum size of 5 × 7 inches at 300 dpi. Digital images should be submitted on a CD or posted to an online photo gallery.

Making Contact & Terms Send query letter with samples, stock list via mail or e-mail. Photographer will be contacted for portfolio review if interested. Does not keep samples on file; include SASE for return of material. Pays $350 maximum for color cover; $80-130

for color inside. Pays on publication. Credit line given. Buys one-time North American and nonexclusive rights.

Tips "Lists of plant species for which photographs are needed are sent out to a selected list of photographers approximately 10 weeks before publication. We currently have about 20 photographers on that list. Most of them have photo libraries representing thousands of species. Before adding photographers to our list, we need to determine both the quality and quantity of their collections. Therefore, we ask all photographers to submit both some samples of their slides (these will be returned immediately if sent with a SASE) and a list indicating the types and number of plants in their collection. After reviewing both, we may decide to add the photographer to our photo call for a trial period of 6 issues (1 year)."

▣ $$ AMERICAN HUNTER

NRA, 11250 Waples Mill Rd., Fairfax VA 22030. (703)267-1336. Fax: (703)267-3971. E-mail: AMERICANHUNTER@nrahq.org. Website: www.nrapublications.org. **Contact:** J. Scott Olmsted, editor-in-chief. Circ. 1 million. Monthly magazine of the National Rifle Association. Sample copy and photo guidelines free with 9 × 12 SAE.

Needs Uses wildlife shots and hunting action scenes. Photos purchased with or without accompanying manuscript. Seeks general hunting stories on North American game. Model release required "for every recognizable human face in a photo." Photo captions preferred.

Specs Accepts images in digital format only, no slides. Send via CD as TIFF, GIF, or RAW files at 300 dpi. Vertical format required for cover.

Making Contact & Terms Send material by mail for consideration; include SASE for return of material. Pays $125-600/image;; $1000 for color cover; $400-1400 for text/photo package. Pays on publication. Credit line given. Buys one-time rights.

Tips "Most successful photographers maintain a file in our offices so editors can select photos to fill holes when needed. We keep files on most North American big game, small game, waterfowl, upland birds, and some exotics. We need live hunting shots as well as profiles and portraits in all settings. Many times there is not enough time to call photographers for special needs. This practice puts your name in front of the editors more often and increases the chances of sales."

ANIMAL TRAILS

2660 Petersborough St., Herndon VA 20171. E-mail: animaltrails@yahoo.com. Quarterly publication.

Needs Needs photos of environmental, landscapes/scenics, wildlife, architecture, cities/urban, gardening, interiors/decorating, pets, religious, rural, performing arts, agriculture, product shots/still life—as related to animals. Interested in alternative process, avant garde, documentary, fashion/glamour, fine art, historical/vintage, seasonal. Reviews photos with or without a manuscript. Model/property release preferred.

Specs Uses glossy or matte color and/or b&w prints.

Making Contact & Terms Send query letter via e-mail. Provide résumé, business card, self-promotion piece to be kept on file for possible future assignments. "A photograph or two is requested but not required. Illustrations and artwork are also accepted." Responds within 1 month to queries; 1 week to portfolios. Simultaneous submissions and previously

published work OK. **Pays on acceptance.** Credit line given. Buys one-time rights, first rights; negotiable.

APERTURE

547 W. 27th St., 4th Floor, New York NY 10001. (212)505-5555. E-mail: editorial@aperture. org. Website: www.aperture.org. **Contact:** Michael Famighetti, managing editor. Circ. 30,000. Quarterly. Emphasizes fine-art and contemporary photography, as well as social reportage. Readers include photographers, artists, collectors, writers.

Needs Uses about 60 photos/issue; biannual portfolio review. Model release required. Photo captions required.

Making Contact & Terms Submit portfolio for review in January and July; include SASE for return of material. Responds in 2 months. No payment. Credit line given.

Tips "We are a nonprofit foundation. Do not send portfolios outside of January and July."

◨ $ ⊘ AQUARIUM FISH INTERNATIONAL

P.O. Box 6050, Mission Viejo CA 92690. Fax: (949)855-3045. E-mail: aquariumfish@ bowtieinc.com. Website: www.fishchannel.com. **Contact:** Patricia Knight, managing editor. Estab. 1988. Monthly magazine. Emphasizes aquarium fish. Readers are both genders, all ages. Photo guidelines free with SASE, via e-mail or on Website.

Needs Buys 30 photos from freelancers/issue; 360 photos/year. Needs photos of aquariums and fish, freshwater and saltwater; ponds.

Specs Uses 35mm slides, transparencies. Accepts digital images—"but digital image guidelines must be strictly followed for submissions to be considered."

Making Contact & Terms Send slides, transparencies, original prints (no laser printouts) or CDs (no DVDs) by mail for consideration; include SASE for return of material. Pays $200 for color cover; $15-150 for color inside. Pays on publication. Credit line given. Buys first North American serial rights.

◨ $ ASTRONOMY

21027 Crossroads Circle, Waukesha WI 53187. (262)796-8776. Fax: (262)798-6468. E-mail: mbakich@astronomy.com. Website: www.astronomy.com. **Contact:** Michael Bakich, photo editor. Circ. 133,000. Estab. 1973. Monthly magazine. Emphasizes astronomy, science and hobby. Median reader: 52 years old, 86% male, income approximately $75,000/year. Sample copy available for $3. Photo guidelines free with SASE or via Website.

Needs Buys 70 photos from freelancers/issue; 840 photos/year. Needs photos of astronomical images. Model/property release preferred. Photo captions required.

Specs Accepts images by mail attn: Photo Editor, Astronomy, 21027 Crossroads Circle Box 1612. "If you are submitting digital images, please send TIFF or JPG files to us via our FTP site: http://contribute.kalmbach.com/ or on CD."

Making Contact & Terms Send duplicate images by mail for consideration. Keeps samples on file. Responds in 1 month. Pays $100 for cover; $25 for routine uses. Pays on publication. Credit line given.

◨ A $ $ ⊘ ATLANTA HOMES & LIFESTYLES

1100 Johnson Ferry Rd. NE, Suite 595, Atlanta GA 30342. (404)252-6670. Website: www.

atlantahomesmag.com. **Contact**: Rachel Cardina, creative director. Editor: Clinton Ross Smith. Circ. 34,000. Estab. 1983. Monthly magazine. Covers residential design (home and garden); food, wine and entertaining; people, lifestyle subjects in the metro Atlanta area. Sample copy available for $3.95.

Needs Needs photos of homes (interior/exterior), people, decorating ideas, products, gardens. Model/property release required. Photo captions preferred.

Specs Uses 35mm, 2¼ × 2¼, 4 × 5 transparencies. Accepts images in digital format.

Making Contact & Terms Contact creative director to review portfolio. Provide résumé, business card, brochure, flier or tearsheets to be kept on file for possible future assignments. Responds in 2 months. Simultaneous submissions and previously published work OK. Pays $150-750/job. **Pays on acceptance**. Credit line given. Buys one-time rights.

▣ ◪ ATLANTA LIFE MAGAZINE

2500 Hospital Blvd., Suite 370, Roswell GA 30076. (770) 664-6466. Fax: (770) 664-6465. E-mail: graphics@atlantalifemag.com. Website: www.atlantalifemag.com. **Contact:** Natalie Sokol. Estab. 2006. Monthly consumer magazine. "We are an upscale lifestyle magazine covering north metro Atlanta. We cover a variety of topics, including sports, fashion, travel, health, finances, home design."

Needs Needs photos of architecture, cities/urban, gardening, interiors/decorating, entertainment, food/drink, health/fitness/beauty, performing arts, sports, travel. Interested in lifestyle. Reviews photos with or without a manuscript. Model release required. Captions required: include identification of subjects.

Specs Accepts images in digital format. Send JPEG or GIF files.

Making Contact & Terms Payment negotiated. Pays on publication. Credit line given. Buys one-time rights, Web usage rights.

Tips "Have high-resolution photo support if you are also submitting a manuscript."

▣ $ ▢ AUTO RESTORER

3 Borrough, P.O. Box 6050, Irvine CA 92618. (949)855-8822, ext. 3412. Fax: (949)855-3045. E-mail: tkade@fancypubs.com. Website: www.autorestorermagazine.com. **Contact:** Ted Kade, editor. Circ. 60,000. Estab. 1989. Monthly magazine. Emphasizes restoration of collector cars and trucks. Readers are 98% male, professional/technical/managerial, ages 35-65.

Needs Buys 47 photos from freelancers/issue; 564 photos/year. Needs photos of auto restoration projects and restored cars. Reviews photos with accompanying manuscript only. Model/property release preferred. Photo captions required; include year, make and model of car; identification of people in photo.

Specs Prefers images in high-resolution digital format. Send via CD at 240 dpi with minimum width of 5 inches. Uses transparencies, mostly 35mm, 2¼ × 2¼.

Making Contact & Terms Submit inquiry and portfolio for review. Provide résumé, business card, brochure, flier or tearsheets to be kept on file for possible future assignments. Responds in 1 month. Simultaneous submissions OK. Pays $50 for b&w cover; $35 for b&w inside. Pays on publication. Credit line given. Buys first North American serial rights.

Tips Looks for "technically proficient or dramatic photos of various automotive subjects, auto portraits, detail shots, action photos, good angles, composition and lighting. We're

also looking for photos to illustrate how-to articles such as how to repair a damaged fender or how to repair a carburetor."

▣ $$ ⊘ BACKPACKER MAGAZINE

2520 55th St., Suite 210, Boulder CO 80301. (610)967-8371. Fax: (610)967-8181. Website: www.backpacker.com. **Contact:** Julia Vandenoever, photo editor. Photo Assistant: Genny Wright (genny.wright@rodale.com; (610)967-7754). Magazine published 9 times/year. Readers are male and female, ages 35-45. Photo guidelines available on website or free with SASE marked Attn: Guidelines.

 • *Backpacker* will be moving to Colorado in late 2007.

Needs Buys 80 photos from freelancers/issue; 720 photos/year. Needs transparencies of people backpacking, camping, landscapes/scenics. Reviews photos with or without a manuscript. Model/property release required.

Specs Accepts images in digital format. Send via CD, Zip, e-mail as JPEG files at 72 dpi for review (300 dpi needed to print).

Making Contact & Terms Send query letter with résumé of credits, photo list and example of work to be kept on file. Sometimes considers simultaneous submissions and previously published work. Pays $500-1,000 for color cover; $100-600 for color inside. Pays on publication. Credit line given. Rights negotiable.

▣ ⊘ BASEBALL

2660 Petersborough St., Herndon VA 20171. E-mail: shannonaswriter@yahoo.com. Quarterly magazine covering baseball. Photo guidelines available by e-mail request.

Needs Wants photos of baseball scenes featuring children and teens; photos of celebrities, couples, multicultural, families, parents, environmental, landscapes/scenics, wildlife, agriculture—as related to the sport of baseball. Interested in alternative process, avant garde, documentary, fine art, historical/vintage, seasonal. Reviews photos with or without a manuscript.

Specs Uses glossy or matte color and/or b&w prints.

Making Contact & Terms Send query letter via e-mail. "If possible, please do not include photographs in files if they are sent through e-mail. A disk with your photographs is acceptable. If you plan to send a disk, photographs or portfolio, please send an e-mail stating this." Provide résumé, business card, self-promotion piece to be kept on file for possible future assignments. "Photographs sent with CDs are requested but not required. Illustrations and artwork are also accepted." Responds within 1 month to queries; 1 week to portfolios. Simultaneous submissions and previously published work OK. **Pays on acceptance.** Credit line given. Buys one-time, first rights; negotiable.

▣ $ ⊘ THE BEAR DELUXE MAGAZINE

Orlo, P.O. Box 10342, Portland OR 97296. (503)242-1047. E-mail: bear@orlo.org. Website: www.orlo.org. **Contact:** Kristen Rogers, art director. Circ. 20,000. Estab. 1993. Quarterly magazine. "We use the arts to focus on environmental themes." Sample copy available for $5. Photo guidelines available for SASE.

Needs Buys 10 photos from freelancers/issue; 40 photos/year. Needs photos of environmental, landscapes/scenics, wildlife, adventure, political. Reviews photos with

or without a manuscript. Model release required (as needed); property release preferred. Photo captions preferred; include place, year, photographer, names of subjects.

Specs Uses 8 × 10 matte b&w prints. Accepts images in digital format. Send via CD, Zip, or low-res e-mail files.

Making Contact & Terms Send query letter with résumé, slides, prints, photocopies. Portfolio may be dropped off by appointment. Provide résumé, self-promotion piece to be kept on file for possible future assignments. Responds in 6 months to queries; 2 months to portfolios. Only returns materials if appropriate SASE included. Not liable for submitted materials. Simultaneous submissions and previously published work OK as long as it is noted as such. Pays $200 for b&w cover; $30-50 for b&w inside. Pays approximately 3 weeks after publication. Credit line given. Buys one-time rights; negotiable.

Tips "Read the magazine. We want unique and unexpected photos, not your traditional nature or landscape stuff."

⑤ $ ☑ BIRD WATCHER'S DIGEST

149 Acme St., Marietta OH 45750. (740)373-5285. E-mail: editor@birdwatchersdigest.com. Website: www.birdwatchersdigest.com. **Contact**: Bill Thompson III, editor. Circ. 99,000. Bimonthly; digest size. Emphasizes birds and bird watchers. Readers are bird watchers/birders (backyard and field, veterans and novices). Sample copy available for $3.99. Photo guidelines available on Website.

Needs Buys 25-35 photos from freelancers/issue; 150-210 photos/year. Needs photos of North American species.

Specs Accepts high-resolution (300 dpi) digital images via CD or DVD. "We appreciate quality thumbnails to accompany digital images."

Making Contact & Terms Send query letter with list of stock photo subjects, samples, SASE. Responds in 2 months. *Work previously published in other bird publications should not be submitted.* Pays $75 for color inside. Pays on publication. Credit line given. Buys one-time rights.

Tips "Query with slides or digital images on a CD to be considered for photograph want-list. Send a sample of no more than 20 images for consideration. Sample will be reviewed and responded to in 8 weeks."

⊕ ▣ Ⓐ $ ☑ BIRD WATCHING MAGAZINE

Bauer Active, Media House Lynchwood, Peterborough PE2 6EA United Kingdom. (44)(733)264-666. Fax: (44)(733)465-376. E-mail: sue.begg@emap.com. Website: www.birdwatching.co.uk. **Contact:** Sue Begg, photo researcher. Circ. 22,000. Estab. 1986. Monthly hobby magazine for bird watchers. Sample copy free for SAE with first-class postage/IRC.

Needs Needs photos of "wild birds photographed in the wild, mainly in action or showing interesting aspects of behavior. Also stunning landscape pictures in birding areas and images of people with binoculars, telescopes, etc." Also considers travel, hobby and gardening shots related to bird watching. Reviews photos with or without a manuscript. Photo captions preferred.

Specs Uses 35mm, 2¼ × 2¼ transparencies. Accepts images in digital format. Send via CD, e-mail as TIFF, EPS, JPEG files at 200 dpi.

Making Contact & Terms Provide résumé, business card, self-promotion piece or tearsheets

to be kept on file for possible future assignments. Returns unsolicited material if SASE enclosed. Responds in 1 month. Simultaneous submissions OK. Pays £70-100 for color cover; £15-120 for color inside. Pays on publication. Buys one-time rights.

Tips "All photos are held on file here in the office once they have been selected. They are returned when used or a request for their return is made. Make sure all slides are well labeled: bird, name, date, place taken, photographer's name and address. Send sample of images to show full range of subject and photographic techniques."

⚅ ▣ Ⓐ ◯ BLACKFLASH

Buffalo Berry Press, P.O. Box 7381, Station Main, Saskatoon SK S7K 4J3 Canada. (306)374-5115. E-mail: editor@blackflash.ca. Website: www.blackflash.ca. **Contact:** Lissa Robinson, managing editor. Circ. 1,700. Estab. 1983. Canadian journal of photo-based and electronic arts published 3 times/year.

Needs Looking for lens-based and new media contemporary fine art and electronic arts practitioners." Reviews photos with or without a manuscript.

Specs Accepts images in digital format. Send via CD, Zip, e-mail as TIFF, EPS, BMP, JPEG files at 300 dpi.

Making Contact & Terms Send query letter with résumé, digital images. Does not keep samples on file; will return material with SASE only. Simultaneous submissions OK. Pays when copy has been proofed and edited. Credit line given. Buys one-time rights.

Tips "We need alternative and interesting contemporary photography. Understand our mandate and read our magazine prior to submitting."

▣ $ ◪ BLUE RIDGE COUNTRY

P.O. Box 21535, Roanoke VA 24018. (540)989-6138. Fax: (540)989-7603. E-mail: cmodisett@ leisurepublishing.com. Website: www.blueridgecountry.com. **Contact:** Cara Ellen Modisett, editor. Circ. 60,000. Estab. 1988. Bimonthly magazine. Emphasizes outdoor scenics, recreation, travel destinations in 9-state Blue Ridge Mountain region. Photo guidelines available for SASE or on Website.

Needs Buys 20-40 photos from freelancers/issue; 100-300 photos/year. Need photos of travel, scenics and wildlife. Seeking more scenics with people in them. Model release preferred. Photo captions required.

Specs Uses 35mm, 2¼ × 2¼, 4 × 5 transparencies. Accepts images in digital format. Send via CD, e-mail, or FTP (contact editor for information) at 300 dpi; low-res images okay for initial review, but accepted images must be high-res.

Making Contact & Terms Send query letter with list of stock photo subjects, samples with caption info and SASE. Responds in 2 months. Pays $150 for color cover; $40-150 for color inside. Pays on publication. Credit line given. Buys one-time rights.

▣ Ⓢ $ ◯ BOROUGH NEWS MAGAZINE

2941 N. Front St., Harrisburg PA 17110. (717)236-9526. Fax: (717)236-8164. Website: www.boroughs.org. **Contact:** Courtney Accurti, editor. Circ. 6,000. Estab. 2001. Monthly magazine of Pennsylvania State Association of Boroughs. Emphasizes borough government in Pennsylvania. Readers are officials in municipalities in Pennsylvania. Sample copy free with 9 × 12 SAE and 5 first-class stamps.

Needs Number of photos/issue varies with inside copy. Needs "color photos of scenics (Pennsylvania), local government activities, Pennsylvania landmarks, ecology—for cover photos only; authors of articles supply their own photos." Special photo needs include street and road maintenance work; wetlands scenic. Model release preferred. Photo captions preferred; include identification of place and/or subject.

Specs Uses color prints and 35mm transparencies. Accepts images in digital format. Send via CD, Zip, e-mail as TIFF, EPS, JPEG, PSD files at 300 dpi.

Making Contact & Terms Send query letter with résumé of credits and list of stock photo subjects. Send unsolicited photos by mail for consideration; include SASE for return of material. Provide résumé, business card, brochure, flier or tearsheets to be kept on file for possible future assignments. Responds in 1 month. Pays $30 for color cover. Pays on publication. Buys one-time rights.

Tips "We're looking for a variety of scenic shots of Pennsylvania for front covers of the magazine, especially special issues such as engineering, street/road maintenance, downtown revitalization, technology, tourism and historic preservation, public safety and economic development, and recreation."

$$ BOWHUNTER

6385 Flank Dr., Harrisburg PA 17112. (717)695-8083. E-mail: bowhunter_magazine@ intermediaoutdoors.com. Website: www.bowhunter.com. **Contact**: Mark Olszewski, art director. Editor: Dwight Schuh. Publisher: Jeff Waring. Circ. 180,067. Estab. 1971. Published 9 times/year. Emphasizes bow and arrow hunting. Sample copy available for $2. Submission guidelines free with SASE.

Needs Buys 50-75 photos/year. Wants scenic (showing bowhunting) and wildlife (big and small game of North America) photos. "No cute animal shots or poses. We want informative, entertaining bowhunting adventure, how-to and where-to-go articles." Reviews photos with or without a manuscript.

Specs Digital submissions preferred—300 dpi, RAW, JPG, or TIFF format; CMYK preferred, provided on CD or DVD named in a simple and logical system with accompanying contact sheet. Also uses 5 × 7, 8 × 10 glossy b&w and/or color prints, both vertical and horizontal format; 35mm and 2¼ × 2¼ transparencies; vertical format preferred for cover.

Making Contact & Terms Send query letter with samples, SASE. Responds in 2 weeks to queries; 6 weeks to samples. Pays $50-125 for b&w inside; $75-300 for color inside; $600 for cover, "occasionally more if photo warrants it." Pays on acceptance. Credit line given. Buys one-time publication rights.

Tips "Know bowhunting and/or wildlife and study several copies of our magazine before submitting any material. We're looking for better quality, and we're using more color on inside pages. Most purchased photos are of big game animals. Hunting scenes are second. In b&w we look for sharp, realistic light, good contrast. Color must be sharp; early or late light is best. We avoid anything that looks staged; we want natural settings, quality animals. Send only your best, and, if at all possible, let us hold those we indicate interest in. Very little is taken on assignment; most comes from our files or is part of the manuscript package. If your work is in our files, it will probably be used."

⬙ ◯ **BRIARPATCH**

2138 McIntyre St., Regina SK S4P 2R7 Canada. (306)525-2949. E-mail: editor@ briarpatchmagazine.com. Website: www.briarpatchmagazine.com. **Contact:** Dave Mitchell, editor. Circ. 3,000. Estab. 1973. Magazine published 6 times/year. Emphasizes Canadian and international politics, labor, environment, women, peace. Readers are socially progressive and politically engaged. Sample copy available for $6 plus shipping.

Needs Buys 5-20 photos from freelancers/issue; 30-120 photos/year. Needs photos of Canadian and international politics, labor, environment, women, peace and personalities. Model/property release preferred. Photo captions preferred; include name of person(s) in photo, etc.

Specs Minimum 300 dpi color or b&w prints.

Making Contact & Terms Send query letter with samples or link to online portfolio. Do not send slides. Provide resume, business card, brochure, flier, or tearsheets to be kept on file for possible future assignments. Include SASE for return of material. Responds in 1 month. Simultaneous submissions and previously published work OK. Pays $20 per published photo and $100 for cover. Credit line given. Buys one-time rights.

▣ $ ◪ **BRIDAL GUIDES**

2660 Petersborough St., Herndon VA 20171. E-mail: BridalGuides@yahoo.com. Estab. 1998. Quarterly. Photo guidelines available by e-mail request.

Needs Buys 12 photos from freelancers/issue; 48-72 photos/year. Needs photos of babies/children/teens, celebrities, couples, multicultural, families, parents, cities/urban, environmental, landscapes/scenics, wildlife, architecture, gardening, interiors/decorating, pets, religious, rural, adventure, entertainment, events, food/drink, health/fitness, performing arts, travel, agriculture—as related to weddings. Interested in alternative process, avant garde, documentary, fashion/glamour, fine art, historical/vintage, seasonal. Also wants photos of weddings "and those who make it all happen, both behind and in front of the scene." Reviews photos with or without a manuscript. Model/property release preferred.

Specs Uses glossy or matte color and/or b&w prints.

Making Contact & Terms Send query letter via e-mail. "If possible, please do not include photographs in files if they are sent through e-mail. A disk with your photographs is acceptable. If you plan to send a disk, photographs or portfolio, please send an e-mail stating this." Provide résumé, business card or self-promotion piece to be kept on file for possible future assignments. "A photograph or two sent with CD is requested but not required. Illustrations and artwork are also accepted." Responds within 1 month to queries; 1 week to portfolios. Simultaneous submissions and previously published work OK. **Pays on acceptance**. Credit line given. Buys one-time rights, first rights; negotiable.

▣ $ **THE BRIDGE BULLETIN**

American Contract Bridge League, 2990 Airways Blvd., Memphis TN 38116-3847. (901)332-5586. Fax: (901)398-7754. E-mail: editor@acbl.org. Website: www.acbl.org. Circ. 154,000. Estab. 1937. Monthly association magazine for tournament/duplicate bridge players. Sample copies available.

Needs Buys 6-10 photos/year. Reviews photos with or without a manuscript.

Specs Prefers high-res digital images, color only.

Making Contact & Terms Query by phone. Responds only if interested; send nonreturnable samples. Previously published work OK. Pays $200 or more for suitable work. Pays on publication. Credit line given. Buys all rights.

Tips Photos must relate to bridge. Call first.

$ CALLIOPE

Cobblestone Publishing, 30 Grove St., Peterborough NH 03458. (603)924-7209. Fax: (603)924-7380. Website: www.cobblestonepub.com. **Contact:** Rosalie Baker, editor. Circ. 13,000. Estab. 1990. Magazine published 9 times/year (May/June, July/August, November/December). Emphasis on non-United States history. Readers are children ages 10-14. Sample copies available for $5.95 with 9 × 12 or larger SAE and 5 first-class stamps. Photo guidelines available on website or free with SASE.

Needs Needs contemporary shots of historical locations, buildings, artifacts, historical reenactments and costumes. Reviews photos with or without accompanying manuscript. Model/property release preferred.

Specs Uses b&w and/or color prints; 35mm transparencies.

Making Contact & Terms Send query letter with stock photo list. Provide résumé and, if desired, business card, brochure, flier or tearsheets to be kept on file for possible future assignments. Responds within 5 months. Simultaneous submissions and previously published work OK. Pays $15-100 for inside; cover (color) photo payment negotiated. Pays on publication. Credit line given. Buys one-time rights; negotiable.

Tips "Given our young audience, we like to have pictures that include people, both young and old. Pictures must be dynamic to make history appealing. Submissions must relate to themes in each issue."

☒ ▣ $ ◪ CANADA LUTHERAN

302-393 Portage Ave., Winnipeg MB R3B 3H6 Canada. (204)984-9172. Fax: (204)984-9185. E-mail: canaluth@elcic.ca. Website: www.elcic.ca/clweb. **Contact:** Trina Gallop, director of communications. Circ. 10,000. Estab. 1986. Monthly publication of Evangelical Lutheran Church in Canada. Emphasizes faith/religious content, Lutheran denomination. Readers are members of the Evangelical Lutheran Church in Canada. Sample copy available for $5 Canadian (includes postage).

Needs Buys 1-2 photos from freelancers/issue; 12-24 photos/year. Needs photos of people in worship, at work/play, diversity, advocacy, youth/young people, etc. Canadian sources preferred.

Specs Accepts images in digital format. Send via CD, e-mail as JPEG files at 300 dpi minimum.

Making Contact & Terms Send sample prints and photo CDs by mail (include SASE for return of material) or send low-resolution images by e-mail. Pays $75-125 for color cover; $15-50 for b&w inside. Prices are in Canadian dollars. Pays on publication. Credit line given. Buys one-time rights.

Tips "Give us many photos that show your range. We prefer to keep them on file for at least a year. We have a short-term turnaround and turn to our file on a monthly basis to illustrate articles or cover concepts. Changing technology speeds up the turnaround time

considerably when assessing images, yet forces publishers to think farther in advance to be able to achieve promised cost savings. U.S. photographers—send via U.S. mail. We sometimes get wrongly charged duty at the border when shipping via couriers."

⟨⟩ Ⓐ $ ⊘ CANADIAN HOMES & COTTAGES

2650 Meadowvale Blvd., Unit 4, Mississauga ON L5N 6M5 Canada. (905)567-1440. Fax: (905)567-1442. E-mail: editorial@homesandcottages.com. Website: www. homesandcottages.com. **Contact:** Steven Chester, managing editor. Circ. 79,099. Bimonthly. Canada's largest building, renovation and home improvement magazine. Photo guidelines free with SASE.

Needs Needs photos of landscapes/scenics, architecture, interiors/decorating.

Making Contact & Terms Does not keep samples on file; cannot return material. Responds only if interested; send nonreturnable samples. **Pays on acceptance**. Credit line given.

⟨⟩ ▣ THE CANADIAN ORGANIC GROWER

Canadian Organic Growers, National Office, 323 Chapel St., Ottawa ON K1N 7Z2 Canada. E-mail: janet@cog.ca. Website: www.cog.ca. **Contact:** Janet Wallace, managing editor. Circ. 4,000. Estab. 1975. Quarterly consumer magazine for organic gardeners, farmers and consumers in Canada.

Needs Needs photos of gardening, rural, agriculture, organic gardening and farming in Canada. Reviews photos with or without accompanying manuscript. Captions required; include identification of subjects.

Specs Accepts images in digital format. Send JPEG or GIF files

Making Contact & Terms Pays on publication. Credit line given. Buys one-time rights.

▣ $ ⊘ CAPE COD LIFE INCLUDING MARTHA'S VINEYARD & NANTUCKET

60 North St., Hyannis MA 02601. (508)775-9800. Fax: (508)775-9801. E-mail: wkipfmiller@ capecodlife.com. Website: www.capecodlife.com. **Contact:** Wendy Kipfmiller, art director. Circ. 45,000. Estab. 1979. Bimonthly magazine. Emphasizes Cape Cod lifestyle. Also publishes Cape Cod & Islands Home. Readers are 55% female, 45% male, upper income, second home, vacation homeowners. Sample copy available for $4.95. Photo guidelines free with SASE.

Needs Buys 30 photos from freelancers/issue; 180 photos/year. Needs "photos of Cape and Island scenes, southshore and south coast of Massachusetts, people, places; general interest of this area." Subjects include boating and beaches, celebrities, families, environmental, landscapes/scenics, wildlife, architecture, gardening, interiors/decorating, rural, adventure, events, travel. Interested in fine art, historical/vintage, seasonal. Reviews photos with or without a manuscript. Model release required; property release preferred. Photo captions required; include location.

Specs Uses 35mm, 2¼ × 2¼, 4 × 5 transparencies. Accepts images in digital format. Send via e-mail or FTP as TIFF files at 300 dpi.

Making Contact & Terms Submit portfolio for review. "Photographers should not drop by unannounced. We prefer photographers to mail portfolio, then follow up with a phone call 1 to 2 weeks later." Send unsolicited photos by mail for consideration. Keeps samples on file.

Simultaneous submissions and previously published work OK. Pays $225 for color cover; $25-175 for b&w or color inside, depending on size. Pays 30 days after publication. Credit line given. Buys one-time rights; reprint rights for *Cape Cod Life* reprints; negotiable.

Tips "Write for photo guidelines. Mail photos to the attention of our art director, Pam Conrad. Photographers who do not have images of Cape Cod, Martha's Vineyard, Nantucket or the Elizabeth Islands should not submit." Looks for "clear, somewhat graphic slides. Show us scenes we've seen hundreds of times with a different twist and elements of surprise. Photographers should have a familiarity with the magazine and the region first. Prior to submitting, photographers should send a SASE to receive our guidelines. They can then submit works (via mail) and follow up with a brief phone call. We love to see images by professional-caliber photographers who are new to us, and prefer it if the photographer can leave images with us at least 2 months, if possible."

$ THE CAPE ROCK

Southeast Missouri State University, Cape Girardeau MO 63701. (573)651-2500. E-mail: hhecht@semo.edu. Website: http://cstl-cla.semo.edu/hhecht/caperock.htm. **Contact:** Harvey Hecht, editor-in-chief. Circ. 1,000. Estab. 1964. Semiannual. Emphasizes poetry and poets for libraries and interested persons. Photo guidelines available on Website.

Needs Uses 11 photos/issue (at least 9 of which must be "portrait format." A cover photo is usually color; the others are printed in b&w. "We feature a single photographer each issue. Submit 25-30 thematically organized black-and-white glossies (at least 5 × 7), or send 5 pictures with plan for complete issue. We favor a series that conveys a sense of place, e.g., an issue featuring Chicago might show buildings or other landmarks, people of the city (no nudes), travel or scenic. No how-to or products. Sample issues and guidelines provide all information a photographer needs to decide whether to submit to us." Model release not required, "but photographer is liable." Photo captions not required, "but photographer should indicate where series was shot."

Making Contact & Terms Send query letter with list of stock photo subjects, actual photos or a high quality digital file for review; include SASE for return of material. Response time varies. Pays $100 and 10 copies of publication. Credit line given. Buys all rights, but will release rights to photographer on request.

Tips "We don't give assignments, but we look for a unified package put together by the photographer. We may request additional or alternative photos when accepting a package."

N ◘ $$ CHARISMA MAGAZINE

Strang Communications, 600 Rinehart Rd., Lake Mary FL 32746. (407)333-0600. E-mail: joe. deleon@strang.com. Website: www.charismamag.com and www.strang.com. **Contact:** Joe Deleon, magazine design director. Circ. 200,000. Monthly magazine. Emphasizes Christian life. General readership. Sample copy available for $2.50.

Needs Buys 3-4 photos from freelancers/issue; 36-48 photos/year. Needs editorial photos— appropriate for each article. Model release required. Photo captions preferred.

Specs Accepts images in digital format. Send via CD as TIFF, JPEG, EPS files at 300 dpi. Low-res images accepted for sample submissions.

Making Contact & Terms Send unsolicited photos by mail for consideration. Provide

brochure, flier or tearsheets to be kept on file for possible future assignments. Simultaneous submissions and previously published work OK. Cannot return material. Responds ASAP. Pays $650 for color cover; $150 for b&w inside; $50-150/hour or $400-750/day. Pays on publication. Credit line given. Buys all rights; negotiable.

Tips In portfolio or samples, looking for "good color and composition with great technical ability."

◼ $ CHESS LIFE FOR KIDS

U.S. Chess Federation, P.O. Box 3967, Crossville TN 38557. (732)252-8388. E-mail: gpetersen@uschess.org. Website: www.uschess.org. **Contact:** Glenn Petersen, editor. Estab. 2006. Circ. 28,000. Bimonthly association magazine geared for the young reader, age 12 and under, interested in chess; fellow chess players; tournament results; and instruction. Sample copy available with SAE and first-class postage. Photo guidelines available via e-mail.

Needs Wants photos of babies/children/teens, celebrities, multicultural, families, senior citizens, events, humor. Some aspect of chess must be present: playing, watching, young/old contrast. Reviews photos with or without a manuscript. Property release is required. Captions required.

Specs Accepts images in digital format. Send via Zip or e-mail. Contact Frankie Butler at fbutler@uschess.org for more information on digital specs. Uses glossy color prints.

Making Contact & Terms E-mail query letter with link to photographer's Website. Provide self-promotion piece to be kept on file. Responds in 1 week to queries and portfolios. Simultaneous submissions and previously published work OK. Pays $150 minimum/$300 maximum for color cover. Pays $35 for color inside. Pays on publication. Credit line given. Rights are negotiable. Will negotiate with a photographer unwilling to sell all rights.

Tips "Read the magazine. What would appeal to *your* 10-year-old? Be original. We have plenty of people to shoot headshots and award ceremonies. And remember, you're competing against proud parents as well."

◪ ◼ ◲ CHICKADEE MAGAZINE

10 Lower Spadina Ave., Suite 400, Toronto ON M5V 2Z2 Canada. (416)340-2700. Fax: (416)340-9769. E-mail: deb.yea@owlkids.com. Website: www.owlkids.com. **Contact:** Debbie Yea, photo editor. Circ. 92,000. Estab. 1979. Published 10 times/year. A discovery magazine for children ages 6-9. Sample copy available for $4.95 with 9 × 12 SAE and $1.50 money order to cover postage. Photo guidelines available for SAE or via e-mail.

 • *chickaDEE* has received Magazine of the Year, Parents' Choice, Silver Honor, Canadian Children's Book Centre Choice and several Distinguished Achievement awards from the Association of Educational Publishers.

Needs Photo stories, photo puzzles, children ages 6-10, multicultural, environmental, wildlife, pets, adventure, events, hobbies, humor, performing arts, sports, travel, science, technology, animals in their natural habitats. Interested in documentary, seasonal. Model/property release required. Photo captions required.

Specs Prefers images in digital format. E-mail as JPEG files at 72 dpi; 300 dpi required for publication.

Making Contact & Terms Previously published work OK. Credit line given. Buys one-time rights.

✂ ▣ ⬤ CHIRP MAGAZINE

10 Lower Spadina Ave., Suite 400, Toronto ON M5V 2Z2 Canada. (416)340-2700. Fax: (416)340-9769. E-mail: deb.yea@owlkids.com. Website: www.owlkids.com. **Contact:** Debbi Yea, photo editor. Circ. 85,000. Estab. 1997. Published 10 times/year. A discovery magazine for children ages 3-6. Sample copy available for $4.95 with 9 × 12 SAE and $1.50 money order to cover postage. Photo guidelines available for SAE or via e-mail.

- *Chirp* has received Best New Magazine of the Year, Parents' Choice, Canadian Children's Book Centre Choice and Distinguished Achievement awards from the Association of Educational Publishers.

Needs Photo stories, photo puzzles, children ages 5-7, multicultural, environmental, wildlife, adventure, events, hobbies, humor, animals in their natural habitats. Interested in documentary, seasonal. Model/property release required. Photo captions required.

Specs Prefers images in digital format. E-mail as TIFF, JPEG files at 72 dpi; 300 dpi required for publication.

Making Contact & Terms Request photo packages before sending photos for review. Responds in 3 months. Previously published work okay. Credit line given. Buys one-time rights.

▣ Ⓐ $ ⬤ THE CHRONICLE OF THE HORSE

P.O. Box 46, Middleburg VA 20118. (540)687-6341. Fax: (540)687-3937. E-mail: editorial@chronofhorse.com. Website: www.chronofhorse.com. **Contact:** Tricia Booker, editor. Circ. 23,000. Estab. 1937. Weekly magazine. Emphasizes English horse sports. Readers range from young to old. "Average reader is a college-educated female, middle-aged, well-off financially." Sample copy available for $2. Photo guidelines free with SASE or on Website.

Needs Buys 10-20 photos from freelancers/issue. Needs photos from competitive events (horse shows, dressage, steeplechase, etc.) to go with news story or to accompany personality profile. "A few stand alone. Must be cute, beautiful or newsworthy. Reproduced in black and white." Prefers purchasing photos with accompanying manuscript. Photo captions required with every subject identified.

Specs Uses b&w and/or color prints, slides (reproduced b&w). Accepts images in digital format at 300 dpi.

Making Contact & Terms Send query letter by mail or e-mail. Responds in 6 weeks. Pays $30 base rate. Pays on publication. Buys one-time rights. Credit line given. Prefers first North American rights.

Tips "We do not want to see portfolio or samples. Contact us first, preferably by letter; include SASE for reply. Know horse sports."

▣ $ $ ⬤ CLEVELAND MAGAZINE

Great Lakes Publishing, 1422 Euclid Ave., #730, Cleveland OH 44115. (216)771-2833. Fax: (216)781-6318. E-mail: kessen@clevelandmagazine.com. Website: www.clevelandmagazine.com. **Contact:** Jennifer Kessen, art director. Circ. 40,000. Estab. 1972. Monthly consumer magazine emphasizing Cleveland, Ohio. General interest to upscale audience.

Needs Buys an average of 50 photos from freelancers/issue; 600 photos/year. Needs photos of architecture, business concepts, education, entertainment, environmental, events, food/drink, gardening, health/fitness, industry, interiors/decorating, landscapes/scenics,

medicine, people (couples, families, local celebrities, multicultural, parents, senior citizens), performing arts, political, product shots/still life, sports, technology, travel, interested in documentary and fashion/glamour. Model release required for portraits; property release required for individual homes. Photo captions required; include names, date, location, event, phone.

Specs Prefers images in digital format. Send via CD, e-mail as TIFF, JPEG files at 300 dpi. Also uses color and b&w prints.

Making Contact & Terms Provide self-promotion, samples, or tearsheets via e-mail or mail to be kept on file for possible future assignments. Responds only if interested. Pays on publication. Credit line given. Buys one-time publication, electronic and promotional rights.

▣ $ ☑ COBBLESTONE

Cobblestone Publishing, 30 Grove St., Suite C, Peterborough NH 03458. (603)924-7209. Fax: (603)924-7380. Website: www.cobblestonepub.com. **Contact:** Meg Chorlian, editor. Circ. 29,000. Estab. 1980. Published 9 times/year, September-May. Emphasizes American history; each issue covers a specific theme. Readers are children ages 8-14, parents, teachers. Sample copy available for $4.95 and 9 × 12 SAE with 5 first-class stamps. Photo guidelines free with SASE.

Needs Buys 10-20 photos from freelancers/issue; 90-180 photos/year. Needs photos of children, multicultural, landscapes/scenics, architecture, cities/urban, agriculture, industry, military. Interested in fine art, historical/vintage, reenacters. "We need photographs related to our specific themes (each issue is theme-related) and urge photographers to request our themes list." Model release required. Photo captions preferred.

Specs Uses 8 × 10 glossy prints; 35mm, 2¼ × 2¼ transparencies. Accepts images in digital format. Send via CD, SyQuest, Zip as TIFF files at 300 dpi, saved at 8 × 10 size.

Making Contact & Terms Send query letter with samples or list of stock photo subjects; include SASE for return of material. "Photos must pertain to themes, and reporting dates depend on how far ahead of the issue the photographer submits photos. We work on issues 6 months ahead of publication." Simultaneous submissions and previously published work OK. Pays $150-300 for color cover; $10-100 for color inside (payment depends on size of photo). Pays on publication. Credit line given. Buys one-time rights.

Tips "Most photos are of historical subjects, but contemporary color images of, for example, a Civil War battlefield, are great to balance with historical images. However, the amount varies with each monthly theme. Please review our theme list and submit related images."

▣ Ⓐ $ COMPANY MAGAZINE

P.O. Box 60790, Chicago IL 60660-0790. (773)761-9432. Fax: (773)761-9443. E-mail: editor@ companymagazine.org. Website: www.companymagazine.org. **Contact:** Martin McHugh, editor. Circ. 114,000. Estab. 1983. Quarterly magazine published by the Jesuits (Society of Jesus). Emphasizes Jesuit works/ministries and the people involved in them. Sample copy available for 9 × 12 SAE.

Needs Needs photos and photo-stories of Jesuit and allied ministries and projects. Reviews photos with or without manuscript. Photo captions required.

Specs Accepts images in digital format. Send via CD, Zip, e-mail "at screen resolution as long as higher-res is available."

Making Contact & Terms Query with samples; include SASE for return of material. Provide résumé, business card, brochure, flier or tearsheets to be kept on file for possible future assignments. Responds in 1 month. Pays $50-100 for individual photos; $300 for color cover; up to $750 for photo story. Pays on publication. Credit line given. Buys one-time rights; negotiable.

Tips "Avoid large-group, 'smile-at-camera' photos. We are interested in people/activity photographs that tell a story about Jesuit ministries."

▣ ◪ COMPETITOR COLORADO

Competitor Group, Inc., P.O. Box 3036, Boulder CO 80211. (303) 477-9770. Fax: (303)477-9747. E-mail: rheaton@competitorgroup.com. Website: www.competitor.com. **Contact:** Rebecca Heaton. Estab. 1986. Circ. 95,000. Monthly consumer magazine covering running, mountain biking, road racing, snowboarding, both alpine and Nordic skiing, kayaking, hiking, climbing, mountaineering, and other individual sports.

Needs Needs photos of adventure, running, mountain biking, road racing, snowboarding, both alpine and Nordic skiing, kayaking, hiking, climbing, mountaineering, and other individual sports. Interested in lifestyle. Editorial calendar: March: running; April: adventure; May: triathlon; June: climbing/paddling/mountain biking; July: summer travel; August: organic; September: women; October: gym/fitness; November: snow sports; December: snow sports. Reviews photos with or without a manuscript. Model release required. Captions required; include identification of subjects.

Specs Accepts images in digital format. Send JPEG or TIFF files at 300 dpi minimum.

Making Contact & Terms Payment negotiated. Pays on publication. Credit line given. Buys one-time rights.

Tips "Think fun. Don't be afraid to try something new. We like new."

$ ◪ CONFRONTATION MAGAZINE

English Dept., C.W. Post Campus of Long Island University, 720 Northern Blvd., Brookville NY 11548. (516)299-2391. Fax: (516)299-2735. E-mail: martin.tucker@liu.edu. **Contact:** Martin Tucker, editor. Circ. 2,000. Estab. 1968. Semiannual literary magazine. Readers are college-educated lay people interested in literature. Sample copy available for $3.

Needs Reviews photos with or without manuscript. Photo captions preferred.

Making Contact & Terms Send query letter with résumé of credits, stock list. Responds in 1 month. Simultaneous submissions OK. Pays $100-300 for b&w or color cover; $40-100 for b&w inside; $50-100 for color inside. Pays on publication. Credit line given. Buys first North American serial rights; negotiable.

▣ CONTEMPORARY BRIDE MAGAZINE

216 Stelton Rd., Unit D-1, Piscataway NJ 08854. (732)968-0123. Fax: (732)968-0220. E-mail: gary@contemporarybride.com. Website: www.contemporarybride.com. **Contact:** Gary Paris, publisher. Circ. 120,000. Estab. 1994. Biannual bridal magazine with wedding planner; 4-color publication with editorial, calendars, check-off lists and advertisers. Sample copy available for first-class postage.

Needs Needs photos of travel destinations, fashion, bridal events. Reviews photos with accompanying manuscript only. Model/property release preferred. Photo captions preferred; include photo credits.

Specs Accepts images in digital format. Send as high-res files at 300 dpi.

Making Contact & Terms Send query letter with samples. Art director will contact photographer for portfolio review if interested. Provide b&w and/or color prints, disc. Keeps samples on file; cannot return material. Responds only if interested; send nonreturnable samples. Simultaneous submissions and previously published work OK. Payment negotiable. Buys all rights, electronic rights.

Tips "Digital images preferred with a creative eye for all wedding-related photos. Give us the *best* presentation."

⑤ $ ▢ CONTINENTAL NEWSTIME

501 W. Broadway, Plaza A, PMB #265, San Diego CA 92101-3802. (858)492-8696. E-mail: ContinentalNewsService@yahoo.com. Website: www.ContinentalNewsService.com. **Contact:** Gary P. Salamone, editor-in-chief. Estab. 1987. Twice-monthly general interest magazine of news and commentary on U.S. national and world news, with travel columns, entertainment features, humor pieces, comic strips, general humor panels, and editorial cartoons. Covers the unreported and under-reported national (U.S.) and international news. Sample copy available for $4 in US and $6.50 CAN/foreign.

Needs Buys variable number of photos from freelancers. Needs photos of celebrities, public figures, U.S. and foreign government officials/cabinet ministers, breaking/unreported/under-reported news. Reviews photos with or without a manuscript. Model/property release required. Photo captions required.

Specs Uses 8 × 10 color and/or b&w prints.

Making Contact & Terms Send query letter with résumé, photocopies, tearsheets, stock list. Provide résumé to be kept on file for possible future assignments. Responds only if interested in absence of SASE being received; send nonreturnable samples. Simultaneous submissions OK. Pays $10 minimum for b&w cover. Pays on publication. Credit line given. Buys one-time rights.

Tips "Read our magazine to develop a better feel for our photo applications/uses and to satisfy our stated photo needs."

⊘ COSMOPOLITAN

Hearst Communications, Inc., 224 W. 57th St., 8th Floor, New York NY 10019. (212)649-2000. E-mail: cosmopolitan@hearst.com. Website: www.cosmopolitan.com. Cosmopolitan targets young women for whom beauty, fashion, fitness, career, relationships and personal growth are top priorities. It includes articles and columns on nutrition and food, travel, personal finance, home/lifestyle and celebrities. **Query before submitting.**

▣ $ ⊘ CYCLE CALIFORNIA! MAGAZINE

1702-L Meridian Ave., #289, San Jose CA 95125. (888)292-5323. Fax: (408)292-3005. E-mail: bmack@cyclecalifornia.com. Website: www.cyclecalifornia.com. **Contact:** Bob Mack, publisher. Circ. 31,000. Estab. 1995. Monthly magazine providing readers with a comprehensive source of bicycling information, emphasizing the bicycling life in northern

California and Nevada; promotes bicycling in all its facets. Sample copy available for 9 × 12 SAE with $1.31 first-class postage. Photo guidelines available for 44¢ SASE.

Needs Buys 3-5 photos from freelancers/issue; 45 photos/year. Needs photos of recreational bicycling, bicycle racing, triathlons, bicycle touring and adventure racing. Cover photos must be vertical format, color. All cyclists must be wearing a helmet if riding. Reviews photos with or without manuscript. Model release required; property release preferred. Photo captions preferred; include when and where photo is taken; if an event, include name, date and location of event; for nonevent photos, location is important.

Specs High-resolution TIFF images preferred (2000 × 3000 pixel minimum). Cover photos are 7x9 inches. Uses 4x6 matte color and b&w prints.

Making Contact & Terms Send query letter with slides, prints or CD/disk. Keeps usable images on file; include SASE for return of material. Responds in 3 weeks. Simultaneous submissions OK. Pays $125 for color cover; $50 for inside. Pays on publication.

Tips "We are looking for photographic images that depict the fun of bicycle riding. Your submissions should show people enjoying the sport. Read the magazine to get a feel for what we do. Label images so we can tell what description goes with which image."

Ⓝ $ CYCLE WORLD MAGAZINE

1499 Monrovia Ave., Newport Beach CA 92663. (949)720-5300. E-mail: dedwards@hfmus. com. Website: www.cycleworld.com. **Contact:** David Edwards, Vice President/Editor-in-Chief. Vice President/Senior Editor: Paul Dean. Monthly magazine. Circ. 300,000. Readers are active motorcyclists who are "affluent, educated and very perceptive."

Needs Buys 10 photos/issue. Wants "outstanding" photos relating to motorcycling. Prefers to buy photos with manuscripts. For Slipstream column, see instructions in a recent issue.

Specs Prefers high-res digital images at 300 dpi or quality 35mm color transparencies.

Making Contact & Terms Send photos for consideration; include SASE for return of material. Responds in 6 weeks. "Cover shots are generally done by the staff or on assignment." Pays $50-200/photo. Pays on publication. Buys first publication rights.

▣ ◪ DANCE

2660 Petersborough St., Herndon VA 20171. E-mail: shannonaswriter@yahoo.com. Quarterly publication featuring international dancers.

Needs Performing arts, product shots/still life-as related to international dance for children and teens. Interested in alternative process, avant garde, documentary, fashion/glamour, fine art, historical/vintage, seasonal. Reviews photos with or without a manuscript. Model/property release preferred.

Specs Uses glossy or matte color and/or b&w prints.

Making Contact & Terms Send query letter via e-mail. Provide résumé, business card, self-promotion piece to be kept on file for possible future assignments. "Photographs sent along with CDs are requested but not required. Artwork and illustrations also accepted." Responds within 1 month to queries; 1 week to portfolios. Simultaneous submissions and previously published work OK. **Pays on acceptance.** Credit line given. Buys one-time rights, first rights; negotiable.

⊞ ▣ $ ☑ DIGITAL PHOTO

Bauer Media, Media House, Lynchwood, Peterborough PE2 6EA United Kingdom. +44 1733 468 546. Fax: +44 1733 468 387. E-mail: dp@bauermedia.co.uk. Circ. 68,687. Estab. 1997. Monthly consumer magazine. "UK's best-selling photography and imaging magazine."

Needs Stunning, digitally manipulated images of any subject and Photoshop or Elements step-by-step tutorials of any subject. Reviews photos with or without a manuscript. Model/property release preferred. Photo captions preferred.

Specs Accepts images in digital format. Send via CD as PSD, TIFF or JPEG files at 300 dpi, or via email as JPEG.

Making Contact & Terms Send query letter with resume, tearsheets, contact prints and CD with high-res files. Provide SAE for eventual return. Responds in 1 month to queries. Rates negotiable, but typically 60 GBP per page. Pays on publication. Credit line given. Buys first rights.

Tips "Study the magazine to check the type of images we use, and send a sample of images you think would be suitable. The broader your style, the better for general acceptance, while individual styles appeal to our Gallery section. Step-by-step technique pieces must be formatted to house style, so check magazine before submitting. Supply a contact sheet or thumbnail of all the images supplied in electronic form to make it easier for us to make a quick decision on the work."

Ⓝ ▣ $ $ ☑ DOG FANCY

Fancy Publications, a division of BowTie, Inc., P.O. Box 6050, Mission Viejo CA 92690. (949)855-8822. Fax: (949)855-3045. E-mail: jschwartze@bowtieinc.com. Website: www. dogfancy.com. **Contact:** John Schwartze, associate editor. Circ. 268,000. Estab. 1970. Monthly magazine. Readers are "men and women of all ages interested in all aspects of dog ownership." Sample copy available for $5.50. Photo guidelines free with SASE or on website.

Needs Three specific breeds featured in each issue. Prefers "photographs that show the various physical and mental attributes of the breed. Include both environmental and action photographs. Dogs must be well groomed and, if purebred, good examples of their breed. By good example, we mean clean, healthy-looking dogs who conform to their breed standard (found at www.akc.org or www.ukcdogs.com). We also need for high-quality, interesting photographs of pure or mixed-breed dogs in canine situations (dogs with veterinarians; dogs eating, drinking, playing, swimming, etc.) for use with feature articles. Shots should have natural, modern background, style and setting, avoiding studio backgrounds. Photographer is responsible for model releases.

Specs Prefers high-resolution digital images either TIFF or JPEG at least 5 inches at 300 dpi. Can be sent on disk or via FTP site. Instructions for FTP submittal provided upon request. Also accepts images in 35mm slide format.

Making Contact & Terms Send CD, DVD, or actual 35mm slides. Address submission to "Photo Editor." Present a professional package: Disks with photographer's name on it separated by subject with contact sheets and 35mm slides in sleeves with photographer's name and breed of dog. Pays $300 for color cover; $25-100 for color inside; $200 for 4-color centerspreads. Credit line given. Buys first North American print rights and non-exclusive rights to use in electronic media.

Tips "Send a variety of shots. We mainly want to see outdoor and action photos of dogs alone and dogs with people. Once we review your images, we will notify you whether we will or will not be adding you to our list of freelance photographers. Poor lighting, focus, and composition in photographs are what make a particular photographer a likely candidate for rejection."

$$ ☑ DOGS IN CANADA

Apex Publishing Ltd., 200 Ronsone Dr., Suite 401, Etobicoke ON M9W 5Z9 Canada. (416)798-9778. Fax: (416)798-9671. Website: www.dogsincanada.com. **Contact:** Kelly Caldwell, editor-in-chief/art director. Circ. 41,769. Estab. 1889. Monthly consumer magazine. "Dogs in Canada magazine is a reliable and authoritative source of information about dogs. Our mix of editorial content and photography must satisfy a diverse readership, including breed fanciers and those who simply have a beloved family pet. Photography is of central importance." Sample copy available for $4.95 and 8 × 10 SAE with postage. Request photo guildelines via e-mail.

Needs Buys 10-30 photos/year. Needs photos from any category as long as there is a dog in the shot. Reviews photos with or without a manuscript. Model/property release preferred. Photo captions preferred; include breed of dog.

Specs Prefers images in digital format. Send via CD as TIFF or ESP files at 300 dpi.

Making Contact & Terms E-mail query letter with link to photographer's website and JPEG samples at 72 dpi. Send query letter with slides, prints. Provide résumé, business card, self-promotion piece to be kept on file for possible future assignments. Responds only if interested; send nonreturnable samples. Considers previously published work. Pays $80-600 for b&w or color cover; $50-300 for b&w or color inside. Pays net 30 days. Credit line given. Buys first rights, electronic rights.

Tips "Well-composed, high-quality photographs are expected. A creative approach catches our eye. Photos that capture a moment in time and the essence of a dog are preferred to a staged portrait."

$ THE DRAKE MAGAZINE

For Those Who Fish 1600 Maple St., Fort Collins CO 80521. (949)218-8642. E-mail: info@drakemag.com. Website: www.drakemag.com. **Contact:** Tom Bie, managing editor. Circ. 10,000. Estab. 1998. Annual magazine for fly-fishing enthusiasts.

Needs Buys 50 photos from freelancers/issue. Needs creative fly-fishing shots. Reviews photos with or without a manuscript.

Specs Uses glossy prints; 35mm transparencies.

Making Contact & Terms Send query letter with slides. Provide business card to be kept on file for possible future assignments. Responds in 6 months to queries. Pays $200 minimum for color cover; $40 minimum for b&w inside. Pays on publication. Credit line given. Buys one-time rights.

Tips "No 'grip and grins' for fishing photos. Think creative. Show me something new."

▣ $$ DUCKS UNLIMITED

One Waterfowl Way, Memphis TN 38120. (901)758-3864. E-mail: jhoffman@ducks.org. Website: www.ducks.org. **Contact:** John Hoffman, photo editor. Circ. 700,000. Estab. 1937.

Bimonthly association magazine of Ducks Unlimited, a nonprofit organization. Emphasizes waterfowl hunting and conservation. Readers are professional males, ages 40-50. Sample copy available for $3. Photo guidelines available on Website, via e-mail or with SASE.

Needs Buys 84 photos from freelancers/issue; 504 photos/year. Needs images of wild ducks and geese, waterfowling and scenic wetlands. Special photo needs include waterfowl hunters, dynamic shots of waterfowl interacting in natural habitat.

Specs Accepts images in digital format. Send via CD as TIFF, JPEG, EPS files at 300 dpi; include thumbnails.

Making Contact & Terms Send only top-quality portfolio of not more than 40 transparencies (35mm or larger) with SASE for consideration. Responds in 1 month. Previously published work OK, if noted. Pays on publication. Credit line given. Buys one-time rights "plus permission to reprint in our Mexican and Canadian publications."

▣ ⑤ $$ ☑ THE ELKS MAGAZINE

425 W. Diversey Pkwy., Chicago IL 60614-6196. (773)755-4894. Fax: (773)755-4792. E-mail: cheryls@elks.org. Website: www.elks.org/elksmag. **Contact:** Cheryl T. Stachura, editor/publisher. Circ. nearly 1 million. Estab. 1922. Magazine published 10 times/year. Mission is to provide news of Elks to all 1 million members. "In addition, we have general interest articles. Themes: Americana; history; wholesome, family info; sports; industries; adventure; technology. We do not cover religion, politics, controversial issues." Sample copy free.

Needs Buys 10 cover photos/year; mostly from stock photo houses; approximately 20 photos/month for interior use. "Photographs of Elks in action are particularly welcome." Reviews photos with or without a manuscript. Photo captions required; include location.

Specs Accepts high-resolution digital images.

Making Contact & Terms Send query letter with samples. Does not keep samples on file; include SASE for return of material. Responds in 2 months to queries. Simultaneous submissions OK. Pays $475 for color cover. Pays on publication. Credit line given. Buys one-time rights.

Tips "Artistry and technical excellence are as important as subject matter. We are now purchasing 90 percent of our photographs from photographic stock houses."

▣ $$ ☑ ENTREPRENEUR

2445 McCabe Way, Suite 400, Irvine CA 92614. (949)261-2325. Website: www.entrepreneur.com. **Contact:** Richard R. Olson, design director. Circ. 650,000. Estab. 1977. Monthly magazine emphasizing business. Readers are existing and aspiring small business owners.

Needs Uses about 40 photos/issue; about 10% supplied by freelance photographers; 80% on assignment; 10% from stock. Needs "people at work, home office, business situations. I want to see colorful shots in all formats and styles." Model/property release preferred. Photo captions required; include names of subjects.

Specs Accepts images in digital format and film. Send via Zip, CD, e-mail as TIFF, EPS, JPEG files at 300 dpi.

Making Contact & Terms Provide résumé, business card, brochure, flier or tearsheets to be kept on file for possible future assignments. Pays $2,000 for color cover; $700 for color inside. **Pays on acceptance.** Credit line given. Buys one-time North American rights; negotiable.

Tips "I am looking for photographers who use the environment creatively; I do not like blank walls for backgrounds. Lighting is also important. I prefer medium-format for most shoots. I think photographers are going back to the basics—a good, clean shot, different angles and bright colors. I also like gelled lighting. I prefer examples of your work—promo cards and tearsheets—along with business cards and résumés."

⊕ ▣ $ ▢ EOS MAGAZINE

Robert Scott Publishing Ltd., The Old Barn, Ball Lane, Tackley, Kidlington, Oxfordshire OX5 3AG United Kingdom. (44)(186)933-1741. Fax: (44)(186)933-1641. E-mail: editorial@eos-magazine.com. Website: www.eos-magazine.com. **Contact:** Angela August, editor. Circ. 20,000. Estab. 1993. Quarterly consumer magazine for all users of Canon EOS cameras. Photo guidelines free.

Needs Looking for quality stand-alone images as well as photos showing specific photographic techniques and comparison pictures. All images must be taken with EOS cameras but not necessarily with Canon lenses. Model release preferred. Photo captions required; include technical details of photo equipment and techniques used.

Specs Accepts images in digital format exclusively.

Making Contact & Terms E-mail to request 'Notes for Contributors' (Put this in the subject line). You will be e-mailed with further information about how to submit images, current requirements, and rates of payment. Pays on publication. Credit line given. Buys one-time rights.

Tips "We are more likely to use images from photographers who submit a wide selection of top-quality images (40-60 images)."

▣ Ⓢ $$ ⊘ E/THE ENVIRONMENTAL MAGAZINE

28 Knight St., Norwalk CT 06851. (203)854-5559. Fax: (203)866-0602. E-mail: bbelli@emagazine.com. Website: www.emagazine.com. **Contact:** Brita Belli, editor, photos editor. Trudy Hodenfield, art director. Circ. 60,000. Estab. 1988. Nonprofit consumer magazine. Emphasizes environmental issues. Readers are environmental activists, people concerned about the environment. Sample copy available for 9 × 12 SAE and $5. Photo guidelines free with SASE or via e-mail.

Needs Buys 20 photos from freelancers/issue. Needs photos of threatened landscapes, environmental leaders, people and the environment, pollution, transportation, energy, wildlife and activism. Photo captions required; include location, identities of people in photograph, date, action in photograph.

Specs Accepts images in digital format. Send via CD, Zip, e-mail as TIFF, EPS, JPEG files at 300 dpi and at least 3 × 4 print size.

Making Contact & Terms "The specific focus of E is environmental activism. We are therefore interested in photographs that will enlarge our readers' awareness of the threats to our natural environment. We look for professional slides and photographs that can be easily understood and tell a story. Please do not submit artwork unless accompanying a story and/or pertaining to a specific photographic request. All photographic needs are based on editorial content." Send samples of work to be kept on file. Do not send slides for review. "We prefer non-returnable samples such as tearsheets, promotional pieces, photocopies, etc. Also, include photo stock lists and note areas in which you specialize."

Tips Wants to see "straightforward, journalistic images. Abstract or art photography or landscape photography is not used." In addition, "please do not send manuscripts with photographs. These can be addressed as queries to the managing editor."

N ⚘ ▣ S $ ⊘ EVENT

Douglas College, Box 2503, New Westminster BC V3L 5B2 Canada. (604)527-5293. Fax: (604)527-5095. E-mail: event@douglas.bc.ca. Website: http://event.douglas.bc.ca. **Contact:** Ian Cockfield, managing editor. Circ. 1,300. Magazine published every 4 months. Emphasizes literature (short stories, reviews, poetry, creative nonfiction). Sample copy available for $9.

Needs Buys 3 photos/year intended for cover art. Documentary, fine art, human interest, nature, special effects/experimental, still life, travel or "any subject suitable for the cover of a literary magazine, particularly images that are self-sufficient and do not lead the reader to expect further artwork within the journal." Wants any "non-applied" photography, or photography not intended for conventional commercial purposes. Needs excellent quality. "No unoriginal, commonplace or hackneyed work."

Specs Uses color and/or b&w prints or slides. Any smooth finish OK. Accepts images in digital format.

Making Contact & Terms Send material by mail with SAE and IRC or Canadian stamps for consideration. Simultaneous submissions OK. Pays $150 on publication. Credit line given. Buys one-time rights.

Tips "We prefer work that appears as a sequence: thematically, chronologically, stylistically. Individual items will only be selected for publication if such a sequence can be developed. Photos should preferably be composed for horizontal (landscape) format (approx. 12.5 × 9.25). Please send no more than 10 images to Event along with a SASE (Canadian postage or International Reply Coupons only) for return of work."

⚘ ▣ $$ ⊘ FAITH TODAY

Evangelical Fellowship of Canada, MIP Box 3745, Markham ON L3R 0Y4 Canada. (905)479-6071, ext 241. Fax: (905)479-4742. E-mail: FTeditor@efc-canada.com. Website: www. faithtoday.ca. **Contact:** Bill Fledderus, senior editor. Circ. 18,000. Estab. 1983. Bimonthly consumer publication. Sample copy free for SAE.

Needs Buys 1 photo from freelancers/issue; 6 photos/year. Needs photojournalism of Canadian religious events and photos of multicultural, families, senior citizens, education, religious. Interested in religious historical/vintage. Also looking for scenes of church life: people praying, singing, etc. Reviews photos with or without a manuscript. Photo captions required.

Specs Uses color prints. Accepts images in digital format. Send via e-mail as TIFF, EPS, JPEG files at 266 dpi.

Making Contact & Terms Send query letter with photocopies, stock list. Does not keep samples on file; include SASE for return of material. Responds only if interested; send nonreturnable samples. Simultaneous submissions and previously published work OK. Pays $25-400 for color cover; $25-150 for color inside. Pays on publication. Credit line given "if requested." Buys one-time rights.

Tips "We emphasize Canada and so generally use photos that are clearly Canadian. Our

website does not adequately represent our use of photos but does list sample articles, so you can see the kind of topics we cover. We also commission illustrations and welcome queries on that. Many of our photos come via DesignPics.com."

$ ◯ FELLOWSHIP

P.O. Box 271, Nyack NY 10960. (845)358-4601, ext. 42. Fax: (845)358-4924. E-mail: editor@ forusa.org. Website: www.forusa.org. **Contact:** Ethan Vesely-Flad, editor. Circ. 6,000. Estab. 1935. Publication of the Fellowship of Reconciliation; quarterly magazine (32-48 pages) published 4 times/year. Emphasizes peace-making, social justice, nonviolent social change. Readers are interested in peace, justice, nonviolence and spirituality. Sample copy available for $7.50.

Needs Buys 1-2 photos from freelancers/issue; 4-10 photos/year. Needs stock photos of people, civil disobedience, demonstrations—Middle East, Latin America, Caribbean, prisons, anti-nuclear, children, gay/lesbian, human rights issues, Asia/Pacific. Captions required.

Making Contact & Terms Provide résumé, business card, brochure, flier or tearsheets to be kept on file for possible future assignments. "Call on specs." Responds in 4-6 weeks. Simultaneous submissions and previously published work OK. Pays $100 for color cover; $35 for b&w inside. Pays on publication. Credit line given. Buys one-time rights.

Tips "You must want to make a contribution to peace movements. Money is simply token."

▣ $ ◪ FIELD & STREAM

2 Park Ave., New York NY 10016. (212)779-5238. Fax: (212)779-5114. Website: www. fieldandstream.com. **Contact:** Amy Berkley, photo editor. Circ. 1.5 million. Broad-based service magazine published 11 times/year. Editorial content ranges from very basic "how it's done" filler stories that tell in pictures and words how an outdoor technique is accomplished or device is made, to feature articles of penetrating depth about national conservation, game management and resource management issues; also recreational hunting, fishing, travel, nature and outdoor equipment. Photo guidelines available.

Needs Photos using action and a variety of subjects and angles in color and occasionally b&w. "We are always looking for cover photographs, in color, vertical or horizontal. Remember: a cover picture must have room for cover lines." Also looking for interesting photo essay ideas related to hunting and fishing. Query photo editor by mail. Needs photo information regarding subjects, the area, the nature of the activity and the point the picture makes. First Shots: these photos appear every month (2/issue). Prime space, 2-page spread. One of a kind, dramatic, impactful images, capturing the action and excitement of hunting and fishing. Great beauty shots. Unique wildlife images. See recent issues. "Please do not submit images without reviewing past issues and having a strong understanding of our audience."

Specs Uses 35mm slides. Will also consider large-format photography. Accepts images in digital format. Send via CD, e-mail as JPEG files at 300 dpi.

Making Contact & Terms Submit photos by registered mail. Send slides in 8½ × 11 plastic sheets, and pack slides and/or prints between cardboard. Include SASE for return of material. Drop portfolios at receptionist's desk, ninth floor. Buys first North American serial rights.

▣ FLY FISHERMAN

Intermedia Outdoors, Inc., 6385 Flank Dr., Harrisburg PA 17112. (717)657-9555. Fax: (717)657-9552. Website: www.flyfisherman.com. **Contact**: Jim Pfaff, art director. Managing editor; Geoff Mueller. Circ. 130,000. Magazine published 6 times/year. Emphasizes all types of fly fishing for readers who are "80% male, 83% college-educated, 98% married; average household income is $138,000, and 49% are managers or professionals; 68% keep their copies for future reference and spend 33 days/year fishing." Sample copy available via website or for $4.95 with 9 × 12 SAE and 4 first-class stamps. Photo guidelines available on website or free with SASE.

Needs Buys 36 photos from freelancers/issue; 216 photos/year. Needs shots of "fly fishing and all related areas—scenics, fish, insects, how-to." Photo captions required.

Making Contact & Terms Send 35mm, 2¼ × 2¼, 4 × 5 or 8 × 10 color transparencies by mail with SASE for consideration. Accepts color digital images on CD or via e-mail for submissions. Responds in 6 weeks. Payment negotiable. Pays on publication. Credit line given. Buys one-time or all rights.

$ $ FOOD & WINE

American Express Publishing Corporation, 1120 Avenue of the Americas, New York NY 10036. (212)382-5600. Website: www.foodandwine.com. **Contact:** Fredrika Stjarne, director o f photography. Circ. 950,000. Estab. 1978. Monthly magazine. Emphasizes food and wine. Readers are "upscale people who cook, entertain, dine out and travel stylishly."

Needs Uses about 25-30 photos/issue; 85% freelance photography on assignment basis; 15% freelance stock. "We look for editorial reportage specialists who do restaurants, food on location, and travel photography." Model release required. Photo captions required.

Making Contact & Terms Drop off portfolio on Wednesday (attn: Rebecca Jacobs). Call for pickup. Submit fliers, tearsheets, etc., to be kept on file for possible future assignments and stock usage. Pays $450/color page; $100-450 for color photos. **Pays on acceptance.** Credit line given. Buys one-time world rights.

Ⓐ $ $ FORTUNE

Rockefeller Center, Time-Life Bldg., 1271 Avenue of the Americas, New York NY 10020. (212)522-8021. Fax: (212)467-1213. E-mail: letters@fortune.com. Website: www.fortune.com. **Contact:** Scott Thode, deputy picture editor. Emphasizes analysis of news in the business world for management personnel.

Making Contact & Terms Picture Editor reviews photographers' portfolios on an overnight drop-off basis. Photos purchased on assignment only. Day rate on assignment (against space rate): $500; page rate for space: $400; minimum for b&w or color usage: $200.

▦ ▣ ▤ $ ▢ FRANCE MAGAZINE

Archant House, Oriel Rd., Cheltenham, Gloucestershire GL50 1BB United Kingdom. (44)(124)221-6050. Fax: (44)(124)221-6076. E-mail: editorial@francemag.com. Website: www.francemag.com. **Contact:** Stephanie Sheldrake. Circ. 40,000. Estab. 1990. Monthly magazine about France. Readers are male and female, ages 45 and over; people who holiday in France.

Needs Needs photos of France and French subjects: people, places, customs, curiosities,

produce, towns, cities, countryside. Photo captions required; include location and as much information as is practical.

Specs Uses 35mm, medium-format transparencies; high-quality digital.

Making Contact & Terms "E-mail in the first instance with list of subjects. Please do not send digital images. We will add you to our photographer list and contact you on an ad-hoc basis for photographic requirements."

▣ $ �‍ FT. MYERS MAGAZINE

15880 Summerlin Rd., Suite 189, Ft. Myers FL 33908. E-mail: ftmyers@optonline.net. **Contact:** Andrew Elias, director. Circ. 20,000. Estab. 2002. Magazine published every 2 months for southwest Florida, focusing on local and national arts and lifestyle. Ft. Myers Magazine is targeted at successful, educated and active residents of southwest Florida, ages 20-60, as well as guests at the best hotels and resorts on the Gulf Coast. Media columns and features include: books, music, video, films, theater, Internet, software (news, previews, reviews, interviews, profiles). Lifestyle columns and features include: art & design, house & garden, food & drink, sports & recreation, health & fitness, travel & leisure, science & technology (news, previews, reviews, interviews, profiles). Sample copy available for $3 including postage & handling.

Needs Buys 3-6 photos from freelancers/year. Needs photos of celebrities, architecture, gardening, interiors/decorating, medicine, product shots/still life, environmental, landscapes/scenics, wildlife, entertainment, events, food & drink, health/fitness/beauty, performing arts, sports, travel. Interested in alternative process, avant garde, documentary, fashion/glamour, fine art, historical/vintage. Also needs beaches, beach scenes/sunsets over beaches, boating/fishing, palm trees. Reviews photos with or without a manuscript. Model release required. Photo captions preferred; include description of image and photo credit.

Specs Uses 4 × 5, 8 × 10 glossy or matte color and/or b&w prints; 35mm, 2 × 2, 4 × 5, 8 × 10 transparencies ("all are acceptable, but we prefer prints or digital"). Accepts images in digital format. Send via CD or e-mail (preferred) as TIFF, EPS, PICT, JPEG, PDF files (prefers TIFF or JPEG) at 300-600 dpi.

Making Contact & Terms Send query letter via e-mail with digital images and stock list. Responds only if interested; send nonreturnable samples. Simultaneous submissions and previously published work OK. Pays $100 for b&w or color cover; $25-100 for b&w or color inside. Pays on publication. Credit line given. Buys one-time rights.

$ FUR-FISH-GAME

A.R. Harding Publishing, 2878 E. Main St., Columbus OH 43212. Website: www.furfishgame. com. **Contact**: Mitch Cox, editor. Monthly outdoor magazine emphasizing hunting, trapping, fishing and camping.

Needs Buys 4 photos from freelancers/issue; 50 photos/year. Needs photos of freshwater fish, wildlife, wilderness and rural scenes. Reviews photos with or without a manuscript. Photo captions required; include subject.

Specs Uses color and/or b&w prints; 35mm transparencies.

Making Contact & Terms Send query letter "and nothing more." Does not keep samples on file; include SASE for return of material. Responds in 1 month to queries. Simultaneous

submissions and previously published work OK. Pays $35 minimum for b&w and color inside. Pays on publication. Credit line given. Buys one-time rights.

N ▣ $ ⊘ GAME & FISH MAGAZINES

2250 Newmarket Pkwy., Suite 110, Marietta GA 30067. (678)589-2029. E-mail: ron.sinfelt@ imoutdoors.com. Website: www.gameandfish.about.com. **Contact:** Ron Sinfelt, photo editor. Editorial Director: Ken Dunwoody. Combined circ. 576,000. Estab. 1975. Publishes 31 different monthly outdoors magazines: Alabama Game & Fish, Arkansas Sportsman, California Game & Fish, Florida Game & Fish, Georgia Sportsman, Great Plains Game & Fish, Illinois Game & Fish, Indiana Game & Fish, Iowa Game & Fish, Kentucky Game & Fish, Louisiana Game & Fish, Michigan Sportsman, Mid-Atlantic Game & Fish, Minnesota Sportsman, Mississippi Game & Fish, Missouri Game & Fish, New England Game & Fish, New York Game & Fish, North Carolina Game & Fish, Ohio Game & Fish, Oklahoma Game & Fish, Pennsylvania Game & Fish, Rocky Mountain Game & Fish, South Carolina Game & Fish, Tennessee Sportsman, Texas Sportsman, Virginia Game & Fish, Washington-Oregon Game & Fish, West Virginia Game & Fish, Wisconsin Sportsman, and North American Whitetail. All magazines (except Whitetail) are for experienced hunters and fishermen and provide information about where, when and how to enjoy the best hunting and fishing in their particular state or region, as well as articles about game and fish management, conservation and environmental issues. Sample copies available for $3.50 with 10 × 12 SAE. Photo guidelines and current needs list free with SASE.

Needs Fifty percent of photos supplied by freelance photographers; 5% assigned. Needs photos of live game animals/birds in natural environments and hunting scenes; game fish photos and fishing scenes. Photo captions required; include species identification and location. Number slides/prints.

Specs Accepts images in digital format. Send via CD at 300 dpi with output of 8 × 12 inches.

Making Contact & Terms Send 5 × 7, 8 × 10 glossy b&w prints or 35mm transparencies (preferably Fujichrome, Kodachrome) with SASE for consideration. Responds in 1 month. Simultaneous submissions not accepted. Pays $250 for color cover; $25 for b&w inside; $75 for color inside. Pays 60 days prior to publication. Tearsheet provided. Credit line given. Buys one-time rights.

Tips "Send separate cd and proof sheet for each species, with digital submissions. We'll return photos we don't expect to use and hold remainder in-house so they're available for monthly photo selections. Please do not send dupes. Photos will be returned upon publication or at photographer's request."

⟱ $ $ GEORGIA STRAIGHT

1701 W. Broadway, Vancouver BC V6J 1Y3 Canada. (604)730-7000. Fax: (604)730-7010. E-mail: photos@straight.com. Website: www.straight.com. **Contact:** Charlie Smith, editor. Circ. 117,000. Estab. 1967. Weekly tabloid. Emphasizes entertainment. Readers are generally well-educated people, ages 20-45. Sample copy free with 10 × 12 SASE.

Needs Buys 7 photos from freelancers/issue; 364 photos/year. Needs photos of entertainment events and personalities. Photo captions essential.

Making Contact & Terms Send query letter with list of stock photo subjects. Provide

résumé, business card, brochure, flier or tearsheets to be kept on file for possible future assignments. Responds in 1 month. Simultaneous submissions and previously published work OK. Include SASE for return of material. Pays $250-300 for cover; $100-200 for inside. Pays on publication. Credit line given. Buys one-time rights.

Tips "Almost all needs are for in-Vancouver assigned photos, except for high-quality portraits of film stars. We rarely use unsolicited photos, except for Vancouver photos for our content page."

▣ $ ◻ GERMAN LIFE MAGAZINE

1068 National Hwy., LaVale MD 21502. (301)729-6190. Fax: (301)729-1720. E-mail: mslider@ germanlife.com. Website: www.germanlife.com. **Contact:** Mark Slider, editor. Circ. 40,000. Estab. 1994. Bimonthly magazine focusing on history, culture, and travel relating to German-speaking Europe and German-American heritage. Sample copy available for $5.95.

Needs Limited number of photos purchased separate from text articles.

Specs Queries welcome for specs.

Making Contact & Terms Payment varies. Pays on publication. Credit line given. Buys one-time rights.

▣ GHOST TOWN

2660 Petersborough St., Herndon VA 20171. E-mail: shannonsdustytrails@yahoo.com. Estab. 1998. Quarterly magazine. Photo guidelines available by e-mail request.

Needs Buys 12 photos from freelancers/issue; 48-72 photos/year. Needs photos of babies/children/teens, celebrities, couples, multicultural, families, parents, disasters, environmental, landscapes/scenics, wildlife, architecture, cities/urban, education, gardening, interiors/decorating, pets, religious, rural, adventure, events, food/drink, sports, travel, agriculture, medicine, military, political, product shots/still life, science, technology—as related to archaeology and ghost towns. Interested in alternative process, avant garde, documentary, fashion/glamour, fine art, historical/vintage, seasonal. Wants photos of archaeology sites and excavations in progress of American ghost towns. "Would like photographs of artifacts and Paleobiology." Reviews photos with or without a manuscript. Model/property release preferred.

Specs Uses glossy or matte color and/or b&w prints.

Making Contact & Terms Send query letter via e-mail. "If possible, please do not include photographs in files if they are sent through e-mail. A CD sent with your photographs is acceptable." Provide résumé, business card or self-promotion piece to be kept on file for possible future assignments. "Photographs sent with CDs are requested but not required. Illustrations and artwork are also accepted." Responds within 1 month to queries; 1 week to portfolios. Simultaneous submissions and previously published work OK. **Pays on acceptance.** Credit line given. Buys one-time rights, first rights; negotiable.

▣ Ⓢ $ ◪ GRIT MAGAZINE

1503 SW 42nd St., Topeka KS 66609. (785)274-4300. Fax: (785)274-4305. E-mail: grit@ grit.com. Website: www.grit.com. **Contact:** Hank Will, editor. Circ. 150,000. Estab. 1882. Bimonthly magazine. Emphasizes small town life, country lifestyle or "hobby" farm-oriented material. Readership is national. Sample copy available for $4.

Needs Buys 24 + photos/year with accompanying stories or articles; 90% from freelancers. Needs, on a regular basis, photos of small-farm livestock, animals, farm labor, gardening, produce and related images. "Be certain pictures are well composed, properly exposed and pin sharp. Must be *shot* at high resolution (no less than 300 dpi). No cheesecake. No pictures that cannot be shown to any member of the family. No pictures that are out of focus or over- or under-exposed. No ribbon-cutting, check-passing or hand-shaking pictures. Story subjects include all aspects of the hobby or country lifestyle farm, such as livestock, farm dogs, barn cats, sowing and hoeing, small tractors, fences, etc." Photo captions required. "Any image that stands alone must be accompanied by 50-100 words of meaningful caption information."

Specs Uses 35mm, slides and high-resolution digital images. Send digital images via CD, Zip as JPEG files at 300 dpi.

Making Contact & Terms Study the magazine. "We use a beautiful country scene for 'Reverie', the last page in each issue. Take a look at previous issues to get a sense of the sort of shot we're looking for." Send material by mail with SASE for consideration. Responds ASAP. Pay is negotiable up to $1,000 for color cover; $35-200 for color inside; $25-100 for b&w inside. Rarely uses b&w, and only if "irresistibly atmospheric." Pays on publication. Buys shared rights; negotiable.

Tips "This is a relaunch of an old title. You must study the new publication to make sure your submissions are appropriate to *Grit*'s new direction."

▣ ☑ GUITAR WORLD

4000 Shoreline Court, Suite 400, South San Francisco CA 94080. (650)872-1642. Fax: (650)872-1643. E-mail: jimmyhubbard@guitarworld.com. Website: www.guitarworld. com. **Contact:** Jimmy Hubbard, photo editor. Circ. 150,000. Consumer magazine for guitar players and enthusiasts.

Needs Buys 20 photos from freelancers/issue; 240 photos/year. Needs photos of guitarists. Reviews photos with or without a manuscript. Property release preferred. Photo captions preferred.

Specs Uses glossy or matte color and/or b&w prints; 35mm, 2¼ × 2¼ transparencies. Accepts images in digital format. Send via e-mail as TIFF, EPS, JPEG files at 300 dpi.

Making Contact & Terms Send query letter with slides, prints, photocopies, tearsheets. Keeps samples on file. Responds in 2 weeks to queries. Previously published work OK. Pay rates vary by size. **Pays on acceptance.** Credit line given. Buys one-time rights.

▣ $$ HARPER'S MAGAZINE

Harper's Magazine Foundation, 666 Broadway, 11th Floor, New York NY 10012. (212)420-5720. Fax: (212)228-5889. E-mail: alyssa@harpers.org. Website: www.harpers.org. **Contact:** Alyssa Coppelman, assistant art director. Circ. 250,000. Estab. 1850. Monthly literary magazine. "The nation's oldest continually published magazine providing fiction, satire, political criticism, social criticism, essays."

Needs Buys 8-10 photos from freelancers/issue; 120 photos/year. Needs photos of human rights issues, environmental, political. Interested in alternative process, avant garde, documentary, fine art, historical/vintage. Model/property release preferred.

Specs Uses any format. Accepts images in digital format. Send preferably via e-mail to

alyssa@harpers.org or on CD; TIFF, EPS, JPEG files at 300 dpi.

Making Contact & Terms Send query letter with résumé, slides, prints, photocopies, tearsheets, transparencies. Portfolio may be dropped off last Wednesday of the month. Provide self-promotion piece to be kept on file for possible future assignments. Responds in 1 week. Pays $200-800 for b&w/color cover; $250-400 for b&w/color inside. Pays on publication. Credit line given. Buys one-time rights; negotiable.

Tips "*Harper's* is geared more toward fine art photos or artist's portfolios than to 'traditional' photo usages. For instance, we never do fashion, food, travel (unless it's for political commentary), lifestyles or celebrity profiles. A good understanding of the magazine is crucial for photo submissions. We consider all styles and like experimental or nontraditional work. Please don't confuse us with *Harper's Bazaar*!"

☐ $ HIGHLIGHTS FOR CHILDREN

803 Church St., Honesdale PA 18431. (570)253-1080. Website: www.highlights.com. **Contact:** Cindy Faber Smith, art director. Circ. around 2.5 million. Monthly magazine for children ages 2-12. Sample copy free.

• *Highlights* is currently expanding photographic needs.

Needs Buys 100 or more photos/year. "We will consider outstanding photo essays on subjects of high interest to children." Reviews photos with accompanying manuscript only. Wants no single photos without captions or accompanying manuscript.

Specs Accepts images in digital format. Send via CD at 300 dpi. Also accepts transparencies of all sizes.

Making Contact & Terms Send photo essays with SASE for consideration. Responds in 7 weeks. Pays $30 minimum for b&w photos; $50 minimum for color photos; $100 minimum for manuscript. Buys all rights.

Tips "Tell a story that is exciting to children. We also need mystery photos, puzzles that use photography/collage, special effects, anything unusual that will visually and mentally challenge children."

☐ ⑤ $ $ ⊘ HIGHWAYS, The Official Publication of The Good Sam Club

Affinity Group Inc., 2575 Vista Del Mar Dr., Ventura CA 93001-3920. (805)667-4003. Fax: (805)667- 4122. E-mail: info@affinitygroup.com. Website: www.goodsamclub.com/highways. **Contact:** Valerie Law, editorial director. Circ. 975,000. Estab. 1966. Monthly consumer magazine. "Your authoritative source for information on issues of concern to all RVers, as well as your link to the RV community." Sample copy free with 8½ × 11 SAE.

Specs Accepts images in digital format. Send via CD or e-mail at 300 dpi.

Making Contact & Terms Editorial director will contact photographer for portfolio review if interested. Pays $500 for cover; $75-350 for inside. Buys one-time rights.

$ $ HOOF BEATS

750 Michigan Ave., Columbus OH 43215. (614)224-2291. Fax: (614)222-6791. E-mail: hoofbeats@ustrotting.com. Website: www.hoofbeatsmagazine.com. **Contact:** Nicole Kraft, executive editor. Art Director/Production Manager: Gena Gallagher. Circ. 13,500. Estab. 1933. Monthly publication of the U.S. Trotting Association. Emphasizes harness racing.

Readers are participants in the sport of harness racing. Sample copy free.

Needs Buys 6 photos from freelancers/issue; 72 photos/year. Needs "artistic or striking photos that feature harness horses for covers; other photos on specific horses and drivers by assignment only."

Making Contact & Terms Send query letter with samples; include SASE for return of material. Responds in 3 weeks. Simultaneous submissions OK. Pays $150 minimum for color cover; $25-150 for b&w inside; $50-200 for color inside; freelance assignments negotable. Pays on publication. Credit line given if requested. Buys one-time rights.

Tips "We look for photos with unique perspective and that display unusual techniques or use of light. Send query letter first. Know the publication and its needs before submitting. Be sure to shoot pictures of harness horses only, not thoroughbred or riding horses. We always need good night racing action or creative photography."

$$ HORIZONS MAGAZINE

P.O. Box 1091, Bismarck ND 58502. (701)335-4458. Fax: (701)223-4645. E-mail: ndhorizons@ btinet.net. Website: www.ndhorizons.com. **Contact:** Andrea W. Collin, editor. Estab. 1971. Quality regional magazine. Photos used in magazines, audiovisual, calendars.

Needs Buys 50 photos/year; offers 25 assignments/year. Needs scenics of North Dakota events, places and people. Also needs wildlife, cities/urban, rural, adventure, entertainment, events, hobbies, performing arts, travel, agriculture, industry. Interested in historical/ vintage, seasonal. Model/property release preferred. Photo captions preferred.

Specs Prefers images in digital format. Send via CD, as TIFF, EPS files at 600 dpi.

Making Contact & Terms Prefers email query letter. Pays by the project, varies ($300-500); negotiable. Pays on usage. Credit line given. Buys one-time rights; negotiable.

Tips "Know North Dakota events, places. Have strong quality of composition and light."

$ HORSE ILLUSTRATED

BowTie Magazines, P.O. Box 8237, Lexington KY 40533. (859)260-9800. Fax: (859)260-1154. E-mail: horseillustrated@bowtieinc.com. Website: www.horseillustrated.com. **Contact**: Elizabeth Moyer, editor. Circ. 185,000. Readers are "primarily adult horsewomen, ages 18-40, who ride and show mostly for pleasure, and who are very concerned about the well being of their horses. Editorial focus covers all breeds and all riding disciplines." Sample copy available for $4.50. Photo guidelines free with SASE.

Needs Buys 30-50 photos from freelancers/issue. Needs stock photos of riding and horse care. "Photos must reflect safe, responsible horsekeeping practices. We prefer all riders to wear protective helmets; prefer people to be shown only in action shots (riding, grooming, treating, etc.). We like all riders—especially those jumping—to be wearing protective headgear."

Specs Prefer digital images - high resolution JPEGs on a CD with printout of thumbnails.

Making Contact & Terms Send by mail for consideration. Responds in 2 months. Pays $250 for color cover; $65-250 for color inside. Credit line given. Buys one-time rights.

Tips "Looks for clear, sharp color shots of horse care and training. Healthy horses, safe riding and care atmosphere is standard in our publication. Send SASE for a list of photography needs, photo guidelines, and to submit work. Photo guidelines are also available on our website."

⑤ ◯ **ILLOGICAL MUSE**

1953 Union Street, Apt. 2C, Benton Harbor MI 49022. E-mail: illogicalmuse@yahoo.com. Website: http://illogicalmuse.blogspot.com. **Contact:** Amber Rothrock, editor. Estab. 2004. Irregular literary magazine. Online journal publishing fiction, poetry, reviews, essays and artwork. Photo guidelines available on website.

Needs Wants photos of babies/children/teens, couples, multicultural, parents, senior citizens, architecture, cities/urban, gardening, pets, religious, rural, agriculture, disasters, environmental, wildlife, hobbies, performing arts; interested in avant garde, historical/vintage, seasonal. Does not want to see anything pornographic; mild erotica is fine. "I am open to all schools and styles but tend to lean toward the more experimental and avant garde." Reviews photos with or without a manuscript. Model release preferred. Property release preferred. Photo captions preferred.

Specs Accepts images in digital format only. Send JPEG or GIF files via CD or e-mail.

Making Contact & Terms E-mail query letter with link to photographer's website, JPEG samples at 72 dpi. "Send a cover letter with a brief, publishable bio. An exceptionally long list of prior achievements is not necessary. Tell me a little bit about yourself and the work you do." Does not keep samples on file; include SASE for return of material. Responds in 1 month to queries; 6 months to portfolios. Simultaneous submissions and previously published work OK. All rights remain with the photographer.

Tips "Visit the website to see if it appeals to you. It's hard to say what I am specifically looking for as I try to keep an open mind with every submission. Just send your best."

▣ **IMMIGRANT ANCESTORS**

2660 Petersborough St., Herndon VA 20171. E-mail: immigrantancestors@yahoo.com. Estab. 2005. Quarterly magazine, "searching for immigrants and immigrant ancestors." Photo guidelines available by e-mail request.

Needs Buys 12-24 photos/year. Needs photos of babies/children/teens, multicultural, families, parents, disasters, environmental, landscapes/scenics, wildlife, cities/urban, education, religious, rural, adventure, events, food/drink, sports, travel, agriculture, medicine, military, political, product shots/still life, science, technology-as related to early immigration and those who made its history. Interested in alternative process, avant garde, documentary, fashion/glamour, fine art, historical/vintage, seasonal. Reviews photos with or without manuscript. Model/property release preferred.

Specs Uses glossy or matte color and/or b&w prints.

Making Contact & Terms Send query letter via e-mail. "If possible, please do not include photographs in files if they are sent through e-mail. A disk with your photographs is acceptable." Provide résumé, business card or self-promotion piece to be kept on file for possible future assignments. Responds within 1 month to queries; 1 week to portfolios. Simultaneous submissions and previously published work OK. **Pays on acceptance.** Credit line given. Buys one-time rights, first rights; negotiable.

▣ **$ $ INDIANAPOLIS MONTHLY**

40 Monument Circle, Suite 100, Indianapolis IN 46204. (317)237-9288. Website: www.indianapolismonthly.com. **Contact:** Art Director. Monthly regional magazine. Readers are upscale, well-educated. Circ. 50,000. Sample copy available for $4.95 and 9 × 12 SASE.

Needs Buys 10-12 photos from freelancers/issue; 120-144 photos/year. Needs seasonal, human interest, humorous, regional; subjects must be Indiana- or Indianapolis-related. Model release preferred. Photo caption information required.

Specs Glossy prints; transparencies, digital. Send via CD, e-mail as TIFF, EPS, JPEG files at 300 dpi at actual size.

Making Contact & Terms Send query letter with samples, SASE. Responds in 1 month. Previously published work on occasion OK, if different market. Pays $300-1,200 for color cover; $75-350 for b&w inside; $75-350 for color inside. Pays on publication. Credit line given. Buys first North American serial rights.

Tips "Read publication. Send photos similar to those you see published. If you see nothing like what you are considering submitting, it's unlikely we will be interested. We are always interested in photo essay queries if they are Indiana-specific."

$ $ ☑ INSIGHT MAGAZINE

Review and Herald Publishing Association, 55 W. Oak Ridge Dr., Hagerstown MD 21740-7390. (301)393-4038. Fax: (301)393-4055. E-mail: insight@rhpa.org. Website: www.insightmagazine.org. **Contact:** Jason Diggs, art director. Circ. 20,000. Estab. 1970. Weekly Seventh-Day Adventist teen magazine. "We print teens' true stories about God's involvement in their lives. All stories, if illustrated by a photo, must uphold moral and church organization standards while capturing a hip, teen style." Sample copy free.

Needs "Send query letter with photo samples so we can evaluate style." Model/property release required. Photo captions preferred; include who, what, where, when.

Making Contact & Terms Send query letter with samples. Provide résumé, business card, self-promotion piece or tearsheets to be kept on file for possible future assignments. Responds only if interested; send nonreturnable samples. Simultaneous submissions and previously published work OK. Pays $200-300 for color cover; $200-400 for color inside. Pays 30-45 days after receiving invoice and contract. Credit line given. Buys first rights.

▣ $ ☑ THE IOWAN MAGAZINE

Address to be announced; see website. (515)246-0402. Fax: (515)282-0125. E-mail: editor@iowan.com or artdirector@iowan.com. Website: www.iowan.com. **Contact**: Beth Wilson, editor; Bobbie Russie, art director. Circ. 22,000. Estab. 1952. Bimonthly magazine. Emphasizes "Iowa's people, places, events, nature and history." Readers are over age 40, college-educated, middle-to-upper income. Sample copy available for $4.50 + shipping/handling; call the Distribution Center toll-free at (877)899-9977. Photo guidelines available on website or via e-mail.

Needs "We print only Iowa-related images from Iowa photographers, illustrators, and artists. Show us Iowa's residents, towns, environmental, landscape/scenics, wildlife, architecture, rural, entertainment, events, performing arts, travel." Interested in Iowa heritage, historical/vintage, seasonal. Accepts unsolicited stock photos related to above. Editorial stock photo needs available on website or via e-mail. Model/property release preferred. Photo captions required.

Specs Digital format preferred on clearly labeled CD/DVD with submission form, printed contact sheet, and image reference. See website for details. Press resolution is 300 dpi at 9X12. Digital materials will not be returned. Uses 35mm, color transparencies, which will

be returned following press deadline.

Making Contact & Terms Pays $50-250 for stock photo one-time use, depending on size printed; pays on publication. Contract rates run $200-500/day for assigned editorials; pays within 60 days of receipt of invoice.

⊡ $$ ⊘ ISLANDS

460 N. Orlando Ave., Suite 200, Winter Park FL 32789. (407)571-4930. Fax: (407) 628- 7061. E-mail: lori.barbely@ bonniercorp.com. Website: www.islands.com. **Contact:** Lori Barbely, photography editor. Circ. 200,000. Published 8 times/year.

Needs Buys 50 photos from freelancers/issue; 400 photos/year. Needs photos of island travel. Reviews photos with or without a manuscript. Model/property release preferred. Detailed captions required (please use metadata); include name, phone, address, subject information.

Specs Prefers images in digital format. Send via CD, e-mail, Web gallery, FTP site as JPEG files at 72 dpi (must have 300 dpi file available if image is selected for use). Film is not desired.

Making Contact & Terms Send query letter with tearsheets. Provide business card and self-promotion piece or tearsheets to be kept on file for possible future assignments. You will be contacted if additional information or a portfolio is desired. Keeps samples on file. Simultaneous submissions OK. Pays $600-1,000 for color cover; $100-500 for inside. Pays 45 days after publication. Credit line given. Buys one-time rights. No phone calls.

⊡ $ ⊘ ITALIAN AMERICA

219 E St. NE, Washington DC 20002. (202)547-2900. Fax: (202)547-0121. E-mail: ddesanctis@ osia.org. Website: www.osia.org. **Contact:** Dona De Sanctis, editor-in-chief. Circ. 65,000. Estab. 1996. Quarterly. "*Italian America* is the official publication of the Order Sons of Italy in America, the nation's oldest and largest organization of American men and women of Italian heritage. *Italian America* strives to provide timely information about OSIA, while reporting on individuals, institutions, issues and events of current or historical significance in the Italian American community." Sample copy and photo guidelines free.

Needs Buys 5-10 photos from freelancers/issue; 25 photos/year. Needs photos of travel, history, personalities; anything Italian or Italian-American. Reviews photos with or without a manuscript. Special photo needs include travel in Italy. Model release preferred. Photo captions required.

Specs Accepts images in digital format. Send via CD, e-mail as TIFF, EPS, PICT, BMP, GIF, JPEG files at 400 dpi.

Making Contact & Terms Send query letter with tearsheets. Provide resume, business card, self-promotion piece or tearsheets to be kept on file for possible future assignments. Art director will contact photographer for portfolio review if interested. Portfolio should include color tearsheets. Responds only if interested; send nonreturnable samples. Simultaneous submissions OK. Pays $250 for b&w or color cover; $50-250 for b&w or color inside. Pays on publication. Credit line given. Buys one-time rights.

ⓝ ⊡ $$ JOURNAL OF ASIAN MARTIAL ARTS

(505)983-1919. E-mail: info@goviamedia.com. Website: www.goviamedia.com. **Contact:**

Michael DeMarco, editor-in-chief. Circ. 10,000. Estab. 1991. "An indexed, notch-bound quarterly magazine exemplifying the highest standards in writing and graphics available on the subject. Comprehensive, mature and eye-catching. Covers all historical and cultural aspects of Asian martial arts." Sample copy available for $10. Photo guidelines free with SASE.

Needs Buys 120 photos from freelancers/issue; 480 photos/year. Needs photos of health/fitness, sports, action shots; technical sequences of martial arts; photos that capture the philosophy and aesthetics of Asian martial traditions. Interested in alternative process, avant garde, digital, documentary, fine art, historical/vintage. Model release preferred for photos taken of subjects not in public demonstration; property release preferred. Photo captions preferred; include short description, photographer's name, year taken.

Specs Uses color and/or b&w prints; 35mm, 2¼ × 2¼, 4 × 5, 8 × 10 transparencies. Accepts images in digital format. Send via CD, Zip as TIFF files at 300 dpi.

Making Contact & Terms Send query letter with samples, stock list. Provide résumé, business card, self-promotion piece or tearsheets to be kept on file for possible future assignments. Art director will contact photographer for portfolio review if interested. Keeps samples on file. Responds in 2 months. Previously published work OK. Pays $100-500 for color cover; $10-100 for b&w inside. Credit line given. Buys first rights and reprint rights.

Tips "Read the journal. We are unlike any other martial arts magazine and would like photography to compliment the text portion, which is sophisticated with the flavor of traditional Asian aesthetics. When submitting work, be well organized and include a SASE."

$$ ☑ KANSAS!

1000 SW Jackson St., Suite 100, Topeka KS 66612-1354. (785)296-3479. Fax: (785)296-6988. Website: www.kansmag.com. **Contact:** Jennifer Haugh, editor. Circ. 40,000. Estab. 1945. Quarterly magazine published by the Travel & Tourism Development Division of the Kansas Department of Commerce. Emphasizes Kansas travel, scenery, arts, recreation and people. Photo guidelines available on Website.

Needs Buys 60-80 photos from freelancers/year. Subjects include animal, human interest, nature, seasonal, rural, scenic, sport, travel, wildlife, photo essay/photo feature, all from Kansas. No b&w, nudes, still life or fashion photos. Reviews photos with or without a manuscript. Model/property release preferred. Photo captions required; include subject and specific location.

Specs Prefers digital at 300 dpi for 8x10.

Making Contact & Terms Send material by mail for consideration. Previously published work OK. Pays on acceptance. Credit line given. Buys one-time or limited universal rights.

Tips Kansas-oriented material only. Prefers Kansas photographers. "Follow guidelines, submission dates specifically. Shoot a lot of seasonal scenics."

Ⓝ $ ☑ KASHRUS MAGAZINE

P.O. Box 204, Parkville Station, Brooklyn NY 11204. (718)336-8544. Website: www. kashrusmagazine.com. **Contact:** Rabbi Yosef Wikler, editor. Circ. 10,000. Bimonthly. Emphasizes kosher food and food technology, travel (Israel-desirable), catering, weddings, remodeling, humor. Readers are kosher food consumers, vegetarians and food producers.

Sample copy available for $2.

Needs Buys 3-5 photos from freelancers/issue; 18-30 photos/year. Needs photos of babies/children/teens, environmental, landscapes, interiors, Jewish, rural, food/drink, humor, travel, product shots, technology/computers. Interested in seasonal, nature photos and Jewish holidays. Model release preferred. Photo captions preferred.

Specs Uses 2¼ × 2¼, 3½ × 3½ or 7½ × 7½ matte b&w and color prints.

Making Contact & Terms Send unsolicited photos by mail with SASE for consideration. Provide business card, brochure, flier or tearsheets to be kept on file for possible future assignments. Responds in 1 week. Simultaneous submissions and previously published work OK. Pays $40-75 for b&w cover; $50-100 for color cover; $25-50 for b&w inside; $75-200/job; $50-200 for text for photo package. Pays part on acceptance, part on publication. Buys one-time rights, first North American serial rights, all rights; negotiable.

Tips "Seriously in need of new photo sources, but *call first* to see if your work is appropriate before submitting samples."

▣ $ ◻ KENTUCKY MONTHLY

106-C St. James Court, Frankfort KY 40601-0559. (502)227-0053. Fax: (502)227-5009. E-mail: steve@kentuckymonthly.com. Website: www.kentuckymonthly.com. **Contact:** Stephen Vest, editor, or Amanda Hervey, managing editor. Circ. 40,000. Estab. 1998. Monthly magazine focusing on Kentucky and/or Kentucky-related stories. Sample copy available for $4.

Needs Buys 10 photos from freelancers/issue; 120 photos/year. Needs photos of celebrities, wildlife, entertainment, landscapes. Reviews photos with or without a manuscript. Model release required. Photo captions required.

Specs Uses glossy prints; 35mm transparencies. Accepts images in digital format. Send via CD, e-mail at 300 dpi.

Making Contact & Terms Send query letter. Provide self-promotion piece to be kept on file for possible future assignments. Responds in 1 month. Simultaneous submissions OK. Pays $25 minimum for inside photos. Pays the 15th of the following month. Credit line given. Buys one-time rights.

▣ $$ ◉ KNOWATLANTA

New South Publishing, 1303 Hightower Trail, Suite 101, Atlanta GA 30350. (770)650-1102. Fax: (770)650-2848. E-mail: editor1@knowatlanta.com. Website: www.knowatlanta.com. **Contact**: Amy Selby or Laura Newsome, editors. Circ. 48,000. Estab. 1986. Quarterly magazine serving as a relocation guide to the Atlanta metro area with a corporate audience. Photography reflects regional and local material as well as corporate-style imagery.

Needs Buys more than 10 photos from freelancers/issue; more than 40 photos/year. Needs photos of cities/urban, events, performing arts, business concepts, medicine, technology/computers. Reviews photos with or without a manuscript. Model release required; property release preferred. Photo captions preferred.

Specs Uses 8x10 glossy color prints; 35mm, transparencies. Accepts images in digital format. Send via CD, Zip, e-mail as TIFF, EPS, JPEG files at 300 dpi.

Making Contact & Terms Send query letter with photocopies. Provide resume, business card, self-promotion piece to be kept on file for possible future assignments. Responds

only if interested; send nonreturnable samples. Pays $600 maximum for color cover; $300 maximum for color inside. Pays on publication. Credit line given. Buys first rights.

Tips "Think like our readers. What would they want to know about or see in this magazine? Try to represent the relocated person if using subjects in photography."

▣ Ⓐ $ ◯ LACROSSE MAGAZINE

113 W. University Pkwy., Baltimore MD 21210. (410)235-6882. Fax: (410)366-6735. E-mail: pkrome@uslacrosse.org. Website: www.laxmagazine.com. **Contact:** Paul Krome, editor. Circ. 250,000. Estab. 1978. Publication of US Lacrosse. Monthly magazine. Emphasizes sport of lacrosse. Readers are male and female lacrosse enthusiasts of all ages. Sample copy free with general information pack.

Needs Buys 15-30 photos from freelancers/issue; 120-240 photos/year. Needs lacrosse action shots. Photo captions required; include rosters with numbers for identification.

Specs Accepts images in digital format. Send via disc. Original RAW/NEF files or 300 dpi TIFFs.

Making Contact & Terms Send unsolicited photos by mail with SASE for consideration. Provide résumé, business card, brochure, flier or tearsheets to be kept on file for possible future assignments. Responds in 3 weeks. Simultaneous submissions and previously published work OK. Pays $250 for color cover; $75-150 inside. Pays on publication. Credit line given. Buys one-time rights.

$ $ LADIES HOME JOURNAL

125 Park Ave., 20th Floor, New York NY 10017. (212)455-1033. Fax: (212)455-1313. Website: www.lhj.com. **Contact:** Sabrina Regan, photo associate. Circ. 6 million. Monthly magazine. Features women's issues. Readership consists of women with children and working women in 30s age group.

Needs Uses 90 photos/issue; 100% supplied by freelancers. Needs photos of children, celebrities and women's lifestyles/situations. Reviews photos only without manuscript. Model release preferred. Photo captions preferred.

Making Contact & Terms Provide résumé, business card, brochure, flier or tearsheet to be kept on file for possible assignment. "Do not send slides or original work; send only promo cards or disks." Responds in 3 weeks. Pays $500/page. **Pays on acceptance.** Credit line given. Buys one-time rights.

▣ $ ◪ LAKE COUNTRY JOURNAL MAGAZINE

Evergreen Press, 201 W. Laurel St., P.O. Box 465, Brainerd MN 56401. (218)828-6424. Fax: (218)825-7816.Website: www.lakecountryjournal.com. **Contact:** Andrea Baumann, art director. Estab. 1996. Bimonthly regional consumer magazine focused on northern Minnesota. Sample copy and photo guidelines available for $5 and 9 × 12 SAE.

Needs Buys 35 photos from freelancers/issue; 210 photos/year. Needs photos of environmental, landscapes, wildlife, architecture, gardening, decorating, rural, entertainment, events, food/drink, health/fitness/beauty, hobbies, humor, sports, agriculture, medicine. Interested in documentary, fine art, historical/vintage, seasonal; Minnesota outdoors. Reviews photos with or without a manuscript. Model release preferred. Photo captions preferred; include who, where, when.

Specs Prefers images in digital format. Send via CD, DVD as TIFF, EPS files at 300 dpi. Also accepts 35mm slides.

Making Contact & Terms Send query letter with résumé, slides, prints, tearsheets, transparencies, stock list. Provide résumé, business card or self-promotion piece to be kept on file for possible future assignments. Responds in 3 weeks to queries. Previously published work OK. Pays $180 for cover; $35-150 for inside. Pays on publication. Credit line given. Buys one-time rights; negotiable.

▣ $ ◪ LAKE SUPERIOR MAGAZINE

Lake Superior Port Cities, Inc., P.O. Box 16417, Duluth MN 55816-0417. (218)722-5002. Fax: (218)722-4096. E-mail: edit@lakesuperior.com. Website: www.lakesuperior.com. **Contact:** Konnie LeMay, editor. Circ. 20,000. Estab. 1979. Bimonthly magazine. "Beautiful picture magazine about Lake Superior." Readers are male and female, ages 35-55, highly educated, upper-middle and upper-management level through working. Sample copy available for $4.95 plus $5.95 S&H. Photo guidelines free with SASE or via Website.

Needs Buys 21 photos from freelancers/issue; 126 photos/year. Also buys photos for calendars and books. Needs photos of landscapes/scenics, travel, wildlife, personalities, boats, underwater—all Lake Superior-related. Photo captions preferred.

Specs Uses 5 × 7, 8 × 10 glossy b&w and color-corrected prints; 35mm, 2¼ × 2¼, 4 × 5, 8 × 10 transparencies. Accepts images in digital format. Send via CD with at least thumbnails on a printout.

Making Contact & Terms Send unsolicited photos by mail with SASE for consideration. Provide résumé, business card, brochure, flier or tearsheets to be kept on file for possible future assignments. Responds in 2 months. Simultaneous submissions OK. Pays $150 for color cover; $50 for b&w or color inside. Pays on publication. Credit line given. Buys first North American serial rights; reserves second rights for future use.

Tips "Be aware of the focus of our publication—Lake Superior. Photo features concern only that. Features with text can be related. We are known for our fine color photography and reproduction. It has to be 'tops.' We try to use images large; therefore, detail quality and resolution must be good. We look for unique outlook on subject, not just snapshots. Must communicate emotionally. Some photographers send material we can keep in-house and refer to, and these will often get used."

▣ ◖ LEFT BEHIND

832 Shasta Dr, Colton CA 92324. E-mail: jeffe@myleftbehind.com. Website: www. myleftbehind.com. **Contact:** Jeff Green, editor. Estab. 2008. Circ. 1,000. Quarterly literary magazine of poetry, short stories, short plays, screenplays, essays, and visual art. "We want the work you thought was too racy to ever admit you wrote. The blasphemous, erotic, misanthropic, politically incorrect, homoerotic, homophobic, homo-habilis, scatalogical, you know, the good stuff. Pseudonyms welcome. The serious and dark are encouraged, but the humorous is prized. Make us blush and say, 'jeez, did we print that?' Imagine you're Mapplethorpe but without the soft touch."

Needs "*Left Behind* desperately needs cover art featuring the left buttock; both color and b/w art inside (model releases required)." Buys 10 photos from freelancers/issue; 40 photos/year. Senior Citizens, outdoor and environmental disasters, cities and urban scenes,

pets, religious, humor. Interested in alternative process and avant garde, documentary, erotic, fine art, historical/vintage, and lifestyle photos. Reviews photos with or without a manuscript. Model release is required, photo captions preferred.

Specs Accepts 35 mm prints of any size in glossy, matte, color, or accepts 4x5 digital images via CD, zip, e-mail, as TIFF, GIF, or JPEG files at +300 dpi.

Making Contact & Terms Email query letter with link to photographer's website or JPEG samples at 72 dpi or send query letter with slides, prints, photocopies, or transparencies. Does not keep samples on file; include SASE for return of material. Responds in 2 months. Considers simultaneous submissions and previously published work. Pays 2 copies minimum. Pays on publication, credit line given. Buys one-time and electronic rights, will negotiate with photographer.

N ▣ A $ $ ◑ THE LION

Lions Clubs International, 300 W. 22nd St., Oak Brook IL 60523-8842. (630)571-5466. Fax: (630)571-1685. E-mail: jay.copp@lionsclubs.org. Website: www.lionsclubs.org. **Contact:** Jay Copp, senior editor. Circ. 490,000. Estab. 1918. Monthly magazine for members of the Lions Club and their families. Emphasizes Lions Club activities and membership. Sample copy and photo guidelines free.

Needs Uses 50-60 photos/issue. Needs photos of Lions Club service or fundraising projects. "All photos must be as candid as possible, showing an activity in progress. Please, no award presentations, meetings, speeches, etc. Generally, photos are purchased with manuscript (300-1,500 words) and used as a photo story. We seldom purchase photos separately." Model release preferred for young or disabled children. Photo caption s required.

Specs Uses 5 × 7, 8 × 10 glossy color prints; 35mm transparencies; also accepts digital images via e-mail at 300 dpi or larger.

Making Contact & Terms Works with freelancers on assignment only. Provide résumé to be kept on file for possible future assignments. Query first with résumé of credits or story idea. Pays $150-600 for text/photo package. "Must accompany story on the service or fundraising project of the The Lions Club." **Pays on acceptance**. Buys all rights; negotiable.

Tips "Query on specific project and photos to accompany manuscript."

▣ $ ◌ LIVING FREE

P.O. Box 969, Winnisquam NH 03289. (603)455-7368. E-mail: free@natnh.com. Websites: www.natnh.com/lf/mag.html. **Contact:** Tom Caldwell, editor-in-chief. Quarterly electronic magazine succeeding Naturist Life International's Online e-zine. Emphasizes nudism. Readers are male and female nudists. Sample copy available on CD for $10. Photo guidelines free with SASE. We periodically organize naturist photo safaris to shoot nudes in nature.

Needs Buys 36 photos from freelancers/issue; 144 photos/year. Needs photos depicting family-oriented nudist/naturist work, recreational activity and travel. Reviews photos with or without a manuscript. Model release required (including Internet use) for recognizable nude subjects. Photo captions preferred.

Specs Prefers digital images submitted on CD or via e-mail; 8 × 10 glossy color and/or b&w prints.

Making Contact & Terms Send query letter with résumé of credits. Send unsolicited photos by mail or e-mail for consideration; include SASE for return of material. Provide résumé,

business card, brochure, flier or tearsheets to be kept on file for possible future assignments. Responds in 2 weeks. Pays $50 for color cover; $10-25 for others. Pays on publication. Credit line given. "Prefer to own all rights but sometimes agree to one-time publication rights."

Tips "The ideal photo shows ordinary-looking people of all ages doing everyday activities, in the joy of nudism. We do not want 'cheesecake' glamour images or anything that emphasizes the erotic."

▣ $ ◻ MISSOURI LIFE

Missouri Life, Inc., 515 E. Morgan St., Boonville MO 65233. (660)882-9898. Fax: (660)882-9899. E-mail: info@missourilife.com. Website: www.missourilife.com. **Contact:** Tina Wheeler, art dirctor. Circ. 22,000. Estab. 1973. Bimonthly consumer magazine. "Missouri Life celebrates Missouri people and places, past and present, and the unique qualities of our great state with interesting stories and bold, colorful photography." Sample copy available for $4.95 and SASE with $2.44 first-class postage. Photo guidelines available on Website.

Needs Buys 80 photos from freelancers/issue; more than 500 photos/year. Needs photos of environmental, seasonal, landscapes/scenics, wildlife, architecture, cities/urban, rural, adventure, historical sites, entertainment, events, hobbies, performing arts, travel. Reviews photos with or without manuscript. Model/property release required. Photo captions required; include location, names and detailed identification (including any title and hometown) of subjects.

Specs Prefers images in high-res digital format (minimum 300 ppi at 8 × 10). Send via e-mail, CD, Zip as EPS, JPEG, TIFF files.

Making Contact & Terms Send query letter with résumé, stock list. Provide self-promotion piece to be kept on file for possible future assignments. Responds in 1 month. Pays $100-150 for color cover; $50 for color inside. Pays on publication. Credit line given. Buys first rights, nonexclusive rights, limited rights.

Tips "Be familiar with our magazine and the state of Missouri. Provide well-labeled images with detailed caption and credit information."

Ⓝ ▣ $ $ MOUNTAIN LIVING

1777 S. Harrison St., Suite 903, Denver CO 80210. (303)248-2052. Fax: (303)248-2064. E-mail: lshowell@mountainliving.com. Website: www.mountainliving.com. **Contact:** Loneta Showell, art director. Circ. 45,000. Estab. 1994. Bimonthly magazine. Emphasizes shelter, lifestyle.

Needs Buys 10 photos from freelancers/issue; 120 photos/year. Needs photos of home interiors, architecture. Reviews photos with accompanying manuscript only. Model/property release required. Photo captions preferred.

Specs Prefers images in digital format. Send via CD as TIFF files at 300 dpi. Also uses 35mm, 2¼ × 2¼, 4 × 5 transparencies.

Making Contact & Terms Submit portfolio for review. Send query letter with stock list. Provide résumé, business card, brochure, flier or tearsheets to be kept on file for possible future assignments. Responds in 6 weeks. Pays $500-600/day; $0-600 for color inside. **Pays on acceptance.** Credit line given. Buys one-time and first North American serial rights as well as rights to use photos on the *Mountain Living* website and in promotional materials; negotiable.

▣ ⑤ $ ⦿ MUZZLE BLASTS

P.O. Box 67, Friendship IN 47021. (812)667-5131. Fax: (812)667-5137. E-mail: mblastdop@ seidata.com. Website: www.nmlra.org. **Contact:** Terri Trowbridge, director of publications. Circ. 20,000. Estab. 1939. Publication of the National Muzzle Loading Rifle Association. Monthly magazine emphasizing muzzleloading. Sample copy free. Photo guidelines free with SASE.

Needs Interested in muzzleloading, muzzleloading hunting, primitive camping. "Ours is a specialized association magazine. We buy some big-game wildlife photos but are more interested in photos featuring muzzleloaders, hunting, powder horns and accoutrements." Model/property release required. Photo captions preferred.

Specs Accepts images in digital format. Send via e-mail or on a CD in JPEG or TIFF format. Also accepts 3x5 color transparencies, quality color and b&w prints; sharply contrasting 35mm color slides are acceptable.

Making Contact & Terms Send query letter with stock list. Keeps samples on file; include SASE for return of material. Responds in 2 weeks. Simultaneous submissions OK. Pays $300 for color cover; $25-50 for b&w inside. Pays on publication. Credit line given. Buys one-time rights.

▣ $ ⦿ NA'AMAT WOMAN

350 Fifth Ave., Suite 4700, New York NY 10118. (212)563-5222. Fax: (212)563-5710. E-mail: judith@naamat.org. Website: www.naamat.org. **Contact:** Judith A. Sokoloff, editor. Circ. 15,000. Estab. 1926. Quarterly organization magazine focusing on issues of concern to contemporary Jewish families and women. Sample copy free with SAE and $2 first-class postage.

Needs Buys 5-10 photos from freelancers/issue; 50 photos/year. Needs photos of Jewish themes, Israel, women, babies/children/teens, families, parents, senior citizens, landscapes/scenics, architecture, religious, travel. Interested in documentary, fine art, historical/vintage, seasonal. Reviews photos with or without manuscript. Photo captions preferred.

Specs Uses color and/or b&w prints. Accepts images in digital format. Contact editor before sending.

Making Contact & Terms Provide résumé, business card, self-promotion piece or tearsheets to be kept on file for possible future assignments. Art director will contact photographer for portfolio review if interested. Keeps samples on file; include SASE for return of material. Responds in 6 weeks. Pays $250 maximum for cover; $35-75 for inside. Pays on publication. Credit line given. Buys one-time, first rights.

⦿ NATIONAL GEOGRAPHIC

National Geographic Society, 1145 17th St. NW, Washington DC 20036. Website: www. nationalgeographic.com. **Contact:** Susan Smith, deputy director of photography. Director of Photography: David Griffin. Circ. 7 million. Monthly publication of the National Geographic Society.

- This is a premiere market that demands photographic excellence. *National Geographic* does not accept unsolicited work from freelance photographers. Photography internships and faculty fellowships are available. Contact Susan Smith, deputy director of photography, for application information.

▣ $ ☑ NATIVE PEOPLES MAGAZINE

5333 N. Seventh St., Suite C-224, Phoenix AZ 85014. (602)265-4855. Fax: (602)265-3113. E-mail: kcoochwytewa@nativepeoples.com. Website: www.nativepeoples.com. **Contact:** Kevin Coochwytewa, art director. Circ. 50,000. Estab. 1987. Bimonthly magazine. "Dedicated to the sensitive portrayal of the arts and lifeways of the Native peoples of the Americas." Photo guidelines free with SASE or on website.

Needs Buys 20-50 photos from freelancers/issue; 120-300 photos/year. Needs Native American lifeways photos (babies/children/teens, celebrities, couples, multicultural, families, parents, senior citizens, events). Also uses photos of entertainment, performing arts, travel. Interested in fine art. Model/property release preferred. Photo captions preferred; include names, location and circumstances.

Specs Uses transparencies, all formats. Accepts images in digital format. Send via CD, Zip, e-mail as TIFF, JPEG, EPS files at 300 dpi.

Making Contact & Terms Submit portfolio for review. Send unsolicited photos by mail for consideration; include SASE for return of material. Responds in 1 month. Pays $250 for color cover; $45-150 for color or b&w inside. Pays on publication. Buys one-time rights.

Tips "Send samples, or, if in the area, arrange a visit with the editors."

Ⓝ ▣ $$ NATURAL HISTORY MAGAZINE

36 W. 25th St., 5th Floor, New York NY 10010. (646)356-6500. Fax: (646)356-6511. E-mail: nhmag@nhmag.com. Website: www.naturalhistorymag.com. **Contact:** Steve Black, art director. Circ. 200,000. Magazine printed 10 times/year. Readers are primarily well-educated people with interests in the sciences. Free photo guidelines.

Needs Buys 400-450 photos/year. Subjects include animal behavior, photo essay, documentary, plant and landscape. "We are interested in photo essays that give an in-depth look at plants, animals, or people and that are visually superior. We are also looking for photos for our photographic feature, 'The Natural Moment.' This feature focuses on images that are both visually arresting and behaviorally interesting." Photos used must relate to the social or natural sciences with an ecological framework. Accurate, detailed captions required.

Specs Uses 35mm, 2¼ × 2¼, 4 × 5, 6 × 7, 8 × 10 color transparencies; high-res digital images. Covers are always related to an article in the issue.

Making Contact & Terms Send query letter with résumé of credits. "We prefer that you come in and show us your portfolio, if and when you are in New York. Please don't send us any photographs without a query first, describing the work you would like to send. No submission should exceed 30 original transparencies or negatives. However, please let us know if you have additional images that we might consider. Potential liability for submissions that exceed 30 originals shall be no more than $100 per slide." Responds in 2 weeks. Previously published work OK but must be indicated on delivery memo. Pays (for color and b&w) $400-600 for cover; $350-500 for spread; $300-400 for oversize; $250-350 for full-page; $200-300 for ¼ page; $175-250 for less than ¼ page. Pays $50 for usage on contents page. Pays on publication. Credit line given. Buys one-time rights.

Tips "Study the magazine—we are more interested in ideas than individual photos."

■ ⑤ **$** ☑ **NATURE FRIEND**

4253 Woodcock Lane, Dayton VA 22821. (540)867-0764. Fax: (540)867-9516. **Contact:** Kevin Shank, editor. Circ. 13,000. Estab. 1982. Monthly children's magazine. Sample copy available for $5 plus $2 first-class postage.

Needs Buys 5-10 photos from freelancers/issue; 100 photos/year. Needs photos of wildlife, wildlife interacting with each other, humorous wildlife, all natural habitat appearance. Reviews photos with or without manuscript. Model/property release preferred. Photo captions preferred.

Specs Prefers images in digital format. Send via CD or DVD as TIFF files at 300 dpi at 8 × 10 size; provide color thumbnails when submitting photos. "Transparencies are handled and stored carefully; however, we do not accept liability for them so discourage submissions of them."

Making Contact & Terms Responds in one month to queries; 2 weeks to portfolios. "Label contact prints and digital media with your name, address, and phone number so we can easily know how to contact you if we select your photo for use." Please send articles rather than queries. We try to respond within 4-6 months. Simultaneous submissions and previously published work OK. Pays $75 for front cover; $50 for back cover; $15-25 for inside photos. Pays on publication. Credit line given. Buys one-time rights.

Tips "We're always looking for photos of wild animals doing something unusual or humorous. Please label every sheet of paper or digital media with name, address and phone number. We may need to contact you on short notice, and you do not want to miss a sale. Also, photos are selected on a monthly basis, after the articles. What this means to a photographer is that photos are secondary to writings and cannot be selected far in advance. High-resolution photos in our files the day we are making selections will stand the greatest chance of being published."

■ **$** **NATURE PHOTOGRAPHER**

P.O. Box 220, Lubec ME 04652. (207)733-4201. Fax: (207)733-4202. E-mail: nature_ photographer@yahoo.com. Website: www.naturephotographermag.com. **Contact:** Helen Longest-Saccone, editor-in-chief/photo editor. Circ. 41,000. Estab. 1989. Quarterly 4-color, high-quality magazine. Emphasizes "conservation-oriented, low-impact nature photography" with strong how-to focus. Readers are male and female nature photographers of all ages. Sample copy available for 10 × 13 SAE with 6 first-class stamps.

 • *Nature Photographer* charges $80/year to be a "field contributor."

Needs Buys 90-120 photos from freelancers/issue; 400 photos/year. Needs nature shots of "all types—abstracts, animals/wildlife, flowers, plants, scenics, environmental images, etc. Shots must be in natural settings; no set-ups, zoo or captive animal shots accepted." Reviews photos (slides or digital images on CD) with or without ms 4 times/year: May (for fall issue); August (for winter issue); November (for spring issue); and January (for summer issue). Photo captions required; include description of subject, location, type of equipment, how photographed. "This information published with photos."

Making Contact & Terms Contact by e-mail or with SASE for guidelines before submitting images. Prefers to see 35mm transparencies or CD of digital images. "Send digital images via CD; please do not

Tips Recommends working with "the best lens you can afford and slow-speed slide film;

or, if shooting digital, using the RAW mode." Suggests editing with a 4 × or 8 × loupe (magnifier) on a light board to check for sharpness, color saturation, etc. "Color prints are not normally used for publication in our magazine. When editing digital captured images, please enlarge to the point that you are certain that the focal point is tack sharp. Also avoid having grain in the final image."

◨ $ $ NEW MEXICO MAGAZINE

495 Old Santa Fe Trail, Santa Fe NM 87501. (505)827-7447. Fax: (505)827-6496. E-mail: artdirector@nmmagazine.com. Website: www.nmmagazine.com. **Contact:** Ms. Fabian West, Art Director. Circ. 123,000. Monthly magazine for affluent people ages 35-65 interested in the Southwest or who have lived in or visited New Mexico. Sample copy available for $4.95 with 9 × 12 SAE and 3 first-class stamps. Photo guidelines available on Website.

Needs Buys 10 photos from freelancers/issue; 120 photos/year. Needs New Mexico photos only—landscapes, people, events, architecture, etc. "Most work is done on assignment in relation to a story, but we welcome photo essay suggestions from photographers. Cover photos usually relate to the main feature in the magazine." Model release preferred.

Specs Uses 300 dpi digital files with contact sheets (8-9 per page). Photo captions required; include who, what, where.

Making Contact & Terms Submit portfolio; include SASE for return of material. Pays $450/day; $300 for color or b&w cover; $60-100 for color or b&w stock. Pays on publication. Credit line given. Buys one-time rights.

Tips "*New Mexico Magazine* is the official magazine for the state of New Mexico. Photographers should know New Mexico. We are interested in the less common stock of the state. The magazine is editorial driven, and all photos run directly related to a story in the magazine."

◉ NEWSWEEK

395 Hudson St., New York NY 10014. (212)445-4000. Website: www.newsweek.com. Circ. 3,180,000. Newsweek reports the week's developments on the newsfront of the world and the nation through news, commentary and analysis. News is divided into National Affairs; International; Business; Society; Science & Technology; and Arts & Entertainment. Relevant visuals, including photos, accompany most of the articles. Query before submitting.

◨ $ ◉ NORTH AMERICAN WHITETAIL MAGAZINE

(770)953-9222. Fax: (770)933-9510. E-mail: ron.sinfelt@imoutdoors.com. Website: www.northamericanwhitetail.com. **Contact**: Ron Sinfelt, photo editor. Circ. 150,000. Estab. 1982. Published 8 times/year (July-February) by Primedia. Emphasizes trophy whitetail deer hunting. Sample copy available for $3. Photo guidelines free with SASE.

Needs Buys 8 photos from freelancers/issue; 64 photos/year. Needs photos of large, live whitetail deer, hunter posing with or approaching downed trophy deer, or hunter posing with mounted head. Also uses photos of deer habitats and signs. Model release preferred. Photo captions preferred; include when and where scene was photographed.

Specs Accepts images in digital format. Send via CD at 300 dpi with output of 8 × 12 inches. Also uses 35mm transparencies.

Making Contact & Terms Send query letter with résumé of credits and list of stock photo

subjects. Will return unsolicited material in 1 month if accompanied by SASE. Simultaneous submissions not accepted. Pays $400 for color cover; $75 for color inside. Tearsheets provided. Pays 60 days prior to publication. Credit line given. Buys one-time rights.

Tips "In samples we look for extremely sharp, well-composed photos of whitetailed deer in natural settings. We also use photos depicting deer hunting scenes. Please study the photos we are using before making submission. We'll return photos we don't expect to use and hold the remainder for potential use. Please do not send dupes. Use an 8 × 10 envelope to ensure sharpness of images, and put name and identifying number on all slides and prints. Photos returned at time of publication or at photographer's request."

▣ $ NORTH CAROLINA LITERARY REVIEW

East Carolina University, Greenville NC 27858-4353. (252)328-1537. Fax: (252)328-4889. E-mail: BauerM@ecu.edu. Website: www.ecu.edu/nclr. **Contact:** Diane Rodman, art acquisitions editor. Circ. 750. Estab. 1992. Annual literary magazine with North Carolina focus. NCLR publishes poetry, fiction and nonfiction by and interviews with NC writers, and articles and essays about NC literature, literary history and culture. Photographs must be NC-related. Sample copy available for $15. Photo guidelines available for SASE or on website.

Needs Buys 3-6 photos from freelancers/issue. Model/property release preferred. Photo captions preferred.

Specs Uses b&w prints; 4 × 5 transparencies. Accepts images in digital format. Inquire first; request, submit TIFF, GIF files at 300 dpi to nclruser@ecu.edu.

Making Contact & Terms Send query letter with website address to show sample of work. Portfolios may be dropped off. Provide résumé, business card, self-promotion piece to be kept on file for possible future assignments. Send nonreturnable samples or include SASE for return of material. Responds in 2 months to queries. Pays $50-250 for cover; $5-100 for b&w inside. Pays on publication. Credit line given. Buys first rights.

Tips "Look at our publication—1998-present back issues. See our Website."

▣ $$ ☑ NORTHEAST BOATING MAGAZINE

(Formerly *Offshore)* Offshore Communications, Inc., 500 Victory Rd., Marina Bay, North Quincy MA 02171. (617)221-1400. Fax: (617)847-1871. Website: www.northeastboating. net. **Contact:** Dave Dauer, director of creative services. Monthly magazine. Focuses on recreational boating in the Northeast region of U.S., from Maine to New Jersey. Sample copy free with 9 × 12 SASE.

Needs Buys 35-50 photos from freelancers/issue; 420-600 photos/year. Needs photos of recreational boats and boating activities. " Boats covered are mostly 20-50 feet; mostly power, but some sail, too." Photo captions required; include location.

Specs Accepts slides or digital images only. " Cover photos should be vertical format and have strong graphics and/or color."

Making Contact & Terms "Please call before sending photos." Simultaneous submissions and previously published work OK. Pays $400 for color cover; $75-250 for color inside. Pays on publication. Credit line given. Buys one-time rights.

▣ $ NORTHERN WOODLANDS

P.O. Box 471, Corinth VT 05039-9900. (802)439-6292. Fax: (802)439-6296. Website: www. northernwoodlands.org. **Contact:** managing editor. Circ. 17,000. Estab. 1994. Quarterly consumer magazine "created to inspire landowners' sense of stewardship by increasing their awareness of the natural history and the principles of conservation and forestry that are directly related to their land; to encourage loggers, foresters, and purchasers of raw materials to continually raise the standards by which they utilize the forest's resources; to increase the public's awareness and appreciation of the social, economic, and environmental benefits of a working forest; to raise the level of discussion about environmental and natural resource issues; and to educate a new generation of forest stewards." Sample copies available for $5. Photo guidelines available on Website.

Needs Buys 10-50 photos from freelancers/year. Needs photos of forestry, environmental, landscapes/scenics, wildlife, rural, adventure, travel, agriculture, science. Interested in historical/vintage, seasonal. Other specific photo needs: vertical format, photos specific to assignments in northern New England and upstate New York. Reviews photos with or without a manuscript. Model release preferred. Photo captions required.

Specs Uses glossy or matte color and b&w prints; 35mm, 2¼ × 2¼ transparencies. Prefers images in digital format. Send via CD, Zip, e-mail as TIFF, EPS files at 300 dpi minimum. No e-mails larger than 10 MB.

Making Contact & Terms Send query letter with slides. Provide self-promotion piece to be kept on file for possible future assignments. Responds only if interested; send nonreturnable samples. Previously published work OK. Pays $150 for color cover; $25-75 for b&w inside. "We might pay upon receipt or as late as publication." Credit line given. Buys one-time rights.

Tips "Read our magazine or go to our website for samples of the current issue. We're always looking for high-quality cover photos on a seasonal theme. Vertical format for covers is essential. Also, note that our title goes up top, so photos with some blank space up top are best. Please remember that not all good photographs make good covers—we like to have a subject, lots of color, and we don't mind people. Anything covering the woods and people of Vermont, New Hampshire, Maine, northern Massachusetts or northern New York is great. Unusual subjects, and ones we haven't run before (we've run lots of birds, moose, large mammals, and horse-loggers), get our attention. For inside photos we already have stories and are usually looking for regional photographers willing to shoot a subject theme."

$ NORTHWEST TRAVEL MAGAZINE

4969 Hwy. 101, Suite 2, Florence OR 97439. (800)348-8401. Fax: (541)997-1124. E-mail: Rosemary@nwmags.com. Website: www.northwestmagazines.com. **Contact:** Rosemary Camozzi, editor. Circ. 50,000. Estab. 1991. Bimonthly consumer magazine emphasizing travel in Oregon, Washington, Idaho, western Montana, and British Columbia, Canada. Readers are middle-class, middle-age. Sample copy available for $6. Photo guidelines free with SASE or on Website.

Needs Buys 3-5 photos from freelancers/issue; 18-30 photos/year. Wants seasonal scenics. Model release required. Photo captions required; include specific location and description. "Label all slides and transparencies with captions and photographer's name."

Specs Uses 35mm, 2¼ × 2¼, 4 × 5 positive transparencies. "Do not e-mail images."

Making Contact & Terms We recommend acquiring model releases for any photos that include people, but we don't require releases except for photos used on covers or in advertising. Prefers positive transparences, 35 mm to 4 × 5. Photos must be current, shot within the last five years. Digital photos must be sent on CDs as high resolution (300 dpi) TIFF, JPEG, or EPS files without compression. Images should be 8½ × 11½. Include clear, color contact sheets of all images (no more than 8 per page). CDs are not returned. To be considered for calendars, photos must have horizontal formats. The annual deadline for Calendars is June 15. Responds in 1 month. Pays $425 for color cover; $100 for calendar usage; $25-50 for b&w inside; $25-100 for color inside; $100-250 for photo/text package. Credit line given. Buys one-time rights. Note: we do not sign personal delivery memoms. SASE or return postage required.

Tips "Send slide film that can be enlarged without graininess (50-100 ASA). We don't use color filters. Send 20-40 slides. Protect slides with sleeves put in plastic holders. Don't send in little boxes. We work about 3 months ahead, so send spring images in winter, summer images in spring, etc."

Ⓝ ▣ $ ⊘ NOW & THEN: The Appalachian Magazine

Center for Appalachian Studies & Services, Box 70556 ETSU, 807 University Pkwy., Johnson City TN 37614-1707. (423)439-7 994. Fax: (423)439-7870. E-mail: sandersr@etsu.edu. Website: www.etsu.edu/cass. **Contact:** Randy Sanders, managing editor. Circ. 1,000. Estab. 1984. Literary magazine published twice/year. Now & Then tells the story of Appalachia, the mountain region that extends from northern Mississippi to southern New York state. The magazine presents a fresh, revealing picture of life in Appalachia, past and present, with engaging articles, personal essays, fiction, poetry and photography. Sample copy available for $8 plus $2 shipping. Photo guidelines free with SASE or visit Website.

Needs Needs photos of environmental, landscapes/scenics, architecture, cities/urban, rural, adventure, performing arts, travel, agriculture, political, disasters. Interested in documentary, fine art, historical/vintage. Photographs must relate to theme of issue. Themes are posted on the website or available with guidelines. "We publish photo essays based on the magazine's theme." Reviews photos with or without a manuscript. Model/ property release preferred. Photo captions preferred; include where the photo was taken, identify places/people.

Specs Require images in digital format sent as e-mail attachments as JPEG or TIFF files at 300 dpi minimum.

Making Contact & Terms Send query letter with résumé, photocopies. Provide self-promotion piece to be kept on file for possible future assignments. Responds only if interested; send nonreturnable samples. Simultaneous submissions OK. Pays $100 maximum for color cover; $25 for b&w inside. Pays on publication. Credit line given. Buys one-time rights; negotiable.

Tips "Know what our upcoming themes are. Keep in mind we cover only the Appalachian region. (See the website for a definition of the region)."

Ⓝ ▣ $$ ⊘ OKLAHOMA TODAY

120 N. Robinson, Suite 600, Oklahoma City OK 73102. (405)230-8450. E-mail: liz@

oklahomatoday.com. Website: www.oklahomatoday.com. **Contact:** Liz Blood, assistant editor. Circ. 45,000. Estab. 1956. Bimonthly magazine. "We cover all aspects of Oklahoma, from history to people profiles, but we emphasize travel." Readers are "Oklahomans, whether they live in-state or are exiles; studies show them to be above average in education and income." Sample copy available for $4.95. Photo guidelines free with SASE or on website.

Needs Buys 45 photos from freelancers/issue; 270 photos/year. Needs photos of "Oklahoma subjects only; the greatest number are used to illustrate a specific story on a person, place or thing in the state. We are also interested in stock scenics of the state." Other areas of focus are adventure—sport/travel, reenactment, historical and cultural activities. Model release required. Photo captions required.

Specs Uses 8 × 10 glossy b&w prints; 35mm, 2¼ × 2¼, 4 × 5, 8 × 10 transparencies. Accepts images in digital format. Send via CD or e-mail.

Making Contact & Terms Send query letter with samples; include SASE for return of material. Responds in 2 months. Simultaneous submissions and previously published work OK (on occasion). Pays $50-150 for b&w photos; $50-250 for color photos; $125-1,000/job. Pays on publication. Buys one-time rights with a 4-month from publication exclusive, plus right to reproduce photo in promotions for magazine without additional payment with credit line.

Tips To break in, "read the magazine. Subjects are normally activities or scenics (mostly the latter). I would like good composition and very good lighting. I look for photographs that evoke a sense of place, look extraordinary and say something only a good photographer could say about the image. Look at what Ansel Adams and Eliot Porter did and what Muench and others are producing, and send me that kind of quality. We want the best photographs available, and we give them the space and play such quality warrants."

$ OREGON COAST MAGAZINE

4969 Hwy. 101, Suite 2, Florence OR 97439. (800)348-8401. Fax: (541)997-1124. E-mail: Rosemary@nwmags.com. Website: www.northwestmagazines.com. **Contact**: Rosemary Camozzi, editor. Circ. 50,000. Estab. 1982. Bimonthly magazine. Emphasizes Oregon coast life. Readers are middle-class, middle-aged. Sample copy available for $6, including postage. Photo guidelines available with SASE or on Website.

Needs Buys 3-5 photos from freelancers/issue; 18-30 photos/year. Needs scenics. Especially needs photos of typical subjects—waves, beaches, lighthouses—with a fresh perspective. Needs mostly vertical format. Model release required. Photo captions required; include specific location and description. "Label all slides and transparencies with captions and photographer's name."

Making Contact & Terms We recommend acquiring model releases for any photos that include people, but we don't require releases except for photos used on covers or in advertising. Prefers positive transparences, 35 mm to 4x5. Photos must be current, shot within the last five years. Digital photos must be sent on CDs as high resolution (300 dpi) TIFF, JPEG, or EPS files without compression. Images should be 8½ × 11. Include clear, color contact sheets of all images (no more than 8 per page). CDs are not returned. To be considered for calendars, photos must have horizontal formats. The annual deadline for Calendars is June 15. Responds in 1 month. Pays $425 for color cover; $100 for calendar

usage; $25-50 for b&w inside; $25-100 for color inside; $100-250 for photo/text package. Credit line given. Buys one-time rights. Note: we do not sign personal delivery memoms. SASE or return postage required.

Tips "Send only the very best. Use only slide film that can be enlarged without graininess. Don't use color filters. An appropriate submission would be 20-40 slides. Protect slides with sleeves—put in plastic holders. Don't send in little boxes."

N ▣ $$ ▢ OUTDOOR AMERICA

Izaak Walton League of America, 707 Conservation Lane, Gaithersburg MD 20878-2983. (301)548-0150. Fax: (301)548-9409. E-mail: oa@iwla.org. Website: www.iwla.org/oa. **Contact:** Dawn Merritt, editorial director. Art Director: Jay Clark. Circ. 36,000. Estab. 1922. Published quarterly. Covers conservation topics, from clean air and water to public lands, fisheries and wildlife. Also focuses on outdoor recreation issues and covers conservation-related accomplishments of the League's membership.

Needs Needs vertical wildlife photos or shots of campers, boaters, anglers, hunters and other traditional outdoor recreationists for cover. Reviews photos with or without a manuscript. Model release required. Photo captions preferred; include date taken, model info, location and species.

Specs Uses 35mm, 6 × 9 transparencies or negatives. Accepts images in digital format. Send via CD, Zip, e-mail as TIFF, EPS, JPEG files at 300 dpi.

Making Contact & Terms "Tearsheets and nonreturnable samples only. Not responsible for return of unsolicited material." Simultaneous submissions and previously published work OK. Pays $500 and up for cover; $50-600 for inside. **Pays on acceptance**. Credit line given. Buys one-time rights and occasionally Web rights.

Tips "We prefer the unusual shot—new perspectives on familiar objects or subjects. We occasionally assign work. Approximately one half of the magazine's photos are from freelance sources."

▣ $ OVER THE BACK FENCE

Long Point Media, LLC, 2947 Interstate Pkwy., Brunswick OH 44212. (330)220-2483. Fax: (330)220-3083. E-mail: RockyA@LongPointMedia.com. Website: www.backfencemagazine. com. **Contact:** Rocky Alten, creative director. Estab. 1994. Bimonthly magazine. "*Over the Back Fence* is a regional magazine serving southern and central Ohio. We are looking for photos of interesting people, events and history of our area." Sample copy available for $5. Photo guidelines available on website.

Needs Buys 50 photos from freelancers/issue; 200 photos/year. Needs photos of scenics, attractions, food (specific to each issue), historical locations in region (call for specific counties). Model release required for identifiable people. Photo captions preferred; include location, description, names, date of photo (year), and if previously published, where and when.

Specs Prefers images in digital format. Review guidelines before submitting.

Making Contact & Terms Send query letter with stock list and résumé of credits. Provide résumé, business card, brochure, flier or tearsheets to be kept on file for possible future assignments. Responds in 3 months. Simultaneous submissions and previously published work OK, "but you must identify photos used in other publications." Pays $100 for cover;

$25-100 for inside. "We pay mileage fees to photographers on assignments. See our photographer's rates and guidelines for specifics." Pays on publication. Credit line given "except in the case of ads, where it may or may not appear." Buys one-time rights.

Tips "We are looking for sharp, colorful images and prefer using digital files or color transparencies over color prints when possible. Nostalgic and historical photos are usually in black and white."

◩ ▣ ◪ OWL MAGAZINE

10 Lower Spadina Ave., Suite 400, Toronto ON M5V 2Z2 Canada. (416)340-2700. Fax: (416)340-9769. E-mail: deb.yea@owlkids.com. Website: www.owlkids.com. **Contact:** Debbie Yea, photo editor. Circ. 80,000. Estab. 1976. Published 10 times/year. A discovery magazine for children ages 9-13. Sample copy available for $4.95 and 9 × 12 SAE with $1.50 money order for postage. Photo guidelines free with SAE or via e-mail.

Needs Photo stories, photo puzzles, photos of children ages 12-14, extreme weather, wildlife, science, technology, environmental, pop culture, multicultural, events, adventure, hobbies, humor, sports and extreme sports. Interested in documentary, seasonal. Model/property release required. Photo captions required. Will buy story packages.

Specs Accepts images in digital format. E-mail as JPEG files at 72 dpi. "For publication, we require 300 dpi."

Making Contact & Terms Accepts no responsibility for unsolicited material. Previously published work OK. Credit line given. Buys one-time rights.

Tips "Photos should be sharply focused with good lighting, and engaging for kids. We are always on the lookout for humorous, action-packed shots; eye-catching, sports, animals, bloopers, etc. Photos with a 'wow' impact."

Ⓝ ◩ Ⓐ $ ◪ PACIFIC YACHTING MAGAZINE

500-200 West Esplanade, North Vancouver BC V7M1A4 Canada. (604)998-3310. Fax: (604)998-3320. E-mail: editorial@pacificyachting.com. Website: www.pacificyachting. com. **Contact:** Dale Miller, editor. Circ. 20,000. Estab. 1968. Monthly magazine. Emphasizes boating on West Coast. Readers are ages 35-60; boaters, power and sail. Sample copy available for $6.95 Canadian plus postage.

Needs Buys 75 photos from freelancers/issue; 900 photos/year. Needs photos of landscapes/scenics, adventure, sports. Interested in historical/vintage, seasonal. "All should be boating related." Reviews photos with accompanying manuscript only. "Always looking for covers; must be shot in British Columbia."

Making Contact & Terms Keeps samples on file. Simultaneous submissions and previously published work OK. Pays $400 Canadian for color cover. Payment negotiable. Credit line given. Buys one-time rights.

▣ $ PENNSYLVANIA

P.O. Box 755, Camp Hill PA 17011. (717)697-4660. E-mail: editor@pa-mag.com. Website: www.pa-mag.com. **Contact:** Matthew K. Holliday, editor. Circ. 30,000. Bimonthly. Emphasizes history, travel and contemporary topics. Readers are 40-70 years old, professional and retired. Samples available upon request. Photo guidelines free with SASE or via e-mail.

Needs Uses about 40 photos/issue; most supplied by freelancers. Needs include travel, wildlife and scenic. All photos must be taken in Pennsylvania. Reviews photos with or without accompanying manuscript. Photo captions required.

Making Contact & Terms Send query letter with samples. Send digital submissions of 5.0 MP or higher (OK on CD-ROM with accompanying printout with image file references); 5 × 7 and larger color prints; 35mm and 2¼ × 2¼ transparencies (duplicates only, in camera or otherwise, no originals) by mail for consideration; include SASE for return of material. Responds in 1 month. Simultaneous submissions and previously published work OK with notification. Pays $100-150 for color cover; $35 for color inside; $50-500 for text/photo package. Credit line given. Buys one-time, first rights or other rights as arranged.

Tips Look at several past issues and review guidelines before submitting.

▣ $$ PENNSYLVANIA ANGLER & BOATER

P.O. Box 67000, Harrisburg PA 17106-7000. (717)705-7844. Fax: (717)705-7831. Website: www.fishandboat.com. **Contact:** editor. Bimonthly. *"Pennsylvania Angler & Boater* is the Keystone State's official fishing and boating magazine, published by the Pennsylvania Fish & Boat Commission." Readers are anglers and boaters in Pennsylvania. Sample copy and photo guidelines free for 9 × 12 SAE and 9 oz. postage, or via website.

Needs Buys 8 photos from freelancers/issue; 48 photos/year. Needs "action fishing and boating shots." Model release required. Photo captions required.

Making Contact & Terms "Don't submit without first considering contributor guidelines, available on Website. Then send query letter with résumé of credits. Send 35mm or larger transparencies by mail for consideration; include SASE for return of material. Send low-res images on CD; we'll later request high-res images of those shots that interest us." Responds in several weeks. Pays $400 maximum for color cover; $30 minimum for color inside; $50-300 for text/photo package. Pays between acceptance and publication. Credit line given.

Ⓝ ▣ $ PENNSYLVANIA GAME NEWS

2001 Elmerton Ave., Harrisburg PA 17110-9797. (717)787-3745. Website: www.pgc.state. pa.us. **Contact:** Bob Mitchell, editor. Circ. 75,000. Monthly magazine published by the Pennsylvania Game Commission. Readers are people interested in hunting, wildlife management and conservation in Pennsylvania. Sample copy available for 9 × 12 SASE. Editorial guidelines free.

Needs Considers photos of "any outdoor subject (Pennsylvania locale), except fishing and boating." Reviews photos with accompanying manuscript. Manuscript not required.

Making Contact & Terms Send prints or slides. "No negatives, please." Include SASE for return of material. Will accept electronic images via CD only (no e-mail). Will also view photographer's website if available. Responds in 2 months. Pays $40-300. **Pays on acceptance.**

PHOTOGRAPHER'S FORUM MAGAZINE

Serbin Communications, Inc., 813 Reddick St., Santa Barbara CA 93103. (805)963-0439 or (800)876-6425. Fax: (805)965-0496. E-mail: julie@serbin.com. Website: www.pfmagazine. com. **Contact:** Julie Simpson, managing editor. Quarterly magazine for the serious student and emerging professional photographer. Includes feature articles on historic and

contemporary photographers, interviews, book reviews, workshop listings, new products. (See separate listings for annual photography contests in the Contests section.)

🖥 $ $ ☑ PHOTO TECHNIQUES

Preston Publications, 6600 W. Touhy Ave., Niles IL 60714. (847)647-2900. Fax: (847)647-1155. E-mail: slewis@phototechmag.com. Website: www.phototechmag.com. **Contact:** Scott Lewis, editor. Circ. 20,000. Estab. 1979. Bimonthly magazine for advanced traditional and digital photographers. Sample copy available for $6. Photo guidelines free with SAE or available on Website.

Needs Publishes expert technical articles about photography. Needs photos of rural, landscapes/scenics, "but if extensively photographed by others, ask yourself if your photo is sufficiently different." Also "some urban or portrait if it fits theme of article." Especially needs digital ink system testing and coloring and alternative processes articles. Reviews photos with or without a manuscript. Photo captions required; include technical data.

Specs Uses any and all formats.

Making Contact & Terms "E-mail queries work best." Send article or portfolio for review. Portfolio should include b&w and/or color prints, slides or transparencies. Keeps samples on file; include SASE for return of material. "Prefer that work not have been previously published in any competing photography magazine; small, scholarly, or local publication OK." Pays $300 for color cover; $100-150/page. Pays on publication. Credit line given. Buys one-time rights.

Tips "We need people to be familiar with our magazine before submitting/querying. Include return postage/packaging. Also, we much prefer complete, finished submissions. When people ask, 'Would you be interested in...?', often the answer is simply, 'We don't know! Let us see it.' Most of our articles are written by practicing photographers and use their work as illustrations."

🖥 POETS & WRITERS MAGAZINE

90 Broad Street, 2100, New York NY 10004. (212)226-3586. Fax: (212)226-3963. E-mail: editor@pw.org. Website: www.pw.org/magazine. Circ. 60,000. Estab. 1987. Bimonthly literary trade magazine. "Designed for poets, fiction writers and creative nonfiction writers. We supply our readers with information about the publishing industry, conferences and workshop opportunities, grants and awards available to writers, as well as interviews with contemporary authors."

Needs Needs photos of contemporary writers: poets, fiction writers, writers of creative nonfiction. Photo captions required.

Specs Digital format.

Making Contact & Terms Provide URL, self-promotion piece or tearsheets to be kept on file for possible future assignments. Managing editor will contact photographer for portfolio review if interested. Pays on publication. Credit line given.

Tips "We seek photographs to accompany articles and profiles. We'd be pleased to have photographers' lists of author photos."

🔄 🖥 ⑤ $ ◯ THE PRAIRIE JOURNAL

P.O. Box 61203, Brentwood PO, Calgary AB T2L 2K6 Canada. E-mail: prairiejournal@yahoo.

com. Website: www.geocities.com/prairiejournal. Circ. 600. Estab. 1983. Literary magazine published twice/year. Features mainly poetry and artwork. Sample copy available for $6 and 7 × 8½ SAE. Photo guidelines available for SAE and IRC.

Needs Buys 4 photos/year. Needs literary only, artistic.

Specs Uses b&w prints. Accepts images in digital format. Send via e-mail "if your query is successful."

Making Contact & Terms Send query letter with photocopies only (no originals) by mail. Provide self-promotion piece to be kept on file. Responds in 6 months, only if interested; send nonreturnable samples. Pays $10-50 for b&w cover or inside. Pays on publication. Credit line given. Buys first rights.

Tips "Black & white literary, artistic work preferred; not commercial. We especially like newcomers. Read our publication or check out our website. You need to own copyright for your work and have permission to reproduce it. We are open to subjects that would be suitable for a literary arts magazine containing poetry, fiction, reviews, interviews. We do not commission but choose from your samples."

$ $ ◙ RANGER RICK

11100 Wildlife Center Dr., Reston VA 20190-5362. (703)438-6525. Fax: (703)438-6094. E-mail: mcelhinney@nwf.org. Website: www.nwf.org/rangerrick. **Contact:** Susan McElhinney, photo editor. Circ. 500,000. Estab. 1967. Monthly educational magazine published by the National Wildlife Federation for children ages 8-12. Photo guidelines free with SASE.

Needs Needs photos of children, multicultural, environmental, wildlife, adventure, science.

Specs Uses transparencies or digital capture; dupes or lightboxes OK for first edit.

Making Contact & Terms Send nonreturnable printed samples or website address. *Ranger Rick* space rates: $300 (quarter page) to $1,000 (cover).

Tips "NWF's mission is to inspire Americans to protect wildlife for our children's future. Seeking experienced photographers with substantial publishing history only."

REFORM JUDAISM

633 Third Ave., 7th Floor, New York NY 10017-6778. (212)650-4240. E-mail: rjmagazine@ urj.org. Website: www.reformjudaismmag.org. **Contact:** Joy Weinberg, managing editor. Circ. 305,000. Estab. 1972. Quarterly publication of the Union for Reform Judaism. Offers insightful, incisive coverage of the challenges faced by contemporary Jews. Readers are members of Reform congregations in North America. Sample copy available for $3.50. Photo guidelines available via e-mail or on Website.

Needs Buys 3 photos from freelancers/issue; 12 photos/year. Needs photos relating to Jewish life or Jewish issues, Israel, politics. Model release required for children. Photo captions required.

Making Contact & Terms Provide Website. Responds in 1 month. Simultaneous submissions and previously published website work OK. Include self-addressed, stamped postcard for response. Pays on publication. Credit line given. Buys one-time rights, first North American serial rights.

Tips Wants to see "excellent photography: artistic, creative, evocative pictures that involve the reader."

◫ REVOLUTIONARY WAR TRACKS

2660 Petersborough St., Herndon VA 20171. E-mail: revolutionarywartracks@yahoo.com. Estab. 2005. Quarterly magazine, "bringing Revolutionary War history alive for children and teens." Photo guidelines available by e-mail request.

Needs Buys 12-24 photos/year. Needs photos of babies/children/teens, multicultural, families, parents, disasters, environmental, landscapes/scenics, wildlife, cities/urban, education, religious, rural, adventure, events, food/drink, sports, travel, agriculture, medicine, military, political, product shots/still life, science, technology—as related to Revolutionary War history. Interested in alternative process, avant garde, documentary, fashion/glamour, fine art, historical/vintage, seasonal. Reviews photos with or without a manuscript. Model/property release preferred.

Specs Uses glossy or matte color and/or b&w prints.

Making Contact & Terms Send query letter via e-mail. "If possible, please do not include photographs in files if they are sent through e-mail. A disk with your photographs is acceptable." Provide résumé, business card or self-promotion piece to be kept on file for possible future assignments. "Photographs sent with CDs are requested but not required." Responds within 1 month to queries; 1 week to portfolios. Simultaneous submissions and previously published work OK. **Pays on acceptance.** Credit line given. Buys one-time rights, first rights; negotiable.

◫ ◪ RHODE ISLAND MONTHLY

Rhode Island Monthly Communications, Inc., 280 Kinsley Ave., Providence RI 02903-1017. (401)277-8174. Fax: (401)277-8080. Website: www.rimonthly.com. **Contact:** Ellen Dessloch, art director. Circ. 40,000. Estab. 1988. Monthly regional publication for and about Rhode Island.

Needs Buys 15 photos from freelancers/issue; 200 photos/year. "Almost all photos have a local slant: portraits, photo essays, food, lifestyle, home, issues."

Specs Accepts images in digital format.

Making Contact & Terms Portfolio may be dropped off. Provide self-promotion piece to be kept on file for possible future assignments. Will return anything with SASE. Responds in 2 weeks. Pays "a month after invoice is submitted." Credit line given. Buys one-time rights.

Tips "Freelancers should be familiar with *Rhode Island Monthly* and should be able to demonstrate their proficiency in the medium before any work is assigned."

ROCKFORD REVIEW

P.O. Box 858, Rockford IL 61105. Website: http://writersguild1.tripod.com. **Contact:** David Ross, editor. Circ. 750. Estab. 1982. Association publication of Rockford Writers' Guild. Published twice/year (summer and winter). Emphasizes poetry and prose of all types. Readers are of all stages and ages who share an interest in quality writing and art. Sample copy available for $9.

• This publication is literary in nature and publishes very few photographs. However, the photos on the cover tend to be experimental (e.g., solarized images, photograms, etc.).

Needs Uses 1-5 photos/issue; all supplied by freelancers. Needs photos of scenics and personalities. Model/property release preferred. Photo captions preferred; include when and where, and biography.

Specs Uses 8 × 10 or 5 × 7 glossy b&w prints.

Making Contact & Terms Send unsolicited photos by mail for consideration. Does not keep samples on file; include SASE for return of material. Responds in 6 weeks. Simultaneous submissions OK. Payment is one copy of magazine, but work is eligible for *Review*'s $25 Editor's Choice prize. Pays on publication. Credit line given. Buys first North American serial rights.

Tips "Experimental work with a literary magazine in mind will be carefully considered. Avoid the 'news' approach."

▣ $ RUSSIAN LIFE MAGAZINE

P.O. Box 567, Montpelier VT 05601. (802)223-4955. E-mail: editors@russianlife.com. Website: www.russianlife.com. **Contact:** Paul Richardson, publisher. Estab. 1956. Bimonthly magazine.

Needs Uses 25-35 photos/issue. Offers 10-15 freelance assignments/year. Needs photojournalism related to Russian culture, art and history. Model/property release preferred.

Making Contact & Terms Works with local freelancers only. Send query letter with samples. Send 35mm, 2¼ × 2¼, 4 × 5, 8 × 10 transparencies; 35mm film; digital format. Include SASE "or material will not be returned." Responds in 1 month. Pays $20-50 (color photo with accompanying story), depending on placement in magazine. Pays on publication. Credit line given. Buys one-time and electronic rights.

▣ $ ◩ SANDLAPPER MAGAZINE

P.O. Box 1108, Lexington SC 29071. Fax: (803)359-0629. E-mail: aida@sandlapper. org. Website: www.sandlapper.org. **Contact:** Aida Rogers, editor. Estab. 1989. Quarterly magazine. Emphasizes South Carolina topics only.

Needs Uses about 10 photographers/issue. Needs photos of anything related to South Carolina in any style, "as long as they're not in bad taste." Model release preferred. Photo captions required; include places and people.

Specs Uses 8 × 10 color and b&w prints; 35mm, 2¼ × 2¼, 4 × 5, 8 × 10 transparencies. Accepts images in digital format. Send via CD, Zip as TIFF, JPEG files at 300 dpi. "Do not format exclusively for PC. RGB preferred. Submit low-resolution and high-resolution files, and label them as such. Please call or e-mail Elaine Gillespie with any questions" about digital submissions: (803)779-2126; elaine@thegillespieagency.com.

Making Contact & Terms Send query letter with samples. Keeps samples on file; include SASE for return of material. Responds in 1 month. Pays $100 for color cover; $50-100 for color inside. Pays 1 month *after* publication. Credit line given. Buys first rights plus right to reprint.

Tips "We see plenty of beach sunsets, mountain waterfalls, and shore birds. Would like fresh images of people working and playing in the Palmetto state."

▣ $ SCHOLASTIC MAGAZINES

568 Broadway, New York NY 10012. (212)343-7147. Fax: (212)343-7799. E-mail: sdiamond@ scholastic.com. Website: www.scholastic.com. **Contact:** Steven Diamond, executive director of photography. Estab. 1920. Publication of magazines varies from weekly to monthly.

"We publish 27 titles on topics from current events, science, math, fine art, literature and social studies. Interested in featuring high-quality, well-composed images of students of all ages and all ethnic backgrounds. We Publish hundreds of books on all topics, Educational programs, Internet products and new media."

Needs Needs photos of various subjects depending upon educational topics planned for academic year. Model release required. Photo captions required. "Images must be interesting, bright and lively!"

Specs Accepts images in digital format. Send via CD, e-mail.

Making Contact & Terms Send query letter with résumé, business card, brochure, flier or tearsheets to be kept on file for possible future assignments. Material cannot be returned. Previously published work OK. Pays on publication.

Tips Especially interested in good photography of all ages of student population. All images must have model/property releases.

$ $ SCIENTIFIC AMERICAN

75 Varick St., 9th Floor, New York NY 10013-1917. (212)451-8200. E-mail: eharrison@ sciam.com. Website: www.sciam.com. **Contact:** Emily Harrison, photography editor. Circ. one million. Estab. 1854. Emphasizes science, policy, technology and people involved in science. Seeking to broaden our 20-40 year-old readership.

Needs Buys 100 photos from freelancers/issue. Needs all kinds of photos. Model release required; property release preferred. Photo captions required.

Making Contact & Terms Arrange a personal interview to show portfolio. "Do not send unsolicited photos." Provide résumé, business card, brochure, flier or tearsheets to be kept on file for possible future assignments and note photo Website. Cannot return material. Responds in 1 month. Pays $600/day; $1,000 for color cover. Pays on publication. Credit line given. Buys one-time rights and world rights. Frequently leads to re-use buying and develops relationships with scientists and writers needing photo work.

Tips Wants to see strong natural and artificial lighting, location portraits and location shooting. Intelligent artistic photography and photo-illustration welcomed. Send business cards and promotional pieces frequently when dealing with magazine editors. Find a niche.

▣ Ⓐ $ $ ⊘ SEATTLE HOMES AND LIFESTYLES

Network Communications, Inc., 1221 E. Pike St., Suite 305, Seattle WA 98122. (206)322-6699. Fax: (206)322-2799. E-mail: swilliams@seattlehomesmag.com. Website: www. seattlehomesmag.com. **Contact:** Shawn Williams, art director. Circ. 30,000. Estab. 1996. Magazine published 10 times/year. Emphasizes interior home design, gardens, architecture, lifestyles (food, wine, entertaining). Sample copy available for $3.95 and SAE.

Needs All work is commissioned specifically for magazine. Buys 35-50 photos from freelancers/issue; 200 photos/year. Needs photos of architecture, interior design, gardens, food, wine, entertaining. All work is commissioned specifically for magazine. Model release required. Photo captions required. "Do not send photos without querying first."

Specs Accepts images in digital format.

Making Contact & Terms No phone calls please. Send query letter with résumé, photocopies, tearsheets. Provide self-promotion piece to be kept on file for possible future assignments.

Responds only if interested; send nonreturnable samples. Payment varies by assignment, $140-900, depending on number of photos and complexity of project. **Pays on acceptance**. Credit line given. Buys exclusive, first rights for one year; includes Web usage.

Tips "Assignments contracted to experienced architectural and interior photographers for home-design and garden features. Photographers must be in Seattle area."

■ $ ☑ SHARING THE VICTORY

Fellowship of Christian Athletes, 8701 Leeds Rd., Kansas City MO 64129. (816)921-0909. Fax: (816)921-8755. E-mail: stv@fca.org. Website: www.sharingthevictory.com. **Contact:** Jill Ewert, managing editor. Circ. 80,000. Estab. 1982. Monthly association magazine featuring stories and testimonials of prominent athletes and coaches in sports who proclaim a relationship with Jesus Christ. Sample copy available for $1 and 9 × 12 SAE. No photo guidelines available.

Needs Needs photos of sports. "We buy photos of persons being featured in our magazine. We don't buy photos without story being suggested first." Reviews photos with accompanying manuscript only. "All submitted stories must be connected to the FCA Ministry." Model release preferred; property release required. Photo captions preferred.

Specs Uses glossy or matte color prints; 35mm, 2¼ × 2¼ transparencies. Accepts images in digital format. Send via CD, Zip, e-mail as TIFF, JPEG files at 300 dpi.

Making Contact & Terms Contact through e-mail with a list of types of sports photographs in stock. Do not send samples. Simultaneous submissions OK. Pays $150 maximum for color cover; $100 maximum for color inside. Pays on publication. Credit line given. Buys one-time rights.

Tips "We would like to increase our supply of photographers who can do contract work."

■ ☑ SHOTS

P.O. Box 27755, Minneapolis MN 55427-0755. E-mail: shotsmag@juno.com. Website: www.shotsmag.com. **Contact:** Russell Joslin, editor/publisher. Circ. 2,000. Quarterly fine art photography magazine. "We publish black-and-white fine art photography by photographers with an innate passion for personal, creative work." Sample copy available for $6. Photo guidelines free with SASE or on Website.

Needs Fine art photography of all types accepted for consideration (but not bought). Reviews photos with or without a manuscript. Model/property release preferred. Photo captions preferred.

Specs Uses 8 × 10 b&w prints. Accepts images in digital format. Send via CD as TIFF files at 300 dpi. "See website for further specifications."

Making Contact & Terms Send query letter with prints. There is a **$15 submission fee for nonsubscribers** (free for subscribers). Include SASE for return of material. Responds in 3 months. Credit line given. Does not buy photographs/rights.

ℕ ■ ◯ SKIPPING STONES

P.O. Box 3939, Eugene OR 97403. (541)342-4956. E-mail: editor@SkippingStone s.org. Website: www.skippingstones.org. **Contact:** Arun N. Toké, managing editor. Circ. 2,000 and electronic readership. Estab. 1988. Nonprofit, noncommercial magazine published 5 times/year. Emphasizes multicultural and ecological issues. Readers are youth ages 8-16,

their parents and teachers, schools and libraries. Sample copy available for $6 (including postage). Photo guidelines free with SASE.

Needs Buys 10-15 photos from freelancers/issue; 50 photos/year. Needs photos of nature (animals, wildlife), children and youth, cultural celebrations, international travel, school/home life in other countries or cultures. Model release preferred. Photo captions preferred; include site, year, names of people in photo.

Specs Uses 4 × 6, 5 × 7 glossy color and/or b&w prints. Accepts images in digital format. Send via CD as TIFF, JPEG files at 300 dpi or e-mail low-res files of photos for preview.

Making Contact & Terms Send unsolicited photos by mail for consideration. Keeps samples on file; include SASE for return of material. Responds in 4 months. Simultaneous submissions OK. Pays in contributor's copies; "we're a labor of love." For photo essays, "we provide 5-10 copies to contributors. Additional copies at a 25% discount." Credit line given. Buys first North American serial rights and nonexclusive reprint rights; negotiable.

Tips "We publish black & white inside; color on cover. Should you send color photos, choose the ones with good contrast that can translate well into black & white photos. We are seeking meaningful, humanistic and realistic photographs."

⊘ SMITHSONIAN

MRC 513, P.O. Box 37012, Washington DC 20013-7012. (202)633-6090. Fax: (202)633-6095. Website: www.smithsonianmagazine.com. **Contact:** Jeff Campagna, art department administrator. Monthly magazine. Smithsonian chronicles the arts, environment, sciences and popular culture of the times for today's well-rounded individuals with diverse, general interests, providing its readers with information and knowledge in an entertaining way. Visit website for photo submission guidelines. Does not accept unsolicited photos or portfolios. Call or query before submitting.

▣ SOUTHCOMM PUBLISHING COMPANY, INC.

310 Paper Trail Way, Suite 108, Canton GA 30115. (678)624-1075. Fax: (678)624-1079. E-mail: cwwalker@southcomm.com. Website: www.southcomm.com. **Contact:** Carolyn Williams-Walker, managing editor. Estab. 1985. "We publish approximately 35 publications throughout the year. They are primarily for chambers of commerce throughout the Southeast (Georgia, Tennessee, South Carolina, North Carolina, Alabama, Virginia, Florida). We are expanding to the Northeast (Pennsylvania) and Texas. Our publications are used for tourism, economic development and marketing purposes. We also are a custom publishing company, offering brochures and other types of printed material."

Needs "We are only looking for photographers who can travel to the communities with which we're working as we need shots that are specific to those locations. We will not consider generic stock-type photos. Images are generally for editorial purposes; however, advertising shots sometimes are required." Model/property release preferred. Photo captions required. "Identify people, buildings and as many specifics as possible."

Specs Prefers images in digital format. Send via CD, saved as TIFF, GIF or JPEG files for Mac at no less than 300 dpi. Uses matte color prints. "We prefer digital photography for all our publications."

Making Contact & Terms Send query letter with résumé and photocopies. Keeps samples on file; provide résumé, business card. Responds only if interested; send nonreturnable

samples. Pays $40 minimum; $60 maximum for color inside. "Payment per photo varies per project. However, rates are mainly toward the minimum end of the range. We pay the same rates for cover images as for interior shots because, at times, images identified for the cover cannot be used as such. They are then used in the interior instead." **Pays on acceptance**. Credit line given. "Photos that are shot on assignment become the property of SouthComm Publishing Company, Inc. They cannot be released to our clients or another third party. We will purchase one-time rights to use images from photographers should the need arise." Will negotiate with a photographer unwilling to sell all rights.

Tips "We are looking for photographers who enjoy traveling and are highly organized and can communicate well with our clients as well as with us. Digital photographers *must* turn in contact sheets of all images shot in the community, clearly identifying the subjects."

▣ ⑤ $ $ SOUTHERN BOATING

Southern Boating & Yachting, Inc., 330 N. Andrews Ave., Ft. Lauderdale FL 33301. (954)522-5515. Fax: (954)522-2260. E-mail: marilyn@southernboating.com. Website: www.southernboating.com. **Contact:** Marilyn Mower, editor. Circ. 40,000. Estab. 1972. Monthly magazine. Emphasizes "powerboating, sailing, and cruising in the southeastern and Gulf Coast U.S., Bahamas and the Caribbean." Readers are "concentrated in 30-60 age group, mostly male, affluent, very experienced boat owners." Sample copy available for $7.

Needs Number of photos/issue varies; many supplied by freelancers. Seeks "boating lifestyle" cover shots. Buys stock only. No "assigned covers." Model release required. Photo captions required.

Specs Accepts images in digital format. Send via CD or e-mail as JPEG, TIFF files, minimum 4 × 6 in. at 300 dpi.

Making Contact & Terms Send query letter with list of stock photo subjects, SASE. Response time varies. Simultaneous submissions and previously published work OK. Pays $300 minimum for color cover; $70 minimum for color inside; photo/text package negotiable. Pays within 30 days of publication. Credit line given. Buys one-time print and electronic/website rights.

Tips "We want lifestyle shots of saltwater cruising, fishing or just relaxing on the water. Lifestyle or family boating shots shots are actively sought."

Ⓝ ▣ $ SPORTSCAR

16842 Von Karman Ave., Suite 125, Irvine CA 92606. (949)417-6700. Fax: (949)417-6116. E-mail: sportscar@haymarketworldwide.com. Website: www.sportscarmag.com. **Contact:** Philip Royle, editor. Circ. 50,000. Estab. 1944. Monthly magazine of the Sports Car Club of America. Emphasizes sports car racing and competition activities. Sample copy available for $4.99.

Needs Uses 75-100 photos/issue; 75% from assignment and 25% from freelance stock. Needs action photos from competitive events, personality portraits and technical photos.

Making Contact & Terms Prefers electronic submissions on CD with query letter. Provide résumé, business card, brochure or flier to be kept on file for possible future assignments. Responds in 1 month. Simultaneous submissions OK. Pays $250-400 for color cover; $25-100 for color inside; negotiates all other rates. Pays on publication. Credit line given.

Tips To break in with this or any magazine, "always send only your absolute best work; try

to accommodate the specific needs of your clients. Have a relevant subject, strong action, crystal-sharp focus, proper contrast and exposure. We need good candid personality photos of key competitors and officials."

🖥 $ ▢ STICKMAN REVIEW

721 Oakwater Lane, Port Orange, FL 32128. (386)756-1795. E-mail: art@stickmanreview. com. Website: www.stickmanreview.com. **Contact:** Anthony Brown, editor. Estab. 2001. Biannual literary magazine publishing fiction, poetry, essays and art for a literary audience. Sample copies available on website.

Needs Buys 1-2 photos from freelancers/issue; 4 photos/year. Interested in alternative process, avant garde, documentary, erotic, fine art. Reviews photos with or without a manuscript.

Specs Accepts images in digital format. Send via e-mail as JPEG, GIF, TIFF, PS D files at 72 dpi (500K maximum).

Making Contact & Terms Contact through e-mail only. Does not keep samples on file; cannot return material. Do not query, just submit the work you would like considered. Responds 2 months to portfolios. Simultaneous submissions OK. Pays $25-50. **Pays on acceptance.** Credit line given. Buys electronic rights.

Tips "Please check out the magazine on our website. We are open to anything, so long as its intent is artistic expression."

🖥 $ SUB-TERRAIN MAGAZINE

P.O. Box 3008, MPO, Vancouver BC V6B 3X5 Canada. (604)876-8710. Fax: (604)879-2667. E-mail: subter@portal.ca. Website: www.subterrain.ca. **Contact:** Brian Kaufman, editor-in-chief. Estab. 1988. Literary magazine published 3 times/year.

Needs Uses "many" unsolicited photos. Needs "artistic" photos. Photo captions preferred.

Specs Uses color and/or b&w prints.

Making Contact & Terms Submit portfolio for review. Send unsolicited photos by mail for consideration. Keeps samples on file "sometimes." Responds in 6 months. Simultaneous submissions OK. Pays $25-100/photo. Also pays in contributor's copies. Pays on publication. Credit line given. Buys one-time rights.

🖥 $ ◨ THE SUN

107 N. Roberson St., Chapel Hill NC 27516. (919)942-5282. Fax: (919)932-3101. Website: www.thesunmagazine.org. **Contact:** Art Director. Circ. 70,000. Estab. 1974. Monthly literary magazine featuring personal essays, interviews, poems, short stories, photos and photo essays. Sample copy available for $5. Photo guidelines free with SASE or on website.

Needs Buys 10-30 photos/issue; 200-300 photos/year. Needs " slice of life" photographs of people and environments. "We also need photographs that relate to political, spiritual, and social themes. We consider documentary-style images. Most of our photos of people feature unrecognizable individuals, although we do run portraits in specific places, including the cover." Model/property release strongly preferred.

Specs Uses 4 × 5 to 11 × 17 glossy or matte b&w prints. Slides are not accepted, and color photos are discouraged. "We cannot review images via e-mail or website. If you are submitting digital images, please send high-quality digital prints first. If we accept your

images for publication, we will request the image files on CD or DVD media (Mac or PC) in uncompressed TIFF grayscale format at 300 dpi or greater."

Making Contact & Terms Send query letter with prints. Portfolio may be dropped off Monday-Friday. Does not keep samples on file; include SASE for return of material. Responds in 3 months. Simultaneous submissions and previously published work OK. "Submit no more than 30 of your best b&w prints. Please do not e-mail images." Pays $500 for b&w cover; $100-300 for b&w inside. Pays on publication. Credit line given. Buys one-time rights.

Tips "We're looking for artful and sensitive photographs that aren't overly sentimental. We're open to unusual work. Read the magazine to get a sense of what we're about. Send the best possible prints of your work. Our submission rate is extremely high; please be patient after sending us your work. Send return postage and secure return packaging."

▣ Ⓐ ◯ TENNIS WEEK

304 Park Avenue South, 8th Fl., New York NY 10010. (914)967-4890. Fax: (914)967-8178. E-mail: tennisweek@tennisweek.com. Website: www.tennisweek.com. **Contact:** Kent Oswald, editor. Art Director: Terry Egusa. Circ. 110,000. Published 11 times/year. Readers are "tennis fanatics." Sample copy available for $4 (current issue) or $5 (back issue).

Needs Uses about 16 photos/issue. Needs photos of "off-court color, beach scenes with pros, social scenes with players, etc." Emphasizes originality. Subject identification required.

Specs Uses color prints. Accepts images in digital format. Send via CD, e-mail as EPS files at 300 dpi.

Making Contact & Terms Send actual 8 × 10 or 5 × 7 b&w photos by mail for consideration. Send portfolio via mail or CD-ROM. Responds in 2 weeks. Pays barter. Pays on publication. Rights purchased on a work-for-hire basis.

▣ $ TEXAS GARDENER MAGAZINE

P.O. Box 9005, 10566 North River Crossing, Waco TX 76714. (254)848-9393. Fax: (254)848-9779. E-mail: info@texasgardener.com. Website: www.texasgardener.com. **Contact:** Chris S. Corby, editor/publisher. Circ. 25,000. Bimonthly. Emphasizes gardening. Readers are "51% male, 49% female, home gardeners, 98% Texas residents." Sample copy available for $4.

Needs Buys 18-27 photos from freelancers/issue; 108-162 photos/year. Needs "color photos of gardening activities in Texas." Special needs include "cover photos shot in vertical format. Must be taken in Texas." Photo captions required.

Specs Prefers high-resolution digital images. Send via e-mail as JPEG files at 300 dpi.

Making Contact & Terms Send query letter with samples, SASE. Responds in 3 weeks. Pays $100-200 for color cover; $25-100 for color inside. Pays on publication. Credit line given. Buys one-time rights.

Tips "Provide complete information on photos. For example, if you submit a photo of watermelons growing in a garden, we need to know what variety they are and when and where the picture was taken."

▣ $ ◯ THEMA

THEMA Literary Society, P.O. Box 8747, Metairie LA 70011-8747. (504)940-7156. E-mail: thema@cox.net. Website: http://members.cox.net/thema. **Contact:** Virginia Howard,

manager/editor. Circ. 300. Estab. 1988. Literary magazine published 3 times/year emphasizing theme-related short stories, poetry and art. Sample copy available for $10.

Needs Photo must relate to one of *THEMA*'s upcoming themes (indicate the target theme on submission of photo). Upcoming themes (submission deadlines in parenthesis); The Trip Not Taken (March 1, 2010); About Two Miles Down the Road (July 1, 2010); One Thing Done Superbly (November 1, 2010). Reviews photos with or without a manuscript. Model/ property release preferred. Photo captions preferred.

Specs Uses 5 × 7 glossy color and/or b&w prints. Accepts images in digital format. Send via Zip as TIFF files at 200 dpi.

Making Contact & Terms Send query letter with prints, photocopies. Does not keep samples on file; include SASE for return of material. Responds in 1 week to queries; 3 months to portfolios. Simultaneous submissions and previously published work OK. Pays $25 for cover; $10 for b&w inside. **Pays on acceptance.** Credit line given. Buys one-time rights.

Tips "Submit only work that relates to one of *THEMA*'s upcoming themes. Contact by snail mail preferred."

▣ $ TIKKUN

2342 Shattack Ave., #1200, Berkeley CA 94704. (510)644-1200. Fax: (510)644-1255. E-mail: magazine@tikkun.org. Website: www.tikkun.org. **Contact:** Dave Belden, managing editor. Circ. 25,000. Estab. 1986. "A bimonthly Jewish and interfaith critique of politics, culture and society." Readers are 60% Jewish, professional, middle-class, literary people ages 30-60.

Needs Uses 15 photos/issue; 30% supplied by freelancers. Needs political, social commentary; Middle East and U.S. photos. Reviews photos with or without a manuscript.

Specs Uses b&w and color prints. Accepts images in digital format for Mac (Photoshop EPS). Send via CD.

Making Contact & Terms Send prints or good photocopies. Keeps samples on file; include SASE for return of material. Response time varies. "Turnaround is 4 months, unless artist specifies other." Previously published work OK. Pays $50 for b&w inside. Pays on publication. Credit line given. Buys all rights; negotiable.

Tips "Look at our magazine and suggest how your photos can enhance our articles and subject material. Send samples."

⊕ ▣ $ ◖ TIMES OF THE ISLANDS

Times Publications Ltd., Lucille Lightbourne Building #7, Box 234, Providenciales, Turks & Caicos Islands, British West Indies. (649)946-4788. E-mail: timespub@tciway.tc. Website: www.timespub.tc. **Contact:** Kathy Borsuk, editor. Circ. 14,000. Estab. 1988. Quarterly magazine focusing on in-depth topics specifically related to Turks & Caicos Islands. Targeted beyond mass tourists to homeowners/investors/developers and others with strong interest in learning about these islands. Sample copy available for $6. Photo guidelines available on website.

Needs Buys 5 photos from freelancers/issue; 20 photos/year. Needs photos of environmental, landscapes/scenics, wildlife, architecture, adventure, travel. Interested in historical/vintage. Also scuba diving, islands in TCI beyond main island of Providenciales. Reviews photos with or without a manuscript. Photo captions required; include specific location, names of any people.

Specs Prefers images in high resolution digital format. Send via CD or e-mail as JPEG files.

Making Contact & Terms Send query e-mail with photo samples. Provide business card, self-promotion piece to be kept on file for possible future assignments. Responds in 6 weeks to queries. Simultaneous submissions and previously published work OK. Pays $100-300 for color cover; $50-100 for inside. Pays on publication. Credit line given. Buys one-time rights; negotiable.

Tips "Make sure photo is specific to Turks & Caicos and location/subject accurately identified."

⊕ ▣ Ⓐ $ ☑ TOTAL 911

Imagine Publishing Limited, Richmand House, 33 Richmond Hill, Bournemouth Dorset BH2 6EZ United Kingdom. +44 0845 450 6964. E-mail: phil.raby@imagine-publishing. co.uk. Website: www.total911.com. **Contact:** Philip Raby, publishing editor. Estab. 2005. Monthly consumer magazine. "A high-quality magazine for enthusiasts of the Porsche 911 in all its forms. Sold all around the world." Request photo guidelines via e-mail.

Needs Needs professional car photographers only.

Specs High quality digital.

Making Contact & Terms E-mail query letter with link to photographer's Website. Commissioned work only with purchase order and contract. **Payment sent 30 days after invoice**.

Tips "Do not contact us unless you are a professional photographer who can produce outstanding work using top-quality digital equipment. Especially keen to contact good photographers in the United States."

▣ $ ☑ TRACK & FIELD NEWS

2570 El Camino Real, Suite 606, Mountain View CA 94040. (650)948-8188. Fax: (650)948-9445. E-mail: editorial@trackandfieldnews.com. Website: www.trackandfieldnews.com. **Contact:** Jon Hendershott, associate editor (features/photography). Circ. 25,000. Estab. 1948. Monthly magazine. Emphasizes national and world-class track and field competition and participants at those levels for athletes, coaches, administrators and fans. Sample copy free with 9 × 12 SASE. Photo guidelines free.

Needs Buys 10-15 photos from freelancers/issue; 120-180 photos/year. Wants, on a regular basis, photos of national-class athletes, men and women, preferably in action. "We are always looking for quality pictures of track and field action, as well as offbeat and different feature photos. We always prefer to hear from a photographer before he/she covers a specific meet. We also welcome shots from road and cross-country races for both men and women. Any photos may eventually be used to illustrate news stories in *T&FN*, feature stories in *T&FN*, or may be used in our other publications (books, technical journals, etc.). Any such editorial use will be paid for, regardless of whether material is used directly in *T&FN*. About all we don't want to see are pictures taken with someone's Instamatic. No shots of someone's child or grandparent running. Professional work only." Photo captions required; include subject name, meet date/name.

Specs Images must be in digital format. Send via CD, e-mail; all files at 300 dpi.

Making Contact & Terms Send query letter with samples, SASE. Responds in 10-14 days. Pays $225 for color cover; $25 for b&w inside (rarely used); $50 for color inside ($100). Payment is made monthly. Credit line given. Buys one-time rights.

Tips "No photographer is going to get rich via *T&FN*. We can offer a credit line, nominal payment and, in some cases, credentials to major track and field meets. Also, we can offer the chance for competent photographers to shoot major competitions and competitors up close, as well as being the most highly regarded publication in the track world as a forum to display a photographer's talents."

Ⓝ ▣ $$ ⊘ TRAILER BOATS MAGAZINE

Affinity Group, Inc., 20700 Belshaw Ave., Carson CA 90746. (310)537-6322. Fax: (310)537-8735. Website: www.trailerboats.com. **Contact:** Jim Hendricks, editor. Circ. 90,000. Estab. 1971. Distributed 9 times/year. "We are the only magazine devoted exclusively to trailerable boats and related activities" for owners and prospective owners. Sample copy available for $1.25.

Needs Uses 15 photos/issue; 95-100% of freelance photography comes from assignment, 0-5% from stock. Needs how-to trailerable boat, travel (with manuscript). For accompanying manuscripts, needs articles related to trailer boat activities. Photos purchased with or without accompanying manuscript. "Photos must relate to trailer boat activities. No long list of stock photos or subject matter not related to editorial content." Photo captions preferred; include location of travel pictures.

Specs Accepts images in digital format. Send as JPEG files at 300 dpi.

Making Contact & Terms Query or send photos or contact sheet by mail with SASE for consideration. Responds in 1 month. Pays per text/photo package or on a per-photo basis. Pays $500 for cover; $25-200 for color inside. **Pays on acceptance.** Credit line given.

Tips "Shoot with imagination and a variety of angles. Don't be afraid to 'set up' a photo that looks natural. Think in terms of complete feature stories: photos and manuscripts.

Ⓝ ▣ $ ⊘ TRAVELWORLD INTERNATIONAL MAGAZINE

NATJA, 3579 E. Foothill Blvd. #744, Pasadena CA 91107. (626)376-9754. Fax: (626)628-1854. E-mail: info@natja.org. Website: www.natja.org and www.travelworldmagazine.com. **Contact:** Helen Hernandez, CEO. Circ. 75,000 unique visitors. Estab. 1992. Quarterly online magazine of the North American Travel Journalists Association (NATJA). Emphasizes travel, food, wine, and hospitality industries.

Needs Uses photos of food/drink, travel.

Specs Uses color and/or b&w. Prefers images in digital format.

Making Contact & Terms Send query via e-mail.

▣ $$ ◻ TRICYCLE: The Buddhist Review

The Buddhist Ray, Inc., 92 Vandam St., New York NY 10013. (212)645-1143. Fax: (212)645-1493. E-mail: editorial@tricycle.com. Website: www.tricycle.com. **Contact:** Alexandra Kaloyanides, senior editor. Circ. 60,000. Estab. 1991. Quarterly nonprofit magazine devoted to the exploration of Buddhism, literature and the arts.

Needs Buys 10 photos from freelancers/issue; 40 photos/year. Reviews photos with or without a m anus cript. Model/property release preferred. Photo captions preferred.

Specs Uses glossy b&w and color prints; 35mm transparencies. Accepts images in digital format. Send via CD, Zip, e-mail as TIFF, EPS, BMP, GIF, JPEG files at 300 dpi.

Making Contact & Terms "We prefer to receive copies or CDs of photographs or art, rather than originals, in both color and black and white. For the safety of your own work, please do not send anything which you would fear losing, as we cannot assume responsibility for the loss of unsolicited artwork. If you would like to receive a reply from us and wish your work returned, you must include a self-addressed stamped envelope with sufficient postage."

Tips "Read the magazine to get a sense of the kind of work we publish. We don't only use Buddhist art; we select artwork depending on the content of the piece."

N ▣ $ $ TURKEY COUNTRY

P.O. Box 530 (parcel services: 770 Augusta Rd.), Edgefield SC 29824. (803)637-3106. Fax: (803)637-0034. E-mail: turkeycall@nwtf.net. Website: www.nwtf.org. **Contact:** Burt Carey, editor. Photo Editor: Matt Lindler. Circ. 200,000. Estab. 2009. Bimonthly magazine for members of the National Wild Turkey Federation—people interested in conserving the American wild turkey. Sample copy available for $5 with 9 × 12 SASE. Photo guidelines free with SASE or on Website.

Needs Buys at least 100 photos/year. Needs photos of "wildlife, including wild turkeys, upland birds, North American Big Game; wild turkey hunting; wild turkey management techniques (planting food, trapping for relocation, releasing); wild turkey habitat; families, women, children and people with disabilities hunting or enjoying the outdoors." Photo captions required.

Specs Prefers images in digital format from 6mp or higher resolution cameras. Send via CD/DVD at 300 ppi with thumbnail page (see guidelines for more details).

Making Contact & Terms Send copyrighted photos to editor for consideration; include SASE. Responds in 6 weeks. Pays $800 for cover; $400 maximum for color inside. Pays on publication. Credit line given. Buys one-time rights.

Tips Wants "no poorly posed or restaged shots, no mounted turkeys representing live birds, no domestic animals representing wild animals. Photos of dead animals in a tasteful hunt setting are considered. Contributors must agree to the guidelines before submitting."

◖ TV GUIDE

11 West 42nd St., New York NY 10036. (212)852-7323. Website: www.tvguide.com. **Contact:** Photo Editor. TV Guide watches television with an eye for how TV programming affects and reflects society. It looks at the shows and the stars, and covers the medium's impact on news, sports, politics, literature, the arts, science and social issues through reports, profiles, features and commentaries.

Making Contact & Terms Works only with celebrity freelance photographers. "Photos are for one-time publication use. Mail self-promo cards to photo editor at above address. No calls, please."

N ▣ S ◯ UP AND UNDER

P.O. Box 115, Hainesport NJ 08036. E-mail: qndpoets@yahoo.com. Website: www. quickanddirtypoets.com. **Contact:** Kendall A. Bell, co-editor. Circ. 100. Estab. 2005. Annual

literary magazine. "A literary journal with an eclectic mix of poetry: sex, death, politics, IKEA, Mars, food and jug handles, alongside a smorgasbord of other topics covered in such diverse forms as the sonnet, villanelle, haiku and free verse." Sample copy available for $7 and SAE.

Needs Acquires 8 photos from freelancers/issue; 8 photos/year. Interested in architecture, cities/urban, rural, landscapes/scenics, avant garde, fine art, historical/vintage. Reviews photos with or without a manuscript.

Specs Uses 8 × 10 or smaller b&w prints. Accepts digital images in Windows format. Send via e-mail as GIF or JPEG files.

Making Contact & Terms Send query letter with prints. Does not keep samples on file; include SASE for return of material. Responds in 2-3 months to queries. Simultaneous submissions OK. Pays 1 copy on publication. Credit line sometimes given, depending on space allowance in the journal. Acquires one-time rights.

Tips "This is predominantly a poetry journal, and we choose photographs to complement the poems, so we prefer unusual, artistic images whether they are landscapes, buildings or art. Include a short (3- to 5-line) bio."

⊘ VANITY FAIR

Condé Nast Building, 4 Times Square, New York NY 10036. (212)286-2860. Fax: (212)286-7787 or (212)286-6787. Website: www.vanityfair.com. **Contact:** Susan White, photography director. Monthly magazine.

Needs Freelancers supply 50% of photos. Needs portraits. Model/property release required for everyone. Photo captions required for photographer, styles, hair, makeup, etc.

Making Contact & Terms Contact through rep or submit portfolio for review. Provide résumé, business card, brochure, flier or tearsheets to be kept on file for possible future assignments. Responds in 2 weeks. Payment negotiable. Pays on publication.

Tips "We solicit material after a portfolio drop. So, really we don't want unsolicited material."

▣ WASHINGTON TRAILS

2019 3rd Ave., Suite 100, Seattle WA 98121-2430. (206)625-1367. E-mail: editor@wta.org. Website: www.wta.org. **Contact:** Andrew Engelson, editor. Circ. 7,000. Estab. 1966. Magazine of the Washington Trails Association, published 6 times/year. Emphasizes "backpacking, hiking, cross-country skiing, all nonmotorized trail use, outdoor equipment and minimum-impact camping techniques." Readers are "people active in outdoor activities, primarily backpacking; residents of the Pacific Northwest, mostly Washington; age group: 9-90; family-oriented; interested in wilderness preservation, trail maintenance." Photo guidelines free with SASE or on website.

Needs Uses 10-15 photos from volunteers/issue; 100-150 photos/year. Needs "wilderness/scenic; people involved in hiking, backpacking, skiing, wildlife; outdoor equipment photos, all with Pacific Northwest emphasis." Photo captions required.

Making Contact & Terms Send JPEGs by e-mail, or 5 × 7 or 8 × 10 glossy b&w prints by mail for consideration; include SASE for return of material. Responds in 1-2 months. Simultaneous submissions and previously published work OK. No payment for photos. A 1-year subscription offered for use of color cover shot. Credit line given.

Tips "Photos must have a Pacific Northwest slant. Photos that meet our cover specifications are always of interest to us. Familiarity with our magazine will greatly aid the photographer in submitting material to us. Contributing to *Washington Trails* won't help pay your bills, but sharing your photos with other backpackers and skiers has its own rewards."

$ $ WATERSKI

World Publications, LLC, 460 N. Orlando Ave., Suite 200, Winter Park FL 32789. (407)628-4802. Fax: (407)628-7061. E-mail: bill.doster@worldpub.net. Website: www.waterskimag.com. **Contact**: Bill Doster, photo editor. Circ. 105,000. Estab. 1978. Published 8 times/year. Emphasizes water skiing instruction, lifestyle, competition, travel. Readers are 36-year-old males, average household income $65,000. Sample copy available for $2.95. Photo guidelines free with SASE.

Needs Buys 20 photos from freelancers/issue; 160 photos/year. Needs photos of instruction, travel, personality. Model/property release preferred. Photo captions preferred; include person, trick described.

Making Contact & Terms Query with good samples, SASE. Keeps samples on file. Responds within 2 months. Pays $200-500/day; $500 for color cover; $50-75 for b&w inside; $75-300 for color inside; $150/color page rate; $50-75/b&w page rate. Pays on publication. Credit line given. Buys first North American serial rights.

Tips "Clean, clear, tight images. Plenty of vibrant action, colorful travel scenics and personality. Must be able to shoot action photography. Looking for photographers in other geographic regions for diverse coverage."

☒ ▣ $ ◯ WAVELENGTH MAGAZINE

2101 Cinnabar Dr., Nanaimo, BC V9X 1B3 Canada. (250)244-6437. E-mail: info@wavelengthmagazine.com. Website: www.wavelengthmagazine.com. **Contact**: John Kimantas, editor. Circ. 20,000. Estab. 1991. Quarterly magazine. Emphasizes safe, ecologically sensitive paddling. For sample copy, see downloadable PDF version on Website.

Needs Buys 10 photos from freelancers/issue ("usually only from authors"); 60 photos/year. Needs kayaking shots. Photos should have sea kayak in them. Reviews photos with or without a manuscript. Model/property release preferred. Photo captions preferred.

Specs Prefers digital submissions, but only after query. Send as low-res for assessment.

Making Contact & Terms Send query letter. Provide business card or self-promotion piece to be kept on file for possible future assignments. Responds in 2 months to queries. Absolutely no simultaneous submissions or previously published work accepted. Pays $100-200 for color cover; $25-50 for inside. Pays on publication. Credit line given. Buys one-time print rights including electronic archive rights.

Tips "Look at free downloadable version on website and include kayak in picture wherever possible. Always need vertical shots for cover!"

▣ $ $ WINE & SPIRITS

2 W. 32nd St., Suite 601, New York NY 10001. (212)695-4660, ext. 15. Fax: (212)695-2920. E-mail: info@wineandspiritsmagazine.com. Website: www.wineandspiritsmagazine.com. **Contact**: Elena Bessarabova, art director. Circ. 70,000. Estab. 1982. Bimonthly magazine. Emphasizes wine. Readers are male, ages 39-60, married, parents, $70,000-plus income,

wine consumers. Sample copy available for $4.95; Special issues are $4.95-6.50 each.

Needs Buys 0-30 photos from freelancers/issue; 0-180 photos/year. Needs photos of food, wine, travel, people. Photo captions preferred; include date, location.

Specs Accepts images in digital format. Send via SyQuest, Zip at 300 dpi.

Making Contact & Terms Submit portfolio for review. Provide résumé, business card, brochure, flier or tearsheets to be kept on file for possible future assignments. Responds in 2 weeks, if interested. Simultaneous submissions OK. Pays $200-1,000/job. Pays on publication. Credit line given. Buys one-time rights.

Ⓝ ▣ $ WISCONSIN SNOWMOBILE NEWS

P.O. Box 182, Rio WI 53960-0182. (920)992-6370. Fax: (920)992-6369. E-mail: wisnow@centurytel.net. **Contact:** Cathy Hanson, editor. Circ. 30,000. Estab. 1969. Magazine published 7 times/year. Official publication of the Association of Wisconsin Snowmobile Clubs. Emphasizes snowmobiling. Sample copy free with 9 × 12 SAE and 5 first-class stamps.

Needs Buys very few stand-alone photos from freelancers. "Most photos are purchased in conjunction with a story (photo/text) package. Photos need to be Midwest region only!" Needs photos of family-oriented snowmobile action, posed snowmobiles, travel. Model/property release preferred. Photo captions preferred; include where, what, when.

Specs Uses 8 × 10 glossy color and/or b&w prints; 35mm, 2¼ × 2¼, 4 × 5, 8 × 10 transparencies. Digital files accepted at 300 dpi.

Making Contact & Terms Submit portfolio for review. Send unsolicited photos by mail for consideration; include SASE for return of material. Provide résumé, business card, brochure, flier or tearsheets to be kept on file for possible future assignments. Responds in 2 weeks. Simultaneous submissions and previously published work OK. Pays $10-50 for color photos. Pays on publication. Credit line given. Buys one-time rights, all rights; negotiable.

▣ $ $ ▣ WRITER'S DIGEST

F + W Media, Inc., 4700 E. Galbraith Rd., Cincinnati OH 45236. (513)531-2690, ext. 11573. Fax: (513)891-7153. E-mail: kathy.dezarn@fwmedia.com. Website: www.writersdigest.com. **Contact:** Jessica Boonstra, art director. Editor: Jessica Strawser. Circ. 120,000. Estab. 1920. Monthly consumer magazine. "Our readers write fiction, nonfiction, plays and scripts. They're interested in improving their writing skills and the ability to sell their work, and finding new outlets for their talents." Photo guidelines free with SASE or via e-mail.

Needs Occasionally buys photos from freelancers. Needs photos of education, hobbies, writing life, business concepts, product shots/still life. Other specific photo needs: photographers to shoot authors on location for magazine cover. Model/property release required. Photo captions required; include your copyright notice.

Specs Uses 8x10 color and/or digital (resizable) images. Accepts images in digital format if hired. Send via CD as TIFF, EPS, JPEG files at 300 dpi (at hire).

Making Contact & Terms Provide business card, self-promotion piece to be kept on file for possible future assignments. Keeps samples on file. Responds only if interested; send nonreturnable samples. Pays $0-1,000 for color cover; $0-600 for color inside. Pays when billed/invoiced. Credit line given. Buys one-time rights.

Tips "Please don't submit/re-submit frequently. We keep samples on file and will contact you if interested. Submissions are considered for other Writer's Digest publications as well.

For stock photography, please include pricing/sizes of black & white usage if available."

◫ $ YOUTH RUNNER MAGAZINE

P.O. Box 1156, Lake Oswego OR 97035. (503)236-2524. E-mail: dank@youthrunner.com. Website: www.youthrunner.com. **Contact:** Dan Kesterson, editor. Circ. 100,000. Estab. 1996. Ten issues per year. Features track, cross country and road racing for young athletes, ages 8-18. Photo guidelines available on Website.

Needs Uses 30-50 photos/issue. Also uses photos on website daily. Needs action shots from track, cross country and indoor meets. Model release preferred; property release required. Photo captions preferred.

Specs Accepts images in digital format only. Send via e-mail or CD.

Making Contact & Terms Send low-res photos via e-mail first or link to gallery for consideration. Responds to e-mail submissions immediately. Simultaneous submissions OK. Pays $25 minimum. Credit line given. Buys electronic rights, all rights.

Newspapers & Newsletters

When working with newspapers, always remember that time is of the essence. Newspapers have various deadlines for each of their sections. An interesting feature or news photo has a better chance of getting in the next edition if the subject is timely and has local appeal. Most of the markets in this section are interested in regional coverage. Find publications near you and contact editors to get an understanding of their deadline schedules.

More and more newspapers are accepting submissions in digital format. In fact, most newspapers prefer digital images. However, if you submit to a newspaper that still uses film, ask the editors if they prefer certain types of film or if they want color slides or black & white prints. Many smaller newspapers do not have the capability to run color images, so black & white prints are preferred. However, color slides and prints can be converted to black & white. Editors who have the option of running color or black & white photos often prefer color film because of its versatility.

Although most newspapers rely on staff photographers, some hire freelancers as stringers for certain stories. Act professionally and build an editor's confidence in you by supplying innovative images. For example, don't get caught in the trap of shooting "grip-and-grin" photos when a corporation executive is handing over a check to a nonprofit organization. Turn the scene into an interesting portrait. Capture some spontaneous interaction between the recipient and the donor. By planning ahead you can be creative.

When you receive assignments, think about the image before you snap your first photo. If you are scheduled to meet someone at a specific location, arrive early and scout around. Find a proper setting or locate some props to use in the shoot. Do whatever you can to show the editor you are willing to make that extra effort.

Always try to retain resale rights to shots of major news events. High news value means high resale value, and strong news photos can be resold repeatedly. If you have an image with national appeal, search for larger markets, possibly through the wire services. You also may find buyers among national news magazines such as *Time* or *Newsweek*.

While most newspapers offer low payment for images, they are willing to negotiate if the image will have a major impact. Front-page artwork often sells newspapers, so don't underestimate the worth of your images.

$ ☑ ARCHAEOLOGY

2660 Petersborough St., Herndon VA 20171. E-mail: shannonaswriter@yahoo.com. Estab. 1998. Quarterly magazine. Photo guidelines available via e-mail.

Needs Buys 12 photos from freelancers/issue; 48-72 photos/year. Needs photos of disasters, environmental, landscapes/scenics, wildlife, architecture, cities/urban, education, gardening, interiors/decorating, pets, religious, rural, adventure, events, food/drink, sports, travel, agriculture, medicine, military, political, product shots/still life, science, technology—as related to archaeology. Interested in alternative process, avant garde, documentary, fashion/glamour, fine art, historical/vintage, seasonal. Wants photos of archaeology sites and excavations in progress that are available for children and teens to visit. "Would like photographs of artifacts and Paleobiology." Reviews photos with or without a manuscript. Model/property release preferred.

Specs Uses glossy or matte color and/or b&w prints.

Making Contact & Terms Send query letter via e-mail. "If possible, please do not include photographs in files if they are sent through e-mail. A CD with your photographs sent to *Archaeology* is acceptable." Provide résumé, business card or self-promotion piece to be kept on file for possible future assignments. "A CD with your photographs is requested but not required. Illustrations and artwork are also accepted." Responds within 1 month to queries; 1 week to portfolios. Simultaneous submissions and previously published work OK. **Pays on acceptance**. Credit line given. Buys one-time rights, first rights; negotiable.

▣ ⑤ $ CAPPER'S

1503 SW 42nd St., Topeka KS 66609-1265. (800)678-5779, ext. 4348. Fax:(800)274-4305. E-mail: cappers@cappers.com. Website: www.cappers.com. **Contact:** K.C. Compton, editor-in-chief. Circ. 200,000. Estab. 1879. Bimonthly magazine. Emphasizes small town life, country lifestyle, or "hobby" farm-oriented material. Readership is national. Sample copy available for $4.

Needs Buys 24 + photos/year with accompanying stories and articles; 90% from freelancers. Needs, on a regular basis, photos of small-farm livestock, animals, farm labor, gardening, produce and related images. "Be certain pictures are well composed, properly exposed and pin sharp. Must be *shot* at high resolution (no less than 300 dpi). No cheesecake. No pictures that cannot be shown to any member of the family. No pictures that are out of focus or over- or under-exposed. No ribbon-cutting, check-passing or hand-shaking pictures. Story subjects include all aspects of the hobby or country lifestyle farm, such as livestock, farm dogs, barn cats, sowing and hoeing, small tractors, fences, etc." Photo captions required. "Any image that stands alone must be accompanied by 50-100 words of meaningful caption information."

Specs Uses 35mm, slides and high-resolution digital images. Send digital images via CD, Zip as JPEG files at 300 dpi.

Making Contact & Terms Study the magazine. "We use a beautiful country scene for 'Reverie', the last page in each issue. Take a look at previous issues to get a sense of the sort of shot we're looking for." Send material by mail with SASE for consideration. Responds ASAP. Pay is negotiable up to $1,000 for color cover; $35-200 for color inside; $25-100 for b&w inside. Rarely uses b&w, and only if "irresistibly atmospheric." Pays on publication. Buys shared rights; negotiable.

Tips "This is a relaunch of an old title. You must study the new publication to make sure your submissions are appropriate to *Capper's* new direction."

N E A $ ○ CATHOLIC SENTINEL

P.O. Box 18030, Portland OR 97218. (503)281-1191. Fax: (503)460-5496. E-mail: sentinel@ocp.org. Website: www.sentinel.org. Circ. 8,000. Estab. 1870. Weekly newspaper. "We are the newspaper for the Catholic community in Oregon." Sample copies available for 9 × 12 SAE with $1.06 first-class postage. Photo guidelines available via e-mail.

Needs Buys 15 photos from freelancers/issue; 800 photos/year. Needs photos of religious and political subjects. Interested in seasonal. Model/property release preferred. Photo captions required; include names of people shown in photos, spelled correctly.

Specs Prefers images in digital format. Send via e-mail or FTP as TIFF or JPEG files at 300 dpi. Also uses 5 × 7 glossy or matte color and b&w prints; 35mm 2 × 2, 4 × 5, 8 × 10 transparencies.

Making Contact & Terms Send query letter with résumé and tearsheets. Portfolio may be dropped off every Thursday. Keeps samples on file. Responds only if interested; send nonreturnable samples. Simultaneous submissions and previously published work OK. Pays $60-75 for single shot; $90-125 for 5 shots; $150-200 for 12 shots. Pays on publication or on receipt of photographer's invoice. Credit line given. Buys first rights and electronic rights.

Tips "We use photos to illustrate editorial material, so all photography is on assignment. Basic knowledge of Catholic Church (e.g., don't climb on the altar) is a big plus. Send accurately spelled cutlines. Prefer images in digital format."

E A $ ○ FULTON COUNTY DAILY REPORT

Dept. PM, 190 Pryor St. SW, Atlanta GA 30303. (404)521-1227. Fax: (404)659-4739. E-mail: jbennitt@alm.com. Website: www.dailyreportonline.com. **Contact:** Jason R. Bennitt, art director. Daily newspaper (5 times/week). Emphasizes legal news and business. Readers are male and female professionals, age 25 +, involved in legal field, court system, legislature, etc. Sample copy available for $2 with 9¾ × 12¾ SAE and 6 first-class stamps.

Needs Buys 1-2 photos from freelancers/issue; 260-520 photos/year. Needs informal environmental photographs of lawyers, judges and others involved in legal news and business. Some real estate, etc. Photo captions preferred; include complete name of subject and date shot, along with other pertinent information. Two or more people should be identified from left to right.

Specs Accepts images in digital format. Send via CD or e-mail as JPEG files at 200-600 dpi.

Making Contact & Terms Submit portfolio for review. Mail or e-mail samples. Keeps samples on file. Simultaneous submissions and previously published work OK. "Freelance work generally done on an assignment-only basis." Pays $75-100 for color cover; $50-75 for color inside. Credit line given.

Tips Wants to see ability with "casual, environmental portraiture, people—especially in office settings, urban environment, courtrooms, etc.—and photojournalistic coverage of people in law or courtroom settings." In general, needs "competent, fast freelancers from time to time around the state of Georgia who can be called in at the last minute. We keep

a list of them for reference. Good work keeps you on the list." Recommends that "when shooting for *FCDR*, it's best to avoid law-book-type photos if possible, along with other overused legal clichés."

N $ $ NEW YORK TIMES MAGAZINE

620 Eighth Av., New York NY 10018. (212)556-7434. E-mail: magphoto@nytimes.com. **Contact:** Kathy Ryan, photo editor. Circ. 1.8 million. Weekly newspaper.

Needs Number of freelance photos purchased varies. Model release required. Photo captions required.

Making Contact & Terms "Please Fed Ex all submissions." Include SASE for return of material. Responds in 1 week. Pays $345 for full page; $260 for half page; $230 for quarter page; $400/job (day rates); $750 for color cover. **Pays on acceptance.** Credit line given. Buys one-time rights.

$ PITTSBURGH CITY PAPER

650 Smithfield St., Suite 2200, Pittsburgh PA 15222. (412)316-3342. Fax: (412)316-3388. E-mail: lcunning@steelcitymedia.com. Website: www.pghcitypaper.com. **Contact:** Lisa Cunningham, art director. Editor: Chris Potter. Circ. 80,000. Estab. 1991. Weekly tabloid. Emphasizes Pittsburgh arts, news, entertainment. Readers are active, educated adults, ages 29-54, with disposable incomes. Sample copy free with 12 × 15 SASE.

Needs Occasionally uses freelancers as needed. Most photography is digital. Model/ property release preferred. Photo captions preferred. "We can write actual captions, but we need all the pertinent facts." **Works with local photographers only.**

Making Contact & Terms Arrange a personal interview to show portfolio. Send query letter with résumé of credits. Provide résumé, business card, brochure, flier or tearsheets to be kept on file for possible future assignments. Does not keep samples on file; does not accept file photos. Include SASE for return of material. Responds in 2 weeks. Previously published work OK. Pays $25-125/job. Pays on publication. Credit line given.

Tips Provide "something beyond the sort of shots typically seen in daily newspapers. Consider the long-term value of exposing your work through publication. In negotiating prices, be honest about your costs, while remembering there are others competing for the assignment. Be reliable and allow time for possible re-shooting to end up with the best pic possible."

$ STREETPEOPLE'S WEEKLY NEWS (Homeless Editorial/ Business/Sports/Finance)

P.O. Box 270942, Dallas TX 75227-0942. E-mail: sw_n@yahoo.com. **Contact:** Lon G. Dorsey, Jr., publisher. Estab. 1990. Newspaper. Sample copy available by sending $ 7.35 to cover immediate handling (same day as received) and postage. Includes photo guidelines package now required. "Also contains information about our homeless television show and photo gallery."

• *SWNews* wishes to establish relationships with professionals interested in homeless issues. "Photographers may be certified by *SWN* by submitting $35 check or money order and samples of work. Photographers needed in every metropolitan city in U.S."

Needs Wants photos of babies/children/teens, celebrities, couples, multicultural, families,

parents, senior citizens, cities/urban, education, pets, religious, rural, events, food/ drink, health/fitness, hobbies, humor, political, technology/computers. Interested in alternative process, documentary, fine art, historical/vintage, seasonal. Subjects include: photojournalism on homeless or street people. Model/property release required. "All photos *must* be accompanied by *signed* model releases." Photo captions required.

Specs Accepts images in digital format. Send via CD, e-mail as GIF, JPEG files. Items to be considered for publishing must be in pdf. Write first to gain clearance to publisher.

Making Contact & Terms "Hundreds of photographers are needed to show national state of America's homeless." Send unsolicited photos by mail for consideration with SASE for return. Responds promptly. Pays $15-450 for cover; $15-150 for inside. Pays extra for electronic usage (negotiable). Pays on acceptance or publication. Credit line sometimes given. Buys all rights; negotiable.

Tips "In freelancer's samples, wants to see professionalism, clarity of purpose, without sex or negative atmosphere which could harm purpose of paper." The trend is toward "kinder, gentler situations, the 'let's help our fellows' attitude." To break in, "find out what we're about so we don't waste time with exhaustive explanations. We're interested in all homeless situations. Inquiries not answered without SASE. **All persons interested in providing photography should get registered with us.** Now using 'Registered photographers and Interns of *SW News*' for publishing and upcoming Internet worldwide awards competition. Info regarding competition is outlined in *SWN*'s photo guidelines package. Photographers not registered will not be considered due to the continuous sending of improper materials, inadequate information, wasted hours of screening matter, etc. **If you don't wish to register with us, please don't send anything for consideration.** You'll find that many professional pubs are going this way to reduce the materials management pressures which have increased. We are trying something else new—salespeople who are also photographers. So, if you have a marketing/sales background with a photo kicker, contact us!"

⊕ ▣ $ ◰ THE SUNDAY POST

D.C. Thomson & Co. Ltd., 2 Albert Square, Dundee DD1 9QJ Scotland. (44)(1382)223131. Fax: (44)(1382)201064. E-mail: mail@sundaypost.com. Website: www.sundaypost.com. **Contact:** Alan Morrison, picture editor. Circ. 355,000. Readership 1.1 million. Estab. 1919. Weekly family newspaper.

Needs Needs photos of "UK news and news involving Scots," sports. Other specific needs: exclusive news pictures from the UK, especially Scotland. Reviews photos with accompanying manuscript only. Model/property release preferred. Photo captions required; include contact details, subjects, date. "Save in the caption field of the file info, so they can be viewed on our picture desk system. Mac users should ensure attachments are PC-compatible as we use PCs."

Specs Prefers images in digital format. Send via e-mail as JPEG files. "We need a minimum 5MB file saved at quality level 9 or above, ideally at 200 ppi/dpi."

Making Contact & Terms Send query letter with tearsheets, stock list. Does not keep samples on file; include SASE for return of material. Responds in 2 weeks to queries. Simultaneous submissions OK. Pays $200 (USD) for b&w or color cover; $100-150 (USD) for b&w or color inside. Pays on publication. Credit line not given. Buys single use, all editions, one date, worldwide rights; negotiable.

Tips "Offer pictures by e-mail before sending: lo-res only, please—72 ppi, 800 pixels on the widest side; no more than 10 at a time. Make sure the daily papers aren't running the story first and that it's not being covered by the Press Association (PA). We get their pictures on our contracted feed."

$$ TORONTO SUN PUBLISHING

333 King St. E., Toronto ON M5A 3X5 Canada. (416)947-2399. E-mail: torsun.photoeditor@ sunmedia.ca. Website: www.torontosun.com. **Contact:** Jim Thomson, photo editor. Circ. 180,000. Estab. 1971. Daily newspaper. Emphasizes sports, news and entertainment. Readers are 60% male, 40% female, ages 25-60. Sample copy free with SASE.

Needs Uses 30-50 photos/issue; occasionally uses freelancers (spot news pics only). Needs photos of Toronto personalities making news out of town. Also disasters, beauty, sports, fashion/glamour. Reviews photos with or without a manuscript. Photo captions preferred.

Specs Accepts images in digital format. Send via CD or e-mail.

Making Contact & Terms Arrange a personal interview to show portfolio. Send any size color prints; 35mm transparencies; press link digital format. Deadline: 11 p.m. daily. Does not keep samples on file. Responds in 1-2 weeks. Simultaneous submissions and previously published work OK. Pays $125-500 for color cover; $50-500 for b&w inside. Pays on publication. Credit line given. Buys one-time and other negotiated rights.

Tips "The squeaky wheel gets the grease when it delivers the goods. Don't try to oversell a questionable photo. Return calls promptly."

$ THE WASHINGTON BLADE

529 14th St. NW,, Washington DC 20004. (202)797-7000. Fax: (202)797-7040. E-mail: news@washblade.com. Website: www.washblade.com. **Contact:** Chris Crain, executive editor. Circ. 100,000. Estab. 1969. Weekly tabloid for and about the gay community. Readers are gay men and lesbians; moderate- to upper-level income; primarily Washington, DC, metropolitan area. Sample copy free with 9 × 12 SAE plus 11 first-class stamps.

• *The Washington Blade* stores images on CD; manipulates size, contrast, etc.—but not content.

Needs Uses about 6-7 photos/issue. Needs "gay-related news, sports, entertainment, events; profiles of gay people in news, sports, entertainment, other fields." Photos purchased with or without accompanying manuscript. Model release preferred. Photo captions preferred.

Specs Accepts images in digital format. Send via e-mail.

Making Contact & Terms Send query letter with résumé of credits. Provide résumé, business card and tearsheets to be kept on file for possible future assignments. Responds in 1 month. Simultaneous submissions and previously published work OK. Pays $10 fee to go to location, $15/photo, $5/reprint of photo; negotiable. Pays within 30 days of publication. Credit line given. Buys all rights when on assignment, otherwise one-time rights.

Tips "Be timely! Stay up-to-date on what we're covering in the news, and call if you know of a story about to happen in your city that you can cover. Also, be able to provide some basic details for a caption (*tell* us what's happening, too)." Especially important to "avoid stereotypes."

Trade Publications

Most trade publications are directed toward the business community in an effort to keep readers abreast of the ever-changing trends and events in their specific professions. For photographers, shooting for these publications can be financially rewarding and can serve as a stepping stone toward acquiring future assignments.

As often happens with this category, the number of trade publications produced increases or decreases as professions develop or deteriorate. In recent years, for example, magazines involving new technology have flourished as the technology continues to grow and change.

Trade publication readers are usually very knowledgeable about their businesses or professions. The editors and photo editors, too, are often experts in their particular fields. So, with both the readers and the publications' staffs, you are dealing with a much more discriminating audience. To be taken seriously, your photos must not be merely technically good pictures, but also should communicate a solid understanding of the subject and reveal greater insights.

In particular, photographers who can communicate their knowledge in both verbal and visual form will often find their work more in demand. If you have such expertise, you may wish to query about submitting a photo/text package that highlights a unique aspect of working in a particular profession or that deals with a current issue of interest to that field.

Many photos purchased by these publications come from stock—both freelance inventories and stock photo agencies. Generally, these publications are more conservative with their freelance budgets and use stock as an economical alternative. For this reason, some listings in this section will advise sending a stock list as an initial method of contact. (See sample stock list on page 17.) Some of the more established publications with larger circulations and advertising bases will sometimes offer assignments as they become familiar with a particular photographer's work. For the most part, though, stock remains the primary means of breaking in and doing business with this market.

▣ $ ◪ 9-1-1 MAGAZINE

18201 Weston Place, Tustin CA 92780. (714)544-7776. E-mail: editor@9-1-1magazine.com. Website: www.9-1-1magazine.com. **Contact:** Randall Larson, editor. Circ. 18,000. Estab. 1988. Published 9 times/year. Emphasizes public safety communications for police, fire, paramedic, dispatch, medical, etc. Readers are ages 20-65. Sample copy free with 9 × 12 SASE and 7 first-class stamps. Photo guidelines free with SASE.

Needs Buys 20-30 photos from freelancers/issue; 270 photos/year. "Primary needs include dramatic photographs of incidents and unusual situations for covers; *From the Field*, our 2-page photo department included in each issue; and to illustrate articles. We especially need communications-related photos and law enforcement images. We have an overabundance of car-crash and structure-fire images, and are only looking for the more unusual or spectacular images in those categories. We rarely use stock photos, and we insist that all photography submitted to *9-1-1 Magazine* be for our exclusive use." Photo captions required; if possible, include incident location by city and state, agencies involved, incident details.

Specs Prefers digital images but also accepts color prints; 35mm, 2¼ × 2¼, 4 × 5, 8 × 10 transparencies. "Digital picture submissions should be from a (minimum) 4-megapixel camera at highest setting (or minimum resolution of 1,500 pixels wide; or 5" wide at 300 dpi). Low-res samples acceptable with query."

Making Contact & Terms Send query letter with list of stock photo subjects. "Prefer original images versus stock content." Send unsolicited photos by post or e-mail for consideration; include SASE for return of material. Responds in 3 weeks. Pays $300 for color cover; $50 for color inside, ¼ page or less; $75 for color inside, ½ page; $100 for color inside, full page. Pays on publication. Credit line given. Buys one-time rights.

Tips "We need photos for unillustrated cover stories and features appearing in each issue. See editorial calendar on website under 'Advertising' link. Assignments possible. Emphasis is on interesting composition, clarity and uniqueness of image."

$ AMERICAN BEE JOURNAL

51 S. Second St., Hamilton IL 62341. (217)847-3324. Fax: (217)847-3660. E-mail: abj@dadant.com. Website: www.dadant.com/journal. **Contact:** Joe M. Graham, editor. Circ. 13,000. Estab. 1861. Monthly trade magazine. Emphasizes beekeeping for hobby and professional beekeepers. Sample copy free with SASE.

Needs Buys 1-2 photos from freelancers/issue; 12-24 photos/year. Needs photos of beekeeping and related topics, beehive products, honey and cooking with honey. Special needs include color photos of seasonal beekeeping scenes. Model release preferred. Photo captions preferred.

Making Contact & Terms Send query letter with samples. Send 5 × 7 or 8½ × 11 color prints by mail for consideration; include SASE for return of material. Responds in 2 weeks. Pays $75 for color cover; $10 for color inside. Pays on publication. Credit line given. Buys all rights.

▣ Ⓐ $ ◪ AMERICAN POWER BOAT ASSOCIATION

17640 E. Nine Mile Rd., Box 377, Eastpointe MI 48021-0377. (586)773-9700. Fax: (586)773-6490. E-mail: propeller@apba-racing.com. Website: www.apba-racing.com. **Contact:**

Tana Moore, publications editor. Estab. 1903. Sanctioning body for US power boat racing; monthly magazine. Majority of assignments made on annual basis. Photos used in monthly magazine, brochures, audiovisual presentations, press releases, programs and website.

Needs Needs photos of APBA boat racing—action and candid. Interested in documentary, historical/vintage. Photo captions or class/driver ID required.

Specs Accepts images in digital format. Send via CD, e-mail as TIFF, EPS, JPEG files at 300 dpi.

Making Contact & Terms Initial personal contact preferred. Suggests initial contact by e-mail, letter or phone, possibly to be followed by evaluating samples. Provide business card to be kept on file for possible future assignments. Responds in 2 weeks when needed. Payment varies. Standard is $25 for color cover; $15 for interior pages. Credit line given. Buys one-time rights; negotiable. Photo usage must be invoiced by photographer within the month incurred.

Tips Prefers to see selection of shots of power boats in action or pit shots, candids, etc., (all identified). Must show ability to produce clear color action shots of racing events. "Send a few samples with introduction letter, especially if related to boat racing."

N ▣ $ ☑ ANIMAL SHELTERING

HSUS, 2100 L St. NW, Washington DC 20037. (202)452-1100. Fax: (301)258-3081. E-mail: asm@hsus.org. Website: www.animalsheltering.org. **Contact:** Amy Briggs, Production/Marketing Manager. Circ. 7,500. Estab. 1978. Bimonthly magazine of The Humane Society of the United States. Emphasizes animal protection. Readers are animal control workers, shelter workers, animal rescuers, volunteers, veterinarians, men and women, all ages. Sample copy free.

Needs Buys about 2-10 photos from freelancers/issue; 30 photos/year. Needs photos of domestic animals interacting with animal control and shelter workers; animals in shelters, including farm animals and wildlife; general public visiting shelters and adopting animals; humane society work, functions, and equipment. Photo captions preferred.

Specs Accepts color images in digital or print format. Send via CD, Zip, e-mail as TIFF, JPEG files at 300 dpi.

Making Contact & Terms Provide samples of work to be kept on file for possible future use or assignments; include SASE for return of material. Responds in 1 month. Pays $150 for cover; $75 for inside. Pays on publication. Credit line given. Buys one-time and electronic rights.

Tips "We almost always need good photos of people working with animals in an animal shelter or in the field. We do not use photos of individual dogs, cats and other companion animals as often as we use photos of people working to protect, rescue or care for dogs, cats and other companion animals."

$ ☑ APPALOOSA JOURNAL

Appaloosa Horse Club, 2720 W. Pullman Rd., Moscow ID 83843. (208)882-5578. Fax: (208)882-8150. E-mail: journal@appaloosa.com. Website: www.appaloosajournal.com. **Contact:** Diane Rice, editor. Circ. 22,000. Estab. 1946. Monthly association magazine. "Appaloosa Journal is the official publication of the Appaloosa Horse Club. We are dedicated to educating and entertaining Appaloosa enthusiasts from around the world." Readers are

Appaloosa owners, breeders and trainers, child through adult. Complimentary sample copies available. Photo guidelines free with SASE or online.

Needs Buys 3 photos from freelancers/issue; 36 photos/year. Needs photos for cover, and to accompany features and articles. Specifically wants photographs of high-quality Appaloosa horses, especially in winter scenes. Model release required. Photo captions required.

Specs Uses glossy color prints; 35 mm transparencies; digital images 300+ dpi at 5X7 inches or larger, depending on use.

Making Contact & Terms Send query letter with résumé, slides, prints, or e-mail as PDF or GIF. Keeps samples on file. Responds only if interested; send nonreturnable samples. Simultaneous submissions OK. Pays $200 for color cover; $25 minimum for color inside. **Pays on publication.** Credit line given. Buys first rights.

Tips "The Appaloosa Horse Club is a not-for-profit organization. Serious inquiries within specified budget only." In photographer's samples, wants to see "high-quality color photos of world-class, characteristic (coat patterned) Appaloosa horses in appealing, picturesque outdoor environments. Send a letter introducing yourself and briefly explaining your work. If you have inflexible preset fees, be upfront and include that information. Be patient. We are located at the headquarters; although an image might not work for the magazine, it might work for other printed materials. Work has a better chance of being used if allowed to keep on file. If work must be returned promptly, please specify. Otherwise, we will keep it for other departments' consideration."

▣ Ⓐ $ ▭ BEE CULTURE

The Magazine of American Beekeeping A.I. Root, 623 W. Liberty St., Medina OH 44256-6677. (800)289-7668, ext. 3214 or (330)725-6677, ext. 3214. E-mail: kim@beeculture.com. Website: www.beeculture.com. **Contact:** Kim Flottum, editor. Circ. 1 5,000. Estab. 1873. Monthly trade magazine emphasizing beekeeping industry—how-to, politics, news and events. Sample copies available. Photo guidelines available on website.: The Magazine of American Beekeeping A.I. Root, 623 W. Liberty St., Medina OH 44256-6677. (800)289-7668, ext. 3214 or (330)725-6677, ext. 3214. E-mail: kim@beeculture.com. Website: www.beeculture.com. **Contact:** Kim Flottum, editor. Circ. 1 5,000. Estab. 1873. Monthly trade magazine emphasizing beekeeping industry—how-to, politics, news and events. Sample copies available. Photo guidelines available on website.

Needs Buys 1-2 photos from freelancers/issue; 6-8 photos/year. Needs photos of honey bees and beekeeping, honey bees on flowers, etc. Reviews photos with or without a manuscript. Model release required. Photo captions preferred.

Specs Accepts images in digital format. Send via e-mail as TIFF, EPS, JPEG files at 300 dpi. Low-res for review encouraged.

Making Contact & Terms Send e-mail with low-res photos. Does not keep samples on file; include SASE for return of material. "E-mail contact preferred. Send low-res samples electronically for examination." Responds in 2 weeks to queries. Payment negotiable. **Pays on acceptance.** Credit line given. Buys first rights.

Tips "Read 2-3 issues for layout and topics. Think in vertical!"

▣ $ ▭ BIZTIMES MILWAUKEE

126 N. Jefferson St., Ste. 403, Milwaukee WI 53202-6120. (414)277-8181. (414)277-8191.

Website: www.biztimes.com. **Contact**: Shelly Tabor, art director. Circ. 15,000. Estab. 1994. Biweekly business-to-business publication.

Needs Buys 2-3 photos from freelancers/issue; 200 photos/year. Needs photos of Milwaukee, including cities/urban, business men and women, business concepts. Interested in documentary.

Specs Uses various sizes of glossy color prints. Accepts images in digital format. Send via CD as TIFF files at 300 dpi.

Making Contact & Terms Provide résumé, business card, self-promotion piece to be kept on file for possible future assignments. Responds only if interested; send nonreturnable samples. Simultaneous submissions and previously published work OK. Pays $250 maximum for color cover; $80 maximum for inside. **Pays on acceptance**.

Tips "Readers are owners/managers/CEOs. Cover stories and special reports often need conceptual images and portraits. Clean, modern and cutting edge with good composition. Covers have lots of possibility! Approximate one-week turnaround. Most assignments are for the Milwaukee area."

$ CASINO JOURNAL

Ascen Media Gaming Group, 505 E. Capovilla Ave., Suite 102, Las Vegas NV 89119. (702)794-0718. Fax: (702)794-0799. E-mail: aholtmann@ascendmedia.com. Website: www.casinojournal.com. **Contact:** Tammy Gizicki, art director. Circ. 35,000. Estab. 1985. Monthly journal. Emphasizes casino operations. Readers are casino executives, employees and vendors. Sample copy free with 11 × 14 SAE and 9 first-class stamps. Ascend Media Gaming Group also publishes IGWB, Slot Manager, and Indian Gaming Business. Each magazine has its own photo needs.

Needs Buys 0-2 photos from freelancers/issue; 12-24 photos/year. Needs photos of gaming tables and slot machines, casinos and portraits of executives. Model release required for gamblers, employees. Photo captions required.

Making Contact & Terms Send query letter with résumé of credits, stock list. Responds in 3 months. Pays $100 minimum for color cover; $10-25 for b&w inside; $10-35 for color inside. Pays on publication. Credit line given. Buys all rights; negotiable.

Tips "Read and study photos in current issues."

▣ CATHOLIC LIBRARY WORLD

100 North St., Suite 224, Pittsfield MA 01201-5178. (413)443-2CLA. Fax: (413)442-2252. E-mail: cla@cathla.org. Website: www.cathla.org. **Contact:** Jean R. Bostley, SSJ, executive director. Circ. 1,100. Estab. 1929. Quarterly magazine of the Catholic Library Association. Emphasizes libraries and librarians (community/school libraries; academic/research librarians; archivists). Readers are librarians who belong to the Catholic Library Association; other subscribers are generally employed in Catholic institutions or academic settings. Sample copy available for $15.

Needs Uses 2-5 photos/issue. Needs photos of authors of children's books, and librarians who have done something to contribute to the community at large. Special needs include photos of annual conferences. Model release preferred for photos of authors. Photo captions preferred.

Making Contact & Terms Send b&w prints; include SASE for return of material. Deadlines:

January 15, April 15, July 15, September 15. Responds in 2 weeks. Credit line given. Acquires one-time rights.

▣ CONSTRUCTION BULLETIN

15524 Highwood Dr., Minnetonka MN 55345. (952)933-3386. Fax: (952)933-5063. E-mail: ivy.chang@reedbusiness.com. Website: www.ce.com. **Contact:** Ivy Chang, editor. Circ. 3,000. Estab. 1893. Weekly magazine. Emphasizes construction in Minnesota, North Dakota and South Dakota only. Readers are male and female executives, ages 23-70. Sample copy available for $4.

Needs Uses 15 photos/issue; digital images only. Needs photos of construction equipment in use on Minnesota, North Dakota, South Dakota job sites. Photo captions required; include who, what, where, when.

Making Contact & Terms Send high-resolution digital images (minimum 300 dpi) for consideration. Credit line given.

Tips "Be observant; keep camera at hand when approaching construction sites in Minnesota, North Dakota and South Dakota."

Ⓝ ▣ $$ ⊘ ELECTRIC PERSPECTIVES

701 Pennsylvania Ave. NW, Washington DC 20004. (202)508-5584. Fax: (202)508-5759. E-mail: lrose@eei.org. Website: www.eei.org. **Contact:** LaVonne Rose, photo coordinator. Circ. 11,000. Estab. 1976. Bimonthly magazine of the Edison Electric Institute. Emphasizes issues and subjects related to shareholder-owned electric utilities. Sample copy available on request.

Needs Needs photos relating to the business and operational life of electric utilities—from customer service to engineering, from executive to blue collar. Model release required. Photo captions preferred.

Specs Uses 8 × 10 glossy color prints; 35mm, 2¼ × 2¼, 4 × 5 transparencies. Accepts images in digital format. Send via Zip, e-mail as TIFF, JPEG files at 300 dpi and scanned at a large size, at least 4 × 5.

Making Contact & Terms Send query letter with stock list or send unsolicited photos by mail for consideration. Provide résumé, business card, brochure, flier or tearsheets to be kept on file for possible future assignments. Keeps samples on file; include SASE for return of material. Pays $300-500 for color cover; $100-300 for color inside; $200-350 color page rate; $750-1,500 for photo/text package. Pays on publication. Buys one-time rights; negotiable (for reprints).

Tips "We're interested in annual-report-quality images in particular. Quality and creativity are often more important than subject."

Ⓝ Ⓐ $ ELECTRICAL APPARATUS

Barks Publications, Inc., 400 N. Michigan Ave., Chicago IL 60611-4198. (312)321-9440. E-mail: edickson@barks.com. Website: www.barks.com/eacurr.html. **Contact:** Elsie Dickson, associate publisher. Circ. 16,000. Monthly trade magazine. Emphasizes industrial electrical machinery maintenance and repair for the electrical aftermarket. Readers are "persons engaged in the application, maintenance and servicing of industrial and commercial electrical and electronic equipment." Sample copies available.

Needs "Assigned materials only. We welcome innovative industrial photography, but most of our material is staff-prepared." Photos purchased with accompanying manuscript or on assignment. Model release required "when requested." Photo captions preferred.

Making Contact & Terms Send query letter with résumé of credits. Contact sheet or contact sheet with negatives OK; include SASE for return of material. Responds in 3 weeks. Pays $200 for color. Pays on publication. Credit line given. Buys all rights, but exceptions are occasionally made.

▣ $ $ ◖ EL RESTAURANTE MEXICANO

Maiden Name Press, P.O. Box 2249, Oak Park IL 60303. (708)488-0100. Fax: (708)488-0101. E-mail: kfurore@restmex.com. Website: www.restmex.com. **Contact:** Kathy Furore, editor. Circ. 26,000. Estab. 1997. Bimonthly trade magazine for restaurants that serve Mexican, Tex-Mex, Southwestern and Latin cuisine. Sample copies available.

Needs Buys at least 1 photo from freelancers/issue; at least 6 photos/year. Needs photos of food/drink. Reviews photos with or without a manuscript.

Specs Uses 35mm transparencies. Accepts images in digital format. Send via e-mail as TIFF, JPEG files of at least 300 dpi.

Making Contact & Terms Send query letter with slides, prints, photocopies, tearsheets, transparencies or stock list. Provide résumé, business card, self-promotion piece to be kept on file for possible future assignments. Responds in 2 months to queries. Previously published work OK. Pays $450 maximum for color cover; $125 maximum for color inside. Pays on publication. Credit line given. Buys all rights; negotiable.

Tips "We look for outstanding food photography; the more creatively styled, the better."

▣ ESL TEACHER TODAY

2660 Petersborough St., Herndon VA 20171. E-mail: shannonaswriter@yahoo.com. **Contact:** Shannon Murphy. Quarterly trade magazine. Photo guidelines available via e-mail.

Needs Buys 12-24 photos/year. Needs photos of babies/children/teens, multicultural, families, parents, disasters, environmental, landscapes/scenics, wildlife, cities/urban, education, religious, rural, adventure, events, food/drink, sports, travel, agriculture, medicine, military, political, product shots/still life, science, technology—as related to teaching ESL (English as a Second Language) around the globe. Interested in alternative process, avant garde, documentary, fashion/glamour, fine art, historical/vintage, seasonal. Reviews photos with or without a manuscript. Model/property release preferred.

Specs Uses glossy or matte color and/or b&w prints.

Making Contact & Terms Send query letter via e-mail. "If possible, please do not include photographs in files if they are sent through e-mail. A disk with your photographs sent to *ESL Teacher Today* is acceptable." Provide résumé, business card or self-promotion piece to be kept on file for possible future assignments. Responds within 1 month to queries; 1 week to portfolios. Simultaneous submissions and previously published work OK. **Pays on acceptance.** Credit line given. Buys one-time rights, first rights; negotiable.

▣ Ⓐ $ FIRE CHIEF

330 N. Wabash Ave., Suite 2300, Chicago IL 60611. (312)595-1080. Fax: (312)595-0295. E-mail: sundee@firechief.com. Website: www.firechief.com. **Contact:** Sundee Koffarnus,

art director. Circ. 53,000. Estab. 1956. Monthly magazine. Emphasizes fire department management and operations. Readers are primarily fire officers and predominantly chiefs of departments. Sample copy free. Photo guidelines free with SASE or on website.

Needs Fire and emergency response, especially leadership themes - if you do not have fire or EMS, please do not contact.

Specs Digital format preferred, filename less than 15 characters. Send via e-mail, CD, Zip as TIFF, EPS files at highest possible resolution.

Making Contact & Terms Send low-resolution JPGs for consideration along with caption, date, time, and location. Samples are kept on file. Expect confirmation/response within 1 month. Payment upon publication. Buys first serial rights; negotiable.

Tips "As the name Fire Chief implies, we prefer images showing a leading officer (white, yellow, or red helmet) in action—on scene of a fire, disaster, accident/rescue, hazmat, etc. Other subjects: administration, communications, decontamination, dispatch, EMS, foam, heavy rescue, incident command, live fire training, public education, SCBA, water rescue, wildland fire."

▤ $ ◪ FIRE ENGINEERING

21-00 Route 208 South, Fairlawn NJ 07410. (973)251-5040. Fax: (973)251-5065. E-mail: dianef@pennwell.com. Website: www.fireengineering.com. **Contact:** Diane Feldman, executive editor. Estab. 1877. Training magazine for firefighters. Photo guidelines free.

Needs Uses 400 photos/year. Needs action photos of disasters, firefighting, EMS, public safety, fire investigation and prevention, rescue. Photo captions required; include date, what is happening, location and fire department contact.

Specs Accepts images in digital format. Send via e-mail or mail on CD as JPEG files at 300 dpi minimum.

Making Contact & Terms Send unsolicited photos by mail for consideration. Responds in 3 months. Pays $300 for color cover; $35-150 for color inside. Pays on publication. Credit line given. We retain copyright.

Tips "Firefighters must be doing something. Our focus is on training and learning lessons from photos."

Ⓝ ▤ $ $ ◪ FLEET SOLUTIONS

NAFA, 125 Village Blvd., Suite 200, Princeton NJ 08540. (609)720-0882. Fax: (609)452-8004. E-mail: gwien@nafa.org. Website: www.nafa.org. **Contact:** Gary Wien, Communications Manager. Circ. 4,500. Estab. 1957. Official magazine of the National Association of Fleet Administrators, Inc., published 6 times/year. Sample copy available for $4. Photo guidelines available.

Needs Needs photos of automobiles, business concepts, technology/computers. Interested in historical/vintage. Assignments include photo coverage of association members' work environments and vehicle fleets. Reviews photos with or without ms. Model/property release preferred. Photo captions preferred.

Specs Uses color prints. Accepts images in digital format. Send via CD, Zip, e-mail as TIFF files at 300 dpi.

Making Contact & Terms Provide business card or self-promotion piece to be kept on file for possible future assignments. Responds only if interested; send nonreturnable samples.

Pays on acceptance. Buys all rights; negotiable.

Tips "Research publication so samples are on target with magazine's needs."

$ GENERAL AVIATION NEWS

P.O. Box 39099, Lakewood WA 98439-0099. (253)471-9888. Fax: (253)471-9911. E-mail: janice@GeneralAviationNews.com. Website: www.GeneralAviationNews.com. **Contact:** Janice Wood, editor. Circ. 50,000. Estab. 1949. Biweekly tabloid. Emphasizes aviation. Readers are pilots, airplane owners and aviation professionals. Sample copy available for $3.50. Photo guidelines free with SASE.

Needs Photo captions preferred.

Making Contact & Terms Send query letter with résumé of credits. Do *not* send unsolicited prints; contact editor first. Does not keep samples on file; include SASE for return of material. Responds in 1 month. Fee varies according to subject, how/where photo is used. Pays on publication. Credit line given. Buys one-time rights.

Tips Wants to see "sharp photos of planes with good color; airshows not generally used."

▣ GEOSYNTHETICS

Industrial Fabrics Association International, 1801 County Road-B W., Roseville MN 55113. (651)222-2508 or (800)225-4324. Fax: (651)225-6966. E-mail: rwbygness@ifai.com. Website: geosyntheticsmagazine.info and www.ifai.com. **Contact:** Ron Bygness, editor. Circ. 18,000. Estab. 1983. Association magazine published 6 times/year. Emphasizes geosynthetics in civil engineering applications. Readers are civil engineers, professors and consulting engineers. Sample copies available.

Needs Uses 10-15 photos/issue; various number supplied by freelancers. Needs photos of finished applications using geosynthetics; photos of the application process. Reviews photos with accompanying manuscript only. Model release required. Photo captions required; include project, type of geosynthetics used and location.

Specs Prefers images in high-res digital format.

Making Contact & Terms "Please call before submitting samples!" Keeps samples on file. Responds in 1 month. Simultaneous submissions OK. Credit line given. Buys all rights; negotiable.

▣ $ ◨ GOVERNMENT TECHNOLOGY

e.Republic, Inc., 100 Blue Ravine Rd., Folsom CA 95630. (916)932-1300. Fax: (916)932-1470. E-mail: kmartinelli@erepublic.com. Website: www.govtech.net. **Contact:** Kelly Martinelli, creative director. Circ. 60,000. Estab. 1987. Monthly trade magazine. Emphasizes information technology as it applies to state and local government. Readers are government executives.

Needs Buys 2 photos from freelancers/issue; 20 photos/year. Needs photos of government officials, disasters, environmental, political, technology/computers. Reviews photos with accompanying manuscript only. Model release required; property release preferred. Photo captions required.

Specs Accepts images in digital format only. Send via DVD, CD, Zip, e-mail as TIFF, JPEG files at 300 dpi.

Making Contact & Terms Send query letter with résumé, prints, tearsheets. Provide

business card, self-promotion piece to be kept on file for possible future assignments. Responds only if interested; send nonreturnable samples. Simultaneous submissions and previously published work OK. Payment is dependent upon pre-publication agreement between photographer and *Government Technology*. Pays on publication. Credit line given. Buys one-time rights, electronic rights.

Tips "View samples of magazines for style, available online at www.govtech.com/gt/magazines."

■ $ ☑ JOURNAL OF ADVENTIST EDUCATION

General Conference of Seventh-day Adventists, 12501 Old Columbia Pike, Silver Spring MD 20904-6600. (301)680-5075. Fax: (301)622-9627. E-mail: rumbleb@gc.adventist.org. Website: http://jae.adventist.org. **Contact:** Beverly J. Robinson-Rumble, editor. Circ. 11,000. Estab. 1939. Published 5 times/year. Emphasizes procedures, philosophy and subject matter of Christian education. Official professional organ of the Department of Education covering elementary, secondary and higher education for all Seventh-day Adventist educational personnel (worldwide).

Needs Buys 5-15 photos from freelancers/issue; up to 75 photos/year. Needs photos of children/teens, multicultural, parents, education, religious, health/fitness, technology/computers with people, committees, offices, school photos of teachers, students, parents, activities at all levels, elementary though graduate school. Reviews photos with or without a manuscript. Model release preferred. Photo captions preferred.

Specs Uses mostly digital color images but also accepts color prints; 35mm, 2¼ × 2¼, 4 × 5 transparencies. Send digital photos via Zip, CD-ROM or DVD (preferred); e-mail as TIFF, GIF, JPEG files at 300 dpi. Do not send large numbers of photos as e-mail attachments.

Making Contact & Terms Send query letter with prints, photocopies, transparencies. Provide self-promotion piece to be kept on file for possible future assignments. Responds in 1 month to queries. Simultaneous submissions and previously published work OK. Pays $100-350 for color cover; $50-100 for color inside. Willing to negotiate on electronic usage of photos. Pays on publication. Credit line given. Buys one-time rights for use in magazine and on website.

Tips "Get good-quality people shots—close-ups, verticals especially; use interesting props in classroom shots; include teacher and students together, teachers in groups, parents and teachers, cooperative learning and multiage, multicultural children. Pay attention to backgrounds (not too busy) and understand the need for high-res photos!"

$ JOURNAL OF PSYCHOACTIVE DRUGS

Haight-Ashbury Publications, 856 Stanyan St., San Francisco CA 94117. (415)752-7601. Fax: (415)933-8674. E-mail: hajournal@comcast.net. Website: http://www.hajpd.com. **Contact:** Terry Chambers, managing editor. Circ. 1,400. Estab. 1967. Quarterly. Emphasizes "psychoactive substances (both legal and illegal)." Readers are "professionals (primarily health) in the drug abuse treatment field."

Needs Uses 1 photo/issue; supplied by freelancers. Needs "full-color abstract, surreal, avant garde or computer graphics."

Making Contact & Terms Send query letter with 4 × 6 color prints or 35mm slides. Online and e-mail submissions are accepted. Include SASE for return of material. Responds in 2

weeks. Simultaneous submissions and previously published work OK. Pays $50 for color cover. Pays on publication. Credit line given. Buys one-time rights.

▣ $$ ◪ JUDICATURE

2700 University Ave., Des Moines IA 50311. (773)973-0145. Fax: (773)338-9687. E-mail: drichert@ajs.org. Website: www.ajs.org. **Contact:** David Richert, editor. Circ. 6,000. Estab. 1917. Bimonthly publication of the American Judicature Society. Emphasizes courts, administration of justice. Readers are judges, lawyers, professors, citizens interested in improving the administration of justice. Sample copy free with 9 × 12 SAE and 6 first-class stamps.

Needs Buys 1-2 photos from freelancers/issue; 6-12 photos/year. Needs photos relating to courts, the law. "Actual or posed courtroom shots are always needed." Interested in fine art, historical/vintage. Model/property release preferred. Photo captions preferred.

Specs Uses b&w and/or color prints. Accepts images in digital format. Send via CD, Zip, e-mail as JPEG files at 600 dpi.

Making Contact & Terms Submit samples via e-mail. Simultaneous submissions and previously published work OK. Pays $250 for b&w cover; $350 for color cover; $125-250 for b&w inside; $125-300 for color inside. Pays on publication. Credit line given. Buys one-time rights.

$$ ◪ MARKETING & TECHNOLOGY GROUP

1415 N. Dayton, Chicago IL 60622. (312)274-2216. Fax: (312)266-3363. E-mail: qburns@ meatingplace.com. Website: www.meatingplace.com. **Contact:** Queenie Burns, vice president/design & production. Circ. 18,000. Estab. 1993. Publishes magazines that emphasize meat and poultry processing. Readers are predominantly male, ages 35-65, generally conservative. Sample copy available for $4.

Needs Buys 1-3 photos from freelancers/issue. Needs photos of food, processing plant tours, product shots, illustrative/conceptual. Model/property release preferred. Photo captions preferred.

Making Contact & Terms Provide résumé, business card, brochure, flier or tearsheets to be kept on file for possible future assignments. Submit portfolio for review. Keeps samples on file. Responds in 1 month. Simultaneous submissions and previously published work OK. Payment negotiable. Pays on publication. Credit line given.

Tips "Work quickly and meet deadlines. Follow directions when given; and when none are given, be creative while using your best judgment."

▣ ⑤ $$ ◯ PI MAGAZINE

4400 Rt. 9 S., Suite 1000, P.O. Box 7198, Freehold NJ 07728-7198. (732)308-3800. Fax: (732)308-3314. E-mail: jim@pimagazine.com. Website: www.pimagazine.com. **Contact:** Jimmie Mesis, publisher. Circ. 10,000. Estab. 1987. Bimonthly trade magazine. "Our audience is 80% private investigators with the balance law enforcement, insurance investigators, and people with interest in becoming a PI. The magazine features educational articles about the profession. Serious conservative format." Sample copy available for $7.95 and SAE with $1.75 first-class postage.

Needs Buys 10 photos from freelancers/issue; 60-100 photos/year. Needs photos of

technology/computers, law/crime. Reviews photos with or without a manuscript. Model/ property release required. Photo captions preferred.

Specs Accepts images in digital format. Send via CD, e-mail as TIFF, EPS files at highest dpi.

Making Contact & Terms Send query letter with tearsheets, stock list. Provide résumé, business card, self-promotion piece to be kept on file for possible future assignments. Responds only if interested; send nonreturnable samples. Simultaneous submissions OK. Pays $200-500 for color cover; $50-200 for color inside. Pays on publication. Credit line given. Buys all rights; negotiable.

▣ $$ PLANNING

American Planning Association, 122 S. Michigan Ave, Chicago IL 60603. (312)431-9100. E-mail: rsessions@planning.org. Website: www.planning.org. **Contact:** Richard Sessions, art director. Editor: Sylvia Lewis. Circ. 43,000. Estab. 1972. Monthly magazine. "We focus on urban and regional planning, reaching most of the nation's professional planners and others interested in the topic." Sample copy and photo guidelines free with 10 × 13 SASE with 4 first-class stamps (do not send cash or checks).

Needs Buys 4-5 photos from freelancers/issue; 60 photos/year. Photos purchased with accompanying manuscript and on assignment. Photo essay/photo feature (architecture, neighborhoods, historic preservation, agriculture); scenic (mountains, wilderness, rivers, oceans, lakes); housing; transportation (cars, railroads, trolleys, highways). "No cheesecake; no sentimental shots of dogs, children, etc. High artistic quality is very important. We publish high-quality nonfiction stories on city planning and land use. Ours is an association magazine but not a house organ, and we use the standard journalistic techniques: interviews, anecdotes, quotes. Topics include energy, the environment, housing, transportation, land use, agriculture, neighborhoods and urban affairs." Photo captions required.

Specs Uses 4-color prints; 35mm, 4 × 5 transparencies. Accepts images in digital format. Send via Zip, CD as TIFF, EPS, JPEG files at 300 dpi and around 5 × 7 in physical size.

Making Contact & Terms Send query letter with samples; include SASE for return of material. Responds in 1 month. Previously published work OK. Pays $50-100 for b&w photos; $75-200 for color photos; $375 maximum for cover; $200-600 for manuscript. Pays on publication. Credit line given.

Tips "Just let us know you exist. Eventually, we may be able to use your services. Send tearsheets or photocopies of your work, or a little self-promo piece. Subject lists are only minimally useful, as are website addresses. How the work looks is of paramount importance. Please don't send original slides or prints with the expectation of them being returned. Send something we can keep in our files."

$ PLASTICS NEWS

1725 Merriman Rd., Akron OH 44313. (330)836-9180. Fax: (330)836-2322. E-mail: dloepp@ crain.com. Website: www.plasticsnews.com. **Contact:** Don Loepp, managing editor. Circ. 60,000. Estab. 1989. Weekly tabloid. Emphasizes plastics industry business news. Readers are male and female executives of companies that manufacture a broad range of plastics products; suppliers and customers of the plastics processing industry. Sample copy available for $1.95.

Needs Buys 1-3 photos from freelancers/issue; 52-156 photos/year. Needs photos of technology related to use and manufacturing of plastic products. Model/property release preferred. Photo captions required.

Making Contact & Terms Send unsolicited photos by mail for consideration. Provide résumé, business card, brochure, flier or tearsheets to be kept on file for possible future assignments. Send query letter with stock list. Keeps samples on file; include SASE for return of material. Responds in 2 weeks. Simultaneous submissions and previously published work OK. Pays $125-175 for color cover; $100-150 for b&w inside; $125-175 for color inside. Pays on publication. Credit line given. Buys one-time and all rights.

N $ POLICE AND SECURITY NEWS

DAYS Communications, Inc., 1208 Juniper St., Quakertown PA 18951. (215)538-1240. Fax: (215)538-1208. E-mail: amenear@policeandsecuritynews.com. Website: www.policeandsecuritynews.com. **Contact:** Al Menear, associate publisher. Circ. 22,200. Estab. 1984. Bimonthly trade journal. "Police and Security News is edited for middle and upper management and top administration. Editorial content is a combination of articles and columns ranging from the latest in technology, innovative managerial concepts, training and industry news in the areas of both public law enforcement and private security." Sample copy free with 9¾ × 10 SAE and $2.17 first-class postage.

Needs Buys 2 photos from freelancers/issue; 12 photos/year. Needs photos of law enforcement and security related. Reviews photos with or without a manuscript. Photo captions preferred.

Specs Uses color and b&w prints.

Making Contact & Terms Provide résumé, business card, self-promotion piece or tearsheets to be kept on file for possible future assignments. Art director will contact photographer for portfolio review if interested. Portfolio should include b&w and/or color prints or tearsheets. Keeps samples on file; include SASE for return of material. Simultaneous submissions and previously published work OK. Pays $20-40 for color inside. Pays on publication. Credit line given. Buys one-time rights; negotiable.

□ A $ PRODUCE MERCHANDISING

Vance Publishing Corp., 10901 W. 84th Terrace, Lenexa KS 66214. (800)255-5113. Fax: (913)438-0691. E-mail: dbabcock@producemerchandising.com. Website: www.producemerchandising.com. **Contact:** David Babcock, chief editor. Circ. 12,000. Estab. 1988. Monthly magazine, email newsletters, and website. Emphasizes the retail end of the fresh produce industry. Readers are male and female executives who oversee produce operations in US and Canadian supermarkets as well as in-store produce department personnel. Sample copies available.

Needs Buys 2-5 photos from freelancers/issue; 24-60 photos/year. Needs in-store shots, environmental portraits for cover photos or display pictures. Photo captions required; include subject's name, job title and company title-all verified and correctly spelled.

Specs Accepts images in digital format. Send via email as TIFF, JPEG files.

Making Contact & Terms Email only. Response time "depends on when we will be in a specific photographer's area and have a need." Pays $500-750 for color cover; $25-50/color photo. **Pays on acceptance.** Credit line given. Buys all rights.

Tips "We seek photographers who serve as our on-site 'art director' to ensure capture of creative angles and quality images."

N ▣ $ $ ◪ QSR

4905 Pine Cone Dr., Suite 2, Durham NC 27707. (919)489-1916. Fax: (919)489-4767. Website: www.qsrmagazine.com. **Contact:** Mitch Avery, production manager. Estab. 1997. Trade magazine directed toward the business aspects of quick-service restaurants (fast food). "Our readership is primarily management level and above, usually franchisors and franchisees. Our goal is to cover the quick-service and fast, casual restaurant industries objectively, offering our readers the latest news and information pertinent to their business." Photo guidelines free.

Needs Buys 10-15 photos/year. Needs corporate identity portraits, images associated with fast food, general food images for feature illustration. Reviews photos with or without a manuscript. Model/property release preferred.

Specs Prefers images in digital format. Send via CD/DVD, Zip as TIFF, EPS files at 300 dpi. Uses 2¼ × 2¼, transparencies.

Making Contact & Terms Send query letter with samples, brochure, stock list, tearsheets. Art director will contact photographer for portfolio review if interested. Portfolio should include slides and digital sample files. Keeps samples on file. Responds only if interested; send nonreturnable samples. Simultaneous submissions and previously published work OK. Pays $250-500 for color cover; $250-500 for color inside. Pays on publication. Publisher only interested in acquiring all rights unless otherwise specified.

Tips "Willingness to work with subject and magazine deadlines essential. Willingness to follow artistic guidelines necessary but should be able to rely on one's own eye. Our covers always feature quick-service restaurant executives with some sort of name recognition (i.e., a location shot with signage in the background, use of product props which display company logo)."

N ▣ $ ◪ QUICK FROZEN FOODS INTERNATIONAL

2125 Center Ave., Suite 305, Fort Lee NJ 07024-5898. (201)592-7007. Fax: (201)592-7171. Website: www.qffintl.com. **Contact:** John M. Saulnier, chief editor/publisher. Circ. 15,000. Quarterly magazine. Emphasizes retailing, marketing, processing, packaging and distribution of frozen foods around the world. Readers are international executives involved in the frozen food industry: manufacturers, distributors, retailers, brokers, importers/exporters, warehousemen, etc. Sample copy available for $12.

Needs Buys 10-25 photos/year. Uses photos of agriculture, plant exterior shots, step-by-step in-plant processing shots, photos of retail store frozen food cases, head shots of industry executives, etc. Photo captions required.

Specs Uses 5 × 7 glossy b&w and/or color prints. Accepts digital images via CD at 300 dpi, CMYK.

Making Contact & Terms Send query letter with résumé of credits. Responds in 1 month. Payment negotiable. Pays on publication. Buys all rights but may reassign to photographer after publication.

Tips A file of photographers' names is maintained; if an assignment comes up in an area close to a particular photographer, she/he may be contacted. "When submitting your name, inform us if you are capable of writing a story if needed."

RANGEFINDER

6059 Bristol Pkwy., Ste. 100, Culver City CA 90230. (310)846-4770 x319. Fax: (310)395-9058. E-mail: bhurter@rfpublishing.com, aronck@rfpublishing.com. Website: www.rangefindermag.com. **Contact:** Jen Chen, features editor or Abigail Ronck, managing editor. Circ. 61,000. Estab. 1952. Monthly magazine. Emphasizes topics, developments and products of interest to the professional photographer. Readers are professionals in all phases of photography. Sample copy free with 11 × 14 SAE and 2 first-class stamps. Photo guidelines free with SASE.

Needs Buys very few photos from freelancers/issue. Needs all kinds of photos; almost always run in conjunction with articles. "We prefer photos accompanying 'how-to' or special interest stories from the photographer." No pictorials. Special needs include seasonal cover shots (vertical format only). Model release required; property release preferred. Photo captions preferred.

Making Contact & Terms Send query letter with résumé of credits. Keeps samples on file; include SASE for return of material. Responds in 1 month. Previously published work occasionally OK; give details. Payment varies. Covers submitted gratis. Pays on publication. Credit line given. Buys first North American serial rights; negotiable.

▣ ⑤ $ ◿ REFEREE

P.O. Box 161, Franksville WI 53126. (262)632-8855. Fax: (262)632-5460. E-mail: jstern@referee.com. Website: www.referee.com. **Contact:** Jeffrey Stern, senior editor. Circ. 40,000. Estab. 1976. Monthly magazine. Readers are mostly male, ages 30-50. Sample copy free with 9 × 12 SAE and 5 first-class stamps. Photo guidelines free with SASE.

Needs Buys 37 photos from freelancers/issue; 444 photos/year. Needs action officiating shots—all sports. Photo needs are ongoing. Photo captions required; include officials' names and hometowns.

Specs Prefers to use digital files (minimum 300 dpi submitted on CD only—no DVDs) and 35mm slides. Also uses color prints.

Making Contact & Terms Send unsolicited photos by mail for consideration. Responds in 2 weeks. Simultaneous submissions and previously published work OK. Pays $100 for color cover; $35 for color inside. Pays on publication. Credit line given. Rights purchased negotiable.

Tips "Prefer photos that bring out the uniqueness of being a sports official. Need photos primarily of officials at or above the high school level in baseball, football, basketball, softball, volleyball and soccer in action. Other sports acceptable, but used less frequently. When at sporting events, take a few shots with the officials in mind, even though you may be on assignment for another reason. Don't be afraid to give it a try. We're receptive, always looking for new freelance contributors. We are constantly looking for pictures of officials/umpires. Our needs in this area have increased. Names and hometowns of officials are required."

▣ $$ ◿ RESTAURANT HOSPITALITY

Penton Media, 1300 E. Ninth St., Cleveland OH 44114. (216)931-9942. Fax: (216)696-0836. E-mail: chris.roberto@penton.com. Website: www.restaurant-hospitality.com. **Contact:**

Chris Roberto, group creative director. Editor-in-Chief: Michael Sanson. Circ. 123,000. Estab. 1919. Monthly magazine. Emphasizes "hands-on restaurant management ideas and strategies." Readers are restaurant owners, chefs, food service chain executives.

Needs Buys 15 photos from freelancers/issue; 180 photos/year. Needs "on-location portraits, restaurant and food service interiors, and occasional food photos." Special needs include "subject-related photos; query first." Model release preferred. Photo captions preferred.

Specs Accepts images in digital format. Send via CD, FTP, e-mail as JPEG files at 300 dpi.

Making Contact & Terms Send postcard samples. Provide business card, samples or tearsheets to be kept on file for possible future assignments. Previously published work OK. Pay varies; negotiable. Cover fees on per project basis. **Pays on acceptance.** Credit line given. Buys one-time rights plus usage in all media.

Tips "Send postcard samples including your Web address for online viewing of your work."

▣ $ RETAILERS FORUM

383 E. Main St., Centerport NY 11721. (631)754-5000. Fax: (631)754-0630. E-mail: forumpublishing@aol.com. **Contact:** Martin Stevens, publisher. Circ. 70,000. Estab. 1981. Monthly magazine. Readers are entrepreneurs and retail store owners. Sample copy available for $7.50.

Needs Buys 3-6 photos from freelancers/issue; 36-72 photos/year. "We publish trade magazines for retail variety goods stores and flea market vendors. Items include jewelry, cosmetics, novelties, toys, etc. (five-and-dime-type goods). We are interested in creative and abstract impressions—not straight-on product shots. Humor a plus." Model/property release required.

Specs Uses color prints. Accepts images in digital format. Send via e-mail at 300 dpi.

Making Contact & Terms Send unsolicited photos by mail or e-mail for consideration. Does not keep samples on file; include SASE for return of material. Responds in 2 weeks. Simultaneous submissions and previously published work OK. Pays $100 for color cover; $50 for color inside. **Pays on acceptance.** Buys one-time rights.

▣ $$ ◨ SCRAP

1615 L St. NW, Suite 600, Washington DC 20036-5664. (202)662-8547. E-mail: kentkiser@scrap.org. Website: www.scrap.org. **Contact:** Kent Kiser, publisher and editor-in-chief. Circ. 11,559. Estab. 1988. Bimonthly magazine of the Institute of Scrap Recycling Industries. Emphasizes scrap recycling for owners and managers of recycling operations worldwide. Sample copy available for $8.

Needs Buys 0-15 photos from freelancers/issue; 15-70 photos/year. Needs operation shots of companies being profiled and studio concept shots. Model release required. Photo captions required.

Specs Accepts images in digital format. Send via CD, Zip, e-mail as TIFF files at 270 dpi.

Making Contact & Terms Provide résumé, business card, brochure, flier or tearsheets to be kept on file for possible future assignments. Previously published work OK. Pays $800-1,500/day; $100-400 for b&w inside; $200-600 for color inside. **Pays on delivery of images.** Credit line given. Rights negotiable.

Tips Photographers must possess "ability to photograph people in corporate atmosphere, as well as industrial operations; ability to work well with executives, as well as laborers.

We are always looking for good color photographers to accompany our staff writers on visits to companies being profiled. We try to keep travel costs to a minimum by hiring photographers located in the general vicinity of the profiled company. Other photography (primarily studio work) is usually assigned through freelance art director."

$ THOROUGHBRED TIMES

P.O. Box 8237, Lexington KY 40533. (859)260-9800. E-mail: photos@thoroughbredtimes. com. Website: www.thoroughbredtimes.com. **Contact:** Sarah Dorroh, photo editor. Circ. 18,000. Estab. 1985. Weekly tabloid news magazine. Emphasizes Thoroughbred breeding and racing. Readers are wide demographic range of industry professionals. Photo guidelines available upon request.

Needs Buys 10-15 photos from freelancers/issue; 520-780 photos/year. Looks for photos "only from desired trade (Thoroughbred breeding and racing)." Needs photos of specific subject features (personality, farm or business). Model release preferred. Photo captions preferred. "File info required."

Making Contact & Terms Provide business card, brochure, flier or tearsheets to be kept on file for possible future assignments. Responds in 1 month. Previously published work OK. Pays $50 for b&w cover or inside; $50 for color; $250/day. Pays on publication. Credit line given. Buys one-time rights.

◼ $$ ☑ VETERINARY ECONOMICS

Advanstar Veterinary Healthcare Communications, 8033 Flint, Lenexa KS 66214. (913)492-4300. Fax: (913)492-4157. Website: www.vetecon.com. **Contact:** Alison Fulton, senior art director. Circ. 58,000. Estab. 1960. Monthly trade magazine emphasizing practice management for veterinarians. Sample copies and photo guidelines available.

Needs Photographers on an "as needed" basis for editorial portraits; must be willing to sign license agreement; 6-12 photos/year. Needs photos of business concepts and medicine. Reviews photos with or without a manuscript. Model release and license agreement required. Photo captions preferred.

Specs Prefers images in digital format. Send via CD, Zip, e-mail as JPEG files at 300 dpi.

Making Contact & Terms Send 1 e-mail with sample image less than 1 MB; repeat e-mails are deleted. Does not keep samples on file. **Pays on acceptance.** Credit line given.

THE WHOLESALER

1838 Techny Court, Northbrook IL 60062. (847)564-1127. Fax: (847)564-1264. E-mail: editor@ thewholesaler.com. Website: www.thewholesaler.com. **Contact:** Mary Jo Martin, editor. Circ. 35,000. Estab. 1946. Monthly news tabloid. Emphasizes wholesaling/distribution in the plumbing, heating, air conditioning, piping (including valves), fire protection industry. Readers are owners and managers of wholesale distribution businesses; manufacturer representatives. Sample copy free with 11 × 15¾ SAE and 5 first-class stamps.

Needs Buys 3 photos from freelancers/issue; 36 photos/year. Interested in field and action shots in the warehouse, on the loading dock, at the job site. Property release preferred. Photo captions preferred; "Just give us the facts."

Making Contact & Terms Send query letter with stock list. Send any size glossy color and/ or b&w prints by mail with SASE for consideration. Responds in 2 weeks. Simultaneous

submissions and previously published work OK. Pays on publication. Buys one-time rights.

▣ $$ WINES & VINES

1800 Lincoln Ave., San Rafael CA 94901. (415)453-9700. Fax: (415)453-2517. E-mail: info@winesandvines.com. Website: www.winesandvines.com. **Contact**: Bridget Holland. Circ. 5,000. Estab. 1919. Monthly magazine. Emphasizes winemaking, grape growing, and marketing in North America and internationally for wine industry professionals, including winemakers, grape growers, wine merchants and suppliers.

Needs Wants color cover subjects on a regular basis.

Specs Accepts images in digital format. Send via CD, Zip, e-mail as TIFF, or JPEG files at 400 dpi.

Making Contact & Terms Prefers e-mail query with link to portfolio; or send material by mail for consideration. Will e-mail if interested in reviewing photographer's portfolio. Provide business card to be kept on file for possible future assignments. Responds in 3 months. Previously published work considered. Pays $100-350 for color cover, or negotiable ad trade out. Pays on publication. Credit line given. Buys one-time rights.

ⓝ $ WISCONSIN ARCHITECT

321 S. Hamilton St., Madison WI 53703. (608)257-8477. E-mail: editor@aiaw.org. Website: www.aiaw.org. **Contact:** Brenda Taylor, managing editor. Circ. 3,700. Estab. 1931. Annual magazine of the American Institute of Architects Wisconsin. Emphasizes architecture. Readers are design/construction professionals.

Needs Uses approximately 100 photos/issue. "Photos are almost exclusively supplied by architects who are submitting projects for publication. Of these, approximately 65% are professional photographers hired by the architect."

Making Contact & Terms "Contact us through architects." Keeps samples on file. Responds in 1-2 weeks when interested. Simultaneous submissions and previously published work OK. Pays $50-100 for color cover when photo is specifically requested. Pays on publication. Credit line given. Rights negotiable.

▣ $ ◯ WRITERS' JOURNAL

Val-Tech Media, P.O. Box 394, Perham MN 56573. (218)346-7921. Fax: (218)346-7924. E-mail: writersjournal@writersjournal.com. Website: www.writersjournal.com. **Contact:** John Ogroske, publisher. Circ. 20,000. Estab. 1980. Bimonthly trade magazine. Sample copy available for $6.

Needs Buys 1 photo from freelancers/issue; 6 photos/year. Needs photos of landscapes/scenics or wildlife; more recently, uses photos about reading or writing. *WRITERS' Journal* offers 2 photography contests yearly. Send SASE for contest guidelines or visit website. Model release required ("if applicable to photo"). Photo titles needed.

Specs Uses 8 × 10 color prints digital images for non-contest photos. "Digital images must be accompanied by a hardcopy printout."

Making Contact & Terms Send query letter. Does not keep samples on file; include SASE for return of material. Responds in 2 months. Pays $50-60 for color cover. Pays on publication. Credit line given. Buys one time North American rights.

Book Publishers

There are diverse needs for photography in the book publishing industry. Publishers need photos for the obvious (covers, jackets, text illustrations and promotional materials), but they may also need them for use on CD-ROMs and websites. Generally, though, publishers either buy individual or groups of photos for text illustration, or they publish entire books of photography.

Those in need of text illustration use photos for cover art and interiors of textbooks, travel books and nonfiction books. For illustration, photographs may be purchased from a stock agency or from a photographer's stock, or the publisher may make assignments. Publishers usually pay for photography used in book illustration or on covers on a per-image or per-project basis. Some pay photographers hourly or day rates, if on an assignment basis. No matter how payment is made, however, the competitive publishing market requires freelancers to remain flexible.

To approach book publishers for illustration jobs, send a cover letter with photographs or slides and a stock photo list with prices, if available. (See sample stock list on page 17.) If you have a website, provide a link to it. If you have published work, tearsheets are very helpful in showing publishers how your work translates to the printed page.

PHOTO BOOKS

Publishers who produce photography books usually publish books with a theme, featuring the work of one or several photographers. It is not always necessary to be well-known to publish your photographs as a book. What you do need, however, is a unique perspective, a salable idea and quality work.

For entire books, publishers may pay in one lump sum or with an advance plus royalties (a percentage of the book sales). When approaching a publisher for your own book of photographs, query first with a brief letter describing the project, and include sample photographs. If the publisher is interested in seeing the complete proposal, you can send additional information in one of two ways depending on the complexity of the project.

Prints placed in sequence in a protective box, along with an outline, will do for

easy-to-describe, straightforward book projects. For more complex projects, you may want to create a book dummy. A dummy is basically a book model with photographs and text arranged as they will appear in finished book form. Book dummies show exactly how a book will look, including the sequence, size, format and layout of photographs and accompanying text. The quality of the dummy is important, but keep in mind that the expense can be prohibitive.

To find the right publisher for your work, first check the Subject Index on page 507 to help narrow your search, then read the appropriate listings carefully. Send for catalogs and guidelines for those publishers that interest you. You may find guidelines on publishers' websites as well. Also, become familiar with your local bookstore or visit the site of an online bookstore such as Amazon.com. By examining the books already published, you can find those publishers who produce your type of work. Check for both large and small publishers. While smaller firms may not have as much money to spend, they are often more willing to take risks, especially on the work of new photographers. Keep in mind that photo books are expensive to produce and may have a limited market.

▣ $$ ◰ ABSEY AND CO. INC.

23011 Northcrest Dr., Spring TX 77389. (281)257-2340 or (888)412-2739. Fax: (281)251-4676. E-mail: info@absey.biz. Website: www.absey.com. **Contact:** Edward Wilson, editor-in-chief. Estab. 1997. Publishes hardcover, trade paperback and mass market paperback originals. Subjects include young adult, educational material. Photos used for text illustrations, promotional materials, book covers, dust jackets. Examples of recently published titles: *Authentic Strategies for High-Stakes Tests, Stealing a Million Kisses, Dr. JAC's Guide to Writing Depth.*

Needs Buys 5-50 freelance photos/year. Needs photos of babies/children/teens, multicultural, environmental, landscapes/scenics, wildlife, education, health/fitness, agriculture, product shots/still life. Interested in avant garde. Model/property release required. Photo captions required.

Specs Uses 3 × 5 glossy or matte color and/or b&w prints. Accepts images in digital format. Send as TIFF, EPS, GIF, JPEG files at 600 dpi.

Making Contact & Terms Send query letter with résumé, photocopies, tearsheets, stock list. Provide résumé or self-promotion piece to be kept on file for possible future assignments. Responds in 3 months if interested. Pays $50-1,000 for b&w or color cover; $25-100 for b&w inside; $25-150 for color inside. Pays on publication. Credit line given. Buys one-time rights; negotiable.

Tips Does not want "cutesy" photos.

▣ Ⓐ AERIAL PHOTOGRAPHY SERVICES

2511 S. Tryon St., Charlotte NC 28203. (704)333-5144. Fax: (704)333-4911. E-mail: aps@aps-1.com. Website: www.aps-1.com. **Contact:** Catherine Joseph. Estab. 1960. Publishes pictorial books, calendars, postcards, etc. Photos used for text illustrations, book covers, souvenirs. Examples of recently published titles: *Blue Ridge Parkway Calendar*; *Great Smoky Mountain Calendar*; *North Carolina Calendar*; *North Carolina Outer Banks Calendar*—all depicting the seasons of the year. Photo guidelines free with SASE.

Needs Buys 100 photos/year. Wants landscapes/scenics, mostly seasons (fall, winter,

spring). Reviews stock photos. Model/property release preferred. Photo captions required; include location.

Specs Uses 5 × 7, 8 × 10 matte color prints; 35mm, 2¼ × 2¼, 4 × 5 transparencies; C41 120mm film mostly. Accepts images in digital format on CD.

Making Contact & Terms Send unsolicited photos by mail with SASE for consideration. Works with local freelancers on assignment only. Responds in 3 weeks. Simultaneous submissions OK. Payment negotiable. **Pays on acceptance.** Credit line given. Buys all rights; negotiable.

Tips Looking for "fresh looks; creative, dynamic, crisp images. We use a lot of nature photography, scenics of the Carolinas area including Tennessee and the mountains. We like to have a nice variety of the 4 seasons. We also look for quality chromes good enough for big reproduction. Only submit images that are very sharp and well exposed. For the fastest response time, please limit your submission to only the highest-quality transparencies. Seeing large-format photography the most (120mm-4 × 5). If you would like to submit images on a CD, that is acceptable also."

Ⓐ $$ ALL ABOUT KIDS PUBLISHING

9333 Bendow Dr., Gilroy CA 95020. (408)846-1833. Fax: (408)846-1835. Website: www.aakp.com. **Contact:** Linda L. Guevara, editor. Estab. 2000. Publishes children's books, including picture books and books for young readers.

Needs Uses freelance photographers on assignment only. Model/property release required.

Specs Uses 35mm transparencies.

Making Contact & Terms Submit portfolio, color samples/copies. Include cover letter, résumé, contact info. Keeps samples on file for possible future assignments; include SASE for return of material. Pays by the project, $500 minimum or royalty of 5% based on wholesale price.

Tips "Visit out our website for updates and submission guidelines."

▣ $$ ☑ ALLYN & BACON PUBLISHERS

75 Arlington St., Suite 300, Boston MA 02116. (617)848-7328. E-mail: annie.pickert@ablongman.com. Website: www.ablongman.com. **Contact:** Annie Pickert, photography director. Estab. 1868. Publishes college textbooks. Photos used for text illustrations, book covers. Examples of recently published titles: *Criminal Justice*; *Including Students with Special Needs*; *Social Psychology* (text illustrations and promotional materials).

Needs Offers 1 assignment plus 80 stock projects/year. Needs photos of babies/children/teens, celebrities, couples, multicultural, families, parents, senior citizens, disasters, education, special education, science, technology/computers. Interested in fine art, historical/vintage. Also uses multi-ethnic photos in education, health and fitness, people with disabilities, business, social sciences, and good abstracts. Reviews stock photos. Model/property release required.

Specs Uses b&w prints, any format; all transparencies. Accepts images in digital format. Send via CD, Zip, e-mail as TIFF, EPS, PICT, GIF, JPEG files at 72 dpi for review, 300 dpi for use.

Making Contact & Terms Provide self-promotion piece or tearsheets to be kept on file

for possible future assignments. "Do not call or send stock lists." Cannot return samples. Responds in "24 hours to 4 months." Pays $100-250 for b&w cover; $100-600 for color cover; $100-200 for b&w inside; $100-250 for color inside. Pays on usage. Credit line given. Buys one-time rights; negotiable. Offers internships for photographers January-June.

Tips "Send tearsheets and promotion pieces. Need bright, strong, clean abstracts and unstaged, nicely lit people photos."

◼ $ ☑ AMERICAN PLANNING ASSOCIATION

122 S. Michigan, Suite 1600, Chicago IL 60603. (312)431-9100. Fax: (312)431-9985. Website: www.planning.org. **Contact:** Richard Sessions, Susan Deegan or Jessica Campbell, art directors. Publishes planning and related subjects. Photos used for text illustrations, promotional materials, book covers, dust jackets. Examples of recently published titles: *Planning* (text illustrations, cover); *PAS Reports* (text illustrations, cover). Photo guidelines and sample (*Planning*) available for $1 postage (stamps only please, no cash or checks).

Needs Buys 100 photos/year; offers 8-10 freelance assignments/year. Needs planning-related photos. Photo captions required; include what's in the photo and credit information.

Specs Uses 35mm color slides; 5 × 7, 8 × 10 b&w prints. Accepts images in digital format. Send via CD, floppy disk, Zip, e-mail as TIFF, EPS, JPEG files at 300 dpi minimum; maximum quality, lowest compression.

Making Contact & Terms Provide résumé, business card, brochure, flier, tearsheets, promo pages or good photocopies to be kept on file for possible future assignments. "Do not send original work—slides, prints, whatever—with the expectation of it being returned." Responds in 2 weeks. Simultaneous submissions and previously published work OK. Pays $350 maximum for cover; $100-150 for b&w or color inside. **Pays on receipt of invoice**. Credit line given. Buys one-time and electronic rights (CD-ROM and online).

Tips "Send a sample I can keep."

AMERICAN SCHOOL HEALTH ASSOCIATION

7263 State Route 43, P.O. Box 708, Kent OH 44240. (330)678-1601. Fax: (330)678-4526. E-mail: asha@ashaweb.org. Website: www.ashaweb.org. **Contact:** Thomas M. Reed, director of editorial services. Estab. 1927. Publishes professional journals. Photos used for book covers.

Needs Looking for photos of school-age children. Model/property release required. Photo captions preferred; include photographer's full name and address.

Specs Uses 35mm transparencies.

Making Contact & Terms Send query letter with samples. Does not keep samples on file; include SASE for return of material. Responds as soon as possible. Simultaneous submissions and previously published work OK. Payment negotiable. Pays on publication. Credit line given. Buys one-time rights.

AMHERST MEDIA®

175 Rano St., Suite 200, Buffalo NY 14207. (716)874-4450. Fax: (716)874-4508. E-mail: submissions@amherstmedia.com. Website: www.amherstmedia.com. **Contact:** Craig Alesse, photo book publisher. Estab. 1974. Publishes trade paperback originals and reprints. Subjects include photography how-to. Photos used for text illustrations, book

covers. Examples of recently published titles: *Portrait Photographer's Handbook*; *The Best of Professional Digital Photography*; *How to Create a High-Profit Photography Business in Any Market*. Catalog and submission guidelines free.

Needs Does not buy single photos, but accepts proposals for photography how-to books. "Looking for well-written and illustrated photo books." Reviews photos as part of a manuscript package only.

Making Contact & Terms Send query letter with book outline, 2 sample chapters and SASE. Responds in 2 months to queries. Simultaneous submissions OK. Pays 6-8% royalties on retail price; offers advance. Rights negotiable.

Tips "Our audience is made up of beginning to advanced photographers. If I were trying to market a photography book, I would fill the need of a specific audience and self-edit in a tight manner."

▣ Ⓐ $ $ ◪ APPALACHIAN MOUNTAIN CLUB BOOKS

5 Joy St., Boston MA 02108. (617)391-6628. E-mail: alakri@outdoors.org. Website: www. outdoors.org. **Contact:** Athena Lakri, production manager. Estab. 1876. Publishes hardcovers and trade paperbacks. Photos used for text illustrations, book covers. Examples of recently published titles: *Discover* series, *Best Day Hikes* series, *Trail Guide* series.

Needs Looking for photos of nature, hiking, backpacking, biking, paddling, skiing in the Northeast. Model release required. Photo captions preferred; include location, description of subject, photographer's name and phone number.

Specs Uses print-quality color and gray-scale images.

Making Contact & Terms E-mail light boxes. Art director will contact photographer if interested. Keeps samples on file. Responds only if interested.

▣ Ⓢ $ $ ◩ BEDFORD/ST. MARTIN'S

33 Irving Place 10th Fl., New York NY 10003. (617)399-4000. Website: www.bedfordstmartins. com. **Contact:** Art Director. Estab. 1981. Publishes college textbooks. Subjects include English, communications, philosophy, music, history. Photos used for text illustrations, promotional materials, book covers. Examples of recently published titles: *Stages of Drama, 5th Edition* (text illustration, book cover); *12 Plays* (book cover); *Campbell Media & Cultural 5*.

Needs "We use photographs editorially, tied to the subject matter of the book." Needs mostly historical photos. Also wants artistic, abstract, conceptual photos; people—predominantly American; multicultural, cities/urban, education, performing arts, political, product shots/ still life, business concepts, technology/computers. Interested in documentary, fine art, historical/vintage. Not interested in photos of children or religous subjects. Also uses product shots for promotional material. Reviews stock photos. Model/property release required.

Specs Prefers images in digital format. Send via CD, Zip as TIFF, EPS, JPEG files at 300 dpi. Also uses 8 × 10 b&w and/or color prints; 35mm, 2¼ × 2¼, 4 × 5 transparencies.

Making Contact & Terms Send query letter with nonreturnable samples. Provide résumé, business card, brochure, flier or tearsheets to be kept on file for possible future assignments. Previously published work OK. Pays $50-1,000 for cover. Credit line always included for covers, never on promo. Buys one-time rights and all rights in every media; depends on

project; negotiable.

Tips "We like Web portfolios; we keep postcards, sample sheets on file if we like the style and/or subject matter."

Ⓝ ▣ Ⓐ ◑ CENTERSTREAM PUBLICATION

P.O. Box 17878, Anaheim CA 92807. Phone/fax: (714)779-9390. E-mail: centerstrm@aol. com. **Contact:** Ron Middlebrook, owner. Estab. 1982. Publishes music history, biographies, DVDs, music instruction (all instruments). Photos used for text illustrations, book covers. Examples of published titles: *Dobro Techniques*; *History of Leedy Drums*; *History of National Guitars*; *Blues Dobro*; *Jazz Guitar Christmas* (book covers).

Needs Reviews stock photos of music. Model release preferred. Photo captions preferred.

Specs Uses color and/or b&w prints; 35mm, 2¼ × 2¼, 4 × 5 transparencies. Accepts images in digital format. Send via Zip as TIFF files.

Making Contact & Terms Send query letter with samples and stock list. Send unsolicited photos by mail for consideration. Provide résumé, business card, brochure, flier or tearsheets to be kept on file for possible future assignments. Works on assignment only. Responds in 1 month. Simultaneous submissions and previously published work OK. Payment negotiable. **Pays on receipt of invoice.** Credit line given. Buys all rights.

$ CLEANING CONSULTANT SERVICES

P.O. Box 98757, Seattle WA 98198. (206)824-4434. Fax: (206)824-4554. E-mail: wgriffin@ cleaningconsultants.com. Website: www.cleaningconsultants.com. **Contact:** William R. Griffin, publisher. "We publish books on cleaning, maintenance and self-employment. Examples are related to janitorial, housekeeping, maid services, window washing, carpet cleaning and pressure washing, etc. We also publish a quarterly magazine for self-employed cleaners. For information and a free sample, visit www.cleaningbusiness.com." Photos used for text illustrations, promotional materials, book covers and all uses related to production and marketing of books.

Needs Buys 20-50 freelance photos/year; offers 5-15 freelance assignments/year. Needs photos of people doing cleaning work. "We are always looking for unique cleaning-related photos." Reviews stock (cleaning-related photos only). Model release preferred. Photo captions preferred.

Specs Uses 4 × 6, 5 × 7, 8 × 10 glossy color prints.

Making Contact & Terms Send query with résumé of credits, samples, list of stock photo subjects, or send unsolicited photos for consideration via e-mail. Provide résumé, business card, brochure, flier or tearsheets to be kept on file for possible future assignments. Responds in 3-4 weeks if interested. Simultaneous submissions and previously published work OK if not used in competitive publications. Pays $5-50/b&w photo; $5/color photo; $10-30/hour; $40-250/job; negotiable depending on specific project. Credit lines generally given. Buys all rights; depends on need and project.

Tips "We are especially interested in color photos of people doing cleaning work in USA and other countries for use on the covers of our publications. Be willing to work at reasonable rates. Selling 2 or 3 photos does not qualify you to earn top-of-the-line rates. We expect to use more photos, but they must be specific to our market, which is quite select. Don't send stock sample sheets that do not relate to our target audience. Send photos that fit our specific

interest only. E-mail if you need more information or would like specific guidance."

▣ $$ CONARI PRESS

Red Wheel/Weiser/Conari, 500 Third St., Suite 230, San Francisco, CA 94107. E-mail: info@ redwheelweiser.com. Website: www.redwheelweiser.com. **Contact:** Art Director. Estab. 1987. Publishes hardcover and trade paperback originals and reprints. Subjects include women's studies, psychology, parenting, inspiration, home and relationships (all nonfiction titles). Photos used for text illustrations, book covers, dust jackets.

Needs Buys 5-10 freelance photos /year. Looking for artful photos; subject matter varies. Interested in reviewing stock photos of most anything except high-tech, corporate or industrial images. Model release required. Photo caption s preferred; include photography copyright.

Specs Prefers images in digital format.

Making Contact & Terms Provide résumé, business card, self-promotion piece or tearsheets to be kept on file for possible future assignments. Art director will contact photographer for portfolio review if interested. Portfolio should include prints, tearsheets, slides, transparencies or thumbnails. Keeps samples on file. Simultaneous submissions and previously published work OK. Pays by the project: $400-1,000 for color cover; rates vary for color inside. Pays on publication. Credit line given on copyright page or back cover.

Tips "Review our website to make sure your work is appropriate."

▣ $ CRABTREE PUBLISHING COMPANY

PMB 16A, 350 Fifth Ave., Suite 3308, New York NY 10118. (800)387-7650. Fax: (800)355-7166. Website: www.crabtreebooks.com. **Contact:** Crystal Sikkens, photo researcher. Estab. 1978. Publishes juvenile nonfiction, library and trade. Subjects include science, cultural events, history, geography (including cultural geography), sports. Photos used for text illustrations, book covers. Examples of recently published titles: *The Mystery of the Bermuda Triangle, Environmental Activist, Paralympic Sports Events, Presidents' Day, Plant Cells, Bomb and Mine Disposal Officers.*

• This publisher also has offices in Canada, United Kingdom and Australia.

Needs Buys 20-50 photos/year. Wants photos of cultural events around the world, animals (exotic and domestic). Model/property release required for children, photos of artwork, etc. Photo captions preferred; include place, name of subject, date photographed, animal behavior.

Specs Uses high-resolution digital files (no JPEG compressed files).

Making Contact & Terms *Does not accept unsolicited photos.* Provide resume, business card, brochure, flier or tearsheets to be kept on file for possible future assignments. Simultaneous submissions and previously published work OK. Pays $100 for color photos. Pays on publication. Credit line given. Buys non-exclusive, worldwide and electronic rights.

Tips "Since our books are for younger readers, lively photos of children and animals are always excellent." Portfolio should be "diverse and encompass several subjects rather than just 1 or 2; depth of coverage of subject should be intense so that any publishing company could, conceivably, use all or many of a photographer's photos in a book on a particular subject."

▣ $ ◯ THE CREATIVE COMPANY

Imprint: Creative Editions. P.O. Box 227, Mankato MN 56002. (507)388-2024. Fax: (507)388-2746. E-mail: info@thecreativecompany.us. Website: www.thecreativecompany.us. **Contact**: Tricia Kleist, photo researcher. Estab. 1933. Publishes hardcover originals, textbooks for children. Subjects include animals, nature, geography, history, sports (professional and college), science, technology, biographies. Photos used for text illustrations, book covers. Examples of recently published titles: Let's Investigate Wildlife series (text illustrations, book cover); Ovations (biography) series (text illustrations, book cover). Catalog available for 9 × 12 SAE with $2 first-class postage. Photo guidelines free with SASE.

Needs Buys 2,000 stock photos/year. Needs photos of celebrities, disasters, environmental, landscapes/scenics, wildlife, architecture, cities/urban, gardening, pets, rural, adventure, automobiles, entertainment, health/fitness, hobbies, sports, travel, agriculture, industry, medicine, military, science, technology/computers. Other specific photo needs: NFL, NHL, NBA, Major League Baseball. Photo captions required; include photographer's or agent's name.

Specs Accepts images in digital format for Mac only. Send via CD as JPEG files.

Making Contact & Terms Send query letter with photocopies, tearsheets, stock list. Provide self-promotion piece to be kept on file for possible future assignments. Responds in 1 month to queries. Simultaneous submissions and previously published work OK. Pays $100-150 for cover; $50-150 for inside. Projects with photos and text are considered as well. Pays on publication. Credit line given. Buys one-time rights and foreign publication rights as requested.

Tips "Inquiries must include nonreturnable samples. After establishing policies and terms, we keep photographers on file and contact as needed. All photographers who agree to our policies can be included on our e-mail list for specific, hard-to-find image needs. We rarely use black-and-white or photos of people unless the text requires it. Project proposals must be for a 4-, 6-, or 8-book series for children."

▣ $ ◯ CREATIVE EDITIONS

The Creative Company, P.O. Box 227, Mankato MN 56002. Fax: (507)388-1364. E-mail: info@thecreativecompany.us. Website: www.thecreativecompany.us. **Contact:** Tricia Kleist, photo researcher. Estab. 1989. Publishes hardcover originals. Subjects include photo essays, biography, poetry, stories designed for children. Photos used for text illustrations, book covers, dust jackets. Examples of recently published titles: Little Red Riding Hood (text illustrations, book cover, dust jacket); Poe (text illustrations, book cover, dust jacket). Catalog available.

Needs Looking for photo-illustrated documentaries or gift books. Must include some text. Publishes 5-10 books/year.

Specs Uses any size glossy or matte color and/or b&w prints. Accepts images in digital format for Mac only. Send via CD as JPEG files at 72 dpi minimum (high-res upon request only).

Making Contact & Terms Send query letter with publication credits and project proposal, prints, photocopies, tearsheets of previous publications, stock list for proposed project. Responds in 1 month to queries. Simultaneous submissions and previously published work OK. Advance to be negotiated. Credit line given. Buys world rights for the book; photos

remain property of photographer.

Tips "Creative Editions publishes unique books for the book-lover. Emphasis is on aesthetics and quality. Completed manuscripts are more likely to be accepted than preliminary proposals. Please do not send slides or other valuable materials."

▣ $$ ◪ CREATIVE HOMEOWNER

24 Park Way, Upper Saddle River NJ 07458. (201)934-7100, ext. 375. Fax: (201)934-7541. E-mail: info@creativehomeowner.com. Website: www.creativehomeowner.com. **Contact:** Robyn Poplasky, photo researcher. Estab. 1975. Publishes soft cover originals, mass market paperback originals. Photos used for text illustrations, promotional materials, book covers. Examples of recently published titles: *Design Ideas for Curb Appeal*; *The Smart Approach to the Organized Home*; *1,001 Ideas for Architectural Trimwork*. Catalog available. Photo guidelines available via fax.

Needs Buys 1,000 freelance photos/year. Needs photos of architecture, interiors/decorating, some gardening. Other needs include interior and exterior design photography; garden beauty shots. Photo captions required; include photographer credit, designer credit, location, small description, if possible.

Specs Accepts images in digital format. Send via CD as TIFF files at 300 dpi. Transparencies are preferred.

Making Contact & Terms Send query letter with résumé, photocopies, tearsheets, transparencies, stock list. Provide résumé, business card, self-promotion piece to be kept on file for possible future assignments. Responds in 2 weeks to queries. Simultaneous submissions and previously published work OK. Pays $800 for color cover; $100-150 for color inside; $200 for back cover. Pays on publication. Credit line given. Buys one-time rights.

Tips "Be able to pull submissions for fast delivery. Label and document all transparencies for easy in-office tracking and return."

CREATIVE WITH WORDS PUBLICATIONS (CWW)

P.O. Box 223226, Carmel CA 93922. Fax: (831)655-8627. E-mail: geltrich@mbay.net. Website: http://members.tripod.com/CreativeWithWords. **Contact:** Brigitta Geltrich, editor. Estab. 1975. Publishes poetry and prose anthologies according to set themes. Black & white photos used for text illustrations, book covers. Photo guidelines free with SASE.

Needs Looking for theme-related b&w photos. Model/property release preferred.

Specs Uses any size b&w photos. "We will reduce to fit the page."

Making Contact & Terms Request theme list, then query with photos. Does not keep samples on file; include SASE for return of material. Responds 3 weeks after deadline if submitted for a specific theme. Payment negotiable. Pays on publication. Credit line given. Buys one-time rights.

▣ Ⓐ DOCKERY HOUSE PUBLISHING, INC.

P.O. Box 1237, Lindale TX 75771. (903)882-6900. Fax: (903)882-7607. E-mail: questions@ dockerypublishing.com. Website: www.dockerypublishing.com. **Contact:** Catrice Tradlec, director of photography. Publishes customized books and magazines. Subjects include food, travel, healthy living. Photos used for text illustrations, promotional materials, book

covers, magazine covers and articles. Examples of recently published titles: *The Magical Taste of Grilling*; *Total Health and Wellness*.

Needs Looking for lifestyle trends, people, travel, food, luxury goods. Needs vary. Reviews stock photos. Model release preferred.

Specs Uses all sizes and finishes of color and b&w prints; 35mm and digital.

Making Contact & Terms Send query letter with samples. Provide résumé, business card, brochure, flier or tearsheets to be kept on file for possible future assignments. Works on assignment only. Keeps samples on file. Cannot return material. Payment negotiable. Pays net 30 days. Buys all rights; negotiable.

Ⓝ ▣ Ⓢ $ ◲ DOWN THE SHORE PUBLISHING CORP.

P.O. Box 100, West Creek NJ 08092. Fax: (609)597-0422. E-mail: info@down-the-shore. com. Website: www.down-the-shore.com. **Contact:** Raymond G. Fisk, publisher. Estab. 1984. Publishes regional calendars; seashore, coastal, and regional books (specific to the mid-Atlantic shore and New Jersey). Photos used for text illustrations, scenic calendars (New Jersey and mid-Atlantic only). Examples of recently published titles: *Great Storms of the Jersey Shore* (text illustrations); *NJ Lighthouse Calendar* (illustrations, cover); *Shore Stories* (text illustrations, dust jacket). Photo guidelines free with SASE or on website.

Needs Buys 30-50 photos/year. Needs scenic coastal shots, photos of beaches and New Jersey lighthouses (New Jersey and mid-Atlantic region). Interested in seasonal. Reviews stock photos. Model release required; property release preferred. Photo captions preferred; *specific location* identification essential.

Specs "We have a very limited use of prints." Prefers 35mm, 2¼ × 2¼, 4 × 5 transparencies. Accepts digital submissions via high-resolution files on CD. Refer to guidelines before submitting.

Making Contact & Terms Send query letter with stock list. Provide résumé, business card, brochure, flier or tearsheets to be kept on file for possible future requests. Responds in 6 weeks. Previously published work OK. Pays $100-200 for b&w or color cover; $10-100 for b&w or color inside. Pays 90 days from publication. Credit line given. Buys one-time or book rights; negotiable.

Tips "We are looking for an honest depiction of familiar scenes from an unfamiliar and imaginative perspective. Images must be specific to our very regional needs. Limit your submissions to your best work. Edit your work very carefully."

Ⓝ $ ◻ EMPIRE PUBLISHING SERVICE

Imprints: Gaslight, Empire, Empire Music & Percussion. P.O. Box 1344, Studio City CA 91614-0344. (818)784-8918. **Contact:** J. Cohen, art director. Estab. 1960. Publishes hardcover and trade paperback originals and reprints, textbooks. Subjects include entertainment, plays, health, Sherlock Holmes, music. Photos used for text illustrations, book covers. Examples of recently published titles: *Men's Costume Cut and Fashion, 17th Century* (text illustrations); *Scenery* (text illustrations).

Needs Needs photos of celebrities, entertainment, events, food/drink, health/fitness, performing arts. Interested in fashion/glamour, historical/vintage. Model release required. Photo captions required.

Specs Uses 8 × 10 glossy prints.

Making Contact & Terms Send query letter with résumé, samples. Provide résumé, business card to be kept on file for possible future assignments. Responds only if interested; send nonreturnable samples. Simultaneous submissions considered depending on subject and need. Pays on publication. Credit line given. Buys all rights.

Tips "Send appropriate samples of high-quality work only. Submit samples that can be kept on file and are representative of your work."

Ⓝ F+W MEDIA

Imprints: Writer's Digest Books, HOW Books, Betterway Books, North Light Books, IMPACT Books, Popular Woodworking Books, Memory Makers Books, Adams Media, David & Charles, Krause Publications. 4700 E. Galbraith Rd., Cincinnati OH 45236. Website: www. fwmedia.com. **Contact:** Art Directors: Grace Ring, Marissa Bowers, Wendy Dunning, Claudean Wheeler. Publishes 120 books/year for writers, artists, graphic designers and photographers, plus selected trade (humor, lifestyle, home improvement) titles.

Needs Tries to fill photo needs through stock first, before making assignments.

Making Contact & Terms Send nonreturnable photocopies of printed work to be kept on file. Art director will contact photographer for portfolio review if interested. "Pay rates usually depend on the scope of the project; $1,000 for a cover is pretty typical." Considers buying second rights (reprint rights) to previously published photos. "We like to know where art was previously published." Finds photographers through word of mouth, submissions, self promotions.

Tips "Don't call. Send appropriate samples we can keep."

Ⓝ ▣ Ⓢ $ ⊘ FORT ROSS INC.

26 Arthur Place, Yonkers NY 10701-1703. (914)375-6448. E-mail: fortross@optonline.net. Website: www.fortrossinc.com. **Contact:** Vladimir Kartsev, executive director. Estab. 1992. Co-publishes hardcover reprints, trade paperback originals; offers photos to East European publishers and advertising agencies. Subjects include romance, science fiction, fantasy. Photos used for book covers.

Needs Buys up to 200 photos/year. Needs photos of couples, "clinches," jewelry, flowers. Interested in alternative process, fashion/glamour. Model release required. Photo captions preferred.

Specs Accepts images in digital format. Send via CD, e-mail as JPEG files.

Making Contact & Terms Send query letter with photocopies. Provide self-promotion piece to be kept on file for possible future assignments. Responds only if interested. Simultaneous submissions and previously published work OK. Pays $50-150 for color images. **Pays on acceptance**. Buys one-time rights.

$ ◯ FORUM PUBLISHING CO.

Imprint: Retailers Forum. 383 E. Main St., Centerport NY 11721. (631)754-5000. Fax: (631)754-0630. E-mail: forumpublishing@aol.com. Website: www.forum123.com. **Contact:** Marti, art director. Estab. 1981. Publishes trade magazines and directories.

Needs Buys 24 freelance photos/year. Needs photos of humor, business concepts, industry, product shots/still life. Interested in seasonal. Other photo needs include humorous and creative use of products and merchandise. Model/property release preferred.

Specs Uses any size color prints; 4 × 5, 8 × 10 transparencies.

Making Contact & Terms Send query letter with prints. Does not keep samples on file; include SASE for return of material. Responds in 2 weeks to queries. Simultaneous submissions and previously published work OK. Works with local freelancers only. Pays $50-100 for color cover. **Pays on acceptance.** Credit line sometimes given. Buys one-time rights.

Tips "We publish trade magazines and directories and are looking for creative pictures of products/merchandise. Call Marti for complete details."

Ⓝ Ⓔ ☑ GRYPHON HOUSE

6848 Leons Way, Lewisville NC 27023. (800)638-0928. Fax: (301)595-0051. E-mail: rosanna@ghbooks.com. Website: www.ghbooks.com. **Contact:** Rosanna Mollett, art director. Estab. 1970. Publishes educational resource materials for teachers and parents of young children. Examples of recently published titles: *Great Games for Young Children* (text illustrations); *Starting With Stories* (book cover).

Needs Looking for b&w and color photos of young children (from birth to 6 years.) Reviews stock photos. Model release required.

Specs Uses 5x7 glossy color (cover only) and b&w prints. Accepts images in digital format. Send via CD, Zip, e-mail as TIFF files at 300 dpi.

Making Contact & Terms Send query letter with samples and stock list. Keeps samples on file. Simultaneous submissions OK. Payment negotiable. **Pays on receipt of invoice.** Credit line given. Buys book rights.

⊠ Ⓔ $ GUERNICA EDITIONS, INC.

P.O. Box 117, Station P, Toronto ON M5S 2S6 Canada. Fax: (416)657-8885. Website: www.guernicaeditions.com. **Contact:** Antonio D'Alfonso, editor. Estab. 1978. Publishes adult trade (literary). Photos used for book covers. Examples of recently published titles: *Barry Callagan: Essays on His Work*, edited by Priscila Uppal; *Mary Di Michele: Essays on Her Works*, edited by Joseph Pivato; *Maria Mazziotti: Essays on Her Works*, edited by Sean Thomas Doughtery; *Mary Melfi*: *Essays on Her Works*, edited by William Anselmi.

Needs Buys varying number of photos/year; "often" assigns work. Needs life events, including characters; houses. Photo captions required.

Specs Uses color and/or b&w prints. Accepts images in digital format. Send via CD, Zip as TIFF, GIF files at 300 dpi minimum.

Making Contact & Terms Send query letter with samples. Does not accept manuscript enquiries by e-mail. Sometimes keeps samples on file. Cannot return material. Responds in 2 weeks. Pays $150 for cover. Pays on publication. Credit line given. Buys book rights. "Photo rights go to photographers. All we need is the right to reproduce the work."

Tips "Look at what we do. Send some samples. If we like them, we'll write back."

Ⓔ ☐ HERALD PRESS

616 Walnut Ave., Scottdale PA 15683. (724)887-8500. Fax: (724)887-3111. E-mail: merrill@mpn.net. Website: www.mpn.net. **Contact:** Design Director. Estab. 1908. Photos used for book covers, dust jackets. Examples of published titles: *Simply In Season; What IS Iran?; Where Was God on September 11?* (all cover shots).

Needs Buys 5 photos/year; offers occasional freelance assignments. Subject matter varies. Reviews stock photos of people and other subjects including religious, environmental. Model/property release required. Photo captions preferred; include identification information.
Specs Prefers images in digital format. Submit URL or link to Web pages or light box.
Making Contact & Terms Send query letter or e-mail with samples. Provide résumé, business card, brochure, flier or tearsheets to be kept on file for possible future assignments. Keeps samples on file. Works on assignment only or selects from file of samples. Simultaneous submissions and previously published work OK. Payment negotiable. **Pays on acceptance.** Credit line given. Buys book rights; negotiable.
Tips "We put your résumé and samples on file. It is best to direct us to your website."

▣ ◡ HYPERION BOOKS FOR CHILDREN

114 Fifth Ave., New York NY 10011. (914)288-4100. Fax: (212)807-5880. Website: www. hyperionchildrensbooks.com. **Contact:** Susan Masry, design coordinator. Publishes children's books, including picture books and books for young readers. Subjects include adventure, animals, history, multicultural, sports. Catalog available for 9 × 12 SAE with 3 first-class stamps.
Needs Needs photos of multicultural subjects.
Making Contact & Terms Provide résumé, business card, self-promotion piece to be kept on file for possible future assignments. Pays royalties based on retail price of book, or a flat fee.

▣ ▣ $ $ ☑ JUDICATURE

2700 University Ave., Des Moines IA 50311. (773)973-0145. Fax: (773)338-9687. E-mail: drichert@ajs.org. Website: www.ajs.org. **Contact:** David Richert, editor. Estab. 1917. Publishes legal journal, court and legal books. Photos used for text illustrations, cover of bimonthly journal.
Needs Buys 10-12 photos/year; occasionally offers freelance assignments. Looking for photos relating to courts, the law. Reviews stock photos. Model/property release preferred. Photo captions preferred.
Specs Uses 5 × 7 color and/or b&w prints; 35mm transparencies. Prefers images in digital format.
Making Contact & Terms Send query letter with samples. Works on assignment only. Keeps samples on file. Responds in 2 weeks. Simultaneous submissions and previously published work OK. Pays $250-350 for cover; $125-300 for color inside; $125-250 for b&w inside. **Pays on receipt of invoice.** Credit line given. Buys one-time rights.

▣ $ LAYLA PRODUCTION INC.

370 E. 76th St., New York NY 10021. (212)879-6984. E-mail: laylaprod@aol.com. **Contact:** Lori Stein, manager. Estab. 1980. Publishes adult trade and how-to gardening. Photos used for text illustrations, book covers. Examples of recently published titles: *Spiritual Gardening* and *American Garden Guides*, 12 volumes (commission or stock, over 4,000 editorial photos).
Needs Buys over 150 photos/year; offers 6 freelance assignments/year. Needs photos of gardening.

Making Contact & Terms Provide résumé, business card, brochure, flier or tearsheets to be kept on file for possible future assignments. Prefers no unsolicited material. Simultaneous submissions and previously published work OK. Pays $50-300 for color photos; $50-300 for b&w photos; $30-75/hour; $250-500/day. Other methods of pay depend on job, budget and quality needed. Buys all rights.

Tips "We're usually looking for a very specific subject. We do keep all résumés/brochures received on file—but our needs are small, and we don't often use unsolicited material."

▣ $ $ ◪ LERNER PUBLISHING GROUP, INC.

241 First Ave. N., Minneapolis MN 55401. (612)332-3344. Fax: (612)332-7615. E-mail: dwallek@lernerbooks.com. Website: www.lernerbooks.com. **Contact:** Dan Wallek, director of electronic content and photo research. Estab. 1959. Publishes educational books for grades K-12. Subjects include animals, biography, history, geography, science, vehicles, and sports. Photos used for editorial purposes for text illustrations, promotional materials, book covers. Examples of recently published titles: *A Temperate Forest Food Chain—Follow That Food* (text illustrations, book cover); *Protecting Earth's Water Supply—Saving Our Living Earth* (text illustrations, book cover).

Needs Buys more than 6,000 photos/year; occasionally offers assignments. Needs photos of children/teens, celebrities, multicultural, families, disasters, environmental, landscapes/scenics, wildlife, cities/urban, education, pets, rural, hobbies, sports, agriculture, industry, political, science, vehicles, technology/computers. Model/property release preferred when photos are of social issues (e.g., the homeless). Photo captions required; include who, where, what and when.

Specs Prefers images in digital format. Send via FTP, CD, or e-mail as TIFF or JPEG files at 300 dpi.

Making Contact & Terms Send query letter with detailed stock list by mail, fax or e-mail. Provide current editorial use pricing. "No calls, please." Cannot return material. Responds only if interested. Previously published work OK. Pays by the project: $150-400 for cover; $50-150 for inside. **Pays on receipt of invoice.** Credit line given. Licenses images for book based on print-run rights, electronic rights, all language rights, worldwide territory rights.

Tips Prefers crisp, clear images that can be used editorially. "Send in as detailed a stock list as you can (including fees for clearing additional rights), and be willing to negotiate price."

Ⓝ Ⓐ MBI PUBLISHING COMPANY

Imprints: Motorbooks, Zenith Press, Voyageur Press, MBI. 400 First Ave N., Suite 300, Minneapolis MN 55401. (612)344-8100. Fax: (651)287-5001. E-mail: mlabarre@mbipublishing.com. Website: www.mbipublishing.com. **Contact:** Photo Researcher. Estab. 1965. Publishes trade, specialist and how-to automotive, aviation and military, as well as regional U.S. travel, Americana, collectibles, nature/wildlife, country life, history. Photos used for text illustrations, book covers, dust jackets. Examples of recently published titles: *Organic Farming: Everything You Need to Know; The Surfboard: Art, Style, Stoke; Harley-Davidson; Jeep Offroad; Leave No Man Behind: The Saga of Combat Search and Rescue.*

Needs Anything to do with transportation, including tractors, motorcycles, bicycles, trains, aviation, automobiles, construction equipment. Also wants photos of Americana, regional

U.S. travel, country life, nature. Model release preferred.

Making Contact & Terms "Present a résumé and cover letter first, and we'll follow up with a request to see samples." Unsolicited submissions of original work are discouraged. Works on assignment typically as part of a book project. Responds in 10 weeks. Simultaneous submissions and previously published work OK. Payment negotiable. Credit line given. Rights negotiable.

🖥 $ $ $ ☑ MCGRAW-HILL

1333 Burr Ridge Parkway, Burr Ridge IL 60527. (630)789-4000. Fax: (614)759-3749. Website: www.mhhe.com. Publishes hardcover originals, textbooks, CD-ROMs. Photos used for book covers.

Needs Buys 20 freelance photos/year. Needs photos of business concepts, industry, technology/computers.

Specs Uses 8 × 10 glossy prints; 35mm, 2¼ × 2¼, 4 × 5 transparencies. Accepts images in digital format. Send via CD.

Making Contact & Terms Contact through rep. Provide business card, self-promotion piece to be kept on file for possible future assignments. Responds only if interested. Previously published work OK. Pays $650-1,000 for b&w cover; $650-1,500 for color cover. Pays extra for electronic usage of photos. Pays on publication. Credit line given. Buys one-time rights.

🖥 Ⓢ $ MITCHELL LANE PUBLISHERS, INC.

P.O. Box 196, Hockessin DE 19707. (302)234-9426. Fax: (302)234-4742. E-mail: mitchelllane@ mitchelllane.com. Website: www.mitchelllane.com. **Contact:** Barbara Mitchell, publisher. Estab. 1993. Publishes hardcover originals for library market. Subjects include biography and other nonfiction for children and young adults. Photos used for text illustrations, book covers. Examples of recently published titles: *Meet Our New Student from Nigeria* (text illustrations and book cover); *A Backyard Flower Garden for Kids*(text illustrations, book cover).

Needs Photo captions required.

Specs Accepts images in digital format. Send via CD as TIFF, JPEG files at 300 dpi.

Making Contact & Terms Send query letter with stock list (stock photo agencies only). Does not keep samples on file; cannot return material. Responds only if interested. Pays on publication. Credit line given. Buys one-time rights.

Ⓝ $ $ MUSIC SALES GROUP

257 Park Ave. S., 20th Floor, New York NY 10010. (212)254-2100. Fax: (212)254-2013. E-mail: de@musicsales.com. Website: www.musicsales.com. **Contact:** Daniel Earley. Publishes instructional music books, song collections and books on music. Photos used for covers and/or interiors. Examples of recently published titles: *Bob Dylan: Time Out of Mind*; *Paul Simon: Songs from the Capeman*; *AC/DC: Bonfire*.

Needs Buys 200 photos/year. Model release required on acceptance of photo. Photo captions required.

Specs Uses 8 × 10 glossy prints; 35mm, 2 × 2, 5 × 7 transparencies.

Making Contact & Terms Send query letter first with résumé of credits. Provide business card, brochure, flier or tearsheets to be kept on file for possible future assignments. Responds

in 2 months. Simultaneous submissions and previously published work OK. Pays $75-100 for b $250-750 for color.

Tips In samples, wants to see "the ability to capture the artist in motion with a sharp eye for framing the shot well. Portraits must reveal what makes the artist unique. We need rock, jazz, classical—onstage and impromptu shots. Please send us an inventory list of available stock photos of musicians. We rarely send photographers on assignment and buy mostly from material on hand." Send business card and tearsheets or prints stamped 'proof' across them. Due to the nature of record releases and concert events, we never know exactly when we may need a photo. We keep photos on permanent file for possible future use."

▣ $ PAULIST PRESS

997 Macarthur Blvd., Mahwah NJ 07430. (201)825-7300. Fax: (201)825-8345. E-mail: pmcmahon@paulistpress.com. Website: www.paulistpress.com. **Contact:** Paul McMahon, managing editor. Estab. 1857. Publishes hardcover and trade paperback originals, juvenile and textbooks. Types of books include religion, theology and spirituality including biography. Specializes in academic and pastoral theology. Recent titles include *He Said Yes, Finding Purpose in Narnia,* and *Our Daily Bread.* Publishes 90 titles/year; 5% requires freelance illustration; 5% require freelance design. Paulist Press also publishes the general trade imprint HIDDENSPRING.

Needs Works with 5 illustrators and 10 designers/year. Prefers local freelancers particularly for juvenile titles, jacket/cover, and text illustration. Prefers knowledge of QuarkXPress. Works on assignment only.

Making Contact & Terms Send query letter with brochure, résumé and tearsheets. Samples are filed. Portfolio review not required. Negotiates rights purchased. Originals are returned at job's completion if requested. Book design assigns 8 freelance design jobs/year. Jackets/Covers assigns 30 freelance design jobs/year. Pays by the project, $400-$800. Text Illustration assigns 5 freelance illustration jobs/year. Pays by the project.

ℕ ▣ ⓢ $ ⊘ PLAYERS PRESS INC.

P.O. Box 1132, Studio City CA 91614. **Contact:** David Cole, vice president. Estab. 1965. Publishes entertainment books including theater, film and television. Photos used for text illustrations, promotional materials, book covers, dust jackets. Examples of recently published titles: *Women's Wear for the 1930s* (text illustrations); *Period Costume for Stage & Screen* (text illustrations).

Needs Buys 50-1,000 photos/year. Needs photos of entertainers, actors, directors, theaters, productions, actors in period costumes, scenic designs and clowns. Reviews stock photos. Model release required for actors, directors, productions/personalities. Photo captions preferred for names of principals and project/production.

Specs Uses 8 × 10 glossy or matte b&w prints; 5 × 7 glossy color prints; 35mm, 2¼ × 2¼ transparencies. Accepts images in digital format. Send via Zip as TIFF files at 600 dpi.

Making Contact & Terms Send query letter with list of stock photo subjects. Send unsolicited photos by mail for consideration; include SASE for return of material. Responds in 3 weeks. Simultaneous submissions and previously published work OK. Pays $1-100 for b&w cover; $1-500 for color cover; by the project, $10-100 for cover shots; $1-50 for b&w and color inside; by the project, $10-100 for inside shots. Credit line sometimes given, depending on

book. Buys all rights; negotiable in "rare cases."

Tips Wants to see "photos relevant to the entertainment industry. Do not telephone; submit only what we ask for."

◧ ⊘ PRAKKEN PUBLICATIONS, INC.

832 Phoenix Dr., P.O. Box 8623, Ann Arbor MI 48107. (734)975-2800. Fax: (734)975-2787. Website: http://techdirections.com or http://eddigest.com. **Contact**: Sharon K. Miller, art/design/production manager. Estab. 1934. Publishes *The Education Digest* (magazine), *Tech Directions* (magazine for technology and career/technical educators), text and reference books for technology and career/technical education, and posters. Photos used for text illustrations, promotional materials, book covers, magazine covers and posters. Photo guidelines available at website.

Needs Wants photos of education "in action," especially technology, career/technical education and general education; prominent historical figures, technology/computers, industry. Photo captions required; include scene location, activity.

Specs Uses all media; any size. Accepts images in digital format. Send via CD, Zip as TIFF, EPS, JPEG files at 300 dpi.

Making Contact & Terms Send query letter with samples. Send unsolicited photos by mail for consideration. Keeps samples on file. Payment negotiable. Methods of payment to be arranged. Credit line given. Rights negotiable.

Tips Wants to see "high-quality action shots in tech/career tech-ed and general education classrooms" when reviewing portfolios. Send inquiry with relevant samples to be kept on file. "We buy very few freelance photographs but would be delighted to see something relevant."

◧ $ $ ⊘ RUNNING PRESS BOOK PUBLISHERS

The Perseus Books Group, 2300 Chestnut St., Suite 200, Philadelphia PA 19103. (215)567-5080. Fax: (215)567-4636. E-mail: perseus.promos@perseusbooks.com. Website: www.runningpress.com. **Contact:** Sue Oyama, photo editor. Estab. 1972. Publishes hardcover originals, trade paperback originals. Subjects include adult and children's nonfiction; cooking; photo pictorials on every imaginable subject; kits; miniature editions. Photos used for text illustrations, promotional materials, book covers, dust jackets. Examples of recently published titles: *Desperate Housecats*; *Steven Caney's Ultimate Building Book*; *Wine Enthusiast Pocket Guide to Wine*.

Needs Buys a few hundred freelance photos/year. Needs photos for gift books; photos of wine, food, lifestyle, landscapes/scenics, wildlife, architecture, cities/urban, gardening, interiors/decorating, rural, hobbies, performing arts, travel. Interested in fine art, folk art, historical/vintage, seasonal. Model/property release preferred. Photo captions preferred; include exact locations, names of pertinent items or buildings, names and dates for antiques or special items of interest.

Specs Uses b&w prints; medium- and large-format transparencies. Accepts images in digital format. Send via CD as TIFF, EPS files at 300 dpi.

Making Contact & Terms Send stock list and provide business card, self-promotion piece to be kept on file for possible future assignments. Do not send original art. Responds only if interested. Simultaneous submissions and previously published work OK. Pays $300-500

for color cover; $100-250 for inside. Pays on publication. Credit line given. Credits listed on separate copyright or credit pages. Buys one-time rights.

Tips "Look at our catalog on the website."

▣ $ ◯ SENTIENT PUBLICATIONS, LLC

1113 Spruce St., Boulder CO 80302. (303)443-2188. Fax: (303)381-2538. E-mail: cshaw@ sentientpublications.com. Website: www.sentientpublications.com. **Contact:** Connie Shaw, editor. Estab. 2001. Publishes trade paperback originals and reprints. Subjects include education, ecology, spirituality, travel, publishing, self-help, health, parenting. Photos used for book covers. Examples of recently published titles: *The Shut-Down Learner, You Can Beat the Odds.* Catalog free with #10 SASE.

Needs Buys 8 freelance photos/year. Needs photos of babies/children/teens, landscape/ scenics, religious. Interested in avant garde.

Specs Accepts images in digital format. Send via e-mail as TIFF files at 300 dpi.

Making Contact & Terms Send query letter with résumé, prints, photocopies, stock list. Provide self-promotion piece to be kept on file for possible future assignments. Responds only if interested; send nonreturnable samples. Simultaneous submissions and previously published work OK. Pays $300 maximum for color cover. Pays on publication. Credit line given. Buys one-time rights.

Tips "Look at our website for the kind of cover art we need."

ℕ ▣ Ⓐ ◖ TRICYCLE PRESS

Ten Speed Press. P.O. Box 7123-S, Berkeley CA 94707. (510)559-1600. Fax: (510)559-1629. Website: www.tricyclepress.com. **Contact:** The Editors. Estab. 1993. Publishes children's books, including board books, picture books, and books for middle readers. Photos used for text illustrations and book covers. Example of recently published titles: *Busy Barnyard* (photography by Stepven Holt).

Needs Needs photos of children, multicultural, wildlife, performing arts, science.

Specs Uses 35mm transparencies; also accepts images in digital format.

Making Contact & Terms Responds only if interested; send nonreturnable samples. Pays royalties of 7¾-8¾%, based on net receipts.

Tips "Tricycle Press is looking for something outside the mainstream; books that encourage children to look at the world from a different angle. Like its parent company, Ten Speed Press, Tricycle Press is known for its quirky, offbeat books. We publish high-quality trade books."

ℕ $ $ $ ☑ TYNDALE HOUSE PUBLISHERS

351 Executive Dr., Carol Stream IL 60188. Website: www.tyndale.com. **Contact:** Talinda Iverson, art buyer. Estab. 1962. Publishes hardcover and trade paperback originals. Subjects include Christian content. Photos used for promotional materials, book covers, dust jackets. Examples of recently published titles: *Inside the Revolution, First Things First.* Photo guidelines free with #10 SASE.

Needs Buys 5-20 freelance photos/year. Needs photos of babies/children/teens, couples, multicultural, families, parents, senior citizens, landscapes/scenics, cities/urban, gardening, religious, rural, adventure, entertainment. Model/property release required.

Specs Accepts hard copy samples only.

Making Contact & Terms Send query letter with prints, tearsheets. Provide self-promotion piece to be kept on file for possible future assignments. Responds only if interested; send nonreturnable samples. Simultaneous submissions OK. Pays by the project; $200-1,750 for cover; $100-500 for inside. **Pays on acceptance**. Credit line given.

Tips "We don't have portfolio viewings. Negotiations are different for every project. Have every piece submitted with legible contact information."

N P A $ VICTORY PRODUCTIONS

55 Linden St., Worcester MA 01609. (508)755-0051. Fax: (508)755-0025. E-mail: susan.littlewood@ victoryprd.com. Website: www.victoryprd.com. **Contact:** Susan Littlewood. Publishes children's books. Examples of recently published titles: *OPDCA Readers* (text illustrations); *Ecos del Pasado* (text illustrations); *Enciclopedia Puertorriquena* (text illustrations).

Needs Needs a wide variety of photographs. "We do a lot of production for library reference and educational companies." Model/property release required.

Specs Accepts images in digital format. Send via CD, e-mail, floppy disk, Jaz, SyQuest, Zip as TIFF, GIF, JPEG files.

Making Contact & Terms Provide résumé, business card, brochure, flier or tearsheets to be kept on file for possible future assignments. Works on assignment only. Keeps samples on file. Responds in 1-2 weeks. Payment negotiable; varies by project. Credit line usually given, depending upon project. Rights negotiable.

P $$ VOYAGEUR PRESS

MBI Publishing Company, 729 Prospect Ave., P.O. Box 1, Osceola WI 54020. (715) 294-3345. Fax: (715) 294-4448. Website: www.mbipublishing.com or www.voyageurpress. com. **Contact:** Publishing Assistant. Estab. 1972. Publishes adult trade books, hardcover originals and reprints. Subjects include regional history, nature, popular culture, travel, wildlife, Americana, collectibles, lighthouses, quilts, tractors, barns and farms. Photos used for text illustrations, book covers, dust jackets, calendars. Examples of recently published titles: *Legendary Route 66: A Journey Through Time Along America's Mother Road; Illinois Central Railroad; Birds in Love: The Secret Courting & Mating Rituals of Extraordinary Birds; Backroads of New York; How to Raise Cattle; Knitknacks; Much Ado About Knitting; Farmall: The Red Tractor that Revolutionzed Farming; Backroads of Ohio; Farmer's Wife Baking Cookbook; John Deere Two-Cylinder Tractor Encyclopedia* (text illustrations, book covers, dust jackets). Photo guidelines free with SASE.

- Voyageur Press is an imprint of MBI Publishing Company (see separate listing in this section).

Needs Buys 500 photos/year. Wants photos of wildlife, Americana, environmental, landscapes/scenics, cities/urban, gardening, rural, hobbies, humor, travel, farm equipment, agricultural. Interested in fine art, historical/vintage, seasonal. "Artistic angle is crucial—books often emphasize high-quality photos." Model release required. Photo captions preferred; include location, species, "interesting nuggets," depending on situation.

Specs Uses 35mm and large-format transparencies. Accepts images in digital format for review only; prefers transparencies for production. Send via CD, Zip, e-mail as TIFF, BMP, GIF, JPEG files at 300 dpi.

Making Contact & Terms Provide résumé of credits, samples, brochure, detailed stock list or tearsheets. Cannot return material. Responds only if interested; send nonreturnable samples. Simultaneous submissions OK. Pays $300 for cover; $75-175 for inside. Pays on publication. Credit line given, "but photographer's website will not be listed." Buys all rights; negotiable.

Tips "We are often looking for specific material (crocodile in the Florida Keys; farm scenics in the Midwest; wolf research in Yellowstone), so subject matter is important. However, outstanding color and angles and interesting patterns and perspectives are strongly preferred whenever possible. If you have the capability and stock to put together an entire book, your chances with us are much better. Though we use some freelance material, we publish many more single-photographer works. Include detailed captioning info on the mounts."

▣ Ⓢ $ ◪ WAVELAND PRESS, INC.

4180 IL Rt. 83, Suite 101, Long Grove IL 60047-9580. (847)634-0081. Fax: (847)634-9501. E-mail: info@waveland.com. Website: www.waveland.com. **Contact:** Jan Weissman, photo editor. Estab. 1975. Publishes college textbooks. Photos used for text illustrations, book covers. Examples of recently published titles: *Our Global Environment: A Health Perspective, 6th Edition; Juvenile Justice, 2nd Edition.*

Needs Number of photos purchased varies depending on type of project and subject matter. Subject matter should relate to college disciplines: criminal justice, anthropology, speech/communication, sociology, archaeology, etc. Needs photos of multicultural, disasters, environmental, cities/urban, education, religious, rural, health/fitness, agriculture, political, technology. Interested in fine art, historical/vintage. Model/property release required. Photo captions preferred.

Specs Accepts images in digital format. Send via CD, Zip, e-mail as TIFF, EPS, JPEG files at 300 dpi.

Making Contact & Terms Send query letter with stock list. Provide résumé, business card, brochure, flier or tearsheets to be kept on file for possible future assignments. Simultaneous submissions and previously published work OK. Pays $100-200 for cover; $50-100 for inside. Pays on publication. Credit line given. Buys one-time and book rights.

Tips "Mail stock list and price list."

Ⓝ ▣ $ $ ◪ WILLOW CREEK PRESS

P.O. Box 147, Minocqua WI 54548. (715)358-7010. Fax: (715)358-2807. E-mail: joyr@willowcreekpress.com. Website: www.willowcreekpress.com. **Contact:** Joy Rasmussen, art director. Estab. 1986. Publishes hardcover, paperback and trade paperback originals; hardcover and paperback reprints; calendars and greeting cards. Subjects include pets, outdoor sports, gardening, cooking, birding, wildlife. Photos used for text illustrations, promotional materials, book covers, dust jackets, calendars and greeting cards. Examples of recently published titles: *Pug Mugs, Horse Wisdom, How to Work Like a Cat.* Catalog free with #10 SASE. Photo guidelines free with #10 SASE or on website.

Needs Buys 2,000 freelance photos /year. Needs photos of gardening, pets, outdoors, recreation, landscapes/scenics, wildlife. Model/property release required. Photo captions required.

Specs Uses only digital format. Send 300dpi JPEGS and TIFFS.

Making Contact & Terms Send query letter with sample of work. Provide self-promotion piece to be kept on file. Responds only if interested. Simultaneous submissions and previously published work OK. Pays by the project. Pays on publication. Credit line given. Buys one-time rights.

Tips "CDs are hard to browse as quickly as a slide sheet or prints. Slides or transparencies are best, as the quality can be assessed immediately. Be patient. Communicate through e-mail. Will not review submissions on CDs or websites - printouts only."

▣ ⑤ $ ☑ WILSHIRE BOOK COMPANY

9731 Variel Ave., Chatsworth CA 91311-4315. (818)700-1522. Fax: (818)700-1527. E-mail: mpowers@mpowers.com. Website: www.mpowers.com. **Contact**: Melvin Powers, president. Estab. 1947. Publishes trade paperback originals and reprints. Photos used for book covers.

Needs Needs photos of horses. Model release required.

Specs Uses 35mm, 2¼ × 2¼, 4 × 5 transparencies. Accepts images in digital format. Send via floppy disk, e-mail.

Making Contact & Terms Send query letter with slides, prints, transparencies. Portfolio may be dropped off Monday through Friday. Does not keep samples on file; include SASE for return of material. Responds in 6 weeks. Simultaneous submissions and previously published work OK. Pays $250 for color cover. **Pays on acceptance**. Credit line given.

Greeting Cards, Posters & Related Products

The greeting card industry takes in close to $7.5 billion per year—80 percent through the giants American Greetings and Hallmark Cards. Naturally, these big companies are difficult to break into, but there is plenty of opportunity to license your images to smaller companies.

There are more than 2,000 greeting card companies in the United States, many of which produce low-priced cards that fill a niche in the market, focusing on anything from the cute to the risqué to seasonal topics. A number of listings in this section produce items like calendars, mugs and posters, as well as greeting cards.

Before approaching greeting card, poster or calendar companies, it's important to research the industry to see what's being bought and sold. Start by checking out card, gift and specialty stores that carry greeting cards and posters. Pay attention to the selections of calendars, especially the large seasonal displays during December. Studying what you see on store shelves will give you an idea of what types of photos are marketable.

Greetings etc., published by Edgell Publications, is a trade publication for marketers, publishers, designers and retailers of greeting cards. The magazine offers industry news and information on trends, new products, and trade shows. Look for the magazine at your library or visit their Web site: www.greetingsmagazine.com. Also the National Stationery Show (www.nationalstationeryshow.com) is a large trade show held every year in New York City. It is the main event of the greeting card industry.

APPROACHING THE MARKET

After your initial research, query companies you are interested in working with and send a stock photo list. (See sample stock list on page 17.) You can help narrow your search by consulting the Subject Index on page 507. Check the index for companies interested in the subjects you shoot.

Since these companies receive large volumes of submissions, they often appreciate knowing what is available rather than actually receiving samples. This kind of query can lead to future sales even if your stock inventory doesn't meet

their immediate needs. Buyers know they can request additional submissions as their needs change. Some listings in this section advise sending quality samples along with your query while others specifically request only a list. As you plan your queries, follow the instructions to establish a good rapport with companies from the start.

Some larger companies have staff photographers for routine assignments but also look for freelance images. Usually, this is in the form of stock, and images are especially desirable if they are of unusual subject matter or remote scenic areas for which assignments—even to staff shooters—would be too costly. Freelancers are usually offered assignments once they have established track records and demonstrated a flair for certain techniques, subject matter or locations. Smaller companies are more receptive to working with freelancers, though they are less likely to assign work because of smaller budgets for photography.

The pay in this market can be quite lucrative if you provide the right image at the right time for a client in need of it, or if you develop a working relationship with one or a few of the better-paying markets. You should be aware, though, that one reason for higher rates of payment in this market is that these companies may want to buy all rights to images. But with changes in the copyright law, many companies are more willing to negotiate sales that specify all rights for limited time periods or exclusive product rights rather than complete surrender of copyright. Some companies pay royalties, which means you will earn the money over a period of time based on the sales of the product.

▣ $$ ☑ ADVANCED GRAPHICS

466 N. Marshall Way, Layton UT 84041. 801-499-5000. E-mail: info@advancedgraphics. com. Website: www.advancedgraphics.com. **Contact:** John Tenpenny, editor. Estab. 1984. Specializes in life-size standups and cardboard displays, decorations and party supplies.
Needs Buys 20 images/year; number supplied by freelancers varies. Needs photos of celebrities (movie and TV stars, entertainers), babies/children/teens, couples, multicultural, families, parents, senior citizens, wildlife. Interested in seasonal. Reviews stock photos.
Specs Uses 4 × 5, 8 × 10 transparencies. Accepts images in digital format. Send via CD, Jaz, Zip, e-mail.
Making Contact & Terms Send query letter with stock list. Keeps samples on file. Responds in 1 month. Pays $400 maximum/image; royalties of 7-10%. Simultaneous submissions and previously published work OK. **Pays on acceptance.** Credit line given. Buys exclusive product rights; negotiable.
Tips "We specialize in publishing life-size standups which are cardboard displays of celebrities. Any pictures we use must show the entire person, head to toe. We must also obtain a license for each image that we use from the celebrity pictured or from that celebrity's estate. The image should be vertical and not too wide."

▦ ▣ ART IN MOTION

2000 Hartley Ave., Coquitlam BC V3K 6W5 Canada. (604)525-3900 or (800)663-1308. Fax: (604)525-6166 or (877)525-6166. E-mail: artistrelations@artinmotion.com. Website: www. artinmotion.com. **Contact:** Artist Relations. Specializes in open edition reproductions, framing prints, wall decor and licensing.
Needs "We are publishers of fine art reproductions, specializing in the decorative and

gallery market. In photography, we often look for alternative techniques such as hand coloring, Polaroid transfer, or any process that gives the photograph a unique look."

Specs Accepts unzipped digital images sent via e-mail as JPEG files at 72 dpi.

Making Contact & Terms Submit portfolio for review. Pays royalties of 10%. Royalties paid monthly. "Art In Motion covers all associated costs to reproduce and promote your artwork."

Tips "Contact us via e-mail, or direct us to your website; also send slides or color copies of your work (all submissions will be returned)."

▣ ⊘ ARTVISIONS: FINE ART LICENSING

12117 SE 26th St., Bellevue WA 98005-4118. Website: www.artvisions.com. Estab. 1993. Licenses "fashionable, decorative fine art photography and high-quality art to the commercial print, décor and puzzle/game markets."

Needs Handles fine art and photography licensing only. "We're not currently seeking new talent. However, we are always willing to view the work of top-notch established artists."

Making Contact & Terms "See website. Not currently seeking new talent. However, we are always willing to view the work of top-notch established artists and photographers. If you fit this category, please contact ArtVisions via e-mail and include a link to a website where your art can be seen. Or, you may include a few small samples attached to your e-mail as JPEG files." Exclusive worldwide representation for licensing is required. Written contract provided.

Tips "To gain an idea of the type of art we license, please view our website. Animals, children, people and pretty places should be generic, rather than readily identifiable (this also prevents potential copyright issues and problems caused by not having personal releases for use of a 'likeness'). We prefer that your original work be in the form of high-resolution TIFF files from a 'pro-quality' digital camera. Note: scans/digital files are not to be interpolated or compressed in any way. We are firmly entrenched in the digital world; if you are not, then we cannot represent you. If you need advice about marketing your art, please visit: www.artistsconsult.com."

▣ $$ ⊘ AVANTI PRESS INC.

6 W. 18 St., 6th Floor, New York NY 10011. (212)414-1025. E-mail: artsubmissions@ avantipress.com. Website: www.avantipress.com. **Contact:** Art Submissions. Estab. 1980. Specializes in photographic greeting cards. Photo guidelines free with SASE or on website.

Needs Buys approximately 200 images/year; all are supplied by freelancers. Interested in humorous, narrative, colorful, simple, to-the-point photos of babies, children (4 years old and younger), mature adults, animals (in humorous situations) and exceptional florals. Has specific deadlines for seasonal material. Does NOT want travel, sunsets, landscapes, nudes, high-tech. Reviews stock photos. Model/property release required.

Specs Will work with all mediums and formats. Accepts images in digital format. Send via CD as TIFF, JPEG files.

Making Contact & Terms Request guidelines for submission with SASE or visit website. DO NOT submit original material. Pays on license. Credit line given. Buys 5-year worldwide, exclusive card rights.

ⓃⒺⒶ◑ BON ARTIQUE.COM/ART RESOURCES INT., LTD.

129 Glover Ave., Norwalk CT 06850-1311. (203)845-8888. E-mail: info@bonartique.com. Web site:www.bonartique.com. **Contact:** Brett Bennist, art coordinator. Estab. 1980. Licensing and design studio specializing in posters and open edition fine art prints.

Needs Buys 50 images/year. Needs artistic/decorative photos (not stock photos) of landscapes/scenics, wildlife, architecture, cities/urban, gardening, interiors/decorating, rural, adventure, health/fitness, extreme sports. Interested in fine art, cutting edge b&w, sepia photography. Model release required. Photo captions preferred.

Specs Accepts images in digital format with color proof.

Making Contact & Terms Send unsolicited photos by mail with SASE for consideration. Works on assignment only. Responds in 3 months. Simultaneous submissions and previously published work OK. Pays advance against royalties—specific dollar amount is subjective to project. Pays on publication. Credit line given if required. Buys all rights; exclusive reproduction rights.

Tips "Send us new and exciting material; subject matter with universal appeal. Submit color copies, slides, transparencies, actual photos of your work; if we feel the subject matter is relevant to the projects we are currently working on, we'll contact you."

Ⓔ◑ THE BOREALIS PRESS

P.O. Box 230, Surry ME 04684. (207)667-3700 or (800)669-6845. Fax: (207)667-9649. E-mail: info@borealispress.net. Website: www.borealispress.net. **Contact:** Mark Baldwin. Estab. 1989. Specializes in greeting cards, magnets and "other products for thoughtful people." Photo guidelines available for SASE.

Needs Buys more than 100 images/year; 90% are supplied by freelancers. Needs photos of humor, babies/children/teens, couples, families, parents, senior citizens, adventure, events, hobbies, pets/animals. Interested in documentary, historical/vintage, seasonal. Photos must tell a story. Model/property release preferred.

Specs Uses 5 × 7 to 8 × 10 prints; 35mm, 2¼ × 2¼, 4 × 5, 8 × 10 transparencies. Accepts images in digital format. Send via CD. Send low-resolution files if e-mailing. Send images to art@borealispress.net.

Making Contact & Terms Send query letter with slides (if necessary), prints, photocopies, SASE. Send no originals on initial submissions. "Artist's name must be on every image submitted." Responds in 2 weeks to queries; 3 weeks to portfolios. Previously published work OK. Pays by the project, royalties. **Pays on acceptance**, receipt of contract.

Tips "Photos should have some sort of story, in the loosest sense. They can be in any form. We do not want multiple submissions to other card companies. Include SASE, and put your name on every image you submit."

ⒺⓈ $ ◑ BRISTOL GIFT CO., INC.

P.O. Box 425, Washingtonville NY 10992. (845)496-2821. Fax: (845)496-2859. E-mail: bristol6@frontiernet.net. website: http://bristolgift.net. **Contact:** Matthew Ropiecki, president. Estab. 1988. Specializes in gifts.

Needs Interested in religious, nature, still life. Submit seasonal material 6 months in advance. Reviews stock photos. Model/property release preferred.

Specs Uses 4 × 5, 8 × 10 color prints; 4 × 5 transparencies. Accepts images in digital format.

Send via CD, floppy disk, Zip, e-mail as TIFF, JPEG files.

Making Contact & Terms Send query letter with samples. Keeps samples on file. Responds in 1 month. Previously published work OK. Pays $50-200/image. Buys exclusive product rights.

🖥 $ ▢ CENTRIC CORPORATION

6712 Melrose Ave., Los Angeles CA 90038. (323)936-2100. Fax: (323)936-2101. E-mail: centric@juno.com. Website: www.centriccorp.com. **Contact:** Sammy Okdot, president. Estab. 1986. Specializes in products that have nostalgic, humorous, thought-provoking images or sayings on them and in the following product catergories: T-shirts, watches, pens, clocks, pillows, and drinkware.

Needs Photos of cities' major landmarks, attractions and things for which areas are well-known, and humorous or thought-provoking images. Submit seasonal material 5 months in advance. Reviews stock photos.

Specs Uses 8 × 12 color and/or b&w prints; 35mm transparencies. Accepts images in digital format. Send via CD as JPEG files.

Making Contact & Terms Submit portfolio for review or query with résumé of credits. Provide résumé, business card, self-promotion piece or tearsheets to be kept on file for possible future assignments. Responds in 2 weeks. Works mainly with local freelancers. Pays by the job; negotiable. **Pays on acceptance.** Rights negotiable.

N̄ 🖥 S̄ $$ ▢ CONCORD LITHO

92 Old Turnpike Rd., Concord NH 03301. (603)225-3328. Fax: (603)225-5503. E-mail: brockwell@concordlitho.com. Website: www.concordlitho.com. **Contact:** Brian Rockwell. Estab. 1958. Specializes in bookmarks, greeting cards, calendars, postcards, stationery and gift wrap. Photo guidelines free with SASE or by emailing guidelines@concordlitho.com.

Needs Buys 150 images/year; 50% are supplied by freelancers. Rarely offers assignments. Needs photos of nature, seasonal, domestic animals, dogs and cats, religious, inspirational, florals and scenics. Also considers babies/children, multicultural, families, gardening, rural, business concepts, fine art. Submit seasonal material minimum 6-8 months in advance. Does not want nudes, comedy or humorous—nothing wild or contemporary. Model/property release required for historical/nostalgia, homes and gardens, dogs and cats. Photo captions preferred; include accurate information pertaining to image (location, dates, species, etc.).

Specs Uses 8 × 10 satin color prints; 35mm, 2¼ × 2¼, 4 × 5, 8 × 10 transparencies. Accepts images in digital format. Send via CD, e-mail as TIFF, EPS, PICT, GIF, JPEG files at 300 dpi (TIFF, EPS, JPEG).

Making Contact & Terms Submit samples/dupes for review along with stock list. Keeps samples/dupes on file. Response time may be as long as 6 months. Simultaneous submissions and previously published work OK. Pays by the project, $50-800. Pays on usage. Credit line sometimes given depending upon client and/or product. Buys one-time rights.

Tips "Send nonreturnable samples/color copies demonstrating skill and creativity, along with a complete-as-possible stock list. No phone calls, please."

🖥 DESIGN DESIGN, INC.

P.O. Box 2266, Grand Rapids MI 49501. (616)771-8359. Fax: (616)774-4020. E-mail: susan.

birnbaum@designdesign.us. Website: www.designdesign.us. **Contact:** Susan Birnbaum, creative director. Estab. 1986. Specializes in greeting cards and paper-related product development.

Needs Licenses stock images from freelancers and assigns work. Specializes in humorous topics. Submit seasonal material 1 year in advance. Model/property release required.

Specs Uses 35mm transparencies. Accepts images in digital format. Send via Zip.

Making Contact & Terms Submit portfolio for review. Provide résumé, business card, self-promotion piece or tearsheets to be kept on file for possible future assignments. Do not send original work. Pays royalties. Pays upon sales. Credit line given.

GRAPHIC ARTS CENTER PUBLISHING COMPANY

P.O. Box 10306, Portland OR 97296-0306. (503)226-2402, ext. 306. Fax: (503)223-1410. E-mail: editorial@gacpc.com. Website: www.gacpc.com. **Contact:** editorial assistant. "We are an independent book packager/producer."

Needs Photos of environment, regional, landscapes/scenics. "We only publish regionally focused books and calendars." Photo captions required.

Specs Contact the editorial department at the phone number above to receive permission to send in a submission. Upon acceptance, send bio, samples, 20-40 transparencies that are numbered, labeled with descriptions and verified in a delivery memo, return postage or a filled-out FedEx form. Responds in up to 4 months. Uses transparencies of any format, 35mm, 2¼ × 2¼, 4 × 5, but must be tack sharp and possess high reproductive quality; or submit equivalent digital files. "Our books/calendars usually represent one photographer. We use only full-time, professional photographers and/or well-established photographic businesses. New calendar/book proposals must have large market appeal and/or have corporate sale possibilities as well as fit our company's present focus."

$ $ INTERCONTINENTAL GREETINGS LTD.

38 West 32nd St., Ste. 910, New York NY 10016. (212)683-5830. Fax: (212)779-8564. E-mail: intertg@intercontinental-ltd.com. Website: www.intercontinental-ltd.com. **Contact:** Jerra Parfitt. Estab. 1967. Sells reproduction rights of designs to manufacturers of multiple products around the world. Represents artists in 50 different countries. "Our clients specialize in greeting cards, giftware, giftwrap, calendars, postcards, prints, posters, stationery, paper goods, food tins, playing cards, tabletop, bath and service ware and much more."

Needs Approached by several hundred artists/year. Seeking creative decorative art in traditional and computer media (Photoshop and Illustrator work accepted). Prefers artwork previously made with few or no rights pending. Graphics, sports, occasions (i.e., Christmas, baby, birthday, wedding), humorous, "soft touch," romantic themes, animals. Accepts seasonal/holiday material any time. Prefers artists/designers experienced in greeting cards, paper products, tabletop and giftware.

Making Contact & Terms Send unsolicited CDs or DVDs by mail or Lo-resolution Jpegs by email. "Please do not send original artwork." Upon request, submit portfolio for review. Provide resume, business card, brochure, flyer, or tear sheets to be kept on file for possible future assignments. "Once your art is accepted, we require original color art-Photoshop files on disc (TIFF, 300 dpi). We will respond only if interested (will send back non-

accepted artwork in SASE if provided)." Pays on publication. No credit line given. Offers advance when appropriate. Sells one-time rights and exclusive product rights. Simultaneous submissions and previously published work OK. "Please state reserved rights, if any."

Tips Recommends the annual New York SURTEX and Licensing shows. In photographer's portfolio samples, wants to see "a neat presentation, perhaps thematic in arrangement."

Ⓝ ▣ $ $ ☺ BRUCE MCGAW GRAPHICS, INC.

389 W. Nyack Rd., West Nyack NY 10994. (845)353-8600. Fax: (845)353-8907 or (800)446-8230. E-mail: acquisitions@bmcgaw.com. Website: www.bmcgaw.com. **Contact:** Katy Murphy, product development manager. Estab. 1979. Specializes in posters, framing prints, wall decor.

Needs Licenses 250-300 images/year in a variety of media; 10-15% in photography. Interested in b&w: still life, floral, figurative, landscape; color: landscape, still life, floral. Also considers celebrities, environmental, wildlife, architecture, rural, fine art, historical/vintage. Does not want images that are too esoteric or too commercial. Model/property release required for figures, personalities, images including logos or copyrighted symbols. Photo captions required; include artist's name, title of image, year taken. Not interested in stock photos.

Specs Uses color and/or b&w prints; 35mm, 2¼ × 2¼, 4 × 5, 8 × 10 transparencies. Accepts images in digital format at 300 dpi.

Making Contact & Terms Submit portfolio for review. "Review is typically 2 weeks on portfolio drop-offs. Be certain to leave phone number for pick up." Provide résumé, business card, self-promotion piece or tearsheets to be kept on file for possible future assignments. "Do not send originals!" Responds in 1 month. Simultaneous submissions and previously published work OK. Pays royalties on sales. Pays quarterly following first sale and production expenses. Credit line given. Buys exclusive product rights for all wall decor.

Tips "Work must be accessible without being too commercial. Our posters/prints are sold to a mass audience worldwide who are buying art prints. Images that relate a story typically do well for us. The photographer should have some sort of unique style or look that separates him from the commercial market. It is important to take a look at our catalog or website before submitting work to get a sense of our aesthetic. You can view the catalog in any poster shop. We do not typically license traditional stock-type images—we are a decorative house appealing to a higher-end market. Send your best work (20-60 examples)."

▣ $ ☑ NOVA MEDIA INC.

1724 N. State St., Big Rapids MI 49307-9073. (231)796-4637. E-mail: trund@netonecom. net. Website: www.novamediainc.com. **Contact:** Thomas J. Rundquist, president. Estab. 1981. Specializes in CD-ROMs, CDs/tapes, games, limited edition plates, posters, school supplies, T-shirts. Photo guidelines free with SASE.

Needs Buys 100 images/year; most are supplied by freelancers. Offers 20 assignments/year. Seeking art fantasy photos. Needs photos of children/teens, celebrities, multicultural, families, landscapes/scenics, education, religious, rural, entertainment, health/fitness/beauty, military, political, technology/computers. Interested in documentary, erotic, fashion/glamour, fine art, historical/vintage. Submit seasonal material 2 months in advance.

Reviews stock photos. Model release required. Photo captions preferred.

Specs Uses color and/or b&w prints. Accepts images in digital format. Send via CD.

Making Contact & Terms Send query letter with samples. Accepts e-mail submissions. Responds in 1 month. Keeps samples on file; does not return material. Simultaneous submissions and previously published work OK. Payment negotiable. Pays extra for electronic usage of photos. Pays on usage. Credit line given. Buys electronic rights; negotiable.

Tips "The most effective way to contact us is by e-mail or regular mail. Visit our website."

▣ PALM PRESS, INC.

1442A Walnut St., Berkeley CA 94709. (510)486-0502. Fax: (510)486-1158. E-mail: theresa@palmpressinc.com. Website: www.palmpressinc.com. **Contact:** Theresa McCormick, assistant art director. Estab. 1980. Specializes in greeting cards. Photo guidelines available on website.

Needs Buys only photographic images from freelancers. Buys 200 images/year. Wants photos of humor, nostalgia; unusual, interesting, original b&w or color images for all occasions including Christmas and Valentine's Day. Submit seasonal material 1 year in advance. Model/property release required.

Specs Accepts digital format. Submit no more than 50 photos. Send via e-mail as small files. If mailing prints or slides, include SASE for work to be returned. Pays royalties on sales. Credit line given.

Making Contact & Terms "SASE must be included for work to be returned." Responds in 3-4 weeks. Pays royalties on sales. Credit line given.

▣ ☑ PAPER PRODUCTS DESIGN

60 Galli Dr., Novato CA 94949. (415)883-1888. Fax: (415)883-1999. E-mail: carol@paperproductsdesign.com. Website: www.paperproductsdesign.com. **Contact:** Carol Florsheim. Estab. 1992. Specializes in napkins, plates, candles, porcelain.

Needs Buys 500 images/year; all are supplied by freelancers. Needs photos of babies/children/teens, architecture, gardening, pets, food/drink, humor, travel. Interested in avant garde, fashion/glamour, fine art, historical/vintage, seasonal. Submit seasonal material 6 months in advance. Model release required. Photo captions preferred.

Specs Uses glossy color and/or b&w prints; 35mm, 2¼ × 2¼, 4 × 5, 8 × 10 transparencies. Accepts images in digital format. Send via Zip, e-mail at 350 dpi.

Making Contact & Terms Send query letter with photocopies, tearsheets. Responds in 1 month to queries, only if interested. Simultaneous submissions and previously published work OK.

▣ Ⓢ ☑ PORTFOLIO GRAPHICS, INC.

4680 Kelly Circle, Salt Lake City UT 84117. (801)424-2574. E-mail: info@portfoliographics.com. Website: www.nygs.com. **Contact:** Kent Barton, creative director. Estab. 1986. Publishes and distributes open edition fine art prints, posters, and canvas.

Needs Buys 100 images/year; nearly all are supplied by freelancers. Seeking creative, fashionable, and decorative art for commercial and designer markets. Clients include galleries, designers, poster distributors (worldwide), framers and retailers. For posters, "keep in mind that we need decorative art that can be framed and hung in home or office."

Submit seasonal material on an ongoing basis. Reviews stock photos. Photo captions preferred.

Specs Uses prints, transparencies, digital files.

Making Contact & Terms Send photos, transparencies, tearsheets or gallery booklets with SASE. Does not keep samples on file; must include SASE for return of material. Art director will contact photographer for portfolio review if interested. Responds in 3 months. Pays royalties of 10% on sales. Semi-annual royalties paid per pieces sold. Credit line given. Buys exclusive product rights license per piece.

Tips "We find artists through galleries, magazines, art exhibits and submissions. We are looking for a variety of artists, styles and subjects that are fresh and unique."

$$ POSTERS INTERNATIONAL

1180 Caledonia Rd., Toronto ON M6A 2W5 Canada. (416)789-7156. Fax: (416)789-7159. E-mail: dow@pifineart.com. Website: www.postersinternational.net. **Contact:** Dow Marcus, art director. Estab. 1976. Specializes in posters/prints. Photo guidelines available.

Needs Needs photos of landscapes/scenics, floral, architecture, cities/urban, European, hobbies. Interested in alternative process, avant garde, fine art, historical/vintage. Interesting effects, Polaroids, painterly or hand-tinted submissions welcome. Submit seasonal material 2 months in advance. Model/property release preferred. Photo captions preferred; include date, title, artist, location.

Specs Accepts images in digital format. Send via CD, Zip, e-mail as low res JPEG files for review. Images of interest will be requested in min 300 dpi TIFF files.

Making Contact & Terms Send query letter with résumé, slides, prints, photocopies, tearsheets, transparencies, stock list. Provide business card, self-promotion piece to be kept on file for possible future assignments. Responds in 2 weeks to queries; 5 weeks to portfolios. Simultaneous submissions OK. Pays royalties of 10% minimum. Buys worldwide rights for approximately 4-5 years to publish in poster form.

Tips "Keep all materials in contained unit. Provide easy access to contact information. Provide any information on previously published images. Submit a number of pieces. Develop a theme (we publish in series of 2, 4, 6, etc.). Black & white performs very well. Vintage is also a key genre; sepia great, too. Catalog is published with supplement 2 times/ year. We show our images in our ads, supporting materials and website."

$$ RECYCLED PAPER GREETINGS, INC.

111 N. Canal St., Suite 700, Chicago IL 60606-7206. (800)777-9494. Website: www.recycled. com. **Contact:** Art Director. Estab. 1971. Specializes in greeting cards. Photo guidelines available on website.

Needs Buys 200-400 images/year; all supplied by freelancers. Wants " primarily humorous photos for greeting cards. Unlikely subjects and offbeat themes have the best chance, but we'll consider all types. Text ideas required with all photo submissions." Needs photos of babies/children/teens, landscapes/scenics, wildlife, pets, humor. Interested in alternative process, fine art, historical/vintage, seasonal. Model release required.

Specs Uses b&w and/or color prints; b&w and/or color contact sheets. "Please do not submit slides, disks, tearsheets or original photos."

Making Contact & Terms Send for artists' guidelines or visit website. Include SASE with

submissions for return of material. Responds in up to 2 months. Simultaneous submissions OK. Pays $250/photo, some royalty contracts. **Pays on acceptance.** Credit line given. Buys card rights.

Tips Prefers to see "up to 10 samples of photographer's best work. Cards are printed in 5 × 7 format. Please include messages."

N ▣ S $$ RIG

INC. 500 Paterson Plank Road, Union City NJ 07087. (201863-4500. Fax: (201)222-0694. E-mail: info@rightsinternational.com. Website: www.rightsinternational.com. **Contact:** Robert Hazaga, president. Estab. 1996. Licensing agency specializing in the representation of photographers and artists to manufacturers for licensing purposes. Manufacturers include greeting card, calendar, poster and home furnishing companies.

Needs Needs photos of architecture, entertainment, humor, travel, floral, coastal. "Globally influenced—not specific to one culture. Moody feel." See website for up-to-date needs. Reviews stock photos. Model/property release required.

Specs Uses prints, slides, transparencies. Accepts images in digital format. Send via CD, e-mail as JPEG files.

Making Contact & Terms Submit portfolio for review. Keeps samples on file. Responds in 2 weeks. Simultaneous submissions and previously published work OK. Payment negotiable. Pays on license deal. Credit line given. Buys exclusive product rights.

⊕ ▣ SANTORO GRAPHICS LTD.

Rotunda Point, 11 Hartfield Crescent, Wimbledon, London SW19 3RL United Kingdom. (44) (208)781-1100. Fax: (44)(208)781-1101. E-mail: kclague@santorographics.com; fbostock@ santorographics.com. Website: www.santorographics.com. **Contact:** Kathryn Clague, art director's assistant. Specializes in greeting cards, stationery, gift wrap, party supplies, school supplies.

Needs Wants "humorous, cute, retro, nostalgic and unusual pictures of animals, people and situations." Also interested in fine art imagery. "Do not submit seasonal material; we do not print it."

Specs Accepts images in digital format sent via CD or e-mail; glossy prints; 35mm transparencies.

Making Contact & Terms Send query letter/e-mail with CV, slides/prints/photocopies/ digital files. Include SASE for return of material. **Pays on receipt of invoice.** Credit line not given. Rights and fees determined by negotiation.

▣ S $$ ☑ TIDE-MARK PRESS

P.O. Box 20, Windsor CT 06095. (860)683-4499, ext. 107. Fax: (860)683-4055. E-mail: mara@ tide-mark.com. Website: www.tidemarkpress.com. **Contact:** Mara Braverman, acquisitions editor. Estab. 1979. Specializes in calendars. Photo guidelines available on website.

Needs Buys 1,000 images/year; 800 are supplied by freelancers. Categories: landscapes/ scenics, wildlife, architecture, gardening, interiors/decorating, pets, religious, adventure, automobiles, entertainment, events, food/drink, health/fitness, hobbies, humor, performing arts, sports, travel. Interested in fine art, historical/vintage; Native American; African American. Needs "complete calendar concepts that are unique but also have identifiable

markets; groups of photos that could work as an entire calendar; ideas and approach must be visually appealing and innovative but also have a definable audience. No general nature or varied subjects without a single theme." Submit seasonal material 18 months in advance. Reviews stock photos. Model release preferred. Photo captions required.

Specs Uses film and digital images. Accepts lo-res images in PDF or JPEG format for initial review; send high-res only on selection.

Making Contact & Terms "Offer specific topic suggestions that reflect specific strengths of your stock." Send e-mail with sample images. Editor will contact photographer for portfolio review if interested. Responds in 3 weeks. Pays $150-350/color image for single photos; royalties on net sales if entire calendar supplied. Pays on publication or per agreement. Credit line given. Buys one-time rights.

Tips "We tend to be a niche publisher and rely on photographers with strong stock to supply our needs. Check the website, then call or send a query suggesting a specific calendar concept."

▣ $$ ☑ THE ZOLAN COMPANY, LLC

9947 E. Desert Jewel Dr., Scottsdale AZ 85255. (480)306-5680. E-mail: donaldz798@aol.com. Website: www.zolan.com. **Contact:** Jennifer Zolan, president/art director. Commercial and fine art business. Photos used for artist reference in oil paintings.

Needs Buys 16-24 images/year; assignments vary with need. Looking for candid, heartwarming and endearing photos of children (ages 1-3) with high emotional appeal, capturing the magical moments of early childhood." Interested in Christmas/Holiday photos. We are looking for kids in the following scenes: Hispanic kids in endearing scenes, boys in country scenes with farm tractors, boys on the farm, girls working on the farm, girls at the beach, boys playing sports, children with dogs and puppies. Reviews stock photos. Model release preferred.

Specs Uses any size color and/or b&w prints. Prefers images in digital format. Send via e-mail, CD, Zip as TIFF, EPS, PICT, GIF, JPEG files at 72 dpi.

Making Contact & Terms Request photo guidelines by e-mail. Does not keep samples on file; include SASE for return of material. Responds in 2 months to queries. Pays $300-1,000 "depending on the extent of photo shoot and if backgrounds are part of the assignment shoot." **Pays on acceptance**.

Tips "Photos should have high emotional appeal and tell a story. Photos should look candid and natural. Call or write for free photo guidelines before submitting your work. We are happy to work with amateur and professional photographers. We are always looking for human interest types of photographs on early childhood, ages 1-3. Photos should evoke pleasant and happy memories of early childhood. Photographers should write, e-mail for guidelines before submitting their work. No submissions without receiving the guidelines."

Stock Photo Agencies

If you are unfamiliar with how stock agencies work, the concept is easy to understand. Stock agencies house large files of images from contracted photographers and market the photos to potential clients. In exchange for licensing the images, agencies typically extract a 50-percent commission from each use. The photographer receives the other 50 percent.

In recent years, the stock industry has witnessed enormous growth, with agencies popping up worldwide. Many of these agencies, large and small, are listed in this section. However, as more and more agencies compete for sales, there has been a trend toward partnerships among some small to mid-size agencies. Other agencies have been acquired by larger agencies and essentially turned into subsidiaries. Often these subsidiaries are strategically located to cover different portions of the world. Typically, smaller agencies are bought if they have images that fill a need for the parent company. For example, a small agency might specialize in animal photographs and be purchased by a larger agency that needs those images but doesn't want to search for individual wildlife photographers.

The stock industry is extremely competitive, and if you intend to sell stock through an agency, you must know how they work. Below is a checklist that can help you land a contract with an agency.

- Build a solid base of quality images before contacting any agency. If you send an agency 50-100 images, they are going to want more if they're interested. You must have enough quality images in your files to withstand the initial review and get a contract.
- Be prepared to supply new images on a regular basis. Most contracts stipulate that photographers must send additional submissions periodically—perhaps quarterly, monthly or annually. Unless you are committed to shooting regularly, or unless you have amassed a gigantic collection of images, don't pursue a stock agency.
- Make sure all of your work is properly cataloged and identified with a file number. Start this process early so that you're prepared when agencies ask for this information. They'll need to know what is contained in each photograph so that the images can be properly keyworded on websites.

- Research those agencies that might be interested in your work. Smaller agencies tend to be more receptive to newcomers because they need to build their image files. When larger agencies seek new photographers, they usually want to see specific subjects in which photographers specialize. If you specialize in a certain subject area, be sure to check out our Subject Index on page 507, which lists companies according to the types of images they need.
- Conduct reference checks on any agencies you plan to approach to make sure they conduct business in a professional manner. Talk to current clients and other contracted photographers to see if they are happy with the agency. Also, some stock agencies are run by photographers who market their own work through their own agencies. If you are interested in working with such an agency, be certain that your work will be given fair marketing treatment.
- Once you've selected a stock agency, contact them via e-mail or whatever means they have stipulated in their listing or on their website. Today, almost all stock agencies have websites and want images submitted in digital format. If the agency accepts slides, write a brief cover letter explaining that you are searching for an agency and that you would like to send some images for review. Wait to hear back from the agency before you send samples. Then send only duplicates for review so that important work won't get lost or damaged. Always include a SASE when sending samples by regular mail. It is best to send images in digital format; some agencies will only accept digital submissions.
- Finally, don't expect sales to roll in the minute a contract is signed. It usually takes a few years before initial sales are made.

SIGNING AN AGREEMENT

There are several points to consider when reviewing stock agency contracts. First, it's common practice among many agencies to charge photographers fees, such as catalog insertion rates or image duping fees. Don't be alarmed and think the agency is trying to cheat you when you see these clauses. Besides, it might be possible to reduce or eliminate these fees through negotiation.

Another important item in most contracts deals with exclusive rights to market your images. Some agencies require exclusivity to sales of images they are marketing for you. In other words, you can't market the same images they have on file. This prevents photographers from undercutting agencies on sales. Such clauses are fair to both sides as long as you can continue marketing images that are not in the agency's files.

An agency also may restrict your rights to sign with another stock agency. Usually such clauses are designed merely to keep you from signing with a competitor. Be certain your contract allows you to work with other agencies. This may mean limiting the area of distribution for each agency. For example, one agency may get to sell your work in the United States, while the other gets Europe. Or it could mean that one agency sells only to commercial clients, while the other handles editorial work. Before you sign any agency contract, make sure you can live with the conditions, including 40/60 fee splits favoring the agency.

Finally, be certain you understand the term limitations of your contract. Some agreements renew automatically with each submission of images. Others renew

Learn More About the Stock Industry

For More Info

There are numerous resources available for photographers who want to learn about the stock industry. Here are a few of the best.

- **PhotoSource International, (800)223-3860,** website: www.photosource.com. Owned by author/photographer Rohn Engh, this company produces several newsletters that can be extremely useful for stock photographers. A few of these include *PhotoStockNotes, PhotoDaily, PhotoLetter,* and *PhotoBulletin.* Engh's *Sellphotos.com* (Writer's Digest Books) is a comprehensive guide to selling editorial stock photography online. *Sell & Re-Sell Your Photos* (Writer's Digest Books) tells how to sell stock to book and magazine publishers.

- **Selling Stock, (301)251-0720,** website: www.pickphoto.com. This newsletter is published by one of the photo industry's leading insiders, Jim Pickerell. He gives plenty of behind-the-scenes information about agencies and is a huge advocate for stock photographers.

- ***Negotiating Stock Photo Prices* 5th edition,** by Jim Pickerell and Cheryl Pickerell DiFrank, 110 Frederick Avenue, Suite A, Rockville MD 20850, (301)251-0720. This is the most comprehensive and authoritative book on selling stock photography.

- **The Picture Archive Council of America, (800)457-7222,** website: www. pacaoffice.org. Anyone researching an American agency should check to see if the agency is a member of this organization. PACA members are required to practice certain standards of professionalism in order to maintain membership.

- **British Association of Picture Libraries and Agencies, (44)(171)713-1780,** website: www.bapla.org.uk. This is PACA's counterpart in the United Kingdom and is a quick way to examine the track record of many foreign agencies.

- ***Photo District News,*** website: www.pdn-pix.com. This monthly trade magazine for the photography industry frequently features articles on the latest trends in stock photography, and publishes an annual stock photography issue.

- ***Stock Artists Alliance,*** website: www.stockartistsalliance.org. This trade organization focuses on protecting the rights of independent stock photographers.

automatically after a period of time unless you terminate your contract in writing. This might be a problem if you and your agency are at odds for any reason. Make sure you understand the contractual language before signing anything.

REACHING CLIENTS

One thing to keep in mind when looking for a stock agent is how they plan to market your work. A combination of marketing methods seems the best way to attract buyers,

and most large stock agencies are moving in that direction by offering catalogs, CDs and websites.

But don't discount small, specialized agencies. Even if they don't have the marketing muscle of big companies, they do know their clients well and often offer personalized service and deep image files that can't be matched by more general agencies. If you specialize in regional or scientific imagery, you may want to consider a specialized agency.

MICROSTOCK

A relatively new force in the stock photography business is microstock. The term microstock comes from the "micro payments" that these agencies charge their clients—often as little as one dollar (the photographer gets only half of that), depending on the size of the image. Compare that to a traditional stock photo agency, where a rights-managed image could be licensed for hundreds of dollars, depending on the image and its use. Unlike the traditional stock agencies, microstock agencies are more willing to look at work from amateur photographers, and they consider their content "member generated." However, they do not accept all photos or all photographers; images must still be vetted by the microstock site before the photographer can upload his collection and begin selling. Microstock sites are looking for the lifestyle, people and business images that their traditional counterparts often seek. Unlike most traditional stock agencies, microstock sites offer no rights-managed images; all images are royalty free.

So if photographers stand to make only fifty cents from licensing an image, how are they supposed to make money from this arrangement? The idea is to sell a huge quantity of photos at these low prices. Microstock agencies have tapped into a budget-minded client that the traditional agencies have not normally attracted—the small business, nonprofit organization, and even the individual who could not afford to spend $300 for a photo for their newsletter or brochure. There is currently a debate in the photography community about the viability of microstock as a business model for stock photographers. Some say it is driving down the value of *all* photography and making it harder for all photographers to make a living selling their stock photos. While others might agree that it is driving down the value of photography, they say that microstock is here to stay and photographers should find a way to make it work for them or find other revenue streams to counteract any loss of income due to the effects of microstock. Still others feel no pinch from microstock: They feel their clients would never purchase from a microstock site and that they are secure in knowing they can offer their clients something unique.

If you want to see how a microstock site works, see the following websites, which are some of the more prominent microstock sites. You'll find directions on how to open an account and start uploading photos.

- www.shutterstock.com
- www.istockphoto.com
- www.bigstockphoto.com
- www.fotolia.com
- www.dreamstime.com

DIGITAL IMAGING GUIDELINES AND SYSTEMS

The photography industry is in a state of flux as it grapples with the ongoing changes that digital imaging has brought. In an effort to identify and promote digital imaging standards, the Universal Photographic Digital Imaging Guidelines (UPDIG, www.updig. org) were established. The objectives of UPDIG are to: make digital imaging practices more clear and reliable Develop a Web resource for imaging professionals (including photo buyers, photographers and nonprofit organizations related to the photography industry) Demonstrate the creative and economic benefits of the guidelines to clients Develop industry guidelines and workflows for various types of image reproduction, including RAW file delivery, batch-converted files, color-managed master files, and CMYK with proofs.

PLUS (Picture Licensing Universal System) is a cooperative, multi-industry initiative designed to define and categorize image usage around the world. It does not address pricing or negotiations, but deals solely with defining licensing language and managing license data so that photographers and those who license photography can work with the same systems and use the same language when licensing images. To learn more about PLUS, visit www.useplus.com

MARKETING YOUR OWN STOCK

If you find the terms of traditional agencies unacceptable, there are alternatives available. Many photographers are turning to the Internet as a way to sell their stock images without an agent and are doing very well. Your other option is to join with other photographers sharing space on the Web. Check out PhotoSource International at www.photosource. com and www.agpix.com.

If you want to market your own stock, it is not absolutely necessary that you have your own website, but it will help tremendously. Photo buyers often "google" the keyword they're searching for—that is, they use an Internet search engine, keying in the keyword plus "photo." Many photo buyers, from advertising firms to magazines, at one time or another, either have found the big stock agencies too unwieldy to deal with, or they simply did not have exactly what the photo buyer was looking for. Googling can lead a photo buyer straight to your site; be sure you have adequate contact information on your website so the photo buyer can contact you and possibly negotiate the use of your photos.

One of the best ways to get into stock is to sell outtakes from assignments. The use of stock images in advertising, design and editorial work has risen in the last five years. As the quality of stock images continues to improve, even more creatives will embrace stock as an inexpensive and effective means of incorporating art into their designs. Retaining the rights to your assignment work will provide income even when you are no longer able to work as a photographer.

911 PICTURES

63 Gardiners Lane., East Hampton NY 11937. (631)324-2061. Fax: (631)329-9264. E-mail: 911pix@optonline.net. Website: www.911pictures.com. **Contact:** Michael Heller, president. Estab. 1996. Stock agency. Has 3,200 photos in files. Clients include: advertising agencies, public relations firms, audiovisual firms, businesses, book publishers, magazine publishers, calendar companies, insurance companies, public safety training facilities.

Needs Wants photos of disaster services, public safety/emergency services, fire, police, EMS, rescue, hazmat. Interested in documentary.

Specs Accepts images in digital format on CD at minimum 300 dpi, 8" minimum short dimension. Images for review may be sent via e-mail, CD as BMP, GIF, JPEG files at 72 dpi.

Payment & Terms Pays 50% commission for b&w and color photos; 75% for film and videotape. Enforces minimum prices. Offers volume discounts to customers. Works with photographers on contract basis only. Offers nonexclusive contract. Charges any print fee (from negative or slide) or dupe fee (from slide). Statements issued/sale. Payment made/ sale. Photographers allowed to review account records in cases of discrepancies only. Offers one-time rights. Informs photographers and allows them to negotiate when client requests all rights. Model release preferred. Photo captions preferred; include photographer's name, and a short caption as to what is occurring in photo.

How to Contact Send query letter with résumé, slides, prints, photocopies, tearsheets. "Photographers can also send e-mail with thumbnail (low-resolution) attachments." Does not keep samples on file; include SASE for return of material. Responds only if interested; send nonreturnable samples. Photo guidelines sheet free with SASE.

Tips "Keep in mind that there are hundreds of photographers shooting hundreds of fires, car accidents, rescues, etc., every day. Take the time to edit your own material, so that you are only sending in your best work. We are especially in need of hazmat, police and natural disaster images. At this time 911 Pictures is only soliciting work from those photographers who shoot professionally or who shoot public safety on a regular basis. We are not interested in occasional submissions of one or two images."

ACCENT ALASKA/KEN GRAHAM AGENCY

P.O. Box 272, Girdwood AK 99587. (907)783-2796. Fax: (907)783-3247. E-mail: info@ accentalaska.com. Website: www.accentalaska.com. **Contact:** Ken Graham, owner. Estab. 1979. Stock agency. Has 18,000 photos online. Clients include: advertising agencies, public relations firms, audiovisual firms, businesses, book publishers, magazine publishers, newspapers, calendar companies, greeting card companies, postcard publishers, CD-ROM encyclopedias.

Needs Wants modern stock images of Alaska, Antarctica. "Please do not submit material which we already have in our files."

Specs Uses images from digital cameras 10 megapixels or greater; no longer accepting film but will review and select then you return us scanned images with metadata embedded. Send via CD, Zip, e-mail lightbox URL.

Payment & Terms Pays 50% commission. Negotiates fees at industry-standard prices. Works with photographers on contract basis only. Offers nonexclusive contract. Payment made quarterly. "We are a rights managed agency."

How to Contact "See our website contact page. Any material must include SASE for returns." Expects minimum initial submission of 60 images. Prefers online Web gallery for initial review.

Tips "Realize we specialize in Alaska although we do accept images from Antarctica. The bulk of our sales are Alaska-related. We are always interested in seeing submissions of sharp, colorful, and professional-quality images with model-released people when applicable. Do not want to see same material repeated in our library."

⊕ ▣ ACE STOCK LIMITED

Satellite House, 2 Salisbury Rd., Wimbledon, London SW19 4EZ United Kingdom. (44) (208)944-9944. Fax: (44)(208)944-9940. E-mail: web@acestock.com. Website: www. acestock.com. **Contact:** John Panton, director. Estab. 1980. Stock photo agency. Has approximately 500,000 photos in files; over 65,000 online. Clients include: ad agencies, audiovisual firms, businesses, book/encyclopedia publishers, magazine publishers, postcard companies, calendar companies, greeting card companies, design companies, direct mail companies.

Needs Photos of babies/children/teens, couples, multicultural, families, parents, senior citizens, environmental, landscapes/scenics, wildlife, pets, adventure, automobiles, food/drink, health/fitness, hobbies, humor, sports, travel, business concepts, industry, medicine, product shots/still life, science, technology/computers. Interested in alternative process, avant garde, documentary, fashion/glamour, seasonal.

Specs "Under duress will accept 35mm, 6×6 cm, 4×5, 8×10 transparencies. Prefer digital submissions saved as RGB, JPEG, Photoshop 98 color space, Quality High. Scanning resolutions for low-res at 72 dpi and high-res at 300 dpi with 30MB minimum size. Send via CD-ROM, or e-mail low-res samples."

Payment & Terms Pays 50% commission on net receipts. Average price per image (to clients): $400. Works with photographers on contract basis only. Offers limited regional exclusivity. Contracts renew automatically for 2 years with each submission. No charges for scanning. Charges $200/image for catalog insertion. Statements issued quarterly. Payment made quarterly. Photographers permitted to review sales records with 1-month written notice. Offers one-time rights, first rights or mostly nonexclusive rights. Informs photographers when client requests to buy all rights, but agency negotiates for photographer. Model/property release required for people and buildings. Photo captions required; include place, date and function. "Prefer data as IPTC-embedded within Photoshop File Info 'caption' for each scanned image."

How to Contact Send e-mail with low-res attachments or website link or FTP or send 50 sample transparencies. Alternatively, arrange a personal interview to show portfolio or post 50 sample transparencies. Responds within 1 month. Photo guidelines sheet free with SASE. Online tips sheet for contracted photographers.

Tips Prefers to see "definitive cross-section of your collection that typifies your style and prowess. Must show originality, command of color, composition and general rules of stock photography. All people must be mid-Atlantic to sell in UK. No dupes. Scanning and image manipulation is all done in-house. We market primarily online search engines and e-mail promos. In addition, we distribute printed catalogs and CD-ROMs."

⊕ ▣ **A+E**

9 Hochgernstr., Stein D-83371 Germany. Phone: (+49)8621-61833. Fax: (+49)8621-63875. E-mail: apluse@aol.com. Website: www.aplus.de. **Contact**: Elisabeth Pauli, director. Estab. 1987. Picture library. Has 30,000 photos in files. Clients include newspapers, postcard publishers, book publishers, calendar companies, magazine publishers.

Needs Wants photos of nature/landscapes/scenics, pets, "only your best material."

Specs Uses 35mm, 6 × 6 transparencies. Accepts images in digital format. Send via CD as JPEG files at 100 dpi for referencing purposes only.

Payment & Terms Pays 50% commission. Average price per image (to clients): $15-100 for b&w photos; $75-1,000 for color photos. Offers volume discounts to customers. Works with photographers on contract basis only. Offers nonexclusive contract. Subject exclusivity may be negotiated. Statements issued annually. Payment made annually. Photographers allowed to review account records in cases of discrepancies only. Offers one-time rights. Model/property release required. Photo captions must include country, date, name of object (person, town, landmark, etc.)

How to Contact Send query letter with your qualification, description of your equipment, transparencies or CD, stock list. Include SASE for return of material in Europe. Cannot return material outside Europe. Expects minimum initial submission of 100 images with annual submissions of at least 100 images. Responds in 1 month.

Tips "Judge your work critically. Only technically perfect photos will attract a photo editor's attention—sharp focus, high colors, creative views."

▣ ◩ **AERIAL ARCHIVES**

Petaluma Airport, 561 Sky Ranch Dr., Petaluma CA 94954. (415)771-2555. Fax: (707)769-7277. E-mail: www.aerialarchives.com/contact.htm. Website: www.aerialarchives.com. **Contact:** Herb Lingl. Estab. 1989. Has 100,000 photos in files. Has 2,000 hours of film, video footage. Clients include: advertising agencies, public relations firms, audiovisual firms, businesses, book publishers, magazine publishers, newspapers, calendar companies.

Needs Aerial photography only.

Specs Accepts images in digital format only, unless they are historical. Uses 2¼ × 2¼, 4 × 5, 9 × 9 transparencies; 70mm, 5" and 9 × 9 (aerial film). Other media also accepted.

Payment & Terms Buys photos, film, videotape outright only in special situations where requested by submitting party. Pays on commission basis. Average price per image (to clients): $325. Enforces minimum prices. Offers volume discounts to customers. Photographers can choose not to sell images on discount terms. Works with photographers on contract basis only. Statements issued quarterly. Payment made monthly. Photographers allowed to review account records in cases of discrepancies only. Offers one-time rights, electronic media rights, agency promotion rights. Informs photographers and allows them to negotiate when client requests all rights. Property release preferred. Photo captions required; include date and location, and altitude if available.

How to Contact Send query letter with stock list. Provide résumé, business card, self-promotion piece to be kept on file. Expects minimum initial submission of 100 images with quarterly submissions of at least 50 images. Responds only if interested; send nonreturnable samples. Photo guidelines sheet available via e-mail.

Tips "Supply complete captions with date and location; aerial photography only."

⊞ ▣ AGE FOTOSTOCK

Buenaventura Muñoz 16, 08018 Barcelona, Spain. (34)(93)300-2552. E-mail: agency@agefotostock.com (New York); age@agefotostock.com (Barcelona). Website: www.agefotostock.com. Estab. 1973. Stock agency. There is a branch office in Madrid and a subsidiary company in New York City, age fotostock america, inc. Photographers may submit their images to Barcelona directly or through the New York office at: age fotostock america, inc., 594 Broadway, Suite 707, New York NY 10012-3257. Clients include: advertising agencies, businesses, newspapers, postcard publishers, public relations firms, book publishers, calendar companies, audiovisual firms, magazine publishers, greeting card companies.

Needs "We are a general stock agency and are constantly uploading images onto our website. Therefore, we constantly require creative new photos from all categories."

Specs Accepts all formats. Details available upon request, or see website, "Photographers/submitting images."

Payment & Terms Pays 50% commission for all formats. Terms specified in photographer's contract. Works with photographers on contract basis only. Offers image exclusivity worldwide. Statements issued monthly. Payment made monthly. Photographers allowed to review account records. Model/property release required. Photo captions required.

How to Contact "Send query letter with résumé and 100 images for selection. Download the photographer's info pack from our website."

▣ AGSTOCKUSA INC.

25315 Arriba Del Mundo Dr., Carmel CA 93923. (831)624-8600. Fax: (831)626-3260. E-mail: edyoung@agstockusa.com. Website: www.agstockusa.com. **Contact:** Ed Young, owner. Estab. 1996. Stock photo agency. Has 100,000 photos. Clients include: advertising agencies, graphic design firms, businesses, public relations firms, book/encyclopedia publishers, calendar companies, magazine publishers, greeting card companies.

Needs Photos should cover all aspects of agriculture worldwide: fruits, vegetables and grains in various growth stages; studio work, aerials; harvesting, processing, irrigation, insects, weeds, farm life, agricultural equipment, livestock, plant damage and plant disease.

Specs Uses 35mm, 2¼ × 2¼, 4 × 5, 6 × 7, 6 × 17 transparencies. Accepts images in digital format. Send as high-res TIFF files.

Payment & Terms Pays 50% commission for color photos. Average price per image (to clients): $ 100-25,000 for color photos. Works with photographers on contract basis only. Offers nonexclusive contract. Contracts renew automatically with additional submissions for 2 years. Charges 50% website insertion fee. Statements issued monthly. Payment made monthly. Photographers allowed to review account records. Offers unlimited use and buyouts if photographer agrees to sale. Informs photographer when client requests all rights; final decision made by agency. Model/property release preferred. Photo caption s required; include location of photo and all technical information (what, why, how, etc.).

How to Contact "Review our website to determine if work meets our standards and requirements." Submit low-res JPEGs on CD for review. Call first. Keeps samples on file; include SASE for return of material. Expects minimum initial submission of 250 images. Responds in 3 weeks. Photo guidelines available on website. Agency newsletter distributed yearly to contributors under contract.

Tips "Build up a good file (quantity and quality) of photos before approaching any agency. A portfolio of 16,000 images is currently displayed on our website. CD-ROM catalog with 7,600 images available to qualified photo buyers."

▣ AKM IMAGES, INC.

109 Bushnell Place, Mooresville NC 28115. E-mail: um83@yahoo.com. Website: www. akmimages.com. **Contact:** Annie-Ying Molander. Estab. 2002. Stock agency. Has over 50,000 photos in files. Clients include: advertising agencies, book publishers, magazine publishers, newspapers, calendar companies, greeting card companies, postcard publishers.

Needs Wants photos of agriculture, cities/urban, food/wine, gardening, multicultural, religious, rural, landscapes/scenics, entertainment, bird, wildlife, macro, travel and underwater. "We also need landscape and culture from Asian countries, Nordic countries (Sweden, Norway, Finland), Alaska, Greenland, Iceland. Also need culture about Sami and Lapplander, from Nordic countries and Native American."

Specs Uses 4 × 6 glossy color prints; 35mm transparencies. Accepts images in digital format. Send via CD, DVD at jpeg or TIFF files at low resolution and high resolution files (300 dpi) for PC Windows XP.

Payment & Terms Pays 50% commission for color photos. Average price per image (to clients) varies for color photos. Terms specified in photographers' contracts. Works with photographers with contract. Offers nonexclusive contract. Contracts renew automatically with additional submissions. Photographers allowed to review account records in cases of discrepancies only. Offers one-time rights. Model/property release required. Photo captions required.

How to Contact Send query letter by e-mail with images and stock list. Does not keep samples on file; include SASE for return of material. Expects minimum initial submissions of 100 images. Responds in 1 month to samples. Photo submission guidelines available free with SASE or via e-mail.

▣ ALASKA STOCK IMAGES

2505 Fairbanks St., Anchorage AK 99503. (907)276-1343. Fax: (907)258-7848. E-mail: info@ alaskastock.com. Website: www.alaskastock.com. **Contact:** Jeff Schultz, owner. Stock photo agency. Member of the Picture Archive Council of America (PACA) and ASMP. Has 350,000 photos in files. Clients include: international and national advertising agencies; businesses; magazines and newspapers; book/encyclopedia publishers; calendar, postcard and greeting card publishers.

Needs Wants photos of everything related to Alaska, including babies/children/teens, couples, multicultural, families, parents, senior citizens involved in winter activities and outdoor recreation, wildlife, environmental, landscapes/scenics, cities/urban, pets, adventure, travel, industry. Interested in alternative process, avant garde, documentary (images which were or could have been shot in Alaska), historical/vintage, seasonal, Christmas.

Specs Uses 35mm, 2 × 2, 4 × 5, 6 × 17 panoramic transparencies. Accepts images in digital format. Send via CD as JPEG files at 72 dpi for review purposes. "Put together a gallery of low-res images on your website and send us the URL, or send via PC-formatted CD as JPEG files no larger than 9 × 12 at 72 dpi for review purposes." Accepted images must be 50MB minimum shot as raw originals.

Payment & Terms Pays 40% commission for color and b&w photos; minimum use fee $125. No charges for catalog, dupes, etc. Offers volume discounts to customers; inquire about specific terms. Photographers can choose not to sell images on discount terms. Works with photographers on contract basis only. Offers nonexclusive contract; exclusive contract for images in promotions. Contracts renew automatically with additional submissions; nonexclusive for 3 years. Statements issued monthly. Payment made monthly. Photographers allowed to review account records. Offers negotiable rights. Informs photographer and negotiates rights for photographer when client requests all rights. Model/property release preferred for any people and recognizable personal objects (boats, homes, etc.). Photo captions required; include who, what, when, where.

How to Contact Send query letter with samples. Does not keep samples on file; include SASE for return of material. Expects minimum initial submission of 200 images with periodic submissions of 100-200 images 1-4 times/year. Responds in 3 weeks. Photo guidelines free on request. Market tips sheet distributed 2 times/year to those with contracts. "View our guidelines online at www.alaskastock.com/prospectivephotographers.asp."

Tips "E-mailed sample images should be sent in one file, not separate images. For photographers shooting digital images, Alaska Stock assumes that you are shooting RAW format and are able to properly process the RAW image to meet our 50MB minimum standards with acceptable color, contrast and density range."

⊕ ▣ AMANA IMAGES INC.

2-2-43 Higashi Shinagawa, Shinagawa-ku, Tokyo 140-0002 Japan. (81)(3)3740-4019. Fax: (81)(3)3740-4036. E-mail: planet-info@amanaimages.com. Website: http://amanaimages.com. **Contact:** Ms. Mariko Kawashima, photographer relations. Estab. 1979. Stock photo agency. Member of the Picture Archive Council of America (PACA). Has 2,300,000 digital files and continuously growing. Clients include: advertising agencies, public relations firms, businesses, book/encyclopedia publishers, magazine publishers, newspapers, postcard publishers, calendar companies, greeting card companies, and TV stations.

Needs Wants photos of babies/children/teens, celebrities, couples, multicultural, families, parents, senior citizens, disasters, environmental, landscapes/scenics, wildlife, architecture, cities/urban, education, gardening, interiors/decorating, pets, religious, rural, adventure, automobiles, entertainment, events, food/drink, health/fitness, hobbies, humor, performing arts, sports, travel, agriculture, business concepts, medicine, military, political, industry, product shots/still life, science, technology/computers. Interested in documentary, erotic, fashion/glamour, fine art, historical/vintage, seasonal.

Specs Digital format by single-lens reflex camera, data size should be larger than 30MB with 8-bit, AdobeRGB, Tiff format. Digital high-res image size: larger than 48MB for CG, 3D, etc. using editing software, e.g. Photoshop or Shade, digital change made by scanning, composed images, collage images.

Payment & Terms Based on agreement.

How to Contact Send 30-50 sample images (shorter side has to be 600 pixel as JPEG file) and your profile by e-mail. "After inspection of your images we may offer you an agreement. Submissions are accepted only after signing the agreement."

N ⊕ ▣ THE ANCIENT ART & ARCHITECTURE COLLECTION, LTD.

410-420 Rayners Lane, Suite 1, Pinner, Middlesex, London HA5 5DY United Kingdom. (44)(208)429-3131. Fax: (44)(208)429-4646. E-mail: library@aaacollection.co.uk. Website: www.aaacollection.com. **Contact:** Haruko Sheridan. Picture library. Has 250,000 photos in files. Represents C.M. Dixon Collection. Clients include: advertising agencies, book/encyclopedia publishers, magazine publishers, newspapers.

Needs Wants photos of ancient/archaeological site, sculptures, objects, artifacts of historical nature. Interested in fine art, historical/vintage.

Specs Digital images only. 35050 MB file size. JPEG format.

Payment & Terms Pays 40% commission for color photos. Average price per image (to clients): $80-180 for color photos. Works with photographers on contract basis only. Offers nonexclusive contract. Contracts renew automatically with additional submissions. Statements issued quarterly. Payment made quarterly. Photographers allowed to review account records. Offers one-time rights. Detailed photo captions required.

How to Contact Send query letter with samples, stock list, SASE. Responds in 2 weeks.

Tips "Material must be suitable for our specialist requirements. We cover historical and archeological periods from 25,000 BC to the 19th century AD, worldwide. All civilizations, cultures, religions, objects and artifacts as well as art are includable. Pictures with tourists, cars, TV aerials, and other modern intrusions not accepted. Send us a submission of CD by mail together with a list of other material that may be suitable for us."

⊕ ▣ ANDES PRESS AGENCY

26 Padbury Ct., London E2 7EH United Kingdom. (44)(0)20 7613 5417. Fax: (44)(0)20 7739 3159. E-mail: apa@andespressagency.com. Website: www.andespressagency.com. **Contact:** Val Baker. Picture library and news/feature syndicate. Has 300,000 photos in files. Clients include: magazine publishers, businesses, book publishers, non-governmental charities, newspapers.

Needs Wants photos of multicultural, senior citizens, disasters, environmental, landscapes/scenics, architecture, cities/urban, education, religious, rural, travel, agriculture, business, industry, political. "We have color and black & white photographs on social, political and economic aspects of Latin America, Africa, Asia and Britain, specializing in contemporary world religions."

Specs Uses 35mm and digital files.

Payment & Terms Pays 50% commission for b&w and color photos. General price range (to clients): £60-300 for color photos. Works with photographers on contract basis only. Offers nonexclusive contract. Contracts renew with additional submissions. Statements issued bimonthly. Payment made bimonthly. Offers one-time rights. "We never sell all rights; photographer has to negotiate if interested." Model/property release preferred. Photo captions required.

How to Contact Send query via e-mail. Do not send unsolicited images.

Tips "We want to see that the photographer has mastered one subject in depth. Also, we have a market for photo features as well as stock photos. Please write to us first via e-mail."

▣ ANIMALS ANIMALS/EARTH SCENES

17 Railroad Ave., Chatham NY 12037. (800)392-5503 or (518)392-5500. Fax: (518)392-5550. E-mail: info@animalsanimals.com. Website: www.animalsanimals.com. **Contact:** Nancy Carrizales. Member of Picture Archive Council of America (PACA). Has 1.5 million photos in files. Clients include: ad agencies, public relations firms, businesses, audiovisual firms, book publishers, magazine publishers, encyclopedia publishers, newspapers, postcard companies, calendar companies, greeting card companies.

Needs "We are currently not reviewing any new portfolios."

Specs Accepts images in digital and transparency formats.

Payment & Terms Pays 50% commission. Works with photographers on contract basis only. Offers exclusive contract. Photographers allowed to review account records to verify sales figures "if requested and with proper notice and cause." Statements issued quarterly. Payment made quarterly. Offers one-time rights; other uses negotiable. Informs photographers and allows them to negotiate when client requests all rights. Model release required if used for advertising. Photo captions required; include Latin names ("they must be correct!").

Tips "First, pre-edit your material. Second, know your subject."

▣ ANTHRO-PHOTO FILE

33 Hurlbut St., Cambridge MA 02138. (617)484-6428. Fax: (617)497-7227. E-mail: cdevore@ anthrophoto.com. Website: www.anthrophoto.com. **Contact:** Nancy DeVore. Estab. 1969. Has 10,000 photos in files. Clients include: book publishers, magazine publishers.

Needs Wants photos of environmental, wildlife, social sciences.

Specs Uses b&w prints; 35mm transparencies. Accepts images in digital format.

Payment & Terms Pays 50% commission. Average price per image (to clients): $170 minimum for b&w photos; $200 minimum for color photos. Offers volume discounts to customers; discount terms negotiable. Works with photographers with contract. Contracts renew automatically. Statements issued annually. Payment made annually. Photographers allowed to review account records. Offers one-time rights. Photo captions required.

How to Contact Send query letter with stock list. Keeps samples on file; include SASE for return of material.

Tips Photographers should call first.

▣ ▣ ANT PHOTO LIBRARY

P.O. Box 576, Mornington VIC 3931 Australia. (61)(3)5978.-8877. Fax: (61)(3)5978-8144. E-mail: images@antphoto.com.au. Website: www.antphoto.com.au. **Contact:** Peter Crawley-Boevey. Estab. 1982. Has 170,000 photos in files, with 30,000 high-res files online. Clients include: advertising agencies, public relations firms, businesses, book publishers, magazine publishers, newspapers, calendar companies, greeting card companies, postcard publishers.

Needs Wants photos of "flora and fauna of Australia, Asia and Antarctica, and the environments in which they live."

Specs "Use digital camera files supplied as a minimum of 16-bit TIFF files from a minimum of 8-megapixel SLR digital camera. Full specs on our website."

Payment & Terms Pays 50% commission for color photos. Offers volume discounts to

customers. Discount sales terms not negotiable. Discount sales terms negotiable. Works with photographers on contract basis only. Offers limited regional exclusivity. Statements issued quarterly. Payment made quarterly. Model release required. Photo captions required; include species, common name and scientific name on supplied Excel spreadsheet.

How to Contact Send e-mail with 10 of your best images attached (images must be relevant to our needs). Expects minimum initial submission of 200 images with regular submissions of at least 100 images. Responds in 3 weeks to samples. Photo guidelines available on website. Market tips sheet "available to all photographers we represent."

Tips "Our clients come to us for images of all common and not-so-common wildlife species from around the world particularly. Good clean shots. Good lighting and very sharp."

▣ ⊘ APPALIGHT

230 Griffith Run Rd., Spencer WV 25276. E-mail: wyro@appalight.com. Website: www. appalight.com. **Contact**: Chuck Wyrostok, director. Estab. 1988. Stock photo agency. Has over 30,000 photos in files. Clients include advertising agencies, public relations firms, businesses, book/encyclopedia publishers, magazine publishers, calendar companies, greeting card companies, graphic designers.

- Currently not accepting submissions. This agency also markets images through the Photo Source Bank.

Needs General subject matter with emphasis on the people, natural history, culture, commerce, flora, fauna, and travel destinations of the Appalachian Mountain region and Eastern Shore of the United States. Wants photos of West Virginia, babies/children/teens, couples, multicultural, families, parents, senior citizens, disasters, environmental, landscapes, wildlife, cities/urban, education, gardening, pets, religious, rural, adventure, events, health/fitness, hobbies, humor, travel, agriculture, business concepts, industry, medicine, military, political, science, technology/computers. Interested in documentary, seasonal.

Specs Uses 8 × 10 glossy b&w prints; 35mm, 2¼ × 2¼, 4 × 5 transparencies and digital images.

Payment & Terms Pays 50% commission for b&w or color photos. Works with photographers on nonexclusive contract basis only. Contracts renew automatically for 2-year period with additional submissions. Payment made quarterly. Photographers allowed to review account records during regular business hours or by appointment. Offers one-time rights, electronic media rights. Model release preferred. Photo captions required.

How to Contact AppaLight is not currently accepting submissions.

Tips "We look for a solid blend of topnotch technical quality, style, content and impact. Images that portray metaphors applying to ideas, moods, business endeavors, risk-taking, teamwork and winning are especially desirable."

▣ ▣ ARCHIVO CRIOLLO

Ignacio San Maria e3-30 y nuñez de vela edificio Metropoli 6to piso, oficina 603, Quito, Ecuador. Phone/fax: (593)(2)60 38 748. E-mail: info@archivocriollo.com. Website: www. archivocriollo.com. **Contact:** Diana Santander, administrator. Estab. 1998. Picture library. Has 20,000 photos in files. Clients include: advertising agencies, businesses, newspapers, postcard publishers, calendar companies, magazine publishers, greeting card companies,

travel agencies.

Needs Wants photos of multicultural, environmental, landscapes/scenics, wildlife, architecture, cities/urban, religious, rural, adventure, travel, art and culture, photo production, photo design, press photos. Interested in alternative process, documentary, fine art, historical/vintage.

Specs Uses 35mm transparencies. Accepts images in digital format. Send via CD, Zip, e-mail or FTP as JPEG files at 300 dpi, 11 inches.

Payment & Terms Pays 50% commission for color photos. Average price per image (to clients): $50-150 for color photos; $450-750 for videotape. Enforces minimum prices. Offers volume discounts to customers; terms specified in photographers' contracts. Photographers can choose not to sell images on discount terms. Works with photographers with or without a contract; negotiable. Offers nonexclusive contract. Charges 50% sales fee. Payment made quarterly. Photographers allowed to review account records. Informs photographers and allows them to negotiate when client requests all rights. Photo captions preferred.

How to Contact Send query letter with stock list. Responds only if interested. Catalog available.

⊕ ▣ ARGUS PHOTO, LTD. (APL)

Room 2001-4 Progress Commercial Bldg., 9 Irving St., Causeway Bay, Hong Kong. (852)2890-6970. Fax: (852)2881-6979. E-mail: argus@argusphoto.com. Website: www.argusphoto.com. **Contact:** Lydia Li, photo editor. Estab. 1992. Stock photo agency with branches in Beijing and Guangzhou. Has over 1 million searchable photos online. Clients include: advertising agencies, graphic houses, corporations, real estate developers, book and magazine publishers, postcard, greeting card, calendar and paper product manufacturers.

Needs "We cover general subject matters with constant needs of high-end lifestyle images, wellness, interior design/home decor, hospitality, garden and pool, Asian/Oriental people, and sports images. High quality feature stories with English text on travel, food and drink, architectural/interior design, high-end fashion/luxurious accessory, and celebrities are most welcome."

Specs Accepts high-quality digital images only. Send 50MB JPEG files at 300 dpi via DVD or website link for review. English captions and keywords are required.

Payment & Terms Pays 50% commission. Average price per image (to clients): US$100-6,000. Offers volume discounts to customers. Works with photographers on contract basis only. Statements/payment made quarterly. Informs photographers and allows them to negotiate when client requests all rights. Model/property release may be required. Expects minimum initial submission of 200 images.

⊕ ▣ ARKRELIGION.COM

57 Burdon Lane, Cheam Surrey SM2 7BY United Kingdom. (44)(208)642-3593. Fax: (44)(208)395-7230. E-mail: images@artdirectors.co.uk. Website: www.arkreligion.com. Estab. 2004. Stock agency. Has 100,000 photos in files. Clients include: advertising agencies, businesses, newspapers, postcard publishers, calendar companies, magazine publishers, greeting card companies.

Needs Wants photos of major, minor and alternative religions. This covers all aspects of religion from birth to death.

Specs Prefers digital submissions. Initial submission: 1MB JPEG. High-res requirement: 50MB TIFF. See contributors' page on website for full details. Uses 35mm, 2¼ × 2¼, 4 × 5, 8 × 10 transparencies.

Payment & Terms Pays 50% commission for b&w or color photos when submitted digitally; pays 40% commission when film is submitted. Average price per image (to clients): $65-1,000 for b&w or color photos. Enforces strict minimum prices. Offers volume discounts to customers. Discount sales terms not negotiable. Works with photographers on contract basis only. Offers nonexclusive contract. Statements issued quarterly. Payment made quarterly. Photographers allowed to review account records in cases of discrepancies only. Offers one-time rights, electronic media rights. Model/property release preferred. Photo captions required; include as much relevant information as possible.

How to Contact Contact by e-mail. Does not keep samples on file. Expects minimum initial submission of 50 images with periodic submissions of at least 50 images. Responds in 6 weeks to queries. Photo guidelines available on website.

Tips "Fully caption material and follow the full requirements for digital submissions as detailed on the website. Will only accept slides/transparencies where these represent exceptional and/or difficult-to-obtain images."

ART DIRECTORS & TRIP PHOTO LIBRARY

57 Burdon Lane, Cheam Surrey SM2 7BY United Kingdom. (44)(208)642-3593. Fax: (44)(208)395-7230. E-mail: images@artdirectors.co.uk. Website: www.artdirectors.co.uk. Estab. 1992. Stock agency. Has 1 million photos in files. Clients include: advertising agencies, businesses, newspapers, postcard publishers, public relations firms, book publishers, calendar companies, magazine publishers, greeting card companies.

Needs Wants photos of babies/children/teens, couples, multicultural, families, parents, senior citizens, disasters, environmental, landscapes/scenics, wildlife, architecture, cities/urban, education, gardening, interiors/decorating, pets, religious, rural, adventure, automobiles, entertainment, events, food/drink, health/fitness, hobbies, humor, performing arts, sports, travel, agriculture, business concepts, industry, medicine, military, political, product shots/still life, science, technology/computers. Interested in alternative process, avant garde, documentary, historical/vintage, seasonal.

Specs Prefers digital submissions. Initial submission: 1MB JPEG. High-res requirement: 50MB TIFF. See contributors' page on website for full details. Uses 35mm, 2¼ × 2¼, 4 × 5, 8 × 10 transparencies.

Payment & Terms Pays 50% commission for b&w or color photos when submitted digitally; pays 40% commission when film is submitted. Average price per image (to clients): $65-1,000 for b&w or color photos. Enforces strict minimum prices. Offers volume discounts to customers. Discount sales terms not negotiable. Works with photographers on contract basis only. Offers nonexclusive contract. Statements issued quarterly. Payment made quarterly. Photographers allowed to review account records in cases of discrepancies only. Offers one-time rights, electronic media rights. Model/property release preferred. Photo captions required; include as much relevant information as possible.

How to Contact Contact by e-mail. Does not keep samples on file. Expects minimum initial submission of 50 images with periodic submissions of at least 50 images. Responds in 6 weeks to queries. Photo guidelines available on website.

Tips "Fully caption material and follow the full requirements for digital submissions as detailed on the website. Will only accept slides/transparencies where these represent exceptional and/or difficult-to-obtain images."

ART LICENSING INTERNATIONAL INC.

1022 Hancock Ave., Sarasota FL 34232. (941)966-8912. Fax: (941)296-7345. E-mail: artlicensing@comcast.net. Website: www.artlicensinginc.com; www.licensingcourse. com; www.out-of-the-blue.us. **Contact:** Michael Woodward, president. Licensing manager Jane Mason. Estab. 1986. "We represent artists, photographers and creators who wish to establish a licensing program for their work. We are particularly interested in photographic images that we can license internationally particularly for fine art posters, limited edition giclees for interior design projects and home and office decor.

Needs "We prefer concepts that have a unique look or theme and that are distinctive from the generic designs produced in-house by publishers and manufacturers. Images for prints and posters must be in pairs or sets of 4 or more with a regard for trends and color palettes related to the home décor and intererior design trends. Nature themes are of particular interest."

Payment & Terms "Our general commission rate is 50% with no expenses to the photographer as long as the photographer provides high-resolution digital files at 300 dpi."

How to Contact Send CD/photocopies, e-mail JPEGS or details of your website. Send SASE if you want material returned.

Tips "We require substantial portfolios of work that can generate good incomes, or concepts that have wide commercial appeal."

ART RESOURCE

536 Broadway, 5th Floor, New York NY 10012. (212)505-8700. Fax: (212)505-2053. E-mail: requests@artres.com. Website: www.artres.com. **Contact:** Diana Reeve. Estab. 1970. Stock photo agency specializing in fine arts. Member of the Picture Archive Council of America (PACA). Has access to 3 million photos. Clients include: advertising agencies, public relations firms, audiovisual firms, businesses, book/encyclopedia publishers, magazine publishers, newspapers, postcard publishers, calendar companies, greeting card companies, all other publishing.

Needs Wants photos of painting, sculpture, architecture *only*.

Specs Uses 8 × 10 b&w prints; 35mm, 4 × 5, 8 × 10 transparencies.

Payment & Terms Pays 50% commission. Average price per image (to client): $185-10,000 for color photos. Negotiates fees below standard minimum prices. Offers volume discounts to customers; terms specified in photographer's contract. Discount sales terms not negotiable. Offers one-time rights, electronic media rights, agency promotion and other negotiated rights. Photo captions required.

How to Contact Send query letter with stock list.

Tips "We represent European fine art archives and museums in the U.S. and Europe but occasionally represent a photographer with a specialty in photographing fine art."

ARTWERKS STOCK PHOTOGRAPHY

5045 Brennan Bend, Idaho Falls ID 83406. (208)523-1545. E-mail: photojournalistjerry@msn.

com. **Contact:** Jerry Sinkovec, owner. Estab. 1984. News/feature syndicate. Has 100 million photos in files. Clients include: advertising agencies, public relations firms, businesses, book publishers, magazine publishers, calendar companies, postcard publishers.

Needs Wants photos of American Indians, ski action, ballooning, British Isles, Europe, Southwest scenery, disasters, environmental, landscapes/scenics, wildlife, adventure, events, food/drink, hobbies, performing arts, sports, travel, business concepts, industry, product shots/still life, science, technology/computers. Interested in documentary, fine art, historical/vintage, lifestyle.

Specs Uses 8 × 10 glossy color and/or b&w prints; 35mm, 2¼ × 2¼, 4 × 5 transparencies. Accepts images in digital format. Send via CD, Zip as JPEG files.

Payment & Terms Pays 50% commission. Average price per image (to clients): $125-800 for b&w photos; $150-2,000 for color photos; $250-5,000 for film and videotape. Negotiates fees below stated minimums depending on number of photos being used. Offers volume discounts to customers; terms not specified in photographers' contracts. Discount sales terms not negotiable. Works with photographers with or without a contract, negotiable. Offers nonexclusive contract. Charges 100% duping fee. Statements issued quarterly. Payment made quarterly. Offers one-time rights. Does not inform photographers or allow them to negotiate when a client requests all rights. Model/property release preferred. Photo captions preferred.

How to Contact Send query letter with brochure, stock list, tearsheets. Provide résumé, business card. Portfolios may be dropped off every Monday. Agency will contact photographer for portfolio review if interested. Portfolio should include slides, tearsheets, transparencies. Works with freelancers on assignment only. Does not keep samples on file; include SASE for return of material. Expects minimum initial submission of 20 images. Responds in 2 weeks. Catalog free with SASE.

ASIA IMAGES GROUP

15 Shaw Rd., #08-02, Teo Bldg., Singapore 367953. (65)6288-2119. Fax: (65)6288-2117. E-mail: info@asia-images.com. Website: www.asia-images.com. **Contact:** Alexander Mares-Manton, founder and creative director. Estab. 2001. Stock agency. "We specialize in creating, distributing and licensing locally relevant Asian model-released lifestyle and business images. Our image collections reflect the visual trends, styles and issues that are current in Asia, home of the world's fastest growing economies. We have three major collections: Asia Images (rights managed); AsiaPix (royalty free); and PictureIndia (royalty free)." Clients include: advertising agencies, corporations, public relations firms, book publishers, calendar companies, magazine publishers.

Needs Wants photos of babies/children/teens, couples, families, parents, senior citizens, health/fitness/beauty, science, technology. "We are only interested in seeing images about or from Asia."

Specs Accepts images in digital format. "We want to see 72-dpi JPEGs for editing and 300-dpi TIFF files for archiving and selling."

Payment & Terms "We have minimum prices that we stick to unless many sales are given to one photographer at the same time." Works with photographers on image-exclusive contract basis only. "We need worldwide exclusivity for the images we represent, but photographers are encouraged to work with other agencies with other images." Statements

issued monthly. Payment made monthly. Photographers allowed to review account records. Offers one-time rights, electronic media rights. Model and property releases are required for all images.

Tips "Asia Images Group is a small niche agency specializing in images of Asia for both advertising and editorial clients worldwide. We are interested in working closely with a small group of photographers rather than becoming too large to be personable. When submitting work, please send 10-20 JPEGs in an

▣ AURORA PHOTOS

81 West Commercial St., Suite 201, Portland ME 04101. (207)828-8787. Fax: (207)828-5524. E-mail: info@auroraphotos.com. Website: www.auroraphotos.com. **Contact:** José Azel, owner. Estab. 1993. Stock agency, news/feature syndicate. Member of the Picture Archive Council of America (PACA). Has 500,000 photos in files. Clients include: advertising agencies, businesses, book publishers, magazine publishers, newspapers, calendar companies, postcard publishers.

Needs Wants photos of babies/children/teens, celebrities, couples, multicultural, families, parents, senior citizens, disasters, environmental, landscapes/scenics, wildlife, architecture, cities/urban, education, rural, adventure, events, sports, travel, agriculture, industry, military, political, science, technology/computers.

Specs Accepts digital submissions only; contact for specs.

Payment & Terms Pays 50% commission for film. Average price per image (to clients): $225 minimum-$30,000 maximum. Offers volume discounts to customers. Works with photographers on image-exclusive contract basis only. Statements issued monthly. Payment made monthly. Photographers allowed to review account records once/year. Offers one-time rights, electronic media rights. Model/property release required. Photo captions required.

How to Contact Contact through website form. Does not keep samples on file; does not return material. Responds in 1 month. Photo guidelines available after initial contact.

Tips "Review our website closely. List area of photo expertise/interest and forward a personal website address where your photos can be found."

⊕ ▣ AUSCAPE INTERNATIONAL

8/44-48 Bowral St., Bowral NSW 2576 Australia. (61)(024)861-6818. Fax: (61)(024)861-6838. E-mail: auscape@auscape.com.au. Website: www.auscape.com.au. **Contact:** Sarah Tahourdin, director. Has 250,000 photos in files. Clients include: advertising agencies, book publishers, magazine publishers, newspapers, calendar companies, greeting card companies.

Needs Wants photos of environmental, landscapes/scenics, wildlife, pets, health/fitness, medicine, model-released Australian lifestyle.

Specs Uses 35mm, 2¼ × 2¼, 4 × 5, 8 × 10 transparencies. Accepts images in digital format. Send via CD or DVD as TIFF files at 300 dpi.

Payment & Terms Pays 50% commission for color photos. Enforces minimum prices. Offers volume discounts to customers. Works with photographers on contract basis only. Requires exclusive contract. Statements issued quarterly. Payment made quarterly. Photographers allowed to review account records. Charges scan fees for all transparencies scanned

inhouse; all scans placed on website. Offers one-time rights. Photo captions required; include scientific names, common names, locations.

How to Contact Does not keep samples on file. Expects minimum initial submission of 200 images with monthly submissions of at least 50 images. Responds in 3 weeks to samples. Photo guidelines sheet free.

Tips "Send only informative, sharp, well-composed pictures. We are a specialist natural history agency and our clients mostly ask for pictures with content rather than empty-but-striking visual impact. There must be passion behind the images and a thorough knowledge of the subject."

▣ THE BERGMAN COLLECTION

Division of Project Masters, Inc., P.O. Box AG, Princeton NJ 08542-0872. (609)921-0749. E-mail: information@pmiprinceton.com. Website: http://pmiprinceton.com. **Contact:** Victoria B. Bergman, vice president. Estab. 1980 (Collection established in the 1930s.) Stock agency. Has 20,000 photos in files. Clients include: advertising agencies, book publishers, audiovisual firms, magazine publishers.

Needs "Specializes in medical, technical and scientific stock images of high quality and accuracy."

Specs Uses color and/or b&w prints; 35mm, 2¼ × 2¼ transparencies. Accepts images in digital format. Send via CD, floppy disk, Zip, e-mail as TIFF, BMP, JPEG files.

Payment & Terms Pays on commission basis. Works with photographers on contract basis only. Offers one-time rights. Model/property release required. Photo captions required; must be medically, technically, scientifically accurate.

How to Contact "Do not send unsolicited images. Call, write, fax or e-mail to be added to our database of photographers able to supply, on an as-needed basis, specialized images not already in the collection. Include a description of the field of medicine, technology or science in which you have images. We contact photographers when a specific need arises."

Tips "Our needs are for very specific images that usually will have been taken by specialists in the field as part of their own research or professional practice. A good number of the images placed by The Bergman Collection have come from photographers in our database."

▣ BIOLOGICAL PHOTO SERVICE AND TERRAPHOTOGRAPHICS

P.O. Box 490, Moss Beach CA 94038. (650)359-6219. E-mail: bpsterra@pacbell.net. Website: www.agpix.com/biologicalphoto. **Contact:** Carl W. May, photo agent. Stock photo agency. Estab. 1980. Has 80,000 photos in files. Clients include: ad agencies, businesses, book/encyclopedia publishers, magazine publishers.

Needs All subjects in the pure and applied life and earth sciences. Stock photographers must be scientists. Subject needs include: electron micrographs of all sorts; biotechnology; modern medical imaging; marine and freshwater biology; diverse invertebrates; organisms used in research; tropical biology; and land and water conservation. All aspects of general and pathogenic microbiology, normal human biology, petrology, volcanology, seismology, paleontology, mining, petroleum industry, alternative energy sources, meteorology and the basic medical sciences, including anatomy, histology, medical microbiology, human embryology and human genetics.

Specs Uses 4 × 5 through 11 × 14 glossy, high-contrast b&w prints for EM's; 35mm, 2¼ × 2¼, 4 × 5, 8 × 10 transparencies. "Dupes acceptable for rare and unusual subjects, but we prefer originals." Welcomes images in digital format as 50-100MB TIFF files.

Payment & Terms Pays 50% commission for b&w and color photos. General price range (for clients): $75-500, sometimes higher for advertising uses. Works with photographers with or without a contract, but only as an exclusive agency. Photographers may market directly on their own, but not through other agencies or portals. Statements issued quarterly. Payment made quarterly; "one month after end of quarter." Photographers allowed to review account records to verify sales figures "by appointment at any time." Offers only rights-managed uses of all kinds; negotiable. Informs photographers and allows them veto authority when client requests a buyout. Model/property release required for photos used in advertising and other commercial areas. Thorough scientific photo captions required; include complete identification of subject and location.

How to Contact Interested in receiving work from scientific and medical photographers if they have the proper background. Send query letter or e-mail with stock list, résumé of scientific and photographic background; include SASE for return of material. Responds in 2 weeks. Photo guidelines free with query, résumé and SASE. Tips sheet distributed intermittently to stock photographers only. "Nonscientists should not apply."

Tips "When samples are requested, we look for proper exposure, maximum depth of field, adequate visual information and composition, and adequate technical and general information in captions. Digital files should have image information in IPTC and EXIF fields. We avoid excessive overlap among our photographer/scientists. Our three greatest problems with potential photographers are: 1) inadequate captions/metadata; 2) inadequate quantities of *fresh* and *diverse* photos; 3) poor sharpness/depth of field/grain/composition in photos."

N ◫ THE BRIDGEMAN ART LIBRARY

65 E. 93rd St., New York NY 10128. (212)828-1238. Fax: (212)828-1255. E-mail: newyork@ bridgemanart.com. Website: www.bridgemanart.com. Estab. 1972. Member of the Picture Archive Council of America (PACA). Has 300,000 photos in files. Has branch offices in London, Paris and Berlin. Clients include: advertising agencies, public relations firms, audiovisual firms, businesses, book publishers, magazine publishers, newspapers, calendar companies, greeting card companies, postcard publishers.

Needs Interested in fine art, historical photography.

Specs Uses 4 × 5, 8 × 10 transparencies and 50MB+ digital files.

Payment & Terms Pays 50% commission for color photos. Enforces minimum prices. Offers volume discounts to customers; terms specified in photographers' contracts. Discount sales terms not negotiable. Works with photographers on contract basis only. Charges 100% duping fee. Statements issued quarterly. Photographers allowed to review account records. Offers one-time rights, electronic media rights, agency promotion rights.

How to Contact Send query letter with photocopies, stock list. Does not keep samples on file; include SASE for return of material. Expects minimum initial submission of 20 images. Responds only if interested; send nonreturnable samples. Catalog available.

ⓃⒼ▣ BSIP

34 Rue Villiers-de-l'Isle-Adam, Paris 75020 France. (33)(143)58-6987. Fax: (33)(143)58-6214. E-mail: international@bsip.com. Website: www.bsip.com. **Contact:** Barbara Labous. Estab. 1990. Member of Coordination of European Picture Agencies Press Stock Heritage (CEPIC). Has 200,000 downloadable high-res images online. Clients include: advertising agencies, book publishers, magazine publishers, newspapers.

Needs Wants photos of environmental, food/drink, health/fitness, medicine, science, nature and animals.

Specs Accepts images in digital format only. Send via CD, DVD, FTP as TIFF or jpg files at 330 dpi, 3630 × 2420 pixels.

Payment & Terms Pays 50% commission for color photos. Offers volume discounts to customers; terms specified in photographers' contracts. Discount sales terms not negotiable. Works with photographers with or without a contract; negotiable. Offers guaranteed subject exclusivity. Contracts renew automatically with additional submissions for 5 years. Statements issued monthly. Payment made monthly. Photographers allowed to review account records. Offers one-time rights, electronic media rights, agency promotion rights. Model release required. Photo captions required.

How to Contact Send query letter. Portfolio may be dropped off every Monday through Friday. Keeps samples on file. Expects minimum initial submission of 50 images with monthly submissions of at least 20 images. Responds in 1 week to samples; 2 weeks to portfolios. Photo guidelines sheet available on website. Catalog free with SASE. Market tips sheet available.

ⓖ▣◑ CAMERA PRESS LTD.

21 Queen Elizabeth St., London SE1 2PD United Kingdom. +44 (0)20 7378 1300 or (44) (207)940-9123. Fax: +44 (0)20 7278 5126. E-mail: info@camerapress.com or j.wald@camerapress.com. Website: www.camerapress.com. **Contact:** Jacqui Ann Wald, editor. Quality syndication service and picture library. Clients include: advertising agencies, public relations firms, audiovisual firms, book/encyclopedia publishers, magazine publishers, newspapers, postcard companies, calendar companies, greeting card companies and TV stations. Clients principally press but also advertising, publishers, etc.

- Camera Press sends and receives images via ISDN, FTP, and e-mail. Camera Press has a fully operational electronic picture desk to receive/send digital images via modem/ISDN lines, FTP.

Needs Celebrities, world personalities (e.g., politics, sports, entertainment, arts, etc.), news/documentary, scientific, human interest, humor, women's features, stock.

Specs Accepts images in digital format as TIFF, JPEG files as long as they are a minimum of 300 dpi or 16MB.

Payment & Terms Standard payment term: 50% net commission. Statements issued every 2 months along with payments.

Tips "Camera Press, one of the oldest and most celebrated family-owned picture agencies, will celebrate its 60th anniversary in November 2007. We represent some of the top names in the photographic world but also welcome emerging talents and gifted newcomers. We seek quality celebrity images; lively, colorful features which tell a story; and individual portraits of world personalities, both established and up-and-coming. Accurate captions

are essential. Remember there is a big worldwide demand for celebrity premieres and openings. Other needs include: scientific development and novelties; beauty, fashion, interiors, food and women's interests; humorous pictures featuring the weird, the wacky and the wonderful."

⊞ ▣ ▨ CAPITAL PICTURES

85 Randolph Ave., London W9 1DL United Kingdom. (44)(207)286-2212. E-mail: sales@ capitalpictures.com. Website: www.capitalpictures.com. Picture library. Has 500,000 photos on file. Clients include: advertising agencies, book publishers, magazine publishers, newspapers. Specializes in high-quality photographs of famous people (politics, royalty, music, fashion, film and television).

Needs "We have a lot of clients looking for 'picture of the capital.' We need very high-quality images of London—postcard-type images for international sales. Not just large files, but great content—famous landmarks photographed at the best time, from the best angle, creating interesting and evocative images. Try looking on the Internet for pictures of London for some inspiration."

Specs High-quality digital format only. Send via CD or e-mail as JPEG files.

Payment & Terms Pays 50% commission of money received. "We have our own price guide but will negotiate competitive fees for large quantity usage or supply agreements." Offers volume discounts to customers. Discount sales terms negotiable. Works with photographers with or without a contract; negotiable, whatever is most appropriate. No charges—only 50% commission for sales. Statements issued monthly. Payment made monthly. Photographers allowed to review account records. Offers any rights they wish to purchase. Informs photographers and allows them to negotiate when client requests all rights we think it is appropriate." Photo captions preferred; include date, place, event, name of subject(s).

How to Contact Send query letter with samples. Agency will contact photographer for portfolio review if interested. Keeps samples on file. Expects minimum initial submission of 24 images with monthly submissions of at least 24 images. Responds in 1 month to queries.

▣ ▨ CHARLTON PHOTOS, INC.

3605 Mountain Dr., Brookfield WI 53045. (262)781-9328. Fax: (262)781-9390. E-mail: jim@ charltonphotos.com. Website: www.charltonphotos.com. **Contact:** James Charlton, director of research. Estab. 1981. Stock photo agency. Has 475,000 photos; 200 hours of video. Clients include: ad agencies, public relations firms, audiovisual firms, businesses, book/ encyclopedia publishers, magazine publishers, newspapers, calendar companies.

Needs "We handle photos of agriculture and pets."

Specs Uses color photos; 35mm, 2¼ transparencies, as well as digital. Also uses video.

Payment & Terms Pays 60/40% commission. Average price per image (to clients): $500-650 for color photos. Offers volume discounts to customers; terms specified in photographers' contracts. Works with photographers on contract basis only. Prefers exclusive contract, but negotiable based on subject matter submitted. Contracts renew automatically with additional submissions for 3 years minimum. Charges duping fee, 50% catalog insertion fee and materials fee. Statements issued monthly. Payment made monthly. Photographers allowed to review account records that relate to their work. Model/property release required

for identifiable people and places. Photo captions required; include who, what, when, where.

How to Contact Query by phone before sending any material. Expects initial submission of 1,000 images. Responds in 2 weeks. Photo guidelines free with SASE. Market tips sheet distributed quarterly to contract freelance photographers; free with SASE.

Tips "Provide our agency with images we request by shooting a self-directed assignment each month. Visit our website."

⊕ ▣ CODY IMAGES/TRH PICTURES

2 Reform St., Beith, Scotland, KA15 2AE United Kingdom. (08)(45) 223-5451. Fax: (08) (45)223—5452. E-mail: sam@codyimages.com. Website: www.codyimages.com. **Contact**: Ted Nevill. Estab. 1982. Picture library. Has 100,000 photos in files. Clients include: advertising agencies, newspapers, book publishers, calendar companies, audiovisual firms, magazine publishers.

Needs Wants photos of historical and modern aviation and warfare.

Specs Accepts images in digital format.

Payment & Terms Pays commission. Average price per image (to clients): $80 minimum. Offers volume discounts to customers. Discount sales terms not negotiable. Works with photographers with or without a contract; negotiable. Offers nonexclusive contract. Contracts renew automatically with additional submissions. Statements issued quarterly. Payment made quarterly. Photographers allowed to review account records. Offers one-time rights, electronic media rights. Informs photographers and allows them to negotiate when a client requests all rights. Model/property release preferred. Photo captions preferred.

How to Contact Send e-mail with examples and stock list. Provide résumé, business card, self-promotion piece to be kept on file. Expects minimum initial submission of 1,000 images. Responds in 1 month.

⊕ ▣ EDUARDO COMESANA AGENCIA DE PRENSA/BANCO FOTOGRAFICO

Av. Olleros 1850 4to. "F" C1426CRH Buenos Aires, Argentina. (54)(11)4771-9418. Fax: (54)(11)4771-0080. E-mail: info@comesana.com. Website: www.comesana.com. **Contact:** Eduardo Comesaña, managing director. Estab. 1977. Stock agency, news/feature syndicate. Has 500,000 photos in files. Clients include: advertising agencies, businesses, newspapers, postcard publishers, book publishers, calendar companies, magazine publishers.

Needs Wants photos of babies/children/teens, celebrities, couples, families, parents, disasters, environmental, landscapes/scenics, wildlife, education, adventure, entertainment, events, health/fitness, humor, performing arts, travel, agriculture, business concepts, industry, medicine, political, science, technology/computers. Interested in documentary, fine art, historical/vintage.

Specs Accepts images in digital format only. Send via CD, DVD as TIFF or JPEG files at 300 dpi.

Payment & Terms Pays 50% commission for b&w or color photos. Offers volume discounts to customers; terms specified in photographer's contracts. Photographers can choose not to sell images on discount terms. Works with photographers with or without a contract; negotiable. Offers limited regional exclusivity. Contracts renew automatically with additional

submissions. Statements issued quarterly. Payment made quarterly. Photographers allowed to review account records in cases of discrepancies only. Offers one-time rights. Model release preferred; property release required.

How to Contact Send query letter with tearsheets, stock list. Provide self-promotion piece to be kept on file. Expects minimum initial submission of 200 images in low-res files with monthly submissions of at least 200 images. Responds only if interested; send nonreturnable samples.

CORBIS

710 Second Av., Suite 200 Seattle WA 98104. (206)373-6000. Website: www.corbis.com. Estab. 1991. Stock agency, picture library, news/feature syndicate. Member of the Picture Archive Council of America (PACA). Corbis also has offices in London, Paris, Dusseldorf, Tokyo, Seattle, Chicago and Los Angeles. Clients include: advertising agencies, businesses, newspapers, public relations firms, book publishers, calendar companies, audiovisual firms, magazine publishers, greeting card companies, businesses/corporations, media companies.

How to Contact "Please check "About Corbis" on our website for current submission information."

▣ CUSTOM MEDICAL STOCK PHOTO

The Custom Medical Bldg., 3660 W. Irving Park Rd., Chicago IL 60618-4132. (773)267-3100. Fax: (773)267-6071. E-mail: sales@cmsp.com. Website: www.cmsp.com. **Contact:** Mike Fisher and Henry Schleichkorn, medical archivists. Clients include: advertising agencies, magazines, journals, textbook publishers, design firms, audiovisual firms, hospitals, Web designers—all commercial and editorial markets that express interest in medical and scientific subject area.

Needs "Check our blog for updated image needs at http://cmspblog.blogspot.com. Wants photos of biomedical, scientific, healthcare environmentals and general biology for advertising illustrations, textbook and journal articles, annual reports, editorial use and patient education.

Specs "Accepting only digital submissions. Contact us before submitting images to receive image specifications and template for captions."

Payment & Terms Pays per shot or commission. Per-shot rate depends on usage. Commission: 30% on domestic leases; 25% on foreign leases. Works with photographers on contract basis only. Contracts of 5 years. Royalty-free contract available. Credit line given if applicable, at client's discretion. Offers one-time, electronic media and agency promotion rights; other rights negotiable. Informs photographers but does not permit them to negotiate when a client requests all rights.

How to Contact Send query letter with list of stock photo subjects. Do not send uncaptioned, unsolicited photos by mail." Responds in 1 month on average. Photo guidelines available on website. Model/property release required.

Tips "Looking for technical imagery beside images concerning; environmentals of researchers, hi-tech biomedicine, physicians, nurses and patients of all ages in situations from neonatal care to mature adults are requested frequently. Almost any image can qualify to be medical if it touches an area of life: breakfast, sports, etc. Photos should be good, clean

images that portray a single idea, whether it is biological, medical, scientific or conceptual. Put together a minimum of 10 images for a review for a submission. Contributing to our agency can be very profitable if a solid commitment can exist."

◪ DDB STOCK PHOTOGRAPHY, LLC

P.O. Box 80155, Baton Rouge LA 70898. (225)763-6235. Fax: (225)763-6894. E-mail: info@ ddbstock.com. Website: www.ddbstock.com. **Contact:** Douglas D. Bryant, president. Estab. 1970. Stock photo agency. Member of American Society of Picture Professionals. Rights managed stock only, no RF. Currently represents 103 professional photographers. Has 550,000 transparencies in files and 30,000 high resolution digital images available for download on website. Clients include: text-trade book/encyclopedia publishers, travel industry, museums, ad agencies, audiovisual firms, magazine publishers, CD-ROM publishers and many foreign publishers.

Needs Specializes in picture coverage of Latin America with emphasis on Mexico, Central America, South America, and the Caribbean. Needs photos of anthropology/archeology, art, commerce, crafts, secondary and university education, festivals and ritual, geography, history, indigenous people and culture, museums, parks, political figures, religion. Also uses teens 6th-12th grade/young adults college age, couples, multicultural, families, parents, senior citizens, architecture, rural, adventure, entertainment, events, food/ drink, restaurants, health/fitness, performing arts, business concepts, industry, science, technology/computers.

Specs Prefers images in TIFF digital format on DVD at 10 megapixels or higher. Prepare digital submissions per http://www.ddbstock.com/submissionguidelines.html. Accepts uncompressed JPEGS, TIFFS, and original 35mm transparencies.

Payment & Terms Pays 40% commission for color photos; 25% on foreign sales through foreign agents. Payment rates: $50-$20,000. Average price per image (to clients): $275. Offers volume discount to customers; terms specified in photographers' contracts. 4-year initial minimum holding period for original transparencies. Payment made quarterly. Does not allow independent audits. "We are a small agency and do not have staff to oversee audits." Offers one-time, print/electronic media, world and all language rights. Model/ property release preferred for ad set-up shots. Photo captions required; include location and detailed description. "We have a geographic focus and need specific location info on captions (Geocode latitude/longitude if you carry a GPS unit, and include latitude/ longitude in captions)."

How to Contact Interested in receiving work from professional photographers who regularly visit Latin America. Send query letter with brochure, tearsheets, stock list. Expects minimum initial submission of 300 digital images/original transparencies and yearly submissions of at least 500 images. Responds in 6 weeks. Photo guidelines available on website.

Tips "Speak Spanish and spend one to six months shooting in Latin America and the Caribbean every year. Follow our needs list closely. Call before leaving on assignment. Shoot digital TIFFs at 12 megapixels or larger. Shoot RAW/NEF/DNG adjust and convert to TIFF or Fuji professional transparency film if you have not converted to digital. Edit carefully. Eliminate images with focus, framing, excessive grain/noise, or exposure problems. The market is far too competitive for average pictures and amateur photographers. Review guidelines for photographers on our website. Include coverage from at least three Latin

American countries or five Caribbean Islands. No one-time vacation shots! Shoot subjects in demand listed on website."

⊕ ▣ DINODIA PHOTO LIBRARY

13-15 Vithoba Lane, Vithalwadi, Kalbadevi, Mumbai 400 002 India. 91 22 2240 4026. Fax: 91 22 2240 1675. E-mail: jagdish@dinodia.com. Website: www.dinodia.com. **Contact:** Jagdish Agarwal, founder. Estab. 1987. Stock photo agency. Has 500,000 photos in files. Clients include: advertising agencies, public relations firms, audiovisual firms, businesses, book/encyclopedia publishers, magazine publishers, newspapers, postcard companies, calendar companies, greeting card companies.

Needs Wants photos of babies/children/teens, celebrities, couples, multicultural, families, parents, senior citizens, disasters, environment, landscapes/scenics, wildlife, architecture, cities/urban, education, gardening, interiors/decorating, pets, religious, rural, adventure, automobiles, entertainment, events, food/drink, health/fitness/beauty, hobbies, humor, performing arts, sports, travel, agriculture, business concepts, industry, medicine, military, political, product shots/still life, science, technology/computers. Interested in alternative process, avant garde, documentary, erotic, fashion/glamour, fine art, historical/vintage, seasonal.

Specs "At the moment we are only accepting digital. Initially it is better to send a few nonreturnable printed samples for our review."

Payment & Terms Pays 50% commission for b&w and color photos. General price range (to clients): US $50-600. Negotiates fees below stated minimum prices. Offers volume discounts to customers; inquire about specific terms. Discount sales terms not negotiable. Works with photographers on contract basis only. Offers limited regional exclusivity; "Prefer exclusive for India." Contracts renew automatically with additional submissions for 5 years. Statement issued monthly. Payment made monthly. Photographers permitted to review sales figures. Informs photographers and allows them to negotiate when client requests all rights. Offers one-time rights. Model release preferred. Photo captions required.

How to Contact Send query letter with résumé of credits, nonreturnable samples, stock list and SASE. Responds in 1 month. Photo guidelines free with SASE. Dinodia news distributed monthly to contracted photographers.

Tips "We look for style—maybe in color, composition, mood, subject matter, whatever—but the photos should have above-average appeal." Sees trend that "market is saturated with standard documentary-type photos. Buyers are looking more often for stock that appears to have been shot on assignment."

▣ DK STOCK, INC.

3524 78th Street Ste 29A, Jackson Heights, New York NY 11372. (212)405-1891. Fax: (212)405-1890. E-mail: david@dkstock.com. Website: www.dkstock.com. **Contact:** David Deas, photo editor. Estab. 2000. "A multicultural stock photo company based in New York City. Prior to launching DK Stock, its founders worked for years in the advertising industry as a creative team specializing in connecting clients to the $1.6 trillion ethnic market. This market is growing, and DK Stock's goal is to service it with model-released, well composed, professional imagery." Member of the Picture Archive Council of America (PACA). Has 15,000 photos in files. Clients include: advertising agencies, public relations

firms, businesses, book publishers, magazine publishers, newspapers, calendar companies, greeting card companies.

Needs "Looking for contemporary lifestyle images that reflect the black diaspora." Wants photos of babies/children/teens, celebrities, couples, multicultural, families, parents, senior citizens, education, adventure, entertainment, health/fitness/beauty, hobbies, humor, performing arts, sports, travel, agriculture, business concepts, industry, medicine, military, political, science, technology/computers. Interested in historical/vintage, lifestyle. "Images should include models of Hispanics and/or people of African descent. Images of Caucasian models interacting with black people can also be submitted. Be creative, selective and current. Visit website to get an idea of the style and range of representative work. E-mail for a current copy of 'needs list.'"

Specs Accepts images in digital format. 50 megs, 300 dpi.

Payment & Terms Pays 50% commission for b&w or color photos. Average price per image (to clients): $485. Enforces minimum prices. Offers volume discounts to customers; terms specified in photographers' contracts. Photographers can choose not to sell images on discount terms. Works with photographers on contract basis only. Offers nonexclusive contract. Contracts renew automatically with additional submissions for 5 years. Statements issued monthly. Payment made monthly. Photographers allowed to review account records. Model/property release required. Photo captions not necessary.

How to Contact Send query letter with slides, prints, photocopies, tearsheets, transparencies. Portfolio may be dropped off every Monday-Friday. Does not keep samples on file; include SASE for return of material. Expects minimum initial submission of 50 images with 5 times/year submissions of at least 25 images. Responds in 2 weeks to samples, portfolios. Photo guidelines free with SASE. Catalog free with SASE.

Tips "We love working with talented people. If you have 10 incredible images, let's begin a relationship. Also, we're always looking for new and upcoming talent as well as photographers who can contribute often. There is an increasing demand for lifestyle photos of multicultural people. Our clients are based in the Americas, Europe, Asia and Africa. Be creative, original and technically proficient."

N 🔲 ☑ DRK PHOTO

100 Starlight Way, Sedona AZ 86351. (928)284-9808. Website: www.drkphoto.com. **Contact:** Daniel R. Krasemann, president. "We handle only the personal best of a select few photographers—not hundreds. This allows us to do a better job aggressively marketing the work of these photographers." Member of Picture Archive Council of America (PACA) and American Society of Picture Professionals (ASPP). Clients include: ad agencies; PR and AV firms; businesses; book, magazine, textbook and encyclopedia publishers; newspapers; postcard, calendar and greeting card companies; branches of the government; and nearly every facet of the publishing industry, both domestic and foreign.

Needs "Especially need marine and underwater coverage." Also interested in S.E.M.'s, African, European and Far East wildlife, and good rainforest coverage.

Specs Digital capture, digital scans.

Payment & Terms Pays 50% commission for color photos. General price range (to clients): $100-"into thousands." Works with photographers on contract basis only. Contracts renew automatically. Statements issued quarterly. Payment made quarterly. Offers one-time

rights; "other rights negotiable between agency/photographer and client." Model release preferred. Photo captions required.

How to Contact "With the exception of established professional photographers shooting enough volume to support an agency relationship, we are not soliciting open submissions at this time. Those professionals wishing to contact us in regards to representation should query with a brief letter of introduction."

🌐 🖵 DW STOCK PICTURE LIBRARY (DWSPL)

108 Beecroft Rd., Beecroft, New South Wales 2119 Australia. (61)(02)9869-0717. E-mail: info@dwpicture.com.au. Website: www.dwpicture.com.au. Estab. 1997. Has more than 200,000 photos on file and 30,000 online. "Strengths include historical images, marine life, African wildlife, Australia, travel, horticulture, agriculture, people and lifestyles." Clients include: advertising agencies, designers, printers, book publishers, magazine publishers, calendar companies.

Needs Wants photos of babies/children/teens, families, parents, senior citizens, disasters, gardening, pets, rural, health/fitness, travel, industry. Interested in lifestyle.

Specs Accepts images in digital format. Send as low-res JPEG files via CD.

Payment & Terms Pays 50% commission. Average price per image (to clients): $200 for color photos. Enforces minimum prices. Offers volume discounts to customers. Works with photographers on contract basis only. Statements issued quarterly. Photographers allowed to review account records in cases of discrepancies only. Offers one-time rights. Model release preferred. Photo captions required.

How to Contact Send query letter with images; include SASE if sending by mail. Expects minimum initial submission of 200 images. Responds in 2 weeks to samples.

🌐 🖵 E & E PICTURE LIBRARY

Beggars Roost, Woolpack Hill, Brabourne Lees, Ashford, Kent TN25 6RR United Kingdom. E- mail: info@eeimages.co. Website: www.eeimages.com and www.heritage-images.com (go to E & E Image Library); www.eeimages.co.uk. **Contact:** Isobel Sinden. Estab. 1998. Member of BAPLA (British Association of Picture Libraries and Agencies). Has 250,000 images on file. Clients include: advertisers/designers, businesses, book publishers, magazine publishers, newspapers, calendar/card companies, merchandising, TV.

Needs worldwide religion, faith, spiritual images, buildings, clergy, festivals, ceremony, objects, places, food, ritual, monks, nuns, stained glass, carvings, the unusual. Mormons, Shakers, all groups/sects, large or small. Death: burial, funerals, graves, gravediggers, green burial, commemorative. Ancient/heritage/biblelands/saints/eccentricities/festivals: curiosities, unusual oddities like follies, signs, symbols. Architecture, religious or secular. Manuscripts and illustrations, old and new, linked with any of the subjects above.

Specs Accepts images in digital format. Send via CD, JPEG files in medium-high resolution. Uses 35mm, 2¼ × 2¼, 4 × 5 transparencies.

Payment & Terms Average price per image (to clients): $140-200 for color photos. Offers volume discounts to customers. Works with photographers on contract basis for 5 years, offering exclusive/nonexclusive contract renewable automatically with additional submissions. Offers one-time rights. Model release where necessary. Photo captions very important and must be accurate. Include what, where, any special features or connections,

name, date (if possible), and religion.

How to Contact Send query letter with slides, tearsheets, transparencies/CD. Expects minimum initial submission of 40 images. Responds in 2 weeks. Photo guidelines sheet and "wants list" available via e-mail.

Tips "Decide on exact subject of image. *Get in close and then closer*. Exclude all extraneous matter. Fill the frame. Dynamic shots. Interesting angles, light. No shadows or miniscule subject matter far away. Tell us what is important about the picture. No people in shot unless they have a role in the proceedings as in a festival or service, etc."

⊞ ▣ ECOSCENE

Empire Farm, Throop Rd., Templecombe Somerset BA8 0HR United Kingdom. (44)(196)337-1700. E-mail: pictures@ecoscene.com. Website: www.ecoscene.com. **Contact:** Sally Morgan, director. Estab. 1988. Picture library. Has 80,000 photos in files. Clients include: advertising agencies, businesses, book/encyclopedia publishers, magazine publishers, newspapers, Internet, multimedia.

Needs Wants photos of disasters, environmental, energy issues, sustainable development, wildlife, gardening, rural, health/fitness, agriculture, medicine, science, pollution, industry, energy, indigenous peoples.

Specs Accepts digital submissions only. Send via CD as 50MB (minimum) TIFF files at 300 dpi.

Payment & Terms Pays 55% commission for color photos. Average price per image (to clients): $70 minimum for color photos. Negotiates fees below stated minimum prices, depending on quantity reproduced by a single client. Offers volume discounts to customers. Discount sales terms not negotiable. Works with photographers on contract basis only. Offers nonexclusive contract. Contracts renew automatically with additional submissions, 4 years minimum. Statements issued quarterly. Payment made quarterly. Offers one-time and electronic media rights. Informs photographers and allows them to negotiate when client requests all rights. Model/property release required. Photo captions required; include location, subject matter, and common and Latin names of wildlife and any behavior shown in pictures.

How to Contact Send query letter with résumé of credits. Digital submissions only. Keeps samples on file; include SASE for return of material. Expects minimum initial submission of 100 images with annual submissions of at least 100 images. Responds in 3 weeks. Photo guidelines free with SASE. Market tips sheets distributed quarterly to anybody who requests, and to all contributors.

Tips Photographers should have a "neat presentation and accurate, informative captions. Images must be tightly edited with no fillers. Photographers must be critical of their own work and check out the website to see the type of image required. Substandard work is never accepted, whatever the subject matter. Enclose return postage."

▣ ◩ ESTOCK PHOTO, LLC

27-28 Thomson Ave., Ste. 628, Long Island City NY 11101. (800)284-3399. Fax: (212)545-1185. E-mail: sales@estockphoto.com. Website: www.estockphoto.com. **Contact**: Laura Diez, president. Member of Picture Archive Council of America (PACA). Has over 1 million photos in files. Clients include: ad agencies, public relations and AV firms; businesses;

book, magazine and encyclopedia publishers; newspapers, calendar and greeting card companies; textile firms; travel agencies and poster companies.

Needs Wants photos of travel, destination, people, lifestyles, business.

Specs Uses 35mm, medium-format, 4 × 5 transparencies. Accepts images in digital format.

Payment & Terms Price depends on quality and quantity. Usually pays 50% commission. General price range (to clients): $125-6,500. Works with photographers on contract basis only. Offers exclusive and limited regional exclusive contracts. Contracts renew automatically for 3 years. Offers to clients "any rights they want to have; payment is calculated accordingly." Statements issued bimonthly and quarterly. **Payment made bimonthly and quarterly.** Photographers allowed to review account records to verify their sales figures. Offers one-time and electronic media rights. Informs photographers and allows them to negotiate when client requests all rights; some conditions. Model release required; "depends on subject matter." Photo captions preferred.

How to Contact Send query letter with samples—"about 100 is the best way." Send query letter with list of stock photo subjects or submit portfolio for review. Response time depends; often the same day. Photo guidelines free with SASE.

Tips "Photos should show what the photographer is all about. They should show technical competence—photos that are sharp, well-composed, have impact; if color, they should show color."

ETHNO IMAGES, INC.

5966 Lofland, Frisco TX 75034. (510)773-4492. E-mail: flynn@ethnobrands.com. Website: www.ethnoimages.com. **Contact:** Troy A. Jones, CEO/president; T. Lynn Jones, COO. Estab. 1999. Since its inception, Ethno Images has become the resource of choice for multicultural imagery. The Ethno collection contains lifestyle-driven images spanning traditional to contemporary to cutting edge. Clients are marketing professionals in advertising agencies, book and magazine publishers, in-house marketing departments and design shops.

Needs Wants multicultural images representing lifestyles, families, teenagers, children, couples, celebrities, sports and business. "All multicultural groups accepted; African-American images are requested frequently."

Specs Digital submissions only. Send digital images via CD, Zip as TIFF, JPEG files at 300 dpi (at least 48MB).

Payment & Terms Pays 50% commission for b&w or color photos. Average price per image (to clients): $300. Enforces minimum prices. Offers volume discounts to customers. Works with photographers on contract and freelance basis. Offers nonexclusive contract. Payment made monthly. Model release required; property release preferred. Photo captions required.

How to Contact E-mail us and send low-resolution files or a Web address for review. Photo guidelines and a current needs list provided upon request.

Tips "Caption each image and provide contact information. Prefer initial submissions on CD-ROM in JPEG format or TIFF format. Call or e-mail for more information."

EYE UBIQUITOUS/HUTCHINSON

(formerly Eye Ubiquitous) 65 Brighton Rd., Shoreham, West Sussex BN43 6RE United

Kingdom. +44 (0)1273 440113. Fax: +44 (0)1273 440 116. E-mail: library@eyeubiquitous. com. Website: www.eyeubiquitous.com. **Contact:** Stephen Rafferty, library manager. Estab. 1988. Picture library. Has 300,000 photos in files. Clients include: ad agencies, public relations firms, businesses, book/encyclopedia publishers, magazine publishers, newspapers, television companies.

Needs Wants photos of worldwide social documentary and general stock.

Specs Transparencies and 50 MB files at 300 DPI, color corrected Adobe 1998.

Payment & Terms Pays commission exclusive 40% and 35% non exclusive. Offers volume discounts to customers; inquire about specific terms. Discount sales terms not negotiable. Works with photographers on contract basis only. Offers exclusive, limited regional exclusivity and nonexclusive contracts. Contracts renew automatically with additional submissions. Charges to photographers "discussed on an individual basis." Payment made quarterly. Photographers allowed to review account records. Buys one-time, electronic media and agency promotion rights; negotiable. Does not inform photographers or allow them to negotiate when client requests all rights. Model/property release preferred for people, "particularly Americans." Photo captions required; include where, what, why, who.

How to Contact Submit portfolio for review. Works with freelancers only. Keeps samples on file. Include SASE for return. No minimum number of images expected in initial submission, but "the more the better." Responds as time allows. Photo guidelines free with SASE. Catalog free with SASE. Market tips sheet distributed to contributors "when we can"; free with SASE.

Tips "Find out how picture libraries operate. This is the same for all libraries worldwide. Amateurs can be very good photographers but very bad at understanding the industry after reading some irresponsible and misleading articles. Research the library requirements."

⊞ ▣ FAMOUS PICTURES & FEATURES AGENCY

13 Harwood Rd., London SW6 4QP United Kingdom. (44)(207)731-9333. Fax: (44)(207)731-9330. E-mail: contributors@famous.uk.com or pictures@famous.uk.com. Website: www. famous.uk.com. **Contact:** Rob Howard. Estab. 1985. Picture library, news/feature syndicate. Has more than 500,000 photos on database. Clients include: advertising agencies, book publishers, magazine publishers, newspapers, calendar companies, postcard publishers and poster publishers.

Needs Wants photos of music, film, TV personalities; international celebrities; live, studio, party shots (paparazzi) with stars of all types.

Specs Prefers images in digital format. Send via FTP or e-mail: as JPEG files at 300 dpi or higher.

Payment & Terms Pays 50% commission for color photos. Offers volume discounts to customers. Photographers can choose not to sell images on discount terms. Works with photographers with or without a contract; contracts available for all photographers. Offers limited regional exclusivity. Statements issued monthly. Payment made monthly. Photographers allowed to review account records. Offers one-time rights. Photo captions preferred.

How to Contact E-mail, phone or write, provide samples. Provide résumé, business card, self-promotion piece or tearsheets to be kept on file. Agency will contact photographer for

portfolio review if interested. Keeps samples in online database. Will return material with SAE/IRC.

Tips "We are solely marketing images via computer networks. Our fully searchable archive of new and old pictures is online. Send details via e-mail for more information. When submitting work, please caption pictures correctly."

⚑ 🖼 FIRST LIGHT ASSOCIATED PHOTOGRAPHERS

9 Davies Avenue, Suite 410, Toronto ON Canada. (416)597-8625. Fax: (416)597-2035. E-mail: info@firstlight.com. Website: www.firstlight.com. **Contact**: Wendy Gomoll, director, photography. Estab. 1984. Stock agency and image partner of Getty Images, represents over 150 photographers and 40 rights-managed and royalty-free collections. Over one million images available online. Clients include: advertising agencies, public relations firms, audiovisual firms, businesses, book/encyclopedia publishers, magazine publishers, newspapers, calendar companies.

Needs Wants commercial imagery in all categories. Special emphasis on model-released people, lifestyle, conceptual photography and business and Canadian images. "Our broad files require variety of subjects." Sister company WAVE royalty-free also requires environmentally relevant imagery; contact First Light for more information.

Specs "For initial review submission we prefer low-res JPEG files via e-mail; for final submissions we require clean 50MB (minimum) high-res TIFF files."

Payment & Terms Photographer's imagery is represented as rights-managed. 45% commission rate. Works on contract basis only, nonexclusive. Statements issued monthly. Payment made monthly. Offers one-time rights. Informs photographers and allows them to negotiate when client requests buy-out. Model releases required. IPTC embedding required for all final files. Photo captions required.

How to Contact Send query letter via e-mail.

Tips "Wants to see tightly edited submissions. Well-produced, non-candid imagery."

🌐 ▣ FOCUS NEW ZEALAND PHOTO LIBRARY LTD.

Box 84 153, Westgate, Auckland 0657 New Zealand. (64)(9)411 5416. Fax: (64)(9)411 5417. E-mail: photos@focusnewzealand.com. Website: www.focusnewzealand.com. **Contact:** Brian Moorhead, director. Estab. 1985. Stock agency. Has 40,000 photos in files. Clients include: advertising agencies, businesses, newspapers, postcard publishers, public relations firms, book publishers, calendar companies, magazine publishers, greeting card companies, electronic graphics.

Needs Wants photos of babies/children/teens, couples, multicultural, families, parents, senior citizens, environmental, landscapes/scenics, architecture, cities/urban, education, rural, adventure, events, health/fitness/beauty, hobbies, performing arts, sports, travel, agriculture, business concepts, industry, science, technology/computers. Interested in seasonal. Also needs New Zealand, Australian and South Pacific images.

Specs Uses 35mm, medium-format and up to full-frame panoramic 6 × 17 transparencies. Accepts images in digital format, RGB, TIFF, 300 dpi, A4 minimum.

Payment & Terms Pays 50% commission. Offers volume discounts to customers. Discount sales terms not negotiable. Works with photographers on contract basis only. Offers nonexclusive contract. Statements issued quarterly. Payment made quarterly. Photographers allowed to review account records. Offers one-time, electronic media and agency promotion

rights. Model/property release preferred. Photo captions required; include exact location, content, details, releases, date taken.

How to Contact Send query letter. Does not keep samples on file; include SASE for return of material. Expects minimum initial submission of 100 images with yearly submissions of at least 100-200 images. Responds in 3 weeks to samples. Photo guidelines sheet free with SASE or by e-mail. Catalog free on website. Market tips sheet available by mail or e-mail to contributors only.

Tips "Only submit original, well-composed, well-constructed, technically excellent work, fully captioned."

▣ FOODPIX

Jupiter Images, 601 N. 34th St., Seattle WA 998103. (800)764-7427. E-mail: sales@jupiterimages.com. Website: www.jupiterimages.com. **Contact:** Amy Osburn, sr. collection director. Estab. 1994. Stock agency. Member of the Picture Archive Council of America (PACA). Has 40,000 photos in files. Clients include: advertising agencies, businesses, newspapers, book publishers, calendar companies, design firms, magazine publishers.

Needs Wants food, beverage and food/lifestyle images.

Specs Accepts analog and digital images. Review and complete the Online Submission Questionnaire on the website before submitting work.

Payment & Terms Enforces minimum prices. Offers volume discounts to customers; terms specified in photographers' contracts. Works with photographers on contract basis only. Offers exclusive contract only. Statements issued monthly. Payment made quarterly. Offers one-time rights. Model/property release required. Photo captions required.

How to Contact Send query e-mail with samples. Expects maximum initial submission of 50 images. Responds in 1 month. Catalog available.

ⓝ FOTOAGENT.COM/FOTOCONCEPT, INC.

747 Shotgun Rd., Weston FL 33326. (954)888-7726. Fax: (954)888-5997. Website: www.fotoagent.com. **Contact:** Werner J. Bertsch, president. Estab. 1985. Stock photo agency. Has 1.5 million photos in files. Clients include: magazines, advertising agencies, newspapers, publishers.

Needs Wants general worldwide travel, medical and industrial.

Specs Uses digital files only. Upload your files on website.

Payment & Terms Pays 50% commission for b&w or color photos. Average price per image (to clients): $175 minimum for b&w or color photos. Works with photographers on contract basis only. Offers nonexclusive contract. Contracts renew automatically with each submission for 1 year. Statements issued quarterly. Payment made quarterly. Photographers allowed to review account records to verify sales figures. Offers one-time rights. Model release required. Photo captions required.

How to Contact Use the "Contact Us" feature on website.

Tips Wants to see "clear, bright colors and graphic style. Looking for photographs with people of all ages with good composition, lighting and color in any material for stock use."

🌐 ▣ FOTO-PRESS TIMMERMANN

Speckweg 34A, D-91096 Moehrendorf, Germany. (49) (9131)42801. Fax: (49) (9131)450528. E-mail: info@ f-pt.com. Website: www. f-pt.com. **Contact:** Wolfgang Timmermann. Stock photo agency. Has 750,000 photos in files. Clients include: advertising agencies, audiovisual firms, businesses, book/encyclopedia publishers, magazine publishers, newspapers, calendar companies.

Needs Wants landscapes, countries, travel, tourism, towns, people, business, nature, babies/children/teens, couples, families, parents, senior citizens, adventure, entertainment, health/fitness/beauty, hobbies, industry, medicine, technology/computers. Interested in erotic, fine art, seasonal, lifestyle.

Specs Uses 2¼ × 2¼, 4 × 5, 8 × 10 transparencies (no prints). Accepts images in digital format. Send via CD, Zip as TIFF files.

Payment & Terms Pays 50% commission for color photos. Works on nonexclusive contract basis (limited regional exclusivity). First period: 3 years; contract automatically renewed for 1 year. Photographers allowed to review account records. Statements issued quarterly. Payment made quarterly. Offers one-time rights. Informs photographers and allows them to negotiate when a client requests to buy all rights. Model/property release preferred. Photo caption s required; include state, country, city, subject, etc.

How to Contact Send query letter with stock list. Send unsolicited photos by mail for consideration; include SAE/IRC for return of material. Responds in 1 month.

🌐 ▣ FOTOSCOPIO

Jaramillo 3894 8° "18", C1430AGJ Capital Federal, Buenos Aires, Argentina. Phone/fax: (54)(114)542-3512. E-mail: info@fotoscopio.com. Website: www.fotoscopio.com. **Contact:** Gustavo Di Pace, director. Estab. 1999. Fotoscopio is a Latin American stock photo agency. Has 50,000 photos in files. Clients include: advertising agencies, businesses, postcard publishers, book publishers, calendar companies, magazine publishers, greeting card companies.

Needs Wants photos of Hispanic people, Latin American countries, babies/children/teens, celebrities, couples, multicultural, families, senior citizens, disasters, environmental, landscapes/scenics, wildlife, architecture, cities/urban, interiors/decorating, pets, religious, adventure, automobiles, entertainment, health/fitness/beauty, hobbies, sports, travel, agriculture, business concepts, industry, product shots/still life, technology/computers. Interested in documentary, fine art, historical/vintage.

Specs Uses 35mm, 2¼ × 2¼, 4 × 5, 8 × 10 transparencies. Accepts images in digital format. Send via CD, Zip,

Payment & Terms Average price per image (to clients): $50-300 for b&w photos; $50-800 for color photos. Negotiates fees below stated minimums. Offers volume discounts to customers; terms specified in photographer's contracts. Discount sales terms not negotiable. Works with photographers on contract basis only. Offers nonexclusive contract. Contracts renew automatically with additional submissions for 1 year. Statements issued and payment made whenever one yields rights of reproduction of his photography. Photographers allowed to review account records in cases of discrepancies only. Offers one-time and electronic media rights. Model release required; property release preferred. Photo captions preferred.

How to Contact Send query letter with résumé, slides, prints, photocopies, tearsheets,

transparencies, stock list. Provide résumé, business card, self-promotion piece to be kept on file. Expects minimum initial submission of 100 images. Responds in 1 month to samples. Photo guidelines sheet free with SASE.

▣ FUNDAMENTAL PHOTOGRAPHS

210 Forsyth St., Suite 2, New York NY 10002. (212) 473-5770. Fax: (212) 228-5059. E-mail: mail@fphoto.com. Website: www.fphoto.com. **Contact:** Kip Peticolas, partner. Estab. 1979. Stock photo agency. Applied for membership into the Picture Archive Council of America (PACA). Has 100,000 photos in files. Searchable online database. Clients include: textbook/ encyclopedia publishers, advertising agencies, science magazine publishers, travel guide book publishers, corporate industrial.

Needs Wants photos of medicine, biology, microbiology, environmental, industry, weather, disasters, science-related business concepts, agriculture, technology/computers, optics, advances in science and industry, green technologies, pollution, physics and chemistry concepts.

Specs Accepts 35mm and all large-format transparencies but digital is strongly preferred. Send digital as RAW or TIFF unedited original files at 300 dpi, 11 × 14 or larger size. Please email mail@fphoto.com for current submission guidelines.

Payment & Terms Pays 50% commission for color photos. General price range (to clients): $100-500 for b&w photos; $150-1,200 for color photos; depends on rights needed. Enforces strict minimum prices. Offers volume discount to customers. Works with photographers on contract basis only. Offers guaranteed subject exclusivity. Contracts renew automatically with additional submissions for 2 or 3 years. Charges $5/image scanning fee; can increase to $15 if corrective Photoshop work required. Charges copyright registration fee (optional). Statements issued and payment made quarterly for any sales during previous quarter. Photographers allowed to review account records with written request submitted 2 months in advance. Offers one-time and electronic media rights. Gets photographer's approval when client requests all rights; negotiation conducted by the agency. Model release required. Photo captions required; include date and location.

How to Contact Please send email request for current photo guidelines to: mail@fphoto.com. Contact via e-mail to arrange digital submission. Submit link to web portfolio for review. Send query email with resume of credits, samples or list of stock photo subjects. Keeps samples on file; include SASE for return of material if sending by post. Expects minimum initial submission of 100 images. E-mail crucial for communicating current photo needs.

Tips "Our primary market is science textbooks. Photographers should research the type of illustration used and tailor submissions to show awareness of saleable material. We are looking for science subjects ranging from nature and rocks to industrials, medicine, chemistry and physics; macro photography, photomicrography, stroboscopic; well-lit still life shots are desirable. The biggest trend that affects us is the need for images that document new discoveries in sciences and ecology. Please avoid images that appear dated, images with heavy branding, soft focus or poorly lit subjects. "

⊕ GEOSLIDES & GEO AERIAL PHOTOGRAPHY

4 Christian Fields, London SW16 3JZ United Kingdom. +44(115)981-9418. E-mail:

geoslides@geo-group.co.uk. Website: www.geo-group.co.uk. **Contact:** John Douglas, marketing director. Estab. 1968. Picture library. Has approximately 100,000 photos in files. Clients include: advertising agencies, public relations firms, audiovisual firms, businesses, book/encyclopedia publishers, magazine publishers, newspapers, calendar companies, television.

Needs Accent on travel/geography and aerial (oblique) shots. Wants photos of disasters, environmental, landscapes/scenics, wildlife, architecture, rural, adventure, travel, agriculture, industry, medicine, military, political, product shots/still life, science, technology/computers. Interested in documentary, historical/vintage.

Specs High-res digital.

Payment & Terms Pays 50% commission for b&w or color photos. General price range (to clients) $75-750. Works with photographers with or without a contract; negotiable. Offers nonexclusive contract. Charges mailing costs. Statements issued monthly. Payment made upon receipt of client's fees. Offers one-time rights and first rights. Does not inform photographers or allow them to negotiate when clients request all rights. Model release required. Photo captions required; include description of location, subject matter and sometimes the date.

How to Contact Send query letter or e-mail with résumé of credits, stock list; include SAE/IRC for return of material. Photo guidelines available for SAE/IRC. No samples until called for.

Tips Looks for "technical perfection, detailed captions, must fit our needs, especially location needs. Increasingly competitive on an international scale. Quality is important. Needs large stocks with frequent renewals." To break in, "build up a comprehensive (i.e., in subject or geographical area) collection of photographs which are well documented."

GETTY IMAGES

601 N. 34th St., Seattle WA 98103. (206)925-5000. Fax: (206)925-5001. Website: www.gettyimages.com. "Getty Images is the world's leading imagery company, creating and distributing the largest and most relevant collection of still and moving images to communication professionals around the globe and supporting their work with asset management services. From news and sports photography to contemporary and archival imagery, Getty Images' products are found each day in newspapers, magazines, advertising, films, television, books and websites. Gettyimages.com is the first place customers turn to search, purchase, download and manage powerful imagery. Seattle-headquartered Getty Images is a global company with customers in more than 100 countries."

How to Contact Please visit www.gettyimages.com/contributors and select the link "Interested in marketing your imagery through Getty Images?"

GRANT HEILMAN PHOTOGRAPHY, INC.

P.O. Box 317, Lititz PA 17543. (717)626-0296. Fax: (717)626-0971. E-mail: info@heilmanphoto.com. Website: www.heilmanphoto.com. **Contact:** Sonia Wasco, president. Estab. 1948. Member of the Picture Archive Council of America (PACA). Has one million photos in files. Now representing Photo Network Stock. Sub agents in Canada, Europe, England, Japan. Clients include: advertising agencies, public relations firms, businesses, book/textbook publishers, magazine publishers, calendar companies, greeting card companies, postcard publishers.

Needs Wants photos of environmental, landscapes/scenics, wildlife, gardening, pets, rural, agriculture, science, renewable energies and resources, technology/computers. Interested in seasonal.

Specs Uses 35mm, 2¼ × 2¼, 4 × 5 transparencies. Accepts images in digital format. Send via CD, floppy disk, Jaz, Zip,

Payment & Terms Pays on commission basis. Enforces minimum prices. Offers volume discounts to customers. Works with photographers on contract basis only. Offers guaranteed subject exclusivity (within files). Contracts renew automatically with additional submissions per contract definition. Charges determined by contract. Statements issued quarterly. Payment made quarterly. Photographers allowed to review account records. Offers one-time rights, electronic media rights, agency promotion rights. Model/property release required. Photo captions required; include all known information.

How to Contact Send query letter with résumé, slides, prints, photocopies, tearsheets, transparencies, stock list. Provide résumé, business card, self-promotion piece to be kept on file. Expects minimum initial submission of 200 images.

Tips "Make a professional presentation."

⊕ ▣ HORIZON INTERNATIONAL IMAGES LIMITED

Horizon House, Route de Picaterre, Alderney, Guernsey GY9 3UP British Channel Islands. +44 1481 824200. E-mail: mail@hrzn.com. Website: www.hrzn.com; www.e-picturelibrary. net. UK registered. Estab. 1978. Stock photo agency. Horizon sells stock image use rights (in UK and worldwide), both rights managed and royalty free, via its website and international agents.

Needs Wants photos of model-released people in all situations.

Specs Accepts images in digital format. Drum-scanned from transparencies or 12-megapixel camera and above interpolated to minimum 50MB file before JPEG compression. Use factor 10 JPEG compression in current versions of Adobe Photoshop. All submitted image files must be carefully cropped to mask out rebate and retouched with clone or repair tools (do not use dust filter software). Submit via Horizon's website or send by post on CD or DVD (media nonreturnable).

Payment & Terms Considering new photographers of high technical and artistic standard on 50% sales commission. See full Terms and Conditions on website.

How to Contact E-mail low-res sample of ten available images.

Tips "Only Horizon's terms and conditions apply."

▣ HORTICULTURAL PHOTOGRAPHY

337 Bedal Lane, Campbell CA 95008. (408)364-2015. Fax: (408)364-2016. E-mail: requests@ horticulturalphoto.com. Website: www.horticulturalphoto.com. **Contact:** Robin M. Orans, owner. Estab. 1974. Picture library. Has 200,000 photos in files. Clients include: advertising agencies, public relations firms, businesses, book publishers, magazine publishers.

Needs Wants photos of flowers, plants with botanical identification, gardens, landscapes.

Specs Uses color slides; 35mm transparencies. Accepts images in digital format, will convert color 35mm transparencies. Contact prior to sending images.

Payment & Terms Pays commission for images. Average price per image (to clients): $25-

1,000 for color photos. Negotiates fees below stated minimums; depends on quantity. Offers volume discounts to customers. Discount sales terms not negotiable. Works with photographers on contract basis only; negotiable. Statements issued semiannually. Payment made semiannually. Photographers allowed to review account records in cases of discrepancies only. Offers one-time rights, electronic media rights and language rights. Photo captions required; include common and botanical names of plants, date taken, location.

How to Contact Contact through rep. Send e-mail with résumé, stock list. Does not keep samples on file. Expects minimum initial submission of 40 images with quarterly submissions of at least 100 images. Responds in 1 month to samples and portfolios. Photo guidelines available by e-mail or on website.

Tips "Send e-mail for guidelines."

⊕ ▣ HUTCHISON PICTURE LIBRARY

65 Brighton Rd., Shoreham-by-Sea, West Sussex BN43 6RE United Kingdom. E-mail: library@hutchisonpictures.co.uk. Website: www.hutchisonpictures.co.uk. **Contact:** Stephen Rafferty, manager. Stock photo agency, picture library. Has around 500,000 photos in files. Clients include: ad agencies, public relations firms, audiovisual firms, businesses, book/encyclopedia publishers, magazine publishers, newspapers, postcard companies, calendar companies, television and film companies.

Needs "We are a general, documentary library (no news or personalities). We file mainly by country and aim to have coverage of every country in the world. Within each country we cover such subjects as industry, agriculture, people, customs, urban, landscapes, etc. We have special files on many subjects such as medical (traditional, alternative, hospital, etc.), energy, environmental issues, human relations (relationships, childbirth, young children, etc., but all real people, not models)." We constantly require images of Spain and Spanish speaking countries. Also interested in babies/children/teens, couples, multicultural, families, parents, senior citizens, disasters, architecture, education, gardening, interiors/decorating, religious, rural, health/fitness, travel, military, political, science, technology/computers. Interested in documentary, seasonal. "We are a color library."

Specs Uses 35mm transparencies. Accepts images in digital format: 50MB at 300 dpi, cleaned of dust and scratches at 100%, color corrected.

Payment & Terms Pays 40% commission for exclusive; 35% for nonexclusive. Statements issued semiannually. Payment made semiannually. Sends statement with check in June and January. Offers one-time rights. Model release preferred. Photo captions required.

How to Contact Always willing to look at new material or collections. Arrange a personal interview to show portfolio. Send letter with brief description of collection and photographic intentions. Responds in about 2 weeks, depends on backlog of material to be reviewed. "We have letters outlining working practices and lists of particular needs (they change)." Distributes tips sheets to photographers who already have a relationship with the library.

Tips Looks for "collections of reasonable size (rarely less than 1,000 transparencies) and variety; well captioned (or at least well indicated picture subjects; captions can be added to mounts later); sharp pictures, good color, composition; and informative pictures. Prettiness is rarely enough. Our clients want information, whether it is about what a landscape looks like or how people live, etc. The general rule of thumb is that we would consider a collection

which has a subject we do not already have coverage of or a detailed and thorough specialist collection. Please do not send *any* photographs without prior agreement."

🌐 🖿 🖾 I.C.P. INTERNATIONAL COLOUR PRESS

Piazza Vesuvio 19, Milano 20144 Italy. (39)(024)801-3106. Fax: (39)(024)819-5625. E-mail: icp@icponline.it. Website: www.icponline.it. **Contact:** Mr. Alessandro Marosa, CEO. Estab. 1970. Stock photo agency. Clients include: advertising agencies, public relations firms, audiovisual firms, businesses, book/encyclopedia publishers, magazine publishers, postcard publishers, calendar companies and greeting card companies.

Specs High-res digital (A3-A4, 300 dpi), keyworded (English and, if possible, Italian).

Payment & Terms Pays 50% commission for color photos. Offers volume discounts to customers; terms specified in photographer's contract. Discount sales terms not negotiable. Contracts renew automatically with additional submissions, for 3 years. Statements issued monthly. Payment made monthly. Photographers permitted to review account records to verify sales figures or deductions. Offers one-time, first and sectorial exclusive rights. Model/property release required. Photo captions required.

How to Contact Arrange a personal interview to show portfolio. Send query letter with samples and stock list. Works on assignment only. No fixed minimum for initial submission. Responds in 3 weeks, if interested.

🖿 THE IMAGE FINDERS

2570 Superior Ave., Suite 200, Cleveland OH 44114. (216)781-7729. E-mail: imagefinders@sbcglobal.net. Website: www.theimagefinders.com. **Contact:** Jim Baron, owner. Estab. 1988. Stock photo agency. Has 500,000 photos in files. Clients include: advertising agencies, public relations firms, businesses, book/encyclopedia publishers, magazine publishers, calendar companies, greeting card companies.

Needs General stock agency. Always interested in good Ohio images. Also needs babies/children/teens, couples, multicultural, families, senior citizens, landscapes/scenics, wildlife, architecture, gardening, pets, automobiles, food/drink, sports, travel, agriculture, business concepts, industry, medicine, political, technology/computers. Interested in fashion/glamour, fine art, seasonal.

Specs Accepts digital images; see guidelines before submitting. Send via CD.

Payment & Terms Pays 50% commission for b&w and color photos. Average price per image (to clients): $50-500 for b&w photos; $50-2,000 for color photos. "This is a small agency and we will, on occasion, go below stated minimum prices." Offers volume discounts to customers; terms specified in photographers' contracts. Works with photographers on contract basis only. Contracts renew automatically with additional submissions for 2 years. Statements issued monthly if requested. Payment made monthly. Photographers allowed to review account records. Offers one-time rights; negotiable depending on what the client needs and will pay for. Informs photographers and allows them to negotiate when client requests all rights. "This is rare for us. I would inform photographer of what the client wants and work with photographer to strike the best deal." Model/property release preferred. Photo captions required; include location, city, state, country, type of plant or animal, etc.

How to Contact Send query letter with stock list or send e-mail with link to your website. Call before you send anything that you want returned. Expects minimum initial

submission of 100 images with periodic submission of at least 100-500 images. Responds in 2 weeks. Photo guidelines free with SASE. Market tips sheet distributed 2-4 times/year to photographers under contract.

Tips Photographers must be willing to build their file of images. "We need more people images, industry, lifestyles, wildlife, travel, etc. Scenics and landscapes must be outstanding to be considered. Call first or e-mail. Submit at least 100 good images. Must have ability to produce more than 100-200 images per year."

IMAGES.DE DIGITAL PHOTO GMBH

Potsdamer Str. 96, D-10785 Berlin Germany. +49 (0) 30-2579 28980. Fax: +49 (0) 30-2579 28999. Website: www.images.de. **Contact:** Katja Herold. Estab. 1997. News/feature syndicate. Has 50,000 photos in files. Clients include: advertising agencies, newspapers, public relations firms, book publishers, magazine publishers. "Images.de is a service company with 10 years experience on the picture market. We offer fulfillment services to picture agencies, including translation, distribution into Fotofiner and APIS picturemaxx, customer communication, invoicing, media control, cash delivery, and usage control."

Needs Wants photos of babies/children/teens, couples, multicultural, families, parents, senior citizens, environment, entertainment, events, food/drink, health/fitness, hobbies, travel, agriculture, business concepts, industry, medicine, political, science, technology/computers.

Specs Accepts images in digital format. Send via FTP, CD.

Payment & Terms Pays 50% commission for b&w photos; 50% for color photos. Average price per image (to clients): $50-1,000 for b&w photos or color photos. Offers volume discounts to customers. Discount sales terms not negotiable. Works with photographers with or without a contract; negotiable. Offers limited regional exclusivity. Statements issued monthly. Payment made monthly. Photographers allowed to review account records in cases of discrepancies only. Offers one-time rights, electronic media rights. Informs photographers and allows them to negotiate when client requests all rights. Model release preferred; property release required. Photo captions required.

How to Contact Send query letter with CD or link to website. Expects minimum initial submission of 100 images.

THE IMAGE WORKS

P.O. Box 443, Woodstock NY 12498. (845)679-8500. Fax: (845)679-0606. E-mail: info@theimageworks.com. Website: www.theimageworks.com. **Contact:** Mark Antman, president. Estab. 1983. Stock photo agency. Member of Picture Archive Council of America (PACA). Has over 1 million photos in files. Clients include: ad agencies, book/encyclopedia publishers, magazine publishers, newspapers, postcard publishers, greeting card companies, documentary video.

Needs "We are always looking for excellent documentary photography. Our prime subjects are people-related subjects like family, education, health care, workplace issues, worldwide historical, technology, fine arts."

Specs All images must be in digital format; contact for digital guidelines. Rarely accepts 35mm, 2¼ × 2¼ transparencies and prints.

Payment & Terms Pays 50% commission for b&w and color photos. Average price per image

(to clients): $200 for b&w and color photos. Works with photographers on contract basis only. Offers nonexclusive contract. Statements issued monthly. Payment made monthly. Photographers allowed to review account records to verify sales figures by appointment. Offers one-time, agency promotion and electronic media rights. Informs photographers and allows them to negotiate when clients request all rights. Model release preferred. Photo captions required.

How to Contact Send e-mail with description of stock photo archives. Responds in 1 month. Expects minimum initial submission of 500 images.

Tips "The Image Works was one of the first agencies to market images digitally. All digital images from photographers must be reproduction-quality. When making a new submission to us, be sure to include a variety of images that show your range as a photographer. We also want to see some depth in specialized subject areas. Thorough captions are a must. We will not look at uncaptioned images. Write or call first."

⊕ ▣ ⑤ $ $ INMAGINE RF & RM IMAGE SUBMISSIONS (IRIS)

Inmagine Corporation LLC, 2650 Fountain View Dr., Ste 332, Houston TX 77057. (800)810-3888. Fax: (866)234-5310. E-mail: photo@inmagine.com. Website: http://submission.inmagine.com. Stock agency, picture library. Member of the Picture Archive Council of America (PACA). Has 3,500,000 photos in files. Branch offices in USA, Hong Kong, Australia, Malaysia, Thailand, United Arab Emirates, Singapore, Indonesia, and China. Clients include: advertising agencies, businesses, newspapers, public relations firms, magazine publishers.

Needs Wants photos of babies, children, teens, couples, multicultural, families, parents, education, business concepts, industry, medicine, environmental and landscapes, adventure, entertainment, events, food and drink, health, fitness, beauty, hobbies, sports, travel, fashion/glamour, and lifestyle.

Specs Accepts images in digital format. Submit online or send JPEG files at 300 dpi.

Payment & Terms Pays 50% commission for color photos. Average price per image (to clients) is $100 minimum, maximum negotiable. Negotiates fees below stated minimums. Offers volume discounts to customers, terms specified in photographers' contracts. Works with photographers on a contract basis only. Offers nonexclusive contract. Payments made monthly. Photographers are allowed to view account records in cases of discrepancies only. Offers one-time rights. Model and property release required. Photo caption required.

How to Contact Photographers should contact through website. Expects minimum initial submission of 5 images. Responds in 1 week to samples. Photo guidelines available online.

Tips "Complete the steps as outlined in the IRIS submission pages. Email us if there are queries. Send only the best of your portfolio for submission, stock oriented materials only. EXIF should reside in file with keywords and captions."

⊕ ▣ THE IRISH PICTURE LIBRARY

Davison & Associates Ltd., 69b Heather Rd., Sandyford Industrial Estate, Dublin 18 Ireland. (353)1295 0799. Fax: (353)1295 0705. E-mail: ipl@fatherbrowne.com. Website: www.fatherbrowne.com/ipl. **Contact:** David Davison. Estab. 1990. Picture library. Has 60,000 photos in files. Clients include: advertising agencies, businesses, book publishers, magazine publishers, newspapers, calendar companies.

Needs Wants photos of historic Irish material. Interested in alternative process, fine art, historical/vintage.

Specs Uses any prints. Accepts images in digital format. Send via CD as TIFF, JPEG files at 400 dpi.

Payment & Terms Pays 50% commission for b&w and color photos. Average price per image (to clients): $100-1,000 for b&w and color photos. Enforces minimum prices. Offers volume discounts to customers. Photographers can choose not to sell images on discount terms. Works with photographers on contract basis only. Statements issued quarterly. Payment made quarterly. Photographers allowed to review account records. Offers one-time rights, electronic media rights. Property release required. Photo captions required.

How to Contact Send query letter with photocopies. Does not keep samples on file; include SAE/IRC for return of material.

⊕ ▣ ISRAELIMAGES.COM

POB 60 Kammon 20112, Israel. (972)(4)908-2023. Fax: (972)(4)990-5783. E-mail: israel@ israelimages.com. Website: www.israelimages.com. **Contact:** Israel Talby, managing director. Estab. 1991. Has 450,000 photos in files. Clients include: advertising agencies, web designers, businesses, book publishers, magazine publishers, newspapers, calendar companies, greeting card and postcard publishers, multimedia producers, schools and universities, etc.

Needs "We are interested in everything about Israel, Judaism (worldwide) and The Holy Land."

Specs Uses digital material only, minimum accepted size 2000 × 3000 pixels. Send CD with low-res samples for review. "When accepted, we need TIFF or JPEG files at 300 dpi, RGB, saved at quality '11' in Photoshop."

Payment & Terms Average price per image (to clients): $50-3,000/picture. Negotiates fees below standard minimum against considerable volume that justifies it. Offers volume discounts to customers. Works with photographers on contract basis only. Offers limited regional exclusivity, nonexclusive contract. Contracts renew automatically with additional submissions. Statements issued quarterly. Payment made quarterly. Photographers allowed to review account records. Offers one-time rights, electronic media rights, agency promotion rights. Informs photographers and allows them to negotiate when a client requests all rights. Model/property release preferred. Photo captions required (what, who, when, where).

How to Contact Send query letter with CD or send low-res by e-mail. Expects minimum initial submission of 100 images. Responds in 2 weeks.

Tips "We strongly encourage everyone to send us images to review. When sending material, a strong edit is a must. We don't like to get 100 pictures with 50 similars. Last, don't overload our e-mail with submissions. Make an e-mail query, or better yet, view our submission guidelines on the website. Good luck and welcome!"

▣ IVERSON SCIENCE PHOTOS

31 Boss Ave., Portsmouth NH 03801. (603)433-8484. Fax: (603)433-8484. E-mail: bruce. iverson@myfairpoint.net. **Contact:** Bruce Iverson, owner. Estab. 1981. Stock photo agency. Clients include: advertising agencies, book/encyclopedia publishers, museums.

Needs Currently only interested in submissions of scanning electron micrographs and

transmission electron micrographs—all subjects.

Specs Uses all photographic formats and digital imagery.

Payment & Terms Pays 50% commission for b&w and color photos. Offers nonexclusive contract. Photographer paid within 1 month of agency's receipt of payment. Offers one-time rights. Photo captions required; include magnification and subject matter.

How to Contact "Give us a call or e-mail first. Our subject matter is very specialized." Responds in 2 weeks.

Tips "We are a specialist agency for science photos and technical images."

🌐 🖼 JAYAWARDENE TRAVEL PHOTO LIBRARY

7A Napier Road, Wembley, Middlesex HA0 UA United Kingdom. (44)(20)8795-3581. Fax: (44)(20)8795-4083. E-mail: jaytravelphotos@aol.com. Website: www.jaytravelphotos. com. **Contact:** Rohith or Franco, partners. Estab. 1992. Stock photo agency and picture library. Has 150,000 photos in files. Clients include: advertising agencies, businesses, book/encyclopedia publishers, magazine publishers, newspapers, postcard publishers, tour operators/travel companies.

Needs Travel and tourism-related images worldwide.

Specs Uses 35mm up to 6x7cm original transparencies and digital images (see website for guidelines).

Payment & Terms Pays 50% commission. Average price per image (to clients): $125-1,000. Enforces minimum prices of $125, "but negotiable on quantity purchases." Offers volume discounts to customers; inquire about specific terms. Discount sales terms not negotiable. Works with photographers on contract basis only. Offers limited regional exclusivity contract. Statements issued semiannually. Payment made semiannually, within 30 days of payment received from client. Offers one-time and exclusive rights for fixed periods. Does not inform photographers or allow them to negotiate when client requests all rights. Model/property release preferred. Photo captions required; include country, city/location, subject description.

How to Contact Send e-mail with stock list, or call. Expects a minimum initial submission of 300 images with quarterly submissions of at least 100 images. Responds in 3 weeks.

Tips "Study our guidelines on our website on what to submit. If you're planning a photo shoot anywhere, you need to give us an itinerary, with as much detail as possible, so we can brief you on what kind of pictures the library may need."

JEROBOAM

120 27th St., San Francisco CA 94110. (415)312-0198. E-mail: jeroboamster@gmail.com. **Contact:** Ellen Bunning, owner. Estab. 1972. Has 200,000 b&w photos, 200,000 color slides in files. Clients include: text and trade book, magazine and encyclopedia publishers, editorial (mostly textbooks), greeting cards, and calendars.

Needs "We want people interacting, relating photos, comic, artistic/documentary/photojournalistic images, especially ethnic and handicapped. Images must have excellent print quality—contextually interesting and exciting and artistically stimulating." Wants photos of babies/children/teens, couples, multicultural, families, parents, senior citizens, disasters, environmental, cities/urban, education, gardening, pets, religious, rural, adventure, health/fitness, humor, performing arts, sports, travel, agriculture, industry,

medicine, military, political, science, technology/computers. Interested in documentary, historical/vintage, seasonal. Needs shots of school, family, career and other living situations. Child development, growth and therapy, medical situations. No nature or studio shots.
Specs Uses 35mm transparencies.
Payment & Terms Works on consignment only; pays 50% commission. Average price per image (to clients): $150 minimum for b&w and color photos. Works with photographers without a signed contract. Statements issued monthly. Payment made monthly. Photographers allowed to review account records to verify sales figures. Offers one-time and electronic media rights. Informs photographers and allows them to negotiate when client requests all rights. Model/property release preferred for people in contexts of special education, sexuality, etc. Photo captions preferred; include "age of subject, location, etc."
How to Contact Call if in the Bay area; if not, query with samples and list of stock photo subjects; send material by mail for consideration or submit portfolio for review. "Let us know how long you've been shooting." Responds in 2 weeks.
Tips "The Jeroboam photographers have shot professionally a minimum of 5 years, have experienced some success in marketing their talent, and care about their craft excellence and their own creative vision. New trends are toward more intimate, action shots; more ethnic images needed."

◩ KIMBALL STOCK

(Formerly Ron Kimball Stock) 1960 Colony St., Mountain View CA 94043. (888)562-5522 or (650)969-0682. Fax: (650)969-0485. E-mail: submissions@kimballstock.com. Website: www.kimballstock.com. **Contact:** Jeff Kimball. Estab. 1970. Has 1 million photos in files. Clients include: advertising agencies, businesses, newspapers, postcard publishers, public relations firms, book publishers, calendar companies, magazine publishers, greeting card companies.
Needs Wants photos of dogs, cats, lifestyle with cars and domestic animals, landscapes/scenics, wildlife (outside of North America). Interested in seasonal.
Specs Prefers images in digital format, minimum of 12-megapixel digital camera, although 16-megapixel is preferred. Send via e-mail as JPEG files or send CD to mailing address. Uses 35mm, 120mm, 4 × 5 transparencies.
Payment & Terms Pays 50% commission for color photos. Works with photographers with a contract; negotiable. Offers nonexclusive contract. Statements issued quarterly. Payment made quarterly. Photographers allowed to review account records. Offers one-time rights, electronic media rights. Model /property release required. Photo captions required.
How to Contact Send query letter with transparencies, digital files, stock list. Provide self-promotion piece to be kept on file. Expects minimum initial submission of 250 images with quarterly submissions of at least 200 images. Responds only if interested; send nonreturnable samples. Photo guidelines available on website.

◪ JOAN KRAMER AND ASSOCIATES, INC.

10490 Wilshire Blvd., Suite 1701, Los Angeles CA 90024. (310)446-1866. Fax: (310)446-1856. E-mail: ekeeeek@earthlink.net. Website: www.home.earthlink.net/~ekeeeek. **Contact:** Joan Kramer, president. Member of Picture Archive Council of America (PACA). Has 1 million photos in files. Clients include: ad agencies, magazines, recording companies,

photo researchers, book publishers, greeting card companies, promotional companies, AV producers.

Needs "We use any and all subjects! Stock slides must be of professional quality." Subjects on file include travel, cities, personalities, animals, flowers, lifestyles, underwater, scenics, sports and couples.

Specs Uses 8 × 10 glossy b&w prints; any size transparencies.

Payment & Terms Pays 50% commission. Offers all rights. Model release required.

How to Contact Send query letter or call to arrange an appointment. Do not send photos before calling.

LAND OF THE BIBLE PHOTO ARCHIVE

P.O. Box 8441, Jerusalem 91084 Israel. (972)(2)566-2167. Fax: (972)(2)566-3451. E-mail: radovan@netvision.net.il. Website: www.biblelandpictures.com. **Contact:** Zev Radovan. Estab. 1975. Picture library. Has 50,000 photos in files. Clients include: book publishers, magazine publishers, newspapers, calendar companies, postcard publishers.

Needs Wants photos of museum objects, archaeological sites. Also multicultural, landscapes/scenics, architecture, religious, travel. Interested in documentary, fine art, historical/vintage.

Specs Uses high-resolution digital system.

Payment & Terms Average price per image (to clients): $80-700 for b&w, color photos. Offers volume discounts to customers; terms specified in photographers' contracts.

Tips "Our archives contain tens of thousands of color slides covering a wide range of subjects: historical and archaeological sites, aerial and close-up views, museum objects, mosaics, coins, inscriptions, the myriad ethnic and religious groups individually portrayed in their daily activities, colorful ceremonies, etc. Upon request, we accept assignments for in-field photography."

LIGHTWAVE

170 Lowell St., Arlington MA 02174. (781)354-7747. E-mail: paul@lightwavephoto.com. Website: www.lightwavephoto.com. **Contact:** Paul Light. Has 250,000 photos in files. Clients include: advertising agencies, textbook publishers.

Needs Wants candid photos of people in school, work and leisure activities, lifestyle.

Specs Uses color transparencies.

Payment & Terms Pays $210/photo; 50% commission. Works with photographers on contract basis only. Offers nonexclusive contract. Contracts renew automatically each year. Statements issued annually. Payment made "after each usage." Offers one-time rights. Informs photographers and allows them to negotiate when client requests all rights. Model/property release preferred. Photo captions preferred.

How to Contact "Create a small website and send us the URL."

Tips "Photographers should enjoy photographing people in everyday activities. Work should be carefully edited before submission. Shoot constantly and watch what is being published. We are looking for photographers who can photograph daily life with compassion and originality."

🌐 ▣ LINEAIR FOTOARCHIEF, B.V.

van der Helllaan 6, Arnhem 6824 HT Netherlands. (31)(26)4456713. Fax: (31)(26)3511123. E-mail: info@lineairfoto.nl. Website: www.lineairfoto.nl. **Contact:** Ron Giling, manager. Estab. 1990. Stock photo agency. Has still 100,000 analog photos to digitize in files at this moment and more than 1.4 million downloadable images available through the website. Clients include advertising agencies, public relations firms, book/encyclopedia publishers, magazine publishers. Library specializes in images from Asia, Africa, Latin America, Eastern Europe and nature in all forms on all continents. Member of WEA, a group of international libraries that use the same server to market each other's images, uploading only once.

Needs Wants photos of disasters, environmental, landscapes/scenics, wildlife, cities/urban, education, religious, adventure, travel, agriculture, business concepts, industry, political, science, technology/computers. Interested in everything that has to do with the development of countries all over the world, especially in Asia, Africa and Latin America.

Specs Accepts images in digital format only. Send via CD, DVD (or use our FTP) as high-quality JPEG files at 300 dpi, A4 or rather bigger size. "Photo files need to have IPTC information!"

Payment & Terms Pays 50% commission. Average price per image (to clients): $100-500. Enforces minimum prices. Offers volume discounts to customers; inquire about specific terms. Photographers can choose not to sell images on discount terms. Works with or without a signed contract; negotiable. Offers limited regional exclusivity. Statements issued quarterly. Payment made quarterly. Photographers allowed to review account records. "They can review bills to clients involved." Offers one-time rights. Informs photographers and allows them to negotiate when client requests all rights. Photo captions required; include country, city or region, description of the image.

How to Contact Submit portfolio or e-mail thumbnails (20KB files) for review. There is no minimum for initial submissions. Responds in 3 weeks. Market tips sheet available upon request. View website to subject matter and quality.

Tips "We like to see high-quality pictures in all aspects of photography. So we'd rather see 50 good ones than 500 for us to select the 50 out of. Send contact sheets upon our request. We will mark the selected pictures for you to send as high-res, including the very important IPTC (caption and keywords)."

🌐 ▣ LINK PICTURE LIBRARY

41A The Downs, London SW20 8HG United Kingdom. (44)(208)944-6933. E-mail: library@linkpicturelibrary.com. Website: www.linkpicturelibrary.com. **Contact:** Orde Eliason. Has 100,000 photos in files. Clients include: businesses, book publishers, magazine publishers, newspapers. Specializes in images of Southern and Central Africa, Southeast Asia, China and India.

Needs Wants photos of children and teens, multicultural, cities/urban, religious, adventure, travel, business concepts, industry, military, political. Interested in documentary, historical/vintage. Especially interested in India and Africa.

Specs Accepts images in digital format. Send via CD, e-mail as TIFF, JPEG files at 300 dpi.

Payment & Terms Pays 50% commission for color photos. Average price per image (to clients): $120 minimum for b&w, color photos. Enforces minimum prices. Offers volume

discounts to customers. Offers nonexclusive contract. Contracts renew automatically with additional submissions for 3 years. Statements issued semiannually. Payment made semiannually. Photographers allowed to review account records. Offers one-time rights. Photo captions required; include country, city location, subject detail.

How to Contact Provide résumé, business card, self-promotion piece to be kept on file. Expects minimum initial submission of 100 images with quarterly submissions of at least 100 images. Responds in 2 weeks to samples. Responds only if interested; send nonreturnable samples.

Tips "Arrange your work in categories to view. Have metadate embedded in all images. Provide contact details and supply SASE for returns."

▣ LUCKYPIX

1658 N. Milwaukee, #324, Chicago IL 60647. (773)235-2000. Fax: (773)235-2030. E-mail: info@luckypix.com. Website: www.luckypix.com. **Contact:** Director of Photography. Estab. 2001. Stock agency. Has 9,000 photos in files (adding constantly). Clients include: advertising agencies, businesses, book publishers, design companies, magazine publishers.

Needs Wants outstanding people/lifestyle images.

Specs 50 + MB TIFs, 300 DPI, 8-Bit Files. Photos for review: upload to website or e-mail info@luckypix.com. Final: CD/DVD as TIFF files.

Payment & Terms 50% commission for net revenues. Enforces minimum prices. Offers exclusivity by image and similars. Contracts renew automatically annually. Statements and payments issued quarterly. Model/property release required.

How to Contact Call or upload sample from website (preferred). Responds in 1 week. See website for guidelines.

Tips "Have fun shooting. Search the archives before deciding what pictures to send."

▨ ▣ MASTERFILE

3 Concorde Gate, 4th Floor, Toronto ON M3C 3N7 Canada. (800)387-9010. E-mail: portfolio@ masterfile.com. Website: www.masterfile.com. General stock agency offering rights-managed and royalty-free images. The combined collection exceeds 2.5 million images online. Clients include: major advertising agencies, broadcasters, graphic designers, public relations firms, book and magazine publishers, producers of greeting cards, calendars and packaging.

Specs Accepts images in digital format only, in accordance with submission guidelines.

Payment & Terms Pays photographers 40% royalties of amounts received by Masterfile. Contributor terms outlined in photographer's contract, which is image-exclusive. Photographer sales statements and royalty payments issued monthly.

How to Contact Refer to www.masterfile.com/info/artists/submissions.html for submission guidelines.

▤ MICHELE MATTEI PHOTOGRAPHY

1714 Wilton Place, Los Angeles CA 90028. (323)462-6342. Fax: (323)462-7568. E-mail: michele@michelemattei.com. Website: www.michelemattei.com. **Contact:** Michele Mattei, director. Estab. 1974. Stock photo agency. Clients include: book/encyclopedia publishers, magazine publishers, television, film.

Needs Wants photos of television and film celebrities, feature stories. Written information to accompany stories needed. Does not wish to see fashion and greeting card-type scenics. Also wants environmental, architecture, cities/urban, health/fitness, science, technology/computers, lifestyle.

Payment & Terms Pays 50% commission for color and b&w photos. Offers one-time rights. Model release required. Photo captions required.

How to Contact Send query letter with résumé, samples, stock list.

Tips "Shots of celebrities and home/family stories are frequently requested." In samples, looking for "high-quality, recognizable personalities and current newsmaking material. We are interested mostly in celebrity photography. Written material on personality or event helps us to distribute material faster and more efficiently."

☒ ▣ ◪ MAXX IMAGES, INC.

711 W. 15th St., North Vancouver BC V7M 1T2 Canada. (604)985-2560. Fax: (604)985-2590. E-mail: info@maxximages.com. Website: www.maxximages.com. **Contact:** Dave Maquignaz, president. Estab. 1994. Stock agency. Member of the Picture Archive Council of America (PACA). Has 3.2 million images online. Has 350 hours of video footage. Clients include: advertising agencies, public relation firms, audiovisual firms, businesses, book publishers, magazine publishers, newspapers, calendar companies, postcard publishers, video production, graphic design studios.

Needs Wants photos of people, lifestyle, business, recreation, leisure.

Specs Uses all formats.

How to Contact Send e-mail. Review submission guidelines on website prior to contact.

▣ THE MEDICAL FILE INC.

279 E. 44th St., 21st Floor, New York NY 10017. (212)883-0820 or (917)215-6301. E-mail: themedicalfile@gmail.com. Website: www.themedicalfile.com. **Contact:** Barbara Gottlieb, president. Estab. 2005. Clients include: advertising agencies, public relations firms, businesses, book/encyclopedia publishers, magazine publishers, postcard companies, calendar companies and greeting card companies.

Needs Wants photos of any medically related imagery including fitness and food in relation to healthcare.

Specs Accepts digital format images only on CD or DVD. Images can be downloaded to FTP site.

Payment & Terms Average price per image (for clients): $250 and up. Works on exclusive and nonexclusive contract basis. Contracts renew automatically with each submission for length of original contract. Payment made quarterly. Offers one-time rights. Informs photographers when clients request all rights or exclusivity. Model release required. Photo captions required.

How to Contact Arrange a personal interview to show portfolio. Submit portfolio for review. Tips sheet distributed as needed to contract photographers only.

Tips Wants to see a cross-section of images for style and subject. "Photographers should not photograph people *before* getting a model release. The day of the 'grab shot' is over."

N ▣ **MIRA**

716 Iron Post Rd., Moorestown NJ 08057. (856)231-0594. E-mail: mira@mira.com. Website: www.mira.com; www.CreativeEyeCoop.com. "Mira is the stock photo agency of the Creative Eye Cooperative. Mira seeks premium rights-protected images and contributors who are committed to building the Mira archive into a first-choice buyer resource. Mira offers a broad and deep online collection where buyers can search, price, purchase and download on a 24/7 basis. Mira sales and research support are also available via phone and e-mail. "Our commitment to customer care is something we take very seriously and is a distinguishing trait." Client industries include: advertising, publishing, corporate, marketing and education.

How to Contact "E-mail, call or visit our websites to learn more about participation in Mira."

N ▣ **MPTV (MOTION PICTURE AND TELEVISION PHOTO ARCHIVE)**

16735 Saticoy St., Suite 109, Van Nuys CA 91406. (818)997-8292. Fax: (818)997-3998. E-mail: sales@mptvimages.com. Website: www.mptvimages.com. **Contact:** Ron Avery, president or Joe Martinez, director of digital resources. Estab. 1988. Stock photo agency offering "one of the largest and continually expanding collections of entertainment photography in the world—images from Hollywood's Golden Age and all the way up to the present day. " Has over 1 million photos in files. Clients include: advertising agencies, book/encyclopedia publishers, magazine publishers, newspapers, postcard publishers, calendar companies, greeting card companies, record companies, production companies.

Needs Color shots of current stars and old TV and movie stills.

Specs Uses 8 × 10 b&w and/or color prints; 35mm, 2¼ × 2¼, 4 × 5, 8 × 10 transparencies. Accepts images in digital format. Send via CD as TIFF, JPEG files.

Payment & Terms Buys photos/film outright. Pays 50% commission for b&w and color photos. Average price per image (to clients): $180-1,000 for b&w photos; $180-1,200 for color photos. Enforces strict minimum prices. Offers volume discounts to customers; terms specified in photographers' contracts. Works with photographers on contract basis only. Offers exclusive contract. Contracts renew automatically with additional submissions. Statements issued monthly. Payment made monthly. Photographers allowed to review account records. Rights negotiable; "whatever fits the job."

How to Contact If interested in representation, send e-mail to photographers@mptvimages. com.

⊕ ▣ **MUSIC & ARTS PICTURES AT LEBRECHT**

3 Bolton Road, London NW8 0RJ United Kingdom. E-mail: pictures@lebrecht.co.uk. Website: www.lebrecht.co.uk. **Contact:** Ms. E. Lebrecht. Estab. 1992. Has 65,000 high-res images online; thousands more not yet scanned. Clients include: book publishers, magazine publishers, newspapers, calendar companies, film production companies, greeting card companies, public relations firms, advertising agencies.

Needs Wants photos of arts personalities, performing arts, instruments, musicians, dance (ballet, contemporary and folk), orchestras, opera, concert halls, jazz, blues, rock, authors, artists, theatre, comedy, art and artists. Interested in historical/vintage.

Specs Acceptsimages in digital format only.

Payment & Terms Pays 50% commission for b&w or color photos. Offers volume discounts to customers. Works with photographers on contract basis only. Offers limited regional exclusivity. Statements issued quarterly. Offers one-time rights. Informs photographers and allows them to negotiate when a client requests all rights. Model release required. Photo captions required; include who is in photo, location, date.
How to Contact Send e-mail.

▣ NOVASTOCK

1306 Matthews Plantation Dr., Matthews NC 28105-2463. (888)894-8622. Fax: (704)841-8181. E-mail: Novastock@aol.com. Website: www.creativeshake.com/novastock. **Contact:** Anne Clark, submission department. Estab. 1993. Stock agency. Clients include: advertising agencies, businesses, postcard publishers, public relations firms, book publishers, calendar companies, magazine publishers, greeting card companies, and large international network of subagents.
Needs "We need commercial stock subjects such as lifestyles, fitness, business, science, medical, family, etc. We also are looking for unique and unusual imagery. We have one photographer who burns, scratches and paints on his film." Wants photos of babies/children/teens, couples, multicultural, families, parents, senior citizens, disasters, environmental, wildlife, rural, adventure, health/fitness, travel, business concepts, military, science, technology/computers.
Specs Prefers images in digital format as follows: (1) Original digital camera files. (2) Scanned images in the 30-50MB range. "When sending files for editing, please send small files only. Once we make our picks, you can supply larger files. Final large files should be uncompressed TIFF or JPEG saved at best-quality compression. NEVER sharpen or use contrast and saturation filters. Always flatten layers. Files and disks must be readable on Windows PC."
Payment & Terms Pays 50% commission for b&w and color photos. Price range per image: $100-50,000 for b&w and color photos. "We never charge the photographer for any expenses whatsoever." Works with photographers on contract basis only. "We need exclusivity only for images accepted, and similars." Photographer is allowed to market work not represented by Novastock. Statements and payments are made in the month following receipt of income from sales. Informs photographers and discusses with photographer when client requests all rights. Model/property release required. Photo captions required; include who, what and where. "Science and technology need detailed and accurate captions. Model releases must be cross-referenced with the appropriate images."
How to Contact Contact by e-mail or send query letter with digital files, slides, tearsheets, transparencies. Does not keep samples on file; include SASE for return of material or personal check to cover return costs. Expects minimum initial submission of 100 images. Responds in 1 week to submissions.
Tips "Digital files on CD/DVD are preferred. All images must be labeled with caption (if necessary) and marked with model release information and your name and copyright. We market agency material through more than 50 agencies in our international subagency network. The photographer is permitted to freely market nonsimilar work any way he/she wishes. If you are unsure if your work meets the highest level of professionalism as used in current advertising, please do not contact."

Stock Photo Agencies

🌐 ▣ OKAPIA K.G.

Michael Grzimek & Co., Postfach 645, Röderbergweg 168, Frankfurt 60385 Germany. E-mail: info@okapia.de. Website: www.okapia.com. **Contact:** President. Stock photo agency and picture library. Has 700,000 photos in files. Clients include: ad agencies, book/encyclopedia publishers, magazine publishers, newspapers, postcard companies, calendar companies, greeting card companies, school book publishers.

Needs Wants photos of natural history, babies/children/teens, couples, families, parents, senior citizens, gardening, pets, adventure, health/fitness, travel, agriculture, industry, medical, science, technology/computers, general interest.

Specs Uses 35mm, 2¼ × 2¼, 4 × 5 transparencies. Accepts digital images. Send via DVD, CD, floppy disk as JPEG files at 355 dpi.

Payment & Terms Pays 50% commission for color photos. Average price per image (to clients): $60-120 for color photos. Enforces strict minimum prices. Offers volume discounts to customers. Discount sales terms not negotiable. Works with photographers on contract basis only. Offers nonexclusive contract, limited regional exclusivity and guaranteed subject exclusivity (within files). Contracts renew automatically for 1 year with additional submissions. Charges catalog insertion fee. Statements issued quarterly, semiannually or annually, depending on money photographers earn. Payment made quarterly, semiannually or annually with statement. Photographers allowed to review account records in cases of discrepancies only. Offers one-time, electronic media and agency promotion rights. Does not permit photographers to negotiate when client requests all rights. Model/property release preferred. Photo captions required.

How to Contact Send query letter with slides. Does not keep samples on file; include SASE for return of material. Expects minimum initial submission of 300 slides. Responds in 5 weeks. Photo guidelines free with SASE. Distributes tips sheets on request semiannually to photographers with statements.

Tips "We need every theme which can be photographed." For best results, "send pictures continuously."

▣ OMNI-PHOTO COMMUNICATIONS

10 E. 23rd St., New York NY 10010. (212)995-0805. Fax: (212)995-0895. E-mail: info@omniphoto.com. Website: www.omniphoto.com. **Contact:** Mary Fran Loftus, president. Estab. 1979. Stock photo and art agency. Has 100,000 photos in files. Clients include: advertising agencies, public relations firms, businesses, book/encyclopedia/magazines/calendar/greeting card companies.

Needs Wants photos of babies/children/teens, couples, multicultural, families, senior citizens, environmental, wildlife, architecture, cities/urban, religious, rural, entertainment, food/drink, health/fitness, sports, travel, agriculture, industry, medicine.

Specs Accepts images in digital format. High-resolution 30- 50MB JPEGs required for accepted digital images.

Payment & Terms Pays 50% commission. Works with photographers on contract basis only. Offers limited regional exclusivity. Contracts renew automatically with additional submissions for 4 years. Charges catalog insertion fee. Statements issued with payment on a quarterly basis. Offers one-time rights. Informs photographers and allows them to negotiate when client requests all rights. Model/property release required. Photo captions required.

How to Contact Send low-res sample JPEGs (approximately 3 × 5 inches) on DVD, CD, or point us to your website portfolio. Only discs with SASE are returned. No e-mail attachments."

Tips "We want spontaneous-looking, professional-quality photos of people interacting with each other. Have carefully-thought-out backgrounds, props and composition, commanding use of color. Stock photographers must produce high-quality work at an abundant rate. Self-assignment is very important, as is a willingness to obtain model releases; caption thoroughly and make submissions regularly."

⊕ ▣ ONASIA

30 Cecil Street, Prudential Tower Level 15, Singapore 049712. + 66 2673 9407-8. Fax: + 66 2673 9409. E-Mail: sales@onasia.com. Website: www.onasia.com. Contact: Peter Charlesworth or Yvan Cohen, directors. An Asia-specialized agency offering rights-managed stock, features and assignment services. Represents over 180 photographers and has over 180,000 high-resolution images available online and 400,000 photos in files. Offices in Singapore and Bangkok. Clients include: advertising and graphic design agencies, newspapers, magazines, book publishers, calendar and gift card companies.

Needs Wants model-released Asia-related conceptual, lifestyle and business imagery as well as a broad range of nonreleased editorial imagery including current affairs, historical collections, travel and leisure, economics as well as social and political trends. Please note: We only accept images from or relating to Asia.

Specs Accepts images in digital format. Send via CD or to our FTP site as 12 × 18-inch JPEG files at 300 dpi. All files must be retouched to remove dust and dirt. Photo captions required; include dates, location, country and a detailed description of image, including names where possible.

Payment & Terms Pays 50% commission to photographers. Terms specified in photographer contracts. Photographers are required to submit on an image-exclusive basis. Statements issued monthly.

How to Contact E-mail queries to info@onasia.com with lo-res JPEG samples or a link to photographer's website. Does not keep samples on file; cannot return material. Expects minimum initial submission of 150 images. Photo guidelines available via e-mail.

Tips "Provide a well-edited lo-res portfolio for initial evaluation. Ensure that subsequent submissions are tightly edited, sized to Onasia's specs, retouched and submitted with full captions."

⊕ ▣ OPCAO BRASIL IMAGENS

Rua Barata Ribeiro, No. 370 GR. 215/216, Copacabana, Rio de Janeiro, 22040-002 Brazil. Phone/fax: (55)(21)2256-9007. E-mail: opcao@opcaobrasil.com.br. Website: www.opcaobrasil.com.br. **Contact**: Ms. Graca Machado and Mr. Marcos Machado, directors. Estab. 1993. Has 600,000 photos in files. Clients include: advertising agencies, book publishers, magazine publishers, calendar companies, postcard publishers, publishing houses.

Needs Wants photos of babies/children/teens, couples, families, parents, wildlife, health/fitness, beauty, education, hobbies, sports, industry, medicine. "We need photos of wild animals, mostly from the Brazilian fauna. We are looking for photographers who have images of people who live in tropical countries and must be brunette."

Specs Accepts images in digital format.

Payment & Terms Pays 50% commission for b&w or color photos. Average price per image (to clients): $100-400 for b&w photos; $200 minimum for color photos. Negotiates fees below standard minimum prices only in case of renting, at least, 20 images. Offers volume discounts to customers. Works with photographers on contract basis only. Offers limited regional exclusivity. Contracts renew automatically with additional submissions for 3 years. Charges $200/image for catalog insertion. Statements issued quarterly. Payment made quarterly. Photographers allowed to review account records in cases of discrepancies only. Offers one-time rights, electronic media rights, agency promotion rights. Model release required; property release preferred. Photo captions required.

How to Contact Initial contact should be by

Tips "We need creative photos presenting the unique look of the photographer on active and healthy people in everyday life at home, at work, etc., showing modern and up-to-date individuals. We are looking for photographers who have images of people with the characteristics of Latin American citizens."

▣ OUT OF THE BLUE

1022 Hancock Ave., Sarasota FL 34232. (941)966-4042. Fax: (941)296-7345. E-mail: outoftheblue.us@mac.com. Website: www.out-of-the-blue.us. Estab. 2003. **Contact:** Michael Woodward, president or Jane Mason, licensing manager. "We are looking for fine art photographic collections, especially evocative landscapes, flowers, and tropical categories for canvas reproductions, poster and prints for mass market as well as fine art subjects for interior design office and hotel projects."

Needs "We require collections, series, or groups of photographic images which are either decorative or have a more sophisticated fine art look." E-mail or CD presentations only.

How to Contact & Terms "Commission rate is 50% with no expenses to photographers as long as photographer can provide high-resolution scans if we agree to representation." Include short bio.

Tips "Keep aware of current trends in color palettes."

▣ OUTSIDE IMAGERY

4548 Beachcomber Court, Boulder CO 80301. (303)530-3357. E-mail: John@OutsideImagery. com. Website: www.OutsideImagery.com. **Contact:** John Kieffer, president. Estab. 1986. Stock agency. Has 200,000 images in keyword-searchable, online database. Clients include: advertising agencies, businesses, multimedia, greeting card and postcard publishers, book publishers, graphic design firms, magazine publishers.

Needs Photos showing a diversity of people participating in an active and healthy lifestyle in natural and urban settings, plus landscapes and cityscapes. Wants photos of people enjoying the outdoors. Babies/children/teens, couples, multicultural, families, senior citizens. Activities and subject include: recreation, cityscapes, skylines, environmental, landscapes/scenics, wildlife, rural, adventure, health/fitness, sports, travel, wildlife, agriculture.

Specs Requires images in high-resolution digital format. No film. Send low-resolution files via CD or e-mail in JPEG format at 72 dpi.

Payment & Terms Pays 50% commission for all imagery. Average price per image (to clients): $150-3,500 for all imagery. Will often work within a buyer's budget. Offers volume discounts to customers. Offers nonexclusive contract. Payment made quarterly. Model release required; property release preferred. Photo captions and keywords required.

How to Contact " First review our website. Then send a query e-mail, and include a stock list or an active link to your website. If you don't hear from us in three weeks, send a reminder e-mail."

⊕ ▣ ◪ OXFORD SCIENTIFIC (OSF)

Oxford Scientific Films, Network House, 2nd Floor Waterside House, 9 Woodfield Rd., London W9 2BA United Kingdom. (44)(0) 20 7432 8200. Fax: (44)(0) 20 7432 8201. E-mail: creative@osf.co.uk. Website: www.osf.co.uk. **Contact**: Creative Director. Estab. 1968. Stock agency. Stills and footage libraries. Has 350,000 photos, over 2,000 feet of HD, film and video originated footage. Clients include: advertising agencies, design companies, audiovisual firms, book/encyclopedia publishers, magazine and newspaper publishers, merchandising companies, multimedia publishers, film production companies.

Needs Wants photos and footage of natural history: animals, plants, behavior, close-ups, life-histories, histology, embryology, electron microscopy, scenics, geology, weather, conservation, country practices, ecological techniques, pollution, special-effects, high-speed, time-lapse, landscapes, environmental, travel, sports, pets, domestic animals, wildlife, disasters, gardening, rural, agriculture, industry, medicine, science, technology/computers. Interested in seasonal.

Specs Send via CD, e-mail at 72 dpi for initial review; 300 dpi (RGB TIFF files) for final submission. Review guidelines for details.

Payment & Terms Pays 50% commission. Negotiates fees below stated minimums on bulk deals. Average price per image (to clients) $100-2,000 for b&w and color photos; $300-4,000 for film or videotape. Offers volume discounts to regular customers; inquire about specific terms. Discount sale terms not negotiable. Works with photographers on contract basis only; needs image exclusivity. Offers image-exclusive contract, limited regional exclusivity, guaranteed subject exclusivity. Contracts renew automatically every 2 years. There is a charge for handling footage. Offers one-time, electronic media and agency promotion rights. Informs photographers and allows them to negotiate when client requests all rights. Model/property release required. Photo captions required; include common name, Latin name, behavior, location and country, magnification where appropriate, if captive, if digitally manipulated. Contact OSF for footage terms.

How to Contact Submission guidelines available on website. Expects minimum initial submission of 100 images with quarterly submissions of at least 100 images. Interested in receiving high-quality, creative, inspiring work from both amateur and professional photographers. Responds in 1 month.

Tips "Contact via e-mail, phone or fax, or visit our website to obtain submission guidelines." Prefers to see "good focus, composition, exposure, rare or unusual natural history subjects and behavioral and action shots, inspiring photography, strong images as well as creative shots. Read photographer's pack from website or e-mail/write to request a pack, giving brief outline of areas covered and specialties and size."

🖳 PACIFIC STOCK/PRINTSCAPES.COM

Koko Marina Center, 7192 Kalanianaole Hwy., Suite G-230, Honolulu HI 96825. (808)394-5100. Fax: (808)394-5200. E-mail: pics@pacificstock.com. Website: www.pacificstock.com and www.printscapes.com. **Contact:** Barbara Brundage, owner/president. Member of Picture Archive Council of America (PACA). Has 100,000 photos in files; 25,000 digital images online. "Pacific Stock specializes exclusively in rights-managed imagery from throughout Hawaii, Pacific and Asia and its royalty-free collection." Clients include advertising agencies, public relations firms, book/encyclopedia publishers, magazine publishers, postcard companies, calendar companies, greeting card companies. "We also cater to the professional interior design market at our new fine art website, www.printscapes.com."

Needs Needs photos and fine art of Hawaii, Pacific Islands, and throughout the Pacific Rim. Subjects include: people (women, babies/children/teens, couples, multicultural, families, parents, senior citizens), culture, marine science, environmental, landscapes, wildlife, adventure, food/drink, health/fitness, sports, travel, agriculture, business concepts. "We also have an extensive vintage Hawaii file as well as fine art throughout the Pacific Rim."

Specs Accepts images in digital format only. Send via Hard Drive or DVD as 16-bit TIFF files (guidelines on website at http://www.pacificstock.com/photographer_guidelines.asp).

Payment & Terms Pays 40% commission for color, black and white photos, or fine art imagery. Average price per image (to clients): $650. Works with photographers and artists on contract basis only. Statements and payments issued monthly. Contributors allowed to review account records to verify sales figures. Offers one-time or first rights; additional rights with contributor's permission. Informs contributors and allows them to negotiate when client requests all rights. Model/property release required for all people and certain properties, i.e., homes and boats. Photo captions required; include: "who, what, where." See submission guidelines for more details.

How to Contact "E-mail or call us after reviewing our website and our photo guidelines. Want lists distributed regularly to represented photographers; free via e-mail to interested photographers."

Tips Photographer must be able to supply minimum of 500 image files (must be model-released) for initial entry and must make quarterly submissions of fresh material from Hawaii, Pacific and Asia area destinations. Image files must be captioned in File Info (i.e., IPTC headers) according to our submission guidelines. Please contact us to discuss the types of imagery that sell well for us. We are also looking for fine artists whose work is representative of Hawaii and the Pacific Rim. We are interested in working with contributors who work with us and enjoy supplying imagery requested by our valued clients."

🖳 PAINET INC.

20 Eighth St. S., P.O. Box 431, New Rockford ND 58356. (701)947-5932 or (888)966-5932. E-mail: painet@stellarnet.com. Website: www.painetworks.com. **Contact:** S. Corporation, owner. Estab. 1985. Picture library. Has 650,000 digital photos in files. Clients include: advertising agencies, magazine publishers.

Needs "Anything and everything."

Specs "Refer to www.painetworks.com/helppages/submit.htm for information on how to scan and submit images to Painet. The standard contract is also available from this page."

Payment & Terms Pays 60% commission (see contract). Works with photographers with

or without a contract. Offers nonexclusive contract. Payment made immediately after a sale. Informs photographers and allows them to negotiate when client requests all rights. Provides buyer contact information to photographer by sending photographer copies of the original invoices on all orders of photographer's images.

How to Contact " Occasionally receives a list of current photo requests."

Tips "We have added an online search engine with 650,000 images. We welcome submissions from new photographers, since we add approximately 60,000 images quarterly. Painet markets color and black & white images electronically or by contact with the photographer. Because images and image descriptions are entered into a database from which searches are made, we encourage our photographers to include lengthy descriptions that improve the chances of finding their images during a database search. We prefer descriptions be included in the IPTC (File Info area of Photoshop). Photographers who provide us their e-mail address will receive a biweekly list of current photo requests from buyers. Photographers can then send matching images via e-mail or FTP, and we forward them to the buyer. Painet also hosts Photographer's and Photo Agency websites. See details at http://www.painetworks.com/helppages/setupPT.htm."

PANORAMIC IMAGES

2302 Main St., Evanston IL 60202. (847)324-7000. Fax: (847)324-7004. E-mail: images@panoramicimages.com, michelle@panoramicimages.com. Website: www.panoramicimages.com. **Contact:** Michelle Alvardo Novak, director of photography. Estab. 1987. Stock photo agency. Member of ASPP, NANPA and IAPP. Clients include: advertising agencies, magazine publishers, newspapers, design firms, graphic designers, corporate art consultants, postcard companies, calendar companies.

Needs Wants photos of lifestyles, environmental, landscapes/scenics, wildlife, architecture, cities/urban, gardening, interiors/decorating, rural, adventure, automobiles, health/fitness, sports, travel, business concepts, industry, medicine, military, science, technology/computers. Interested in alternative process, avant garde, documentary, fine art, historical/vintage, seasonal. Works only with *panoramic formats* (2:1 aspect ratio or greater). Subjects include: cityscapes/skylines, international travel, nature, tabletop, backgrounds, conceptual.

Specs Uses 2¼ × 5, 2¼ × 7 (6 × 12cm, 6 × 17cm). "Transparencies preferred for initial submission. Call for digital submission guidelines or see website."

Payment & Terms Pays 40% commission for photos. Average price per image (to clients): $600. No charge for scanning, metadata or inclusion on website. Statements issued quarterly. Payment made quarterly. Offers one-time, electronic rights and limited exclusive usage. Model release preferred "and/or property release, if necessary." Photo captions required. Call or see website for submission guidelines before submitting.

How to Contact Send e-mail with stock list or low-res scans/lightbox. Responds in 1-3 months. Specific want lists created for contributing photographers. Photographer's work is represented on full e-commerce website and distributed worldwide through image distribution partnerships with Getty Images, National Geographic Society Image Collection, Amana, Digital Vision, etc.

Tips Wants to see "well-exposed chromes or very high-res stitched pans. Panoramic views of well-known locations nationwide and worldwide. Also, generic beauty panoramics."

⊕ ▣ PAPILIO NATURAL HISTORY LIBRARY

155 Station Rd., Herne Bay, Kent CT6 5QA United Kingdom. (44)(122)736-0996. E-mail: library@papiliophotos.com. Website: www.papiliophotos.com. **Contact:** Justine Pickett. Estab. 1984. Has 120,000 photos in files. Clients include: advertising agencies, book publishers, magazine publishers, newspapers, calendar companies, greeting card companies, postcard publishers.

Needs Wants photos of wildlife.

Specs Prefers digital submissions. Uses digital shot in-camera as RAW and converted to TIFF for submission, minimum file size 17MB. See webpage for further details or contact for a full information sheet about shooting and supplying digital photos.

Payment & Terms Works with photographers on contract basis only. Offers nonexclusive contract. Statements issued quarterly. Payment made quarterly. Offers one-time rights, electronic media rights. Photo captions required; include Latin names and behavioral information and keywords.

How to Contact Send query letter with résumé. Does not keep samples on file. Expects minimum initial submission of 150 images. Responds in 1 month to samples. Returns all unsuitable material with letter. Photo guidelines sheet free with SASE.

Tips "Contact first for information about digital. Send digital submissions on either CD or DVD disk. Supply full caption listing for all images. Wildlife photography is very competitive. Photographers are advised to send only top-quality images."

▣ PHOTO AGORA

3711 Hidden Meadow Lane, Keezletown VA 22832. (540)269-8283. E-mail: PhotoAgora@aol.com. Website: www.photoagora.com. **Contact:** Robert Maust. Estab. 1972. Stock photo agency. Has over 65,000 photos in files. Clients include: businesses, book/encyclopedia and textbook publishers, magazine publishers, calendar companies.

Needs Wants photos of families, children, students, Virginia, Africa and other third world areas, work situations, etc. Also needs babies/children/teens, couples, multicultural, parents, senior citizens, disasters, environmental, landscapes/scenics, wildlife, cities/urban, education, gardening, pets, religious, rural, health/fitness, travel, agriculture, industry, medicine, science, technology/computers.

Specs Send high-resolution digital images. Ask for password to download agreement and submission guidelines from website.

Payment & Terms Pays 50% commission for b&w and color photos. Average price per image (to clients): $40 minimum for b&w photos; $100 minimum for color photos. Negotiates fees below standard minimum prices. Offers volume discounts to customers; inquire about specific terms. Photographers can choose not to sell images on discount terms. Works with photographers with or without a contract. Offers nonexclusive contract. Payment made quarterly. Photographers allowed to review account records. Offers one-time rights. Informs photographers and allows them to negotiate when client requests all rights. Model/property release preferred. Embedded photo captions required; include location, important dates, scientific names, etc.

How to Contact Call, write or e-mail. No minimum number of images required in initial submission. Responds in 3 weeks. Photo guidelines free with SASE or download from website.

🖳 PHOTO EDIT

3505 Cadillac Ave., Ste. H, Costa Mesa CA 92626. (800)860-2098. Fax: (800)804-3707. E-mail: sales@photoeditinc.com. Website: www.photoeditinc.com. **Contact:** Kristen Sachs or Raquel Ramirez. Estab. 1987. Stock agency. 100% digital. 200,000 images online. Clients include: advertising agencies, businesses, public relations firms, book/textbook publishers, calendar companies, magazine/newspaper publishers.

Needs Digital images of babies/children/teens, couples, multicultural, families, parents, senior citizens, disasters, environment, cities/urban, education, religious, food/drink, health/fitness, hobbies, sports, travel, agriculture, business concepts, industry, medicine, political, science, technology/computers.

Specs Uses images in digital format (RAW, unmanipulated). Send via CD as JPEG files at 300 dpi.

Payment & Terms Average price per image (to clients): $175 for color images. Enforces minimum prices. Enjoys preferred vendor status with many clients. Works with photographers on contract basis only. Offers nonexclusive contract. Contracts renew automatically with continuous submissions. Offers one-time rights. Informs photographers and allows them to negotiate when a client requests all rights. Model/property release preferred. Photo captions required.

How to Contact Send query letter by e-mail with images or link to website to view images. Does not keep samples on file. Responds immediately only if interested. Photo guidelines sheet available via e-mail.

Tips "Call to discuss interests, equipment, specialties, availability, etc."

🖳 PHOTOLIBRARY GROUP INDEX STOCK IMAGERY, INC.

23 W. 18th St., 3rd Floor, New York NY 10011. (212)929-4644 or (800)690-6979. Fax: (212)633-1914. Website: www.photolibrary.com. "The Photolibrary Group represents the world's leading stock brands and the finest photographers around the world, to bring memorable, workable content to the creative communities in America, Europe, Asia, and the Pacific. We provide customers with access to over 5 million images and thousands of hours of footage and full composition music. Photolibrary Group was founded in 1967 and, 40 years on has a global presence with offices in the United Kingdom (London), the USA (New York), Australia (Sydney and Melbourne), Singapore, India, Malaysia, the Philippines, Thailand, New Zealand and the United Arab Emirates. Photolibrary is always on the lookout for new and innovative photographers and footage producers. Due to the highly competitive market for stock imagery we are very selective about the types of work that we choose to take on. We specialize in high quality, creative imagery primarily orientated to advertising, business-to-business and the editorial and publishing markets. Interested contributors should go to the website and click on the Artists tab for submission information. For additional information regarding our house brands, follow the About Us link."

🌐 🖳 PHOTOLIFE CORPORATION LTD.

2/F Eton Tower, Hysan Avenue, Causeway Bay, Hong Kong. (852)2808 0012. Fax: (852)2808 0072. E-mail: edit@photolife.com.hk. Website: www.photolife.com.hk. **Contact:** Serene Li, director of business development. Estab. 1994. Stock photo library. Has over 1.6 million photos in files. Clients include: advertising agencies, newspapers, book publishers, calendar

companies, magazine publishers, greeting card companies, corporations, production houses, graphic design firms.

Needs Wants contemporary images of architecture, interiors, garden, infrastructure, concepts, business, finance, sports, lifestyle, nature, travel, animal, marine life, foods, medical.

Specs Accepts images in digital format only. "Use only professional digital cameras (capable of producing 24 MB+ images) with high-quality interchangeable lenses; or images from high-end scanners producing a file up to 50 MB."

Payment & Terms Pays 50% commission for b&w and color photos. Average price per image (to clients): $105-1,550 for b&w photos; $105-10,000 for color photos. Offers volume discounts to customers; terms specified in photographers' contracts. Works with photographers on contract basis only. Contract can be initiated with minimum 300 selected images. Quarterly submissions needed. Informs photographers and allows them to negotiate when client requests all rights. Model release required; property release preferred. Photo captions required; include destination and country.

How to Contact E-mail 50 low-res images (1,000 pixels or less), or send CD with 50 images.

Tips "Visit our website. Edit your work tightly. Send images that can keep up with current trends in advertising and print photography."

▣ PHOTO NETWORK

P.O. Box 317, Lititz PA 17543. (717)626-0296 or (800)622-2046. Fax: (717)626-0971. E-mail: info@heilmanphoto.com. Website: www.heilmanphoto.com. **Contact:** Sonia Wasco, president. Stock photo agency/library. Member of Picture Archive Council of America (PACA). Has more than 1 million photos in files. Clients include: agribusiness companies, ad agencies, textbook companies, graphic artists, public relations firms, newspapers, corporations, magazines, calendar companies, greeting card companies. Member ASPP, NANPA, AAEA.

- Photo Network is now owned by Grant Heilman Photography.; Photo Network is now owned by Grant Heilman Photography.

Needs Wants photos of agriculture, families, couples, ethnics (all ages), animals, travel and lifestyles. Also wants photos of babies/children/teens, parents, senior citizens, disasters, environmental, wildlife, architecture, cities/urban, education, gardening, interiors/decorating, pets, religious, rural, adventure, automobiles, food/drink, health/fitness/beauty, hobbies, humor, sports, business concepts, industry, medicine, military, political, science, technology/computers. Special subject needs include people over age 55 enjoying life; medical shots (patients and professionals); children and domestic animals.

Specs Uses transparencies and digital format. Send via CD as JPEG files.

Payment & Terms Information available upon request.

How to Contact Send query letter with stock list. Send a sample of 200 images for review; include SASE for return of material. Responds in 1 month.

Tips Wants to see a portfolio "neat and well-organized and including a sampling of photographer's favorite photos." Looks for "clear, sharp focus, strong colors and good composition. We'd rather have many very good photos rather than one great piece of art. Would like to see photographers with a specialty or specialties and have it/them covered

thoroughly. You need to supply new photos on a regular basis and be responsive to current trends in photo needs. Contract photographers are supplied with quarterly 'want' lists and information about current trends."

▣ PHOTO RESEARCHERS, INC.

60 E. 56th St., New York NY 10022. (212)758-3420. Fax: (212)355-0731. E-mail: info@ photoresearchers.com. Website: www.photoresearchers.com. Stock agency. Has over 1 million photos and illustrations in files, with 250,000 images in a searchable online database. Clients include: advertising agencies; graphic designers; publishers of textbooks, encyclopedias, trade books, magazines, newspapers, calendars, greeting cards; foreign markets.

Needs Wants images of all aspects of science, astronomy, medicine, people (especially contemporary shots of teens, couples and seniors). Particularly needs model-released people, European wildlife, up-to-date travel and scientific subjects. Lifestyle images must be no older than 2 years; travel images must be no older than 5 years.

Specs Prefers images in digital format.

Payment & Terms Rarely buys outright; pay 50% commission on stock sales. General price range (to clients): $150-7,500. Works with photographers on contract basis only. Offers limited regional exclusivity. Contracts renew automatically with additional submissions for 5 years (initial term; 1 year thereafter). Charges $15 for Web placement for transparencies. Photographers allowed to review account records upon reasonable notice during normal business hours. Statements issued monthly, bimonthly or quarterly, depending on volume. Informs photographers and allows them to negotiate when a client requests to buy all rights, but does not allow direct negotiation with customer. Model/property release required for advertising; preferred for editorial. Photo captions required; include who, what, where, when. Indicate model release.

How to Contact See "About Representation and Submission Guidelines" on website.

Tips "We seek the photographer who is highly imaginative or into a specialty (particularly in the scientific or medical fields). We are looking for serious contributors who have many hundreds of images to offer for a first submission and who are able to contribute often."

▣ PHOTO RESOURCE HAWAII

111 Hekili St., #41, Kailua HI 96734. (808)599-7773. E-mail: prh@photoresourcehawaii.com. Website: www.PhotoResourceHawaii.com. **Contact:** Tami Kauakea Winston, owner. Estab. 1983. Stock photo agency. Has website with electronic delivery of over 12,000 images. Clients include: ad agencies, audiovisual firms, businesses, book/encyclopedia publishers, magazine publishers, calendar companies, greeting card companies, postcard publishers.

Needs Photos of Hawaii and the South Pacific.

Specs Accepts images in digital format only; 48MB or larger; TIFF files from RAW files preferred.

Payment & Terms Pays 50% commission. Enforces minimum prices. Offers volume discounts to customers. Discount sales terms not negotiable. Works with photographers on contract basis only. Offers nonexclusive contract. Contracts renew automatically with additional submissions. Statements issued bimonthly. Payment made bimonthly. Offers royalty-free and rights-managed images. Model/property release preferred. Photo captions

and keywording online required.

How to Contact Send query e-mail with samples. Expects minimum initial submission of 100 images with periodic submissions at least 5 times/year. Responds in 2 weeks.

PHOTOSOURCE NEW ZEALAND LTD.

PhotoSource International, Pine Lake Farm, 1910 35th Rd., Osceola WI 54020-5602. (715)248-3800. E-mail: info@photosource.com. Website: www.photosource.com. **Contact**: Rohn Engh. Estab. 1998. Picture library. Has 80,000 photos in files. Clients include: advertising agencies, businesses, postcard publishers, public relations firms, book publishers, calendar companies, government departments, magazine publishers, greeting card companies.

Needs Wants photos of babies/children/teens, celebrities, couples, multicultural, families (New Zealand only), parents, senior citizens, wildlife, disasters, environmental, landscapes/scenics, architecture, cities/urban, education, gardening, interiors/decorating, adventure, entertainment, food/drink, hobbies, performing arts, sports, travel, business concepts, industry, medicine, product shots/still life, science, technology/computers. Interested in seasonal.

Specs Uses 35mm, 2¼ × 2¼, 4 × 5, 8 × 10 transparencies.

Payment & Terms Pays 50% commission for photos, film. Average price per image (to clients): $200-2,500 for photos. Offers volume discounts. Discount sales terms not negotable. Works with photographers on contract basis only. Offers nonexclusive contract with guaranteed subject exclusivity in New Zealand. Statements issued quarterly. Payment made quarterly. Offers one-time rights. Informs photographers and allows them to negotiate when client requests all rights. Model/property release required. Photo captions preferred; include full description of location or subject.

How to Contact Contact via e-mail.

Tips "All 35mm should be mounted with description and other relevant information on a list. Check all work thoroughly for technical faults and leave 'faulty' material out of submission. Keep subjects in order. Present slides in sleeves, not boxes. 120 format and larger, if mounted, should be labelled, too. 120 format, if unmounted, should be numbered to correspond easily with a description list."

⊕ ▣ ▨ PHOTO STOCK/GRANATAIMAGES.COM

19/5 Via Wildt, Milan 20131 Italy. (39)(022) 668- 0702. Fax: (39)(022) 668-1126. E-mail: paolo.granata@granataimages.com. Website: www.granataimages.com. **Contact:** Paolo Granata, manager. Estab. 1985. Stock and press agency. Member of CEPIC. Has 2 million photos in files and 800,000 images online. Clients include: advertising agencies, newspapers, book publishers, calendar companies, audiovisual firms, magazine publishers, production houses.

Needs Wants photos of celebrities, people.

Specs Uses high-resolution digital files. Send via Zip, FTP, e -mail as TIFF, JPEG files.

Payment & Terms Pays 60% commission for color photos. Negotiates fees below stated minimums in cases of volume deals. Offers volume discounts to customers. Photographers can choose not to sell images on discount terms. Works with photographers on contract basis only. Offers exclusive contract only. Contracts renew automatically with additional submissions for 1 year. Statements issued monthly. Photographers allowed to review

account records in cases of discrepancies only. Offers one-time rights. Model/property release preferred. Photo captions required; include location, country and any other relevant information.

How to Contact Send query letter with digital files.

⊕ ▣ SYLVIA PITCHER PHOTO LIBRARY

75 Bristol Rd., Forest Gate, London E7 8HG United Kingdom. E-mail: SPphotolibrary@aol. com. Website: www.sylviapitcherphotos.com. **Contact:** Sylvia Pitcher. Estab. 1965. Picture library. Has 70,000 photos in files. Clients include: book publishers, magazine publishers, design consultants, record and TV companies.

Needs Wants photos Musicians—blues, country, bluegrass, old time and jazz with views of America that could be used as background to this music. Also, other relevant subject matter such as recording studios, musicians' birth places, clubs etc. Please see website for a good indication of the library's contents.

Specs Accepts images in digital format.

Payment & Terms Pays 50% commission for b&w and color photos. Average price per image (to clients): $105-1,000. Negotiates fees below stated minimum for budget CDs or multiple sale. Offers volume discounts to customers; terms specified in photographers' contracts. Photographers can choose not to sell images on discount terms, if specified at time of depositing work in library. Works with photographers with or without contract; negotiable. Offers nonexclusive contract. Contracts renew automatically with additional submissions for 3 years. Statements issued quarterly. Payment made when client's check has cleared. Offers one-time rights. Model/property release preferred. Photo captions required; include artist, place/venue, date taken.

How to Contact Send query letter with CD of approximately 10 low-res sample images and stock list. Provide self-promotion piece to be kept on file. Expects minimum initial submission of 50 high-res images on CD with further submissions when available.

▣ PIX INTERNATIONAL

3600 N. Lake Shore Dr., Unit 612 Floor, Chicago IL 60613. (773)472-7457. E-mail: pixintl@ yahoo.com. Website: www.pixintl.com. **Contact:** Linda Matlow, president. Estab. 1978. Stock agency, news/feature syndicate. Has 200,000 photos in files. Clients include: advertising agencies, public relations firms, businesses, book publishers, magazine publishers, newspapers.

Needs Wants photos of celebrities, entertainment, performing arts.

Specs Accepts images in digital format only. E-mail link to website. "Do not e-mail any images. Do not send any unsolicited digital files. Make contact first to see if we're interested."

Payment & Terms Pays 50% commission for b&w or color photos, film. Average price per image (to clients): $35 minimum for b&w or color photos; $75-3,000 for film. Enforces minimum prices. Offers volume discounts to customers; terms specified in photographers' contracts. Discount sales terms not negotiable. Works with photographers with or without a contract; negotiable. Statements issued monthly. Payment made monthly. Photographers allowed to review account records in cases of discrepancies only. Offers one-time rights. Informs photographers and allows them to negotiate when client requests all rights. Model

release not required for general editorial. Photo captions required; include who, what, when, where, why.

How to Contact "E-mail us your URL with thumbnail examples of your work that can be clicked for a larger viewable image." Responds in 2 weeks to samples, only if interested.

Tips "We are looking for razor-sharp images that stand up on their own without needing a long caption. Let us know by e-mail what types of photos you have, your experience, and cameras used. We do not take images from the lower-end consumer cameras—digital or film. They just don't look very good in publications. For photographers we do accept, we would only consider high-res 300-dpi at 6×9 or higher scans submitted on CDR. Please direct us to samples on your website."

🌐 ▣ PLANS, LTD. (PHOTO LIBRARIES AND NEWS SERVICES)

#201 Kamako Bldg., 1-8-9 Ohgi-gaya, Kamakura 248-0011 Japan. (81)(46)723-2350. Fax: (81) (46)723-2351. E-mail: yoshida@plans.jp. Website: www.plans.jp. **Contact:** Takashi Yoshida, president. Estab. 1982. Was stock agency. Is now representing JaincoTech as JaincoTech Japan as a joint project such as scanning, key wording, dust busting, or color correction for photographers in the stock photo market. Has 100,000 photos in files. Clients include: photo agencies, newspapers, book publishers, magazine publishers, advertising agencies.

Needs "We do consulting for photo agencies for the Japanese market."

How to Contact Send query e-mail. Responds only if interested.

▣ POSITIVE IMAGES (STOCK PHOTOGRAPHY & GALLERY 61)

(Formerly Positive Images) 61 Wingate St., Haverhill MA 01832. (978)556-9366. Fax: (978)556-9448. E-mail: pat@positiveimagesphoto.com. Website: www.agpix.com/ positiveimages. **Contact:** Patricia Bruno, owner. Stock photo agency and fine art gallery. Member of ASPP, GWAA. Clients include advertising agencies, public relations firms, book/ encyclopedia publishers, magazine publishers, greeting card and calendar companies, sales/promotion firms, design firms.

Needs Wants horticultural images showing technique and lifestyle, photo essays on property-released homes and gardens, travel images from around the globe, classy and funky pet photography, health & nutrition, sensitive and thought-provoking images suitable for high-end greeting cards, calendar-quality landscapes, castles, lighthouses, country churches. Model/property releases preferred.

Payment & Terms Pays 50% commission for stock photos; 60% commission for fine art. Average price per image (to clients): $250. Works with photographers on contract basis only. Offers limited regional exclusivity. Payment made quarterly. Offers one-time and electronic media rights. "We never sell all rights."

How to Contact "Positive Images Stock is accepting limited new collections; however, if your images are unique and well organized digitally, we will be happy to review online after making email contact. Our Gallery 61 will review fine art photography portfolios online as well and will consider exhibiting nonmembers' work."

Tips "Positive Images has taken on more of a boutique approach, limiting our number of photographers so that we can better service them and offer a more in-depth and unique collection to our clients. Our brand-new Gallery 61 is a storefront in a small historic arts

district. Our plan is to evolve this into an online gallery as well. We are always in search of new talent, so we welcome anyone with a fresh approach to contact us!"

☐ RETNA LTD.

24 W. 25th St., 12th Floor, New York NY 10010. (212)255-0622. Fax: (212)255-1224. E-mail: info@retna.com. Website: www.retna.com. **Contact:** Jessica Daly or Walter McBride. Estab. 1978. Member of the Picture Archive Council of America (PACA). Stock photo agency, assignment agency. Has more than 2 million photos in files. Clients include advertising agencies, public relations firms, book/encyclopedia publishers, magazine publishers, newspapers, record companies.

• Retna handles shoots and assignments for clients and pulls from their talented pool of photographers.

Needs Handles photos of musicians (pop, country, rock, jazz, contemporary, rap, R&B) and celebrities (movie, film, television and politicians). Covers New York, Milan and Paris fashion shows; has file on royals. Also uses events, sports. Interested in fashion/glamour, historical/vintage.

Specs Original material required. All formats accepted. Send digital images via CD, Zip, e-mail as TIFF, JPEG files at 300 dpi.

Payment & Terms Commission varies. General price range (to clients): $200 and up. Works with photographers on contract basis only. Contracts renew automatically with additional submissions for 3 years. Statements issued monthly. Payment made monthly. Offers one-time rights; negotiable. When client requests all rights photographer will be consulted, but Retna will negotiate. Model/property release required. Photo captions required.

How to Contact Arrange a personal interview to show portfolio. Primarily concentrating on selling stock, but does assign on occasion. Does not publish "tips" sheets, but makes regular phone calls to photographers.

Tips "Wants to see strong celebrity studio shooters, some music photography. We are also always seeking event photographers who have great access. Photography must be creative, innovative and of the highest aesthetic quality possible."

☐ REX USA LTD

1133 Broadway, Suite 1626, New York NY 10010. (212)586-4432. Fax: (323)372-3598. E-mail:sselby@rexusa.co. Website: www.rexusa.com. **Contact:** Charles Musse, manager. Estab. 1935. Stock photo agency, news/feature syndicate. Affiliated with Rex Features in London. Member of Picture Archive Council of America (PACA). Has 1.5 million photos. Clients include: advertising agencies, public relations firms, audiovisual firms, businesses, book/encyclopedia publishers, magazine publishers, newspapers, postcard companies, calendar companies, greeting card companies and TV, film and record companies.

Needs Wants primarily editorial material: celebrities, personalities (studio portraits, candid, paparazzi), human interest, news features, movie stills, glamour, historical, geographic, general stock, sports and scientific.

Specs Digital only.

Payment & Terms Pays 50-65% commission; payment varies depending on quality of subject matter and exclusivity. "We obtain highest possible prices, starting at $100-100,000 for one-time sale." Pays 50% commission for b&w and color photos. Works with or without contract. Offers nonexclusive contract. Statements issued monthly. Payment made monthly.

Photographers allowed to review account records. Offers one-time, first and all rights. Informs photographers and allows them to negotiate when client requests all rights. Model release required. Photo captions required.

How to Contact E-mail query letter with samples and list of stock photo subjects.

ROBERTSTOCK/CLASSICSTOCK

4203 Locust St., Philadelphia PA 19104. (800)786-6300. Fax: (800)786-1920. E-mail: sales@ robertstock.com. Website: www.robertstock.com or www.classicstock.com. **Contact**: Bob Roberts, president. Estab. 1920. Stock photo agency. Member of the Picture Archive Council of America (PACA). Has 2 different Web sites: Robertstock offers contemporary rights-managed and royalty-free images; ClassicStock offers retro and vintage images. Clients include: advertising agencies, public relations firms, audiovisual firms, businesses, book/ encyclopedia publishers, magazine publishers, newspapers, postcard publishers, calendar companies, greeting card companies.

Needs Uses images on all subjects in depth.

Specs Accepts images in digital format. Send via CD, Zip at 300 dpi, 50MB or higher.

Payment & Terms Pays 45-50% commission. Works with photographers with or without a contract; negotiable. Offers various contracts. Statements issued monthly. Payment made monthly. Payment sent with statement. Photographers allowed to review account records to verify sales figures "upon advance notice." Offers one-time rights. Informs photographers when client requests all rights. Model release required. Photo captions required.

How to Contact Send query letter. Does not keep samples on file. Expects minimum initial submission of 250 images with quarterly submissions of 250 images. Responds in 1 month. Photo guidelines available.

SCIENCE PHOTO LIBRARY, LTD.

327-329 Harrow Rd., London W9 3RB United Kingdom. (44)(207)432-1100. Fax: (44) (207)286-8668. E-mail: picture.editing@sciencephoto.com. Website: www.sciencephoto. com. **Contact**: Research Director. Stock photo agency. Clients include: book publishers, magazines, newspapers, medical journals, advertising, design, TV and the Web in the U.K. and abroad. "We currently work with agents in over 30 countries, including America, Japan, and in Europe."

Needs SPL specializes in all aspects of science, medicine and technology."

Specs Digital only via CD/DVD. File sizes at least 38 mb with no interpolation. Captions, model, and property releases required.

Payment & Terms Pays 50% commission. Works on contract basis only. Agreement made for 5 years; general continuation is assured unless otherwise advised. Offers exclusivity. Statements issued quarterly, payment made quarterly. Photographers allowed to review account records to verify sales figures; fully computerized accounts/commission handling system. Model and property release required. Photo captions required. "Detailed captions can also increase sales so please provide us with as much information as possible."

How to Contact "Please complete the enquiry form on our website so that we are better able to advise you on the salability of your work for our market. You may e-mail us low-res examples of your work. Once you have provided us with information, the editing team will be in contact within 2-3 business weeks. Full photo guidelines available on website."

▣ SILVER IMAGE PHOTO AGENCY

4104 NW 70th Terrace, Gainesville FL 32606. (352)373-5771. E-mail: photorequest@aol.com or photorequest@silver-image.com. Website: www.silver-image.com. **Contact:** Carla Hotvedt, president/owner. Estab. 1988. Stock photo agency. Assignments in Florida/southern Georgia. Has 150,000 photos in files. Clients include: public relations firms, book/encyclopedia publishers, magazine publishers, newspapers.

Needs Wants photos from Florida only: nature, travel, tourism, news, people.

Specs Accepts images in digital format only. Send via CD, FTP, e-mail as JPEG files *upon request only*. No longer accepting new photographers.

Payment & Terms Pays 50% commission for image licensing fees. Average price per image (to clients): $150-600. Works with photographers on contract basis only. Offers nonexclusive contract. Payment made monthly. Statements provided when payment is made. Photographers allowed to review account records. Offers one-time rights. Informs photographer and allows them to be involved when client requests all rights. Model release preferred. Photo captions required; include name, year shot, city, state, etc.

How to Contact Send query letter via e-mail only. Do not submit material unless first requested.

Tips "I will review a photographer's work to see if it rounds out our current inventory. Photographers should review our website to get a feel for our needs. We will gladly add a photographer's e-mail address to our online photo requests list."

⊕ ▣ Ⓐ SKISHOOT-OFFSHOOT

Hall Place, Upper Woodcott, Whitchurch, Hants RG28 7PY United Kingdom. +44 (0)1635 255 527. E-mail: info@skishoot.co.uk. Website: www.skishoot.co.uk. Estab. 1986. Stock photo agency. Has over 400,000 photos in files. Clients include: advertising agencies, book publishers, magazine publishers, newspapers, greeting card companies, postcard publishers. Specializes in winter sports but also has photos from around the world (France, in particular) taken all year-round.

Needs Wants photos of skiing, snowboarding and other winter sports. Also photos of children/teens, families, landscapes/scenics, cities/urban, rural, adventure, sports.

Specs Prefers CDs with high-resolution images.

Payment & Terms Pays 50% commission for color photos. Average price per image (to clients): $100-5,000 for color. Enforces strict minimum prices. BAPLA recommended rates are used. Offers volume discounts to customers. Photographers can choose not to sell images on discount terms. Works with photographers with or without a contract; negotiable. Offers limited regional exclusivity. Contracts renew automatically with additional submissions within originally agreed time period. Payments made to photographers through PayPal. Statements issued quarterly. Photographers allowed to review account records in cases of discrepancies only. Offers one-time rights. Informs photographers when a client requests all rights. Model release preferred. Photo caption s required; include location details.

How to Contact Send query letter with samples, stock list. Include SAE for return of material. Portfolio should include color. Works on assignment only. Expects minimum initial submission of 50 images. Responds in 1 month to samples.

🌐 ▣ SKYSCAN PHOTOLIBRARY

Oak House, Toddington, Cheltenham, Gloucestershire GL54 5BY United Kingdom. (44)(124)262-1357. Fax: (44)(124)262-1343. E-mail: info@skyscan.co.uk. Website: www.skyscan.co.uk. **Contact:** Brenda Marks, library manager. Estab. 1984. Picture library. Member of the British Association of Picture Libraries and Agencies (BAPLA) and the National Association of Aerial Photographic Libraries (NAPLIB). Has more than 250,000 photos in files. Clients include: advertising agencies, public relations firms, businesses, book publishers, magazine publishers, newspapers, calendar companies, postcard publishers.

Needs Wants "anything aerial! Air-to-ground; aviation; aerial sports. As well as holding images ourselves, we also wish to make contact with holders of other aerial collections worldwide to exchange information."

Specs Uses color and/or b&w prints; any format transparencies. Accepts images in digital format. Send via CD, e-mail.

Payment & Terms Pays 50% commission for b&w and color photos. Average price per image (to clients): $100 minimum. Enforces strict minimum prices. Offers volume discounts to customers. Photographers can choose not to sell images on discount terms. Works with photographers with or without a contract; negotiable. Offers guaranteed subject exclusivity (within files); negotiable to suit both parties. Statements issued quarterly. Payment made quarterly. Photographers allowed to review account records in cases of discrepancies only. Offers one-time, electronic media and agency promotion rights. Informs photographers and allows them to negotiate when a client requests all rights. Will inform photographers and act with photographer's agreement. Model/property release preferred for "air-to-ground of famous buildings (some now insist they have copyright to their building)." Photo captions required; include subject matter, date of photography, location, interesting features/notes.

How to Contact Send query letter or e-mail. Provide résumé, business card, self-promotion piece or tearsheets to be kept on file. Agency will contact photographer for portfolio review if interested. Portfolio should include color slides and transparencies. Does not keep samples on file; include SAE for return of material. No minimum submissions. Photo guidelines sheet free with SAE. Catalog free with SAE. Market tips sheet free quarterly to contributors only.

Tips "We have invested heavily in suitable technology and training for in-house scanning, colour management, and keywording, which are essential skills in today's market. Contact first by letter or e-mail with resume of material held and subjects covered."

▣ SOVFOTO/EASTFOTO, INC.

263 West 20th Street #3, New York NY 10011. (212)727-8170. Fax: (212)727-8228. E-mail: research@sovfoto.com. Website: www.sovfoto.com. **Contact:** Vanya Edwards. Estab. 1935. Stock photo agency. Has 500,000 photos in files. Clients include: advertising firms, audiovisual firms, book/encyclopedia publishers, magazine publishers, newspapers.

Needs All subjects acceptable as long as they pertain to Russia, Eastern European countries, Central Asian countries or China.

Specs Uses b&w historical; color prints; 35mm transparencies. Accepts images in digital format. Send via CD or DVD as TIFF files.

Payment & Terms Pays 50% commission. Average price per image (to clients): $150-500 for b&w or color photos for editorial use. Statements issued quarterly. Payment made quarterly.

Photographers allowed to review account records to verify sales figures or account for various deductions. Offers one-time print, electronic media, and nonexclusive rights. Model/property release preferred. Photo captions required.

How to Contact Arrange personal interview to show portfolio. Send query letter with samples, stock list. Keeps samples on file. Expects minimum initial submission of 50-100 images. Responds in 2 weeks.

Tips Looks for "news and general interest photos (color) with human element."

⊡ SPORTSLIGHT PHOTO

6 Berkshire Circle, Gt. Barrington MA 01230. (413)528-8457. E-mail: stock@sportslightphoto. com. Website: www.sportslightphoto.com. **Contact:** Roderick Beebe, director. Stock photo agency. Has 500,000 photos in files. Clients include: advertising agencies, public relations firms, corporations, book publishers, magazine publishers, newspapers, postcard companies, calendar companies, greeting card companies, design firms.

Needs "We specialize in every sport in the world. We deal primarily in the recreational sports such as skiing, golf, tennis, running, canoeing, etc., but are expanding into pro sports, and have needs for all pro sports, action and candid close-ups of top athletes. We also handle adventure-travel photos, e.g., rafting in Chile, trekking in Nepal, dog sledding in the Arctic, etc."

Specs Uses 35mm transparencies. Accepts images in digital format. Send via CD. Contact us prior to shipment.

Payment & Terms Pays 50% commission. Average price per image (to clients): $100-6,000. Contract negotiable. Offers limited regional exclusivity. Contract is of indefinite length until either party (agency or photographer) seeks termination. Charges $5/image for duping fee; $3 for catalog and digital CD-ROM insertion promotions. Statements issued quarterly. Payment made quarterly. Photographers allowed to review account records to verify sales figures "when discrepancy occurs." Offers one-time rights; sometimes exclusive rights for a period of time; and other rights, depending on client. Informs photographers and consults with them when client requests all rights. Model release required for corporate and advertising usage. (Obtain releases whenever possible.) Strong need for model-released "pro-type" sports. Photo captions required; include who, what, when, where, why.

How to Contact Interested in receiving work from newer and known photographers. Cannot return unsolicited material. Responds in 2-4 weeks. Photo guidelines free with SASE. See website for more information regarding digital transmission. For review, send JPEG files at 72 dpi via e-mail or CD; or "direct us to your website to review images for consideration."

Tips "We look for a range of sports subjects that shows photographer's grasp of the action, drama, color and intensity of sports, as well as capability of capturing great shots under all conditions in all sports. Want well-edited, perfect exposure and sharpness, good composition and lighting in all photos. Seeking photographers with strong interests in particular sports. Shoot variety of action, singles and groups, youths, male/female—all combinations; plus leisure, relaxing after tennis, lunch on the ski slope, golf's 19th hole, etc. Sports fashions change rapidly, so that is a factor. Art direction of photo shoots is important. Avoid brand names and minor flaws in the look of clothing. Attention to detail is very important. Shoot with concepts/ideas such as teamwork, determination, success, lifestyle, leisure, cooperation in mind. Clients look not only for individual sports but for

photos to illustrate a mood or idea. There is a trend toward use of real-life action photos in advertising as opposed to the set-up slick ad look. More unusual shots are being used to express feelings, attitude, etc."

▣ TOM STACK & ASSOCIATES, INC.

154 Tequesta Street, Taavernier FL 33070. (305)852-5520. Fax: (305)852-5570. E-mail: tomstack@earthlink.net. **Contact**: Therisa Stack. Has 500,000 photos in files. Clients include: advertising agencies, public relations firms, businesses, audiovisual firms, book publishers, magazine publishers, encyclopedia publishers, postcard companies, calendar companies, greeting card companies.

Needs Wants photos of wildlife, endangered species, marine life, landscapes; foreign geography; photomicrogfaphy; scientific research; whales; solar heating; mammals such as weasels, moles, shrews, fisher, marten, etc.; extremely rare endangered wildlife; wildlife behavior photos; lightning and tornadoes; hurricane damage; dramatic and unusual angles and approaches to composition, creative and original photography with impact. Especially needs photos on life science, flora and fauna and photomicrography. No run-of-the-mill travel or vacation shots. Special needs include photos of energy-related topics—solar and wind generators, recycling, nuclear power and coal burning plants, waste disposal and landfills, oil and gas drilling, supertankers, electric cars, geo-thermal energy.

Specs Only accepts images in digital format. Send sample JPEGS or link to website where your images can be viewed.

Payment & Terms Pays 50% commission. Average price per image (to clients): $150-200 for color photos; as high as $7,000. Works with photographers on contract basis only. Contracts renew automatically with additional submissions for 3 years. Statements issued quarterly. Payment made quarterly. Offers one-time and electronic media rights. Informs photographers and allows them to negotiate when client requests all rights. Model release preferred. Photo captions preferred.

How to Contact E-mail tomstack@earthlink.net

Tips "Strive to be original, creative and take an unusual approach to the commonplace; do it in a different and fresh way. We take on only the best so we can continue to give more effective service."

▣ STILL MEDIA

714 Mission Park Dr., Santa Barbara CA 93105. (805)682-2868. E-mail: images@stillmedia. com. Website: www.stillmedia.com. **Contact:** Jeffrey Aaronson, founder/owner. Director: Becky Green Aaronson. Photojournalism and stock photography agency. Has 500,000 photos in files. Clients include: advertising agencies, public relations firms, businesses, book/encyclopedia publishers, magazine publishers, newspapers, calendar companies.

Needs Reportage, world events, travel, cultures, business, the environment, sports, people, industry.

Specs Accepts images in digital format only. Contact via e-mail.

Payment & Terms Pays 50% commission for color photos. Works with photographers on contract basis only. Offers nonexclusive and guaranteed subject exclusivity contracts. Statements issued quarterly. Payment made quarterly. Photographers allowed to review account records. Offers one-time and electronic media rights. Model/property release

preferred. Photo captions required.

How to Contact *"We are not currently accepting new photographers."*

▣ STOCK CONNECTION, INC.

110 Frederick Ave., Suite A, Rockville MD 20850. (301)251-0720. Fax: (301)309-0941. E-mail: photos@scphotos.com. Website: www.scphotos.com. **Contact:** Cheryl Pickerell DiFrank, president or Michael Vallarino, photographer relations. Stock photo agency. Member of the Picture Archive Council of America (PACA). Has over 125,000 photos in files. Clients include advertising agencies, graphic design firms, magazine and textbook publishers, greeting card companies.

Needs "We handle many subject categories including lifestyles, business, concepts, sports and recreation, travel, landscapes and wildlife. We will help photographers place their images into our extensive network of over 35 distributors throughout the world. We specialize in placing images where photo buyers can find them."

Specs Accepts images in digital format (tiff or hi-quality jpeg), minimum 50MB uncompressed, 300 dpi, Adobe RGB. Will also accept film; scanning fees apply.

Payment & Terms Pays 65% commission. Average price per image (to client): $450-500. Works with photographers on contract basis only. Offers non-exclusive contract. Contracts renew automatically with additional submissions. Photographers may cancel contract with 60 days written notice. Charges for scanning and keywording range from $4-13 per image, depending on volume. If photographer provides acceptable scans and keywords, no upload charges apply. Statements issued monthly. Photographers allowed to review account records. Offers Rights-managed and Royalty-Free. Informs photographers when a client requests exclusive rights. Model/property release required. Photo captions required.

How to Contact Please e-mail for submission guidelines. Prefer a minimum of 100 images as an initial submission.

Tips "The key to success in today's market is wide distribution of your images. We offer an extensive network reaching a large variety of buyers all over the world. Increase your sales by increasing your exposure."

⊕ ▣ STOCKFOOD GMBH (THE FOOD IMAGE AGENCY)

Tumblingerstr. 32, 80337 Munich Germany. (49)(89)747-20222. Fax: (49)(89)721-1020. E-mail: petra.thierry@stockfood.com. Website: www.stockfood.com. **Contact:** Petra Thierry, manager, Photographers and Art Dept. Estab. 1979. Stock agency, picture library. Member of the Picture Archive Council of America (PACA). Has over 250,000 photos in files. Clients include: advertising agencies, businesses, newspapers, postcard publishers, public relations firms, book publishers, calendar companies, magazine publishers, greeting card companies.

Needs Wants photos of food/drink, health/fitness/food, wellness/spa, people eating and drinking, interiors, nice flowers and garden images, eating and drinking outside, table settings.

Specs Uses 2¼ × 2¼, 4 × 5, 8 × 10 transparencies. Accepts images in digital format. Send via CD/DVD as TIFF files at 300 dpi, 20MB minimum (8.5 mio pixels).

Payment & Terms Pays 40% commission for rights managed images. Enforces minimum prices. Works with photographers on contract basis only. Offers limited regional exclusivity,

guaranteed subject exclusivity (within files). Contracts renew automatically. Statements issued quarterly. Photographers allowed to review account records. Offers one-time rights. Model release required; photo captions required.

How to Contact Send e-mail with new examples of your work as JPEG files.

STOCK OPTIONS®

P.O. Box 1048, Fort Davis TX 79734. (432)426-2777. Fax: (432)426-2779. E-mail: kh@ stockoptionsphoto.com. **Contact:** Karen Hughes, owner. Estab. 1985. Stock photo agency. Member of Picture Archive Council of America (PACA). Has 150,000 photos in files. Clients include: advertising agencies, public relations firms, audiovisual firms, corporations, book/encyclopedia and magazine publishers, newspapers, postcard companies, calendar companies, greeting card companies.

Needs Emphasizes the southern US. Files include Gulf Coast scenics, wildlife, fishing, festivals, food, industry, business, people, etc. Also western folklore and the Southwest.

Specs Uses 35mm, 2¼ × 2¼, 4 × 5 transparencies.

Payment & Terms Pays 50% commission for color photos. Average price per image (to client): $300-3,000. Works with photographers on contract basis only. Offers nonexclusive contract. Contracts renew automatically with each submission for 5 years from expiration date. When contract ends photographer must renew within 60 days. Charges catalog insertion fee of $300/image and marketing fee of $10/hour. Statements issued upon receipt of payment from client. Payment made immediately. Photographers allowed to review account records to verify sales figures. Offers one-time and electronic media rights. "We will inform photographers for their consent only when a client requests all rights, but we will handle all negotiations." Model/property release preferred for people, some properties, all models. Photo captions required; include subject and location.

How to Contact Interested in receiving work from full-time commercial photographers. Arrange a personal interview to show portfolio. Send query letter with stock list. Contact by phone and submit 200 sample photos. Tips sheet distributed annually to all photographers.

Tips Wants to see "clean, in-focus, relevant and current materials." Current stock requests include industry, environmental subjects, people in up-beat situations, minorities, food, cityscapes and rural scenics.

⊕ ▣ ▨ STOCK TRANSPARENCY SERVICES/STSIMAGES

225, Neha Industrial Estate, Off Dattapada Rd., Borivali (East), Mumbai 400 066 India. (91)(222)870-1586. Fax: (91)(222)870-1609. E-mail: info@stsimages.com. Website: www. stsimages.com. **Contact:** Mr. Pawan Tikku. Estab. 1993. Has over 200,000 photos in files. Has minimal reels of film/video footage. Clients include: advertising agencies, businesses, postcard publishers, public relations firms, book publishers, calendar companies, freelance web designers, audiovisual firms, magazine publishers, greeting card companies.

Needs Wants photos of babies/children/teens, celebrities, couples, multicultural, families, parents, senior citizens, disasters, environmental, landscapes/scenics, wildlife, architecture, cities/urban, education, gardening, interiors/decorating, pets, religious, rural, adventure, automobiles, entertainment, events, food/drink, health/fitness, hobbies, humor, performing arts, sports, travel, agriculture, business concepts, industry, medicine, military, political,

product shots/still life, science, technology/computers. Interested in alternative process, avant garde, documentary, fashion/glamour, fine art, historical/vintage, seasonal. Also needs underwater images.

Specs Uses 10 × 12 glossy color prints; 35mm, 2¼ × 2¼, 4 × 5, 8 × 10 transparencies; 35mm film; Digi-Beta or Beta video. Accepts images in digital format. Send via DVD, CD, e-mail as TIFF, JPEG files at 300 dpi. Minimum file size 25MB, preferred 50MB or more.

Payment & Terms Pays 50% commission. Average price per image (to clients): $20 minimum for b&w or color photos, $50 minimum for film or videotape. Enforces minimum prices. Offers volume discounts to customers. Works with photographers on contract basis only. Offers exclusive contract, limited regional exclusivity. Contracts renew automatically with additional submissions for 3 years. No duping fee. No charges for catalog insertion. Statements issued quarterly. Payment made monthly. Photographers allowed to review account records. Offers royalty-free images as well as one-time rights, electronic media rights. Model release required; property release preferred. Photo captions required; include name, description, location.

How to Contact Send query letter with slides, prints. Portfolio may be dropped off every Saturday. Provide résumé, business card to be kept on file. Expects minimum initial submission of 200 images with regular submissions of at least some images. Responds in 1 month to queries. Photo guidelines sheet free with SASE. Catalog free with SASE. Market tips sheet available to regular contributors only; free with SASE.

Tips 1) Strict self-editing of images for technical faults. 2) Proper cataloging. 3) All images should have the photographer's name on them. 4) Digital images are welcome, should be minimum A4 size in 300 dpi. 5) All digital images must contain necessary keyword and caption information within the "file info" section of the image file. 6) Do not send duplicate images.

▣ STOCKYARD PHOTOS

1410 Hutchins St., Houston TX 77003. (713)520-0898. Fax: (713)227-0399. E-mail: jim@ stockyard.com. Website: www.stockyard.com. **Contact**: Jim Olive. Estab. 1992. Stock agency. Niche agency specializing in Houston, Texas images and China. Has tens of thousands of photos in files. Clients include: advertising agencies, businesses, newspapers, postcard publishers, public relations firms, book publishers, calendar companies, audiovisual firms, magazine publishers, greeting card companies, real estate firms, interior designers, retail catalogs.

Needs Needs photos relating to Houston, Texas, and the Gulf Coast.

Specs Accepts images in digital format only. To be considered, e-mail URL to photographer's Web site, showing a sample of 20 images for review.

Payment & Terms Average price per image (to clients): $250-1,500 for color photos. Offers volume discounts to customers. Photographers can choose not to sell images on discount terms.

▣ SUGARDADDYPHOTOS

Hanklooks Publications, P.O. Box 86776, Los Angeles CA 90086. Estab. 2000. (626)627-5127. E-mail: iphotographu@charter.net. Website: www.sugardaddyphotos.com. **Contact:** Henry Salazar, editor-in-chief. Stock agency and picture library. Clients include: advertising

agencies, businesses, newspapers, postcard publishers, public relations firms, book publishers, calendar companies, audiovisual firms, magazine publishers, greeting card companies.

Needs Wants photos of babies/children/teens, celebrities, couples, multicultural, families, parents, senior citizens, architecture, cities/urban, education, gardening, interiors/decorating, pets, religious, rural, agriculture, business concepts, industry, medicine, military, political, product shots/still life, science, technology/computers, disasters, environmental, landscapes/scenics, wildlife, adventure, automobiles, entertainment, events, food/drink, health/fitness/beauty, hobbies, humor, performing arts, sports, travel, exotic locations. Interested in alternative process, avant garde, documentary, erotic, fashion/glamour, fine art, historical/vintage, lifestyle, seasonal.

Specs Uses 35 mm, 2¼ × 2¼, 4 × 5, 8 × 10 transparencies. Accepts images in digital format. Send TIFF or JPEG files at 300 dpi via CD. Buys photos, film and videotape outright; pays $5-500 for b&w photos; pays $10-1,000 for color photos; pays $20-2,000 for film; pays $30-3,000 for videotape. Pay 40-50% commission. Average price per image (to clients): $1-150 for photos and videotape. Enforces strict minimum prices. "We have set prices; however, they are subject to change without notice." Photographers can choose not to sell images on discount terms. Works with photographers with or without a contract; negotiable. Offers nonexclusive contract. Statements issued quarterly. Payments made quarterly. Offers one-time rights. Informs photographers and allows them to negotiate when a client requests all rights. Model/property release required. Photo captions required; include location, city, state, country, full description, related keywords, date image was taken.

How to Contact E-mail query letter with JPEG samples at 72 dpi. Send query letter with résumé, slides, prints, tearsheets, transparencies. Provide résumé, business card, self-promotion piece to be kept on file. Expects minimum initial submission of 50 images with submissions of at least 50 images every 2 months.

Tips "Please e-mail before sending samples. We're interested in receiving submissions from new photographers. Arrange your work in categories to view. Clients expect the very best in professional-quality material."

▣ SUPERSTOCK INC.

7660 Centurion Pkwy., Jacksonville FL 32256. (904) 565-0066. E-mail: creative@superstock.com. Website: www.superstock.com. International stock photo agency represented in 192 countries. Extensive rights-managed and royalty-free content within 3 unique collections—contemporary, vintage and fine art. Clients include: advertising agencies, businesses, book and magazine publishers, newspapers, greeting card and calendar companies.

Needs "SuperStock is looking for dynamic lifestyle, travel, sports and business imagery, as well as fine art content and vintage images with releases."

Specs Accepts images in digital format only. Digital files must be a minimum of 50MB (up-sized), 300 dpi, 8-bit color, RGB, JPEG format.

Payment & Terms Statements issued monthly to contracted contributors. "Rights offered vary, depending on image quality, type of content, and experience." Informs photographers when client requests all rights. Model release required. Photo captions required.

How to Contact Complete SuperStock's online questionnaire at www.superstock.com/expose. Photo guidelines available on at www.superstock.com/paperwork.

Tips "Please review our website to see the style and quality of our imagery before submitting."

TIMECAST PRODUCTIONS

2801 Poole Way, Carson City NV 89706. (775)883-6427. Fax: (775)883-6427. E-mail: info@ timecastproductions.com. Website: http://timecast.productions.com. **Contact:** Edward Salas, owner. Estab. 1995. Stock photo and video agency. Has 5,000 photos, 150 hours of video footage. "Timecast Productions is the leading Internet-based producer and supplier of factual and event-based stock footage for television advertising and corporate presentation." Clients include: television program content producers, advertising agencies, corporate, and multimedia producers.

Needs "We offer a wide selection of high-quality stock footage from the wild West and its infamous characters to contemporary lifestyle and culture from around the world—people, places, news, events, business, industry cities, transportation, medicine, nature, historical and more."

Specs Accepts footage in all broadcast-quality formats.

Payment & Terms Based on usage, negotiable with client. Offers royalty-free and rights-managed terms. Offers volume discounts to customers. Filmmakers can choose not to sell photos or video on discount terms. Works with filmmakers on contract basis only. Offers nonexclusive contract. Statements issued monthly. Payment made monthly. Filmmakers allowed to review account records. Offers one-time and electronic media rights. Informs filmmakers and allows them to negotiate when client requests all rights. Model, talent and property releases required. Captions and time code logs required.

How to Contact Contact us first by e-mail, through our Web site, or by telephone. Let our representative know the category and format of your material. If we are interested, we will request you send compressed samples in Quicktime format via high-speed Internet, or send material on optical disc for our review. Following our review, consideration will be given for representation.

TRAVEL INK PHOTO LIBRARY

The Old Coach House, Goring-on-Thames, Reading, Berkshire RG8 9AR United Kingdom. (44)(149)187-3011. Fax: (44)(149)187-5558. E-mail: info@travel-ink.co.uk. Website: www. travel-ink.co.uk. Has over 115,000 photos in files. Clients include: advertising agencies, businesses, newspapers, public relations firms, book publishers, calendar companies, audiovisual firms, magazine publishers, greeting card companies.

Needs Wants photos of multicultural, environmental, landscapes/scenics, wildlife, architecture, cities/urban, gardening, religious, rural, adventure, events, food/drink, health/fitness/beauty, hobbies, sports, travel.

Specs Uses 35mm and medium-format transparencies. Accepts images in digital format. See website for details.

Payment & Terms Pays on a commission basis. Enforces minimum prices. Offers volume discounts to customers. Works with photographers on contract basis only. Offers exclusive contract only. Statements issued quarterly. Payment made quarterly. Photographers allowed to review account records. Offers one-time rights. Model/property release required. Photo captions required.

How to Contact "Currently accepting submissions from new photographers. Please e-mail first."

🌐 ▣ TROPIX PHOTO LIBRARY

44 Woodbines Ave., Kingston-Upon-Thames, Surrey KT1 2AY United Kingdom. (44) (208)8546-0823. E-mail: photographers@tropix.co.uk. Website: www.tropix.co.uk. **Contact:** Veronica Birley, proprietor. Picture library specialist. Has 100,000 photos in files. Clients include: book publishers, magazine publishers, newspapers, government departments, design groups, travel companies, new media.

Needs "Sorry, Tropix is currently closed to new contributing photographers. But any temporary exceptions to this will be posted on our website."

Specs Uses large digital files only, minimum 50MB when sent as TIFF files.

Payment & Terms Pays 40% commission for color photos. Average price per image (to clients): $130 for b&w and color photos. Offers guaranteed subject exclusivity. Charges cost of returning photographs by insured post, if required. Statements made quarterly with payment. Photographers allowed to have qualified auditor review account records to verify sales figures in the event of a dispute but not as routine procedure. Offers one-time, electronic media and agency promotion rights. Informs photographers when a client requests all rights, but agency handles negotiation. Model release always required. Photo captions required; accurate, detailed data to be supplied in IPTC, electronically, and on paper. "It is essential to follow captioning guidelines available from agency."

How to Contact "E-mail preferred. Send no unsolicited photos or JPEGs, please."

🌐 ▣ ULLSTEIN BILD

Ullstein GmbH, Axel-Springer-Str. 65, 10888 Berlin Germany. E-mail: kontakt@ullsteinbild. de. Website: www.ullsteinbild.de. Estab. 1900. Stock agency, picture library and news/ feature syndicate. Has approximately 12 million photos in files. Clients include: advertising agencies, public relations firms, audiovisual firms, businesses, book publishers, magazine publishers, newspapers, calendar companies, greeting card companies, postcard publishers, TV companies.

Needs Wants photos of celebrities, couples, multicultural, families, parents, senior citizens, wildlife, disasters, environmental, landscapes/scenics, architecture, cities/urban, education, pets, religious, rural, adventure, automobiles, entertainment, events, health/ fitness, hobbies, humor, performing arts, sports, travel, agriculture, buildings, computers, industry, medicine, military, political, portraits, science, technology/computers. Interested in digital, documentary, fashion/glamour, historical/vintage, regional, seasonal. Other specific photo needs: German history.

Specs Accepts images in digital format only. Send via FTP, CD, e-mail as TIFF, JPEG files at minimum 25MB decompressed.

Payment & Terms Pays on commission basis. Works with photographers on contract basis only. Offers nonexclusive contract for 5 years minimum. Statements issued monthly, quarterly, annually. Payment made monthly, quarterly, annually. Photographers allowed to review account records in cases of discrepancies only. Offers one-time rights. Photo captions required; include date, names, events, place.

How to Contact "Please contact Mr. Ulrich Ramershoven (Ramershoven@ullsteinbild.de) before sending pictures!"

UNICORN STOCK PHOTOS

2501 Bretigne Circle, Lincoln NE 68512. (402)261-5282. E-mail: info@unicorn-photos.com. Website: www.unicorn-photos.com. **Contact:** Larry Durfee, owner. Has over 500,000 photos in files. Clients include: advertising agencies, corporate accounts, textbooks, magazines, calendar companies, religious publishers.

Needs Wants photos of ordinary people of all ages and races doing everyday things at home, school, work and play. Current skylines of all major cities, tourist attractions, historical, wildlife, seasonal/holiday and religious subjects. "We particularly need images showing two or more races represented in one photo and family scenes with BOTH parents. There is a need for more minority shots including Hispanics, Asians and African-Americans." Also wants babies/children/teens, couples, senior citizens, disasters, landscapes, gardening, pets, rural, adventure, automobiles, events, food/drink, health/fitness, hobbies, sports, travel, agriculture.

Specs Uses 35mm color slides.

Payment & Terms Pays 50% commission for color photos. Average price per image (to clients): $200 minimum for color photos. Works with photographers on contract basis only. Offers nonexclusive contract. Contracts renew automatically with additional submissions for 4 years. Statements issued quarterly. Payment made quarterly. Informs photographers and allows them to negotiate when client requests all rights. Model release preferred; increases sales potential considerably. Photo captions required; include location, ages of people, dates on skylines.

How to Contact Write first for guidelines. "We are looking for professionals who understand this business and will provide a steady supply of top-quality images. At least 500 images are generally required to open a file. Contact us by e-mail."

Tips "We keep in close, personal contact with all our photographers. Our monthly newsletter is a very popular medium for doing this."

☐ VIEWFINDERS

Bruce Forster Photography, Inc., 1306 NW Hoyt Street #302, Portland OR 97209. (503)222-5222. Fax: (503)274-7995. E-mail: studio@viewfindersnw.com. Website: www.viewfindersnw.com. **Contact:** Bruce Forster, owner. Estab. 1996. Stock agency. Member of the Picture Archive Council of America (PACA). Has 70,000 photos in files. Clients include: advertising agencies, public relations firms, businesses, book publishers, magazine publishers, design agencies.

- Viewfinders is currently not accepting new submissions as they overhaul and streamline their archive. They will begin accepting work as soon as the review of the archive is complete. Please check their website in the future for updated information regarding changes in the submission process.

Needs All images should come from the Pacific Northwest—Oregon, Washington, northern California, British Columbia and Idaho. Wants photos of babies/children/teens, couples, multicultural, families, senior citizens, environmental, landscapes/scenics, architecture, cities/urban, education, gardening, adventure, entertainment, events, health/fitness, performing arts, sports, travel, agriculture, industry, medicine, science, technology/computers and lifestyle.

Specs Prefers to review samples of photographers' work electronically, via photographer's website or online portfolio.

Payment & Terms Pays 50% commission for b&w and color photos. Works with photographers on contract basis only. Offers limited regional exclusivity. Statements issued monthly. Payment made monthly. Photographers allowed to review account records. Model/property release preferred. Photo captions required.

▣ VIREO (VISUAL RESOURCES FOR ORNITHOLOGY)

The Academy of Natural Sciences, 1900 Benjamin Franklin Pkwy., Philadelphia PA 19103-1195. (215)299-1069. Fax: (215)299-1182. E-mail: vireo@ansp.org. Website: www.ansp.org/vireo. **Contact:** Doug Wechsler, director. Estab. 1979. Picture library. "We specialize in birds only." Has 150,000 photos in files. Clients include: advertising agencies, businesses, book publishers, magazine publishers, newspapers, calendar companies, CD-ROM publishers.

Needs "Wants high-quality photographs of birds from around the world with special emphasis on behavior. All photos must be related to birds or ornithology."

Specs Uses digital format primarily. See website for specs.

Payment & Terms Pays 50% commission for b&w and color photos. Average price per image (to clients): $125. Negotiates fees below stated minimums; "we deal with many small nonprofits as well as commercial clients." Offers volume discounts to customers. Discount sales terms negotiable. Works with photographers on contract basis only. Offers nonexclusive contract. Statements issued semiannually. Payment made semiannually. Offers one-time rights. Model release preferred. Photo captions preferred; include date, location.

How to Contact Read guidelines on website. To show portfolio, photographer should send 10 JPEGs. Follow up with a call. Responds in 1 month to queries.

Tips "Study our web site and show us some bird photos we don't have or better than those we have. Write to us describing the types of bird photographs you have, the type of equipment you use, and where you do most of your bird photography. You may also send us a Web link to a portfolio of your work. Edit work carefully."

⊕ ▣ VISUAL & WRITTEN

Luis Bermejo 8, 7-B, 50009 Zaragoza, Spain. (718) 715-0372 (U.S. number). E-mail: kikecalvo@gmail.com. Website: www.vwpics.com. Contact: Kike Calvo, director. Estab. 1997. Digital stock agency and news agency. Has 500,000 photos in files. Has branch office in New York: 35-36 76th St., Suite 628, New York NY 11372. Clients include: advertising agencies, businesses, newspapers, postcard publishers, public relations firms, book publishers, calendar companies, audiovisual firms, magazine publishers, greeting card companies, zoos, aquariums.

Needs Wants photos of babies/children/teens, celebrities, couples, multicultural, families, parents, senior citizens, disasters, environmental, landscapes/scenics, wildlife, architecture, cities/urban, education, pets, religious, rural, adventure, travel, agriculture, business concepts, industry, science, technology/computers. Interested in documentary, erotic, fashion/glamour, fine art. Also needs underwater imagery: reefs, sharks, whales, dolphins and colorful creatures, divers and anything related to oceans. Images that show the human impact on the environment.

Specs Accepts images in digital format only. Send via CD or DVD, e-mail at 300 dpi, 55MB minimum, largest size: 5400 pixels; from a high-end digital camera, or scanned with a Nikon 4000 or similar scanner.

Payment & Terms Pays 50% commission for b&w photos; 50% for color photos. Enforces minimum prices. Works with photographers with or without contract; negotiable. Offers nonexclusive contract. Statements issued quarterly. Payment made quarterly. Any deductions are itemized. Offers one-time rights. Informs photographers and allows them to negotiate when client requests all rights. Model release required. Photo captions required. "Photo essays should include location, Latin name, what, why, when, how, who. Please make sure IPTC is filled correctly. It's the only way to include photo captions."

How to Contact "The best way is to send an email with some low-res images." Send an email with résumé, tearsheets, stock list. Provide self-promotion piece to be kept on file. Expects minimum initial submission of 100 images with periodic submissions of at least 50 images. Responds in 1 week to samples. "Photo guidelines available in our New Photographers link on website. Photographers can find all technical data there, along with contract information."

Tips "We have opened a new press division, so we are interested in daily news and event photography. Nature and animals are still a strong portion of our sales. We have a large distribution network, with partners all around the world"

WILDLIGHT PHOTO AGENCY

P.O. Box 1606, Double Bay NSW 1360 Australia. (61)(2)9043-3255. E-mail: wild@wildlight. net. Website: www.wildlight.net. **Contact:** Manager. Estab. 1985. Picture library specializing in Australian images only. Has 50,000 photos in files. Clients include: advertising agencies, public relations firms, audiovisual firms, businesses, book/encyclopedia publishers, magazine publishers, newspapers, postcard publishers, calendar companies, greeting card companies.

Needs Wants Australian photos of babies/children/teens, couples, multicultural, families, parents, senior citizens, disasters, environmental, landscapes/scenics, wildlife, architecture, cities/urban, education, gardening, interiors/decorating, pets, religious, rural, adventure, entertainment, events, food/drink, health/fitness, hobbies, humor, performing arts, sports, travel, agriculture, business concepts, industry, medicine, military, political, product shots/ still life, science, technology/computers. Interested in documentary, seasonal.

Specs Accepts images in digital format only.

Payment & Terms Pays 40% commission for color photos. Works with photographers on contract basis only. Offers image exclusive contract within Australia. Statements issued quarterly. Payment made quarterly. Offers one-time rights. Model/property release required. Photo captions required.

How to Contact Send CD to show portfolio. Expects minimum initial submission of 100 images with periodic submissions of at least 50 images/quarter. Responds in 2-3 weeks. Photo guidelines available by e-mail.

WINDIGO IMAGES

Kezar, Inc., 11812 Wayzata Blvd., #122, Minnetonka MN 55305. (952)540-0606. Fax: (952)540-1018. E-mail: info@windigoimages.com. Website: www.windigoimages.com.

Contact: Mitch Kezar, president/owner or Ellen Becker, general manager. Estab. 1982. Stock agency. Has 400,000 photos in files. Also sells fine art prints. Represents 144 photographers. Clients include: advertising agencies, businesses, newspapers, postcard publishers, public relations firms, book publishers, calendar companies, audiovisual firms, magazine publishers, greeting card companies.

Needs "We have a constant need for modern hunting, fishing, camping, hiking and mountain biking images. We seek high-quality images."

Specs Accepts images in digital format. Send via CD, e-mail as JPEG files at 72 dpi for initial consultation.

Payment & Terms Pays 50% commission for color photos. Offers volume discounts to customers; terms specified in photographers' contracts. Works with photographers on contract basis only. Offers nonexclusive contract. Offers one-time, electronic media and agency promotion rights.

How to Contact Send query letter with résumé, stock list. Provide résumé, business card, self-promotion piece to be kept on file. Expects minimum initial submission of 100 images. Responds in 1 week.

Tips "Study the market and offer images that can compete in originality, composition, style and quality. Our clients are the best in the business, and we expect no less of our photographers."

🌐 ▣ WORLD RELIGIONS PHOTO LIBRARY

53A Crimsworth Rd., London SW8 4RJ United Kingdom. E-mail: co@worldreligions.co.uk. Website: www.worldreligions.co.uk. **Contact:** Christine Osborne. Has 12,000 photos online. Clients include: book publishers, magazine publishers, newspapers, museums, websites.

Needs Religious images from anywhere in the world showing worship, rites of passage, sacred sites, shrines, food and places of pilgrimage, especially Hispanic/Mexico and from South America. Also Kabbalah, Mormon, Jehovah's Witnesses, Moonies, Aum, cults and Shamans. New associate library www.religious-tourism.com seeking images of pilgrims, anywhere, multi-faith.

Specs Images must be digital format. Inquire first. Send submissions on a CD as JPEGS, 72 dpi.

Payment & Terms Pays 50% commission. Offers volume discounts to good clients. Works with photographers with a contract. Offers one-time rights. Model release not essential as images are for editorial use only. Photo captions required and must include subject, place, date (if historic); descriptions are essential; no images will be considered without.

How to Contact Send query letter or e-mail. Include SAE for return of material. Expects minimum initial submission of 50 images. Responds in 2 weeks to samples.

Tips "Supply excellent captions and edit your submission very carefully."

Advertising, Design & Related Markets

Advertising photography is always "commercial" in the sense that it is used to sell a product or service. Assignments from ad agencies and graphic design firms can be some of the most creative, exciting and lucrative that you'll ever receive.

Prospective clients want to see your most creative work—not necessarily your advertising work. Mary Virginia Swanson, an expert in the field of licensing and marketing fine art photography, says that the portfolio you take to the Museum of Modern Art is also the portfolio that Nike would like to see. Your clients in advertising and design will certainly expect your work to show, at the least, your technical proficiency. They may also expect you to be able to develop a concept or to execute one of their concepts to their satisfaction. Of course, it depends on the client and their needs: Read the tips given in many of the listings on the following pages to learn what a particular client expects.

When you're beginning your career in advertising photography, it is usually best to start close to home. That way, you can make appointments to show your portfolio to art directors. Meeting the photo buyers in person can show them that you are not only a great photographer but that you'll be easy to work with as well. This section is organized by region to make it easy to find agencies close to home.

When you're just starting out, you should also look closely at the agency descriptions at the beginning of each listing. Agencies with smaller annual billings and fewer employees are more likely to work with newcomers. On the flip side, if you have a sizable list of ad and design credits, larger firms may be more receptive to your work and be able to pay what you're worth.

Trade magazines such as *HOW*, *Print*, *Communication Arts*, and *Graphis* are good places to start when learning about design firms. These magazines not only provide information about how designers operate, but they also explain how creatives use photography. For ad agencies, try *Ad-week* and *Advertising Age*. These magazines are more business oriented, but they reveal facts about the top agencies and about specific successful campaigns. (See Publications on page 468 for ordering information.) The website of Advertising Photographers of America (APA) contains information on business practices and standards for advertising photographers (www.apanational.org).

ⓃⒶ🖾◯ ADVERTEL, INC.

P.O. Box 18053, Pittsburgh PA 15236-0053. (412)344-4700, ext. 104. Fax: (412)344-4712. E-mail: info@advertel.com. Website: www.advertel.com. **Contact:** Leah Callahan. Estab. 1994. Member of Comptia and Pittsburgh Technology Council. Specialized production house. Approximate annual billing: $500,000-1 million. Types of clients: all, including airlines, utility companies, manufacturers, distributors and retailers.

Needs Uses photos for web direct mail, P-O-P displays, catalogs, signage and audiovisual. Subjects include: communications, telecommunications and business. Reviews stock photos. Model release preferred; property release required.

Audiovisual Needs Uses slides and printing and computer files.

Specs Uses 4 × 5 matte color and/or b&w prints; PCX, TIFF, JPEG files.

Making Contact & Terms Send query letter with stock list or with samples. Provide résumé, business card, brochure, flier or tearsheets to be kept on file. Works with local freelancers only. Keeps samples on file. Cannot return material. Response time varies; "I travel a lot." Payment negotiable. **Pays on receipt of invoice**, net 30 days. Rights negotiable.

Tips Looks for ability to mix media—video, print, color, b&w.

Ⓐ $ ◐ BERSON, DEAN, STEVENS INC.

P.O. Box 3997, Thousand Oaks CA 91359-3997. (818)713-0134. Fax: (818)713-0417. E-mail: contact@bersondeanstevens.com. Website: www.BersonDeanStevens.com. **Contact:** Lori Berson, owner. Estab. 1981. Design firm. Number of employees: 3. Firm specializes in annual reports, display design, collateral, packaging, direct mail and video production. Types of clients: industrial, financial, food and retail. Examples of recent clients: Dole Food Company; Charles Schwab & Co., Inc.

Needs Works with 4 photographers/month. Uses photos for billboards, trade magazines, direct mail, P-O-P displays, catalogs, posters, packaging, signage and Web. Subjects include: product shots and food. Reviews stock photos. Model/property release required.

Specs Accepts images in digital format only. Send via CD, DVD as TIFF, EPS, JPEG files at 300 dpi.

Making Contact & Terms Provide résumé, business card, brochure, flier or tearsheets to be kept on file. Works on assignment only. Responds in 1-2 weeks. Payment negotiable. Pays within 30 days after receipt of invoice. Credit line not given. Rights negotiable.

Ⓐ $$ ◐ BOB BOEBERITZ DESIGN

247 Charlotte St., Asheville NC 28801. (828)258-0316. E-mail: bobb@main.nc.us. Website: www.bobboeberitzdesign.com. **Contact:** Bob Boeberitz, owner. Estab. 1984. Member of American Advertising Federation—Asheville Chapter, Asheville Freelance Network, Asheville Creative Services Group, National Academy of Recording Arts & Sciences, Public Relations Association of Western North Carolina. Graphic design studio. Approximate annual billing: $100,000. Number of employees: 1. Firm specializes in annual reports, collateral, direct mail, magazine ads, packaging, publication design, signage, Web sites. Types of clients: management consultants, retail, recording artists, mail-order firms, industrial, nonprofit, restaurants, hotels, book publishers.

Needs Works with 1 freelance photographer "every 6 months or so." Uses photos for consumer and trade magazines, direct mail, brochures, catalogs, posters. Subjects include: babies/

children/teens, couples, multicultural, families, parents, senior citizens, environmental, landscapes/scenics, wildlife, architecture, cities/urban, education, pets, rural, adventure, entertainment, events, food/drink, health/fitness/beauty, hobbies, performing arts, sports, travel, business concepts, industry, medicine, product shots/still life, science, technology/computers; some location, some stock photos. Interested in fashion/glamour, seasonal. Model/property release required.

Specs Uses 8 × 10 glossy b&w prints; 35mm, 4 × 5 transparencies. Accepts images in digital format. Send via CD, Zip, floppy disk, e-mail as TIFF, BMP, JPEG, GIF files at 300 dpi. E-mail samples at 72dpi. No EPS attachments.

Making Contact & Terms Provide résumé, business card, brochure, flier or postcard to be kept on file. Cannot return unsolicited material. Responds "when there is a need." Pays $75-200 for b&w photos; $100-500 for color photos; $75-150/hour; $500-1,500/day. Pays on per-job basis. Buys all rights; negotiable.

Tips "Send promotional piece to keep on file. Do not send anything that has to be returned. I usually look for a specific specialty; no photographer is good at everything. I also consider studio space and equipment. Show me something different, unusual, something that sets you apart from any average local photographer. If I'm going out of town for something, it has to be for something I can't get done locally. I keep and file direct mail pieces (especially postcards). I do not keep anything sent by e-mail. If you want me to remember your website, send a postcard."

Ⓐ $ BRAGAW PUBLIC RELATIONS SERVICES

800 E. Northwest Hwy., Suite 1040, Palatine IL 60074. (847)934-5580. Fax: (847)934-5596. Website: http://bragawpr.com. **Contact:** Richard S. Bragaw, president. Estab. 1981. Member of Publicity Club of Chicago. PR firm. Number of employees: 3. Types of clients: professional service firms, high-tech entrepreneurs.

Needs Uses photos for trade magazines, direct mail, brochures, newspapers, newsletters/news releases. Subjects include: "products and people." Model release preferred. Photo captions preferred.

Specs Uses 3 × 5, 5 × 7, 8 × 10 glossy prints.

Making Contact & Terms Provide résumé, business card, brochure, flier or tearsheets to be kept on file. Works with freelance photographers on assignment basis only. Payment is negotiated at the time of the assignment. **Pays on receipt of invoice.** Credit line "possible." Buys all rights; negotiable.

Tips "Execute an assignment well, at reasonable costs, with speedy delivery."

Ⓝ ▣ CARLA SCHROEDER BURCHETT DESIGN CONCEPT

137 Main St., Unadilla NY 13849. (607)369-4709. **Contact:** Carla Burchett, owner. Estab. 1972. Member of Packaging Designers Council. Design firm. Number of employees: 2. Firm specializes in packaging. Types of clients: manufacturers, houses, parks. Example of recent project: Footlets (direct on package).

Needs Works with "very few" freelancers. Uses photos for posters, packaging and signage. Subjects include: environmental, landscapes/scenics, wildlife, pets, adventure, entertainment, events, health/fitness, hobbies, performing arts, travel, agriculture, business concepts, product shots/still life, technology/computers. Interested in reviewing stock

photos of children and animals, as well as alternative process, avant garde, documentary, fine art, historical vintage. Model release required.

Specs Uses 35mm, 4 × 5 transparencies. Accepts images in digital format.

Making Contact & Terms Send unsolicited photos by mail for consideration. Works with local freelancers only. Keeps samples on file; include SASE for return of material. Responds same week if not interested. Payment negotiable. Credit line given. Buys first rights; negotiable.

▣ $$ ☑ CREATIVE COMPANY

726 NE Fourth St., McMinnville OR 97128. (503)883-4433 or (866)363-4433. Fax: (503)883-6817. E-mail: advance@creativeco.com. Website: www.creativeco.com. **Contact:** Jennifer L. Morrow, president, or Steve Donatelli, Creative Director. Estab. 1978. Member of American Institute of Graphic Artists. Strategic branding and communications firm. Approximate annual billing: $1.5 million. Number of employees: 12. Firm specializes in branding, collateral, direct mail, magazine ads, packaging, publication design. Types of clients: service, industrial, financial, manufacturing, food and wine, education, non-profit, business-to-business.

Needs Works with 1-2 photographers/month. Uses photos for direct mail, P-O-P displays, catalogs, posters, packaging and sales promotion packages. Subjects include: babies/children/teens, multicultural, senior citizens, gardening, food/drink, health/fitness/beauty, agriculture, business concepts, industry, product shots/still life, technology/computers. Model release preferred.

Specs Prefers high-resolution digital files. "We would like to view samples online or via e-mail."

Making Contact & Terms Arrange a personal interview to show portfolio. Works with local freelancers only. Provide resume, business card, brochure, flier or tearsheets to be kept on file. Responds "when needed." Pays $150-300 for b&w photos; $300-1,000 for color photos; $50-100/hour; $700-2,000/day; $200-15,000/job. Credit line not given. Buys one-time, one-year and all rights; negotiable.

Tips In freelancers' portfolios looks for "product shots, lighting, creative approach, understanding of sales message and reproduction." Sees trend toward "more special effect photography and manipulation of photos in computers." To break in with this firm, "do good work, be responsive, and understand how to maximize color and effect on the press."

▣ Ⓐ DYKEMAN ASSOCIATES, INC.

4115 Rawlins St., Dallas TX 75219. (214)528-2991. Fax: (214)528-0241. E-mail: adykeman@airmail.net. Website: www.dykemanassociates.com. **Contact:** Alice Dykeman, APR, Fellow-PRSA. Estab. 1974. Member of Public Relations Society of America. PR, marketing, video production firm. Firm specializes in website creation and promotion, communication plans, media training, collateral, direct marketing. Types of clients: industrial, financial, sports, technology.

Needs Works with 4-5 photographers and/or videographers. Uses photos for publicity, consumer and trade magazines, direct mail, catalogs, posters, newspapers, signage, Web sites.

Audiovisual Needs "We produce and direct video. Just need crew with good equipment and people and ability to do their part."

Making Contact & Terms Arrange a personal interview to show portfolio. Provide business card, brochure, flier or tearsheets to be kept on file. Works on assignment only. Cannot return material. Pays $800-1,200/day; $250-400/1-2 days. "Currently we work only with photographers who are willing to be part of our trade dollar network. Call if you don't understand this term." Pays 30 days after receipt of invoice.

Tips Reviews portfolios with current needs in mind. "If video, we would want to see examples. If for news story, we would need to see photojournalism capabilities."

🖥 🖼 $ 🖉 FLINT COMMUNICATIONS

101 10th St. N., Suite 300, Fargo ND 58102. (701)237-4850. Fax: (701)234-9680. Email: gerriL@flintcom.com or dawnk@flintcom.com. Website: www.flintcom.com. **Contact:** Gerri Lien, creative director or Dawn Koranda, art director. Estab. 1946. Ad agency. Approximate annual billing: $9 million. Number of employees: 30. Firm specializes in display design, direct mail, magazine ads, publication design, signage, annual reports. Types of clients: industrial, financial, agriculture, health care and tourism.

Needs Works with 2-3 photographers/month. Uses photos for direct mail, P-O-P displays, posters and audiovisual. Subjects include: babies/children/teens, couples, parents, senior citizens, architecture, rural, adventure, automobiles, events, food/drink, health/fitness, sports, travel, agriculture, industry, medicine, political, product shots/still life, science, technology, manufacturing, finance, health care, business. Interested in documentary, historical/vintage, seasonal. Reviews stock photos. Model release preferred.

Audiovisual Needs Works with 1-2 filmmakers and 1-2 videographers/month. Uses slides and film.

Specs Uses 35mm, 2¼ × 2¼, 4 × 5 transparencies. Accepts images in digital format. Send via CD, Zip as TIFF, EPS, JPEG files.

Making Contact & Terms Send query letter with stock list. Submit portfolio for review. Provide resume, business card, brochure, flier or tearsheets to be kept on file. Responds in 1-2 weeks. Pays $50-150 for b&w photos; $50-1,500 for color photos; $50-130/hour; $400-1,200/day; $100-2,000/job. **Pays on receipt of invoice.** Buys one-time rights.

🔲 🖥 🖼 $ 🖉 FRIEDENTAG PHOTOGRAPHICS

314 S. Niagara St., Denver CO 80224-1324. (303)333-0570. **Contact:** Harvey Friedentag, manager. Estab. 1957. AV firm. Approximate annual billing: $500,000. Number of employees: 3. Firm specializes in direct mail, annual reports, publication design, magazine ads. Types of clients: business, industry, financial, publishing, government, trade and union organizations. Produces slide sets, motion pictures and videotape. Examples of recent clients: Perry Realtors annual report (advertising, mailing); Lighting Unlimited catalog (illustrations).

Needs Works with 5-10 photographers/month on assignment only. Buys 1,000 photos and 25 films/year. Reviews stock photos of business, training, public relations, and industrial plants showing people and equipment or products in use. Other subjects include agriculture, business concepts, industry, medicine, military, political, science, technology/computers. Interested in avant garde, documentary, erotic, fashion/glamour. Model release required.

Audiovisual Needs Uses freelance photos in color slide sets and motion pictures. "No posed looks." Also produces mostly 16mm Ektachrome and some 16mm b ¾" and VHS

Advertising

videotape. Length requirement: 3-30 minutes. Interested in stock footage on business, industry, education and unusual information. "No scenics, please!"

Specs Uses 8 × 10 glossy b&w and/or color prints; 35mm, 2¼ × 2¼, 4 × 5 color transparencies. Accepts images in digital format. Send via CD as JPEG files.

Making Contact & Terms Send material by mail for consideration. Provide flier, business card, brochure and nonreturnable samples to show clients. Responds in 3 weeks. Pays $500/day for still; $700/day for motion picture plus expenses; $100 maximum for b&w photos; $200 maximum for color photos; $700 maximum for film; $700 maximum for videotape. **Pays on acceptance**. Buys rights as required by clients.

Tips "More imagination needed—be different; *no scenics, pets or portraits*, and above all, technical quality is a must. There are more opportunities now than ever, especially for new people. We are looking to strengthen our file of talent across the nation."

◫ ▨ Ⓐ ◪ GRAPHIC DESIGN CONCEPTS

15329 Yukon Ave., El Camino Village CA 90260-2452. (310)978-8922. **Contact:** C. Weinstein, president. Estab. 1980. Design firm. Number of employees: 10. Firm specializes in annual reports, collateral, publication design, display design, packaging, direct mail, signage. Types of clients: industrial, financial, retail, publishers, nonprofit. Examples of recent clients: Sign of Dove (brochures); Trust Financial (marketing materials).

Needs Works with 10 photographers/month. Uses photos for annual reports, billboards, consumer and trade magazines, direct mail, P-O-P displays, catalogs, posters, packaging, signage. Subjects include babies/children/teens, celebrities, couples, multicultural, families, parents, senior citizens, disasters, environmental, landscapes/scenics, wildlife, architecture, cities/urban, gardening, interiors/decorating, pets, religious, rural, adventure, automobiles, entertainment, events, food/drink, health/fitness, hobbies, humor, performing arts, travel, sports, agriculture, business concepts, industry, medicine, military, political, product shots/still life, science, technology/computers, pictorial. Interested in alternative process, avant garde, documentary, erotic, fashion/glamour, fine art, historical/vintage, seasonal. Model/property release required for people, places, art. Photo captions required; include who, what, when, where.

Audiovisual Needs Uses film and videotape.

Specs Uses 8 × 10 glossy color and/or b&w prints; 35mm, 2¼ × 2¼, 4 × 5, 8 × 10 transparencies. Accepts images in digital format. Send via CD, floppy disk as TIFF, JPEG files at 300 dpi.

Making Contact & Terms Provide résumé, business card, brochure, flier or tearsheets to be kept on file. Works with freelancers on assignment only. Responds as needed. Pays $15 minimum/hour; $100 minimum/day; $100 minimum/job; $50 minimum for color photos; $25 minimum for b&w photos; $200 minimum for film; $200 minimum for videotape. **Pays on receipt of invoice.** Credit line sometimes given depending upon usage. Buys rights according to usage.

Tips In samples, looks for "composition, lighting and styling." Sees trend toward "photos being digitized and manipulated by computer."

Ⓝ ▨ HALLOWES PRODUCTIONS & ADVERTISING

11260 Regent St., Los Angeles CA 90066-3414. (310)390-4767. Fax: (310)745-1107.

Miracle Mile Office: Hallowes Productions, 5670 Wilshire Blvd., Suite 1590, Los Angeles CA 90036-5679. E-mail: adjim@aol.com. Website: www.jimhallowes.com and www.hallowesproductions.com. **Contact:** Jim Hallowes, creative director/producer-director. Estab. 1984. Creates and produces TV commercials, corporate films and videos, and print and electronic advertising.

Needs Buys 8-10 photos/year. Uses photos for magazines, posters, newspapers and brochures. Reviews stock photos; subjects vary.

Audiovisual Needs Uses film and video for TV commercials and corporate films.

Specs Uses 35mm, 4 × 5 transparencies; 35mm/16mm film; Beta SP videotape; all digital formats.

Making Contact & Terms Send query letter with résumé of credits. "Do not fax unless requested." Keeps samples on file. Responds if interested. Payment negotiable. Pays on usage. Credit line sometimes given, depending upon usage, usually not. Buys first and all rights; rights vary depending on client.

Ⓝ ▣ $ $ $ ◨ HAMPTON DESIGN GROUP

417 Haines Mill Rd., Allentown PA 18104. (610)821-0963. Fax: (610)821-3008. E-mail: wendy@hamptondesigngroup.com. Website: www.hamptondesigngroup.com. **Contact:** Wendy Ronga, creative director. Estab. 1997. Member of Type Director Club, Society of Illustrators, Art Directors Club, Society for Publication Designers. Design firm. Approximate annual billing: $450,000. Number of employees: 3. Firm specializes in annual reports, magazine and book design, editorial packaging, advertising, collateral, direct mail. Examples of recent clients: Conference for the Aging, Duke University/Templeton Foundation (photo shoot/5 images); Religion and Science, UCSB University (9 images for conference brochure).

Needs Works with 2 photographers/month. Uses photos for billboards, brochures, catalogs, consumer magazines, direct mail, newspapers, posters, trade magazines. Subjects include: babies/children/teens, multicultural, senior citizens, environmental, landscapes/scenics, wildlife, pets, religious, health/fitness/beauty, business concepts, medicine, science. Interested in alternative process, avant garde, fine art, historical/vintage, seasonal. Model/property release required. Photo captions preferred.

Specs Prefers images in digital format. Send via CD as TIFF, EPS, JPEG files at 300 dpi.

Making Contact & Terms Send query letter. Keeps samples on file. Responds only if interested; send nonreturnable samples or web address to see examples. Pays $150-1,500 for color photos; $75-1,000 for b&w photos. Pays extra for electronic usage of photos, varies depending on usage. Price is determined by size, how long the image is used and if it is on the home page. **Pays on receipt of invoice**. Credit line given. Buys one-time rights, all rights, electronic rights; negotiable.

Tips "Use different angles and perspectives, a new way to view the same old boring subject. Try different films and processes."

Ⓝ ▣ ◪ IMAGE INTEGRATION

2619 Benvenue Ave., #A, Berkeley CA 94704. (510)841-8524. E-mail: vincesail@aol.com. **Contact:** Vince Casalaina, owner. Estab. 1971. Firm specializes in material for TV productions and Internet sites. Approximate annual billing: $100,000. Examples of recent clients: "Ultimate Subscription," Sailing World (30-second spot); "Road to America's Cup,"

ESPN (stock footage); "Sail with the Best," U.S. Sailing (promotional video).

Needs Works with 1 photographer/month. Reviews stock photos of sailing only. Property release preferred. Photo captions required; include regatta name, regatta location, date.

Audiovisual Needs Works with 1 videographer/month. Uses videotape. Subjects include: sailing only.

Specs Uses 4 × 5 or larger matte color and/or b&w prints; 35mm transparencies; 16mm film and Betacam videotape. Prefers images in digital format. Send via e-mail, Zip, CD-ROM (preferred).

Making Contact & Terms Send unsolicited photos of sailing by mail with SASE for consideration. Keeps samples on file. Responds in 2 weeks. Payment depends on distribution. Pays on publication. Credit line sometimes given, depending upon whether any credits included. Buys nonexclusive rights; negotiable.

JUDE STUDIOS

8000 Research Forest, Suite 115-266, The Woodlands TX 77382. (281)364-9366. Fax: (281)364-9529. E-mail: jdollar@judestudios.com. Website: www.judestudios.com. **Contact:** Judith Dollar, art director. Estab. 1994. Number of employees: 2. Firm specializes in collateral, direct mail, packaging. Types of clients: nonprofits, builder, retail, destination marketing, event marketing, service. Examples of recent clients: home builder; festivals and events; corporate collateral; various logos; banking.

Needs Works with 1 photographer/month. Uses photos for newsletters, brochures, catalogs, direct mail, trade and trade show graphics. Needs photos of families, active adults, senior citizens, education, pets, business concepts, industry, product shots/still life, technology/computers. Model release required; property release preferred. Photo captions preferred.

Specs Accepts images in digital format. Send via CD as TIFF, EPS, JPEG files at 350 dpi. "Do not e-mail attachments."

Making Contact & Terms Send e-mail with link to Web site, blog, or portfolio. Provide business card, self-promotion piece to be kept on file. Responds only if interested; send nonreturnable samples. Pays by the project. **Pays on receipt of invoice.**

KOCHAN & COMPANY

800 Geyer Ave., St Louis MO 63104. (314)621-4455. Fax: (314)621-1777. Website: www.kochanandcompany.com. **Contact:** Rebecca Lay, associate creative director. Estab. 1987. Member of AAAA. Ad agency. Number of employees: 15. Firm specializes in display design, print & magazine ads, packaging, direct mail, signage. Types of clients: attractions, retail, nonprofit. Example of recent clients: Argosy Casino (billboards/duratrans); Pasta House Co. (menu inserts); Mystique Casino (billboards/print ads).

Needs Uses photos for billboards, brochures, catalogs, direct mail, newspapers, posters, signage. Reviews stock photos. Model/property release required. Photo captions required.

Making Contact & Terms Send query letter with samples, brochure, stock list, tearsheets. To show portfolio, photographer should follow up with call and/or letter after initial query. Portfolio should include b&w, color, prints, tearsheets, slides, transparencies. Works with freelancers on assignment only. Keeps samples on file. Responds only if interested; send nonreturnable samples. **Pays on receipt of invoice.** Credit line given. Buys all rights.

▣ ▨ \$ \$ ⊘ LINEAR CYCLE PRODUCTIONS

Box 2608, Sepulveda CA 91393-2608. **Contact:** R. Borowy, production manager. Estab. 1980. Member of International United Photographer Publishers, Inc. Ad agency, PR firm. Approximate annual billing: \$5 million. Number of employees: 20. Firm specializes in annual reports, display design, magazine ads, publication design, direct mail, packaging, signage. Types of clients: industrial, commercial, advertising, retail, publishing.

Needs Works with 7-10 photographers/month. Uses photos for billboards, consumer magazines, direct mail, P-O-P displays, posters, newspapers, audiovisual uses. Subjects include: candid photographs. Reviews stock photos, archival. Model/property release required. Photo captions required; include description of subject matter.

Audiovisual Needs Works with 8-12 filmmakers and 8-12 videographers/month. Uses slides and/or film or video for television/motion pictures. Subjects include: archival-humor material.

Specs Uses 8 × 10 color and/or b&w prints; 35mm, 8 × 10 transparencies; 16mm-35mm film; ½", ¾", 1" videotape. Accepts images in digital format. Send via CD, floppy disk, Jaz as TIFF, GIF, JPEG files.

Making Contact & Terms Submit portfolio for review. Send query letter with résumé of credits, stock list. Provide résumé, business card, brochure, flier or tearsheets to be kept on file. Works with local freelancers on assignment and buys stock photos. Responds in 1 month. Pays \$100-500 for b&w photos; \$150-750 for color photos; \$100-1,000/job. Prices paid depend on position. Pays on publication. Credit line given. Buys one-time rights; negotiable.

Tips "Send a good portfolio with color images. No sloppy pictures or portfolios! The better the portfolio is set up, the better the chances we would consider it, let alone look at it!" Seeing a trend toward "more archival/vintage and a lot of humor pieces."

\$ \$ \$ \$ ⊘ THE MILLER GROUP

1516 Bundy Dr., Suite 200, Los Angeles CA 90025. (310)442-0101. Fax: (310)442-0107. E-mail: gary@millergroup.net. Website: www.millergroup.net. **Contact:** Gary Bettman. Estab. 1990. Member of WSAAA. Approximate annual billing: \$12 million. Number of employees: 10. Firm specializes in print advertising. Types of clients: consumer.

Needs Uses photos for billboards, brochures, consumer magazines, direct mail, newspapers. Model release required.

Making Contact & Terms Contact through rep or send query letter with photocopies. Provide self-promotion piece to be kept on file. Buys all rights; negotiable.

Tips "Please, no calls!"

▣ \$ MITCHELL STUDIOS DESIGN CONSULTANTS

1499 Sherwood Drive, East Meadow NY 11554. (516)832-6230. Fax: (516)832-6232. E-mail: msdcdesign@aol.com. **Contact:** Steven E. Mitchell, principal. Estab. 1922. Design firm. Number of employees: 6. Firm specializes in packaging, display design. Types of clients: industrial and retail. Examples of projects: Lipton Cup-A-Soup, Thomas J. Lipton, Inc.; Colgate Toothpaste, Colgate Palmolive Co.; Chef Boy-Ar-Dee, American Home Foods (all 3 involved package design).

Needs Works with varying number of photographers/month. Uses photographs for direct

Advertising

mail, P-O-P displays, catalogs, posters, signage and package design. Subjects include: products/still life. Reviews stock photos of still life/people. Model release required; property release preferred. Photo captions preferred.

Specs Uses all sizes and finishes of color and b&w prints; 35mm, 2¼ × 2¼, 4 × 5, 8 × 10 transparencies. Accepts images in digital format. Send via CD, SyQuest, floppy disk, Jaz, Zip as EPS files.

Making Contact & Terms Submit portfolio for review. Provide résumé, business card, brochure, flier or tearsheets to be kept on file. Cannot return material. Responds as needed. Pays $35-75/hour; $350-1,500/day; $500 and up/job. **Pays on receipt of invoice.** Credit line sometimes given depending on client approval. Buys all rights.

Tips In portfolio, looks for "ability to complete assignment." Sees a trend toward "tighter budgets." To break in with this firm, keep in touch regularly.

▣ ◪ MONDERER DESIGN

2067 Massachusetts Ave., Cambridge MA 02140. (617)661-6125. Fax: (617)661-6126. E-mail: stewart@monderer.com. Website: www.monderer.com. **Contact:** Stewart Monderer, president. Estab. 1981. Member of AIGA. Design firm. Approximate annual billing: $1 million. Number of employees: 4. Firm specializes in annual reports, branding, print and collateral, direct response, publication design and packaging, website and interactive design. Types of clients: technology, life science, industrial, financial and educational. Examples of recent clients: Brochure, Northeastern University (faces, portraits, classroom); Brochure, Makepeace (real estate, nature, landscape); ads, thermo scientific (metaphorical, conceptual).

Needs Works with 2 photographers/month. Uses photos for advertising, annual reports, catalogs, posters and brochures. Subjects include: environmental, architecture, cities/urban, education, adventure, automobiles, entertainment, events, performing arts, sports, travel, business concepts, industry, medicine, product shots/still life, science, technology/computers, conceptual, site specific, people on location. Interested in alternative process, avant garde, documentary, historical/vintage, seasonal. Model release preferred; property release sometimes required.

Specs Accepts images in digital format. Send via CD as TIFF, EPS files at 300 dpi.

Making Contact & Terms Send unsolicited photos by mail for consideration. Keeps samples on file. Follow up from photographers recommended. Payment negotiable. **Pays on receipt of invoice.** Credit line sometimes given depending upon client. Rights always negotiated depending on use.

▣ Ⓐ ◪ MYRIAD PRODUCTIONS

P.O. Box 888886, Atlanta GA 30356. (678)417-0041. E-mail: myriad@mindspring.com. **Contact:** Ed Harris, president. Estab. 1965. Primarily involved with sports productions and events. Types of clients: publishing, nonprofit.

Needs Works with photographers on assignment-only basis. Uses photos for portraits, live-action and studio shots, special effects, advertising, illustrations, brochures, TV and film graphics, theatrical and production stills. Subjects include: celebrities, entertainment, sports. Model/property release required. Photo captions preferred; include name(s), location, date, description.

Specs Uses 8 × 10 b&w and/or color prints; 2¼ × 2¼ transparencies. Accepts images in digital format. Send via "Mac-compatible CD or DVD. No floppy disks or Zips!"

Making Contact & Terms Provide brochure, résumé or samples to be kept on file. Send material by mail for consideration. "No telephone or fax inquiries, please!" Cannot return material. Response time "depends on urgency of job or production." Payment negotiable. Credit line sometimes given. Buys all rights.

Tips "We look for an imaginative photographer—one who captures all the subtle nuances. Working with us depends almost entirely on the photographer's skill and creative sensitivity with the subject. All materials submitted will be placed on file and not returned, pending future assignments. Photographers should not send us their only prints, transparencies, etc., for this reason."

$ $ NOVUS

121 E. 24th St., 12th Floor, New York NY 10010. (212)473-1377. Fax: (212)505-3300. E-mail: info@novuscommunications.com. Website: www.novuscommunications.com. **Contact:** Robert Antonik, owner/president. Estab. 1988. Creative marketing and communications firm. Number of employees: 5. Firm specializes in advertising, annual reports, publication design, display design, multimedia, packaging, direct mail, signage and Web site, Internet and DVD development. Types of clients: industrial, financial, retail, health care, telecommunications, entertainment, nonprofit.

Needs Works with 1 photographer/month. Uses photos for annual reports, billboards, consumer and trade magazines, direct mail, P-O-P displays, catalogs, posters, packaging and signage. Subjects include: babies/children/teens, couples, multicultural, families, parents, senior citizens, environmental, landscapes/scenics, wildlife, architecture, cities/urban, education, gardening, interiors/decorating, pets, religious, rural, adventure, automobiles, entertainment, events, food/drink, health/fitness, hobbies, humor, performing arts, sports, travel, agriculture, business concepts, industry, medicine, military, political, product shots/still life, science, technology/computers. Interested in alternative process, avant garde, documentary, fashion/glamour, fine art, historical/vintage, seasonal. Reviews stock photos. Model/property release required. Photo captions preferred.

Audiovisual Needs Uses film, videotape, DVD.

Specs Uses color and/or b&w prints; 35mm, 2¼ × 2¼, 4 × 5, 8 × 10 transparencies. Accepts images in digital format. Send via Zip, CD as TIFF, JPEG files.

Making Contact & Terms Arrange a personal interview to show portfolio. Works on assignment only. Keeps samples on file. Cannot return material. Responds in 1-2 weeks. Pays $75-150 for b&w photos; $150-750 for color photos; $300-1,000 for film; $150-750 for videotape. Pays upon client's payment. Credit line given. Rights negotiable.

Tips "The marriage of photos with illustrations continues to be trendy. More illustrators and photographers are adding stock usage as part of their business. Send sample postcard; follow up with phone call."

PHOTO COMMUNICATION SERVICES, INC.

P.O. Box 9, Traverse City MI 49685-0009. (231)943-4000. E-mail: Mail@PhotoComm. net. Website: www.photocomm.net. **Contact:** M'Lynn Hartwell, president. Estab. 1970. Commercial/illustrative and multimedia firm. Types of clients: commercial/industrial,

fashion, food, general, human interest.

- This firm also has an office in Hawaii: P.O. Box 458, Kapa'a HI 96746-0458. "Also see our advertising agency at www.UtopianEmpire.com."

Needs Works with varying number of photographers/month. Uses photos for catalogs, P-O-P displays, AV presentations, trade magazines and brochures, and a "large variety of subjects." Sometimes works with freelance filmmakers. Model release required.

Audiovisual Needs "Primarily industrial or training video."

Specs Uses digital, "plus some older technology" such as 8 × 10 (or larger) glossy (or semi-glossy) b&w and/or color prints, 35mm film, transparencies, most current formats of digital videotape.

Making Contact & Terms Send query letter with résumé of credits, samples, stock list; include SASE for return of material. Works with freelance photographers on assignment basis only. Payment determined by private negotiation. Pays 30 days from acceptance. Credit line given "whenever possible."

Tips "Be professional and to the point. If I see something I can use, I will make an appointment to discuss the project in detail."

▣ $ ◪ POSEY SCHOOL

P.O. Box 254, Northport NY 11768. (631)757-2700. E-mail: EPosey@optonline.net. Website: www.poseyschool.com. **Contact:** Elsa Posey, president. Estab. 1953. Sponsors a school of dance, art, music, drama; regional dance company and acting company. Uses photos for brochures, news releases and newspapers.

Needs Buys 12 -15 photos/year; offers 4 assignments/year. Special subject needs include children dancing, ballet, modern dance, jazz/tap (theater dance) and "photos showing class situations in any subjects we offer. Photos must include girls and boys, women and men." Interested in documentary, fine art, historical/vintage. Reviews stock photos. Model release required.

Specs Uses 8 × 10 glossy b&w prints. Accepts images in digital format. Send via CD, e-mail.

Making Contact & Terms "Call us." Responds in 1 week. Pays $ 35 to $50 for most photos, b&w or color. Credit line given if requested. Buys one-time rights; negotiable.

Tips "We are small but interested in quality (professional) work. Capture the joy of dance in a photo of children or adults. Show artists, actors or musicians at work. We prefer informal action photos, not posed pictures. We need photos of *real* dancers dancing. Call first. Be prepared to send photos on request."

▥ ▣ Ⓐ ◪ QUALLY & COMPANY, INC.

2 E. Oak St., Suite 2903, Chicago IL 60611. **Contact:** Mike Iva, creative director. Ad agency. Types of clients: new product development and launches.

Needs Uses photos for every media. "Subject matter varies, but it must always be a 'quality image' regardless of what it portrays." Model/property release required. Photo captions preferred.

Specs Uses b&w and color prints; 35mm, 4 × 5, 8 × 10 transparencies. Accepts images in digital format.

Making Contact & Terms Send query letter with photocopies, tearsheets. Provide résumé,

business card, brochure, flier or tearsheets to be kept on file. Responds only if interested; send nonreturnable samples. Payment negotiable. Pays net 30 days from receipt of invoice. Credit line sometimes given, depending on client's cooperation. Rights purchased depend on circumstances.

▣ Ⓐ ◑ PATRICK REDMOND DESIGN

P.O. Box 75430-PM, St. Paul MN 55175-0430. E-mail: redmond@patrickredmonddesign.com. Website: www.patrickredmonddesign.com. **Contact:** Patrick Redmond, M.A., designer/owner/president. Estab. 1966. Design firm. Number of employees: 1. Firm specializes in publication design, book covers, books, packaging, direct mail, posters, branding, logos, trademarks, annual reports, Web sites, collateral. Types of clients: publishers, financial, retail, advertising, marketing, education, nonprofit, industrial, arts. Examples of recent clients: Flamenco-A Touch of Spain (Web site, Branding, Print); The Alonzo Hauser Collection (website launch; print); Experienced Staff, LLC (Brand identity consulting). See "portfolio" section of website for examples.

- Books designed by Redmond have won awards from Midwest Independent Publishers Association, Midwest Book Achievement Awards, Publishers Marketing Association Benjamin Franklin Awards.

Needs Uses photos for books and book covers, direct mail, P-O-P displays, catalogs, posters, packaging, annual reports. Subject varies with client—may be editorial, product, how-to, etc. May need custom b&w photos of authors (for books/covers designed by PRD). "Poetry book covers provide unique opportunities for unusual images (but typically have miniscule budgets)." Reviews stock photos; subject matter varies with need. Model/property release required; varies with assignment/project. Photo captions required; include correct spelling and identification of all factual matters regarding images; names, locations, etc. to be used optionally if needed.

Specs Accepts images in digital format; type varies with need, production requirements, budgets.

Making Contact & Terms Contact through rep. Arrange a personal interview to show portfolio if requested. "Send query letter with your website address only via brief e-mail text message. Patrick Redmond Design will not reply unless specific photographer may be needed." Works with local freelancers on assignment only. Cannot return material. Payment negotiable. "Client typically pays photographer directly even though PRD may be involved in photo/photographer selection and photo direction." Payment depends on client. Credit line sometimes given depending upon publication style/individual projects. Rights purchased by clients vary with project; negotiable. "Clients typically involved with negotiation of rights directly with photographer. Please include note 'Photographer's Market 2010' in any correspondence (unlikely to open or respond to mail or e-mails which don't include this on envelope or in subject line)."

Tips Needs are "open—vary with project; location work, studio, table-top, product, portraits, travel, etc." Seeing "use of existing stock images when image/price are right for project, and use of black & white photos in low- to mid-budget/price books. Provide URLs and e-mail addresses. Freelance photographers need Web presence in today's market in addition to exposure via direct mail, catalogs, brochures, etc. Do not send any images/files attached to your e-mails. Briefly state/describe your work in e-mail. Do not send unsolicited print samples or digital files in any format via e-mail, traditional mail or other delivery."

▣ ☑ ARNOLD SAKS ASSOCIATES

350 E. 81st St., 4th Floor, New York NY 10028. (212)861-4300. Fax: (212)535-2590. E-mail: afiorillo@saksdesign.com. Website: www.saksdesign.com. **Contact:** Anita Fiorillo, vice president. Estab. 1968. Graphic design firm. Number of employees: 10. Approximate annual billing: $2 million. Types of clients: industrial, financial, legal, pharmaceutical, hospitals. Examples of recent clients: Alcoa; McKinsey; UBS; Wyeth; Xerox; Hospital for Special Surgery.

Needs Works with approximately 15 photographers during busy season. Uses photos for annual reports and corporate brochures. Subjects include corporate situations and portraits. Wants photos of babies/children/teens, couples, multicultural, families, parents, senior citizens, automobiles, health/fitness/beauty, performing arts, sports, business concepts, industry, medicine, product shots/still life, science, technology/computers. Reviews stock photos; subjects vary according to the nature of the annual report. Model release required. Photo captions preferred.

Specs Accepts images in digital format. Send via e-mail as TIFF, EPS, JPEG files.

Making Contact & Terms "Appointments are set up during the spring for summer review on a first-come only basis. We have a limit of approximately 30 portfolios each season." Call to arrange an appointment. Responds as needed. Payment negotiable, "based on project budgets. Generally we pay $1,500-2,500/day." **Pays on receipt of invoice** and payment by client; advances provided. Credit line sometimes given depending upon client specifications. Buys one-time and all rights; negotiable.

Tips "Ideally a photographer should show a corporate book indicating his success with difficult working conditions and establishing an attractive and vital final product. Our company is well known in the design community for doing classic graphic design. We look for solid, conservative, straightforward corporate photography that will enhance these ideals."

▣ $$ ☑ HENRY SCHMIDT DESIGN

14201 SE Bunnell Street, Portland OR 97267-2631. (503)652-1114. E-mail: hank@hankink. com. Website: www.hankink.com. **Contact:** Hank Schmidt, president. Estab. 1976. Design firm. Approximate annual billing: $250,000. Number of employees: 2. Firm specializes in branding, packaging, P-O-P display s, catalog/sales literature.

Needs Works with 1-2 photographers/month. Uses photos for catalogs and packaging. Subjects include product shots/still life. Interested in fashion/glamour. Model/property release required.

Specs Uses digital photography for almost all projects. Send digital images via CD, e-mail as TIFF, JPEG files.

Making Contact & Terms Interested in receiving work from newer, lesser-known photographers. Send query letter with samples; include SASE for return of material. Buys all rights.

▣ ◩ $ ◯ SOUNDLIGHT

5438 Tennessee Ave., New Port Richey FL 34652. (727)842-6788. E-mail: keth@soundlight. org. Website: www.SoundLight.org. **Contact:** Keth Luke. Estab. 1972. Approximate annual billing: $150,000. Number of employees: 2. Firm specializes in websites, direct mail,

magazine ads, model portfolios, publication design. Types of clients: businesses, astrological and spiritual workshops, books, calendars, fashion, magazines, models, special events, products, nonprofit, webpages. Examples of recent clients: Sensual Women of Hawaii (calendars, post cards).

Needs Works with 1 freelance photographer every 7 months. Subjects include: women, celebrities, couples, Goddess, people in activities, landscapes/scenics, animals, religious, adventure, health/fitness/beauty, humor, alternative medicine, spiritual, travel sites and activities, exotic dance and models (art, glamour, lingerie and nude). Interested in alternative process, avant garde, erotic, fine art. Reviews stock photos, slides, computer images. Model release preferred for models and advertising people. Photo captions preferred; include who, what, where.

Audiovisual Needs Uses freelance photographers for slide sets, multimedia productions, videotapes, Web sites.

Specs Uses 4 × 6 to 8 × 10 glossy color prints; 35mm color slides. Accepts images in digital format. Send via CD, floppy disk, e-mail as TIFF, GIF, JPEG files at 70-100 dpi.

Making Contact & Terms Send query letter with résumé, stock list. Provide prints, slides, business card, computer disk, CD, contact sheets, self-promotion piece or tearsheets to be kept on file. Works on assignment; sometimes buys stock nude model photos. May not return unsolicited material. Responds in 3 weeks. Pays $100 maximum for b&w and color photos; $10-1,800 for videotape; $10-100/hour; $50-750/day; $2,000 maximum/job; sometimes also pays in "trades." Pays on publication. Credit line sometimes given. Buys one-time, all rights; various negotiable rights depending on use.

Tips In portfolios or demos, looks for "unique lighting, style, emotional involvement; beautiful, artistic, sensual, erotic viewpoints." Sees trend toward "manipulated computer images. Send query about what you have to show, to see what we can use at that time."

◆ ◆ A $ SUN.ERGOS

130 Sunset Way, Priddis AB T0L 1W0 Canada. (403)931-1527. Fax: (403)931-1534. E-mail: waltermoke@sunergos.com. Website: www.sunergos.com. **Contact:** Robert Greenwood, artistic and managing director. Estab. 1977. "A unique, professional, two-man company of theatre and dance, touring nationally and internationally as cultural ambassadors to urban and rural communities."

Needs Buys 10-30 photos/year; offers 3-5 assignments/year. Uses photos for brochures, newsletters, posters, newspapers, annual reports, magazines, press releases, audiovisual uses and catalogs. Reviews theater and dance stock photos. Property release required for performance photos for media use. Photo captions required; include subject, date, city, performance title.

Audiovisual Needs Uses digital images, slides, film and videotape for media usage, showcases and international conferences. Subjects include performance pieces/showcase materials.

Specs Uses 8 × 10, 8½ × 11 color and/or b&w prints; 35mm, 2¼ × 21¼ transparencies; 16mm film; NTSC/PAL/SECAM videotape.

Making Contact & Terms Arrange a personal interview to show portfolio. Send query letter

with résumé of credits. Provide résumé, business card, self-promotion piece or tearsheets to be kept on file. Works on assignment only. Response time depends on project. Pays $100-150/day; $150-300/job; $2.50-10 for color or b&w photos. Pays on usage. Credit line given. Buys all rights.

Tips "You must have experience shooting dance and *live* theater performances."

▣ ▩ Ⓐ VIDEO I-D, INC.

105 Muller Rd., Washington IL 61571. (309)444-4323. Fax: (309)444-4333. E-mail: videoid@ videoid.com. Website: www.videoid.com. **Contact:** Sam B. Wagner, president. Number of employees: 10. Types of clients: health, education, industry, service, cable and broadcast.

Needs Works with 2 photographers/month to shoot digital stills, multimedia backgrounds and materials, films and videotapes. Subjects "vary from commercial to industrial—always high quality." Somewhat interested in stock photos/footage. Model release required.

Audiovisual Needs Uses digital stills, videotape, DVD, DVD-ROM, CD-ROM.

Specs Uses digital still extension, Beta SP, HDV and HD. Accepts images in digital format. Send via DVD, CD, e-mail, FTP.

Making Contact & Terms Provide résumé, business card, self-promotion piece or tearsheets to be kept on file. "Also send video sample reel." Include SASE for return of material. Works with freelancers on assignment only. Responds in 3 weeks. Pays $10-65/hour; $160-650/ day. Usually pays by the job; negotiable. **Pays on acceptance.** Credit line sometimes given. Buys all rights; negotiable.

Tips "Sample reel—indicate goal for specific pieces. Show good lighting and visualization skills. Show me you can communicate what I need to see, and have a willingness to put out effort to get top quality."

▣ ▩ Ⓐ $ DANA WHITE PRODUCTIONS

2623 29th St., Santa Monica CA 90405. (310)450-9101. E-mail: dwprods@aol.com. **Contact:** Dr. Dana White, president. Estab. 1977. Full-service book development and design, video/film production studio. Types of clients: schools and community-based nonprofit institutions, corporate, government, publishing, marketing/advertising, and art galleries. Examples of recent clients: Copper Cauldron Publishing, Toyota Hybrid Synergy: Mobile Experience Tour (video production); Los Angeles County (annual report); Back Forty Feature Films; Southern California Gas Company/South Coast AQMD (Clean Air Environmental Film Trailers in 300 LA-based motion picture theaters); Glencoe/McGraw-Hill (textbook photography and illustrations, slide shows); Pepperdine University (awards banquet presentations, fundraising, biographical tribute programs); U.S. Forest Service (training programs); Venice Family Clinic (newsletter photography); Johnson & Higgins (brochure photography). "Stock photography is available through PhotoEdit: www.photoeditinc.com; locate Dana White in list of photographers."

Needs Works with 2-3 photographers/month. Uses photos for catalogs, audiovisual, books. Subjects include: people, products, still life, event documentation, architecture. Interested in reviewing 35mm stock photos by appointment. Model release required for people and companies. "If your portfolio is on flickr.com, please send a link to your images."

Audiovisual Needs Uses all AV formats including scanned and digital images for computer-based multimedia; 35mm slides for multi-image presentations; and medium-format as needed.

Specs Uses color and/or b&w prints; 35mm, 2¼ × 2¼ transparencies; digital images (minimum 6mp files).

Making Contact & Terms Arrange a personal interview to show portfolio and samples. "Please do not send originals." Works with freelancers on assignment only. Will assign certain work on spec. Do not submit unsolicited material. Cannot return material. **Pays when images are shot to White's satisfaction**—never delays until acceptance by client. Pays according to job: $25-100/hour, up to $750/day; $20-50/shot; or fixed fee based upon job complexity and priority of exposure. Hires according to work-for-hire and will share photo credit when possible.

Tips In freelancer's portfolio or demo, Dr. White wants to see "quality of composition, lighting, saturation, degree of difficulty, and importance of assignment. The trend seems to be toward more video, less AV. Clients are paying less and expecting more. To break in, freelancers should diversify, negotiate, be personable and flexible, go the distance to get and keep the job. Freelancers need to see themselves as hunters who are dependent upon their hunting skills for their livelihood. Don't get stuck in one-dimensional thinking. Think and perform as a team—service that benefits all sectors of the community and process."

Galleries

The popularity of photography as a collectible art form has improved the market for fine art photographs over the last decade. Collectors now recognize the investment value of prints by Ansel Adams, Irving Penn and Henri Cartier-Bresson, and therefore frequently turn to galleries for photographs to place in their private collections.

The gallery/fine art market can make money for many photographers. However, unlike commercial and editorial markets, galleries seldom generate quick income for artists. Galleries should be considered venues for important, thought-provoking imagery, rather than markets through which you can make a substantial living.

More than any other market, this area is filled with photographers who are interested in delivering a message. Many photography exhibits focus on one theme by a single artist. Group exhibits feature the work of several artists, and they often explore a theme from many perspectives, though not always. These group exhibits may be juried (i.e., the photographs in the exhibit are selected by a committee of judges who are knowledgeable about photography). Some group exhibits also may include other mediums such as painting, drawing or sculpture. In any case, galleries want artists who can excite viewers and make them think about important subjects. They, of course, also hope that viewers will buy the photographs shown in their galleries.

As with picture buyers and art directors, gallery directors love to see strong, well-organized portfolios. Limit your portfolio to 20 top-notch images. When putting together your portfolio, focus on one overriding theme. A director wants to be certain you have enough quality work to carry an entire show. After the portfolio review, if the director likes your style, then you might discuss future projects or past work that you've done. Directors who see promise in your work, but don't think you're ready for a solo exhibition, may place your photographs in a group exhibition.

HOW GALLERIES OPERATE

In exchange for brokering images, a gallery often receives a commission of 40-50 percent. They usually exhibit work for a month, sometimes longer, and hold openings to kick off new shows. And they frequently provide pre-exhibition

publicity. Some smaller galleries require exhibiting photographers to help with opening night reception expenses. Galleries also may require photographers to appear during the show or opening. Be certain that such policies are put in writing before you allow them to show your work.

Gallery directors who foresee a bright future for you might want exclusive rights to represent your work. This type of arrangement forces buyers to get your images directly from the gallery that represents you. Such contracts are quite common, usually limiting the exclusive rights to specified distances. For example, a gallery in Tulsa, Oklahoma, may have exclusive rights to distribute your work within a 200-mile radius of the gallery. This would allow you to sign similar contracts with galleries outside the 200-mile range.

FIND THE RIGHT FIT

As you search for the perfect gallery, it's important to understand the different types of exhibition spaces and how they operate. The route you choose depends on your needs, the type of work you do, your long-term goals, and the audience you're trying to reach. (The following descriptions were provided by the editor of *Artist's & Graphic Designer's Market*.)

- **Retail or commercial galleries.** The goal of the retail gallery is to sell and promote artists while turning a profit. Retail galleries take a commission of 40-50 percent of all sales.
- **Co-op galleries.** Co-ops exist to sell and promote artists' work, but they are run by artists. Members exhibit their own work in exchange for a fee, which covers the gallery's overhead. Some co-ops also take a commission of 20-30 percent to cover expenses. Members share the responsibilities of gallery-sitting, sales, housekeeping and maintenance.
- **Rental galleries.** The rental gallery makes its profit primarily through renting space to artists and consequently may not take a commission on sales (or will take only a very small commission). Some rental spaces provide publicity for artists, while others do not. Showing in this type of gallery is risky. Rental galleries are sometimes thought of as "vanity galleries" and, consequently, they do not have the credibility other galleries enjoy.
- **Nonprofit galleries.** Nonprofit spaces will provide you with an opportunity to sell work and gain publicity, but will not market your work aggressively, because their goals are not necessarily sales-oriented. Nonprofits normally take a commission of 20-30 percent.
- **Museums.** Don't approach museums unless you have already exhibited in galleries. The work in museums is by established artists and is usually donated by collectors or purchased through art dealers.
- **Art consultancies.** Generally, art consultants act as liaisons between fine artists and buyers. Most take a commission on sales (as would a gallery). Some maintain small gallery spaces and show work to clients by appointment.

If you've never exhibited your work in a traditional gallery space before, you may want to start with a less traditional kind of show. Alternative spaces are becoming a viable

way to help the public see your work. Try bookstores (even large chains), restaurants, coffee shops, upscale home furnishings stores and boutiques. The art will help give their business a more pleasant, interesting environment at no cost to them, and you may generate a few fans or even a few sales.

Think carefully about what you take pictures of and what kinds of businesses might benefit from displaying them. If you shoot flowers and other plant life, perhaps you could approach a nursery about hanging your work in their sales office. If you shoot landscapes of exotic locations, maybe a travel agent would like to take you on. Think creatively and don't be afraid to approach a business person with a proposal. Just make sure the final agreement is spelled out in writing so there will be no misunderstandings, especially about who gets what money from sales.

COMPOSING AN ARTIST'S STATEMENT

When you approach a gallery about a solo exhibition, they will usually expect your body of work to be organized around a theme. To present your work and its theme to the public, the gallery will expect you to write an artist's statement, a brief essay about how and why you make photographic images. There are several things to keep in mind when writing your statement: Be brief. Most statements should be 100-300 words long. You shouldn't try to tell your life's story leading up to this moment. Write as you speak. There is no reason to make up complicated motivations for your work if there aren't any. Just be honest about why you shoot the way you do. Stay focused. Limit your thoughts to those that deal directly with the specific exhibit for which you're preparing.

Before you start writing your statement, consider your answers to the following questions: Why do you make photographs (as opposed to using some other medium)? What are your photographs about? What are the subjects in your photographs? What are you trying to communicate through your work?

ADDISON/RIPLEY FINE ART

1670 Wisconsin Ave. NW, Washington DC 20007. (202)338-5180. Fax: (202)338-2341. E-mail: addisonrip@aol.com. Website: www.addisonripleyfineart.com. **Contact:** Christopher Addison, owner. Art consultancy, for-profit gallery. Estab. 1981. Approached by 100 artists/year; represents or exhibits 25 artists. Average display time 6 weeks. Gallery open Tuesday through Saturday from 11 to 6. Closed end of summer. Located in Georgetown in a large, open, light-filled gallery space. Overall price range $500-80,000. Most work sold at $2,500-10,000.

Exhibits Exhibits works of all media.

Making Contact & Terms Gallery provides insurance, promotion, contract. Accepted work should be framed, mounted, matted.

Submissions Mail portfolio for review. Send query letter with artist's statement, bio, photocopies, résumé, SASE. Responds in 1 month.

Tips "Submit organized, professional-looking materials."

ADIRONDACK LAKES CENTER FOR THE ARTS

Route. 28, Blue Mountain Lake NY 12812. (518)352-7715 or (877)752-7715. Fax: (518)352-7333. E-mail: info@adirondackarts.org. Website: www.adirondackarts.org. **Contact:** P. Eaton Siers, executive director. Estab. 1967. "ALCA is a 501c, nonprofit organization showing national and international work of emerging to established artists. A tourist and second-home market, demographics profile our client as highly educated, moderately affluent, environmentally oriented and well-travelled. The busy season is June through September." Sponsors 15-20 exhibits/year. Average display time 1 month. Overall price range $100-2,000. Most work sold at $250.

Exhibits Solo, group, and call for entry exhibits of color and black & white work.

Making Contact & Terms Consignment gallery, fee structure on request. Payment for sales follows within 30 days of close of exhibit. White mat and black frame required, except under prior agreement. ALCA pays return shipping only or cover work in transit.

Submissions Apply by CD or slides, resume and bio. Must include an SASE for return of materials. Upon acceptance notification, price sheet and artist statement required.

Tips "ALCA offers a residency program, maintains a fully-equipped darkroom with 24 hour access."

⊘ AKRON ART MUSEUM

One S. High St., Akron OH 44308. (330)376-9185. Fax: (330)376-1180. E-mail: mail@akronartmuseum.org. Website: www.akronartmuseum.org. **Contact:** Barbara Tannenbaum, director of Curatorial Affairs. The Akron Art Museum re-opened in July 2007 after expanding into a new, larger building.

• This museum annually awards the Knight Purchase Award to a living artist working with photographic media.

Exhibits To exhibit, photographers must possess "a notable record of exhibitions, inclusion in publications, and/or a role in the historical development of photography. We also feature area photographers (northeast Ohio)." Interested in innovative works by contemporary photographers; any subject matter. Interested in alternative process, documentary, fine art, historical/vintage.

Making Contact & Terms Payment negotiable. Buys photography outright.

Submissions Will review websites and CDs. Send material via e-mail or by mail with SASE if you want materials returned. Responds in 2 months, "depending on our workload."

Tips "Send professional-looking materials with high-quality images, a résumé and an artist's statement. Never send original prints."

ALASKA STATE MUSEUM

395 Whittier St., Juneau AK 99801-1718. (907)465-2901. Fax: (907)465-2976. E-mail: bruce_kato@eed.state.ak.us. Website: www.museums.state.ak.us. **Contact:** Bruce Kato, chief curator. Museum. Estab. 1900. Approached by 40 artists/year. Sponsors 1 photography exhibit every 2 years. Average display time 10 weeks. Downtown location—3 galleries.

Exhibits Interested in historical and fine art.

Submissions Finds artists through portfolio reviews.

THE ALBUQUERQUE MUSEUM OF ART & HISTORY

2000 Mountain Rd. NW, Albuquerque NM 87104. (505)243-7255. Fax: (505)764-6546. Website: www.cabq.gov/museum. **Contact**: Andrew Connors, curator of art or Glenn Fye, photo archivist. Estab. 1967. Sponsors 7-10 exhibits/year. Average display time 3-4 months. Gallery open Tuesday through Sunday from 9 to 5. Closed Monday and city holidays.

Exhibits Considers art, historical and documentary photography for exhibition and purchase. Art related to Albuquerque, the state of New Mexico, and the Southwest.

Submissions Submit portfolio of slides, photos, or disk for review. Responds in 2 months.

AMERICAN PRINT ALLIANCE

302 Larkspur Turn, Peachtree City GA 30269-2210. E-mail: director@printalliance.org. Website: www.printalliance.org. **Contact:** Carol Pulin, director. Nonprofit arts organization with online gallery and exhibitions, travelling exhibitions, and journal publication; Print Bin: a place on website that is like the unframed, shrink-wrapped prints in a bricks-and-mortar gallery's "print bin." Estab. 1992. Approached by hundreds of artists/year; represents dozens of artists/year. "We only exhibit original prints, artists' books and paperworks." Usually sponsors 2 travelling exhibits/year—all prints, paperworks and artists' books; photography within printmaking processes but not as a separate medium. Most exhibits travel for 2 years. Hours depend on the host gallery/museum/arts center. "We travel exhibits throughout the U.S. and occasionally to Canada." Overall price range for Print Bin: $150-3,200; most work sold at $300-500.

Exhibits "We accept all styles, genres and subjects; the decisions are made on quality of work."

Making Contact & Terms Individual subscription: $32-39. Print Bin is free with subscription. "Subscribers have free entry to juried travelling exhibitions but must pay for framing, shipping to and from our office." Gallery provides promotion.

Submissions Subscribe to journal, *Contemporary Impressions* (www.printalliance.org/alliance/al_subform.html), send one slide and signed permission form (www.printalliance.org/gallery/printbin_info.html). Returns slide if requested with SASE. Usually does not respond to queries from non-subscribers. Files slides and permission forms. Finds artists through submissions to the gallery or Print Bin, and especially portfolio reviews at

printmakers conferences. "Unfortunately, we don't have the staff for individual portfolio reviews, though we may—and often do—request additional images after seeing one work, often for journal articles. Generally about 100 images are reproduced per year in the journal."

Tips "See the Standard Forms area of our website (www.printalliance.org/library/li_forms. html) for correct labels on slides and much, much more about professional presentation."

AMERICAN SOCIETY OF ARTISTS, INC.

P.O. Box 1326, Palatine IL 60078. (847)991-4748 or (312)751-2500. E-mail: asoa@webtv. net. Website: www.americansocietyofartists.org. **Contact:** Helen Del Valle, membership chairman.

Exhibits Members and nonmembers may exhibit. "Our members range from internationally known artists to unknown artists—quality of work is the important factor. We have about 25 shows throughout the year that accept photographic art."

Making Contact & Terms Accepted work should be framed, mounted or matted.

Submissions Send SASE and 4 slides/photos representative of your work, and request membership information and application. See our website for on-line jury. Responds in 2 weeks. Accepted members may participate in lecture and demonstration service. Member publication: *ASA Artisan*.

A.R.C. GALLERY

832 W. Superior St., #204., Chicago IL 60622. (312)733-2787. E-mail: arcgallery@yahoo. com. Website: www.arcgallery.org. **Contact:** Iris Goldstein, president. Estab. 1973. Sponsors 5-8 exhibits/year. Average display time 1 month. Overall price range $100-1,200.

Exhibits All styles considered. Contemporary fine art photography, documentary and journalism.

Making Contact & Terms Charges no commission, but there is a space rental fee.

Submissions Must send slides, résumé and statement to gallery for review; include SASE. Reviews transparencies. Responds in 1 month.

Tips Photographers "should have a consistent body of work. Show emerging and experimental work."

ARNOLD ART

210 Thames St., Newport RI 02840. E-mail: info@arnoldart.com. Website: www.arnoldart. com. **Contact:** William Rommel, owner. For-profit gallery. Estab. 1870. Represents or exhibits 40 artists. Average display time 1 month. Gallery open Monday through Saturday from 9:30 to 5:30; Sunday from 12 to 5. Closed Christmas, Thanksgiving, Easter. Art gallery is 17 ft × 50 ft., open gallery space (3rd floor). Overall price range $100-35,000. Most work sold at $300.

Exhibits Marine (sailing), classic yachts, America's Cup, wooden boats, sailing/racing.

Making Contact & Terms Artwork is accepted on consignment, and there is a 45% commission. Gallery provides promotion. Accepted work should be framed.

Submissions E-mail to arrange personal interview to show portfolio.

⊠ THE ARSENAL GALLERY

The Arsenal Bldg., 5th Avenue at 64th Street in Central Park, New York NY 10021. (212)360-8163. Fax: (212)360-1329. E-mail: patricia.hamilton@parks.nyc.gov. Website: www.nyc.gov/Parks. **Contact:** Clare Weiss, curator, Public Art Programs. Nonprofit gallery. Estab. 1981. Approached by 100 artists/year; 8-10 exhibits/year. Sponsors 2-3 photography exhibits/year. Average display time 4-6 weeks. Gallery open Monday through Friday from 9 to 5. Closed weekends and holidays. Has 100 linear feet of wall space on the 3rd floor of the Administrative Headquarters of the Parks Department located in Central Park. Overall price range $100-5,000.

Exhibits Exhibits photos of environmental, landscapes/scenics, wildlife, architecture, cities/urban, adventure, NYC parks. Interested in alternative process, avant garde, documentary, fine art, historical/vintage.

Making Contact & Terms Artwork is accepted on consignment, and there is a 15% commission. Gallery provides promotion.

Submissions Mail portfolio for review. Send query letter with artist's statement, bio, brochure, business card, photocopies, resume, reviews, SASE. Responds within 6 months, only if interested. Artist should call. Finds artists through word of mouth, portfolio reviews, art exhibits, referrals by other artists.

Tips "Appear organized and professional."

⊕ ▣ ART@NET INTERNATIONAL GALLERY

(617)495-7451 or (359)898-448132. Fax: (359)(2)851-2838. E-mail: artnetg@yahoo.com. Website: www.designbg.com. **Contact:** Yavor Shopov, director. For-profit Internet gallery. Estab. 1998. Approached by 100 artists/year; represents or exhibits 20 artists. Sponsors 5 photography exhibits/year. Display time permanent. "Our gallery exists only on the Internet. Each artist has individual 'exhibition space' divided into separate thematic exhibitions along with bio and statement." Overall price range $150-55,000.

Exhibits Exhibits photos of multicultural, landscapes/scenics, wildlife, architecture, cities/urban, education, adventure, beauty, sports, travel, science, buildings. Interested in avant garde, erotic, fashion/glamour, fine art, seasonal.

Making Contact & Terms Artwork is accepted on consignment; there is a 10% commission and a rental fee for space of $1/image per month or $5/image per year. First 6 images are displayed free of rental fee. Gallery provides promotion. Accepted work should be matted.

Submissions "We accept computer scans only; no slides, please. E-mail us attached scans, 900 × 1200 px (300 dpi for prints or 900 dpi for 36mm slides), as JPEG files for IBM computers." E-mail query letter with artist's statement, bio, résumé. Responds in 6 weeks. Finds artists through submissions, portfolio reviews, art exhibits, art fairs, referrals by other artists.

Tips "E-mail us a tightly edited selection of less than 20 scans of your best work. All work must force any person to look over it again and again. Main usage of all works exhibited in our gallery is for limited edition (photos) or original (paintings) wall decoration of offices and homes, so photos must have quality of paintings. We like to see strong artistic sense of mood, composition, light, color and strong graphic impact or expression of emotions. For us, only quality of work is important, so newer, lesser-known artists are welcome."

ARTEFACT/ROBERT PARDO GALLERY

121 E. 31st St., PH12C, New York NY 10016. (917)256-1282. Fax: (646)935-0009. Email: robertpardogallery@yahoo.com. Website: www.robertpardogallery.com. **Contact**: Dr. Giovanna Federico. For-profit gallery. Estab. 1986. Approached by 500 artists/year; represents or exhibits 18 artists. Sponsors 3 photography exhibits/year. Average display time 4-5 weeks. Gallery open Tuesday through Saturday from 10 to 6. Closed August.

Exhibits Interested in avant garde, fashion/glamour, fine art.

Submissions Arrange personal interview to show portfolio of slides, transparencies. Responds in 1 month.

ARTISTS' COOPERATIVE GALLERY

405 S. 11th St., Omaha NE 68102. (402)342-9617. Website: www.artistsco-opgallery.com. Estab. 1974. Sponsors 11 exhibits/year. Average display time 1 month. Gallery sponsors all-member exhibits and outreach exhibits; individual artists sponsor their own small group exhibits throughout the year. Overall price range $100-500.

Exhibits Fine art photography only. Interested in all types, styles and subject matter.

Making Contact & Terms Charges no commission. Reviews transparencies. Accepted work should be framed work only. "Artist must be willing to work 13 days per year at the gallery. We are a member-owned-and-operated cooperative. Artist must also serve on one committee."

Submissions Send query letter with résumé, SASE. Responds in 2 months.

Tips "Write for membership application. Membership committee screens applicants August 1-15 each year. Responds by September 1. New membership year begins October 1. Members must pay annual fee of $325. Our community outreach exhibits include local high school photographers and art from local elementary schools."

ARTLINK

437 E. Berry St., Suite 202, Fort Wayne IN 46802. (260)424-7195. Fax: (260)424-8453. E-mail: deb@artlinkfw.com. Website: www.artlinkfw.com. **Contact:** Deb Washler, executive director. Nonprofit gallery. Estab. 1978. Sponsors 1 photography exhibit every other year. Average display time 6 weeks. Gallery open Tuesday through Thursday from 12 to 5; Friday and Saturday 12 to 9; Sundays from 1 to 5. Located in downtown Fort Wayne. Overall price range $100-2,000. Most work sold at $250.

Making Contact & Terms Artwork of Artlink members is accepted on consignment, and there is a 35% commission. Gallery provides insurance. Accepted work should be framed.

Submissions "Please visit the Artlink website for current call for entry, www.artlinkfw.com."

◼ THE ARTS COMPANY

215 5th Ave., Nashville TN 37219. (615)254-2040. Fax: (615)254-9289. E-mail: art@theartscompany.com. Website: www.theartscompany.com. **Contact:** Anne Brown, owner. Art consultancy, for-profit gallery. Estab. 1996. Sponsors 6-10 photography exhibits/year. Average display time 1 month. Open Tuesday through Saturday from 10 to 5. Located in downtown Nashville, the gallery has 6,000 sq. ft. of contemporary space in a historic building. Overall price range $10-35,000. Most work sold at $300-3,000.

Exhibits Exhibits photos of celebrities, architecture, cities/urban, rural, environmental, landscapes/scenics, entertainment, performing arts. Interested in documentary, fine art, historical/vintage.

Making Contact & Terms Artwork is accepted on consignment. Gallery provides insurance, contract. Accepted work should be framed. Requires exclusive representation locally.

Submissions "We prefer an initial info packet via e-mail." Send query letter with artist's statement, bio, brochure, business card, photocopies, résumé, reviews, SASE, CD. Returns material with SASE. Finds artists through word of mouth, art fairs, art exhibits, submissions, referrals by other artists.

Tips "Provide professional images on a CD along with a professional bio, résumé.

N ARTS IOWA CITY

103 E. College St., Iowa City IA 52240. (319)337-7447. E-mail: gallery@artsiowacity.com. Website: www.artsiowacity.com. **Contact:** Richard Sjolund, president. Nonprofit gallery. Estab. 1975. Approached by more than 65 artists/year; represents or exhibits more than 30 artists. Average display time 1 month. Mail gallery open limited hours. Several locations open during business hours satellite galleries at Starbucks Downtown, US Bank, Melrose Meadows, and Englert. Overall price range: $200-6,000. Most work sold at $500.

Exhibits Exhibits photos of landscapes/scenics, architecture, cities/urban, rural. Interested in fine art.

Making Contact & Terms Artwork is accepted on consignment, and there is a 10% commission. Gallery provides insurance (in gallery, not during transit to/from gallery), promotion and contract. Accepted work should be framed, mounted and matted. "We represent artists who are members of Arts Iowa City; to be a member, one must pay a membership fee. Most members are from Iowa and surrounding states."

Submissions Call or write to arrange personal interview to show portfolio of photographs, slides and transparencies. Send query letter with artist's statement, bio, brochure, business card, photographs, résumé, reviews, slides and SASE. Responds to queries in 1 month. Finds artists through referrals by other artists, submissions and word of mouth.

Tips "We are a nonprofit gallery with limited staff. Most work is done by volunteers. Artists interested in submitting work should visit our website to gain a better understanding of the services we provide and to obtain membership and show proposal information. Please submit applications according to the guidelines on the website."

ARTS ON DOUGLAS

123 Douglas St., New Smyrna Beach FL 32168. (386)428-1133. Fax: (386)428-5008. E-mail: mail@artsondouglas.net. Website: www.artsondouglas.net. **Contact:** Meghan Martin, gallery manager. For-profit gallery. Estab. 1996. Represents 60 Florida artists in ongoing group exhibits and features 8 artists/year in solo exhibitions. Average display time 1 month. Gallery open Tuesday through Friday from 11 to 6; Saturday from 10 to 2; by appointment. Location has 5,000 sq. ft. of exhibition space. Overall price range varies.

Exhibits Exhibits photos of environmental. Interested in alternative process, documentary, fine art.

Making Contact & Terms Artwork is accepted on consignment, and there is a 50% commission. Gallery provides insurance, promotion. Accepted work should be framed.

Requires exclusive representation locally. *Accepts only professional artists from Florida.*
Submissions Call in advance to inquire about submissions/reviews. Send query letter with
artist's statement, bio, brochure, résumé, reviews, slides, SASE. Finds artists through
referrals by other artists.

ART SOURCE L.A., INC.

West Coast office: 2801 Ocean Park Blvd., #7, Santa Monica CA 90405. (310)452-4411.
Fax: (310)452-0300. E-mail: info@artsourcela.com. Website: www.artsourcela.com. East
Coast office: 12001 Montrose Park Place, North Bethesda MD 20852. (301)230-0023. Fax:
(301)230-0025. E-mail: bonniek@artsourcela.com. **Contact:** Francine Ellman, president.
Estab. 1980. Overall price range $300-15,000. Most work sold at $600.
Exhibits Exhibits photos of multicultural, environmental, landscapes/scenics, wildlife,
architecture, cities/urban, gardening, interiors/decorating, rural, automobiles, food/
drink, travel, technology/computers. Interested in alternative process, avant garde, fine
art, historical/vintage, seasonal. "We do projects worldwide, putting together fine art
for corporations, healthcare, hospitality, government and public space. We use a lot of
photography."
Making Contact & Terms Interested in receiving work from emerging and established
photographers. Charges 50% commission.
Submissions Prefers digital submissions via e-mail. Send a minimum of 20 JPEGS,
photographs or inkjet prints (laser copies not acceptable), clearly labeled with name, title
and date of work; plus catalogs, brochures, résumé, price list, SASE. Responds in 2 months
maximum.
Tips "Show a consistent body of work, well marked and presented so it may be viewed to
see its merits."

ART WITHOUT WALLS, INC.

P.O. Box 341, Sayville NY 11782. (631)567-9418. Fax: (631)567-9418. E-mail: artwithoutwalls@
webtv.net. **Contact:** Sharon Lippman, executive director. Nonprofit gallery. Estab. 1985.
Approached by 300 artists/year; represents or exhibits 100 artists. Sponsors 3 photography
exhibits/year. Average display time 1 month. Gallery open daily from 9 to 5. Closed December
22 to January 5 and Easter week. Traveling exhibits in various public spaces. Overall price
range $1,000-25,000. Most work sold at $3,000-5,000. "Price varies—especially if student
work."
Exhibits Exhibits photos of multicultural, families, parents, senior citizens, disasters,
environmental, landscapes/scenics, wildlife, architecture, cities/urban, education, rural,
adventure, events, food/drink, health, performing arts, sports, travel, agriculture, medicine,
political, product shots/still life, science, technology/computers. Interested in alternative
process, avant garde, documentary, fashion, fine art, historical/vintage, seasonal.
Making Contact & Terms Artwork is accepted on consignment, and there is a 20% commission.
Gallery provides promotion, contract. Accepted work should be framed, mounted, matted.
Submissions Mail portfolio for review. Send query letter with artist's statement, brochure,
photographs, résumé, reviews, SASE, slides. Responds in 1 month. Finds artists through
submissions, portfolio reviews, art exhibits.
Tips "Work should be properly framed with name, year, medium, title, size."

⊡ ARTWORKS GALLERY

811 Race St., Cincinnati OH 45202. (513)333-0388. Fax: (513)333-0799. E-mail: allen@ artworkscincinnati.com. Website: www.artworkscincinnati.org. **Contact:** Allen Cochran, gallery coordinator. Alternative space, cooperative gallery, nonprofit gallery, rental gallery. Estab. 2003. Average display time 1.5 months. Open Monday through Friday from 9 to 5. Closed January. Has 1,500 sq. ft of exhibition space in downtown Cincinnati. Overall price range $200-15,000. Most work sold at $1,200.

Exhibits Exhibits photos of multicultural, architecture, cities/urban, education, gardening, interiors/decorating, rural, environmental, adventure, performing arts. Interested in alternative process, avant garde, documentary, fashion/glamour, fine art, lifestyle.

Making Contact & Terms Artwork is accepted on consignment, and there is a 30% commission. Gallery provides promotion, contract.

Submissions Call; send images via e-mail; mail portfolio for review; send query letter with résumé, slides, artist's statement, digital slides. Send nonreturnable samples. "We hold on to materials for future exhibition opportunities." Responds to queries in 1 month. Finds artists through word of mouth, art fairs, portfolio reviews, exhibitions, submissions, referrals by other artists.

Tips "ArtWorks is looking for strong artists who are not only talented in terms of their ability to make and create, but who can also professionally present themselves and show a genuine interest in the exhibition of their artwork. We're looking for concise statements that the artists themselves have written about their work as well as a résumé of exhibitions to help back up their written statements. Artists should continue to communicate with us beyond exhibitions and further down the line just to let us know what they're up to and how they've grown."

ASIAN AMERICAN ARTS CENTRE

26 Bowery, 3rd Floor, New York NY 10013. (917)923-8118. E-mail: aaacinfo@artspiral.org. Website: www.artspiral.org. **Contact:** Robert Lee, director. Estab. 1974. Average display time 6 weeks.

Exhibits Should be Asian American or significantly influenced by Asian culture and should be entered into the archive—a historical record of the presence of Asia in the US. Interested in "creative art pieces."

Making Contact & Terms Requests 30% "donation" on works sold. Sometimes buys photos outright.

Submissions To be considered, send dupes of slides, résumé, artist's statement, bio and online form to be entered into the archive. These will be kept for users of archive to review. Recent entries are reviewed once/year for the Art Centre's annual exhibition.

ATLANTIC GALLERY

135 W. 29th, Suite 601, New York NY 10001. (212)219-3183. Website: www.atlanticgallery. org. Cooperative gallery. Estab. 1974. Approached by 50 artists/year; represents or exhibits 40 artists. Average display time 3 weeks. Gallery open Tuesday through Saturday from 12 to 6. Closed August. Located in Soho. Overall price range $100-13,000. Most work sold at $1,500-5,000.

Exhibits Exhibits photos of multicultural, families, environmental, landscapes/scenics, wildlife, architecture, cities/urban, rural, performing arts, travel, product shots/still life, technology/computers. Interested in fine art.

Making Contact & Terms There is a co-op membership fee plus a donation of time. Accepts mostly artists from New York, Connecticut, Massachusetts, New Jersey.

Submissions Call or write to arrange a personal interview to show portfolio of slides. Send artist's statement, bio, brochure, SASE, slides. Responds in 1 month. Views slides monthly. Finds artists through word of mouth, submissions, art exhibits, referrals by other artists.

Tips "Submit an organized folder with slides, bio, and 3 pieces of actual work. If we respond with interest, we then review again."

N ▢ AXIS GALLERY

(212)741-2582. E-mail: info@axisgallery.com. Website: www.axisgallery.com. **Contact:** Lisa Brittan, director. For-profit gallery. Estab. 1997. Approached by 40 African artists/year; represents or exhibits 30 artists. Hours during exhibitions: Friday 12-6 pm, Saturday 12-6 pm, Sunday 1-5 pm and by appointment. Closed during summer. Located in Williamsburg, 900 sq. ft. Overall price range $500-6,000.

Exhibits Interested in alternative process, avant garde, documentary, erotic, fine art, historical/vintage. Also interested in photojournalism, resistance.

Making Contact & Terms Artwork is accepted on consignment, and there is a 50% commission. Gallery provides insurance, promotion, contract. *Accepts only artists from Africa.*

Submissions Send query letter with résumé, reviews, SASE, slides, photographs or CD-ROM. Responds in 3 months. Finds artists through research, recommendations, submissions, portfolio reviews, art exhibits, referrals by other artists.

Tips "Send letter with SASE and materials listed above. Photographers should research galleries first to check if their work fits the gallery program. Avoid bulk mailings."

N BARRON ARTS CENTER

582 Rahway Ave., Woodbridge NJ 07095. (732)634-0413. Fax: (732)634-8633. **Contact:** Cynthia A. Knight, director. Estab. 1975. Overall price range $150-400. Most work sold at $150.

Making Contact & Terms Charges 20% commission.

Submissions Reviews transparencies but prefers portfolio. Submit portfolio for review; include SASE for return. Responds "depending upon date of review, but generally within a month of receiving materials." COS of photos acceptable for review.

Tips "Make a professional presentation of work with all pieces matted or treated in a like manner. In terms of the market, we tend to hear that there are not enough galleries that will exhibit photography."

N BELIAN ART CENTER

5980 Rochester Rd., Troy MI 48085. (248)828-1001. Fax: (248)828-1905. E-mail: BelianArtCenter@aol.com. **Contact:** Zabel Belian, director. Estab. 1985. Sponsors 1-2 exhibits/year. Average display time 3 weeks. Sponsors openings. Average price range $200-2,000.

Exhibits Looks for originality, capturing the intended mood, perfect copy, mostly original editions. Subjects include landscapes, cities, rural, events, agriculture, buildings, still life.
Making Contact & Terms Charges 40-50% commission. Buys photos outright. Reviews transparencies. Requires exclusive representation locally. Arrange a personal interview to show portfolio. Send query letter with résumé and SASE. Responds in 2 weeks.

BELL STUDIO

3428 N. Southport Ave., Chicago IL 60657. (773)281-2172. Fax: (773)281-2415. E-mail: paul@bellstudio.net. Website: www.bellstudio.net. **Contact:** Paul Therieau, director. For-profit gallery. Estab. 2001. Approached by 60 artists/year; represents or exhibits 10 artists. Sponsors 3 photography exhibits/year. Average display time 6 weeks. Open all year; Monday through Friday from 12 to 7; weekends from 12 to 5. Located in brick storefront; 750 sq. ft. of exhibition space; high traffic. Overall price range: $150-3,500. Most work sold at $600.
Exhibits Interested in alternative process, avant garde, fine art.
Making Contact & Terms Artwork is accepted on consignment, and there is a 50% commission. Gallery provides insurance, promotion, contract. Accepted work should be framed. Requires exclusive representation locally.
Submissions Write to arrange personal interview to show portfolio; include bio and résumé. Responds to queries within 3 months, only if interested. Finds artists through referrals by other artists, submissions, word of mouth.
Tips "Send SASE; type submission letter; include show history, résumé."

BENNETT GALLERIES AND COMPANY

5308 Kingston Pike, Knoxville TN 37919. (865)584-6791. Fax: (865)588-6130. E-mail: info@bennettgalleries.com. Website: www.bennettgalleries.com. **Contact:** Marga Ingram, gallery director. For-profit gallery. Estab. 1985. Represents or exhibits 40 artists/year. Sponsors 1-2 photography exhibits/year. Average display time 1 month. Gallery open Monday through Saturday from 10 to 5:30. Conveniently located a few miles from downtown Knoxville in the Bearden area. The formal art gallery has over 2,000 sq. ft. and 20,000 sq. ft. of additional space. Overall price range $100-12,000. Most work sold at $400-600.
Exhibits Exhibits photos of landscapes/scenics, architecture, cities/urban, humor, sports, travel. Interested in alternative process, fine art, historical/vintage.
Making Contact & Terms Artwork is accepted on consignment, and there is a 50% commission. Gallery provides insurance, promotion, contract. Accepted work should be framed. Requires exclusive representation locally.
Submissions Mail portfolio for review. Send query letter with artist's statement, bio, photographs, SASE, CD. Responds within 1 month, only if interested. Finds artists through word of mouth, submissions, art exhibits, referrals by other artists.
Tips "When submitting material to a gallery for review, the package should include information about the artist (neatly written or typed), photographic material, and SASE if you want your materials back."

BONNI BENRUBI GALLERY

41 E. 57th St. #13, New York NY 10022-1908. (212)888-6007. Fax: (212)751-0819. E-mail:

benrubi@bonnibenrubi.com. Website: www.bonnibenrubi.com. **Contact:** Thom Vogel, director. Estab. 1987. Sponsors 7-8 exhibits/year. Average display time 6 weeks. Overall price range $500-50,000.

Exhibits Interested in 19th- and 20th-century photography, mainly contemporary.

Making Contact & Terms Charges commission. Buys photos outright. Accepted work should be matted. Requires exclusive representation locally. No manipulated work.

Submissions Submit portfolio for review; include SASE. Responds in 2 weeks. "Portfolio review is the first Thursday of every month. Out-of-towners can send slides with SASE, and work will be returned."

BERKSHIRE ARTISANS GALLERY

Lichtenstein Center for the Arts, 28 Renne Ave., Pittsfield MA 01201. (413)499-9348. Fax: (413)442-8043. E-mail: mwhilden@pittsfieldch.com. Website: www.pittsfield.com/artsculture.asp. **Contact:** Megan Whilden, artistic director. Estab. 1975. Sponsors 10 exhibits/year. Open Wednesday through Saturday from 12 to 5. Overall price range $50-1,500.

Making Contact & Terms Charges 20% commission. Will review transparencies of photographic work. Accepted work should be framed, mounted, matted.

Submissions "Photographer should send SASE with 20 slides or prints, résumé and statement by mail only to gallery."

Tips To break in, "Send portfolio, slides and SASE. We accept all art photography. Work must be professionally presented and framed. Send in by July 1 each year. Expect exhibition 2-3 years from submission date. We have a professional juror look at slide entries once a year (usually July-September). Expect that work to be tied up for 2-3 months in jury."

☐ MONA BERMAN FINE ARTS

78 Lyon St., New Haven CT 06511. (203)562-4720. E-mail: info@MonaBermanFineArts.com. Website: www.MonaBermanFineArts.com. **Contact:** Mona Berman, director. Estab. 1979. Sponsors 0-1 exhibit/year. Average display time 1 month. Overall price range $500-5,000.

- "We are art consultants serving corporations, architects and designers. We also have private clients. We hold very few exhibits; we mainly show work to our clients for consideration and sell a lot of photographs."

Exhibits "Photographers must have been represented by us for over 2 years. Interested in all except figurative, although we do use some portrait work."

Making Contact & Terms Charges 50% commission. "Payment to artist 30 days after receipt of payment from client." Interested in seeing unframed, unmounted, unmatted work only.

Submissions "E-mail digital images or Web links, or send CDs. Inquire by e-mail; no calls, please. Always include retail prices." Materials returned with SASE only. Responds in 1 month.

Tips "Looking for new perspectives, new images, new ideas, excellent print quality, ability to print in *very* large sizes, consistency of vision. Digital prints must be archival. Not interested in Giclee prints."

BLOUNT-BRIDGERS HOUSE/HOBSON PITTMAN MEMORIAL GALLERY

130 Bridgers St., Tarboro NC 27886. (252)823-4159. Fax: (252)823-6190. E-mail:

edgecombearts@embarqmail.com. Website: www.edgecombearts.org. Museum. Estab. 1982. Approached by 1-2 artists/year; represents or exhibits 6 artists. Sponsors 1 photography exhibit/year. Average display time 6 weeks. Gallery open Monday through Friday from 10 to 4; weekends from 2 to 4. Closed major holidays, Christmas-New Year. Located in historic house in residential area of small town. Gallery is approximately 48 ft. × 20 ft. Overall price range $250-5,000. Most work sold at $500.

Exhibits Exhibits photos of landscapes/scenics, wildlife. Interested in fine art, historical/vintage.

Making Contact & Terms Artwork is accepted on consignment, and there is a 30% commission. Gallery provides insurance, limited promotion. Accepted work should be framed. Accepts artists from the Southeast and Pennsylvania.

Submissions Mail portfolio review. Send query letter with artist's statement, bio, SASE, slides. Responds in 3 months. Finds artists through word of mouth, submissions, art exhibits, referrals by other artists.

BOOK BEAT GALLERY

26010 Greenfield, Oak Park MI 48237. (248)968-1190. Fax: (248)968-3102. E-mail: cary@thebookbeat.com. Website: www.thebookbeat.com. **Contact:** Cary Loren, director. Estab. 1982. Sponsors 6 exhibits/year. Average display time 6-8 weeks. Overall price range $300-5,000. Most work sold at $600.

Exhibits "Book Beat is a bookstore specializing in fine art and photography. We have a backroom gallery devoted to photography and folk art. Our inventory includes vintage work from 19th- to 20th-century, rare books, issues of *Camerawork*, and artist books. Book Beat Gallery is looking for courageous and astonishing image makers, high quality digital work is acceptable. Artists are welcome to submit a handwritten or typed proposal for an exhibition, include artist bio, statement, and Web site, book or CD with sample images. We are especially interested in photographers who have published book works or work with originals in the book format, also those who work in 'dead media' and extinct processes."

Submissions Responds in 6 weeks.

RENA BRANSTEN GALLERY

77 Geary St., San Francisco CA 94108. (415)982-3292. Fax: (415)982-1807. E-mail: info@renabranstengallery.com. Website: www.renabranstengallery.com. For-profit gallery. Estab. 1974. Approached by 200 artists/year; represents or exhibits 12-15 artists. Average display time 4-5 weeks. Open Tuesday through Friday from 10:30 to 5:30; Saturday from 11 to 5.

Submissions E-mail JPEG samples at 72 dpi. Finds artists through word of mouth, art exhibits, submissions, art fairs, portfolio reviews, referrals by other artists.

BUNNELL STREET GALLERY

106 W. Bunnell, Suite A, Homer AK 99603. (907)235-2662. Fax: (907)235-9427. E-mail: asia@bunnellstreetgallery.org. Website: www.bunnellstreetgallery.org. **Contact:** Asia Freeman, director. Nonprofit gallery. Estab. 1990. Approached by 50 artists/year; represents or exhibits 35 artists. Sponsors 1 photography exhibit/year. Average display time 1 month. Gallery open Monday through Saturday from 10 to 6; Sunday from 12 to 4, summer only. Closed January. Located in 30 ft. × 25 ft. exhibition space; good lighting, hardwood floors.

Overall price range $50-2,500. Most work sold at $500.

Exhibits Exhibits photos of families, gardening, food/drink. Interested in alternative process, fine art.

Making Contact & Terms Artwork is accepted on consignment, and there is a 40% commission. A donation of time is requested. Gallery provides insurance, promotion, contract. Accepted work should be framed.

Submissions Call or write to arrange a personal interview to show portfolio of slides. Mail portfolio for review. Responds in 1 month. Finds artists through word of mouth, submissions, art exhibits, referrals by other artists.

BUSINESS OF ART CENTER

513 Manitou Ave., Manitou Springs CO 80829. (719)685-1861. E-mail: mlafontaine@thebac. org. Website: www.thebac.org. **Contact**: Liz Szabo, gallery curator. Nonprofit gallery. Estab. 1988. Sponsors 6 photography exhibits/year. Average display time 1 month. Gallery open Tuesday through Saturday from 11 to 6 and Sunday 12-5. Overall price range $50-3,000. Most work sold at $300.

Exhibits Exhibits photos of environmental, landscapes/scenics, wildlife, gardening, rural, adventure, health/fitness, performing arts, travel. Interested in alternative process, avant garde, documentary, fashion/glamour, fine art.

Making Contact & Terms Artwork is accepted on consignment, and there is a 40% commission. Gallery provides insurance, promotion, contract. Accepted work should be framed.

Submissions Write to arrange a personal interview to show portfolio. Send query letter with artist's statement, bio, slides. Finds artists through word of mouth, submissions, portfolio reviews, art exhibits, referrals by other artists.

THE CAMERA OBSCURA GALLERY

1309 Bannock St., Denver CO 80204. (303)623-4059. Fax: (303)893-4195. E-mail: info@ CameraObscuraGallery.com. Website: www.CameraObscuraGallery.com. **Contact:** Hal Gould, owner/director. Estab. 1980. Approached by 350 artists/year; represents or exhibits 20 artists. Sponsors 7 photography exhibits/year. Open Tuesday through Saturday from 10 to 6; Sunday by appointment. Overall price range $400-20,000. Most work sold at $600-3,500.

Exhibits Exhibits photos of environmental, landscapes/scenics, wildlife. Interested in fine art.

Making Contact & Terms Charges 50% commission. Write to arrange a personal interview to show portfolio of photographs. Send bio, brochure, résumé, reviews. Finds artists by word of mouth, submissions, portfolio reviews, art exhibits, art fairs, referrals by other artists, reputation.

Tips "To make a professional gallery submission, provide a good representation of your finished work that is of exhibition quality. Slowly but surely we are experiencing a more sophisticated audience. The last few years have shown a tremendous increase in media reporting on photography-related events and personalities, exhibitions, artist profiles and market news."

▣ WILLIAM CAMPBELL CONTEMPORARY ART

4935 Byers Ave., Ft. Worth TX 76107. (817)737-9566. Fax: (817)737-5466. Website: www. williamcampbellcontemporaryart.com. **Contact:** William Campbell, owner/director. Estab. 1974. Sponsors 8-10 exhibits/year. Average display time 5 weeks. Sponsors openings; provides announcements, press releases, installation of work, insurance, cost of exhibition. Overall price range $300-8,000.

Exhibits "Primarily interested in photography which has been altered or manipulated in some form."

Making Contact & Terms Charges 50% commission. Reviews transparencies. Accepted work should be mounted. Requires exclusive representation within metropolitan area.

Submissions Send CD (preferred) or slides and résumé by mail with SASE. Responds in 1 month.

CAPITOL COMPLEX EXHIBITIONS

Florida Department of State, Division of Cultural Affairs, 500 S. Bronough St., R.A. Gray Bldg., 3rd Floor, Tallahassee FL 32399-0250. (850)245-6470. Fax: (850)245-6497. E-mail: bjsolomon@dos.state.fl.us. Website: www.florida-arts.org. **Contact:** Brannon Solomon. Average display time 3 months. Overall price range $200-1,000. Most work sold at $400.

Exhibits Exhibits photos of babies/children/teens, couples, multicultural, families, parents, senior citizens, landscapes/scenics, wildlife, architecture, cities/urban, gardening, adventure, entertainment, performing arts, agriculture. Interested in avant garde, fine art, historical/vintage. "The Capitol Complex Exhibitions Program is designed to showcase Florida artists and art organizations. Exhibitions are displayed in the Capitol Gallery (22nd floor) and the Cabinet Meeting Room in Florida's capitol. Exhibitions are selected based on quality, diversity of media, and regional representation."

Making Contact & Terms Does not charge commission. Accepted work should be framed. **Interested only in Florida artists or arts organizations.**

Submissions Download application from website, complete and send with image CD. Responds in 3 weeks.

CENTER FOR CREATIVE PHOTOGRAPHY

University of Arizona, 1030 N. Olive Rd., P.O. Box 210103, Tucson AZ 85721-0103. (520)621-7968. Fax: (520)621-9444. E-mail: oncenter@ccp.library.arizona.edu. Website: www.creativephotography.org. Museum/archive, research center, print study, library, museum retail shop. Estab. 1975. Sponsors 6-8 photography exhibits/year. Average display time 3-4 months. Gallery open Monday through Friday from 9 to 5; weekends from 12 to 5. Closed most holidays. 5,500 sq. ft.

⒩ ▣ ☒ CENTER FOR EXPLORATORY AND PERCEPTUAL ART

617 Main St., Suite 201, Buffalo NY 14203. (716)856-2717. Fax: (716)270-0184. E-mail: info@cepagallery.com. Website: www.cepagallery.org. **Contact:** Lawrence Brose, executive director. "CEPA is an artist-run space dedicated to presenting photographically based work that is under-represented in traditional cultural institutions." Estab. 1974. Sponsors 5-6 exhibits/year. Average display time 6 weeks. Call or see website for hours. Total gallery space is approximately 6,500 sq. ft. Overall price range $200-3,500.

- CEPA conducts an annual Emerging Artist Exhibition for its members. You must join the gallery in order to participate.

Exhibits Interested in political, digital, video, culturally diverse, contemporary and conceptual works. Extremely interested in exhibiting work of newer, lesser-known photographers.

Making Contact & Terms Sponsors openings; reception with lecture. Accepted work should be framed or unframed, mounted or unmounted, matted or unmatted.

Submissions Send query letter with artist's statement, résumé. Accepts images in digital format. Send via CD, Zip as TIFF, JPEG, PICT files. Include SASE for return of material. Responds in 3 months.

Tips "We review CD-ROM portfolios and encourage digital imagery. We will be showcasing work on our website." (See additional information in the CEPA Gallery listing in this section.)

▣ THE CENTER FOR FINE ART PHOTOGRAPHY

400 N. College Ave., Fort Collins CO 80524. (970)224-1010. E-mail: contact@c4fap.org. Website: www.c4fap.org. **Contact:** Hamidah Glasgow, executive director or Azarie Furlong, exhibitions manager. Nonprofit gallery. Estab. 2005. Approached by 4,500 artists/year; represents or exhibits about 500 artists. Average display time 4-5 weeks. Office open Tuesday through Friday from 10 to 5; Saturday from 10 to 5. Closed between exhibitions. Consisting of an 1,600-sq.-ft. gallery, adjoining coffee shop, and events space. Overall price range $180-3,000. Most work sold at $150-500. "The Center provides and markets to buyers its online gallery of artists' portfolios—Artists' ShowCase Online, available to all members of the Center." Workshops and forums are also offered.

Exhibits Exhibits photos of babies/children/teens, celebrities, couples, multicultural, families, parents, senior citizens, architecture, cities/urban, interiors/decorating, rural, political, environmental, landscapes/scenics, wildlife, performing arts; abstract, experimental work. Interested in alternative process, avant garde, documentary, erotic, fine art. "The Center features fine art photography that incorporates all processes, many styles and subjects."

Making Contact & Terms Art is accepted through either juried calls for entry or from portfolio review. Gallery provides insurance. Accepts only fine art photographic work.

Submissions Work accepted for exhibition via the center's juried calls for entry. Details at website.

Tips "Only signed archival-quality work is seriously considered by art collectors. This includes both traditional and digital prints."

CENTER FOR PHOTOGRAPHIC ART

Sunset Cultural Center, San Carlos and 9th Streets, P.O. Box 1100, Carmel CA 93921. (831)625-5181. Fax: (831)625-5199. E-mail: info@photography.org. Website: www.photography.org. Estab. 1988. Nonprofit gallery. Sponsors 7-8 exhibits/year. Average display time 5-7 weeks. Hours: Tuesday-Sunday 1-5 pm.

Exhibits Interested in fine art photography.

Submissions "Currently not accepting unsolicited submissions. Please e-mail the Center and ask to be added to our submissions contact list if you are not a member."

▣ CENTER FOR PHOTOGRAPHY AT WOODSTOCK

59 Tinker St., Woodstock NY 12498. (845)679-9957. Fax: (845)679-6337. E-mail: info@cpw. org. Website: www.cpw.org. **Contact:** Ariel Shanberg, executive director. Megan Flaherty, program associate. Alternative space, nonprofit arts and education center. Estab. 1977. Approached by more than 500 artists/year. Hosts 10 photography exhibits/year. Average display time 7 weeks. Gallery open all year; Wednesday through Sunday from 12 to 5.

Exhibits Interested in presenting all aspects of contemporary creative photography including digital media, film, video, and installation by emerging and under-recognized artists. "We host 5 group exhibitions and 5 solo exhibitions annually. Group exhibitions are curated by guest jurors, curators, and CPW staff. Solo exhibition artists are selected by CPW staff. Visit the exhibition archives on our website to learn more."

Making Contact & Terms CPW hosts exhibition and opening reception; provides insurance, promotion, a percentage of shipping costs, installation and de-installation, and honorarium for solo exhibition artists who give gallery talks. "We take 25% commission in exhibition-related sales." Accepted work should be framed and ready for hanging.

Submissions Send introductory letter with samples, résumé, artist's statement, SASE. Responds in 4 months. Finds artists through word of mouth, art exhibits, open calls, portfolio reviews, referrals by other artists.

Tips "Please send 10-20 slides by mail (labeled with your name, telephone number, image title, image media, size) or JPEGs on CD-ROM. Include a current résumé, statement, SASE for return. We are not responsible for unlabeled slides. We DO NOT welcome solicitations to visit websites. We DO advise artists to visit our website and become familiar with our offerings."

Ⓝ ▣ CEPA GALLERY

617 Main St., Suite 201, Buffalo NY 14203. (716)856-2717. Fax: (716)270-0184. E-mail: sean@ cepagallery.com. Website: www.cepagallery.com. **Contact:** Sean Donaher, artistic director. Alternative space, nonprofit gallery. Estab. 1974. Sponsors 15 photography exhibits/year. Average display time 6-8 weeks. Open Monday through Friday from 10 to 5; Saturday from 12 to 4. Located in the heart of downtown Buffalo's theater district in the historic Market Arcade complex—8 galleries on 3 floors of the building plus public art sites and state-of-the-art Imaging Facility. Overall price range varies depending on artist and exhibition—all prices set by artist.

Exhibits Exhibits photos of multicultural. Interested in alternative process, avant garde, fine art.

Making Contact & Terms Artwork is accepted on consignment, and there is a 25% commission. Gallery provides insurance, promotion.

Submissions E-mail proposal and digital images or send query letter with artist's statement, bio, résumé, reviews, slides, slide script, SASE. Responds in 3 months. Finds artists through word of mouth, submissions, art exhibits, referrals by other artists.

Tips Prefers only photo-related materials. (See additional information in the Center for Exploratory and Perceptual Art listing in this section.)

THE CHAIT GALLERIES DOWNTOWN

218 E. Washington St., Iowa City IA 52240. (319)338-4442. Fax: (319)338-3380. E-mail:

info@thegalleriesdowntown.com. Website: www.thegalleriesdowntown.com. **Contact:** Benjamin Chait, director. For-profit gallery. Estab. 2003. Approached by 100 artists/year; represents or exhibits 100 artists. Open Monday through Friday from 11 to 6; Saturday from 11 to 5; Sunday by appointment or by chance. Located in a downtown building renovated to its original look of 1882 with 14-ft.-high molded ceiling and original 9-ft. front door. Professional museum lighting and Scamozzi-capped columns complete the elegant gallery. Overall price range: $50-10,000.

Exhibits Exhibits landscapes, oil and acrylic paintings, sculpture, fused glass wall pieces, jewelry.

Making Contact & Terms Artwork is accepted on consignment, and there is a 50% commission. Gallery provides insurance, promotion and contract. Accepted work should be framed. Requires exclusive representation locally.

Submissions Call; mail portfolio for review. Responds to queries in 2 weeks. Finds artists through art fairs, art exhibits, portfolio reviews and referrals by other artists.

CHAPMAN FRIEDMAN GALLERY

624 W. Main St., Louisville KY 40202. E-mail: friedman@imagesol.com. Website: www. chapmanfriedmangallery.com or www.imagesol.com. **Contact:** Julius Friedman, owner. For-profit gallery. Estab. 1992. Approached by 100 or more artists/year; represents or exhibits 25 artists. Sponsors 1 photography exhibit/year. Average display time 1 month. Open Wednesday through Saturday from 10 to 5. Closed August. Located downtown; approximately 3,500 sq. ft. with 15-foot ceilings and white walls. Overall price range: $75-10,000. Most work sold at more than $1,000.

Exhibits Exhibits photos of landscapes/scenics, architecture. Interested in alternative process, avant garde, erotic, fine art.

Making Contact & Terms Artwork is accepted on consignment, and there is a 50% commission. Gallery provides insurance, promotion and contract. Accepted work should be framed. Requires exclusive representation locally.

Submissions Send query letter with artist's statement, bio, brochure, photographs, résumé, slides and SASE. Responds to queries within 1 month, only if interested. Finds artists through portfolio reviews and referrals by other artists.

N ◻ CLAMPART

521-531 W. 25th Street, New York NY 10001. E-mail: info@clampart.com. Website: www. clampart.com. **Contact:** Brian Clamp, director. For-profit gallery. Estab. 2000. Approached by 1,200 artists/year; represents or exhibits 15 artists. Sponsors 12 photography exhibits/year. Average display time 6 weeks. Open Tuesday through Saturday from 11 to 6; closed last 2 weeks of August. Located on the ground floor on Main Street in Chelsea. Overall price range: $300-50,000. Most work sold at $2,000.

Exhibits Exhibits photos of couples, disasters, environmental, landscapes/scenics, architecture, cities/urban, humor, performing arts, travel, science, technology/computers. Interested in alternative process, avant garde, documentary, erotic, fashion/glamour, fine art, historical/vintage.

Making Contact & Terms Artwork is accepted on consignment, and there is a 50% commission. Gallery provides insurance, promotion and contract. Accepted work should

be framed, mounted and matted.

Submissions E-mail query letter with artist's statement, bio and JPEGs. Responds to queries in 2 weeks. Finds artists through portfolio reviews, submissions and referrals by other artists.

Tips "Include a bio and well-written artist's statement. Do not submit work to a gallery that does not handle the general kind of work you produce."

N JOHN CLEARY GALLERY

2635 Colquitt, Houston TX 77098. (713)524-5070. E-mail: info@johnclearygallery.com. Website: www.johnclearygallery.com. For-profit gallery. Estab. 1996. Average display time 5 weeks. Open Tuesday through Saturday from 10 to 5 and by appointment. Located in upper Kirby District of Houston, Texas. Overall price range $500-40,000. Most work sold at $1,000-2,500.

Exhibits Exhibits photos of babies/children/teens, celebrities, couples, multicultural, families, parents, senior citizens, landscapes/scenics, wildlife, architecture, cities/urban, education, pets, religious, rural, adventure, automobiles, entertainment, events, humor, performing arts, travel, agriculture, industry, military, political, portraits, product shots/still life, science, technology/computers. Interested in alternative process, documentary, fashion/glamour, fine art, historical/vintage.

Making Contact & Terms Artwork is bought outright or accepted on consignment with a 50% commission. Gallery provides insurance, promotion, contract.

Submissions Call to show portfolio of photographs. Finds artists through submissions, art exhibits.

▣ CONTEMPORARY ARTS CENTER

900 Camp St., New Orleans LA 70130. (504)528-3805. Fax: (504)528-3828. E-mail: info@cacno.org. Website: www.cacno.org. **Contact:** Johnny King, exhibitions manager. Alternative space, nonprofit gallery. Estab. 1976. Gallery open Thursday through Sunday from 11 to 4. Closed Mardis Gras, Christmas, New Year's Day. Located in the central business district of New Orleans; renovated/converted warehouse.

Exhibits Interested in alternative process, avant garde, fine art. Cutting-edge contemporary preferred.

Submissions Send query letter with bio, SASE, slides or CD. Responds in 4 months. Finds artists through word of mouth, submissions, art exhibits, art fairs, referrals by other artists, professional contacts, art periodicals.

Tips "Submit only 1 slide sheet with proper labels (title, date, media, dimensions) or CD-ROM with the same information."

THE CONTEMPORARY ARTS CENTER

44 E. Sixth St., Cincinnati OH 45202. (513)345-8400. Fax: (513)721-7418. E-mail: pr@cacmail.org. Website: www.ContemporaryArtsCenter.org. **Contact:** Public Relations Coordinator. Nonprofit arts center. Sponsors 9 exhibits/year. Average display time 6-12 weeks. Sponsors openings; provides printed invitations, music, refreshments, cash bar.

Exhibits Photographer must be selected by the curator and approved by the board. Exhibits photos of multicultural, disasters, environmental, landscapes/scenics, gardening,

technology/computers. Interested in avant garde, innovative photography, fine art.

Making Contact & Terms Photography sometimes sold in gallery. Charges 15% commission.

Submissions Send query with résumé, slides, SASE. Responds in 2 months.

CONTEMPORARY ARTS COLLECTIVE

101 East Charleston Blvd., Suite 101, Las Vegas NV 89102. (702)382-3886. Fax: (702)598-3886. E-mail: info@lasvegascac.org. Website: www.lasvegascac.org. **Contact:** Natalia Ortiz. Nonprofit gallery. Estab. 1989. Sponsors more than 9 exhibits/year. Average display time 1 month. Gallery open Tuesday through Saturday from 12 to 4. Closed Thanksgiving, Christmas, New Year's Day. 1,200 sq. ft. Overall price range $200-4,000. Most work sold at $400.

Exhibits Interested in alternative process, avant garde, documentary, fine art.

Making Contact & Terms Artwork is accepted through annual call for proposals of self-curated group shows, and there is a 30% requested donation. Gallery provides insurance, promotion, contract.

Submissions Finds artists through annual call for proposals, membership, word of mouth, submissions, portfolio reviews, art exhibits, art fairs, referrals by other artists and walk-ins. Check website for dates and submission guidelines.

Tips Submitted slides should be "well labeled and properly exposed with correct color balance."

CORPORATE ART SOURCE/CAS GALLERY

2960-F Zelda Rd., Montgomery AL 36106. (334)271-3772. Fax: (334)271-3772. Website: www.casgallery.com. Art consultancy, for-profit gallery. Estab. 1990. Approached by 100 artists/year; represents or exhibits 50 artists. Sponsors 1 photography exhibit/year. Average display time 6 weeks. Gallery open Monday through Friday from 10 to 5:30; weekends from 11 to 3. Overall price range $200-20,000. Most work sold at $1,000.

Exhibits Exhibits photos of landscapes/scenics, architecture, rural. Interested in alternative process, avant garde, fine art, historical/vintage.

Making Contact & Terms Artwork is accepted on consignment, and there is a 50% commission. Gallery provides contract.

Submissions E-mail from the Web site, or mail portfolio for review. Send query letter. Responds within 6 weeks, only if interested. Finds artists through submissions, portfolio reviews, art exhibits, art fairs, referrals by other artists.

◼ CROSSMAN GALLERY

University of Wisconsin-Whitewater, 950 W. Main St., Whitewater WI 53190. (262)472-5708. E-mail: flanagam@uww.edu. Website: http://blogs.uss.edu/crossman/. **Contact:** Michael Flanagan, director. Estab. 1971. Photography is frequently featured in thematic exhibits at the gallery. Average display time 1 month. Overall price range $250-3,000.

Exhibits "We primarily exhibit artists from the Midwest but do include some from national and international venues. Works by Latino artists are also featured in a regular series at ongoing exhibits." Interested in all types of innovative approach to photography.

Making Contact & Terms Sponsors openings; provides food, beverage, show announcement,

mailing, shipping (partial) and possible visiting artist lecture/demo.

Submissions Submit 10-20 slides or CD, artist's statement, résumé, SASE.

Tips "The Crossman Gallery operates within a university environment. The focus is on exhibits that have the potential to educate viewers about processes and techniques and have interesting thematic content."

ⓝ CSPS

1103 Third St. SE, Cedar Rapids IA 52401-2305. (319)364-1580. Fax: (319)362-9156. E-mail: info@legionarts.org. Website: www.legionarts.org. **Contact:** Mel Andringa, producing director. Alternative space. Estab. 1991. Approached by 50 artists/year; represents or exhibits 15 artists. Sponsors 4 photography exhibits/year. Average display time 2 months. Gallery open Wednesday through Sunday from 11 to 6. Closed July and August. Overall price range $50-500. Most work sold at $200.

Exhibits Interested in alternative process, avant garde, documentary, fine art.

Making Contact & Terms Artwork is accepted on consignment and there is a 30% commission. Gallery provides insurance, promotion. Accepted work should be framed.

Submissions Send query letter with artist's statement, bio, slides, SASE. Responds in 6 months. Finds artists through word of mouth, art exhibits, referrals by other artists, art trade magazine.

▣ THE DALLAS CENTER FOR CONTEMPORARY ART

2801 Swiss Ave., Dallas TX 75204. (214)821-2522. Fax: (214)821-9103. E-mail: exhibitions@ dallascontemporary.org. Website: www.dallascontemporary.org. **Contact:** Joan Davidow, director. Nonprofit gallery. Estab. 1981. Sponsors 1-2 photography exhibits/year. Other exhibits may include photography as well as other mediums. Average display time 6-8 weeks. Gallery open Tuesday through Saturday from 10 to 5.

Exhibits Exhibits a variety of subject matter and styles.

Making Contact & Terms Charges no commission. "Because we are nonprofit, we do not sell artwork. If someone is interested in buying art in the gallery, they get in touch with the artist. The transaction is between the artist and the buyer."

Submissions Reviews slides/CDs. Send material by mail for consideration; include SASE. Responds October 1 annually.

Tips "Memberships available starting at $50. See our website for info and membership levels."

THE DAYTON ART INSTITUTE

456 Belmonte Park N., Dayton OH 45405-4700. (937)223-5277. Fax: (937)223-3140. E-mail: info@daytonartinstitute.org. Website: www.daytonartinstitute.org. Museum. Estab. 1919. Galleries open Tuesday through Sunday from 10 to 4, Thursdays until 8.

Exhibits Interested in fine art.

DELAWARE CENTER FOR THE CONTEMPORARY ARTS

200 S. Madison St., Wilmington DE 19801. (302)656-6466. Fax: (302)656-6944. E-mail: info@thedcca.org. Website: www.thedcca.org. Alternative space, museum retail shop, nonprofit gallery. Estab. 1979. Approached by more than 800 artists/year; exhibits 50

artists. Sponsors 30 total exhibits/year. Average display time 6 weeks. Gallery open Tuesday, Thursday, Friday, and Saturday from 10 to 5; Wednesday and Sunday from 12 to 5. Closed on Monday and major holidays. Seven galleries located along rejuvenated Wilmington riverfront.

Exhibits Interested in alternative process, avant garde.

Making Contact & Terms Gallery provides PR and contract. Accepted work should be framed, mounted, matted. Prefers only contemporary art.

Submissions Send query letter with artist's statement, bio, SASE, 10 digital images. Returns material with SASE. Responds within 6 months. Finds artists through calls for entry, word of mouth, submissions, portfolio reviews, art exhibits, referrals by other artists.

DEMUTH MUSEUM

120 E. King St., Lancaster PA 17602. (717)299-9940. Fax: (717)299-9749. E-mail: info@ demuth.org. Website: www.demuth.org. **Contact:** Gallery Director. Museum. Estab. 1981. Average display time 2 months. Open Tuesday through Saturday from 10 to 4; Sunday from 1 to 4. Located in the home and studio of Modernist artist Charles Demuth (1883-1935). Exhibitions feature the museum's permanent collection of Demuth's works with changing, temporary exhibitions.

[N] DETROIT FOCUS

P.O. Box 843, Royal Oak MI 48068-0843. (248)541-2210. Fax: (248)541-3403. E-mail: michael@sarnaki.net. Website: www.detroitfocus.org. **Contact:** Michael Sarnalki, director. Artist alliance. Estab. 1978. Approached by 100 artists/year; represents or exhibits 100 artists. Sponsors 1 or more photography exhibit/year.

Exhibits Interested in photojournalism, avant garde, documentary, erotic, fashion/glamour, fine art.

Making Contact & Terms No charge or commission.

Submissions Call or e-mail. Responds in 1 week. Finds artists through word of mouth, submissions, art exhibits, referrals by other artists.

SAMUEL DORSKY MUSEUM OF ART

SUNY at New Paltz, 1 Hawk Dr., New Paltz NY 12561. (845)257-3844. Fax: (845)257-3854. E-mail: sdma@newpaltz.edu. Website: www.newpaltz.edu/museum. **Contact**: Brian Wallace, curator. Estab. 1964. Sponsors ongoing photography exhibits throughout the year. Average display time 2 months. Museum open Tuesday through Friday from 11 to 5; weekends from 1 to 5. Closed legal and school holidays "and during intersession; check website to confirm your visit."

Exhibits Interested in alternative process, avant garde, documentary, fine art, historical/vintage.

Submissions Send query letter with bio and SASE. Responds within 3 months, only if interested. Finds artists through art exhibits.

▣ DOT FIFTYONE GALLERY

51 NW 36 St., Miami FL 33127. (305)573-3754. Fax: (305)573-3754. E-mail: dot@dotfiftyone. com. Website: www.dotfiftyone.com. **Contact:** Isaac Perelman and Alfredo Guzman,

directors. For-profit gallery. Estab. 2004. Approached by 40+ artists/year; represents or exhibits 10 artists. Sponsors 2 photography exhibits/year. Average display time 40 days. Open Monday through Friday from 12 to 7; Saturdays and private viewings available by appointment. Located in the Wynwood Art District; approximately 7,000 sq. ft.; 2 floors. Overall price range $600-30,000. Most work sold at $6,000.

Exhibits Exhibits photos of couples, architecture, cities/urban, interiors/decorating, landscapes/scenics. Interested in avant garde, erotic, fashion/glamour, fine art.

Making Contact & Terms Artwork is accepted on consignment, and there is a 50% commission. Requires exclusive representation locally.

Submissions E-mail with a link to photographer's website. Write to arrange a personal interview to show portfolio. Mail portfolio for review. Finds artists through art fairs, portfolio reviews, referrals by other artists.

Tips "Have a good presentation. Contact the gallery first by e-mail. Never try to show work during an opening, and never show up at the gallery without an appointment."

▣ GEORGE EASTMAN HOUSE

900 East Ave., Rochester NY 14607. (585)271-3361. Fax: (716)271-3970. Website: www. eastmanhouse.org. **Contact:** Alison Nordstrom, curator of photographs. Museum. Estab. 1947. Approached by more than 400 artists/year. Sponsors more than 12 photography exhibits/year. Average display time 3 months. Gallery open Tuesday through Saturday from 10 to 5 (Thursday until 8); Sunday from 1 to 5. Closed Thanksgiving and Christmas. Museum has 7 galleries that host exhibitions, ranging from 50- to 300-print displays.

Exhibits GEH is a museum that exhibits the vast subjects, themes and processes of historical and contemporary photography.

Submissions See website for detailed information: http://eastmanhouse.org/inc/collections/submissions.php. Mail portfolio for review. Send query letter with artist's statement, résumé, SASE, slides, digital prints. Responds in 3 months. Finds artists through word of mouth, art exhibits, referrals by other artists, books, catalogs, conferences, etc.

Tips "Consider as if you are applying for a job. You must have succinct, well-written documents; a well-selected number of visual treats that speak well with written document provided; an easel for reviewer to use."

▣ CATHERINE EDELMAN GALLERY

300 W. Superior St., Lower Level, Chicago IL 60654. (312)266-2350. Fax: (312)266-1967. Website: www.edelmangallery.com. **Contact:** Catherine Edelman, director. Estab. 1987. Sponsors 6 exhibits/year. Average display time 8 weeks. Open Tuesday through Saturday from 10 to 5:30. Overall price range $1,500-15,000.

Exhibits "We exhibit works ranging from traditional photography to mixed media photo-based work."

Making Contact & Terms Charges 50% commission. Accepted work should be matted. Requires exclusive representation within metropolitan area.

Submissions Query first. Will review unsolicited work with SASE or CD-ROM.

Tips Looks for "consistency, dedication and honesty. Try to not be overly eager and realize that the process of arranging an exhibition takes a long time. The relationship between gallery and photographer is a partnership."

PAUL EDELSTEIN STUDIO AND GALLERY

540 Hawthorne Street, Memphis TN 38112-5029. (901)496-8122. Fax: 901-276-1493. E-mail: henrygrove@yahoo.com. Website: www.askart.com. **Contact:** Paul R. Edelstein, director/owner. Estab. 1985. "Shows are presented continually throughout the year." Overall price range: $300-10,000. Most work sold at $1,000.

Exhibits Exhibits photos of celebrities, children, multicultural, families. Interested in avant garde, historical/vintage, C-print, dye transfer, ever color, fine art and 20th-century photography "that intrigues the viewer"—figurative still life, landscape, abstract—by upcoming and established photographers.

Making Contact & Terms Charges 50% commission. Buys photos outright. Reviews transparencies. Accepted work should be framed or unframed, mounted or unmounted, matted or unmatted work. There are no size limitations. Submit portfolio for review. Send query letter with samples. Cannot return material. Responds in 3 months.

Tips "Looking for figurative and abstract figurative work."

ENVOY

131 Chrystie Street, Ground Floor, New York NY 10002. (212)226-4555. E-mail: office@envoyenterprises.com. Website: www.envoygallery.com. **Contact:** Director. Art consultancy and for-profit gallery. Estab. 2005. Approached by 120 artists/year; represents or exhibits 25 artists. Average display time 6 weeks. Open Tuesday through Saturday from 12 to 6. Closed December 23 through January 4, and July 4. Located on Lower East Side. Overall price range $1,000-35,000. Most work sold at $8,000.

Exhibits Exhibits photos of babies/children/teens, celebrities, couples, multicultural, cities/urban, pets, political, landscapes/scenics. Interested in fine art.

Making Contact & Terms Artwork is accepted on consignment, and there is a 50% commission. Requires exclusive representation locally.

Submissions Finds artists through referrals by other artists.

Tips "Check out the gallery first to see if your work is appropriate for the gallery. Then, strictly follow the guidelines for submission of work."

THOMAS ERBEN GALLERY

526 W. 26th St., 4th Floor., New York NY 10001. (212)645-8701. Fax: (212)941-9630. E-mail: info@thomaserben.com. Website: www.thomaserben.com. For-profit gallery. Estab. 1996. Approached by 100 artists/year; represents or exhibits 15 artists. Average display time 5-6 weeks. Gallery open Tuesday through Saturday from 10 to 6 (Monday through Friday in July). Closed Christmas/New Year's Day and August.

Submissions Mail portfolio for review. Responds in 1 month.

ETHERTON GALLERY

135 S. 6th Ave., Tucson AZ 85701. (520)624-7370. Fax: (520)792-4569. E-mail: info@ethertongallery.com. Website: www.ethertongallery.com. **Contact:** Terry Etherton, director. Estab. 1981. Sponsors 10 exhibits/year. Average display time 6 weeks. Sponsors openings; provides wine and refreshments, publicity, etc. Overall price range $400-150,000.

- Etherton Gallery regularly purchases 19th-century, vintage, Western survey photographs and Native American portraits.

Exhibits The gallery is interested in professional photographers with a high-quality, consistent body of work, especially artists working in the Western and Southwestern US.

Making Contact & Terms Charges 50% commission. Occasionally buys photography outright. Please send CD with no more than 20 images of best body of work, resume, and relevant artist statement for consideration or e-mail gallery with the same information. We will respond to your submission if we are interested in the work.

Tips "You should be familiar with the photo art world and with my gallery and the work I show. Please limit submissions to 20, showing the best examples of your work in a presentable, professional format; slides or digital preferred."

EVERSON MUSEUM OF ART

401 Harrison St., Syracuse NY 13202. (315)474-6064. Fax: (315)474-6943. E-mail: everson@ everson.org. Website: www.everson.org. **Contact**: Debora Ryan, curator. Museum. Estab. 1897. Approached by many artists/year; represents or exhibits 16-20 artists. Sponsors 2-3 photography exhibits/year. Average display time 3 months. Gallery open Tuesday through Friday from 12 to 5; Saturday from 10 to 5; Sunday from 12 to 5. "The museum features four large galleries with twenty-four foot ceilings, track lighting and oak hardwood, a sculpture court, a children's gallery, a ceramic study center and five smaller gallery spaces."

Exhibits Photos of multicultural, environmental, landscapes/scenics, wildlife. Interested in alternative process, avant garde, documentary, fine art, historical/vintage.

Submissions Send query letter with artist's statement, bio, résumé, reviews, SASE, slides. Finds artists through submissions, portfolio reviews, art exhibits.

▣ FAHEY/KLEIN GALLERY

148 N. La Brea Ave., Los Angeles CA 90036. (323)934-2250. Fax: (323)934-4243. E-mail: fkg@ earthlink.net. Website: www.faheykleingallery.com. **Contact:** David Fahey or Ken Devlin, co-owners. Estab. 1986. For-profit gallery. Approached by 200 artists/year; represents or exhibits 60 artists. Sponsors 10 exhibits/year. Average display time 5-6 weeks. Gallery open Tuesday through Saturday from 10 to 6. Closed on all major holidays. Sponsors openings; provides announcements and beverages served at reception. Overall price range $500-500,000. Most work sold at $2,500. Located in Hollywood; gallery features 2 exhibition spaces with extensive work in back presentation room.

Exhibits Interested in established work; photos of celebrities, landscapes/scenics, wildlife, architecture, entertainment, humor, performing arts, sports. Interested in alternative process, avant garde, documentary, erotic, fashion/glamour, fine art, historical/vintage. Specific photo needs include iconic photographs, Hollywood celebrities, photojournalism, music-related, reportage and still life.

Making Contact & Terms Artwork is accepted on consignment, and the commission is negotiated. Gallery provides insurance, promotion, contract. Accepted work should be unframed, unmounted and unmatted. Requires exclusive representation within metropolitan area. Photographer must be established for a minimum of 5 years; preferably published.

Submissions Prefers website URLs for initial contact, or send material (CD, reproductions, no originals) by mail with SASE for consideration. Responds in 2 months. Finds artists through art fairs, exhibits, portfolio reviews, submissions, word of mouth, referrals by other artists.

Tips "Please be professional and organized. Have a comprehensive sample of innovative work. Interested in seeing mature work with resolved photographic ideas and viewing complete portfolios addressing one idea."

FRESNO ART MUSEUM

2233 N. First St., Fresno CA 93703. (559)441-4221. Fax: (559)441-4227. E-mail: jacquelin@ fresnoartmuseum.org. Website: www.fresnoartmuseum.org. **Contact:** Jacquelin Pilar, curator. Estab. 1948. "Approached by many California artists throughout the year." Over 25 changing exhibitions/year including at least two photography exhibitions. Average display time 8 weeks. Gallery open Tuesday through Sunday from 11 to 5 (Third Thursday of the month until 8). Closed mid-August to early September.

Exhibits Focused on Modernist and Contemporary art.

Making Contact & Terms Museum provides insurance. Send letter of inquiry through the mail with artist's statement, résumé, slides for curator to review. Studio visit arranged following review of material.

Tips "The Museum shows the work of contemporary California artists; interested in sculpture, the work of mid-career and mature artists working in photography, sculpture, painting, mixed-media, installation work. The Museum also draws exhibitions from its permanent collection."

▣ GALLERY 110 COLLECTIVE

110 S. Washington St., Seattle WA 98104. E-mail: director@gallery110.com. Website: www. gallery110.com. **Contact:** Sarah Dillon, Director. Cooperative gallery. Estab. 2002. Gallery represents a variety of other contemporary media. Average exhibition time 1 month. Open Wednesday through Saturday from 12 to 5. Located in the historic gallery district of Pioneer Square. Overall price range $125-3,000. Most work sold at $500-800.

Exhibits Exhibitions include a variety of subject matter including portraits, still life objects, landscape, and narrative scenes. Interested in alternative and experimental process, documentary, fine art.

Making Contact & Terms Yearly active membership with monthly dues, art on consignment. Artwork is bought outright. Gallery provides insurance, promotion, contract (nonexclusive).

Submissions Application for membership occurs once per year in November or as space opens for new members throughout the year. Application requirements and instructions are located on the Gallery 110 website.

Tips "The artist should research the gallery to confirm it is a good fit for their work. The artist should be interested in being an active member, collaborating with other artists and participating in the success of the gallery. The work should challenge the viewer through concept, a high sense of craftsmanship, artistry, and expressed understanding of contemporary art culture and history. Artists should be emerging or established individuals with a serious focus on their work and participation in the field."

GALLERY 218

207 E. Buffalo St., Suite 218, Milwaukee WI 53202. (414)643-1732. E-mail: director@ gallery218.com. Website: www.gallery218.com. **Contact:** Judith Hooks, president/director.

Estab. 1990. Sponsors 12 exhibits/year. Average display time 1 month. Sponsors openings. "If a group show, we make arrangements and all artists contribute. If a solo show, artist provides everything." Overall price range $150-5,000. Most work sold at $350.

Exhibits Interested in alternative process, avant garde, abstract, fine art. Membership dues: $55/year plus $55/month rent. Artists help run the gallery. Group and solo shows. Photography is shown alongside fine arts painting, printmaking, sculpture, etc.

Making Contact & Terms Charges 25% commission. There is an entry fee for each month. Fee covers the rent for 1 month. Accepted work must be framed.

Submissions Send SASE for an application. "This is a cooperative space. A fee is required."

Tips "Get involved in the process if the gallery will let you. We require artists to help promote their show so that they learn what and why certain things are required. Have inventory ready. Read and follow instructions on entry forms; be aware of deadlines. Attend openings for shows you are accepted into locally."

▣ GALLERY 400

College of Architecture and the Arts, University of Illinois at Chicago, 400 S. Peoria St. (MC 034), Chicago IL 60607. (312)996-6114. Fax: (312)355-3444. E-mail: uicgallery400@gmail.co. Website: http://gallery400.aa.uic.edu. **Contact:** Lorelei Stewart, director. Nonprofit gallery. Estab. 1983. Approached by 500 artists/year; exhibits 80 artists. Sponsors 1 photography exhibit/year. Average display time 4-6 weeks. Gallery open Tuesday through Friday from 10 to 6; Saturday from 12 to 6. Clients include local community, students, tourists, and upscale.

Making Contact & Terms Gallery provides insurance and promotion.

Submissions Check info section of website for guidelines. Responds in 5 months. Finds artists through word of mouth, art exhibits, referrals by other artists.

Tips "Check our website for guidelines for proposing an exhibition and follow those proposal guidelines. Please do not e-mail, as we do not respond to e-mails."

GALLERY NORTH

90 N. Country Rd., Setauket NY 11733. (631)751-2676. E-mail: info@gallerynorth.org. Website: www.gallerynorth.org. **Contact:** Colleen Hanson, director. Nonprofit gallery. Estab. 1965. Approached by 200-300 artists/year; represents or exhibits approximately 100 artists. Sponsors 1-2 photography exhibits/year. Average display time 4 weeks. Open Tuesday through Saturday from 10 to 5; Sunday from 12 to 5. Located on the north shore of Long Island in a professional/university community, in an 1840s house; exhibition space is 1,000 sq. ft. Overall price range $250-20,000. Most work sold at $1,500-5,000.

Exhibits Exhibits photos of architecture, cities/urban, environmental, landscapes/scenics, occasionally people. Interested in alternative process, avant garde, fine art.

Making Contact & Terms Artwork is accepted on consignment, and there is a 50% commission.

Submissions Artists should mail portfolio for review and include artist's statement, bio, résumé, reviews, contact information. "We return all materials with SASE. We file CDs, photographs, slides." Responds to queries within 6 months. Finds artists through word of mouth, art exhibits, submissions, portfolio reviews, referrals by other artists.

Tips "All written material should be typed and clearly written. Slides, CDs and photos should be organized by categories, and no more than 20 images should be submitted."

ⓃGALMAN LEPOW ASSOCIATES, INC.

1879 Old Cuthbert Rd., Unit 12, Cherry Hill NJ 08034. (856)354-0771. Fax: (856)428-7559. Website: www.galmanlepowappraisers.com. **Contact:** Judith Lepow, principal. Estab. 1979.

Submissions Send query letter with résumé and SASE. "Visual imagery of work is helpful." Responds in 3 weeks.

Tips "We are corporate art consultants and use photography for our clients."

ANTON HAARDT GALLERY

2858 Magazine St., New Orleans LA 701115. (504)897-1172. E-mail: gallery@antonart.com. Website: www.antonart.com. **Contact:** Jeffrey Jones, Gallery Director. For-profit gallery. For-profit gallery. Estab. 1985. Represents or exhibits 25 artists. Overall price range $500-5,000. Most work sold at $1,000.

Exhibits Exhibits photos of celebrities. Mainly photographs (portraits of folk artists).

Making Contact & Terms Prefers only artists from the South. Self-taught artists who are original and pure, specifically art created from 1945 to 1980. "I rarely take on new artists, but I am interested in buying estates of deceased artist's work or an entire body of work by artist."

Submissions Send query letter with artist's statement.

Tips "I am only interested in a very short description if the artist has work from early in his or her career."

THE HALSTED GALLERY INC.

P.O. Box 130, Bloomfield Hills MI 48303. (248)895-0204. Fax: (248)332-0227. E-mail: thalsted@halstedgallery.com. Website: www.halstedgallery.com. **Contact:** Wendy or Thomas Halsted. Estab. 1969. Sponsors 3 exhibits/year. Average display time 2 months. Sponsors openings. Overall price range $500-25,000.

Exhibits Interested in 19th- and 20th-century photographs.

Submissions Call to arrange a personal interview to show portfolio only. Prefers to see scans. Send no slides or samples. Unframed work only.

Tips This gallery has no limitations on subjects. Wants to see creativity, consistency, depth and emotional work.

ⓃLEE HANSLEY GALLERY

225 Glenwood Ave., Raleigh NC 27603. (919)828-7557. Fax: (919)828-7550. E-mail: leehansley@bellsouth.net. Website: www.leehansleygallery.com. **Contact:** Lee Hansley, gallery director. Estab. 1993. Sponsors 3 exhibits/year. Average display time 4-6 weeks. Overall price range $250-1600. Most work sold at $400.

Exhibits Exhibits photos of environmental, landscapes/scenics, architecture, cities/urban, gardening, rural, performing arts. Interested in alternative process, avant garde, erotic, fine art. Interested in new images using the camera as a tool of manipulation; also wants minimalist works. Looks for top-quality work with an artistic vision.

Making Contact & Terms Charges 50% commission. Payment within 1 month of sale.

Submissions Send material by mail for consideration; include SASE. May be on CD. Does not accept e-mails. Responds in 2 months.

Tips Looks for "originality and creativity—someone who sees with the camera and uses the parameters of the format to extract slices of life, architecture and nature."

JAMES HARRIS GALLERY

312 Second Ave. S., Seattle WA 98104. (206)903-6220. Fax:(206)903-6226. E-mail: mail@ jamesharrisgallery.com. Website: www.jamesharrisgallery.com. **Contact:** Nancy Stoaks, assistant to the director. For-profit gallery. Estab. 1999. Approached by 40 artists/year; represents or exhibits 26 artists. Average display time 6 weeks. Open Tuesday through Saturday from 11 to 5.

Exhibits Exhibits photos of cities/urban. Interested in fine art.

Submissions E-mail with JPEG samples at 72 dpi. Send query letter with artist's statement, bio, slides.

THE HARWOOD MUSEUM OF ART

238 Ledoux St., Taos NM 87571-6004. (505)758-9826. Fax: (505)758-1475. E-mail: info@ harwoodmuseum.com. Website: www.harwoodmuseum.org. **Contact:** Margaret Bullock, curator. Estab. 1923. Approached by 100 artists/year; represents or exhibits more than 200 artists. Sponsors "at least" 1 photography exhibit/year. Average display time 3 months. Gallery open Tuesday through Saturday from 10 to 5; Sunday from 12 to 5. Overall price range $1,000-5,000. Most work sold at $2,000.

Exhibits Interested in alternative process, avant garde, documentary, fine art.

Making Contact & Terms Artwork is accepted on consignment, and there is a 40% commission. Gallery provides insurance, contract. Accepted work should be framed, mounted, matted. "The museum exhibits work by Taos, New Mexico, artists as well as major artists from outside our region."

Submissions Mail portfolio for review. Send query letter with artist's statement, bio, brochure, résumé, reviews, SASE, slides. Responds in 3 months. Finds artists through word of mouth, submissions, art exhibits, referrals by other artists.

Tips "The gift shops accepts some art on consignment, but the museum itself does not."

⊘ HEMPHILL

1515 14th St. NW, Suite 300, Washington DC 20005. (202)234-5601. Fax: (202)234-5607. E-mail: gallery@hemphillfinearts.com. Website: www.hemphillfinearts.com. Art consultancy and for-profit gallery. Estab. 1993. Represents or exhibits 30 artists/year. Sponsors 2-3 photography exhibits/year. Average display time 6-8 weeks. Gallery open Tuesday through Saturday from 10 to 5. Overall price range $800-200,000. Most work sold at $3,000-9,000.

Exhibits Exhibits photos of landscapes/scenics, architecture, cities/urban, rural. Interested in alternative process, fine art, historical/vintage.

Submissions Query regarding whether artist submissions are currently being accepted for consideration.

HENRY STREET SETTLEMENT/ABRONS ART CENTER

265 Henry St., New York NY 10002. (212)766-9200. E-mail: info@henrystreet.org. Website: www.henrystreet.org. **Contact:** Martin Dust, visual arts coordinator. Alternative space, nonprofit gallery, community center. Holds 9 solo photography exhibits/year. Gallery open Monday through Friday from 9 to 6; Saturday and Sunday from 12 to 6. Closed major holidays.

Exhibits Exhibits photos of multicultural, environmental, landscapes/scenics, architecture, cities/urban, rural. Interested in alternative process, avant garde, documentary, fine art, historical/vintage.

Making Contact & Terms Artwork is accepted on consignment, and there is a 20% commission. Gallery provides insurance, space, contract.

Submissions Send query letter with artist's statement, SASE. Finds artists through word of mouth, submissions, referrals by other artists.

HERA EDUCATIONAL FOUNDATION AND ART GALLERY

P.O. Box 336, Wakefield RI 02903. (401)789-1488. E-mail: info@heragallery.org. Website: www.heragallery.org. **Contact:** Islay Taylor, director. Cooperative gallery. Estab. 1974. The number of photo exhibits varies each year. Average display time 6 weeks. Gallery open Wednesday through Friday from 1-5; Saturday from 10-4. Closed during the month of January. Sponsors openings; provides refreshments and entertainment or lectures, demonstrations and symposia for some exhibits. Call for information on exhibitions. Overall price range: $100-10,000.

Exhibits Interested in all types of innovative contemporary art that explores social and artistic issues. Exhibits photos of disasters, environmental, landscapes/scenics. Interested in fine art.

Making Contact & Terms Charges 25% commission. Works must fit inside a 6'6" × 2'6" door. Photographer must show a portfolio before attaining membership.

Submissions Inquire about membership and shows. Responds in 6 weeks. Membership guidelines and application available on website or mailed on request.

Tips "Hera exhibits a culturally diverse range of visual and emerging artists. Please follow the application procedure listed in the Membership Guidelines. Applications are welcome at any time of the year."

GERTRUDE HERBERT INSTITUTE OF ART

506 Telfair St., Augusta GA 30901-2310. (706)722-5495. Fax: (706)722-3670. E-mail: ghia@ghia.org. Website: www.ghia.org. **Contact:** Rebekah Henry, executive director. Nonprofit gallery. Estab. 1937. Has 5 solo or group shows annually; exhibits approximately 40 artists annually. Average display time 6-8 weeks. Open Tuesday through Friday from 10 to 5; weekends by appointment only. Closed 1st week in August, and December 17-31. Located in historic 1818 Ware's Folly mansion.

Making Contact & Terms Artwork is accepted on consignment, and there is a 35% commission.

Submissions Send query letter with artist's statement, bio, brochure, résumé, reviews, slides or CD of work, SASE. Responds to queries in 1-3 months. Finds artists through art exhibits, submissions, referrals by other artists.

HUNTSVILLE MUSEUM OF ART

300 Church St. S., Huntsville AL 35801. (256)535-4350. E-mail: info@hsvmuseum.org. Website: www.hsvmuseum.org. **Contact:** Peter J. Baldaia, chief curator. Estab. 1970. Sponsors 1-2 exhibits/year. Average display time 2-3 months.

Exhibits No specific stylistic or thematic criteria. Interested in alternative process, avant garde, documentary, fine art, historical/vintage.

Making Contact & Terms Buys photos outright. Accepted work may be framed or unframed, mounted or unmounted, matted or unmatted. Must have professional track record and résumé, slides, critical reviews in package (for curatorial review).

ICEBOX QUALITY FRAMING & GALLERY

1500 Jackson St. NE, Suite 443, Minneapolis MN 55413. (612)788-1790. Fax: (612)788-6947. E-mail: icebox@bitstream.net. Website: www.iceboxminnesota.com. **Contact:** Howard M. Christopherson, owner. Exhibition, promotion and sales gallery. Estab. 1988. Represents photographers and fine artists in all media, predominantly photography. "A sole proprietorship gallery, Icebox sponsors installations and exhibits in the gallery's 1,700-sq.-ft. space in the Minneapolis Arts District." Overall price range $200-1,500. Most work sold at $200-800.

Exhibits Exhibits photos of multicultural, environmental, landscapes/scenics, rural, adventure, travel. Interested in alternative process, documentary, erotic, fine art, historical/vintage. Specifically wants "fine art photographs from artists with serious, thought-provoking work."

Making Contact & Terms Charges 50% commission.

Submissions "Send letter of interest telling why and what you would like to exhibit at Icebox. Include only materials that can be kept at the gallery and updated as needed. Check website for more details about entry and gallery history."

Tips "We are experienced with the out-of-town artist's needs."

ILLINOIS STATE MUSEUM CHICAGO GALLERY

100 W. Randolph, Suite 2-100, Chicago IL 60601. (312)814-5322. Fax: (312)814-3471. Website: www.museum.state.il.us. **Contact:** Kent Smith, director. Assistant Administrator: Jane Stevens. Estab. 1985. Sponsors 2-3 exhibits/year. Average display time 4 months. Sponsors openings; provides refreshments at reception and sends out announcement cards for exhibitions.

Exhibits *Must be an Illinois photographer.* **Interested in contemporary and historical/vintage, alternative process, fine art.**

Submissions Send résumé, artist's statement, 10 slides, SASE. Responds in 6 months.

☐ INDIANAPOLIS ART CENTER

820 E. 67th St., Indianapolis IN 46220. (317)255-2464. Fax: (317)254-0486. E-mail: exhibs@indplsartcenter.org. Website: www.indplsartcenter.org. **Contact:** David Kwasigroh, director of exhibitions. Estab. 1934. Sponsors 1-2 photography exhibits/year. Average display time 8 weeks. Overall price range $50-5,000. Most work sold at $500.

Exhibits Interested in alternative process, avant garde, documentary, fine art and "very contemporary work, preferably unusual processes." Prefers artists who live within 250 miles of Indianapolis.

Making Contact & Terms Charges 35% commission. One-person show: $300 honorarium; 2-person show: $200 honorarium; 3-person show: $100 honorarium; plus $0.32/mile travel stipend (one way). Accepted work should be framed (or other finished-presentation formatted).

Submissions Send minimum of 20 digital images with résumé, reviews, artist's statement and SASE between July 1 and December 31. No wildlife or landscape photography. Interesting color and mixed media work is appreciated.

Tips "We like photography with a very contemporary look that incorporates unusual processes and/or photography with mixed media. Submit excellent images with a full résumé, a recent artist's statement, and reviews of past exhibitions or projects. Please, no glass-mounted slides. Always include a SASE for notification and return of materials, ensuring that correct return postage is on the envelope. Exhibition materials will not be returned. Currently booking 2012."

INDIVIDUAL ARTISTS OF OKLAHOMA

811 N. Broadway, P.O. Box 60824, Oklahoma OK 73146. (405)232-6060. Fax: (405)232-6061. E-mail: stokes@iaogallery.org. Website: www.iaogallery.org. **Contact:** Jeff Stokes, director. Alternative space. Estab. 1979. Approached by 60 artists/year; represents or exhibits 30 artists. Sponsors 10 photography exhibits/year. Average display time 3-4 weeks. Gallery open Tuesday through Friday from 11 to 4; Saturdays from 1 to 4. Closed August. Gallery is located in downtown art district, 2,300 sq. ft. with 10 ft. ceilings and track lighting. Overall price range $100-2,000. Most work sold at $400.

Exhibits Interested in alternative process, avant garde, documentary, fine art, historical/vintage photography. Other specific subjects/processes: contemporary approach to variety of subjects.

Making Contact & Terms Charges 20% commission. Gallery provides insurance, promotion, contract. Accepted work must be framed.

Submissions Mail portfolio for review with artist's statement, bio, photocopies or slides, résumé, SASE. Reviews quarterly. Finds artists through word of mouth, art exhibits, referrals by other artists.

▣ INTERNATIONAL CENTER OF PHOTOGRAPHY

1133 Avenue of the Americas, New York NY 10036. (212)857-0000. Fax: (212)768-4688. E-mail: exhibitions@icp.org. Website: www.icp.org. **Contact:** Department of Exhibitions & Collections. Estab. 1974.

Submissions "Due to the volume of work submitted, we are only able to accept portfolios in the form of 35mm slides or CDs. All slides must be labeled on the front with a name, address, and a mark indicating the top of the slide. Slides should also be accompanied by a list of titles and dates. CDs must be labeled with a name and address. Submissions must be limited to 1 page of up to 20 slides or a CD of no more than 20 images. Portfolios of prints or of more than 20 images will not be accepted. Photographers may also wish to include the following information: cover letter, resume or curriculum vitae, artist's statement and/or project description. ICP can only accept portfolio submissions via mail (or FedEx, etc.). Please include a SASE for the return of materials. ICP cannot return portfolios submitted without return postage."

INTERNATIONAL VISIONS GALLERY

2629 Connecticut Ave. NW, Washington DC 20008. (202)234-5112. Fax: (202)234-4206. E-mail: intvisions@aol.com. Website: www.inter-visions.com. **Contact:** Timothy Davis, owner/director. For-profit gallery. Estab. 1997. Approached by 60 artists/year; represents or exhibits 50 artists. Sponsors 1 photography exhibit/year. Average display time 4-6 weeks. Gallery open Wednesday through Saturday from 11 to 6. Located in the heart of Washington, DC; features 1,000 sq. ft. of exhibition space. Overall price range $1,000-8,000. Most work sold at $2,500.

Exhibits Exhibits photos of babies/children/teens, multicultural.

Making Contact & Terms Artwork is accepted on consignment, and there is a 50% commission. Gallery provides insurance, promotion, contract. Accepted work should be framed. Requires exclusive representation locally.

Submissions Call. Send query letter with artist's statement, bio, photocopies, résumé, SASE. Responds in 2 months. Finds artists through word of mouth, art exhibits, referrals by other artists.

◼ JACKSON FINE ART

3115 E. Shadowlawn Ave., Atlanta GA 30305. (404)233-3739. Fax: (404)233-1205. E-mail: info@jacksonfineart.com. Website: www.jacksonfineart.com. **Contact:** Malia Stewart, associate director. Estab. 1990. Exhibitions are rotated every 6 weeks. Gallery open Tuesday through Saturday from 10 to 5. Overall price range $600-500,000. Most work sold at $5,000.

Exhibits Interested in innovative photography, avant garde, fine art.

Making Contact & Terms Only buys vintage photos outright. Requires exclusive representation locally. Exhibits only nationally known artists and emerging artists who show long term potential. "Photographers must be established, preferably published in books or national art publications. They must also have a strong biography, preferably museum exhibitions, national grants."

Submissions Send JPEG files via e-mail, or CD-ROM by mail with SASE for return. Responds in 3 months, only if interested. Unsolicited original work is not accepted.

JADITE GALLERIES

413 W. 50th St., New York NY 10019. (212)315-2740. Fax: (212)315-2793. E-mail: jaditeart@aol.com. Website: www.jadite.com. **Contact:** Roland Sainz, director. Estab. 1985. Sponsors 3-4 exhibits/year. Average display time 1 month. Open Monday through Saturday from 12 to 6. Overall price range $300-5,000. Most work sold at $1500.

Exhibits Exhibits photos of landscapes/scenics, architecture, cities/urban, travel. Interested in avant garde, documentary and b&w, color and mixed media.

Making Contact & Terms Gallery receives 40% commission. There is a rental fee for space (50/50 split of expenses such as invitations, advertising, opening reception, etc.). Accepted work should be framed.

Submissions Arrange a personal interview to show portfolio. Responds in 5 weeks.

▣ JAMESON GALLERY & FRAME AND THE JAMESON ESTATE COLLECTION

305 Commercial St., Portland ME 04101. (207)772-5522. E-mail: info@jamesongallery.com. Website: www.jamesongallery.com. **Contact:** Martha Gilmartin, gallery director. Retail gallery, custom framing, restoration, appraisals, consultation. Estab. 1992. Represents 20 + artists/year. Mounts 6 shows/year. Average display time 3-4 weeks. Open all year; Monday through Saturday from 10 to 6, and by appointment. Located on the waterfront in the heart of the shopping district; 4,000 sq. ft.; 50% of space for contemporary artists, 25% for frame shop, 25% for The Jameson Estate Collection dealing later 19th- and 20th-century paintings, drawings and photographs. Most work sold at $1,500 and up.

Exhibits B&W photography.

Submissions Send CV and artist's statement, a sampling of images on a PC-compatible CD or Zip, and SASE if you would like the materials returned. "We will not open unsolicited e-mail attachments. We do view photographers' Web sites."

▣ JHB GALLERY

26 Grove St., Suite 4C, New York NY 10014-5329. (212)255-9286. Fax: (212)229-8998. E-mail: info@jhbgallery.com. Website: www.jhbgallery.com. Private art dealer and consultant. Estab. 1982. Gallery open by appointment only. Overall price range $1,000-20,000. Most work sold at $2,500-5,000.

Making Contact & Terms Artwork is accepted on consignment, and there is a 50% commission. Gallery provides promotion.

Submissions "We accept submissions via Internet." Send query letter with résumé, CD, slides, artist's statement, reviews, SASE. Finds artists through submissions, portfolio reviews, art exhibits, art fairs, referrals by other curators.

STELLA JONES GALLERY

Place St. Charles, 201 St. Charles, New Orleans LA 70170. (504)568-9050. Fax: (504)568-0840. E-mail: jones6941@aol.com. Website: www.stellajonesgallery.com. **Contact:** Stella Jones. For-profit gallery. Estab. 1996. Approached by 40 artists/year; represents or exhibits 45 artists. Sponsors 1 photography exhibit/year. Average display time 6-8 weeks. Gallery open Monday through Friday from 11 to 6; Saturday from 12 to 5. Located on 1st floor of corporate 53-story office building downtown, 1 block from French Quarter. Overall price range $500-150,000. Most work sold at $5,000.

Exhibits Exhibits photos of babies/children/teens, multicultural, families, cities/urban, education, religious, rural.

Making Contact & Terms Artwork is accepted on consignment, and there is a 50% commission. Gallery provides insurance, promotion, contract. Accepted work should be framed. Requires exclusive representation locally.

Submissions Call to show portfolio of photographs, slides, transparencies. Mail portfolio for review. Send query letter with artist's statement, bio, brochure, business card, photocopies, photographs, résumé, reviews, slides, SASE. Responds in 1 month. Finds artists through word of mouth, submissions, portfolio reviews, art exhibits, referrals by other artists.

Tips "Photographers should be organized with good visuals."

⊠ JONSON GALLERY, UNIVERSITY OF NEW MEXICO

MSC04 2570 1 University of New Mexico, Albuquerque NM 87131. (505)277-8927. Fax: (505)277-7315. E-mail: jonsong@unm.edu. Website: www.unm.edu/~jonsong. Alternative space, gallery and museum set within the UNM Art Museum. Estab. 1950. Three to six exhibitions per year that may include photography and related mediums. Average display time 12-14 weeks. Gallery open Tuesday through Friday 1 to 4. Beginning May 2010, the gallery will be open Tuesday 10 to 8, Wednesday - Friday from 10 to 4, and Saturday and Sunday 1-4. Closed mid-December - January 1.

Exhibits all mediums, avant garde.

Making Contact & Terms Artwork is accepted on consignment, and there is a 25% commission. Gallery normally provides insurance, promotion. Accepted work should be framed.

Submissions Mail digital versions of artworks on CD/DVD. Include SASE, cover letter, proposal, artist statement, bio, resume, and other supporting materials. Proposals reviewed regularly by UNM Art Museum exhibitions committee.

▣ KIRCHMAN GALLERY

213 N. Nugent St., Johnson City TX 78636. 830-868-9290. E-mail: susan@kirchmangallery.com. Website: www.kirchmangallery.com. **Contact:** Susan Kirchman, owner/director. Art consultancy and for-profit gallery. Estab. 2005. Represents or exhibits 25 artists. Average display time 1 month. Sponsors 4 photography exhibits/year. Open Wednesday through Sunday from 11 to 6; any time by appointment. Located across from Johnson City's historic Courthouse Square in the heart of Texas hill country. Overall price range $250-25,000. Most work sold at $500-1,000.

Exhibits Exhibits photos of landscapes/scenics. Interested in alternative process, avant garde, fine art.

Making Contact & Terms Artwork is accepted on consignment, and there is a 50% commission.

Submissions "Send 20 digital-format examples of your work, along with a resume and artist's statement."

▣ ROBERT KLEIN GALLERY

38 Newbury St., 4th Floor, Boston MA 02116. (617)267-7997. Fax: (617)267-5567. E-mail: inquiry@robertkleingallery.com. Website: www.robertkleingallery.com. **Contact:** Robert L. Klein, owner or Eunice Hurd, director. Estab. 1978. Sponsors 10 exhibits/year. Average display time 5 weeks. Overall price range $1,000-200,000.

Exhibits Interested in fashion, documentary, nudes, portraiture, and work that has been fabricated to be photographs.

Making Contact & Terms Charges 50% commission. Buys photos outright. Accepted work should be unframed, unmmatted, unmounted. Requires exclusive representation locally. Must be established a minimum of 5 years; preferably published.

Submissions "Send materials by e-mail or mail with SASE for consideration."

ROBERT KOCH GALLERY

49 Geary St., San Francisco CA 94108. (415)421-0122. Fax: (415)421-6306. E-mail: info@

kochgallery.com. Website: www.kochgallery.com. For-profit gallery. Estab. 1979. Sponsors 6-8 photography exhibits/year. Average display time 2 months. Gallery open Tuesday through Saturday from 10:30 to 5:30.

Making Contact & Terms Artwork is accepted on consignment. Gallery provides insurance, promotion, contract. Requires West Coast or national representation.

Submissions Finds artists through publications, art exhibits, art fairs, referrals by other artists and curators, collectors, critics.

▣ PAUL KOPEIKIN GALLERY

8810 Melrose Av., West Hollywood CA 90069. (323)937-0765. Fax: (323)937-5974. E-mail: info@KopeikinGallery.com. Website: www.KopeikinGallery.com. Estab. 1990. Sponsors 7-9 exhibits/year. Average display time 4-6 weeks.

Exhibits No restrictions on type, style or subject. "Multimedia also considered."

Making Contact & Terms Charges 50% commission. Requires exclusive West Coast representation. "Must be highly professional. Quality and unique point of view also important."

Submissions *Not currently accepting submissions.*

Tips "Don't waste people's time by showing work before you're ready to do so."

LA ART ASSOCIATION/GALLERY 825

825 N. La Cienega Blvd., Los Angeles CA 90069. (310)652-8272. Fax: (310)652-9251. E-mail: gallery825@laaa.org. Website: www.laaa.org. **Contact:** Peter Mays, executive director. Artistic Director: Sinead Finnerty-Pyne. Estab. 1925. Sponsors 16 exhibits/year. Average display time 4-5 weeks. Sponsors openings. Overall price range $200-5,000. Most work sold at $600. **Exhibits** Considers all media and original handpulled prints. Fine art only. No crafts. Most frequently exhibits mixed media, oil/acrylic, and watercolor. Exhibits all styles.

Making Contact & Terms Retail price set by artist. Gallery provides promotion.

Submissions Submit 2 pieces during biannual screening date. Responds immediately following screening. Call for screening dates.

Tips "Bring work produced in the last three years. No commercial work (i.e. portraits or advertisements)."

⊘ ELIZABETH LEACH GALLERY

417 NW Ninth Ave., Portland OR 97209-3308. (503)224-0521. Fax: (503)224-0844. E-mail: art@elizabethleach.com. Website: www.elizabethleach.com. **Contact:** Daniel Peabody, director. Sponsors 3-4 exhibits/year. Average display time 1 month. "The gallery has extended hours every first Thursday of the month for our openings." Overall price range $300-5,000.

Exhibits Photographers must meet museum conservation standards. Interested in "high-quality concept and fine craftmanship."

Making Contact & Terms Charges 50% commission. Accepted work should be framed or unframed, matted. Requires exclusive representation locally.

Submissions Not accepting submissions at this time.

LEEPA-RATTNER MUSEUM OF ART

P.O. Box 1545, 600 Klosterman Rd., Palm Harbor FL 34683. (727)712-5762. Fax: (727)712-5223. E-mail: LRMA@spcollege.edu. Website: www.spcollege.edu/museum. **Contact:** Lynn Whitelow, director. Museum. Estab. 2002. Open Tuesday through Saturday from 10 to 5; Thursday from 1 to 9; Sunday from 1 to 5. Located on the Tarpon Springs campus of St. Petersburg College.

Exhibits Exhibits photos of babies/children/teens, celebrities, couples, multicultural, families, parents, senior citizens, architecture, cities/urban, education, gardening, interiors/decorating, pets, religious, rural, agriculture, business concepts, industry, medicine, military, political, product shots/still life, science, technology/computers, disasters, environmental, landscapes/scenics, wildlife, adventure, automobiles, entertainment, events, food/drink, health/fitness/beauty, hobbies, humor, performing arts, sports, travel. Interested in alternative process, avant garde, documentary, erotic, fashion/glamour, fine art, historical/vintage, seasonal.

N ⊘ LEWIS LEHR INC.

444 E. 86th St., New York NY 10028. (212)288-6765. **Contact:** Lewis Lehr, director. Estab. 1984. Private dealer. Overall price range $50-30,000.

Exhibits Exhibits FSA, Civil War camera work and European vintage.

Making Contact & Terms Buys vintage photos. No submissions accepted.

Tips Vintage American sells best. Sees trend toward "more color and larger" print sizes. To break in, "knock on doors."

DAVID LEONARDIS GALLERY

1346 N. Paulina St., Chicago IL 60622. (773)278-3058. E-mail: david@dlg-gallery.com. Website: www.dlg-gallery.com. **Contact:** David Leonardis, owner. For-profit gallery. Estab. 1992. Approached by 100 artists/year; represents or exhibits 12 artists. Average display time 30 days. Gallery open Tuesday through Saturday from 12 to 7; Sunday from 12 to 6. "One big room, four big walls." Overall price range $50-5,000. Most work sold at $500.

Exhibits Exhibits photos of celebrities. Interested in fine art.

Making Contact & Terms Artwork is accepted on consignment, and there is a 50% commission. Gallery provides promotion. Accepted work should be framed.

Submissions E-mail to arrange a personal interview to show portfolio. Mail portfolio for review. Send query letter via e-mail. Responds only if interested. Finds artists through word of mouth, art exhibits, referrals by other artists.

Tips "Artists should be professional and easy to deal with."

LIMITED EDITIONS & COLLECTIBLES

697 Haddon, Collingswood NJ 08108. (856)869-5228. E-mail: jdl697ltd@juno.com. Website: www.ltdeditions.net. **Contact:** John Daniel Lynch, Sr., owner. For-profit online gallery. Estab. 1997. Approached by 24 artists/year; represents or exhibits 70 artists. Sponsors 20 photography exhibits/year. Overall price range $100-3,000. Most work sold at $450.

Exhibits Exhibits photos of landscapes/scenics, wildlife, adventure, automobiles, entertainment, events, food/drink, health/fitness/beauty, hobbies, humor, performing arts, sports, travel. Interested in alternative process, documentary, erotic, fashion/glamour, historical/vintage, seasonal.

Making Contact & Terms Artwork is accepted on consignment, and there is a 30% commission. Gallery provides insurance, promotion, contract.

Submissions Call or write to show portfolio. Send query letter with bio, business card, résumé. Responds in 1 month. Finds artists through word of mouth, portfolio reviews, art exhibits, referrals by other artists.

LIMNER GALLERY

123 Warren St., Hudson NY 12534. (518)828-2343. E-mail: slowart@aol.com. Website: www. slowart.com. **Contact:** Trevor Pryce, director. Alternative space. Estab. 1987. Approached by 200-250 artists/year; represents or exhibits 90-100 artists. Sponsors 2 photography exhibits/year. Average display time 4 weeks. Open Wednesday through Sunday from 11 to 5. Closed January, July-August (weekends only). Located in the art and antiques center of the Hudson Valley. Exhibition space is 1,000 sq. ft.

Exhibits Interested in alternative process, avant garde, documentary, erotic, fine art, historical/vintage.

Submissions Artists should e-mail a link to their Web site; or download exhibition application at http://www.slowart.com/prospectus; or send query letter with artist's statement, bio, brochure or photographs/slides, SASE. Finds artists through submissions.

Tips "Artist's website should be simple and easy to view. Complicated animations and scripted design should be avoided, as it is a distraction and prevents direct viewing of the work. Not all galleries and art buyers have cable modems. The website should either work on a telephone line connection or two versions of the site should be offered—one for telephone, one for cable/high-speed Internet access."

N LIZARDI/HARP GALLERY

P.O. Box 91895, Pasadena CA 91109. (626)791-8123. Fax: (626)791-8887. E-mail: lizardiharp@ earthlink.net. **Contact:** Grady Harp, director. Estab. 1981. Sponsors 3-4 exhibits/year. Average display time 4-6 weeks. Overall price range $250-1,500. Most work sold at $500.

Exhibits Primarily interested in the figure. Also exhibits photos of celebrities, couples, religious, performing arts. "Must have more than one portfolio of subject, unique slant and professional manner." Interested in avant garde, erotic, fine art, figurative, nudes, "maybe" manipulated work, documentary and mood landscapes, both b&w and color.

Making Contact & Terms Charges 50% commission. Accepted work should be unframed, unmounted; matted or unmatted.

Submissions Submit portfolio for review. Send query letter by mail résumé, samples, SASE. Responds in 1 month.

Tips Include 20 labeled slides, résumé and artist's statement with submission. "Submit at least 20 images that represent bodies of work. I mix photography of figures, especially nudes, with shows on painting."

MACNIDER ART MUSEUM

303 Second St. SE, Mason City IA 50401. (641)421-3666. Fax: (641)422-9612. E-mail: blanchard@macniderart.org. Website: www.macniderart.org. Nonprofit gallery. Estab. 1966. Represents or exhibits 1-10 artists. Sponsors 2-5 photography exhibits/year (1 is

competitive for the county). Average display time 2 months. Gallery open Tuesday and Thursday from 9 to 9; Wednesday, Friday, Saturday from 9 to 5; Sunday from 1 to 5. Closed Monday. Overall price range $50-2,500. Most work sold at $200.

Making Contact & Terms Artwork is accepted on consignment, and there is a 40% commission. Gallery provides insurance, promotion, contract. Accepted work should be framed.

Submissions Mail portfolio for review. Responds within 3 months, only if interested. Finds artists through word of mouth, submissions, portfolio reviews, art exhibits, art fairs, referrals by other artists. Exhibition opportunities: exhibition in galleries, presence in museum shop on consignment or booth at Festival Art Market in June.

◰ MAIN AND THIRD FLOOR GALLERIES

Northern Kentucky University, Nunn Dr., Highland Heights KY 41099. (859)572-5148. Fax: (859)572-6501. E-mail: knight@nku.edu. Website: www.nku.edu/~art/galleries.html. **Contact:** David J. Knight, director of collections and exhibitions. Estab. 1970. Approached by 30 artists/year; represents or exhibits 5-6 artists. Average display time 1 month. Gallery open Monday through Friday from 9 to 9; weekends by appointment. Closed between fall and spring semesters, university holidays. Main Gallery is 2,500 sq. ft.; Third Floor Gallery is 600 sq. ft. Overall price range $25-3,000. Most work sold at $500.

Making Contact & Terms Gallery provides insurance, promotion, contract. Accepted work should be framed, mounted, matted.

Submissions Finds artists through word of mouth, art exhibits, referrals by other faculty.

Tips "Submission guidelines, current exhibitions and complete information is available on our website."

◰ THE MAIN STREET GALLERY

105 Main St., P.O. Box 161, Groton NY 13073. (607)898-9010. Website: www.mainstreetgal. com. **Contact:** Adrienne Bea Smith, director. For-profit gallery and art consultancy. Estab. 2003. Exhibits 15 artists. Sponsors 1 photography exhibit/year. Average display time 5-6 weeks. Open Thursday through Saturday from 12 to 6; Sunday from 1 to 5. Closed January and February. Located in the village of Groton in the Finger Lakes Region of New York, 20 minutes from Ithaca; 900 sq. ft. Overall price range: $120-5,000.

Exhibits Interested in fine art.

Submissions Write to arrange a personal interview to show portfolio of photographs, slides. Send query letter with artist's statement, bio, brochure, photographs, résumé, reviews, slides/CD images, SASE. Responds to queries in 1 month, only if interested. Finds artists through art exhibits, portfolio reviews, referrals by other artists, submissions, word of mouth.

Tips After submitting materials, the artist will set an appointment to talk over work. Artists should send in up-to-date résumé and artist's statement.

MARKEIM ART CENTER

104 Walnut Street, Haddonfield NJ 08033. (856)429-8585. Fax: (856)429-8585. E-mail: markeim@verizon.net. Website: www.markeimartcenter.org. **Contact:** Elizabeth Madden, executive director. Estab. 1956. Sponsors 10-11 exhibits/year. Average display time 4 weeks.

"The exhibiting artist is responsible for all details of the opening." Overall price range $75-1,000. Most work sold at $350.

Exhibits Interested in all types work. Exhibits photos of babies/children/teens, celebrities, couples, multicultural, families, parents, senior citizens, environmental, landscapes/scenics, wildlife, architecture, cities/urban, education, rural, adventure, automobiles, entertainment, performing arts, sports, travel, agriculture, product shots/still life. Interested in alternative process, avant garde, documentary, fine art, historical/vintage, seasonal.

Making Contact & Terms Charges 30% commission. Accepted work should be framed, mounted or unmounted, matted or unmatted. "Artists from New Jersey and Delaware Valley region are preferred. Work must be professional and high quality."

Submissions Send slides by mail for consideration. Include SASE, résumé and letter of intent. Responds in 1 month.

Tips "Be patient and flexible with scheduling. Look not only for one-time shows, but for opportunities to develop working relationships with a gallery. Establish yourself locally and market yourself outward."

MARLBORO GALLERY

Prince George's Community College, 301 Largo Rd., Largo MD 20772-2199. (301)322-0965. Fax: (301)808-0418. E-mail: tberault@pgcc.edu. Website: www.pgcc.edu. **Contact:** Tom Berault, curator-director. Estab. 1976. Average display time 1 month. Overall price range $50-2,000. Most work sold at $75-350.

Exhibits Exhibits photos of celebrities, landscapes/scenics, wildlife, adventure, entertainment, events, travel. Interested in alternative process, avant garde, fine art. Not interested in commercial work.

Making Contact & Terms "We do not take commission on artwork sold." Accepted work must be framed.

Submissions "We are looking for fine art photos; we need 10-20 to make assessment. Reviews are done every 6 months. We prefer to receive submissions February through April." Send query letter with résumé, slides, photographs, artist statement, bio and SASE. Responds in 1 month.

Tips "Send examples of what you wish to display, and explanations if photos do not meet normal standards (i.e., in focus, experimental subject matter)."

MASUR MUSEUM OF ART

1400 S. Grand St., Monroe LA 71202. (318)329-2237. Fax: (318)329-2847. E-mail: info@masurmuseum.org. Website: www.ci.monroe.la.us/masurmuseum.php. **Contact:** Anne Archer Dennington, Director. Estab. 1963. Approached by 500 artists/year; represents or exhibits 150 artists. Sponsors 2 photography exhibits/year. Average display time 2 months. Museum open Tuesday through Thursday from 9 to 5; Friday through Sunday from 2 to 5. Closed Mondays, between exhibitions and on major holidays. Located in historic home, 3,000 sq. ft. Overall price range $100-12,000. Most work sold at $300.

Exhibits Exhibits photos of babies/children/teens, celebrities, environmental, landscapes/scenics. Interested in alternative process, avant garde, documentary, fine art, historical/vintage.

Making Contact & Terms Artwork is accepted on consignment, and there is a 20%

commission. Gallery provides insurance, promotion. Accepted work should be framed.

Submissions Send query letter with artist's statement, bio, résumé, reviews, slides, SASE. Responds in 6 months. Finds artists through word of mouth, submissions, art exhibits, referrals by other artists.

THE MAYANS GALLERY LTD.

601 Canyon Rd., Santa Fe NM 87501. (505)983-8068. E-mail: arte2@aol.com. **Contact:** Ernesto Mayans, director. Estab. 1977. Publishes books, catalogs and portfolios. Overall price range $200-5,000. "We exhibit Photogravures by Unai San Martin; Pigment prints by Pablo Mayans, Silver Gelatin prints by Richard Faller (Vintage Southwest Works) and Johanna Saretzki and Sean McGann (Nudes)."

Making Contact & Terms Charges 50% commission. Consigns. Requires exclusive representation within area.

Submissions Size limited to 16x20 maximum. Arrange a personal interview to show portfolio. Send query by mail with SASE for consideration. Responds in 2 weeks.

Tips "Please call before submitting."

MCDONOUGH MUSEUM OF ART

Youngstown State University, 525 Wick Ave., Youngstown OH 44555-1400. (330)941-1400. E-mail: labrothers@ysu.edu. Website: http://mcdonoughmuseum.ysu.edu/. **Contact:** Leslie Brothers, director. A center for contemporary art, education and community, the museum offers exhibitions in all media, experimental installation, performance, and regional outreach programs to the public. The museum is also the public outreach facility for the Department of Art and supports student and faculty work through exhibitions, collaborations, courses and ongoing discussion. Estab. 1991.

Submissions Send exhibition proposal.

MESA CONTEMPORARY ARTS AT MESA ARTS CENTER

P.O. Box 1466, Mesa AZ 85211-1466. (480)644-6560. Fax: (480)644-6576. E-mail: artscenterinfo@mesaartscenter.com. Website: www.mesaartscenter.com. **Contact:** Patty Haberman, curator. Not-for-profit art space. Estab. 1980.

Exhibits Exhibits photos of babies/children/teens, celebrities, couples, multicultural, families, parents, senior citizens, disasters, environmental, landscapes/scenics, wildlife, architecture, cities/urban, interiors/decorating, rural, adventure, automobiles, entertainment, events, performing arts, travel, industry, political, science, technology/computers. Interested in alternative process, avant garde, documentary, fine art, historical/vintage, seasonal, and contemporary photography.

Making Contact & Terms Charges $25 entry fee, 25% commission.

Submissions "Please view our online prospectus for further info, or contact Patty Haberman at (480)644-6561."

Tips "We do invitational or national juried exhibits. Submit professional-quality slides."

☑ R. MICHELSON GALLERIES

132 Main St., Northampton MA 01060. (413)586-3964. Fax: (413)587-9811. E-mail: RM@RMichelson.com. Website: www.RMichelson.com. **Contact:** Richard Michelson, owner and

president. Estab. 1976. Sponsors 1 exhibit/year. Average display time 6 weeks. Sponsors openings. Overall price range $1,200-$15,000.

Exhibits Interested in contemporary, landscape and/or figure work.

Making Contact & Terms Sometimes buys photos outright. Accepted work can be framed or unframed, mounted or unmounted, matted or unmatted. Requires exclusive representation locally. Not taking on new photographers at this time.

MILL BROOK GALLERY & SCULPTURE GARDEN

236 Hopkinton Rd., Concord NH 03301. (603)226-2046. E-mail: artsculpt@mindspring.com. Website: www.themillbrookgallery.com. For-profit gallery. Estab. 1996. Exhibits 70 artists. Sponsors 1 photography exhibit/year. Average display time 6 weeks. Gallery open Tuesday through Saturday from 11 to 5, April 1 to December 24; open by appointment December 25 to March 31. Outdoor juried sculpture exhibit. Three rooms inside for exhibitions, 1,800 sq. ft. Overall price range $8-30,000. Most work sold at $500-1,000.

Making Contact & Terms Artwork is accepted on consignment, and there is a 50% commission. Gallery provides insurance, promotion, contract. Accepted work should be framed, matted.

Submissions Write to arrange a personal interview to show portfolio of photographs, slides. Send query letter with artist's statement, bio, photocopies, photographs, résumé, slides, SASE. Responds within 1 month, only if interested. Finds artists through word of mouth, submissions, art exhibits, referrals by other artists.

PETER MILLER GALLERY

118 N. Peoria St., Chicago IL 60607. (312)951-1700. Fax: (312)226-5441. E-mail: director@petermillergallery.com. Website: www.petermillergallery.com. **Contact:** Peter Miller and Natalie R. Domchenko, directors. Estab. 1979. Gallery is 2,400 sq. ft. with 10-foot ceilings. Overall price range $1,000-40,000. Most work sold at $5,000.

Exhibits Painting, sculpture, photography and new media.

Making Contact & Terms Charges 50% commission. Accepted work can be framed or unframed, mounted or unmounted, matted or unmatted. Requires exclusive representation locally.

Submissions Send CD with minimum of 20 images (no details) from the last 18 months with SASE, or email a link to your website to info@petermillergallery.com.

Tips "We look for work we haven't seen before; i.e., new images and new approaches to the medium."

MOBILE MUSEUM OF ART

4850 Museum Dr., Mobile AL 36608. (251)208-5200. Fax: (251)208-5201. Website: www.mobilemuseumofart.com. **Contact:** Tommy McPherson, director. Estab. 1964. Sponsors 4 exhibits/year. Average display time 3 months. Sponsors openings; provides light hors d'oeuvres and wine.

Exhibits Open to all types and styles.

Making Contact & Terms Photography sold in gallery. Charges 20% commission. Occasionally buys photos outright. Accepted work should be framed.

Submissions Arrange a personal interview to show portfolio; send material by mail for

consideration. Returns material when SASE is provided "unless photographer specifically points out that it's not required."

Tips "We look for personal point of view beyond technical mastery."

MONTEREY MUSEUM OF ART

559 Pacific St., Monterey CA 93940. (831)372-5477. Fax: (831)372-5680. E-mail: info@ montereyart.org. Website: www.montereyart.org. **Contact:** E. Michael Whittington, executive director. Estab. 1969. Sponsors 3-4 exhibits/year. Average display time approximately 10 weeks. Open Wednesday through Saturday from 11 to 5; Sunday from 1 to 4.

- 2nd location: 720 Via Miranda, Monterey CA 93940; (831)372-3689.

Exhibits Interested in all subjects.

Making Contact & Terms Accepted work should be framed.

Submissions Send slides by mail for consideration; include SASE. Responds in 1 month.

Tips "Send 20 slides and résumé at any time to the attention of the museum curator."

MULTIPLE EXPOSURES GALLERY

105 N. Union St., #312, Alexandria VA 22314-3217. (703)683-2205. E-mail: multipleexposuresgallery@verizon.net. Website: www.multipleexposuresgallery.com/. **Contact:** Alan Sislen, president. Cooperative gallery. Estab. 1986. Represents or exhibits 14 artists. Sponsors 12 photography exhibits/year. Average display time 1-2 months. Open daily from 11 to 5. Closed on 5 major holidays throughout the year. Located in Torpedo Factory Art Center; 10-ft. walls with about 40 ft. of running wall space; 1 bin for each artist's matted photos, up to 20 × 24 in size with space for 25 pieces.

Exhibits Exhibits photos of landscapes/scenics, architecture, beauty, cities/urban, religious, rural, adventure, automobiles, events, travel, buildings. Interested in alternative process, documentary, fine art. Other specific subjects/processes: "We have on display roughly 300 images that run the gamut from platinum and older alternative processes through digital capture and output."

Making Contact & Terms There is a co-op membership fee, a time requirement, a rental fee and a 15% commission. Accepted work should be matted. *Accepts only artists from Washington, DC, region.* Accepts only photography. "Membership is by jury of active current members. Membership is limited. Jurying for membership is only done when a space becomes available; on average, 1 member is brought in about every 2 years."

Submissions Send query letter with SASE to arrange a personal interview to show portfolio of photographs, slides. Responds in 2 months. Finds artists through word of mouth, referrals by other artists, ads in local art/photography publications.

Tips "Have a unified portfolio of images mounted and matted to archival standards."

MUSEO DE ARTE DE PONCE

P.O. Box 9027, Ponce PR 00732-9027. (787)840-1510. Fax: (787)841-7309. E-mail: map@ museoarteponce.org. Website: www.museoarteponce.org. **Contact**: curatorial department. Museum. Estab. 1959. Approached by 50 artists/year; mounts 3 exhibitions/year. Museum currently closed until fall 2010. Satellite gallery in Plaza las Americas, San Juan open Monday through Sunday from 12 to 5. Closed New Year's Day, January 6, Good Friday, Thanksgiving and Christmas day.

Exhibits Interested in avant garde, fine art, European and Old Masters.

Submissions Send query letter with artist's statement, résumé, images, reviews, publications. Responds in 3 months. Finds artists through research, art exhibits, studio and gallery visits, word of mouth, referrals by other artists.

MUSEO ITALOAMERICANO

Fort Mason Center, Bldg. C, San Francisco CA 94123. (415)673-2200. Fax: (415)673-2292. E-mail: sfmuseo@sbcglobal.net. Website: www.museoitaloamericano.org. **Contact:** Susan Filippo, administrator. Museum. Estab. 1978. Approached by 80 artists/year; exhibits 15 artists. Sponsors 1 photography exhibit/year (depending on the year). Average display time 2-3 months. Gallery open Tuesday through Sunday from 12 to 4; Monday by appointment. Closed major holidays. Gallery is located in the San Francisco Marina District, with a beautiful view of the Golden Gate Bridge, Sausalito, Tiburon and Alcatraz; 3,500 sq. ft. of exhibition space.

Exhibits Exhibits photos of babies/children/teens, celebrities, couples, multicultural, families, parents, senior citizens, environmental, landscapes/scenics, architecture, cities/ urban, education, religious, rural, entertainment, events, food/drink, hobbies, humor, performing arts, sports, travel, product shots/still life. Interested in alternative process, avant garde, documentary, fine art, historical/vintage.

Making Contact & Terms "The museum rarely sells pieces. If it does, it takes 20% of the sale." Museum provides insurance, promotion. Accepted work should be framed, mounted, matted. *Accepts only Italian or Italian-American artists.*

Submissions Call or write to arrange a personal interview to show portfolio of photographs, slides, catalogs. Send query letter with artist's statement, bio, brochure, photographs, résumé, reviews, slides, SASE. Responds in 2 months. Finds artists through word of mouth, submissions.

Tips "Photographers should have good, quality reproduction of their work with slides, and clarity in writing their statements and résumés. Be concise."

▣ MUSEUM OF CONTEMPORARY ART SAN DIEGO

700 Prospect St., La Jolla CA 92037. (858)454-3541. Fax: (858)454-6985. Second location: 1001 Kettner Blvd., San Diego CA 92101. (619)234-1001. E-mail: info@mcasd.org. Website: www.mcasd.org. **Contact:** Curatorial Department. Museum. Estab. 1941. Open Monday through Sunday from 11 to 5 (both locations), Thursday until 7 (La Jolla only). Closed Wednesday and during installation (both locations).

Exhibits Exhibits photos of families, architecture, education. Interested in avant garde, documentary, fine art.

Submissions See Artist Proposal Guidelines at www.mcasd.org/information/proposals. asp.

▣ MUSEUM OF CONTEMPORARY PHOTOGRAPHY, COLUMBIA COLLEGE CHICAGO

600 S. Michigan Ave., Chicago IL 60605-1996. (312)663-5554. Fax: (312)344-8067. E-mail: mocp@colum.edu. Website: www.mocp.org. **Contact:** Rod Slemmons, director or Natasha Egan, associate director: Estab. 1984. "We offer our audience a wide range of provocative

exhibitions in recognition of photography's roles within the expanded field of imagemaking."
Sponsors 6 main exhibits and 4-6 smaller exhibits/year. Average display time 2 months.

Exhibits Exhibits photos of babies/children/teens, celebrities, couples, multicultural, families, parents, senior citizens, environmental, landscapes/scenics, architecture, cities/urban, rural, humor, performing arts, agriculture, medicine, political, science, technology/computers. Interested in alternative process, avant garde, documentary, fine art, mixed media, photojournalism, video. "All high-quality work considered."

Submissions Reviews portfolios, transparencies, images on CD. Interested in reviewing unframed work only. Submit portfolio for review; include SASE. Responds in 2-3 months. No critical review offered.

Tips "Professional standards apply; only very high-quality work considered."

▣ MUSEUM OF PHOTOGRAPHIC ARTS

1649 El Prado, Balboa Park, San Diego CA 92101. (619)238-7559. Fax: (619)238-8777. E-mail: info@mopa.org. Website: www.mopa.org. **Contact:** Deborah Klochko, director. Curator of Photography: Carol McCusker. Estab. 1983. Sponsors 12 exhibits/year. Average display time 3 months.

Exhibits Interested in the history of photography, from the 19th century to the present.

Making Contact & Terms "The criteria is simply that the photography be of advanced artistic caliber, relative to other fine art photography. MoPA is a museum and therefore does not sell works in exhibitions." Exhibition schedules planned 2-3 years in advance. Holds a private Members' Opening Reception for each exhibition.

Submissions "For space, time and curatorial reasons, there are few opportunities to present the work of newer, lesser-known photographers." Send a CD, website or JPEGs to curator. Curator will respond. If interested, will request materials for future consideration. Files are kept on contemporary artists of note for future reference. Send return address and postage if you wish your materials returned. Responds in 2 months.

Tips "Exhibitions presented by the museum represent the full range of artistic and journalistic photographic works. There are no specific requirements. The executive director and curator make all decisions on works that will be included in exhibitions. There is an enormous stylistic diversity in the photographic arts. The museum does not place an emphasis on one style or technique over another."

NEVADA MUSEUM OF ART

160 W. Liberty St., Reno NV 89501. (775)329-3333. Fax: (775)329-1541. Website: www.nevadaart.org. **Contact**: Curatorial department. Estab. 1931. Sponsors 12-15 exhibits/year in various media. Average display time 4-5 months.

Submissions See website for detailed submission instructions. No phone calls, please."

Tips "The Nevada Museum of Art is a private, nonprofit institution dedicated to providing a forum for the presentation of creative ideas through its collections, educational programs, exhibitions and community outreach. We specialize in art addressing the environment and the altered landscape."

▣ NEW ORLEANS MUSEUM OF ART

P.O. Box 19123, City Park, New Orleans LA 70179. (504)658-4110. Fax: (504)658-4199.

E-mail: dcortez@noma.org. Website: www.noma.org. **Contact:** Diego Cortez, curator of photography. Collection estab. 1973. Sponsors exhibits continuously. Average display time 1-3 months.

Exhibits Interested in all types of photography.

Making Contact & Terms Buys photography outright; payment negotiable. "Current budget for purchasing contemporary photography is very small." Sometimes accepts donations from established artists, collectors or dealers.

Submissions Send query letter with color photocopies (preferred) or slides, résumé, SASE. Accepts images in digital format; submit via website. Responds in 3 months.

Tips "Send thought-out images with originality and expertise. Do not send commercial-looking images."

NICOLAYSEN ART MUSEUM & DISCOVERY CENTER

400 E. Collins Dr., Casper WY 82601. (307)235-5247. Fax: (307)235-0923. E-mail: hturner@thenic.org. Website: www.thenic.org. **Contact:** Holly Turner, executive director. Director of Exhibitions and Programming: Ben Mitchell. Estab. 1967. Sponsors 10 exhibits/year. Average display time 3-4 months. Sponsors openings. Overall price range $250-1,500.

Exhibits Work must demonstrate artistic excellence and be appropriate to gallery's schedule. Interested in all subjects and media.

Making Contact & Terms Charges 40% commission.

Submissions Send material by mail for consideration (slides, résumé/CV, proposal); include SASE. Responds in 1 month.

▣ NORTHWEST ART CENTER

500 University Ave. W., Minot ND 58707. (701)858-3264. Fax: (701)858-3894. E-mail: nac@minotstateu.edu. Website: www.minotstateu.edu/nac. **Contact:** Avis Veikley, director. Estab. 1976. Sponsors 18-20 exhibits/year, including 2 national juried shows. Average display time 1 month. Northwest Art Center consists of 2 galleries: Hartnett Hall Gallery and the Library Gallery. Overall price range $50-2,000. Most work sold at $800 or less.

Exhibits Interested in alternative process, avant garde, documentary, fine art, historical/vintage.

Making Contact & Terms Charges 30% commission. Accepted work must be framed.

Submissions Send material by mail with SASE or e-mail for consideration. Responds within 3 months. Prospectus for juried shows available online.

▣ THE NOYES MUSEUM OF ART

733 Lily Lake Rd., Oceanville NJ 08231. (609)652-8848. Fax: (609)652-6166. E-mail: info@noyesmuseum.org. Website: www.noyesmuseum.org. **Contact:** Michael Cagno, Executive Director. Estab. 1983. Sponsors 10-12 exhibits/year. Average display time 12 weeks.

Exhibits Interested in alternative process, avant garde, fine art, historical/vintage.

Making Contact & Terms Charges 30% commission. Accepted work must be ready for hanging, preferably framed. Infrequently buys photos for permanent collection.

Submissions Any format OK for initial review. Send material by mail for consideration; include résumé, artist's statement, slide samples or CD.

Tips "Send challenging, cohesive body of work. May include photography and mixed media."

🌐 🖼 NUDOPIA GALLERY

15 Thermopilon St., 542 48 Analipsi, Thessaloniki, Greece. (30) (231)085-5950. E-mail: AgelouPhotography@gmail.com. Website: www.nudopiagallery.com. **Contact:** Mary Diangelo, art director. Giannis Angelous, owner. Estab. 2007. Online commercial fine art gallery.

Exhibits Artistic and contemporary nudes exclusively.

Making Contact & Terms Charges commission for fine art prints. Other uses, such as printed media (coffee table books, limited edition posters, calendars, etc.) are negotiable. See website for details. Responds within 6 weeks only if interested.

Submissions Initial contact by e-mail. Provide query letter, website portfolio link. Ground mail submission guidelines available on website. Accepts digital submissions only.

🖼 OAKLAND UNIVERSITY ART GALLERY

2200 N. Squirrel Rd./208 Wilson Hall, Rochester MI 48309-4401. (248)370-3005. Fax: (248)370-3377. E-mail: goody@oakland.edu. Website: www.oakland.edu/ouag. **Contact:** Dick Goody, director. Nonprofit gallery. Estab. 1962. Represents 10-25 artists/year. Sponsors 6 exhibits/year. Average display time 4-6 weeks. Open September-May: Tuesday through Sunday from 12 to 5; evenings during special events and theater performances (Wednesday through Friday from 7 through 1st intermission, weekends from 5 through 1st intermission). Closed Monday, holidays and June-August. Located on the campus of Oakland University; exhibition space is approximately 2,350 sq. ft. of floor space, 301-ft. linear wall space, with 10-ft. 7-in. ceiling. The gallery is situated across the hall from the Meadow Brook Theatre. "We do not sell work, but do make available price lists for visitors with contact information noted for inquiries."

Exhibits Considers all styles and all types of prints and media.

Making Contact & Terms Charges no commission. Gallery provides insurance, promotion and contract. Accepted work should be framed, mounted, matted. No restrictions on representation; however, prefers emerging Detroit artists.

Submissions E-mail bio, education, artist's statement and JPEG images. Mail portfolio for review. Send query letter with artist's statement, bio, photocopies, curriculum vitae. Returns material with SASE. Responds to queries in 1-2 months. Finds artists through referrals by other artists, word of mouth, art community, advisory board and other arts organizations.

O.K. HARRIS WORKS OF ART

383 W. Broadway, New York NY 10012. (212)431-3600. Fax: (212)925-4797. E-mail: okharris@okharris.com. Website: www.okharris.com. **Contact:** Ivan C. Karp, director. Estab. 1969. Sponsors 3-8 exhibits/year. Average display time 1 month. Gallery open Tuesday through Saturday from 10 to 6. Closed August and from December 25 to January 1. Overall price range $350-3,000.

Exhibits Exhibits photos of cities/urban, events, rural. "The images should be startling or profoundly evocative. No rocks, dunes, weeds or nudes reclining on any of the above or seascapes." Interested in urban and industrial subjects, "cogent photojournalism," documentary.

Making Contact & Terms Charges 50% commission. Accepted work should be matted and framed.

Submissions Appear in person, no appointment. Responds immediately.

Tips "Do not provide a descriptive text."

⃟N⃟ OPENING NIGHT GALLERY

2836 Lyndale Ave. S., Minneapolis MN 55408-2108. (612)872-2325. Fax: (612)872-2385. E-mail: deen@onframe-art.com. Website: www.onframe-art.com. **Contact:** Deen Braathen. Rental gallery. Estab. 1975. Approached by 40 artists/year; represents or exhibits 15 artists. Sponsors 1 photography exhibit/year. Average display time 6-10 weeks. Gallery open Monday through Friday from 8:30 to 5; Saturday from 10:30 to 4. Overall price range $300-12,000. Most work sold at $2,500.

Exhibits Exhibits photos of landscapes/scenics, architecture, cities/urban.

Making Contact & Terms Artwork is accepted on consignment, and there is a 50% commission. Gallery provides insurance, promotion, contract. Accepted work should be framed "by our frame shop." Requires exclusive representation locally.

Submissions Mail slides for review. Send query letter with artist's statement, bio, résumé, slides, SASE. Responds in 2 months. Finds artists through word of mouth, submissions, portfolio reviews.

⃟N⃟ ORLANDO GALLERY

18376 Ventura Blvd., Tarzaba CA 91356. (818)705-5368. E-mail: Orlando2@Earthlink.net. **Contact:** Robert Gino and Don Grant, directors. Estab. 1958. Average display time 1 month. Overall price range $200-1,500. Most work sold at $600-800.

Exhibits Interested in photography demonstrating "inventiveness" on any subject. Exhibits photos of environmental, landscapes/scenics, wildlife, architecture, cities/urban, gardening, religious, rural, adventure, automobiles, entertainment, performing arts, travel, agriculture, product shots/still life. Interested in avant garde, erotic, fashion/glamour, fine art, historical/vintage.

Making Contact & Terms Charges 50% commission. There is a rental fee for space: $50/month; $600/year. Requires exclusive representation in area.

Submissions Send query letter with resume. Send material by mail with SASE for consideration. Accepts images in digital format. Framed work only. Responds in 1 month.

Tips Make a good presentation. "Make sure that personality is reflected in images. We're not interested in what sells the best—just good photos."

LEONARD PEARLSTEIN GALLERY

The Antoinette Westphal College of Media Arts & Design, Drexel University, 33rd and Market Streets, Philadelphia PA 19104. (215)895-2548. Fax: (215)895-4917. E-mail: gallery@drexel.edu. Website: www.drexel.edu/academics/comad/gallery. **Contact:** Ephraim Russell, director. Nonprofit gallery. Estab. 1986. Sponsors 8 total exhibits/year; 1 or 2 photography exhibits/year. Average display time 1 month. Open Monday through Friday from 11 to 5. Closed during summer.

Making Contact & Terms Artwork is bought outright. Gallery takes 20% commission. Gallery provides insurance, promotion. Accepted work should be framed, mounted, matted.

"We will not pay transport fees."

Submissions Write to arrange a personal interview to show portfolio. Send query letter with artist's statement, bio, résumé, SASE. Returns material with SASE. Responds by February, only if interested. Finds artists through referrals by other artists, academic instructors.

PENTIMENTI GALLERY

145 N. Second St., Philadelphia PA 19106. (215)625-9990. E-mail: mail@pentimenti.com. Website: www.pentimenti.com. Commercial gallery. Estab. 1992. Average display time 6 weeks. Gallery open Tuesday by appointment; Wednesday through Friday from 11 to 5; Saturday from 12 to 5. Closed August, Christmas and New Year's Day. Located in the heart of Old City Cultural District in Philadelphia. Overall price range $500-10,000. Most work sold at $3,000.

Exhibits Exhibits photos of multicultural, families, environmental, landscapes/scenics, wildlife, architecture, cities/urban, gardening, entertainment, events. Interested in avant garde, documentary, fashion/glamour, fine art, historical/vintage.

Making Contact & Terms Artwork is accepted on consignment, and there is a 50% commission. Gallery provides insurance, promotion, contract. Accepted work should be framed, mounted, matted.

Submissions Send query letter with artist's statement, bio, brochure, photocopies, photographs, résumé, reviews, slides, SASE. Responds in 3 months. Finds artists through word of mouth, portfolio reviews, art fairs, referrals by other artists, curators, etc.

▣ PETERS VALLEY CRAFT CENTER

19 Kuhn Rd., Layton NJ 07851. (973)948-5202. Fax: (973)948-0011. E-mail: store.gallery@ petersvalley.org. Website: www.petersvalley.org. **Contact:** Mikal Brutzman, gallery manager. Nonprofit gallery and store. Estab. 1970. Approached by about 100 artists/year; represents about 350 artists. Average display time 1 month in gallery; varies for store items. Open year round; call for hours. Located in northwestern New Jersey in Delaware Water Gap National Recreation Area; 2 floors, approximately 3,000 sq. ft. Overall price range $5-3,000. Most work sold at $100-300.

Exhibits Considers all media and all types of prints. Also exhibits non-referential, mixed media, collage and sculpture.

Making Contact & Terms Artwork is accepted on consignment, and there is a 60% commission to artist. "Retail price set by the gallery in conjunction with artist." Gallery provides insurance and promotion. Accepted work should be framed, mounted and matted.

Submissions Submissions reviewed in March. Send query letter with artist's statement, bio, résumé and images (slides or CD of JPEGs). Returns material with SASE. Responds in 2 months. Finds artists through submissions, art exhibits, art fairs, referrals by other artists.

Tips "Submissions must be neat and well-organized throughout."

PHOENIX GALLERY

210 11th Ave. at 25th St., Suite 902, New York NY 10001. (212)226-8711. Fax: (212)343-7303. E-mail: info@phoenix-gallery.com. Website: www.phoenix-gallery.com. **Contact:** Linda Handler, director. Estab. 1958. Sponsors 10-12 exhibits/year. Average display time 1 month.

Overall price range $100-10,000. Most work sold at $3,000-8,000.

Exhibits "The gallery is an artist-run nonprofit organization; an artist has to be a member in order to exhibit in the gallery. There are 3 types of membership: active, inactive, and associate." Interested in all media; alternative process, documentary, fine art.

Making Contact & Terms Charges 25% commission.

Submissions Artists wishing to be considered for membership must submit an application form, slides and résumé. Call, e-mail or download membership application from website.

Tips "The gallery has a special exhibition space, The Project Room, where nonmembers can exhibit their work. If an artist is interested, he/she may send a proposal with art to the gallery. The space is free; the artist shares only in the cost of the reception with the other artists showing at that time."

PHOTOGRAPHIC RESOURCE CENTER

832 Commonwealth Ave., Boston MA 02215. (617)975-0600. Fax: (617)975-0606. E-mail: prc@bu.edu. Website: www.prcboston.org. **Contact:** Leslie K. Brown, curator. "The PRC is a nonprofit arts organization founded in 1976 to facilitate the study and dissemination of information relating to photography." Average display time 6 weeks. Open Tuesday, Wednesday and Friday from 10 to 6; Saturday and Sunday from 12 to 5; Thursday from 10 to 8. Closed major holidays. Located in the heart of Boston University. Gallery brings in nationally recognized artists to lecture to large audiences and host workshops on photography.

Exhibits Interested in contemporary and historical photography and mixed-media work incorporating photography.

Submissions Send query letter with artist's statement, bio, slides, résumé, reviews, SASE. Responds in 3-6 months. Finds artists through word of mouth, art exhibits, portfolio reviews.

Tips "Present a cohesive body of work."

▣ PHOTOGRAPHY ART

107 Myers Ave., Beckley WV 25801. (304)252-4060 or (304)575-6491. Fax: (304)252-4060 (call before faxing). E-mail: bruceburgin@photographyart.com. Website: www. photographyart.com. **Contact:** Bruce Burgin, owner. Internet rental gallery. Estab. 2003. "Each artist deals directly with his/her customers. I do not charge commissions and do not keep records of sales."

Exhibits Exhibits photos of landscapes/scenics, wildlife. Interested in fine art.

Making Contact & Terms There is a rental fee for space. The rental fee covers 1 year. The standard gallery is $360 to exhibit 40 images with biographical and contact info for 1 year. No commission charged for sales. Artist deals directly with customers and receives 100% of any sale. Gallery provides promotion.

Submissions Internet sign-up. No portfolio required.

Tips "An artist should have high-quality digital scans. The digital images should be cropped to remove any unnecessary background or frames, and sized according to the instructions provided with their Internet gallery. I recommend the artist add captions and anecdotes to the images in their gallery. This will give a visitor to your gallery a personal connection to you and your work."

THE PHOTOMEDIA CENTER
P.O. Box 8518, Erie PA 16505. (617)990-7867. E-mail: info@photomediacenter.org. Website: www.photomediacenter.org. **Contact:** Eric Grignol, executive director. Nonprofit gallery. Estab. 2004. Sponsors 12 "new" photography exhibits/year. "Previously featured exhibits are archived online. We offer many opportunities for artists, including sales, networking, creative collaboration and promotional resources; maintain an information board and slide registry for members; and hold an open annual juried show in the summer."
Exhibits Interested in alternative process, avant garde, documentary, fine art.
Making Contact & Terms Artwork is accepted on consignment, and there is a 25% commission. Gallery provides promotion. Prefers only artists working in photographic, digital and new media.
Submissions "We have a general portfolio review call in the fall for the following year's exhibition schedule. If after December 31, send query letter with artist's statement, bio, résumé, slides, SASE." Responds in 2-6 months. Finds artists through word of mouth, submissions, portfolio reviews, art exhibits, referrals by other artists.
Tips "We are looking for artists who have excellent technical skills, a strong sense of voice and cohesive body of work. Pay careful attention to our guidelines for submissions on our website. Label everything. Must include a SASE for reply."

PIERRO GALLERY OF SOUTH ORANGE
Baird Center, 5 Mead St., South Orange NJ 07079. (973)378-7755, ext. 3. Fax: (973)378-7833. E-mail: pierrogallery@southorange.org. Website: www.pierrogallery.org. **Contact:** Judy Wukitsch, gallery director. Nonprofit gallery. Estab. 1994. Approached by 75-185 artists/year; represents or exhibits 25-50 artists. Average display time 7 weeks. Open Friday through Sunday from 1 to 4; by appointment. Closed mid-December through mid-January and during August. Overall price range $100-10,000. Most work sold at $800.
Exhibits Interested in fine art, "which can be inclusive of any subject matter."
Making Contact & Terms Artwork is accepted on consignment, and there is a 15% commission. Gallery provides insurance, promotion, contract. Accepted work should be framed.
Submissions Mail portfolio for review; 3 portfolio reviews/year: January, June, October. Send query letter with artist's statement, résumé, slides. Responds in 2 months from review date. Finds artists through word of mouth, submissions, portfolio reviews, referrals by other artists.

POLK MUSEUM OF ART
800 E. Palmetto St., Lakeland FL 33801-5529. (863)688-7743. Fax: (863)688-2611. E-mail: info@polkmuseumofart.org. Website: www.polkmuseumofart.org. **Contact:** Todd Behrens, curator of art. Museum. Estab. 1966. Approached by 75 artists/year; represents or exhibits 3 artists. Sponsors 1-3 photography exhibits/year. Galleries open Tuesday through Saturday from 10 to 5; Sunday from 1 to 5. Closed major holidays. Four different galleries of various sizes and configurations.
Exhibits Interested in alternative process, avant garde, documentary, fine art, historical/vintage.
Making Contact & Terms Museum provides insurance, promotion, contract. Accepted work should be framed.

Submissions Mail portfolio for review. Send query letter with artist's statement, bio, résumé, slides, SASE.

ⓝ PRAKAPAS GALLERY

1 Northgate 6B, Bronxville NY 10708. (914)961-5091. Fax: (914)961-5192. E-mail: eugeneprakapas@optonline.net. **Contact:** Eugene J. Prakapas, director. Overall price range $500-100,000.

Making Contact & Terms Commission "depends on the particular situation."

Tips "We are concentrating primarily on vintage work, especially from between the World Wars, but some as late as the 1970s. We are not currently doing exhibitions and so are not a likely home for contemporary work. People expect vintage, historical work from us."

THE PRINT CENTER

1614 Latimer St., Philadelphia PA 19103. (215)735-6090. Fax: (215)735-5511. E-mail: info@printcenter.org. Website: www.printcenter.org. **Contact:** Ashley Peel Pinkham, assistant director. Nonprofit gallery and Gallery Store. Estab. 1915. Represents over 75 artists from around the world in Gallery Store. Sponsors 5 photography exhibits/year. Average display time 2 months. Open all year Tuesday through Saturday 11-5:30. Closed December 23 through January 4. Three galleries. Overall price range $15-15,000. Most work sold at $200.

Exhibits Exhibits contemporary prints and photographs of all processes. Accepts original artwork only - no reproductions.

Making Contact & Terms Accepts artwork on consignment (50% commission). Gallery provides insurance, promotion, contract. Artists must be printmakers or photographers.

Submissions Must be member to submit work—member's work is reviewed by Curator and Gallery Store Manager. See website for membership application. Finds artists through submissions, art exhibits, and membership.

▣ PUCKER GALLERY

171 Newbury St., Boston MA 02116. (617)267-9473. Fax: (617)424-9759. E-mail: contactus@puckergallery.com. Website: www.puckergallery.com. **Contact:** David Winkler, art director. For-profit gallery. Estab. 1967. Approached by 100 artists/year; represents or exhibits 40 artists. Sponsors 2 photography exhibits/year. Average display time 1 month. Gallery open Monday through Saturday from 10 to 5:30; Sunday from 1 to 5. Four floors of exhibition space. Overall price range $500-75,000.

Exhibits Exhibits photos of multicultural, environmental, landscapes/scenics, architecture, cities/urban, religious, rural. Interested in fine art, abstracts, seasonal.

Making Contact & Terms Gallery provides promotion.

Submissions Send query letter with artist's statement, bio, slides/CD, SASE. "We do not accept e-mail submissions." Finds artists through submissions, referrals by other artists.

PUMP HOUSE CENTER FOR THE ARTS

P.O. Box 1613, Chillicothe OH 45601. Phone/fax: (740)772-5783. E-mail: info@pumphouseartgallery.com. Website: www.pumphouseartgallery.com. **Contact:** Priscilla V.

Smith, director. Nonprofit gallery. Estab. 1991. Approached by 6 artists/year; represents or exhibits more than 50 artists. Average display time 6 weeks. Gallery open Tuesday through Friday from 11 to 4; weekends from 1 to 4. Closed Monday and major holidays. Overall price range $150-600. Most work sold at $300. Facility is also available for rent (business, meetings, reunions, weddings, wedding receptions or rehearsals, etc.).

Exhibits Exhibits photos of landscapes/scenics, wildlife, architecture, gardening, travel, agriculture. Interested in fine art, historical/vintage.

Making Contact & Terms Artwork is accepted on consignment, and there is a 30% commission. Gallery provides insurance, promotion. Accepted work should be framed, matted, wired for hanging. Call or stop in to show portfolio of photographs, slides. Send query letter with bio, photographs, slides, SASE. Responds in 1 month. Finds artists through word of mouth, submissions, portfolio reviews, art exhibits, art fairs, referrals by other artists.

Tips "All artwork must be original designs, framed, ready to hang (wired—no sawtooth hangers)."

QUEENS COLLEGE ART CENTER

Benjamin S. Rosenthal Library, Queens College, Flushing NY 11367-1597. (718)997-3770. Fax: (718)997-3753. E-mail: suzanna.simor@qc.cuny.edu. Website: www.qc.cuny.edu. **Contact:** Suzanna Simor, director. Curator: Alexandra de Luise. Estab. 1955. Average display time approximately 6 weeks. Overall price range $200-600.

Exhibits Open to all types, styles, subject matter; decisive factor is quality.

Making Contact & Terms Charges 40% commission. Accepted work can be framed or unframed, mounted or unmounted, matted or unmatted. Sponsors openings. Photographer is responsible for providing/arranging refreshments and cleanup.

Submissions Send query letter with résumé, samples and SASE. Responds after May annual review.

MARCIA RAFELMAN FINE ARTS

10 Clarendon Ave., Toronto ON M4V 1H9 Canada. (416)920-4468. Fax: (416)968-6715. E-mail: info@mrfinearts.com. Website: www.mrfinearts.com. **Contact:** Marcia Rafelman, president. Gallery Director: Meghan Richardson. Semi-private gallery. Estab. 1984. Average display time 1 month. Gallery is centrally located in Toronto; 2,000 sq. ft. on 2 floors. Overall price range $800-25,000. Most work sold at $1,500.

Exhibits Exhibits photos of environmental, landscapes. Interested in alternative process, documentary, fine art, historical/vintage.

Making Contact & Terms Charges 50% commission. Gallery provides insurance, promotion, contract. Requires exclusive representation locally.

Submissions Mail or e-mail portfolio for review; include bio, photographs, reviews. Responds within 2 weeks, only if interested. Finds artists through word of mouth, submissions, art fairs, referrals by other artists.

Tips "We only accept work that is archival."

THE RALLS COLLECTION INC.

1516 31st St. NW, Washington DC 20007. (202)342-1754. Fax: (202)342-0141. E-mail:

maralls@aol.com. Website: www.rallscollection.com. For-profit gallery. Estab. 1991. Approached by 125 artists/year; represents or exhibits 60 artists. Sponsors 7 photography exhibits/year. Average display time 1 month. Gallery open Tuesday through Saturday from 11 to 4 and by appointment. Closed Thanksgiving, Christmas. Overall price range $1,500-50,000. Most work sold at $2,500-15,000.

Exhibits Exhibits photos of babies/children/teens, celebrities, parents, landscapes/scenics, architecture, cities/urban, gardening, interiors/decorating, pets, rural, entertainment, health/fitness, hobbies, performing arts, sports, travel, product shots/still life. Interested in alternative process, avant garde, documentary, fashion/glamour, fine art, historical/vintage.

Making Contact & Terms Artwork is accepted on consignment, and there is a 50% commission. Gallery provides insurance, promotion, contract. Accepted work should be framed, matted. Requires exclusive representation locally. Accepts only artists from America.

Submissions Mail portfolio for review. Send query letter with artist's statement, bio, brochure, business card, photocopies, photographs, résumé, reviews, slides, SASE. Responds in 2 months. Finds artists through word of mouth, submissions, portfolio reviews, art exhibits, art fairs, referrals by other artists.

ROCHESTER CONTEMPORARY

137 East Ave., Rochester NY 14604. (585)461-2222. Fax: (585)461-2223. E-mail: info@rochestercontemporary.org. Website: www.rochestercontemporary.org. **Contact:** Elizabeth Switzer, programming director. Estab. 1977. Sponsors 10-12 exhibits/year. Average display time 4-6 weeks. Gallery open Wednesday through Friday from 1 to 6; weekends from 1 to 5. Overall price range $100-500.

Making Contact & Terms Charges 25% commission.

Submissions Send slides/CD, letter of inquiry, résumé and statement. Responds in 3 months.

SAN DIEGO ART INSTITUTE

1439 El Prado, San Diego CA 92101. (619)236-0011. Fax: (619)236-1974. E-mail: director@sandiego-art.org. Website: www.sandiego-art.org. **Executive Director:** Timothy J. Field. Administrative Director: Kerstin Robers. Art Director: K.D. Benton. Nonprofit gallery. Estab. 1941. Represents 600 emerging and mid-career member/artists. 2,400 artworks juried into shows each year. Sponsors 11 all-media exhibits/year. Average display time: 4-6 weeks. Open Tuesday-Saturday, 10-4; Sunday 12-4. Closed major holidays and all Mondays. 10,000 sq. ft., located in the heart of Balboa Park. Clients include local community, students and tourists. 10% of sales are to corporate collectors. Overall price range: $100-4,000; most work sold at $800.

Making Contact & Terms Artwork is accepted on consignment, and there is a 40% commission. Membership fee: $125/year. Retail price set by the artist. Accepted work should be framed. Work must be carried in by hand for each monthly show, except for annual international show juried by slides. Non-members have a $20 entry fee per submission.

Submissions Request membership packet and information about juried shows. Membership not required for submission in monthly juried shows, but fee required. Returns material

with SASE. Finds artists through word of mouth and referrals by other artists.

Tips "All work submitted must go through jury process for each monthly exhibition. Work required to be framed in professional manner."

SAN DIEGO ART INSTITUTE'S MUSEUM OF THE LIVING ARTIST

1439 El Prado, San Diego CA 92101. (619)236-0011. Fax: (619)236-1974. E-mail: admin@ sandiego-art.org. Website: www.sandiego-art.org. **Contact**: Kerstin Robers, executive administrator. Nonprofit gallery. Estab. 1941. Represents or exhibits 500 member artists. Overall price range $50-3,000. Most work sold at $700.

Exhibits Photos of babies/children/teens, couples, multicultural, families, parents, senior citizens, disasters, environmental, landscapes/scenics, wildlife, architecture, cities/urban, education, gardening, pets, rural, adventure, entertainment, events, food/drink, health/ fitness/beauty, hobbies, humor, performing arts, sports, travel, agriculture, political, product shots/still life, science, technology. Interested in alternative process, avant garde, documentary, erotic, fine art, historical/vintage, seasonal.

Making Contact & Terms Artwork is accepted on consignment, and there is a 40% commission. Membership fee: $125. Accepted work should be framed. Work must be carried in by hand for each monthly show except for annual international show, jpg online submission.

Submissions Membership not required for submission in monthly juried shows, but fee required. Artists interested in membership should request membership packet. Finds artists through referrals by other artists.

Tips "All work submitted must go through jury process for each monthly exhibition. Work must be framed in professional manner. No glass; plexiglass or acrylic only."

WILLIAM & FLORENCE SCHMIDT ART CENTER

Southwestern Illinois College, 2500 Carlyle Ave., Belleville IL 62221. E-mail: libby.reuter@ swic.edu. Website: www.schmidtartcenter.com. **Contact:** Libby Reuter, executive director. Nonprofit gallery. Estab. 2002. Sponsors 3-4 photography exhibits/year. Average display time 6-8 weeks. Open Tuesday through Saturday from 11 to 5 (to 8 on Thursday). Closed during college holidays.

Exhibits Interested in fine art and historical/vintage photography.

Submissions Mail portfolio for review. Send query letter with artist's statement, bio and slides. Finds artists through art fairs and exhibits, portfolio reviews, referrals by other artists, submissions and word of mouth.

▣ SCHMIDT/DEAN SPRUCE

1710 Samson St., Philadelphia PA 19103. (215)569-9433. Fax: (215)569-9434. E-mail: schmidtdean@netzero.net. Website: www.schmidtdean.com. **Contact:** Christopher Schmidt, director. For-profit gallery. Estab. 1988. Sponsors 4 photography exhibits/year. Average display time 6 weeks. Gallery open Tuesday through Saturday from 10:30 to 6. August hours are Tuesday through Friday from 10:30 to 6. Overall price range $1,000-70,000.

Exhibits Interested in alternative process, documentary, fine art.

Making Contact & Terms Charges 50% commission. Gallery provides insurance, promotion.

Accepted work should be framed, mounted, matted. Requires exclusive representation locally.

Submissions Call/write to arrange a personal interview to show portfolio of slides or CD. Send query letter with SASE. "Send 10 to 15 slides or digital images on CD and a résumé that gives a sense of your working history. Include a SASE."

▣ SECOND STREET GALLERY

115 Second St. SE, Charlottesville VA 22902. (434)977-7284. Fax: (434)979-9793. E-mail: ssg@secondstreetgallery.org. Website: www.secondstreetgallery.org. **Contact:** Catherine Barber, interim director. Estab. 1973. Sponsors approximately 2 photography exhibits/year. Average display time 1 month. Open Tuesday through Saturday from 11 to 6; 1st Friday of every month from 6 to 8, with Artist Talk at 6:30. Overall price range $300-2,000.

Making Contact & Terms Charges 30% commission.

Submissions Reviews slides/CDs in fall; $15 processing fee. Submit 10 slides or a CD for review; include artist statement, cover letter, bio/résumé, and most importantly, a SASE. Responds in 2 months.

Tips Looks for work that is "cutting edge, innovative, unexpected."

SELECT ART

1025 E. Levee St., Dallas TX 75207. E-mail: selart@swbell.net. **Contact:** Paul Adelson, owner. Estab. 1986. Overall price range $250-900.

• This market deals fine art photography to corporations and sells to collectors.

Exhibits Wants photos of architectural pieces, landscapes, automobiles and buildings. Interested in fine art.

Making Contact & Terms Charges 50% commission. Accepted work should be unframed and matted.

Submissions Send e-mail with visuals.

SOHO MYRIAD

1250 B Menlo Dr., Atlanta GA 30318. (404)351-5656. Fax: (404)351-8284. E-mail: sarahh@sohomyriad.com. Website: www.sohomyriad.com. **Contact:** Sarah Hall, director of art resources. Art consulting firm and for-profit gallery. Estab. 1997. Represents and/or exhibits over 2,000 artists. Sponsors 1 photography exhibit/year. Average display time 2 months. Gallery open Monday through Friday from 9 to 5:30. Overall price range $500-20,000. Most work sold at $500-5,000.

Exhibits Exhibits photos of landscapes/scenics, architecture, floral/botanical and abstracts. Interested in alternative process, avant garde, fine art, historical/vintage.

Making Contact & Terms *Currently not accepting submissions.* Artwork is accepted on consignment, and there is a 50% commission. Gallery provides insurance.

SOUTH DAKOTA ART MUSEUM

South Dakota State University, Box 2250, Brookings SD 57007. (605)688-5423 or (866)805-7590. Fax: (605)688-4445. Website: www.SouthDakotaArtMuseum.com. **Contact:** John Rychtarik, curator of exhibits. Museum. Estab. 1970. Sponsors 1-2 photography exhibits/year. Average display time 4 months. Gallery open Monday through Friday from 10 to 5;

Galleries

Saturday from 10 to 4; Sunday from 12 to 4. Closed state holidays. Seven galleries offer 26,000 sq. ft. of exhibition space. Overall price range $200-6,000. Most work sold at $500.
Exhibits Interested in alternative process, documentary, fine art.
Making Contact & Terms Artwork is accepted on consignment, and there is a 30% commission. Gallery provides insurance, promotion. Accepted work should be framed.
Submissions Send query letter with artist's statement, bio, résumé, slides, SASE. Responds within 3 months, only if interested. Finds artists through word of mouth, portfolio reviews, art exhibits, referrals by other artists.

▣ SOUTHSIDE GALLERY

150 Courthouse Square, Oxford MS 38655. (662)234-9090. E-mail: southside@ southsideartgallery.com. Website: www.southsideartgallery.com. **Contact:** Wil Cook, director. For-profit gallery. Estab. 1993. Average display time 4 weeks. Gallery open Monday through Saturday from 10 to 6; Sunday from 12 to 5. Overall price range $300-20,000. Most work sold at $425.
Exhibits Exhibits photos of landscapes/scenics, architecture, cities/urban, rural, entertainment, events, performing arts, sports, travel, agriculture, political. Interested in avant garde, fine art.
Making Contact & Terms Artwork is accepted on consignment, and there is a 55% commission. Gallery provides promotion. Accepted work should be framed.
Submissions Mail between 10 and 25 slides that reflect current work with SASE for review. CDs are also accepted with images in JPG or TIFF format. Include artist statement, biography, and resume. Responds within 4-6 months. Finds artists through submissions.

B.J. SPOKE GALLERY

299 Main St., Huntington NY 11743. (631)549-5106. E-mail: managerbjs@verizon.net. Website: www.bjspokegallery.com. **Contact:** Manager. Member-owned cooperative gallery. Average display time 1 month. Sponsors openings. Overall price range $300-2,500.
Exhibits Holds national/international juried competitions. Visit website for details. Interested in "all styles and genres, photography as essay, as well as 'beyond' photography."
Making Contact & Terms Charges 30% commission. Photographer sets price.
Submissions Arrange a personal interview to show portfolio. Send query letter with SASE.

▣ SRO PHOTO GALLERY AT LANDMARK ARTS

School of Art, Texas Tech University, Box 42081, Lubbock TX 79409-2081. (806)742-1947. Fax: (806)742-1971. E-mail: landmarkarts@ttu.edu. Website: www.landmarkarts. org. **Contact:** Joe R. Arredondo, Director. Nonprofit gallery. Estab. 1984. Hosts an annual competition to fill 8 solo photography exhibition slots each year. Average display time 4 weeks. Open Monday through Friday from 8 to 5; Saturday from 10 to 5; Sunday from 12 to 4. Closed university holidays.
Exhibits Interested in art utilizing photographic processes.
Making Contact & Terms "Exhibits are for scholarly purposes. Gallery will provide artist's contact information to potential buyers." Gallery provides insurance, promotion, contract. Accepted work should be matted.

Submissions Exhibitions are determined by juried process. See website for details (under Call for Entries). Deadline for applications is end of March.

THE STATE MUSEUM OF PENNSYLVANIA

300 North St., Harrisburg PA 17120-0024. (717)783-9904. Fax: (717)783-4558. E-mail: nstevens@state.pa.us. Website: www.statemuseumpa.org. **Contact:** N. Lee Stevens, senior curator of art collections. Museum established in 1905; current Fine Arts Gallery opened in 1993. Number of exhibits varies. Average display time 2 months. Overall price range $50-3,000.

Exhibits Fine art photography is a new area of endeavor for The State Museum, both collecting and exhibiting. Interested in works produced with experimental techniques.

Making Contact & Terms Work is sold in gallery, but not actively. Connects artists with interested buyers. No commission. Accepted work should be framed.

STATE OF THE ART

120 W. State St., Ithaca NY 14850. (607)277-1626 or (607)277-4950. E-mail: gallery@soag.org. Website: www.soag.org. Cooperative gallery. Estab. 1989. Sponsors 1 photography exhibit/year. Average display time 1 month. Gallery open Wednesday through Friday from 12 to 6; weekends from 12 to 5. Located in downtown Ithaca, 2 rooms about 1,100 sq. ft. Overall price range $100-6,000. Most work sold at $200-500.

Exhibits Exhibits photos in all media and subjects. Interested in alternative process, avant garde, fine art, computer-assisted photographic processes.

Making Contact & Terms There is a co-op membership fee plus a donation of time. There is a 10% commission for members, 30% for nonmembers. Gallery provides promotion, contract. Accepted work must be ready to hang. Write for membership application.

Tips Other exhibit opportunity: Annual Juried Photo Show in March. Application available on website in January.

STATE STREET GALLERY

1804 State St., La Crosse WI 54601. (608)782-0101. E-mail: ssg1804@yahoo.com. Website: www.statestreetartgallery.com. **Contact:** Ellen Kallies, president. Wholesale, retail and trade gallery. Estab. 2000. Approached by 15 artists/year; exhibits 12-14 artists/quarter in gallery. Average display time 4-6 months. Gallery open Tuesday through Saturday from 10 to 3. Located across from the University of Wisconsin/La Crosse. Overall price range $50-12,000. Most work sold at $500-1,200 and above.

Exhibits Exhibits photos of environmental, landscapes/scenics, architecture, cities/urban, gardening, rural, travel, medicine.

Making Contact & Terms Artwork is accepted on consignment, and there is a 40% commission. Gallery provides insurance, promotion, contract. Accepted work should be framed, matted.

Submissions Call or mail portfolio for review. Send query letter with artist's statement, photographs, slides, SASE. Responds in 1 month. Finds artists through word of mouth, art exhibits, art fairs, referrals by other artists.

Tips "Be organized, professional in presentation, flexible."

THE STUDIO: AN ALTERNATIVE SPACE FOR CONTEMPORARY ART

2 Maryland Ave., Armonk NY 10504-2029. (914)273-1452. Fax: (914)219-5030. E-mail: director@thestudiony-alternative.org. Website: www.thestudiony-alternative.org. **Contact:** Katie Stratis, director. Alternative space and nonprofit gallery. Estab. 1998. Located in Westchester County in the hamlet of Armonk, New York; approximately 500 sq. ft.; sculpture garden. "The Studio Annex in New York City is a satellite gallery of The Studio, and it also shows up to three exhibits a year."

Exhibits Exhibits photos of multicultural, architecture, gardening, rural, environmental, landscapes/scenics, entertainment, events, performing arts. Interested in alternative process, avant garde, documentary. "The subject matter is left up to the artists chosen to be in the curated exhibitions."

Making Contact & Terms Artwork is accepted on consignment, and there is a 30% commission.

Submissions "Curated exhibitions only; no open submission policy. Once a year there is a juried exhibition, but review Juried Prospectus before sending any submissions." See website for call for entries.

SYNCHRONICITY FINE ARTS

106 W. 13th St., New York NY 10011. (646)230-8199. Fax: (646)230-8198. E-mail: synchspa@bestweb.net. Website: www.synchronicityspace.com. Nonprofit gallery. Estab. 1989. Approached by hundreds of artists/year; represents or exhibits 12-16 artists. Sponsors 2-3 photography exhibits/year. Gallery open Tuesday through Saturday from 12 to 6. Closed 2 weeks in August. Overall price range $1,500-10,000. Most work sold at $3,000.

Exhibits Exhibits photos of multicultural, environmental, landscapes/scenics, architecture, cities/urban, education, rural, events, agriculture, industry, medicine, political. Interested in avant garde, documentary, fine art, historical/vintage.

Making Contact & Terms Gallery provides insurance, promotion, contract. Accepted work should be framed, mounted, matted.

Submissions Write to arrange a personal interview to show portfolio of photographs, transparencies, slides. Mail portfolio for review. Send query letter with photocopies, SASE, photographs, slides, résumé. Responds in 3 weeks. Finds artists through art exhibits, submissions, portfolio reviews, referrals by other artists.

TALLI'S FINE ART

Pho-Tal Inc., 15 N. Summit St., Tenafly NJ 07670. (201)569-3199. Fax: (201)569-3392. E-mail: tal@photal.com. Website: www.photal.com. **Contact:** Talli Rosner-Kozuch, owner. Alternative space, art consultancy, for-profit gallery, wholesale gallery. Estab. 1991. Approached by 38 artists/year; represents or exhibits 40 artists. Sponsors 12 photography exhibits/year. Average display time 1 month. Gallery open Monday through Sunday from 9 to 5. Closed holidays. Overall price range $200-3,000. Most work sold at $4,000.

Exhibits Exhibits photos of multicultural, architecture, cities/urban, education, gardening, interiors/decorating, pets, religious, rural, adventure, food/drink, travel, product shots/still life. Interested in alternative process, documentary, erotic, fine art, historical/vintage.

Making Contact & Terms Artwork is accepted on consignment, and there is a 50% commission. Accepted work should be framed, matted.

Submissions Write to arrange a personal interview to show portfolio of slides. Send query letter with artist's statement, bio, brochure, business card, photocopies, résumé, slides, SASE. Responds in 2 months. Finds artists through word of mouth, submissions, portfolio reviews, art exhibits, art fairs, referrals by other artists.

LILLIAN & COLEMAN TAUBE MUSEUM OF ART

2 N. Main St., Minot ND 58703. (701)838-4445. E-mail: taube@srt.com. Website: www. taubemuseum.org. **Contact:** Nancy Brown, executive director. Estab. 1970. Established nonprofit organization. Sponsors 1-2 photography exhibits/year. Average display time 4-6 weeks. Museum is located in a renovated historic landmark building with room to show 2 exhibits simultaneously. Overall price range $15-225. Most work sold at $40-100.

Exhibits Exhibits photos of babies/children/teens, couples, multicultural, families, parents, senior citizens, disasters, landscapes/scenics, wildlife, beauty, rural, travel, agriculture, buildings, military, portraits. Interested in avant garde, fine art.

Making Contact & Terms Charges 30% commission for members; 40% for nonmembers. Sponsors openings.

Submissions Submit portfolio along with a minimum of 6 examples of work in slide format for review. Responds in 3 months.

Tips "Wildlife, landscapes and floral pieces seem to be the trend in North Dakota. We get many slides to review for our photography exhibits each year. We also appreciate figurative, unusual and creative photography work. Do not send postcard photos."

NATALIE AND JAMES THOMPSON ART GALLERY

School of Art & Design, San José State University, San José CA 95192-0089. (408)924-4723. Fax: (408)924-4326. E-mail: jfh@cruzio.com. Website: www.sjsu.edu. **Contact:** Jo Farb Hernandez, director. Nonprofit gallery. Approached by 100 artists/year. Sponsors 1-2 photography exhibits/year. Average display time 1 month. Gallery open Tuesday through Friday from 11 to 4; Tuesday evenings from 6 to 7:30.

Exhibits "We are open to all genres, aesthetics and techniques."

Making Contact & Terms "Works are not generally for sale." Gallery provides insurance, promotion. Accepted work should be framed and/or ready to hang.

Submissions Send query letter with artist's statement, bio, résumé, reviews, slides, SASE. Responds as soon as possible. Finds artists through word of mouth, submissions, portfolio reviews, art exhibits, art fairs, referrals by other artists.

THROCKMORTON FINE ART

145 E. 57th St., 3rd Floor, New York NY 10022. (212)223-1059. Fax: (212)223-1937. E-mail: kraige@throckmorton-nyc.com. Website: www.throckmorton-nyc.com. **Contact:** Kraige Block, director. For-profit gallery. Estab. 1993. Approached by 50 artists/year; represents or exhibits 20 artists. Sponsors 5 photography exhibits/year. Average display time 2 months. Overall price range $1,000-10,000. Most work sold at $2,500.

Exhibits Exhibits photos of babies/children/teens, landscapes/scenics, architecture, cities/urban, rural. Interested in erotic, fine art, historical/vintage, Latin American photography.

Making Contact & Terms Charges 50% commission. Gallery provides insurance, promotion.

Submissions Write to arrange a personal interview to show portfolio of photographs/ slides/CD, or send query letter with artist's statement, bio, photocopies, slides, CD, SASE. Responds in 3 weeks. Finds artists through word of mouth, portfolio reviews.
Tips "Present your work nice and clean."

TURNER CARROLL GALLERY

725 Canyon Rd., Santa Fe NM 87501. (505)986-9800. Fax: (505)986-5027. E-mail: info@ turnercarrollgallery.com. Website: www.turnercarrollgallery.com. **Contact:** Tonya Turner Carroll, owner. Art consultancy and for-profit gallery. Estab. 1991. Approached by 50 artists/year; represents or exhibits 15 artists. Sponsors 1 photography exhibit/year. Average display time 4-6 weeks. Open daily from 10 to 6; Friday from 10 to 7. Three salon rooms; 1,200 sq. ft. Overall price range $1,000-40,000. Most work sold at $4,000-5,000.
Exhibits Interested in fine art.
Making Contact & Terms Artwork is accepted on consignment, and there is a 50% commission. Accepts only museum track artists. Requires exclusive representation locally.
Submissions Send e-mail query with JPEG samples at 72 dpi. Send query letter with artist's statement, bio, brochure, business card. Finds artists through art fairs.

▣ UCR/CALIFORNIA MUSEUM OF PHOTOGRAPHY

University of California, Riverside CA 92521. (951)784-3686. Fax: (951)827-4797. Website: www.cmp.ucr.edu. **Contact:** Director. Sponsors 10-15 exhibits/year. Average display time 8-14 weeks. Open Tuesday through Saturday from 12 to 5. Located in a renovated 23,000-sq.- ft. building. "It is the largest exhibition space devoted to photography in the West."
Exhibits Interested in technology/computers, alternative process, avant garde, documentary, fine art, historical/vintage.
Making Contact & Terms Curatorial committee reviews CDs, slides and/or matted or unmatted work. Photographer must have "highest-quality work."
Submissions Send query letter with résumé, SASE. Accepts images in digital format; send via CD, Zip.
Tips "This museum attempts to balance exhibitions among historical, technological, contemporary, etc. We do not sell photos but provide photographers with exposure. The museum is always interested in newer, lesser-known photographers who are producing interesting work. We're especially interested in work relevant to underserved communities. We can show only a small percent of what we see in a year."

UNI GALLERY OF ART

University of Northern Iowa, 104 Kamerick Art Bldg., Cedar Falls IA 50614-0362. (319)273-6134. E-mail: galleryofart@uni.edu. Website: www.uni.edu/artdept/gallery. **Contact:** Darrell Taylor, director. Estab. 1976. Sponsors 9 exhibits/year. Average display time 1 month. Approximately 5,000 sq. ft. of space and 424 ft. of usable wall space.
Exhibits Interested in all styles of high-quality contemporary art works.
Making Contact & Terms "We do not sell work."
Submissions Please provide a cover letter and proposal as well as an artist's statement, CV (curriculum vitae), and samples. Send material by mail for consideration or submit portfolio for review; include SASE for return of material. Response time varies.

UNION STREET GALLERY

1527 Otto Blvd., Chicago Heights IL 60411. (708)754-2601. E-mail: unionstreetart@ sbcglobal.net. Website: www.unionstreetgallery.org. **Contact**: Renee Klyczek Nordstrom, gallery administrator. Nonprofit gallery. Estab. 1995. Represents or exhibits more than 100 artists. "We offer group invitations and juried shows every year." Average display time 6 weeks. Gallery open Wednesday through Saturday from 12 to 4; 2nd Friday of every month from 6 to 9. Overall price range $30-3,000. Most work sold at $300-600.

Submissions Finds artists through submissions, referrals by other artists, juried exhibits at the gallery. "To receive prospectus for all juried events, call, write or e-mail to be added to our mailing list. Prospectus also available on website. Artists interested in studio space or solo/group exhibitions should contact the gallery to request information packets."

UNIVERSITY ART GALLERY IN THE D.W. WILLIAMS ART CENTER

New Mexico State University, MSC 3572, P.O. Box 30001, Las Cruces NM 88003-8001. (575)646-2545. Fax: (575)646-8036. E-mail: artglry@nmsu.edu. Website: www.nmsu. edu/~artgal. **Contact:** John Lawson, interim director. Estab. 1973. Sponsors 1 exhibit/ year. Average display time 2 months. Overall price range $300-2,500.

Making Contact & Terms Buys photos outright.

Submissions Arrange a personal interview to show portfolio. Submit portfolio for review. Send query letter with samples. Send material by mail with SASE by end of October for consideration. Responds in 3 months.

Tips Looks for "quality fine art photography. The gallery does mostly curated, thematic exhibitions. Very few one-person exhibitions."

UNIVERSITY OF KENTUCKY ART MUSEUM

Rose St. and Euclid Ave., Lexington KY 40506-0241. (859)257-5716. Fax: (859)323-1994. E-mail: jwelk3@email.uky.edu. Website: www.uky.edu/artmuseum. **Contact:** Janie Welker, curator. Museum. Estab. 1979.

Exhibits Annual photography lecture series and exhibits.

Submissions Prefers e-mail query with digital images. Responds in 6 months.

UNIVERSITY OF RICHMOND MUSEUMS

Richmond VA 23173. (804)289-8276. Fax: (804)287-1894. E-mail: rwaller@richmond. edu. Website: http://museums.richmond.edu. **Contact:** Richard Waller, director. Estab. 1968. "University Museums comprises Joel and Lila Harnett Museum of Art, Joel and Lila Harnett Print Study Center, and Lora Robins Gallery of Design from Nature." Sponsors 18-20 exhibits/year. Average display time 8-10 weeks.

Exhibits Interested in all subjects.

Making Contact & Terms Charges 10% commission. Work must be framed for exhibition.

Submissions Send query letter with résumé, samples. Send material by mail for consideration. Responds in 1 month.

Tips "If possible, submit material that can be left on file and fits standard letter file. We are a nonprofit university museum interested in presenting contemporary art as well as historical exhibitions."

◨ UNTITLED [ARTSPACE]

1 NE Third St., Oklahoma City OK 73103. Website: www.1ne3.org. **Contact:** Lori Deemer, operations director. Alternative space, nonprofit gallery. Estab. 2003. Average display time 6-8 weeks. Open Tuesday, Wednesday, Thursday from 11 to 6; Friday from 11 to 8; Saturday from 11 to 4. "Located in a reclaimed industrial space abandoned by decades of urban flight. Damaged in the 1995 Murrah Federal Building bombing, Untitled [[ArtSpace]] has emerged as a force for creative thought. As part of the Deep Deuce historic district in downtown Oklahoma City, Untitled [[ArtSpace]] brings together visual arts, performance, music, film, design and architecture. Our mission is to stimulate creative thought and new ideas through contemporary art. We are committed to providing access to quality exhibitions, educational programs, performances, publications, and to engaging the community in collaborative outreach efforts." Most work sold at $750.

Making Contact & Terms Artwork is accepted on consignment, and there is a 50% commission.

Submissions Mail portfolio for review. Send query letter with artist's statement, bio, résumé, slides, or CD of images. Prefers 10-15 images on a CD. Include SASE for return of materials or permission to file the portfolio. Reviews occur twice annually, in January and July. Finds artists through submissions, portfolio reviews. Responds to queries within 1 week, only if interested.

Tips "Review our previous programming to evaluate if your work is along the lines of our mission. Take the time to type and proof all written submissions. Make sure your best work is represented in the images you choose to show. Nothing takes away from the review like poorly scanned or photographed work."

UPSTREAM GALLERY

26 Main St., Dobbs Ferry NY 10522. (914)674-8548. E-mail: upstreamgallery26@gmail. com. Website: www.upstreamgallery.com. Cooperative gallery. Estab. 1990. Represents or exhibits 22 artists. Sponsors 1 photography exhibit/year. Average display time 1 month. Open all year; Thursday through Sunday from 12:30 to 5:30. Closed July and August (but an appointment can be made by calling 914-375-1693). "We have 2 store fronts, approximately 15 × 30 sq. ft. each." Overall price range: $300-2,000.

Exhibits Interested in fine art. Accepts all subject matters and genres for jurying.

Making Contact & Terms There is a co-op membership fee plus a donation of time. There is a 10% commission. Gallery provides insurance. Accepted work should be framed, mounted and matted.

Submissions Write to arrange a personal interview to show portfolio of photographs and slides. Send query letter with artist's statement, bio, brochure, business card, photographs, résumé, reviews, slides and SASE. Responds to queries within 2 months, only if interested. Finds artists through referrals by other artists and submissions.

UPSTREAM PEOPLE GALLERY

5607 Howard St., Omaha NE 68106. (402)991-4741. E-mail: shows@upstreampeoplegallery. com. Website: www.upstreampeoplegallery.com. **Contact:** Larry Bradshaw, curator. For-profit Internet gallery. Estab. 1998. Approached by approximately 13,000 artists/year; represents or exhibits 1,300 artists. Sponsors 4-6 photography exhibits/year. Average display

time 1 or more years online. Virtual gallery open 24 hours daily. Overall price range $100-125,000. Most work sold at approximately $300.

Exhibits Exhibits photos of babies/children/teens, couples, multicultural, families, parents, senior citizens, disasters, environmental, landscapes/scenics, wildlife, gardening, interiors/decorating, pets, religious, adventure, automobiles, events, health/fitness/beauty, humor, performing arts, sports, travel, agriculture, military, political, product shots/still life, technology/computers. Interested in alternative process, avant garde, documentary, fine art, historical/vintage, seasonal.

Making Contact & Terms Artwork is accepted on consignment, and there is no commission if the artists sells; there is a 20% commission if the gallery sells. There is an entry fee for space; covers 1 or more years.

Submissions Mail or e-mail portfolio of slides/CDs/JPEGS/TIFFS for review. Send images, query letter with brief artist's statement, optional bio and personal photograph. Responds to queries in 1 week. Finds artists through art exhibits, portfolio reviews, referrals by other artists, submissions, word of mouth, Internet.

URBAN INSTITUTE FOR CONTEMPORARY ARTS

41 Sheldon Blvd. SE, Grand Rapids MI 49503. (616)454-7000. Fax: (616)459-9395. E-mail: jteunis@uica.org. Website: www.uica.org. **Contact:** Janet Teunis, managing director. Alternative space and nonprofit gallery. Estab. 1977. Approached by 250 artists/year; represents or exhibits 20 artists. Sponsors 3-4 photography exhibits/year. Average display time 6 weeks. Gallery open Tuesday through Saturday from 12 to 10; Sunday from 12 to 7. Closed Monday, the month of August, and the week of Christmas and New Year's.

Exhibits Interested in avant garde, fine art.

Submissions Send query letter with artist's statement, bio, résumé, reviews, slides, SASE. Finds artists through submissions.

Tips "Get submission requirements at www.uica.org/visualArts.html under 'Apply for a Show.'"

Ⓝ VIENNA ARTS SOCIETY ART CENTER

115 Pleasant St. NW, Viena VA 22180. **Contact:** Teresa Ahmad, director. Nonprofit gallery and work center. Estab. 1969. Art center acquired in 2005. Approached by 200-250 artists/year; represents or exhibits 50-100 artists. Average display time 3-4 weeks. Open Tuesday through Saturday from 10 to 4. Closed on federal holidays, county cancellations, or delays. Historic building with spacious room with modernized hanging system. Overall price range $100-1,500. Most work sold at $250-500.

Exhibits Exhibits photos of all subject matter: celebrities, architecture, gardening, pets, environmental, landscapes/scenics, wildlife, entertainment, performing arts, travel. Exhibits fine arts of all subject matter and mediums throughout the year as well; oil, watercolor, acrylic, mixed media, collage, mosaic, sculpture, jewelry, pottery, and stained glass. Hosts 2 judged shows per year and one juries show. Annual judged show in July, focuses on photography only, all other shows welcomes each medium.

Making Contact & Terms Artwork is accepted on consignment, and there is a 25% commission. The rental fee covers one month. "Rental fee is based on what we consider a 'featured artist' exhibit. For one month, VAS handles publicity with the artist."

Submissions Call. Responds in 2 weeks. Finds artists through art exhibits, art fairs, referrals by other artists, membership.

VIRIDIAN ARTISTS, INC.

530 W. 25th St., #407, New York NY 10001. (212)414-4040. Fax: (212)414-4040. Website: www.viridianartists.com. **Contact:** Barbara Neski, director. Estab. 1968. Sponsors 11 exhibits/year. Average display time 4 weeks. Overall price range $175-10,000. Most work sold at $1,500.

Exhibits Interested in eclectic work in all fine art media including photography, installation, painting, mixed media and sculpture. Interested in alternative process, avant garde, fine art.

Making Contact & Terms Charges 30% commission.

Submissions Will review transparencies and CDs only if submitted as part of membership application for representation with SASE. Request information for representation via phone or e-mail or check website.

Tips "Opportunities for photographers in galleries are improving. Broad range of styles being shown in galleries. Photography is getting a large audience that is seemingly appreciative of technical and aesthetic abilities of the individual artists. Present a portfolio (regardless of format) that expresses a clear artistic and aesthetic focus that is unique, individual, and technically outstanding."

THE WAILOA CENTER GALLERY

P.O. Box 936, Hilo HI 96721. (808)933-0416. Fax: (808)933-0417. E-mail: wailoa@yahoo.com. **Contact:** Ms. Codie King, director. Estab. 1967. Sponsors 24 exhibits/year. Average display time 1 month.

Exhibits Photos must be submitted to director for approval. "All entries accepted must meet professional standards outlined in our pre-entry forms."

Making Contact & Terms Gallery receives 10% "donation" on works sold. No fee for exhibiting. Accepted work should be framed. "Photos must also be fully fitted for hanging. Expenses involved in shipping, insurance, invitations and reception, etc., are the responsibility of the exhibitor."

Submissions Submit portfolio for review. Send query letter with résumé of credits, samples, SASE. Responds in 3 weeks.

Tips "The Wailoa Center Gallery is operated by the State of Hawaii, Department of Land and Natural Resources. We are unique in that there are no costs to the artist to exhibit here as far as rental or commissions are concerned. We welcome artists from anywhere in the world who would like to show their works in Hawaii. Wailoa Center is booked 2-3 years in advance. The gallery is also a visitor information center with thousands of people from all over the world visiting."

WASHINGTON COUNTY MUSEUM OF FINE ARTS

P.O. Box 423, Hagerstown MD 21741. (301)739-5727. Fax: (301)745-3741. E-mail: info@wcmfa.org. Website: www.wcmfa.org. **Contact:** Curator. Estab. 1929. Approached by 30 artists/year. Sponsors 1 juried photography exhibit/year. Average display time 6-8 weeks. Museum open Tuesday through Friday from 9 to 5; Saturday from 9 to 4; Sunday from 1 to

5. Closed legal holidays. Overall price range $50-7,000.

Exhibits Exhibits photos of babies/children/teens, celebrities, couples, multicultural, families, parents, senior citizens, disasters, environmental, landscapes/scenics, wildlife, architecture, cities/urban, education, gardening, interiors/decorating, pets, religious, rural, adventure, automobiles, entertainment, events, food/drink, health/fitness/beauty, hobbies, humor, performing arts, sports, travel, agriculture, business concepts, industry, medicine, military, political, product shots/still life, science, technology/computers. Interested in alternative process, avant garde, documentary, fashion/glamour, fine art, historical/vintage, seasonal.

Making Contact & Terms Museum handles sale of works, if applicable, with 40% commission. Accepted work shall not be framed.

Submissions Write to show portfolio of photographs, slides. Mail portfolio for review. Responds in 1 month. Finds artists through word of mouth, portfolio reviews, art exhibits, referrals by other artists.

Tips "We sponsor an annual juried competition in photography. Entry forms are available in the fall of each year. Send name and address to be placed on list."

⊘ WEINSTEIN GALLERY

908 W. 46th St., Minneapolis MN 55419. (612)822-1722. Fax: (612)822-1745. E-mail: weingall@aol.com. Website: www.weinstein-gallery.com. **Contact**: Laura Hoyt, director. For-profit gallery. Estab. 1996. Approached by hundreds of artists/year; represents or exhibits 12 artists. Average display time 6 weeks. Open Tuesday through Saturday from 12 to 5. Overall price range $4,000-250,000.

Exhibits Interested in fine art. Most frequently exhibits contemporary photography.

Submissions "We do not accept unsolicited submissions."

WISCONSIN UNION GALLERIES

800 Langdon St., Room 507, Madison WI 53706-1495. (608)262-7592. Fax: (608)262-8862. E-mail: art@union.wisc.edu. Website: www.union.wisc.edu/art. **Contact:** Robin Schmoldt, art advisor. Nonprofit gallery. Estab. 1928. Approached by 100 artists/year; represents or exhibits 20 artists. Average display time 6 weeks. Open Monday through Sunday from 10 to 8. Closed during winter break and when gallery exhibitions turn over. "See our website at http://www.union.wisc.edu/art/submit.html to find out more about the galleries' features."

Exhibits Interested in fine art. "Photography exhibitions vary based on the artist proposals submitted."

Making Contact & Terms All sales through gallery during exhibition only.

Submissions Current submission guidelines available at http://www.union.wisc.edu/art/submit.html. Finds artists through art fairs, art exhibits, referrals by other artists, submissions, word of mouth.

WOMEN & THEIR WORK ART SPACE

1710 Lavaca St., Austin TX 78701. (512)477-1064. Fax: (512)477-1090. E-mail: info@womenandtheirwork.org. Website: www.womenandtheirwork.org. **Contact:** Katherine McQueen, associate director. Alternative space, nonprofit gallery. Estab. 1978. Approached

by more than 400 artists/year; represents or exhibits 6 solo and 1 juried show/year. Sponsors 1-2 photography exhibits/year. Average display time 5 weeks. Gallery open Monday through Friday from 9 to 6; Saturday from 12 to 5. Closed December 24 through January 2, and other major holidays. Exhibition space is 2,000 sq. ft. Overall price range $500-5,000. Most work sold at $800-1,000.

Exhibits Interested in contemporary, alternative process, avant garde, fine art.

Making Contact & Terms "We select artists through a juried process and pay them to exhibit. We take 25% commission if something is sold." Gallery provides insurance, promotion, contract. Accepted work should be framed, mounted, matted. *Texas women in solo shows only. "All other artists, male or female, in curated show. Online Artist Slide Registry on website."*

Submissions Finds artists through nomination by art professional.

Tips "Provide quality images, typed résumé and a clear statement of artistic intent."

▣ WORLD FINE ART GALLERY

511 W. 25th St., Suite 507, New York NY 10001-5501. (646)336-1677. Fax: (646) 478-9361. E-mail: info@worldfineart.com. Website: www.worldfineart.com. **Contact:** O'Delle Abney, director. Cooperative gallery. Estab. 1992. Approached by 1,500 artists/year; represents or exhibits 50 artists. Average display time 1 month. Open Tuesday through Saturday from 12 to 6. Closed August. Located in Chelsea, NY; 1,000 sq. ft. Overall price range: $500-5,000. Most work sold at $1,500.

Exhibits Exhibits photos of landscapes/scenics, gardening. Interested in fine art.

Making Contact & Terms The re is a rental fee for space. The rental fee covers 1 month or 1 year. Gallery provides insurance, promotion and contract. Accepted work should be framed; must be considered suitable for exhibition.

Submissions Write to arrange a personal interview to show portfolio, or e-mail JPEG images. Responds to queries in 1 week. Finds artists through the Internet.

Tips "Have a website available for review."

▣ YESHIVA UNIVERSITY MUSEUM

15 W. 16th St., New York NY 10011. (212)294-8330. Fax: (212)294-8335. E-mail: info@yum.cjh.org. Website: www.yumuseum.org. **Contact:** Sylvia A. Herskowitz, director. Estab. 1973. Sponsors 6-8 exhibits/year; at least 1 photography exhibit/year. Average display time 4-6 months. The museum occupies 4 galleries and several exhibition arcades. All galleries are handicapped accessible.

Exhibits Seeks "individual or group exhibits focusing on Jewish themes and interests; exhibition-ready work essential."

Making Contact & Terms Accepts images in digital format. Send CD and accompanying text with SASE for return. Send color slide portfolio of 10-12 slides or photos, exhibition proposal, résumé with SASE for consideration. Reviews take place 3 times/year.

Tips "We exhibit contemporary art and photography based on Jewish themes. We look for excellent quality, individuality, and work that reveals a connection to Jewish identity and/or spirituality."

◙ MIKHAIL ZAKIN GALLERY

561 Piermont Rd., Demarest NJ 07627. (201)767-7160. Fax: (201)767-0497. E-mail: gallery@tasoc.org. Website: www.tasoc.org. **Contact:** Rachael Faillace, gallery director. Nonprofit gallery associated with the Art School at Old Church. Estab. 1974. "10-exhibition season includes contemporary, emerging, and established regional artists, NJ Annual Small Works show, student and faculty group exhibitions, among others." Gallery hours: 9:30 am to 5:00 pm Monday-Friday. Call for weekend and evening hours.

Exhibits All styles and genres are considered.

Making Contact & Terms Charges 35% commission fee on all gallery sales. Gallery provides promotion and contract. Accepted work should be framed, mounted.

Submissions Guidelines are available on gallery's website. Small Works prospectus is available online. Mainly finds artists through referrals by other artists and artist registries.

Tips "Follow guidelines available online."

◙ ZENITH GALLERY

P.O. Box 55295, Washington DC 20040. (202)783-2963. Fax: (202)783-0050. E-mail: art@zenithgallery.com. Website: www.zenithgallery.com. **Contact:** Margery E. Goldberg, owner/director. For-profit gallery. Estab. 1978. Open Tuesday through Friday from 11 to 6; Saturday from 11 to 7; Sunday from 12 to 5. Located in the heart of downtown Washington, DC—street level, 3 exhibition rooms, 2,400 sq. ft. Overall price range: $500-15,000.

Exhibits Exhibits photos of landscapes/scenics and other. Interested in avant garde, fine art.

Submissions Mail portfolio for review. Send query letter with artist's statement, bio, brochure, business card, résumé, reviews, photocopies, photographs, slides, CD, SASE. Responds to queries within 1 year, only if interested. Finds artists through art fairs and exhibits, portfolio reviews, referrals by other artists, submissions and word of mouth.

Art Fairs

How would you like to sell your art from New York to California, showcasing it to thousands of eager art collectors? Art fairs (also called art festivals or art shows) are not only a good source of income for artists but an opportunity to see how people react to their work. If you like to travel, enjoy meeting people, and can do your own matting and framing, this could be a great market for you.

Many outdoor fairs occur during the spring, summer and fall months to take advantage of warmer temperatures. However, depending on the region, temperatures could be hot and humid, and not all that pleasant! And, of course, there is always the chance of rain. Indoor art fairs held in November and December are popular because they capitalize on the holiday shopping season.

To start selling at art fairs, you will need an inventory of work—some framed, some unframed. Even if customers do not buy the framed paintings or prints, having some framed work displayed in your booth will give buyers an idea of how your work looks framed, which could spur sales of your unframed prints. The most successful art fair exhibitors try to show a range of sizes and prices for customers to choose from.

When looking at the art fairs listed in this section, first consider local shows and shows in your neighboring cities and states. Once you find a show you'd like to enter, visit its website or contact the appropriate person for a more detailed prospectus. A prospectus is an application that will offer additional information not provided in the art fair's listing.

Ideally, most of your prints should be matted and stored in protective wraps or bags so that customers can look through your inventory without damaging prints and mats. You will also need a canopy or tent to protect yourself and your wares from the elements as well as some bins in which to store the prints. A display wall will allow you to show off your best framed prints. Generally, artists will have 100 square feet of space in which to set up their tents and canopies. Most listings will specify the dimensions of the exhibition space for each artist.

If you see the icon ⚑ before a listing in this section, it means that the art fair is a juried event. In other words, there is a selection process artists must go through to be admitted into the fair. Many art fairs have quotas for the categories of exhibitors.

For example, one art fair may accept the mediums of photography, sculpture, painting, metal work and jewelry. Once each category fills with qualified exhibitors, no more will be admitted to the show that year. The jurying process also ensures that the artists who sell their work at the fair meet the sponsor's criteria for quality. So, overall, a juried art fair is good for artists because it means they will be exhibiting their work along with other artists of equal caliber.

Be aware there are fees associated with entering art fairs. Most fairs have an application fee or a space fee, or sometimes both. The space fee is essentially a rental fee for the space your booth will occupy for the art fair's duration. These fees can vary greatly from show to show, so be sure to check this information in each listing before you apply to any art fair.

Most art fair sponsors want to exhibit only work that is handmade by the artist, no matter what medium. Unfortunately, some people try to sell work that they purchased elsewhere as their own original artwork. In the art fair trade, this is known as "buy/sell." It is an undesirable situation because it tends to bring down the quality of the whole show. Some listings will make a point to say "no buy/sell" or "no manufactured work."

For more information on art fairs, pick up a copy of *Sunshine Artist* or *Art Calendar*, and consult online sources such as www.artfairsource.com, www.artcalendar.com and www.festival.net.

☑ 49TH ARTS EXPERIENCE

P.O. Box 1326, Palatine IL 60078. (847)991-4748 or (312)751-2500. E-mail: asoa@webtv. net. Website: www.americansocietyofartists.org. Estab. 1979. Fine arts & crafts show held in summer. Outdoors. Accepts photography, paintings, graphics, sculpture, quilting, woodworking, fiber art, hand-crafted candles, glass works, jewelry, etc. Juried by 4 slides/ photo representative of work being exhibited; 1 photo of display set-up, #10 SASE, résumé with 7 show listings helpful. Number of exhibitors: 50. Free to public. Artists should apply by submitting jury material and indicate you are interested in this particular show. If you wish to jury online please see our website and follow directions given there. When you pass the jury, you will receive jury approval number and application you requested. Deadline for entry: 2 months prior to show or earlier if space is filled. Space fee: to be announced. Exhibition space: 100 sq. ft. for single space; other sizes are available. For more information, artists should send SASE to submit jury material.

• Event held in Chicago, Illinois.

Tips "Remember that at work in your studio, you are an artist. When you are at a show, you are a business person selling your work."

☑ AFFAIRE IN THE GARDENS ART SHOW

Greystone Park, 501 Doheny Rd., Beverly Hills CA 90210-2921. (310)550-4796. Fax: (310)858-9238. E-mail: kmclean@beverlyhills.org. Website: www.beverlyhills.org. **Contact:** Karen Fitch McLean, art show coordinator. Estab. 1973. Fine arts & crafts show held biannually 3rd weekend in May and 3rd weekend in October. Outdoors. Accepts photography, painting, sculpture, ceramics, jewelry, digital media. Juried. Awards/prizes: 1st Place in category, cash awards, Best in Show cash award; Mayor's Purchase Award in October show. Number of exhibitors:

225. Public attendance: 30,000-40,000. Free to public. Deadline for entry: end of February, May show; end of July, October show. Application fee: $30. Space fee: $300. Exhibition space: 10 × 12 ft. For more information, artists should e-mail, visit Web site, call or send SASE.

Tips "Art fairs tend to be commercially oriented. It usually pays off to think in somewhat commercial terms—what does the public usually buy? Personally, I like risky and unusual art, but the artists who produce esoteric art sometimes go hungry! Be nice and have a clean presentation."

☑ AKRON ARTS EXPO

1615 W. Market St., Akron OH 44313. (330)375-2836. Fax: (330)375-2883. E-mail: readni@ci.akron.oh.us. Website: www.akronartsexpo.org. **Contact:** Nicole Read, community event planner. Estab. 1979. Fine art & craft show held annually in July. Outdoors. Accepts photography, 3D, 2D art, functional craft, ornamental. Juried by "5 jurors from the art community brought in to select the artists." See website for application information. Awards/prizes: $1,600 in cash awards and ribbons. Number of exhibitors: 165. Public attendance: 30,000. Free to public. Deadline for entry: March 31. Space fee: $180. Exhibition space: 10 × 10 ft. For more information, artists should e-mail, call, or visit website.

Tips "Make sure you send in slides that are in good condition and show your work properly. If you wish to send a sample, this is helpful as well. Make sure you fill out the application correctly."

☑ ALLENTOWN ART FESTIVAL

P.O. Box 1566, Ellicott Station, Buffalo NY 14205-1566. (716)881-4269. E-mail: allentownartfestival@verizon.net. Website: www.allentownartfestival.com. **Contact:** Mary Myszkiewicz, president. Estab. 1958. Fine arts & crafts show held annually 2nd full weekend in June. Outdoors. Accepts photography, painting, watercolor, drawing, graphics, sculpture, mixed media, clay, glass, acrylic, jewelry, creative craft (hard/soft). Slides juried by hired professionals that change yearly. Awards/prizes: $17,925 in 40 cash prizes; Best of Show. Number of exhibitors: 450. Public attendance: 300,000. Free to public. Artists should apply by downloading application from Web site. Deadline for entry: January 31. Application fee: $15. Space fee: $250. Exhibition space: 13 × 10 ft. For more information, artists should e-mail, visit Web site, call or send SASE.

Tips "Artists must have attractive booth and interact with the public."

☑ AMISH ACRES ARTS & CRAFTS FESTIVAL

1600 W Market St., Nappanee IN 46550. (574)773-4188. Fax: (574)773-4180. E-mail: amishacres@amishacres.com. Website: www.amishacres.com. **Contact:** Jenni Wysong, marketplace coordinator. Estab. 1962. Arts & crafts show held annually first weekend in August. Outdoors. Accepts photography, crafts, floral, folk, jewelry, oil, acrylic, sculpture, textiles, watercolors, wearable, wood. Juried by 5 images, either 35mm slides or digital images e-mailed. Awards/prizes: $10,000 cash including Best of Show and $1,500 Purchase Prizes. Number of exhibitors: 350. Public attendance: 60,000. Public admission: $6; children under 12 free. Artists should apply by sending SASE or printing application from Web site. Deadline for entry: April 1. Space fee: 10 × 10 ft. $475; 15 × 12 ft. $675; 20 × 12 ft. $1,095; 30 × 12 ft. $1,595. Exhibition space: from 120-300 sq. ft. Average gross sales/exhibitor:

$7,000. For more information, artists should e-mail, visit Web site, call or send SASE.

Tips "Create a vibrant, open display that beckons to passing customers. Interact with potential buyers. Sell the romance of the purchase."

✒ ANACORTES ARTS FESTIVAL

505 O Ave., Anacortes WA 98221. (360)293-6211. Fax: 360-299-0722. E-mail: info@ anacortesartsfestival.com. Website: www.anacortesartsfestival.com. **Contact:** Mary Leone. Fine arts & crafts show held annually 1st full weekend in August. Accepts photography, painting, drawings, prints, ceramics, fiber art, paper art, glass, jewelry, sculpture, yard art, woodworking. Juried by projecting 3 images on a large screen. Works are evaluated on originality, quality and marketability. Each applicant must provide 3 high-quality digital images or slides—2 of the product and 1 of the booth display. Awards/prizes: over $4,000 in prizes. Number of exhibitors: 250. Artists should apply by visiting website for online submission or by mail (there is a $25 processing fee for application by mail). Deadline for entry: early March. Booth fee: $300. For more information, artists should see Web site.

ANN ARBOR'S SOUTH UNIVERSITY ART FAIR

P.O. Box 4525, Ann Arbor MI 48106. (734)663-5300. Fax: (734)663-5303. Website: www. a2southu.com. **Contact:** Maggie Ladd, director. Estab. 1960. Fine arts & crafts show held annually 3rd Wednesday through Saturday in July. Outdoors. Accepts photography, clay, drawing, digital, fiber, jewelry, metal, painting, sculpture, wood. Juried. Awards/prizes: $3,000. Number of exhibitors: 190. Public attendance: 750,000. Free to public. Deadline for entry: January. Application fee: $25. Space fee: $700-1500. Exhibition space: 10 × 10 to 20 × 10 ft. Average gross sales/exhibitor: $7,000. For more information artists should e-mail, visit website or call.

Tips "Research the market, use a mailing list, advertise in *Art Fair Guide* (150,000 circulation)."

✒ ANN ARBOR STREET ART FAIR

P.O. Box 1352, Ann Arbor MI 48106. (734)994-5260. Fax: (734)994-0504. E-mail: production@ artfair.org. Website: www.artfair.org. **Contact:** Jeannie Uh, production coordinator. Estab. 1958. Fine arts & crafts show held annually 3rd Saturday in July. Outdoors. Accepts photography, fiber, glass, digital art, jewelry, metals, 2D and 3D mixed media, sculpture, clay, painting, drawing, printmaking, pastels, wood. Juried based on originality, creativity, technique, craftsmanship and production. Awards/prizes: cash prizes for outstanding work in any media. Number of exhibitors: 175. Public attendance: 500,000. Free to the public. Artists should apply through www.zapplication.org. Deadline for entry: January. Application fee: $30. Space fee: $595. Exhibition space: 10 × 20 ft. or 10 × 12 ft. Average gross sales/exhibitor: $7,000. For more information, artists should e-mail, visit website, call.

✒ ANNUAL ALTON ARTS & CRAFTS EXPRESSIONS

P.O. Box 1326, Palatine IL 60078. (847)991-4748 or (312)751-2500. E-mail: asoa@webtv.net. Website: www.americansocietyofartists.org. **Contact:** American Society of Artists—"anyone in the office can help." Estab. 1979. Fine arts & crafts show held annually indoors in spring

and fall, usually March and September. Outdoors. Accepts quilting, fabric crafts, artwear, photography, sculpture, jewelry, glass works, woodworking and more. Juried by 4 slides or photos of your work and 1 slide or photo of your display; SASE (No. 10); a resume or show listing is helpful. "See our website for online jury information." Number of exhibitors: 50. Free to the public. Artists should apply by submitting jury materials. If you want to jury via internet see our website and follow directions given there. If juried in, you will receive a jury/approval number. Deadline for entry: 2 months prior to show or earlier if spaces fill. Space fee: $125. Exhibition space: approximately 100 sq. ft for single space; other sizes available. For more information, artists should send SASE, submit jury material.

• Event held in Alton, Illinois.

Tips "Remember that when you are at work in your studio, you are an artist. But when you are at a show, you are a business person selling your work."

☑ ANNUAL ARTS & CRAFTS ADVENTURE

P.O. Box 1326, Palatine IL 60078. (847)991-4748 or (312)751-2500. E-mail: asoa@webtv.net. Website: www.americansocietyofartists.org. **Contact:** American Society of Artists—"anyone in the office can help." Estab. 1991. Fine arts & crafts show held annually in early May and mid-September. Outdoors. Accepts photography, pottery, paintings, sculpture, glass, wood, woodcarving. Juried by 4 slides or photos of work and 1 slide or photo of display; SASE (No. 10); a résumé or show listing is helpful. See our website for on-line jury. Number of exhibitors: 75. Free to the public. Artists should apply by submitting jury materials. If juried in, you will receive a jury/approval number. Deadline for entry: 2 months prior to show or earlier if spaces fill. Space fee: $80. Exhibition space: approximately 100 sq. ft. for single space; other sizes available. For more information, artists should send SASE, submit jury material.

• Event held in Park Ridge, Illinois.

Tips "Remember that when you are at work in your studio, you are an artist. But when you are at a show, you are a business person selling your work."

☑ ANNUAL ARTS & CRAFTS FAIR

Pend Oreille Arts Council, P.O. Box 1694, Sandpoint ID 83864. (208)263-6139. E-mail: art@ sandpoint.net. Website: www.ArtinSandpoint.org. Estab. 1962. Arts & crafts show held annually in August. Outdoors. Accepts photography and all handmade, noncommercial works. Juried by 8-member jury. Number of exhibitors: 100. Public attendance: 5,000. Free to public. Artists should apply by sending in application. Deadline for entry: May 1. Application fee: $15. Space fee: $150-230, no commission. Exhibition space: 10 × 10 ft. or 10 × 15 ft. For more information, artists should e-mail, visit Web site, call or send SASE.

☑ ANNUAL ARTS ADVENTURE

Annual Society of Artists, P.O. Box 1326, Palatine IL 60078. (847)991-4748 or (312)571-2500. E-mail: asoa@webtv.net. Website: www.americansocietyofartists.org. **Contact:** American Society of Artists—"anyone in the office can help." Estab. 2001. Fine arts & crafts show held annually the end of July. Event held in Chicago, Illinois. Outdoors. Accepts photography, paintings, pottery, sculpture, jewelry and more. Juried. Send 4 slides or photos of your work and 1 slide or photo of your display; SASE (No. 10); a resume or show listing is helpful. See our website for on-line jury. Number of exhibitors: 50. Free to the public.

Artists should apply by submitting jury materials. If juried in, you will receive a jury/approval number. Deadline for entry: 2 months prior to show or earlier if spaces fill. Entry fee: $135. Exhibition space: approximately 100 sq. ft. for single space; other sizes available. For more information, artists should send SASE, submit jury material.

• Event held in Chicago, Illinois.

Tips "Remember that when you are at work in your studio, you are an artist. But when you are at a show, you are a business person selling your work."

☑ ANNUAL EDENS ART FAIR

American Society of Artists, P.O. Box 1326, Palatine IL 60078. (847)991-4748 or (312)2500. E-mail: asoa@webtv.net. Website: www.americansocietyofartists.org. **Contact:** American Society of Artists—"anyone in the office can help." Estab. 1995 (after renovation of location; held many years prior to renovation). Fine arts & fine selected crafts show held annually in mid-July. Outdoors. Accepts photography, paintings, sculpture, glass works, jewelry. Juried. Send 4 slides or photos of your work and 1 slide or photo of your display; SASE (No. 10); a resume or show listing is helpful. Number of exhibitors: 50. Free to the public. Artists should apply by submitting jury materials. If you wish to jury online please see our website and follow directions given there. If juried in, you will receive a jury/approval number. Deadline for entry: 2 months prior to show or earlier if spaces fill. Entry fee: $145. Exhibition space: approximately 100 sq. ft. for single space; other sizes available. For more information, artists should send SASE, submit jury material.

• Event held in Willamette, Illinois.

Tips "Remember that when you are at work in your studio, you are an artist. But when you are at a show, you are a business person selling your work."

☑ ANNUAL HYDE PARK ARTS & CRAFTS ADVENTURE

American Society of Artists, P.O. Box 1326, Palatine IL 60078. (847)991-4748 or (312)751-2500. E-mail: asoa@webtv.net. Website: www.americansocietyofartists.org. **Contact:** American Society of Artists—"anyone in the office can help." Estab. 2006. Arts & crafts show held twice a year in late September. Outdoors. Accepts photography, paintings, glass, wood, fiber arts, hand-crafted candles, quilts, sculpture and more. Juried by 4 slides or photos of work and 1 slide or photo of display; SASE (No. 10); a résumé or show listing is helpful. Number of exhibitors: 50. Free to the public. Artists should apply by submitting jury materials. If juried in, you will receive a jury/approval number. See website for jurying on-line. Deadline for entry: 2 months prior to show or earlier if spaces fill. Entry fee: $155. Exhibition space: approximately 100 sq. ft. for single space; other sizes are available. For more information, artists should send SASE, submit jury material.

• Event held in Chicago, Illinois.

Tips "Remember that when you are at work in your studio, you are an artist. But when you are at a show, you are a business person selling your work."

☑ ANNUAL OAK PARK AVENUE-LAKE ARTS & CRAFTS SHOW

American Society of Artists, P.O. Box 1326, Palatine IL 60078. (847)991-4748 or (312)751-2500. E-mail: asoa@webtv.net. Website: www.americansocietyofartists.org. **Contact:** American Society of Artists—"anyone in the office can help." Estab. 1974. Fine arts & crafts

show held annually in mid-August. Outdoors. Accepts photography, paintings, graphics, sculpture, glass, wood, paper, fiber arts, mosaics and more. Juried by 4 slides or photos of work and 1 slide or photo of display; SASE (No. 10); a resume or show listing is helpful. Number of exhibitors: 150. Free to the public. Artists should apply by submitting jury materials. If you want to jury online please see our website and follow directions given there. If juried in, you will receive a jury/approval number. Deadline for entry: 2 months prior to show or earlier if spaces fill. Entry fee: $170. Exhibition space: approximately 100 sq. ft. for single space; other sizes available. For more information, artists should send SASE, submit jury material.

• Event held in Oak Park, Illinois.

Tips "Remember that when you are at work in your studio, you are an artist. But when you are at a show, you are a business person selling your work."

ANNUAL VOLVO MAYFAIRE-BY-THE-LAKE

Polk Museum of Art, 800 E. Palmetto St., Lakeland FL 33801. (863)688-7743, ext. 237. Fax: (863)688-2611. E-mail: info@polkmuseumofart.org; Mayfaire@PolkMuseumofArt.org. Website: www.PolkMuseumOfArt.org. Estab. 1971. Fine arts & crafts show held annually in May on Mother's Day weekend. Outdoors. Accepts photography, oil, acrylic, watercolor, drawing & graphics, sculpture, clay, jewelry, glass, wood, fiber, mixed media. Juried by a panel of jurors who will rank the artist's body of work based on 3 slides of works and 1 slide of booth setup. Awards/prizes: 2 Best of Show, 3 Awards of Excellence, 8 Merit awards, 10 Honorable Mentions, Museum Purchase Awards, Collectors Club Purchase Awards, which equal over $25,000. Number of exhibitors: 185. Public attendance: 65,000. Free to public. Artists should download application from website to apply. Deadline for entry: March 1. Application fee: $25. Space fee: $145. Exhibition space: 10 × 10 ft. For more information, artists should visit website or call.

ART & JAZZ ON BROADWAY

P.O. Box 583, Philipsburg MT 59858. **Contact:** Sherry Armstrong at hitchinpost@blackfoot. net or (406)859-0366, or Connie Donlan at coppersok2@aol.com or (406)859-0165. Estab. 2000. Fine arts/jazz show held annually in August. Outdoors. Accepts photography and handcrafted, original, gallery-quality fine arts and crafts made by selling artist. Juried by Flint Creek Valley Arts Council. Number of exhibitors: 75. Public attendance: 1,500-2,000. Admission fee: donation to Flint Creek Valley Arts Council. Artists should visit www. artinphilipsburg.com, e-mail, or call for more information. Application fee: $55. Exhibition space: 10 × 10 ft. For more information, artists should e-mail or call for more information.

Tips "Be prepared for temperatures of 100 degrees or rain. Display in a professional manner. Friendliness is crucial; fair pricing is essential."

ART IN THE HEART OF THE CITY

171 E. State St., PMB #136, Ithaca NY 14850. (607)277-8679. Fax: (607)277-8691. E-mail: idp@downtownithaca.com. Website: www.downtownithaca.com. **Contact:** Phil White, office manager/event coordinator. Estab. 1999. Sculpture exhibition held annually in early June. Primarily outdoors; limited indoor pieces. Accepts photography, wood, ceramic, metal, stone. Juried by Public Arts Commission. Number of exhibitors: 28-35. Public

attendance: 100,000 + . Free to public. Artists should apply by submitting application, artist statement, slides/photos. Deadline for entry: May. Exhibition space depends on placement. For more information, artists should e-mail. This year we are having a "Green Exhibition, a pioneering step for public art across the country. We will focus on only (3) artists, and publicize their work broadly. The stipend has been increased to $1500. Per artist. We're creating a new online gallery and we're collaborating with area arts, sustainability and education groups for public programs. Art in the heart '09 is asking for you to use the 'Green" interpretation as a starting point- and, through your submissions, help us.
Tips "Be sure there is a market and interest for your work, and advertise early."

❑ ART IN THE PARK

P.O. Box 748, Sierra Vista AZ 85636-0247. (520) 803-8981. E-mail: artinthepark@msm. com. Website: www.huachuca-art.com. **Contact:** Vendor Committee. Estab. 1972. Fine arts & crafts show held annually 1st full weekend in October. Outdoors. Accepts photography, all fine arts and crafts created by vendor. Juried by 3-6 typical customers. Artists submit 6 photos. Number of exhibitors: 240. Public attendance: 20,000. Free to public. Artists should apply by calling, e-mailing or sending SASE between February and May; application package available online at HAA Web site. Deadline for entry: postmarked by June 27. Application fee: $10 included in space fee. Space fee: $175, includes jury fee. Exhibition space: 15 × 35 ft. For more information, artists should e-mail, call or send SASE.

❑ ART IN THE PARK FALL FOLIAGE FESTIVAL

16 S. Main St., Rutland VT 05701. (802)775-0356. Fax: (802)773-4401. E-mail: beyondmarketing@ yahoo.com. Website: www.chaffeeartcenter.org. **Contact:** Sherri Birkheimer Rooker, event coordinator. Estab. 1961. Fine arts & crafts show held annually in October. 2009 dates: October 10 and 11. Accepts photography, clay, fiber, floral, glass, art, specialty foods, wood, jewelry, handmade soaps, lampshades, baskets, etc. Juried by a panel of 10-15 judges who perform a blind review of slide submissions. Number of exhibitors: 130. Public attendance: 8,000. Public admission: voluntary donation. Artists should submit three slides of work and one of booth (photos upon pre-approval). Deadline for entry: on-going but to receive discount for doing both shows, must apply by May 31; $25 late fee after that date. Space fee: $190-$340. For more information, artists should e-mail, visit website, or call.
Tips "Have a good presentation and variety, if possible (in pricing also), to appeal to a large group of people."

❑ ART IN THE PARK

P.O. Box 1540, Thomasville GA 31799. (229)227-7020. Fax: (229)227-3320. E-mail: roseshowfest@rose.net. Website: www.downtownthomasville.com. **Contact:** Felicia Brannen, festival coordinator. Estab. 1998-1999. Arts in the park (an event of Thomasville's Rose Show and Festival) is a 1 day arts & crafts show held annually in April. Outdoors. Accepts photography, handcrafted items, oils, acrylics, woodworking, stained glass, other varieties. Juried by a selection committee. Number of exhibitors: 60. Public attendance: 2,500. Free to public. Artists should apply by application. Deadline for entry: February 1. Space fee: $75, varies by year. Exhibition space: 20 × 20 ft. For more information, artists should e-mail or call.
Tips "Most important, be friendly to the public and have an attractive booth display."

ART IN THE PARK

8707 Forest Ct., Warren MI 48093. (586)795-5471. E-mail: wildart@wowway.com. Website: www.warrenfinearts.org. **Contact:** Paula Wild, chairperson. Estab. 1990. Fine arts & crafts show held annually 2nd weekend in July. Indoors and outdoors. Accepts photography, sculpture, basketry, pottery, stained glass. Juried. Awards/prizes: 2D & 3D monetary awards. Number of exhibitors: 75. Public attendance: 7,500. Free to public. Deadline for entry: May 16. Jury fee: $20. Space fee: $100/outdoor; $150/indoor. Exhibition space: 12 × 12 ft./tent; 12 × 10 ft./atrium. For more information, artists should e-mail, visit website or send SASE.

ART IN THE PARK SUMMER FESTIVAL

16 South Main St., Rutland VT 05701.802-775-0356. Fax: 802-773-4401. E-mail: beyondmarketing@yahoo.com. Website: www.chaffeartcenter.org. Sherri Birkheimer Rooker, event coordinator. Estab. 1961. Fine arts and crafts show held outdoors annually in August. 2010 dates: August 14 and 15. Accepts photography, clay, fiber, floral, glass, art, specialty foods, wood, jewelry, handmade soaps, lampshades, baskets, etc. Juried by a panel of 10-15 judges who perform a blind review of slide submissions. Number of exhibitors: 130. Public attendance: 8,000. Public admission: voluntary donation. Artists should submit three slides of work and one of booth (photos upon pre-approval). Deadline for entry: on-going but to receive discount for doing both shows, must apply by March 31; $25 late fee after that date. Space fee: $190-$340. For more information, artists should e-mail, visit website, or call.

Tips "Have a good presentation, variety if possible (in price ranges, too) to appeal to a large group of people."

AN ARTS & CRAFTS AFFAIR, AUTUMN & SPRING TOURS

P.O. Box 184, Boys Town NE 68010. (402)331-2889. Fax: (402)445-9177. E-mail: hpifestivals@cox.net. Website: www.hpifestivals.com. **Contact:** Huffman Productions. Estab. 1983. An arts & crafts show that tours different cities and states. The Autumn Festival tours annually October-November; Spring Festival tours annually in April. Artists should visit website to see list of states and schedule. Indoors. Accepts photography, pottery, stained glass, jewelry, clothing, wood, baskets. All artwork must be handcrafted by the actual artist exhibiting at the show. Juried by sending in 2 photos of work and 1 of display. Awards/prizes: 4 $30 show gift certificates; $50, $100 and $150 certificates off future booth fees. Number of exhibitors: 300-500 depending on location. Public attendance: 15,000-35,000. Public admission: $7-8/adults; $6-7/seniors; 10 & under, free. Artists should apply by calling to request an application. Deadline for entry: varies for date and location. Space fee: $400-650. Exhibition space: 8 × 11 ft. up to 8 × 22 ft. For more information, artists should e-mail, visit Web site, call or send SASE.

Tips "Have a nice display, make sure business name is visible, dress professionally, have different price points, and be willing to talk to your customers."

ART'S ALIVE

4001 Coastal Highway, Ocean City MD 21842-2247. (410)250-0125. Fax: (410)250-5409. E-mail: Bmoore@ococean.com. Website: www.ococean.com. **Contact:** Brenda Moore, event coordinator. Estab. 2000. Fine art show held annually in mid-June. Outdoors.

Accepts photography, ceramics, drawing, fiber, furniture, glass, printmaking, jewelry, mixed media, painting, sculpture, fine wood. Juried. Awards/prizes: $5,000 in cash prizes. Number of exhibitors: 110. Public attendance: 10,000. Free to pubic. Artists should apply by downloading application from website or call. Deadline for entry: February 28. Space fee: $75. Jury Fee: $25. Exhibition space: 10x10 ft. For more information, artists should e-mail, visit website, call or send SASE.

Tips "Apply early."

☑ ARTS IN THE PARK

302 2nd Ave. East, Kalispell MT 59901. (406)755-5268. Fax: (405)755-2023. E-mail: hockaday@centurytel.net. Website: www.hockadaymuseum.org/artpark.htm. Estab. 1968. Fine arts & crafts show held annually 4th weekend in July. Outdoors. Accepts photography, jewelry, clothing, paintings, pottery, glass, wood, furniture, baskets. Juried by a panel of 5 members. Artwork is evaluated for quality, creativity and originality. Jurors attempt to achieve a balance of mediums in the show. Awards/prizes: $100, Best Booth Award. Number of exhibitors: 100. Public attendance: 10,000. Public admission: $5/weekend pass; $3/day pass; under 12, free. Artists should apply by completing the application form, entry fee, a SASE and a CD containing 5 images in JPEG format; 4 images of work and 1 of booth. Deadline for entry: May 1. Application fee: $25. Space fee: $160-425 per location. Exhibition space: 10 × 10 ft-10 × 20 ft. For more information artists should e-mail, visit website or call.

☑ ARTS ON FOOT

Downtown DC BID, 1250 H St., NW, Suite 1000, Washington DC 20005. (202)661-7592. E-mail: artsonfoot@downtowndc.org. Website: www.artsonfoot.org. **Contact:** Ashley Neeley. Fine arts & crafts show held annually in September. Outdoors. Accepts photography, painting, sculpture, fiber art, furniture, glass, jewelry, leather. Juried by 5 color images of the artwork. Send images as 35mm slides, TIFF or JPEG files on CD or DVD. Also include artist's résumé and SASE for return of materials. Free to the public. Deadline for entry: July. Exhibition space: 10 × 10 ft. "Arts on Foot will pay participating artists a $25 gratuity to help cover out-of-pocket expenses (such as transportation and food) each artist may incur during Arts on Foot." For more information, artists should call, e-mail, visit Web site.

☑ ARTS ON THE GREEN

P.O. Box 752, LaGrange KY 40031. 502-222-3822. Fax: 502-222-3823. E-mail: AOGdir@aaooc. org. Website: www.oldhamcountyarts.org. **Contact:** Marion Gibson, show coordinator. Estab. 2001. Fine arts & crafts show held annually 1st weekend in June. Outdoors. Accepts photography, painting, clay, sculpture, metal, wood, fabric, glass, jewelry. Juried by a panel. Awards/prizes: cash prizes for Best of Show and category awards. Number of exhibitors: 100. Public attendance: 7,500. Free to the public. Artists should apply online or call. Deadline for entry: March 15. Jury fee: $15. Space fee: $125. Electricity fee: $15. Exhibition space: 12 × 12 ft. For more information, artists should e-mail, visit Web site, call.

Tips "Make potential customers feel welcome in your space. Don't overcrowd your work. Smile!"

☑ AUTUMN FESTIVAL, AN ARTS & CRAFTS AFFAIR

P.O. Box 184, Boys Town NE 68010. (402)331-2889. Fax: (402)445-9177. E-mail: hpifestivals@cox.net. Website: www.hpifestivals.com. **Contact:** Huffman Productions. Estab. 1983. Fine arts & craft show held annually in October. Indoors. Accepts photography, pottery, stained glass, jewelry, clothing, furniture, paintings, baskets, etc. All must be handcrafted by the exhibitor. Juried by 2 photos of work and 1 of display. Awards/prizes: $420 total cash awards. Number of exhibitors: 400. Public attendance: 20,000. Public admission: $6-8. Artists should apply by calling for an application. Deadline: Until a category is juried full. Space fee: $600. Exhibition space: 8 × 11 ft. ("We provide pipe and drape plus 500 watts of power.") For more information, artists should e-mail, visit Web site, call, send SASE.

Tips "Make sure to send good, crisp photos that show your current work and display. This gives you the best chance with jurying in a show."

☑ AVON FINE ART & WINE AFFAIRE

15648 N. Eagles Nest Dr., Fountain Hills AZ 85268-1418. (480)837-5637. Fax: (480)837-2355. E-mail: info@thunderbirdartists.com. Website: www.thunderbirdartists.com. **Contact:** Denise Colter, vice president. Estab. 1993. Fine arts & crafts show and wine tasting held annually in mid-July. Outdoors. Accepts photography, painting, mixed media, bronze, metal, copper, stone, stained glass, clay, wood, paper, baskets, jewelry, scratchboard. Juried by 4 slides of work and 1 slide of booth. Number of exhibitors: 150. Public attendance: 3,000-6,000. Free to public. Artists should apply by sending application, fees, 4 slides of work, 1 slide of booth and 2 SASEs. Deadline for entry: March 27. Application fee: $20. Space fee: $360-1,080. Exhibition space: 10 × 10 ft.-10 × 30 ft. For more information, artists should visit Web site.

☑ BLACK SWAMP ARTS FESTIVAL

P.O. Box 532, Bowling Green OH 43402. (419)354-2723. E-mail: info@blackswamparts.org. Website: www.blackswamparts.org.

Tips "Offer a range of prices, from $5 to $500."

☑ CAIN PARK ARTS FESTIVAL

40 Severance Circle, Cleveland Heights OH 44118-9988. (216)291-3669. Fax: (216)3705. E-mail: jhoffman@clvhts.com. Website: www.cainpark.com. **Contact:** Janet Hoffman, administrative assistant. Estab. 1976. Fine arts & crafts show held annually 2nd full week in July. Outdoors. Accepts photography, painting, clay, sculpture, wood, jewelry, leather, glass, ceramics, clothes and other fiber, paper, block printing. Juried by a panel of professional artists; submit 5 slides. Awards/prizes: cash prizes of $750, $500 and $250; also Judges' Selection, Director's Choice and Artists' Award. Number of exhibitors: 155. Public attendance: 60,000. Free to the public. Artists should apply by requesting an application by mail, visiting website to download application or by calling. **Deadline for entry**: March 1. Application fee: $25. Space fee: $350. Exhibition space: 10 × 10 ft. Average gross sales/exhibitor: $4,000. For more information, artists should e-mail, visit website, or call.

Tips "Have an attractive booth to display your work. Have a variety of prices. Be available to answer questions about your work."

CALABASAS FINE ARTS FESTIVAL

100 Civic Center Way, Calabasas CA 91302. (818)224-1657 ext. 270. E-mail: artscouncil@cityofcalabasas.com. Website: www.calabasasartscouncil.com. Estab. 1997. Fine arts & crafts show held annually in late April/early May. Outdoors. Accepts photography, painting, sculpture, jewelry, mixed media. Juried. Number of exhibitors: 250. Public attendance: 10,000 + . Free to public; parking: $5. For more information, artists should visit website or e-mail.

☑ CEDARHURST CRAFT FAIR

P.O. Box 923, Mt. Vernon IL 62864. (618)242-1236 ext. 234. Fax: (618)242-9530. E-mail: linda@cedarhurst.org. Website: www.cedarhurst.org. **Contact:** Linda Wheeler, coordinator. Estab. 1977. Arts & crafts show held annually in September. Outdoors. Accepts photography, paper, glass, metal, clay, wood, leather, jewelry, fiber, baskets, 2D art. Juried. Awards/prizes: Best of each category. Number of exhibitors: 125. Public attendance: 14,000. Public admission: $3. Artists should apply by filling out application form. Deadline for entry: March. Application fee: $25. Space fee: $275. Exhibition space: 10 × 15 ft. For more information, artists should e-mail, visit Web site.

CENTERVILLE/WASHINGTON TOWNSHIP AMERICANA FESTIVAL

P.O. Box 41794, Centerville OH 45441-0794. (937)433-5898. Fax: (937)433-5898. E-mail: americanafestival@sbcglobal.net. Website: www.americanafestival.org. **Contact:** Patricia Fleissner, arts & crafts chair. Estab. 1972. Arts & crafts show held annually on the Fourth of July except when the 4th falls on a Sunday, when the festival is held on Monday the 5th. Festival includes entertainment, parade, food, car show and other activities. Accepts photography and all mediums. "No factory-made items accepted." Awards/prizes: 1st Place; 2nd Place; 3rd Place; certificates and ribbons for most attractive displays. Number of exhibitors: 275-300. Public attendance: 70,000. Free to the public. Artists should send SASE for application form. Deadline for entry: June 26, 2010. "Main Street is usually full by early June." Space fee: $50. Exhibition space: 12 × 10 ft. For more information, artists should e-mail, visit Web site, call.

Tips "Artists should have moderately priced items; bring business cards; and have an eye-catching display."

☑ CHATSWORTH CRANBERRY FESTIVAL

P.O. Box 286, Chatsworth NJ 08019-0286. (609)726-9237. Fax: (609)726-1459. E-mail: lgiamalis@aol.com. Website: www.cranfest.org. **Contact:** Lynn Giamalis, chairperson. Estab. 1983. Arts & crafts show held annually in October. Outdoors. Accepts photography. Juried. Number of exhibitors: 200. Public attendance: 75,000-100,000. Free to public. Artists should apply by sending SASE to above address. Deadline for entry: September 1. Space fee: $200. Exhibition space: 15 × 15 ft. For more information, artists should visit Web site.

☑ CHUN CAPITOL HILL PEOPLE'S FAIR

1290 Williams St., Suite 101, Denver CO 80218. (303)830-1651. Fax: (303)830-1782. E-mail: chun@chundenver.org. Website: www.peoplesfair.com; www.chundenver.org. Estab. 1971. Arts & crafts show held annually 1st weekend in June. Outdoors. Accepts photography,

ceramics, jewelry, paintings, wearable art, glass, sculpture, wood, paper, fiber. Juried by professional artisans representing a variety of mediums and selected members of fair management. The jury process is based on originality, quality and expression. Awards/prizes: Best of Show. Number of exhibitors: 300. Public attendance: 250,000. Free to public. Artists should apply by downloading application from Web site. Deadline for entry: March. Application fee: $35. Space fee: $300. Exhibition space: 10 × 10 ft. For more information, artists should e-mail, visit website or call.

CHURCH STREET ART & CRAFT SHOW

P.O. Box 1409, Waynesville NC 28786. (828)456-3517. Fax: (828)456-2001. E-mail: downtownwaynesville@charter.net. Website: www.downtownwaynesville.com. **Contact:** Ronald Huelster, executive director. Estab. 1983. Fine arts & crafts show held annually 2nd Saturday in October. Outdoors. Accepts photography, paintings, fiber, pottery, wood, jewelry. Juried by committee: submit 4 slides or photos of work and 1 of booth display. Awards/prizes: $1,000 cash prizes in 1st, 2nd, 3rd and Honorable Mentions. Number of exhibitors: 100. Public attendance: 15,000-18,000. Free to public. Deadline for entry: August 15. Application fee: $20; space fee: $100-195. Exhibition space: 10 × 12 ft.-12 × 20 ft. For more information and application, see website.

Tips Recommends "quality in work and display."

CITY OF FAIRFAX FALL FESTIVAL

10455 Armstrong St., Fairfax VA 22030. (703)385-7949. Fax: (703)246-6321. E-mail: klewis@fairfaxva.gov. Web site: www.fairfaxva.gov/SpecialEvents/FallFestival/FallFestival.asp. **Contact:** Kathy Lewis, special events coordinator. Estab. 1975. Arts & crafts show held annually 2nd Saturday in October. Outdoors. Accepts photography, jewelry, glass, pottery, clay, wood, mixed media. Juried by a panel of 5 independent jurors. Number of exhibitors: 400. Public attendance: 25,000. Public admission: $5 for age 18 and older. Artists should apply by contacting Leslie Herman for an application. Deadline for entry: March. Application fee: $10. Space fee: $150. Exhibition space: 10 × 10 ft. For more information, artists should e-mail.

Tips "Be on-site during the event. Smile. Price according to what the market will bear."

CITY OF FAIRFAX HOLIDAY CRAFT SHOW

10455 Armstrong St., Fairfax VA 22030. (703)385-7949. Fax: (703)246-6321. E-mail: klewis@fairfaxva.gov. Website: www.fairfaxva.gov. **Contact:** Leslie Herman, special events coordinator. Estab. 1985. Arts & crafts show held annually 3rd weekend in November. Indoors. Accepts photography, jewelry, glass, pottery, clay, wood, mixed media. Juried by a panel of 5 independent jurors. Number of exhibitors: 247. Public attendance: 10,000. Public admission: $5 for age 18 an older. Artists should apply by contacting Leslie Herman for an application. Deadline for entry: March. Application fee: $10. Space fee: 10 × 6 ft.: $175; 11 × 9 ft.: $250; 10 × 10 ft.: $250. For more information, artists should e-mail. Currently full.

Tips "Be on-site during the event. Smile. Price according to what the market will bear."

COLORSCAPE CHENANGO ARTS FESTIVAL

P.O. Box 624, Norwich NY 13815. (607)336-3378. E-mail: info@colorscape.org. Website: www.colorscape.org. **Contact:** Peggy Finnegan, festival director. Estab. 1995. Fine arts &

crafts show held annually the weekend after Labor Day. Outdoors. Accepts photography and all types of mediums. Juried. Awards/prizes: $5,000. Number of exhibitors: 80-85. Public attendance: 14,000-16,000. Free to public. Deadline for entry: March. Application fee: $15/jury fee. Space fee: $150. Exhibition space: 12 × 12 ft. For more information, artists should e-mail, visit Web site, call or send SASE.

Tips "Interact with your audience. Talk to them about your work and how it is created. Don't sit grumpily at the rear of your booth reading a book. People like to be involved in the art they buy and are more likely to buy if you involve them."

☑ CONYERS CHERRY BLOSSOM FESTIVAL

1996 Centennial Olympic Parkway, Conyers GA 30013. (770)860-4190. Fax: (770)602-2500. E-mail: rebecca.hill@conyersga.com. Website: www.conyerscherryblossomfest.com. **Contact:** Rebecca Hill, event manager. Estab. 1981. Arts & crafts show held annually in late March. Outdoors. Accepts photography, paintings. Juried. Number of exhibitors: 300. Public attendance: 40,000. Free to public; $5 parking fee. **Deadline** for entry: December. Space fee: $125/booth. Exhibition space: 10 × 10 ft. For more information, artists should e-mail, visit website or call.

☑ CRAFT FAIR AT THE BAY

Castleberry Fairs & Festivals, 38 Charles St., Rochester NH 03867. (603)332-2616. E-mail: info@castleberryfairs.com. Website: www.castleberryfairs.com. **Contact:** Terry Mullen, event coordinator. Estab. 1988. Arts & crafts show held annually in July in Alton Bay, New Hampshire. Outdoors. Accepts photography and all other mediums. Juried by photo, slide or sample. Number of exhibitors: 85. Public attendance: 7,500. Free to the public. Artists should apply by downloading application from Web site. Deadline for entry: until full. Space fee: $250. Exhibition space: 100 sq. ft. Average gross sales/exhibitor: "Generally, this is considered an 'excellent' show, so I would guess most exhibitors sell ten times their booth fee, or in this case, at least $2,500 in sales." For more information, artists should visit Web site.

Tips "Do not bring a book; do not bring a chair. Smile and make eye contact with everyone who enters your booth. Have them sign your guest book; get their e-mail address so you can let them know when you are in the area again. And, finally, make the sale—they are at the fair to shop, after all."

☑ CRAFTS AT RHINEBECK

P.O. Box 389, Rhinebeck NY 12572. (845)876-4000. Fax: (845)876-4003. E-mail: vimperati@dutchessfair.com. Website: www.craftsatrhinebeck.com. **Contact:** Vicki Imperati, event coordinator. Estab. 1981. Fine arts & crafts show held biannually in late June and early October. Indoors and outdoors. Accepts photography, fine art, ceramics, wood, mixed media, leather, glass, metal, fiber, jewelry. Juried by 3 slides of work and 1 of booth display. Number of exhibitors: 350. Public attendance: 25,000. Public admission: $7. Artists should apply by calling for application or downloading application from Web site. Deadline for entry: February 1. Application fee: $20. Space fee: $300-730. Exhibition space: inside: 10 × 10 ft. and 10 × 20 ft.; outside:15 × 15 ft. For more information, artists should e-mail, visit website or call.

Tips "Presentation of work within your booth is very important. Be approachable and inviting."

CUNEO GARDENS ART FESTIVAL

3417 R.F.D., Long Grove IL 60047. Phone/Fax: (847)726-8669. E-mail: dwevents@comcast. net. Website: www.dwevents.org. **Contact:** D & W Events, Inc. Estab. 2005. Fine arts & crafts show held outdoors in May. Accepts photography, fiber, oil, acrylic, watercolor, mixed media, jewelry, sculpture, metal, paper, painting. Juried by 3 jurors. Awards/prizes: Best of Show; First Place and awards of excellence. Number of exhibitors: 75. Public attendance: 10,000. Free to public. Artists should apply by downloading application from Web site, e-mail or call. Deadline for entry: March 1. Application fee: $25. Space fee: $275. Exhibition space: 100 sq. ft. For more information, artists should e-mail, visit Web site, call.
Tips "Artists should display professionally and attractively, and interact positively with everyone."

DEERFIELD FINE ARTS FESTIVAL

3417 R.F.D., Long Grove IL 60047. Phone/Fax: (847)726-8669. E-mail: dwevents@comcast. net. Website: www.dwevents.org. **Contact:** D & W Events, Inc. Estab. 2000. Fine arts & crafts show held annually in early June. Outdoors. Accepts photography, fiber, oil, acrylic, watercolor, mixed media, jewelry, sculpture, metal, paper, painting. Juried by 3 jurors. Awards/prizes: Best of Show; First Place, awards of excellence. Number of exhibitors: 150. Public attendance: 35,000. Free to public. Artists should apply by downloading application from Web site, e-mail or call. Deadline for entry: March 1. Application fee: $25. Space fee: $275. Exhibition space: 100 sq. ft. For more information artists should e-mail, visit Web site, call.
Tips "Artists should display professionally and attractively, and interact positively with everyone."

DELAWARE ARTS FESTIVAL

P.O. Box 589, Delaware OH 43015. (740-)363-2695. E-mail: info@delawareartsfestival. org. Website: www.delawareartsfestival.org. **Contact:** Tom King. Estab. 1973. Fine arts & crafts show held annually the Saturday and Sunday after Mother's Day. Outdoors. Accepts photography; all mediums, but no buy/sell. Juried by committee members who are also artists. Awards/prizes: Ribbons, cash awards, free booth for the following year. Number of exhibitors: 160. Public attendance: 25,000. Free to the public. Artists should apply by visiting website for application. Application fee: $10. Space fee: $125. Exhibition fee: 120 sq. ft. For more information, artists should e-mail or visit Web site.
Tips "Have high-quality stuff. Engage the public. Set up a good booth."

DOWNTOWN FESTIVAL & ART SHOW

P.O. Box 490, Gainesville FL 32602. (352)334-5064. Fax: (352)334-2249. E-mail: piperlr@ cityofgainesville.org. Website: www.gvlculturalaffairs.org. **Contact:** Linda Piper, festival director. Estab. 1981. Fine arts & crafts show held annually in November. Outdoors. Accepts photography, wood, ceramic, fiber, glass, and all mediums. Juried by 3 slides of artwork and 1 slide of booth. Awards/prizes: $14,000 in Cash Awards; $5,000 in Purchase Awards. Number of exhibitors: 250. Public attendance: 115,000. Free to the public. Artists should

apply by mailing 4 slides. Deadline for entry: May. Space fee: $185. Exhibition space: 12 ft. × 12 ft. Average gross sales/exhibitor: $6,000. For more information, artists should e-mail, visit website, call, send SASE.

Tips "Submit the highest-quality slides possible. A proper booth slide is so important."

☪ EDWARDS FINE ART & SCULPTURE FESTIVAL

15648 N. Eagles Nest Dr., Fountain Hills AZ 85268-1418. (480)837-5637. Fax: (480)837-2355. E-mail: info@thunderbirdartists.com. Website: www.thunderbirdartists.com. **Contact:** Denise Colter, vice president. Estab. 1999. Fine arts & sculpture show held annually in late July. Outdoors. Accepts photography, painting, drawing, graphics, fiber sculpture, mixed media, bronze, metal, copper, stone, stained glass, clay, wood, baskets, jewelry. Juried by 4 slides of work and 1 slide of booth presentation. Number of exhibitors: 115. Public attendance: 3,000-6,000. Free to public. Artists should apply by sending application, fees, 4 slides of work, 1 slide of booth labeled and 2 SASE. Deadline for entry: March 29. Application fee: $25. Space fee: $410. Exhibition space: 10 × 10 ft. For more information, artists should visit Web site.

☪ ELIZABETHTOWN FESTIVAL

818 Jefferson, Moundsville WV 26041. (304)843-1170. Fax: (304)845-2355. E-mail: jvhblake@aol.com. Website: www.wvpentours.com. **Contact:** Sue Riggs at (304)843-1170 or Hilda Blake at (304)845-2552, co-chairs. Estab. 1999. Arts & crafts show held annually the 3rd weekend in May (Saturday and Sunday). Sponsored by the Moundsville Economic Development Council. Also includes heritage exhibits of 1800s-era food and entertainment. Indoors and outdoors within the walls of the former West Virginia Penitentiary. Accepts photography, crafts, wood, pottery, quilts, jewelry. "All items must be made by the craftspeople selling them; no commercial items." Juried based on design, craftsmanship and creativity. Submit 5 photos: 3 of your medium; 2 of your booth set-up. Jury fee: $10. Number of exhibitors: 70-75. Public attendance: 3,000-5,000. Public admission: $3. Artists should apply by requesting an application form by phone. Deadline for entry: April 1. Space fee: $50. Exhibition space: 100 sq. ft. For more information, artists should e-mail, visit Web site, call, send SASE.

Tips "Be courteous. Strike up conversations—do not sit in your booth and read! Have an attractive display of wares."

☪ ELMWOOD AVENUE FESTIVAL OF THE ARTS, INC.

P.O. Box 786, Buffalo NY 14213. (716)830-2484. E-mail: directoreafa@aol.com. Website: www.elmwoodartfest.org. **Contact:** Joe DiPasquale. Estab. 2000. Arts & crafts show held annually in late-August, the weekend before Labor Day weekend. Outdoors. Accepts photography, metal, fiber, ceramics, glass, wood, jewelry, basketry, 2D media. Juried. Awards/prizes: to be determined. Number of exhibitors: 170. Public attendance: 80,000-120,000. Free to the public. Artists should apply by e-mailing their contact information or by downloading application from Web site. Deadline for entry: April. Application fee: $20. Space fee: $200. Exhibition space: 150 sq. ft. Average gross sales/exhibitor: $3,000. For more information, artists should e-mail, visit Web site, call, send SASE.

Tips "Make sure your display is well designed, with clean lines that highlight your work.

Have a variety of price points—even wealthy people don't always want to spend $500 at a booth where they may like the work."

✠ A FAIR IN THE PARK

4906 Yew St., Pittsburgh PA 15224. (412)370-0695. E-mail: info@craftsmensguild. org. Website: www.craftsmensguild.org. **Contact:** Leah Shannon, director. Estab. 1969. Contemporary fine arts & crafts show held annually the weekend after Labor Day outdoors. Accepts photography, clay, fiber, jewelry, metal, mixed media, wood, glass, 2D visual arts. Juried. Awards/prizes: 1 Best of Show and 4 Craftsmen's Guild Awards. Number of exhibitors: 115. Public attendance: 25,000+. Free to public. Artists should apply by sending application with jury fee, booth fee and 5 digital images. Deadline for entry: May 1. Application fee: $25. Space fee: $250-300. Exhibition space: 11 × 12 ft. Average gross sales/ exhibitor: $1,000 and up. For more information artists should e-mail, visit website or call.

Tips "It is very important for artists to present their work to the public, to concentrate on the business aspect of their artist career. They will find that they can build a strong customer/collector base by exhibiting their work and by educating the public about their artistic process and passion for creativity."

✠ FALL CRAFTS AT LYNDHURST

P.O. Box 28, Woodstock NY 12498. (845)331-7900. Fax: (845)331-7484. E-mail: crafts@ artrider.com. Website: www.artrider.com. **Contact:** Laura Kandel. Estab. 1984. Fine arts & crafts show held annually in mid-September. Outdoors. Accepts photography, wearable and nonwearable fiber, metal and nonmetal jewelry, clay, leather, wood, glass, painting, drawing, prints mixed media. Juried by 5 images of work and 1 of booth, viewed sequentially. Number of exhibitors: 300. Public attendance: 14,000. Public admission: $10. Artists should apply by downloading application from www.artrider.com or can apply online at www. zapplication.org. Deadline for entry: January 1. Application fee: $45. Space fee: $795. Exhibition space: 10 × 10. For more information, artists should e-mail, visit Web site, call.

FALL FEST IN THE PARK

117 W. Goodwin St., Prescott AZ 86301-1147. (928)445-2000 ext 12. Fax: (928)445-0068. E-mail: scott@prescott.org. Website: www. prescott.org. **Contact:** Scott or Jill Currey (Special Events—Prescott Chamber of Commerce) Estab. 1981. Arts & crafts show held annually in mid-October. Outdoors. Accepts photography, ceramics, painting, sculpture, clothing, woodworking, metal art, glass, floral, home décor. " No resale." Juried. " Photos of work and artist creating work are required." Number of exhibitors: 150. Public attendance: 6,000-7,000. Free to public. Application can be printed from website or obtained by phone request. Deadline: Spaces are sold until show is full. Application fee: $50 deposit. Space fee: $225. Exhibition space; 10 × 15 ft. For more information, artists should e-mail, visit website or call.

✠ FALL FINE ART & CRAFTS AT BROOKDALE PARK

12 Galaxy Court, Hillsborough NJ 08844. (908)874-5247. Fax: (908)874-7098. E-mail: info@rosesquared.com. Website: www.rosesquared.com. **Contact:** Janet Rose, president. Estab.1997. Fine arts & craft show held annually in mid-October. Outdoors. Accepts

photography and all other mediums. Juried. Number of exhibitors: 180. Public attendance: 14,000. Free to the public. Artists should apply by downloading application from website or call for application. Deadline: 1 month before show date. Application fee: $15. Space fee: $310. Exhibition space: 120 sq. ft. For more information, artists should e-mail, visit Web site, call.

Tips "Create a professional booth that is comfortable for the customer to enter. Be informative, friendly and outgoing. People come to meet the artist."

FAUST FINE ARTS & FOLK FESTIVAL

15185 Olive St., St. Louis MO 63017. (314)615-8482. E-mail: toconnell@stlouisco.com. Website: www.stlouisco.com/parks. **Contact:** Tonya O'Connell, recreation supervisor. Fine arts & crafts show held biannually in May and September. Outdoors. Accepts photography, oil, acrylic, clay, fiber, sculpture, watercolor, jewelry, wood, floral, baskets, prints, drawing, mixed media, folk art. Juried by a committee. Awards/prizes: $100. Number of exhibitors: 90-100. Public attendance: 5,000. Public admission: $5. Deadline for entry: March, spring show; July, fall show. Application fee: $15. Space fee: $75. Exhibition space: 10 × 10 ft. For more information, artists should call.

FERNDALE ART SHOW

Integrity Shows, 2102 Roosevelt, Ypsilanti MI 48197. (734)216-3958. Fax: (734)482-2070. E-mail: markloeb@aol.com. Website: www.michiganartshow.com. **Contact:** Mark Loeb, president. Estab. 2004. Fine arts & crafts show held annually in September. Outdoors. Accepts photography and all fine art and craft mediums; emphasis on fun, funky work. Juried by 3 independent jurors. Awards/prizes: Purchase Awards and Merit Awards. Number of exhibitors: 90. Public attendance: 30,000. Free to the public. Application is available in March. Deadline for entry: July. Application fee: $15. Space fee: $250. Exhibition space: 10X12 ft. For more information, artists should e-mail or call.

Tips "Enthusiasm. Keep a mailing list. Develop collectors."

FESTIVAL IN THE PARK

1409 East Blvd., Charlotte NC 28203. (704)338-1060. Fax: (704)338-1061. E-mail: festival@ festivalinthepark.org. Website: www.festivalinthepark.org. **Contact:** Julie Whitney Austin, executive director. Estab. 1964. Fine arts & crafts/arts & crafts show held annually 3rd Thursday after Labor Day. Outdoors. Accepts photography, decorative and wearable crafts, drawing and graphics, fiber and leather, jewelry, mixed media, painting, metal, sculpture, wood. Juried by slides or photographs. Awards/prizes: $4,000 in cash awards. Number of exhibitors: 150. Public attendance: 100,000. Free to the public. Artists should apply by visiting website for application. Application fee: $25. Space fee: $350. Exhibition space: 10 × 10 ft. For more information, artists should e-mail, visit website, call.

FILLMORE JAZZ FESTIVAL

P.O. Box 151017, San Rafael CA 94915. (800)310-6563. Fax: (414)456-6436. E-mail: art@ fillmorejazzfestival.com. Website: www.fillmorejazzfestival.com. Estab. 1984. Fine arts & crafts show and jazz festival held annually 1st weekend of July in San Francisco, between Jackson & Eddy Streets. Outdoors. Accepts photography, ceramics, glass, jewelry, paintings,

sculpture, metal clay, wood, clothing. Juried by prescreened panel. Number of exhibitors: 250. Public attendance: 90,000. Free to public. Deadline for entry: ongoing. Space fee: $350-600. Exhibition space: 8 × 10 ft. or 10 × 10 ft. Average gross sales/exhibitor: $800-11,000. For more information, artists should e-mail, visit website or call.

✠ FINE ART & CRAFTS AT ANDERSON PARK

12 Galaxy Ct., Hillsborough NJ 08844. (908)874-5247. Fax: (908)874-7098. E-mail: info@rosesquared.com. Website: www.rosesquared.com. **Contact:** Janet Rose, president. Estab.1984. Fine arts & craft show held annually in mid-September. Outdoors. Accepts photography and all other mediums. Juried. Number of exhibitors: 190. Public attendance: 16,000. Free to the public. Artists should apply by downloading application from website or call for application. Deadline: 1 month before show date. Application fee: $15. Space fee: $310. Exhibition space: 120 sq. ft. For more information, artists should e-mail, visit website, call.

Tips "Create a professional booth that is comfortable for the customer to enter. Be informative, friendly and outgoing. People come to meet the artist."

✠ FINE ART & CRAFTS AT NOMAHEGAN PARK

12 Galaxy Ct., Hillsborough NJ 08844. (908)874-5247. Fax: (908)874-7098. E-mail: info@rosesquared.com. Website: www.rosesquared.com. **Contact:** Janet Rose, president. Estab. 1987. Fine arts & craft show held annually in May. Outdoors. Accepts photography and all other mediums. Juried. Number of exhibitors: 110. Public attendance: 12,000. Free to the public. Artists should apply by downloading application from website or call for application. Deadline: 1 month before show date. Application fee: $15. Space fee: $310. Exhibition space: 120 sq. ft. For more information, artists should e-mail, visit Web site, call.

Tips "Create a professional booth that is comfortable for the customer to enter. Be informative, friendly and outgoing. People come to meet the artist."

✠ FINE ART & CRAFTS FAIR AT VERONA PARK

12 Galaxy Ct., Hillsborough NJ 08844. (908)874-5247. Fax: (908)874-7098. E-mail: info@rosesquared.com. Website: www.rosesquared.com. **Contact:** Janet Rose, president. Estab.1986. Fine arts & craft show held annually in May. Outdoors. Accepts photography and all other mediums. Juried. Number of exhibitors: 140. Public attendance: 14,000. Free to the public. Artists should apply by downloading application from website or call for application. Deadline: 1 month before show date. Application fee: $15. Space fee: $310. Exhibition space: 120 sq. ft. For more information, artists should e-mail, visit website, call.

Tips "Create a professional booth that is comfortable for the customer to enter. Be informative, friendly and outgoing. People come to meet the artist."

✠ FOOTHILLS CRAFTS FAIR

2753 Lynn Rd. #A, Tryon NC 28782-7870. (828)859-7427. E-mail: info@blueridgebbqfestival.com. Website: www.BlueRidgeBBQFestival.com. **Contact:** Julie McIntyre. Estab. 1994. Fine arts & crafts show and Blue Ridge BBQ Festival/Championship held annually 2nd Friday and Saturday in June. Outdoors. Accepts photography, arts and handcrafts by artist only; nothing manufactured or imported. Juried. Number of exhibitors: 50. Public attendance:

25,000 +. Public admission: $8; 12 and under free. Artists should apply by downloading application from website or sending personal information to e-mail or mailing address. Deadline for entry: March 30. Jury fee: $25 nonrefundable. Space fee: $150. Exhibition space: 10 × 10 ft. For more information, artists should visit Web site.

Tips "Have an attractive booth, unique items, and reasonable prices."

☙ FOURTH AVENUE SPRING STREET FAIR

329 E. 7th St., Tucson AZ 85705.(520)624-5004. Fax: (520)624-5933. E-mail: kurt@ fourthavenue.org. Website: www.fourthavenue.org. **Contact:** Kurt Tallis, event director. Estab. 1970. Arts & crafts fair held annually in March. 2009 dates March 20-22. Outdoors. Accepts photography, drawing, painting, sculpture, arts and crafts. Juried by 5 jurors. Awards/prizes: Best of Show. Number of exhibitors: 400. Public attendance: 300,000. Free to the public. Artists should apply by completing the online application. Deadline for entry: December 17, 2008. Application fee: $35. Space fee: $470. Exhibition space: 10 × 10 ft. Average gross sales/exhibitor: $3,000. For more information, artists should e-mail, visit Web site, call, send SASE.

☙ FOURTH AVENUE WINTER STREET FAIR

329 E. 7th St., Tucson AZ 85705. (520)624-5004. Fax: (520)624-5933. E-mail: kurt@ fourthavenue.org. Website: www.fourthavenue.com. **Contact:** Kurt Tallis, event director. Estab. 1970. Arts & crafts fair held annually in December. 2008 dates December 12-14. Outdoors. Accepts photography, drawing, painting, sculpture, arts and crafts. Juried by 5 jurors. Awards/prizes: Best of Show. Number of exhibitors: 400. Public attendance: 300,000. Free to the public. Artists should apply by completing the online application. Deadline for entry: September. Application fee: $35. Space fee: $470. Exhibition space: 10 × 10 ft. Average gross sales/exhibitor: $3,000. For more information, artists should e-mail, visit Web site, call, send SASE.

☙ FOURTH STREET FESTIVAL FOR THE ARTS & CRAFTS

P.O. Box 1257, Bloomington IN 47402. (812) 335-3814. E-mail: info@4thstreet.org. Website: www.4thstreet.org. Estab. 1976. Fine arts & crafts show held annually Labor Day weekend. Outdoors. Accepts photography, clay, glass, fiber, jewelry, painting, graphic, mixed media, wood. Juried by a 4-member panel. Awards/prizes: Best of Show, 1st, 2nd, 3rd in 2D and 3D. Number of exhibitors: 105. Public attendance: 25,000. Free to public. Artists should apply by sending requests by snail mail, e-mail or download application from Web site. Deadline for entry: April 1. Application fee: $15. Space fee: $175. Exhibition space: 10 × 10 ft. Average gross sales/exhibitor: $2,700. For more information, artists should e-mail, visit Web site, call or send for information with SASE.

Tips "Be professional."

☙ FRANKFORT ART FAIR

P.O. Box 566, Frankfort MI 49635.(231)352-7251. Fax: (231)352-6750. E-mail: fcofc@ frankfort-elberta.com. Website: www.frankfort-elberta.com. Estab. 1976. **Contact:** Joanne Bartley, executive director. Fine Art Fair held annually in August. Outdoors. Accepts photography, clay, glass, jewelry, textiles, wood, drawing/graphic arts, painting, sculpture,

baskets, mixed media. Juried by 3 photos of work, one photo of booth display and one photo of work in progress. Prior exhibitors are not automatically accepted. No buy/sell allowed. Artists should apply by downloading application from Web site, e-mailing or calling. Deadline for entry: May 1. Jury fee: $15. Space fee: $105 for Friday and Saturday. Exhibition space: 12 × 12 ft. For more information, artists should e-mail, see website.

◪ GARRISON ART CENTER FINE ART & CRAFT FAIR

P.O. Box 4, 23 Camison's Landing, Garrison NY 10524. (845)424-3960. Fax: (845)424-4711. E-mail: info@garrisonartcenter.org. Website: www.garrisonartcenter.org. Estab. 1969. **Contact:** Carinda Swann, executive director. Fine arts & crafts show held annually 3rd weekend in August. Outdoors. Accepts all mediums. Juried by a committee of artists and community members. Number of exhibitors: 100. Public attendance: 10,000. Public admission: $8. Artists should call for application form or download from Web site. Deadline for entry: April. Application fee: $15. Space fee: $260; covered corner booth: $300. Exhibition space: 10 × 10 ft. For more information, artists should e-mail, visit Web site, call, send SASE.

Tips "Have an inviting booth and be pleasant and accessible. Don't hide behind your product—engage the audience."

GERMANTOWN FESTIVAL

P.O. Box 381741, Germantown TN 38183. (901)757-9212. E-mail: gtownfestival@aol.com. Website: www.germantownfest.com. **Contact:** Melba Fristick, coordinator. Estab. 1971. Arts and crafts show held annually the weekend after Labor Day. Outdoors. Accepts photography, all arts & crafts mediums. Number of exhibitors: 400 + . Public attendance: 65,000. Free to public. Artists should apply by sending applications by mail. Deadline for entry: until filled. Application/space fee: $190-240. Exhibition space: 10 × 10 ft. For more information, artists should e-mail, call or send SASE.

Tips "Display and promote to the public. Price attractively."

◪ GLOUCESTER WATERFRONT FESTIVAL

Castleberry Fairs & Festivals, 38 Charles St., Rochester NH 03867. (603)332-2616. E-mail: info@castelberryfairs.com. Website: www.castleberryfairs.com. **Contact:** Terry Mullen, events coordinator. Estab. 1971. Arts & crafts show held 3rd weekend in August in Gloucester, Massachusetts. Outdoors. Accepts photography and all other mediums. Juried by photo, slide or sample. Number of exhibitors: 300. Public attendance: 50,000. Free to the public. Artists should apply by downloading application from Web site. Deadline for entry: until full. Space fee: $350. Exhibition space: 100 sq. ft. Average gross sales/exhibitor: "Generally, this is considered an 'excellent' show, so I would guess most exhibitors sell ten times their booth fee, or in this case, at least $3,500 in sales." For more information, artists should visit Web site.

Tips "Do not bring a book; do not bring a chair. Smile and make eye contact with everyone who enters your booth. Have them sign your guest book; get their e-mail address so you can let them know when you are in the area again. And, finally, make the sale—they are at the fair to shop, after all."

GOLD RUSH DAYS

P.O. Box 774, Dahlonega GA 30533. (706)864-7247. Website: www.dahlonegajaycees. com. **Contact:** Gold Rush Chairman. Arts & crafts show held annually the 3rd full week in October. Accepts photography, paintings and homemade, handcrafted items. No digitally originated art work. Outdoors. Number of exhibitors: 300. Public attendance: 200,000. Free to the public. Artists should apply online under "Gold Rush," or send SASE to request application. Deadline: March. Space fee: $225, "but we reserve the right to raise the fee to cover costs." Exhibition space: 10 × 10 ft. Artists should e-mail, visit website for more information.

Tips "Talk to other artists who have done other shows and festivals. Get tips and advice from those in the same line of work."

GRADD ARTS & CRAFTS FESTIVAL

3860 US Hwy 60 W., Owensboro KY 42301. (270)926-4433. Fax: (270)684-0714. E-mail: bethgoetz@gradd.com. Website: www.gradd.com. **Contact:** Beth Goetz, festival coordinator. Estab. 1972. Arts & crafts show held annually 1st full weekend in October. Outdoors. Accepts photography taken by crafter only. Number of exhibitors: 180-200. Public attendance: 15,000 + . Free to public; $3 parking fee. Artists should apply by calling to be put on mailing list. Space fee: $100-150. Exhibition space: 10 × 12 ft. For more information, artists should e-mail, visit website or call.

Tips "Be sure that only hand-crafted items are sold. No buy/sell items will be allowed."

☑ GRAND FESTIVAL OF THE ARTS & CRAFTS

P.O. Box 429, Grand Lake CO 80447-0429. (970)627-3402. Fax: (970)627-8007. E-mail: glinfo@grandlakechamber.com. Website: www.grandlakechamber.com. **Contact:** Cindy Cunningham, events coordinator; Elaine Arguien, office chamber. Fine arts & crafts show held annually 1st weekend in June. Outdoors. Accepts photography, jewelry, leather, mixed media, painting, paper, sculpture, wearable art. Juried by chamber committee. Awards/prizes: Best in Show and People's Choice. Number of exhibitors: 50-55. Public attendance: 1,000 + . Free to public. Artists should apply by submitting slides or photos. Deadline for entry: May 1. Application fee: $125, includes space fee, security deposit and business license. Exhibition space: 10 × 10 ft. For more information, artists should e-mail or call.

☑ GREAT NECK STREET FAIR

P.O. Box 477, Smithtown NY 11787-0477.(631)724-5966. Fax: (631)724-5967. E-mail: showtiques@aol.com. Website: www.showtiques.com. **Contact:** Eileen. Estab. 1978. Fine arts & crafts show held annually in May. Outdoors. Accepts photography, all arts & crafts made by the exhibitor. Juried. Number of exhibitors: 250. Public attendance: 50,000. Free to public. Deadline for entry: until full. Space fee: $150-175. Exhibition space: 10 × 10 ft. For more information, artists should e-mail, visit website or call.

⬛ ☑ GUILFORD CRAFT EXPO

P.O. box 28, Woodstock NY 12498.(845)331-7900. Fax: (845)331-7484. E-mail: crafts@ artrider.com. Website: http://guilfordartcenter.org; www.artrider.com. **Contact:** Laura Kandel. Estab. 1957. Fine craft and art show held annually in mid-July. Outdoors. Accepts

photography, wearable and nonwearable fiber, metal and nonmetal jewelry, clay, leather, wood, glass, painting, drawing, prints, mixed media. Juried by 5 images of work and 1 of booth, viewed sequentially. Number of exhibitors: 180. Public attendance: 14,000. Public admission: $7. Artists should apply by downloading application from www.artrider.com or can apply online at www.zapplication.org. Deadline for entry: January 1. Application fee: $45. Space fee: $630. Exhibition space: 10 × 12. For more information, artists should e-mail, visit Web site, call.

☙ GUNSTOCK SUMMER FESTIVAL

Castleberry Fairs & Festivals, 38 Charles St., Rochester NH 03867. (603)332-2616. E-mail: info@castelberryfairs.com. Website: www.castleberryfairs.com. **Contact:** Terry Mullen, events coordinator. Estab. 1971. Arts & crafts show held annually in July in Gilford, New Hampshire. Indoors and outdoors. Accepts photography and all other mediums. Juried by photo, slide or sample. Number of exhibitors: 100. Public attendance: 10,000. Free to the public. Artists should apply by downloading application from Web site. Deadline for entry: until full. Space fee: $200. Exhibition space: 100 sq. ft. For more information, artists should visit Web site.

Tips "Do not bring a book; do not bring a chair. Smile and make eye contact with everyone who enters your booth. Have them sign your guest book; get their e-mail address so you can let them know when you are in the area again. And, finally, make the sale—they are at the fair to shop, after all."

☙ HIGHLAND MAPLE FESTIVAL

P.O. Box 223, Monterey VA 24465-0223. (540)468-2550. Fax: (540)468-2551. E-mail: info@highlandcounty.org. Website: www.highlandcounty.org. **Contact:** Carolyn Pottowsky, executive director. Estab. 1958. Fine arts & crafts show held annually the 2nd and 3rd weekends in March. Indoors and outdoors. Accepts photography, pottery, weaving, jewelry, painting, wood crafts, furniture. Juried by 3 photos or slides. Number of exhibitors: 150. Public attendance: 35,000-50,000. Public admission: $2. Deadline for entry: " There is a late fee after December 20, 2006. Vendors accepted until show is full." Space fee: $125-$150. Exhibition space: 10 × 10 ft. For more information, artists should e-mail, visit Web site, call.

Tips "Have quality work and good salesmanship."

☙ HINSDALE FINE ARTS FESTIVAL

22 E. First St., Hinsdale IL 60521. (630)323-3952. Fax: (630)323-3953. E-mail: info@hindsdalechamber.com. Website: www.hinsdalechamber.com. **Contact:** Jan Anderson, executive director. Fine arts show held annually in mid-June. Outdoors. Accepts photography, ceramics, painting, sculpture, fiber arts, mixed media, jewelry. Juried by 3 slides. Awards/prizes: Best in Show, Presidents Award and 1st, 2nd\nosupersub and 3rd Place in 7 categories. Number of exhibitors: 150. Public attendance: 2,000-3,000. Free to public. Artists should apply by mailing or downloading application from Web site. Deadline for entry: March 2. Application fee: $25. Space fee: $250. Exhibition space: 10 × 10 ft. For more information, artists should e-mail or visit Web site.

Tips "Original artwork sold by artist. Artwork should be appropriately and reasonably priced."

❧ HOLIDAY ARTS & CRAFTS SHOW

60 Ida Lee Dr., Leesburg VA 20176. (703)777-1368. Fax: (703)737-7165. E-mail: lfountain@ leesburgva.gov. Website: leesburgva.gov. **Contact:** Linda Fountain, program supervisor. Estab. 1990. Arts & crafts show held annually 1st weekend in December. Indoors. Accepts photography, jewelry, pottery, baskets, clothing, accessories. Juried. Number of exhibitors: 100. Public attendance: 4,000. Free to public. Artists should apply by downloading application from Web site. Deadline for entry: August 31. Space fee: $100-150. Exhibition space: 10 × 10 ft. For more information, artists should e-mail or visit Web site.

❧ HOLIDAY CRAFTS AT MORRISTOWN

P.O. Box 28, Woodstock NY 12498. (845)331-7900. Fax: (845)331-7484. E-mail: crafts@ artrider.com. Website: www.craftsatmorristown.com; www.artrider.com. **Contact:** Laura Kandel. Estab. 1990. Fine arts & crafts show held annually in early December. Indoors. Accepts photography, wearable and nonwearable fiber, metal and nonmetal jewelry, clay, leather, wood, glass, painting, drawing, prints, mixed media. Juried by 5 images of work and 1 of booth, viewed sequentially. Number of exhibitors: 150. Public attendance: 5,000. Public admission: $7. Artists should apply by downloading application from www.artrider. com or can apply online at www.zapplication.org. Deadline for entry: July 1. Application fee: $45. Space fee: $475. Exhibition space: 10 × 10. For more information, artists should e-mail, visit Web site, call.

Ⓝ ❧ HOLIDAY CRAFTS AT THE LEXINGTON AVENUE ARMORY

P.O. Box 28, Woodstock NY 12498.(845)331-7900. Fax: (845)331-7484. E-mail: crafts@ artrider.com. Website: www.artrider.com. **Contact:** Laura Kandel. Estab. 1984. Fine craft and art show held annually in early December. Indoors. Accepts photography, wearable and nonwearable fiber, metal and nonmetal jewelry, clay, leather, wood, glass, painting, drawing, prints, mixed media. Juried by 5 images of work and 1 of booth, viewed sequentially. Number of exhibitors: 300. Public attendance: 14,000. Public admission: $10. Artists should apply by downloading application from www.artrider.com or can apply online at www.zapplication.org. Deadline for entry: July 1. Application fee: $45. Space fee: $1195. Exhibition space: 10 × 10. For more information, artists should e-mail, visit Web site, call.

❧ HOLLY ARTS & CRAFTS FESTIVAL

P.O. Box 2122, Pinehurst NC 28370. (910)295-7462. E-mail: sbharrison@earthlink.net, pbguild@pinehurst.net. Website: www.pinehurstbusinessguild.com. **Contact:** Susan Harrison, Holly Arts & Crafts committee. Estab. 1978. Arts & crafts show held annually 3rd Saturday in October. Outdoors. Accepts quality photography, arts, and crafts. Juried based on uniqueness, quality of product, and overall display. Awards/prizes: plaque given to Best in Show; 2 Honorable Mentions receive ribbons. Number of exhibitors: 200. Public attendance: 7,000. Free to the public. Artists should apply by filling out application form. Deadline for entry: March 31, 2010. Space fee: $75. Exhibition space: 10 × 10 ft. For more information, artists should e-mail, visit Web site, call, send SASE. Applications accepted after deadline if available space.

HOME, CONDO AND GARDEN ART & CRAFT FAIR

P.O. Box 486, Ocean City MD 21843. (410)524-7020. Fax: (410)524-0051. E-mail: oceanpromotions@beachin.net. Website: www.oceanpromotions.info. **Contact:** Mike, promoter; Starr, assistant. Estab. 1984. Fine arts & crafts show held annually in March. Indoors. Accepts photography, carvings, pottery, ceramics, glass work, floral, watercolor, sculpture, prints, oils, pen & ink. Number of exhibitors: 125. Public attendance: 18,000. Public admission: $7/adults; $6/seniors & students; 13 and under free. Artists should apply by e-mailing request for info and application. Deadline for entry: Until full. Space fee: $250. Exhibition space: 10 × 10 ft. For more information, artists should e-mail, visit website or call.

HOME DECORATING & REMODELING SHOW

P.O. Box 230699, Las Vegas NV 89105-0699. (702)450-7984 or (800)343-8344. Fax: (702)451-7305. E-mail: spvandy@cox.net. Website: www.nashvillehomeshow.com. **Contact:** Vandy Richards, manager member. Estab. 1983. Home show held annually in September. Indoors. Accepts photography, sculpture, watercolor, oils, mixed media, pottery. Awards/prizes: Outstanding Booth Award. Number of exhibitors: 300-350. Public attendance: 25,000. Public admission: $8. Artists should apply by calling. Marketing is directed to middle and above income brackets. Deadline for entry: open until filled. Space fee: $900 + . Exhibition space: 9 × 10 ft. or complement of 9 × 10 ft. For more information, artists should call.

⚑ STAN HYWET HALL & GARDENS WONDERFUL WORLD OF OHIO MART

714 N. Portage Path, Akron OH 44303-1399. (330)836-5533. Website: www.stanhywet.org. **Contact:** Lynda Grieves, exhibitor chair. Estab. 1966. Arts & crafts show held annually 1st full weekend in October. Outdoors. Accepts photography and all mediums. Juried 2 Saturdays in January and via mail application. Awards/prizes: Best Booth Display. Number of exhibitors: 115. Public attendance: 15,000-20,000. Public admission: $7. Deadline for entry: Mid-February. Space fee: $450. Exhibition space: 10 × 10 ft. For more information, artists should visit website or call.

⚑ INTERNATIONAL FOLK FESTIVAL

P.O. Box 318, Fayetteville NC 28302-0318. (910)323-1776. Fax: (910)323-1727. E-mail: kelvinc@theartscouncil.com. Website: www.theartscouncil.com. **Contact:** Kelvin Culbreth, director of special events. Estab. 1978. Fine arts & crafts show held annually in late September. Outdoors. Accepts photography, painting of all mediums, pottery, woodworking, sculptures of all mediums. "Work must be original." Juried. Awards/prizes: $2,000 in cash prizes in several categories. Number of exhibitors: 120 + . Public attendance: 70,000. Free to public. Artists should apply on the Web site. Deadline for entry: September 1. Application fee: $60; includes space fee. Exhibition space: 10 × 10 ft. Average gross sales/exhibitor: $500. For more information, artists should e-mail or visit Web site.

Tips "Have reasonable prices."

⚑ ISLE OF EIGHT FLAGS SHRIMP FESTIVAL

18 N. Second St., Ferninda Beach FL 32034. (904)271-7020. Fax: (904)261-1074. E-mail:

mailbox@islandart.org. Website: www.islandart.org. **Contact:** Shrimp Festival Committee Chairperson. Estab. 1963. Fine arts & crafts show and community celebration held annually the 1st weekend in May. Outdoors. Accepts photography and all mediums. Juried. Awards/prizes: $9,700 in cash prizes. Number of exhibitors: 425. Public attendance: 150,000. Free to public. Artists should apply by downloading application from Web site. Deadline for entry: January 1. Application fee: $30. Space fee: $200. Exhibition space: 10 × 12 ft. Average gross sales/exhibitor: $1,500 + . For more information, artists should visit Web site.
Tips "Quality product and attractive display."

◪ JOHNS HOPKINS UNIVERSITY SPRING FAIR

3400 N Charles Street, Mattin Suite 210, Baltimore MD 21218. (410)513-7692. Fax: (410)516-6185. E-mail: springfair@gmail.com. Website: www.jhuspringfair.com. **Contact:** Catalina McCallum, arts & crafts chair. Estab. 1972. Fine arts & crafts, campus-wide, festival held annually in April. Outdoors. Accepts photography and all mediums. Juried. Number of exhibitors: 80. Public attendance: 20,000 + . Free to public. Artists should apply via Web site. Deadline for entry: March 1. Application fee: $200. Space fee: $200. Exhibition space: 10 × 10 ft. For more information, artists should e-mail, visit website or call.
Tips "Artists should have fun displays, good prices, good variety and quality pieces."

JUBILEE FESTIVAL

P.O. Drawer 310, Daphne AL 36526. (251)621-8222. Fax: (251)621-8001. E-mail: office@eschamber.com. Website: www.eschamber.com. **Contact:** Angela Kimsey, event coordinator. Estab. 1952. Fine arts & crafts show held in September in Olde Towne of Daphne, Alabama. Outdoors. Accepts photography and fine arts and crafts. Juried. Awards/prizes: ribbons and cash prizes. Number of exhibitors: 258. Public attendance: 200,000. Free to the public. Application fee: $25. Space fee: $265. Exhibition space: 10 ft. × 10 ft. For more information, artists should e-mail, call, see Web site.

◪ KIA ART FAIR (KALAMAZOO INSTITUTE OF ARTS)

314 S. Park St., Kalamazoo MI 49007-5102. (269)349-7775. Fax: (269)349-9313. E-mail: sjrodia@yahoo.com. Website: www.kiarts.org. **Contact:** Steve Rodia, artist coordinator. Estab. 1951. Fine arts & crafts show held annually the 1st Friday and Saturday in June. Outdoors. Accepts photography, prints, pastels, drawings, paintings, mixed media, ceramics (functional and nonfunctional), sculpture/metalsmithing, wood, fiber, jewelry, glass, leather. Juried by no fewer than 3 and no more than 5 art professionals chosen for their experience and expertise. See prospectus for more details. Awards/prizes: 1st prize: $500; 2nd prize: 2 at $300 each; 3rd prize: 3 at $200 each. 10 category prizes at $100 each. Number of exhibitors: 200. Public attendance: 40,000-50,000. Free to the public. Artists should apply by filling out application form and submitting 3 digital images of their art and 1 digital image of their booth display. Deadline for entry: March 1. Application fee: $25, nonrefundable. Space fee: $110. Exhibition space: 10 × 12 ft. Height should not exceed 10 ft. in order to clear the trees in the park. For more information, artists should e-mail, visit Web site, call.

☕ KINGS MOUNTAIN ART FAIR

13106 Skyline Blvd., Woodside CA 94062. (650)851-2710. E-mail: kmafsecty@aol.com. **Contact:** Carrie German, administrative assistant. Website: www.kingsmountainartfair.org. Estab. 1963. Fine arts & crafts show held annually Labor Day weekend. Fundraiser for volunteer fire dept. Accepts photography, ceramics, clothing, 2D, painting, glass, jewelry, leather, sculpture, textile/fiber, wood. Juried. Number of exhibitors: 135. Public attendance: 10,000. Free to public. Deadline for entry: January 30. Application fee: $10. Space fee: $100 plus 15%. Exhibition space: 10 × 10 ft. Average gross sales/exhibitor: $3,000. For more information, artists should e-mail, visit website, call or send SASE.

☒ ☕ KRASL ART FAIR ON THE BLUFF

707 Lake Blvd., St. Joseph MI 49085. (269)983-0271. Fax: (269)983-0275. E-mail: sshambarger@krasl.org. Website: www.krasl.org. **Contact:** Sara Shambarger, art fair director. Estab. 1962. Fine arts & crafts show held annually in July. Outdoors. Accepts photography, painting, digital art, drawing, pastels, wearable and nonwearable fiber art, glass, jewelry. Juried. (Returning artists do not have to re-jury or pay the $25 application fee.) Number of exhibitors: 216. Number of attendees: more than 70,000. Free to public. Artists should apply through Zapplication at www.zapplication.org. Deadline for entry: approximately mid-January. Application fee: $25. Space fee: $250. Exhibition space: 15 × 15 ft. or larger, $275. Average gross sales/exhibitor: $3,000. For more information, artists should e-mail or visit Web site.

Tips "Be willing to talk to people in your booth. You are your own best asset!"

☕ LAKE CITY ARTS & CRAFTS FESTIVAL

P.O.Box 1147, Lake City CO 81235. (970)944-2706. E-mail: jlsharpe@centurytel.net. Website: www.lakecityarts.org. **Contact:** Laura Sharpe, festival director. Estab. 1975. Fine arts/arts & craft show held annually 3rd Tuesday in July. One-day event. Outdoors. Accepts photography, jewelry, metal work, woodworking, painting, handmade items. Juried by 3-5 undisclosed jurors. Prize: Winners are entered in a drawing for a free both space in the following year's show. Number of Exhibitors: 85. Public Attendance: 500. Free to the public. Deadline for entry: entries must be postmarked April 25. Application fee: $75; nonrefundable jury fee: $10. Exhibition space: 12 × 12 ft. Average gross sales/exhibitor: $500-$1,000. For more information, artists should visit Web site.

Tips "Repeat vendors draw repeat customers. People like to see their favorite vendors each year or every other year. If you come every year, have new things as well as your best-selling products."

☕ LES CHENEAUX FESTIVAL OF ARTS

P.O. Box 30, Cedarville MI 49719. (906)484-2821. Fax: (906)484-6107. E-mail: lcha@cedarville. net. Contact: A. Goehring, curator. Estab. 1976. Fine arts & crafts show held annually 2nd Saturday in August. Outdoors. Accepts photography and all other media; original work and design only; no kits or commercially manufactured goods. Juried by a committee of 10. Submit 4 slides (3 of the artwork; 1 of booth display). Awards/prizes: monetary prizes for excellent and original work. Number of exhibitors: 70. Public attendance: 8,000. Public admission: $7. Artists should fill out application form to apply. Deadline for entry: April 1.

Application fee: $65. Exhibition space: 10 × 10 ft. Average gross sales/exhibitor: $5-$500. For more information, artists should call, send SASE.

⚜ LILAC FESTIVAL ARTS & CRAFTS SHOW

333 N. Plymouth Av., Rochester NY 14608. (585)256-4960. Fax: (585)256-4968. E-mail: info@lilacfestival.com. Website: www.lilacfestival.com. **Contact:** Sue LeBeau, art show coordinator. Estab. 1985. Arts & crafts show held annually in May. Outdoors. Accepts photography, painting, ceramics, woodworking, metal sculpture, fiber. Juried by a panel. Number of exhibitors: 150. Public attendance: 25,000. Free to public. Deadline for entry: March 1. Application fee: $190. Space fee: $190. Exhibition space: 10 × 10 ft. For more information, artists should visit website or send SASE.

⚜ LOMPOC FLOWER FESTIVAL

P.O. Box 723, Lompoc CA 93438. (805)735-9501. E-mail: web@willeyweb.com. Website: www.lompocvalleyartsassociation.com. **Contact:** Marie Naar, chairman. Estab. 1942. Fine arts & crafts show held annually last week in June. Event includes a parade, food booths, entertainment, beer garden and commercial center, which is not located near arts & crafts. Outdoors. Accepts photography, fine art, woodworking, pottery, stained glass, fine jewelry. Juried by 5 members of the Lompoc Valley Art Association. Vendor must submit 5 photos of their craft and a description on how to make the craft. Number of exhibitors: 95. Public attendance: 95,000 + . Free to public. Artists should apply by calling the contact person for application or download application from Web site. Deadline for entry: April 1. Application fee: $173 plus insurance. Exhibition space: 16 × 16 ft. For more information, artists should visit Web site, call or send SASE.
Tips "Artists should have prices that are under $100 to succeed."

Ⓝ ⚜ LUTZ ARTS & CRAFTS FESTIVAL

P.O. Box 656, Lutz FL 33548-0656. (813)949-1937; (813)949-7060. Fax: (813)949-7060. **Contact:** Phyllis Hoedt, co-director; Shirley Simmons, co-director. Estab. 1979. Fine arts & crafts show held annually in December. Outdoors. Accepts photography, sculpture. Juried. Directors make final decision. Awards/prizes: $2,000 plus other cash awards. Number of exhibitors: 250. Public attendance: 35,000. Free to public. Deadline for entry: September 1 of each year or until category is filled. Application fee: $125. Exhibition space: 12 × 12 ft. For more information, artists should call or send SASE.
Tips "Have varied price range."

⚜ MASON ARTS FESTIVAL

P.O. Box 381, Mason OH 45040. ((513)573-9376. E-mail: pgast@cinci.rr.com for Inside City Gallery; mraffel@cinci.rr.com for outdoor art festival. Website: www.masonarts.org. **Contact:** Pat Gastreich, City Gallery Chairperson. Fine arts and crafts show held annually in September. Indoors and outdoors. Accepts photography, graphics, printmaking, mixed media; painting and drawing; ceramics, metal sculpture; fiber, glass, jewelry, wood, leather. Juried. Awards/prizes: $3,000 + . Number of exhibitors: 75-100. Public attendance: 3,000-5,000. Free to the public. Artists should apply by visiting website for application, e-mailing mraffel@cinci.rr.com, or calling (513)573-0007. Deadline for entry: June. Application fee:

$25. Space fee: $75 for single space; $135 for adjoining spaces. Exhibition space: 12 × 12 ft.; artist must provide 10 × 10 ft. pop-up tent.

- City Gallery show is held indoors; these artists are not permitted to participate outdoors and vice versa. City Gallery is a juried show featuring approximately 30-50 artists who may show up to 2 pieces.

Tips "Photographers are required to disclose both their creative and printing processes. If digital manipulation is part of the composition, please indicate."

☙ MEMORIAL WEEKEND ARTS & CRAFTS FESTIVAL

Castleberry Fairs & Festivals. 38 Charles St., Rochester NH 03867. (603)332-2616. E-mail: info@castleberryfairs.com. Website: www.castleberryfairs.com. **Contact:** Terry Mullen, event coordinator. Estab. 1989. Arts & crafts show held annually on Memorial Day weekend in Meredith, New Hampshire. Outdoors. Accepts photography and all other mediums. Juried by photo, slide or sample. Number of exhibitors: 85. Public attendance: 7,500. Free to the public. Artists should apply by downloading application from Web site. Deadline for entry: until full. Space fee: $300. Exhibition space: 100 sq. ft. Average gross sales/exhibitor: "Generally, this is considered an 'excellent' show, so I would guess most exhibitors sell ten times their booth fee, or in this case, at least $3,000 in sales." For more information, artists should visit Web site.

Tips "Do not bring a book; do not bring a chair. Smile and make eye contact with everyone who enters your booth. Have them sign your guest book; get their e-mail address so you can let them know when you are in the area again. And, finally, make the sale—they are at the fair to shop, after all."

☙ MICHIGAN STATE UNIVERSITY SPRING ARTS & CRAFTS SHOW

322 MSU Union, East Lansing MI 48824. (517)355-3354. E-mail: uab@hfs.msu.edu. Website: www.uabevents.com. Contact: Kate Lake, assistant manager. Estab. 1963. Arts & crafts show held annually in mid-May. Outdoors. Accepts photography, basketry, candles, ceramics, clothing, sculpture, soaps, drawings, floral, fibers, glass, jewelry, metals, painting, graphics, pottery, wood. Juried by a panel of judges using the photographs submitted by each vendor to eliminate commercial products. They will evaluate on quality, creativity and crowd appeal. Number of exhibitors: 329. Public attendance: 60,000. Free to public. Artists can apply online beginning in February. Online applications will be accepted until show is filled. Application fee: $240. Exhibition space: 10x10 ft. For more information, artists should visit website or call.

☙ MID-MISSOURI ARTISTS CHRISTMAS ARTS & CRAFTS SALE

P.O. Box 116, Warrensburg MO 64093. (660)747-6092. E-mail: rlimback@iland.net. **Contact:** Beverly Smith. Estab. 1970. Holiday arts & crafts show held annually in November. Indoors. Accepts photography and all original arts and crafts. Juried by 3 good-quality color photos (2 of the artwork, 1 of the display). Number of exhibitors: 50. Public attendance: 1,200. Free to the public. Artists should apply by e-mailing or calling for an application form. Deadline for entry: November 1. Space fee: $50. Exhibition space: 10 × 10 ft. For more information, artists should e-mail or call.

Tips "Items under $100 are most popular."

✒ MOUNT GRETNA OUTDOOR ART SHOW

P.O. Box 637, Mount Gretna PA 17064. (717)964-3270. Fax: (717)964-3054. E-mail: mtgretnaart@comcast.net. Website: www.mtgretnaarts.com. **Contact:** Linda Bell, show committee chairperson. Estab. 1974. Fine arts & crafts show held annually 3rd full weekend in August. Outdoors. Accepts photography, oils, acrylics, watercolors, mixed media, jewelry, wood, paper, graphics, sculpture, leather, clay/porcelain. Juried by 4 professional artists who assign each applicant a numeric score. The highest scores in each medium are accepted. Awards/prizes: Judges' Choice Awards: 30 artists are invited to return the following year, jury exempt; the top 10 are given a monetary award of $250. Number of exhibitors: 250. Public attendance: 15,000-19,000. Public admission: $7; children under 12: free. Artists should apply via www.zapplication.org. Deadline for entry: April 1. Application fee: $20 jury fee. Space fee: $300-350. Exhibition space: 10 × 12 ft. For more information, artists should e-mail, visit Web site, call.

✒ NAPA WINE & CRAFTS FAIRE

1310 Napa Town Center, Napa CA 94559. (707)257-0322. Fax: (707)257-1821. E-mail: info@napadowntown.com. Website: www.napadowntown.com. **Contact:** Craig Smith, executive director. Wine and crafts show held annually in September. Outdoors. Accepts photography, jewelry, clothing, woodworking, glass, dolls, candles and soaps, garden art. Juried based on quality, uniqueness, and overall craft mix of applicants. Number of exhibitors: over 200. Public attendance: 20,000-30,000. Artists should apply by contacting the event coordinator, Marla Bird, at (707)299-0712 to obtain an application form. Application forms are also available on Web site. Application fee: $15. Space fee: $200. Exhibition space: 10 × 10 ft. For more information, artists should e-mail, visit website or call.

Tips "Electricity is available, but limited. There is a $40 processing fee for cancellations."

✒ NEW ENGLAND ARTS & CRAFTS FESTIVAL

Castleberry Fairs & Festivals, 38 Charles St., Rochester NE 03867. (603)322-2616. E-mail: info@castleberryfairs.com. Website: www.castleberryfairs.com. **Contact:** Terry Mullen, event coordinator. Estab. 1988. Arts & crafts show held annually on Labor Day weekend in Topsfield, Massachusetts. Indoors and outdoors. Accepts photography and all other mediums. Juried by photo, slide or sample. Number of exhibitors: 250. Public attendance: 25,000. Public admission: $5 for adults; free for 13 and under. Artists should apply by downloading application from Web site. Deadline for entry: until full. Space fee: $350. Exhibition space: 100 sq. ft. Average gross sales/exhibitor: "Generally, this is considered an 'excellent' show, so I would guess most exhibitors sell ten times their booth fee, or in this case, at least $3,500 in sales." For more information, artists should visit Web site.

Tips "Do not bring a book; do not bring a chair. Smile and make eye contact with everyone who enters your booth. Have them sign your guest book; get their e-mail address so you can let them know when you are in the area again. And, finally, make the sale—they are at the fair to shop, after all."

✒ NEW ENGLAND CRAFT & SPECIALTY FOOD FAIR

Castleberry Fairs & Festivals, 38 Charles Rd., Rochester NH 03867. (603)332-2616. E-mail: info@castleberryfairs.com. Website: www.castleberryfairs.com. **Contact:** Terry Mullen,

event coordinator. Estab. 1995. Arts & crafts show held annually on Veteran's Day weekend in Salem, New Hampshire. Indoors. Accepts photography and all other mediums. Juried by photo, slide or sample. Number of exhibitors: 200. Public attendance: 15,000. Admissions: $6. Artists should apply by downloading application from Web site. Deadline for entry: until full. Space fee: $300. Exhibition space: 100 sq. ft. Average gross sales/exhibitor: "Generally, this is considered an 'excellent' show, so I would guess most exhibitors sell ten times their booth fee, or in this case, at least $3,000 in sales." For more information, artists should visit Web site.

Tips "Do not bring a book; do not bring a chair. Smile and make eye contact with everyone who enters your booth. Have them sign your guest book; get their e-mail address so you can let them know when you are in the area again. And, finally, make the sale—they are at the fair to shop, after all."

NEW MEXICO ARTS & CRAFTS FAIR

P.O. Box 7279, Albuquerque NM 87194. (505)884-9043. Fax: (505)247-0608. E-mail: info@nmartsandcraftsfair.org. Website: www.nmartsandcraftsfair.org. **Contact:** Trish Behrmann, office manager. Estab. 1962. Fine arts & craft show held annually in June. Indoors and outdoors. Accepts photography, ceramics, fiber, digital art, drawing, jewelry—precious and nonprecious, printmaking, sculpture, wood, mixed media. **Only New Mexico residents 18 years and older are eligible.** Additional details for 2010 to be announced; see website for more details.

OFFICIAL TEXAS STATE ARTS & CRAFTS FAIR

4000 Riverside Dr., Kerrville TX 78028.(830)896-5711. Fax: (830)896-5569. E-mail: fair@tacef.org. Website: www.tacef.org.
Tips "Market and advertise."

ORCHARD LAKE FINE ART SHOW

P.O. Box 79, Milford MI 48381-0079. (248)684-2613. Fax: (248)684-0195. E-mail: patty@hotworks.org. Website: www.hotworks.org. **Contact:** Patty Narozny, show director. Estab. 2002. Fine arts & crafts show held annually late July/early August. Outdoors. Accepts photography, clay, glass, fiber, wood, jewelry, painting, prints, drawing, sculpture, metal, multimedia. Juried by 3 art professionals who view 3 slides of work and 1 of booth. Awards/prizes: $2,500 in awards: 1 Best of Show: $1,000; 2 Purchase Awards: $500 each; 5 Awards of Excellence: $100 each. Free to the public; parking: $5. Artists can obtain an application on the Web site, or they can call the show director who will mail them an application. Deadline for entry: March. Application fee: $25. Space fee: starts at $300. Exhibition space: 12 × 3 ft. " We allow room on either side of the tent, and some space behind the tent." For more information, artists should e-mail, visit Web site, call, send SASE.
Tips "Be attentive to your customers. Do not ignore anyone."

PANOPLY ARTS FESTIVAL, PRESENTED BY THE ARTS COUNCIL, INC.

700 Monroe St. SW, Suite 2, Huntsville AL 35801. (256)519-2787. Fax: (256)533-3811. E-mail: tac@panoply.org. Website: www.panoply.org; www.artshuntsville.org. Estab.

1982. Fine arts show held annually the last weekend in April. Also features music and dance. Outdoors. Accepts photography, painting, sculpture, drawing, printmaking, mixed media, glass, fiber. Juried by a panel of judges chosen for their in-depth knowledge and experience in multiple mediums, and who jury from slides or disks in January. During the festival 1 judge awards the various prizes. Awards/prizes: Best of Show: $1,000; Award of Distinction: $500; Merit Awards: 5 awards, $200 each. Number of exhibitors: 60-80. Public attendance: 140,000 + . Public admission: weekend pass: $10; 1-day pass: $5; children 12 and under: free. Artists should e-mail, call or write for an application form, or check online through November 1. Deadline for entry: January 2008. Application fee: $30. Space fee: $175 for space only; $375 including tent rental. Exhibition space: 10 × 10 ft. Average gross sales/exhibitor: $2,500. For more information, artists should e-mail.

☑ PARADISE CITY ARTS FESTIVALS

30 Industrial Dr. E., Northampton MA 01060-2351. (800)511-9725. Fax: (413)587-0966. E-mail: artist@paradisecityarts.com. Website: www.paradisecityarts.com. **Contact:** Katherine Sanderson. Estab. 1995. Five fine arts & crafts shows held annually in March, April, May, October and November. Indoors. Accepts photography, all original art and fine craft media. Juried by 5 slides or digital images of work and an independent board of jury advisors. Number of exhibitors: 150-275. Public attendance: 5,000-20,000. Public admission: $12. Artists should apply by submitting name and address to be added to mailing list or print application from Web site. Deadline for entry: September 9. Application fee: $30-45. Space fee: $650-1,500. Exhibition space:8' to 10' deep; 10 to 20' wide. For more information, artists should e-mail, visit website or call.

☑ PASEO ARTS FESTIVAL

3022 Paseo, Oklahoma City OK 73103. (405)525-2688. Website: www.ThePaseo.com. **Contact:** Lori Oden, executive director. Estab. 1976. Fine arts & crafts show held annually Memorial Day weekend. Outdoors. Accepts photography and all fine art mediums. Juried by submitting 3 slides or CD. Awards/prizes: $1,000, Best of Show; $350, 2D; $350, 3D; $350, Best New Artist. Number of exhibitors: 75. Public attendance: 50,000-60,000. Free to public. Artists should apply by calling for application form. Deadline for entry: March 1. Application fee: $25. Space fee: $250. Exhibition space: 10 × 10 ft. For more information, artists should visit Web site, call or send SASE.

☑ PATTERSON APRICOT FIESTA

P.O. Box 442, Patterson CA 95363. (209)892-3118. Fax: (209)892-3388. E-mail: makecontact@ patterson-ca.com. Website: www.patterson-ca.com. **Contact:** Chris Rodriguez, chairperson. Estab. 1984. Arts & crafts show held annually in May/June. Outdoors. Accepts photography, oils, leather, various handcrafts. Juried by type of product; number of artists already accepted; returning artists get priority. Number of exhibitors: 140-150. Public attendance: 25,000. Free to the public. Deadline for entry: approximately April 15. Application fee/ space fee: $130. Exhibition space: 12 × 12 ft. For more information, artists should call, send SASE.

Tips "Please get your applications in early!"

⚑ PETERS VALLEY ANNUAL CRAFT FAIR

19 Kuhn Rd., Layton NJ 07851. (973)948-5200. Fax: (973)948-0011. E-mail: craft.fair@ petersvalley.org. Website: www.petersvalley.org. Contact: Gail Leypoldt, craft fair coordinator. Estab. 1970. Arts & crafts show held annually in late September at the Sussex County Fair Grounds in Augusta, New Jersey. Indoors. Accepts photography, ceramics, fiber, glass, basketry, metal, jewelry, sculpture, printmaking, paper book art, drawing, painting. Juried. Awards/prizes: cash awards. Number of exhibitors: 180. Public attendance: 8,000-10,000. Public admission: $7. Artists should apply by downloading application from Web site. Deadline for entry: May 15. Application fee: $30. Space fee: $385. Exhibition space: 10x10 ft. Average gross sales/exhibitor: $2,000-5,000. For more information artists should e-mail, visit Web site, call or send SASE.

PUNGO STRAWBERRY FESTIVAL

P.O. Box 6158, Virginia Beach VA 23456. (757)721-6001. Fax: (757)721-9335. E-mail: pungofestival@aol.com. Website: www.PungoStrawberryFestival.info. **Contact:** Janet Dowdy, secretary of board. Estab. 1983. Arts & crafts show held annually on Memorial Day Weekend. Outdoors. Accepts photography and all media. Number of exhibitors: 60. Public attendance: 120,000. Free to Public; $5 parking fee. Artists should apply by calling for application or downloading a copy from the website and mail in. Deadline for entry: March 1; applications accepted from that point until all spaces are full. Application fee: $50 refundable deposit. Space fee: $175. Exhibition space: 10 × 10 ft. For more information, artists should e-mail, visit website or call.

⚑ RILEY FESTIVAL

312 E. Main St. #C, Greenfield IN 46140. (317)462-2141. Fax: (317)467-1449. E-mail: info@rileyfestival.com. Website: www.rileyfestival.com. **Contact:** Sarah Kesterson, office manager. Estab. 1970. Fine arts & crafts show held October 7-10, 2010. Outdoors. Accepts photography, fine arts, home arts, quilts. Juried. Awards/prizes: small monetary awards and ribbons. Number of exhibitors: 450. Public attendance: 75,000. Free to public. Artists should apply by downloading application on Web site. Deadline for entry: August 15. Space fee: $185. Exhibition space: 10 × 10 ft. For more information, artists should visit Web site.
Tips "Keep arts priced for middle-class viewers."

⚑ RIVERBANK CHEESE & WINE EXPOSITION

6618 Third St., Riverbank CA 95367. (209)863-9600. Fax: (209)863-9601. E-mail:events@ riverbankcheeseandwine.or. Website: www.riverbankcheeseandwine.org. **Contact:** Suzi DeSilva. Estab. 1977. Arts & crafts show and food show held annually 2nd weekend in October. Outdoors. Accepts photography, other mediums depends on the product. Juried by pictures and information about the artists. Number of exhibitors: 400. Public attendance: 70,000-80,000. Free to public. Artists should apply by calling and requesting an application. Deadline for entry: June 30. Space fee: $260/arts & crafts; $380/commercial. Exhibition space: 10 × 12 ft. For more information, artists should e-mail, visit Web site, call or send SASE.
Tips "Make sure your display is pleasing to the eye."

ROYAL OAK OUTDOOR ART FAIR

PO Box 64, Royal Oak MI 48068-0064. (248)246-3180. Fax: (248)246-3007. E-mail: artfaire@ci.royal-oak.mi.us. Website: www.ci.royal-oak.mi.us/rec/r7.html. **Contact**: Recreation Office Staff. Events & Membership. Estab. 1970. Fine arts & crafts show held annually in July. Outdoors. Accepts photography, collage, jewelry, clay, drawing, painting, glass, wood, metal, leather, soft sculpture. Juried. Number of exhibitors: 110. Public attendance: 25,000. Free to pubic. Artists should apply with application form and 3 slides of current work. Deadline for entry: March 1. Application fee: $20. Space fee: $250. Exhibition space: 15x15 ft. For more information, artists should e-mail or call.

Tips "Be sure to label your slides on the front with name, size of work and 'top'."

☒ SACO SIDEWALK ART FESTIVAL

P.O. Box 336, 146 Main St., Saco ME 04072. (207)286-3546. E-mail: sacospirit@hotmail.com. Website: www.sacospirit.com.

Tips "Offer a variety of pieces priced at various levels."

☒ SANDY SPRINGS FESTIVAL

Heritage Sandy Springs, 6110 Bluestone Rd., Sandy Springs GA 30328. (404)851-9111. Fax: (404)851-9807. E-mail: info@sandyspringsfestival.org. Website: www.sandyspringsfestival.com. **Contact:** Christy Nickles, special events director. Estab. 1985. Fine arts & crafts show held annually in mid-September. Outdoors. Accepts photography, painting, sculpture, jewelry, furniture, clothing. Juried by area professionals and nonprofessionals who are passionate about art. Awards/prizes: change annually; usually cash with additional prizes. Number of exhibitors: 100+. Public attendance: 20,000. Public admission: $5. Artists should apply via application on website. Application fee: $10 ($35 for late registration). Space fee: $150. Exhibition space: 10 × 10 ft. Average gross sales/exhibitor: $1,000. For more information, artists should visit website.

Tips "Most of the purchases made at Sandy Springs Festival are priced under $100. The look of the booth and its general attractiveness are very important, especially to those who might not 'know' art."

☒ SANTA CALI GON DAYS FESTIVAL

210 W. Truman Road, Independence MO 64051. (816)252-4745. Fax: (816)252-4917. E-mail: tfreeland@independencechamber.org. Website: www.santacaligon.com. **Contact:** Teresa Freeland, special projects assistant. Estab. 1973. Market vendors show held annually Labor Day weekend. Outdoors. Accepts photography, all other mediums. Juried by committee. Number of exhibitors: 240. Public attendance: 225,000. Free to public. Artists should apply by requesting application. Application requirements include completed application, application fee, 4 photos of product/art and 1 photo of display. Deadline for entry: March 6-April 7. Application fee: $20. Space fee: $330-430. Exhibition space: 8 × 8 ft.-10 × 10 ft. For more information, artists should e-mail, visit website or call.

☒ SAUSALITO ART FESTIVAL

P.O. Box 10, Sausalito CA 94966. (415)332-3555. Fax: (415)331-1340. E-mail: info@sausalitoartfestival.org; apply@sausalitoartfestival.org. Website: www.sausalitoartfestival.

org. **Contact:** Tracy Bell Redig, festival coordinator. Estab. 1952. Fine arts & crafts show held annually Labor Day weekend. Outdoors. Accepts painting, photography, 2D and 3D mixed media, ceramics, drawing, fiber, functional art, glass, jewelry, printmaking, sculpture, watercolor, woodwork. Juried. Jurors are elected by their peers from the previous year's show (1 from each category). They meet for a weekend at the end of March and give scores of 1, 2, 3, 4 or 5 to each applicant (5 being the highest). Awards/prizes: $500 for each 1st and 2nd Place in each category; optional $1,000 for Best in Show. Number of exhibitors: 270. Public attendance: 40,000. Public admission: $20; seniors (age 62 +): $10; children (under 6): $5. Artists should apply by visiting website for instructions and application. Applications are through Juried Art Services. Deadline for entry: March. Application fee: $50. Space fee: $1050-2,800. Exhibition space: 100 or 200 sq. ft. Average gross sales/exhibitor: $14,000. For more information, artists should visit Web site.

⚅ SCOTTSDALE ARTS FESTIVAL

7380 E. 2nd St., Scottsdale AZ 85251. (480)994-2787. Fax: (480)874-4699. E-mail: festival@sccarts.org. Website: www.scottsdaleartsfestival.org. **Contact:** Debbie Rauch, artist coordinator. Estab. 1970. Fine arts & crafts show held annually in March. Outdoors. Accepts photography, jewelry, ceramics, sculpture, metal, glass, drawings, fiber, paintings, printmaking, mixed media, wood. Juried. Awards/prizes: 1st, 2nd, 3rd Places in each category and Best of Show. Number of exhibitors: 200. Public attendance: 40,000. Public admission: $7. Artists should apply through www.zapplication.org. Deadline for entry: October. Application fee: $25. Space fee: $415. Exhibition space: 100 sq. ft. For more information, artists should visit Web site.

⚅ SIERRA MADRE WISTARIA FESTIVAL

37 Auburn Ave., Suite 1, Sierra Madre CA 91024. (626)355-5111. Fax: (626)306-1150. E-mail: info@sierramadrechamber.com. Website: www.SierraMadrechamber.com. Estab. 100 years ago. Fine arts, crafts and garden show held annually in March. Outdoors. Accepts photography, anything handcrafted. Juried. Craft vendors send in application and photos to be juried. Most appropriate are selected. Awards/prizes: Number of exhibitors: 175. Public attendance: 12,000. Free to public. Artists should apply by sending completed and signed application, 3-5 photographs of their work, application fee, license application, space fee and 2 SASEs. Deadline for entry: December 20. Application fee: $25. Space fee: $175 and a city license fee of $29. Exhibition space: 10 × 10 ft. For more information, artists should e-mail, visit website or call.

Tips "Have a clear and simple application. Be nice."

⚅ SOLANO AVENUE STROLL

1563 Solano Ave. #PMB 101, Berkeley CA 94707. (510)527-5358. E-mail: SAA@solanoavenueassn.org. Website: www.solanoave.org. **Contact:** Allen Cain, executive director. Estab. 1974. Fine arts & crafts show held annually 2nd Sunday in September. Outdoors. Accepts photography and all other mediums. Juried by board of directors. Jury fee: $10. Number of exhibitors: 140 spaces for crafts; 600 spaces total. Public attendance: 300,000. Free to the public. Artists should apply online after April 1, or send SASE. Deadline for entry: June 1. Space fee: $10. Exhibition space: 10 × 10 ft. For more information, artists

should e-mail, visit Web site, send SASE.

Tips "Artists should have a clean presentation; small-ticket items as well as large-ticket items; great customer service; enjoy themselves."

✍ SPRING CRAFTS AT LYNDHURST

P.O. Box 28, Woodstock NY 12498. (845)331-7900. Fax: (845)331-7484. E-mail: crafts@ artrider.com. Website: www.craftsatlyndhurst.com; www.artrider.com. **Contact:** Laura Kandel. Estab. 1984. Fine arts & crafts show held annually in early May. Outdoors. Accepts photography, wearable and nonwearable fiber, metal and nonmetal jewelry, clay, leather, wood, glass, painting, drawing, prints, mixed media. Juried by 5 images of work and 1 of booth, viewed sequentially. Number of exhibitors: 300. Public attendance: 14,000. Public admission: $10. Artists should apply by downloading application from www.artrider.com or can apply online at www.zapplication.org. Deadline for entry: January 1. Application fee: $45. Space fee: $750. Exhibition space: 10 × 10. For more information, artists should e-mail, visit Web site, call.

✍ SPRING CRAFTS AT MORRISTOWN

P.O. Box 28, Woodstock NY 12498. (845) 331 -7900. E-mail: crafts@artrider.com. Website: www.craftsatmorristown.com; www.artrider.com. **Contact:** Laura Kandel. Estab. 1990. Fine arts & crafts show held annually beginning of April. Indoors. Accepts photography, wearable and nonwearable fiber, metal and nonmetal jewelry, clay, leather, wood, glass, painting, drawing, prints, mixed media. Juried by 5 images of work and 1 of booth, viewed sequentially. Number of exhibitors: 150. Public attendance: 5,000. Public admission: $7. Artists should apply by downloading application from www.artrider.com or apply online at www.zapplication.org. Deadline for entry: January 1. Application fee: $45. Space fee: $475. Exhibition space: 10 × 10 ft. For more information, artists should e-mail, visit website, call.

SPRINGFEST

P.O. Box 831, Southern Pines NC 28388. (910)315-6508. E-mail: spba@earthlink.net. Website: www.southernpines.biz. **Contact:** Susan Harrison, booth coordinator. Estab. 1979. Arts & crafts show held annually last Saturday in April. Outdoors. Accepts photography and crafts. Number of exhibitors: 200. Public attendance: 8,000. Free to the public. Artists should apply by filling out application form. Deadline for entry: March 15, 2010. Space fee: $75. Exhibition space: 10 × 12 ft. For more information, artists should e-mail, visit Web site, call, send SASE. Application online in fall 2009.

SPRINGFEST AND SEPTEMBERFEST

PO Box 677, Nyack NY 10960-0677. (845)353-2221. Fax: (845)353-4204. Website: www. nyack-ny.com. **Contact:** Lorie Reynolds, executive director. Estab. 1980. Arts & crafts show held annually in April and September. Outdoors. Accepts photography, pottery, jewelry, leather, clothing. Number of exhibitors: 220. Public attendance: 30,000. Free to public. Artists should apply by submitting application, fees, permits, photos of product and display. Deadline for entry: 15 days before show. Space fee: $175. Exhibition space: 10 × 10 ft. For more information, artists should visit Web site, call or send SASE.

🅽 🅥 SPRING FESTIVAL, AN ARTS & CRAFTS AFFAIR

P.O. Box 184, Boys Town NE 68010. (402)331-2889. Fax: (402)445-9177. E-mail: hpifestivals@ cox.net. Website: www.hpifestivals.com. **Contact:** Huffman Productions. Estab. 1983. Fine arts & craft show held annually in April. Indoors. Accepts photography, pottery, stained glass, jewelry, clothing, furniture, paintings, baskets, etc. All must be handcrafted by the exhibitor. Juried by 2 photos of work and 1 of display. Awards/prizes: $420 total cash awards. Number of exhibitors: 400. Public attendance: 15,000. Public admission: $6-8. Artists should apply by calling for an application. **Deadline**: Until a category is full. Space fee: $400. Exhibition space: 8 × 11 ft. ("We provide pipe and drape.") For more information, artists should e-mail, visit Web site, call, send SASE.

Tips "Make sure to send good, crisp photos that show your current work and display. This gives you your best chance with jurying a show."

🅥 SPRING FINE ART & CRAFTS AT BROOKDALE PARK

12 Galaxy Court, Hillsborough NJ 08844. (908)874-5247. Fax: (908)874-7098. E-mail: rosesquared@patmedia.net. Website: www.rosesquared.com. **Contact:** Janet Rose, president. **Contact:** Estab.1988. Fine arts & craft show held annually in mid-June. Outdoors. Accepts photography and all other mediums. Juried. Number of exhibitors: 180. Public attendance: 16,000. Free to the public. Artists should apply by downloading application from website or call for application. Deadline: 1 month before show date. Application fee: $15. Space fee: $310. Exhibition space: 120 sq. ft. For more information, artists should e-mail, visit website, call.

Tips "Create a professional booth that is comfortable for the customer to enter. Be informative, friendly and outgoing. People come to meet the artist."

🅥 ST. CHARLES FINE ART SHOW

213 Walnut St., St. Charles IL 60174. (630)513-5386. Fax: (630)513-6310. E-mail: david@ dtown.org. Website: www.stcharlesfineartshow.com. Estab. 1999. Fine art fair held annually in late May. Outdoors. Accepts photography, painting, sculpture, glass, ceramics, jewelry, nonwearable fiber art. Juried by committee: submit 4 slides of art and 1 slide of booth/ display. Awards/prizes: Cash awards of $3,500 awarded in several categories. Purchase Award Program: $14,000 of art has been purchased through this program since its inception in 2005. Number of exhibitors: 100. Free to the public. Artists should apply by downloading application from website or call for application. Deadline for entry: February. Jury fee: $25. Space fee: $200. Exhibition space: 12 × 12 ft. For more information, artists should e-mail, visit Web site, call.

STEPPIN' OUT

P.O. Box 233, Blacksburg VA 24063. (540)951-0454. E-mail: dmob@downtownblacksburg. com. Website: www.downtownblacksburg.com. **Contact:** Laureen Blakemore, director. Estab. 1981. Arts & crafts show held annually 1st Friday and Saturday in August. Outdoors. Accepts photography, pottery, painting, drawing, fiber arts, jewelry, general crafts. Number of exhibitors: 170. Public attendance: 45,000. Free to public. Artists should apply by e-mailing, calling or by downloading application on Web site. Space fee: $150. For more information, artists should e-mail, visit website or call.

Tips "Visit shows and consider the booth aesthetic—what appeals to you. Put the time, thought, energy and money into your booth to draw people in to see your work."

ST. JAMES COURT ART SHOW

P.O. Box 3804, Louisville KY 40201. (502)635-1842. Fax: (502)635-1296. E-mail: mesrock@ stjamescourtartshow.com. Website: www.stjamescourtartshow.com. **Contact:** Marguerite Esrock, executive director. Estab. 1957. Annual fine arts & crafts show held the first full weekend in October. Accepts photography; has 16 medium categories. Juried in March; there is also a street jury held during the art show. Awards/prizes: Best of Show—3 places; $7,500 total prize money. Number of exhibitors: 300. Public attendance: 275,000. Free to the public. Artists should apply by visiting website and printing out an application or via www.zapplication.org. Deadline for entry in 2010 show: March 31, 2010. Application fee: $30. Space fee: $500. Exhibition space: 10 X 12 ft. For more information, artists should e-mail or visit website.

Tips "Have a variety of price points. Don't sit in the back of the booth and expect sales."

STOCKLEY GARDENS FALL ARTS FESTIVAL

801 Boush St., Norfolk VA 23510.(757)625-6161. Fax: (757)625-7775. E-mail: skaplan@ hope-house.org. Website: www.hope-house.org. **Contact:** Stephanie Kaplan, development coordinator. Estab. 1984. Fine arts & crafts show held annually 3rd weekend in October. Outdoors. Accepts photography and all major fine art mediums. Juried. Number of exhibitors: 150. Public attendance: 30,000. Free to the public. Artists should apply by submitting application, jury and booth fees, 5 slides. Deadline for entry: July. Application fee: $15. Space fee: $225. Exhibition space: 10 × 10 ft. For more information, artists should e-mail, visit Web site, call.

STONE ARCH FESTIVAL OF THE ARTS

219 Main St. SE, Suite 304, Minneapolis MN 55414. (612)623-8347. Fax: (612)623-8348. E-mail: info@kemteck.com. Website: www.stonearchfestival.com. **Contact:** Sara Collins, manager. Estab. 1994. Fine arts & crafts show and culinary arts show held annually Father's Day weekend. Outdoors. Accepts photography, painting, ceramics, jewelry, fiber, printmaking, wood, metal. Juried by committee. Awards/prizes: free booth the following year; $100 cash prize. Number of exhibitors: 230. Public attendance: 80,000. Free to public. Artists should apply by application found on website or through www.zapplication.org. Deadline for entry: March 15. Application fee: $20 jury. Space fee: $250-300. Exhibition space: 10 × 10 ft. For more information, artists should e-mail, visit Web site, call or send SASE.

Tips "Have an attractive display and variety of prices."

STRAWBERRY FESTIVAL

2815 2nd Ave. N., Billings MT 59101. (406)294-5060. Fax: (406)294-5061. E-mail: lisaw@ downtownbillings.com. Website: www.strawberryfun.com. **Contact:** Lisa Woods, executive director. Estab. 1991. Fine arts & crafts show held annually 2nd Saturday in June. Outdoors. Accepts photography. Juried. Number of exhibitors: 76. Public attendance: 15,000. Free to public. Artists should apply by application available on the Web site. Deadline for entry: April 14. Exhibition space: 12 × 12 ft. For more information, artists should visit Web site.

☑ STREET FAIRE AT THE LAKES

PO Box 348, Detroit Lakes MN 56502. (800)542-3992. Fax: (218)847-9082. E-mail: dlchamber@visitdetroitlakes.com. Website: www.dlstreetfaire.com. **Contact:** Sue Braun, artist coordinator. Estab. 2001. Fine arts & crafts show held annually 1st weekend after Memorial Day. Outdoors. Accepts photography, handmade/original artwork, wood, metal, glass, painting, fiber. Juried by anonymous scoring. Submit 4 digital images, 3 of work and 1 of booth display. Top scores are accepted. Number of exhibitors: 125. Public attendance: 15,000. Free to public. Artists should apply by downloading application from Web site. Deadline for entry: January 15. Application fee: $150-175. Exhibition space: 11 × 11 ft. For more information, artists should e-mail or call.

☑ SUMMER ARTS & CRAFTS FESTIVAL

Castleberry Fairs & Festivals, 38 Charles St., Rochester NH 03867. (603)332-2616. Fax: (603)332-8413. E-mail: info@castleberryfairs.com. Website: www.castleberryfairs.com. **Contact:** Terry Mullen, events coordinator. Estab. 1992. Arts & crafts show held annually 2nd weekend in August in Lincoln, New Hampshire. Outdoors. Accepts photography and all other mediums. Juried by photo, slide or sample. Number of exhibitors: 100. Public attendance: 7,500. Free to the public. Artists should apply by downloading application from Web site. Deadline for entry: until full. Space fee: $200. Exhibition space: 100 sq. ft. For more information, artists should visit Web site.

Tips "Do not bring a book; do not bring a chair. Smile and make eye contact with everyone who enters your booth. Have them sign your guest book; get their e-mail address so you can let them know when you are in the area again. And, finally, make the sale—they are at the fair to shop, after all."

☑ SUMMERFAIR

7850 Five Mile Road, Cincinnati OH 45230. (513)531-0050. Fax:(513)531-0377. E-mail: exhibitors@summerfair.org. Website: www.summerfair.org. **Contact:** Sharon Strubbe. Estab. 1968. Fine arts & crafts show held annually the weekend after Memorial Day. Outdoors. Accepts photography, ceramics, drawing/printmaking, fiber/leather, glass, jewelry, painting, sculpture/metal, wood. Juried by a panel of judges selected by Summerfair, including artists and art educators with expertise in the categories offered at Summerfair, including artists and art educators with expertise in the categories offered at Summerfair. Submit application with 5 digital images (no booth image) through ZAPPlication. Awards/prizes: $10,000 in cash awards. Number of exhibitors: 300. Public attendance: 20,000. Public admission: $10. Artists should apply through ZAPP (available in December). Deadline: February. Application fee: $30. Space fee: $375, single single; $750, double space; $75 canopy fee (optional—exhibitors can rent a canopy for all days of the fair.). Exhibition space: 10 × 20 ft. for single space; 10 × 20 for double space. For more information, artists should e-mail, visit Web site, call.

⋈ ☑ TARPON SPRINGS FINE ARTS FESTIVAL

11 E. Orange St., Tarpon Springs FL 34689. (727)937-6109. Fax: (727)937-2879. E-mail: chamber@tarponspringschamber.org. Website: www.tarponsprings.com. **Contact:** Sue Thomas, president. Estab. 1974. Fine arts & crafts show held annually in April. Outdoors.

Accepts photography, acrylic, oil, ceramics, fiber, glass, graphics, drawings, pastels, jewelry, leather, metal, mixed media, sculpture, watercolor, wood. Juried by CD. Awards/prizes: cash and ribbons. Number of exhibitors: 250. Public attendance: 20,000. Public admission: $2; under 16 free. Artists should apply by submitting signed application, slides, fees and SASE. Deadline for entry: mid-December. Jury fee: $25+. Space fee: $175+. Exhibition space: 10 × 12 ft. For more information artists should e-mail, call or send SASE.

Tips "Produce good slides for jurors."

TUBAC FESTIVAL OF THE ARTS

P.O. Box 1866, Tubac AZ 85646. (520)398-2704. Fax: (520)398-1704. E-mail: artfestival@tubacaz.com. Website: www.tubacaz.com. Estab. 1959. Fine arts & crafts show held annually in early February. Next date: February 10-14, 2010. Outdoors. Accepts photography and considers all fine arts and crafts. Juried. A 7-member panel reviews digital images and artist statement. Jury process is blind—applicants' names are withheld from the jurists. Number of exhibitors: 170. Public attendance: 80,000. Free to the public; parking: $6. Applications for the 2009 festival will be available and posted on website mid-summer 2009. Deadline for entry: October 30. Application fee: $25. Space fee: $575 for 10 × 10 ft. space. For more information, artists should e-mail, visit Web site, call, send SASE.

TULIP FESTIVAL STREET FAIR

P.O. Box 1801, Mt. Vernon WA 98273. (360)336-3801. E-mail: exmvdt@cnw.com. Website: www.mountvernondowntown.org. **Contact:** Executive Director. Estab. 1984. Arts & crafts show held annually 3rd weekend in April. Outdoors. Accepts photography and original artists' work only. No manufactured work. Juried by a board. Jury fee: $10 with application and prospectus. Number of exhibitors: 215-220. Public attendance: 20,000-25,000. Free to public. Artists should apply by calling or e-mailing. Deadline for entry: January 30. Application fee: $10. Flat fee: $300. Exhibition space: 10 × 10 ft. Average gross sales/exhibitor: $2,500-4,000. For more information, artists should e-mail, visit Web site, call or send SASE.

Tips "Keep records of your street fair attendance and sales for your résumé. Network with other artists about which street fairs are better to return to or apply for."

TULSA INTERNATIONAL MAYFEST

P.O. Box 521146, Tulsa OK 74103. (918)582-6435. Fax: (918)587-7721. E-mail: comments@tulsamayfest.org. Website: www.tulsamayfest.org. Estab. 1972. Fine arts & crafts show annually held in May. Outdoors. Accepts photography, clay, leather/fiber, mixed media, drawing, pastels, graphics, printmaking, jewelry, glass, metal, wood, painting. Juried by a blind jurying process. Artists should apply online at www.zapplication.org and submit 4 photos of work and 1 of booth set-up. Awards/prizes: Best in Category and Best in Show. Number of exhibitors: 120. Public attendance: 350,000. Free to public. Artists should apply by downloading application in late November. Deadline for entry: January 16. Application fee: $35. Space fee: $300. Exhibition space: 10 × 10 ft. For more information, artists should e-mail or visit website.

N ☒ UPTOWN ART FAIR

1406 West Lake St., Suite 202, Minneapolis MN 55408. (612)823-4581. Fax: (612)823-3158. E-mail: info@uptownminneapolis.com. Website: www.uptownminneapolis.com. **Contact:** Cindy Fitzpatrick. Estab. 1963. Fine arts & crafts show held annually 1st full weekend in August. Outdoors. Accepts photography, painting, printmaking, drawing, 2D and 3D mixed media, ceramics, fiber, sculpture, jewelry, wood. Juried by 4 images of artwork and 1 of booth display. Awards/prizes: Best in Show in each category; Best Artist. Number of exhibitors: 350. Public attendance: 375,000. Free to the public. Artists should apply by visiting www.zapplication.com. Deadline for entry: March. Application fee: $30. Space fee: $450 for 10 × 10 space; $900 for 10 × 20 space. For more information, artists should call or visit Web site.

☒ A VICTORIAN CHAUTAUQUA

1101 E Market St., P.O. Box 606, Jeffersonville IN 47131-0606. (812) 283-3728. Fax: (812)283-6049. E-mail: hsmsteam@aol.com. Website: www.steamboatmuseum.org. **Contact:** Yvonne Knight, administrator. Estab. 1993. Fine arts & crafts show held annually 3rd weekend in May. Outdoors. Accepts photography, all mediums. Juried by a committee of 5. Awards/prizes: $100, 1st Place; $75, 2nd Place; $50, 3rd\nosupersub Place. Number of exhibitors: 80. Public attendance: 3,000. Public admission: $3. Deadline for entry: March 31. Space fee: $40-60. Exhibition space: 12 × 12 ft. For more information, artists should e-mail or call.

☒ VIRGINIA CHRISTMAS SHOW (24th Annual)

P.O. Box 305, Chase City VA 23924. (434)372-3996. Fax: (434)372-3410. E-mail: vashowsinc@aol.com. **Contact:** Patricia Wagstaff, coordinator. Estab. 1986. Holiday arts & crafts show held annually 1st week in November in Richmond, Virginia. Indoors at The Showplace. Accepts photography and other arts and crafts. Juried by 3 slides of artwork and 1 of display. Awards/prizes: Best Display. Number of exhibitors: 350. Public attendance: 25,000. Public admission: $7. Artists should apply by writing or e-mailing for an application. Space fee: $400. Exhibition space: 10 × 10 ft. For more information, artists should e-mail, send SASE.

Tips "If possible, attend the shows before you apply. 22nd annual Virginia Spring show March 12-14, 2010 is held at the same facility. Fee is $300. Requirements same as above."

N ☒ VIRGINIA SPRING SHOW

11050 Branch Rd., Glen Allen VA 23059. (804)253-6284. Fax: (804)253-6285. E-mail: vashowsinc.@aol.com. **Contact:** Bill Wagstaff, coordinator. Estab. 1988. Holiday arts & crafts show held annually 2nd weekend in March in Richmond, Virginia. Indoors at the Showplace Exhibition Center. Accepts photography and other arts and crafts. Juried by 3 slides of artwork and 1 of display. Awards/prizes: Best Display. Number of exhibitors: 300. Public attendance: 20,000. Public admission: $7. Artists should apply by writing or e-mailing for an application. Space fee: $300. Exhibition space: 10 × 10 ft. For more information, artists should e-mail.

Tips "If possible, attend the show before you apply."

◩ WASHINGTON SQUARE OUTDOOR ART EXHIBIT

P.O. Box 1045, New York NY 10276. (212)982-6255. Fax: (212)982-6256. E-mail: jrm.wsoae@ gmail.com. Website: www.washingtonsquareoutdoorartexhibit.org. **Contact:** Margot J. Lufitg, executive director. Estab. 1931. Fine arts & crafts show held semiannually Memorial Day weekend and the following weekend in May/early June and Labor Day weekend and following weekend in September. Outdoors. Accepts photography, oil, watercolor, graphics, mixed media, sculpture, crafts. Juried by submitting 5 slides of work and 1 of booth. Awards/ prizes: certificates, ribbons and cash prizes. Number of exhibitors: 200. Public attendance: 200,000. Free to public. Artists should apply by sending a SASE or downloading application from Web site. Deadline for entry: March, Spring Show; July, Fall Show. Application fee: $20. Exhibition space: 10 × 5 ft. For more information, artists should call or send SASE. **Tips** "Price work sensibly."

◩ WESTMORELAND ART NATIONALS

252 Twin Lakes Rd., Latrobe PA 15650-3554. (724)834-7474. E-mail: info@artsandheritage. com. Website: www.artsandheritage.com. **Contact:** Diana Morreo, executive director. Estab. 1975. Fine arts & crafts show held annually in July. Photography displays are indoors. Accepts photography, all mediums. Juried: 2 jurors review slides. Awards/prizes: $5,000 + in prizes. Number of exhibitors: 200. Public attendance: 100,000. Free to public. WAN exhibits shown at Westmoreland County Community College June 1-12 and Westmoreland Arts & Heritage Festival Juli 1-4. Artists should apply by downloading application from Web site. Application fee: $35/craft show vendors; $25/fine art/photography exhibitors. Space fee: $350. Vendor/exhibition space: 10 × 10 ft. For more information, artists should visit website or call Festival office.

◩ WHITEFISH ARTS FESTIVAL

P.O. Box 131, Whitefish MT 59937. (406)862-5875. Fax: (406)862-3515. Website: www. whitefishartsfestival.org. **Contact:** Rachael Knox, coordinator. Estab. 1979. Fine arts & crafts show held annually 1st full weekend in July. Outdoors. Accepts photography, pottery, jewelry, sculpture, paintings, woodworking. Juried. Art must be original and handcrafted. Work is evaluated for creativity, quality and originality. Awards/prizes: Best of Show awarded half-price booth fee for following year with no application fee. Number of exhibitors: 100. Public attendance: 3,000. Free to public. Deadline for entry: April 14. Application fee: $20. Space fee: $195. Exhibition space: 10 × 10 ft. For more information, artists should e-mail, visit website or call.
Tips Recommends "variety of price range, professional display, early application for special requests."

◩ WILD WIND FOLK ART & CRAFT FESTIVAL

719 Long Lake, New York NY 12847. (814)723-0707 or (518)624-6404. E-mail: wildwindcraftshow@yahoo.com. Website: www.wildwindfestival.com. **Contact:** Liz Allen or Carol Jilk, promoters. Estab. 1979. Fine arts & traditional crafts show held annually the weekend after Labor Day at the Warren County Fairgrounds in Pittsfield, Pennsylvania. Barn locations and outdoors. Accepts photography, paintings, pottery, jewelry, traditional crafts, prints, stained glass. Juried by promoters. Three photos or slides of work plus one of

booth, if available. Number of exhibitors: 140. Public attendance: 8,000. Public admission: $6/adult; $4/seniors; 12 & under free. Artists should apply by visiting website and filling out application request, calling or sending a written request.

☒ WILMETTE FESTIVAL OF FINE ARTS

P.O. Box 902, Wilmette IL 60091-0902. Phone/fax: (847)256-2080. E-mail: wilmetteartsguild@gmail.com. Website: www.wilmetteartsguild.org. **Contact:** Julie Ressler, president. Estab. 1992. Fine arts & crafts show held annually in September. Outdoors. Accepts photography, paintings, prints, jewelry, sculpture, ceramics, and any other appropriate media; no wearable. Juried by a committee of 6-8 artists and art teachers. Awards/prizes: 1st Place: $1,000; 2nd Place: $750; 3rd Place: $500; People's Choice: $50; local merchants offer purchase awards. Number of exhibitors: 100. Public attendance: 4,000. Free to the public. Deadline for entry: April. Application fee: $120. Space fee: $195. Exhibition space: 12 × 12 ft. For more information, artists should e-mail, visit Web site, call, send SASE.

Tips "Maintain a well-planned, professional appearance in booth and person. Greet viewers when they visit the booth. Offer printed bio with photos of your work. Invite family, friends and acquaintances."

☒ WYANDOTTE STREET ART FAIR

3131 Biddle Ave., Wyandotte MI 48192. (734)324-4505. Fax: (734)324-4505. E-mail: info@wyan.org. Website: www.wyandottestreetartfair.org. **Contact:** Lisa Hooper, executive director, Wyandotte Downtown Development Authority. Estab. 1961. Fine arts & crafts show held annually 2nd week in July. Outdoors. Accepts photography, 2D mixed media, 3D mixed media, painting, pottery, basketry, sculpture, fiber, leather, digital cartoons, clothing, stitchery, metal, glass, wood, toys, prints, drawing. Juried. Awards/prizes: Best New Artist: $500; Best Booth Design Award: $500; Best of Show: $1,200. Number of exhibitors: 300. Public attendance: 200,000. Free to the public. Artists may apply online or request application. Deadline for entry: February. Application fee: $20 jury fee. Space fee: $225/single space; $450/double space. Exhibition space: 10 × 10 ft. Average gross sales/exhibitor: $2,000-$4,000. For more information, artists should e-mail, visit website, call, send SASE.

☒ ☒ ZIONSVILLE COUNTY MARKET

135 S. Elm St., Zionsville IN 46077. (317)873-3836. **Contact:** Ray Cortopassi, executive director. Estab. 1975. Fine arts & crafts show held annually the Saturday after Mother's Day. Outdoors. Accepts photography, arts, crafts, antiques, apparel. Juried by sending 5 pictures. Number of exhibitors: 150-160. Public attendance: 8,000-10,000. Free to public. Artists should apply by requesting application. Deadline for entry: March 29. Space fee: $145. Exhibition space: 10 × 8 ft. For more information, artists should call.

Tips "Display is very important. Make it look good."

Contests

Whether you're a seasoned veteran or a newcomer still cutting your teeth, you should consider entering contests to see how your work compares to that of other photographers. The contests in this section range in scope from tiny juried county fairs to massive international competitions. When possible, we've included entry fees and other pertinent information in our limited space. Contact sponsors for entry forms and more details.

Once you receive rules and entry forms, pay particular attention to the sections describing rights. Some sponsors retain all rights to winning entries or even *submitted* images. Be wary of these. While you can benefit from the publicity and awards connected with winning prestigious competitions, you shouldn't unknowingly forfeit copyright. Granting limited rights for publicity is reasonable, but you should never assign rights of any kind without adequate financial compensation or a written agreement. If such terms are not stated in contest rules, ask sponsors for clarification.

If you're satisfied with the contest's copyright rules, check with contest officials to see what types of images won in previous years. By scrutinizing former winners, you might notice a trend in judging that could help when choosing your entries. If you can't view the images, ask what styles and subject matters have been popular.

AFI FEST

2021 N. Western Ave., Los Angeles CA 90027-1657. (323)856-7600 or (866)AFI-FEST. Fax: (323)467-4578. E-mail: AFIfest@AFI.com. Website: www.afifest.com. **Contact:** Director, festivals. Cost: $40 shorts; $50 features. "LA's most prominent annual film festival." Various cash and product prizes are awarded. Open to filmmakers of all skill levels. **Annual July deadline.** Photographers should write, call or e-mail for more information.

ALEXIA COMPETITION

Syracuse University Newhouse School, Syracuse NY 13244-2100. (315)443-2304. E-mail: dcsuther@syr.edu. Website: www.alexiafoundation.org. **Contact:** David Sutherland. Annual contest. Provides financial ability for students to study photojournalism in England, and for professionals to produce a photo project promoting world peace and cultural understanding. Students win cash grants plus scholarships to study photojournalism at Syracuse University in London. A professional wins $15,000 cash grant. **February 1 student deadline. January 12 professional deadline**. Photographers should e-mail or see website for more information.

ANNUAL COLLEGE PHTOGRAPHY CONTEST

Serbin Communications, 813 Reddick St., Santa Barbara CA 93103. (805)963-0439 or (800)876-6425. Fax: (805)965-0496. E-mail: admin@serbin.com. Website: www.pfmagazine. com. Annual student contest. Sponsored by Photographer's Forum Magazine (see separate listing in the Consumer Publications section) and Nikon. Winners and finalists have their photos published in the hardcover book The Best of College Photography. See website for entry form.

ANNUAL EXHIBITION OF PHOTOGRAPHY

San Diego County Fair Entry Office, 2260 Jimmy Durante Blvd., Del Mar CA 92014. (858)792-4207. E-mail: entry@sdfair.com. Website: www.sdfair.com/entry. Sponsor: San Diego County Fair (22nd District Agricultural Association). Annual event for still photos/prints. **Pre-registration deadline:** April/May. Access the dates and specifications for entry on website. There are 3 divisions: Photography, Digital Arts, and Photojournalism. Entry form can be submitted online. Check website in March for entry information.

ANNUAL JURIED PHOTOGRAPHY EXHIBITION

Perkins Center for the Arts, 395 Kings Hwy., Moorestown NJ 08057. (856)235-6488 or (800)387-5226. Fax: (856)235-6624. E-mail: create@perkinscenter.org. Website: www. perkinscenter.org. Cost: $8/entry; up to 3 entries. Regional juried photography exhibition. Works from the exhibition are considered for inclusion in the permanent collection of the Philadelphia Museum of Art and the Woodmere Art Museum. Past jurors include Merry Foresta, former curator of photography at the Smithsonian American Art Museum; Katherine Ware, curator of photographs at the Philadelphia Museum of Art; and photographers Emmett Gowin, Ruth Thorne-Thomsen, Matthew Pillsbury, and Vik Muniz. All work must be framed with wiring in back and hand-delivered to Perkins Center. Prospectus must be downloaded from the Perkins site.

⬭ ANNUAL SPRING PHOTOGRAPHY CONTEST

Serbin Communications, 813 Reddick St., Santa Barbara CA 93103. (805)963-0439 or (800)876-6425. Fax: (805)965-0496. E-mail: admin@serbin.com. Website: www.pfmagazine. com. Annual amateur contest. Sponsored by Photographer's Forum Magazine (see separate listing in the Consumer Publications section) and Canon. Winners and finalists have their photos published in the hardcover book, Best of Photography. See website for entry form.

APOGEE PHOTO MAGAZINE BIMONTHLY PHOTO CONTEST

11749 Zenobia Loop, Westminster CO 80031. (303)838-4848. Fax: (303)463-2885. E-mail: mfulks@apogeephoto.com. Website: www.apogeephoto.com. **Contact:** Michael Fulks, publisher. Bimonthly contest. Themes and prizes change with each contest. Photographers should see website (www.apogeephoto.com/contest.shtml) for more information.

ARC AWARDS

500 Executive Blvd., Ossining-on-Hudson NY 10562. (914)923-9400. Fax: (914)923-9484. E-mail: info@mercommawards.com. Website: www.mercommawards.com. Cost: $185-290. Annual contest. The purpose of the contest is to honor outstanding achievement in annual reports. Major category for annual report photography—covers and interiors. "Best of Show" receives a personalized trophy. Grand Award winners receive personalized award plaques. Gold, silver, bronze and finalists receive a personalized award certificate. Every entrant receives complete judge score sheets and comments. **May 5th deadline.** Photographers should see Web site, write, call or e-mail for more information.

ARTIST FELLOWSHIPS/VIRGINIA COMMISSION FOR THE ARTS

223 Governor St., Richmond VA 23219-2010. (804)225-3132. Fax: (804)225-4327. E-mail: arts@arts.virginia.gov. Website: www.arts.virginia.gov. Applications accepted in alternating years. The purpose of the Artist Fellowship program is to encourage significant development in the work of individual artists, to support the realization of specific artistic ideas, and to recognize the central contribution professional artists make to the creative environment of Virginia. Grant amounts: $5,000. Emerging and established artists are eligible. Open only to photographers who are legal residents of Virginia and at least 18 years of age. Applications are available in July. See Guidelines for Funding and application forms on the website or write for more information.

ARTISTS ALPINE HOLIDAY

P.O. Box 167, Ouray CO 81427. (970)626-3212. Website: http://ourayarts.org/aah.html. **Contact**: Deann McDaniel, business director. Cost: $20 1st entry; $5 2nd entry; $5 3rd entry. Annual fine arts show. Juried. Cash awards for 1st, 2nd and 3rd prizes in all categories total $5,100. Best of Show: $500; People's Choice Award: $300. Open to all skill levels. Photographers should write or call for more information.

ARTSLINK PROJECTS

435 Hudson Street, New York NY 10014. (212)643-1985, ext. 22. Fax: (212)643-1996. E-mail: al@cecartslink.org. Website: www.cecartslink.org. **Contact:** Chelsey Morell. Cost: free. Biennial travel grants. ArtsLink Projects accepts applications from individual artists,

curators and nonprofit arts organizations who intend to undertake projects in Central and Eastern Europe, Russia, Central Asia, and the Caucasus. Grants range from $2,500-10,000. Open to advanced photographers. **January deadline.** Photographers should e-mail or call for more information.

ASTRID AWARDS

500 Executive Blvd., Ossining-on-Hudson NY 10562. (914)923-9400. Fax: (914)923-9484. E-mail: info@mercommawards.com. Website: www.mercommawards.com. Annual contest. The purpose of the contest is to honor outstanding achievement in design communications. Major category for photography, including books, brochures and publications. "Best of Show" receives a personalized trophy. Grand Award winners receive personalized award plaques. Gold, silver, bronze and finalists receive a personalized award certificate. Every entrant receives complete judge score sheets and comments. **January 31st deadline.** Photographers should see Web site, write, call or e-mail for more information.

BANFF MOUNTAIN PHOTOGRAPHY COMPETITION

Box 1020, 107 Tunnel Mountain Dr., Banff AB T1L 1H5 Canada. (403)762-6347. Fax: (403)762-6277. E-mail: BanffMountainPhotos@banffcentre.ca. Website: www. BanffMountainFestivals.ca. **Contact:** Competition Coordinator. Annual contest. Maximum of 3 images (digital or prints) in each of 5 categories: Mountain Landscape, Mountain Adventure, Mountain Flora/Fauna, Mountain Culture, and Mountain Environment. Entry form and regulations available on website. Approximately $6,000 in cash and prizes to be awarded. Open to all skill levels. Photographers should write, e-mail or fax for more information.

THE CENTER FOR FINE ART PHOTOGRAPHY

400 North College Ave., Fort Collins CO 80524. (907)224-1010. E-mail: contact@c4fap. org. Website: www.c4fap.org. **Contact:** Grace Norman, exhibitions director. Cost: typically $35 for first 3 entries; $10 for each additional entry. Competitions held 10 times/year. "The Center's competitions are designed to attract and exhibit quality fine art photography created by emerging and established artists working in traditional, digital and mixed-media photography. The themes for each exhibition vary greatly. The themes, rules, details and entry forms for each call for entry are posted on the Center's Web site." All accepted work is exhibited in the Center gallery. Additionally, the Center offers monetary awards, scholarships, solo exhibitions and other awards. Awards are stated with each call for entry. Open to all skill levels and to all domestic and international photographers working with digital or traditional photography or combinations of both. Photographers should see website for deadlines and more information.

COMMUNICATION ARTS ANNUAL PHOTOGRAPHY COMPETITION

110 Constitution Dr., Menlo Park CA 94025-1107. (650)326-6040. Fax: (650)326-1648. Email: competition@commarts.com. Website: www.commarts.com. Entries must be accompanied by a completed entry form. "Entries may originate from any country. Explanation of the function in English is very important to the judges. The work will be chosen on the basis of its creative excellence by a nationally representative jury of designers, art directors and

photographers." Categories include advertising, books, editorial, for sale, institutional, cinemaphotography, self-promotion, and unpublished. **Deadline: March 29, 2010**. "For further information regarding our competitions, please visit our Web site."

CURATOR'S CHOICE AWARDS

Center, P.O. Box 2483, Santa Fe NM 87504. (505)984-8353. E-mail: programs@visitcenter. org. Website: www.visitcenter.org. **Contact:** Laura Wzorek Pressley, Executive Director. Cost: $25/members $35/non-members. Annual contest. Photographers are invited to submit their most compelling images. Open to all skill levels. Prizes include exhibition and more. Deadline: January 2010. Photographers should see website for more information.

- Center, the organization that sponsors this competition, was formerly known as The Santa Fe Center for Photography.

DANCE ON CAMERA FESTIVAL

48 W. 21st St., #907, New York NY 10010. Phone/fax: (212)727-0764. E-mail: dfa5@ earthlink.net; info@dancefilms.org. Website: www.dancefilms.org. **Contact:** Artistic Director. Sponsored by Dance Films Association, Inc. The oldest annual dance festival competition in the world for films and videotapes on all aspects of dance. Co-presented by the Film Society of Lincoln Center in New York City; also tours internationally. Entry forms available on Web site. **Deadline: September 15, 2009**.

DIRECT ART MAGAZINE PUBLICATION COMPETITION

SlowArt Productions, 123 Warren St., Hudson NY 12534. (518)828-2343. Email: slowart@ aol.com. Website: www.slowart.com. **Contact:** Tim Slowinski, director. Cost: $35. Annual contest. National magazine publication of new and emerging art in all medias. Cover and feature article awards. Open to all skill levels. **Deadline: March 31.** Photographers should send SASE for more information.

THE DIRECTOR'S CHOICE AWARDS

Center, P.O. Box 2483, Santa Fe NM 87504. (505)984-8353. E-mail: programs@visitcenter. org. Website: www.visitcenter.org. **Contact:** Laura Wzorek Pressley, Executive Director. Cost: $25/members $35/non-members. Annual contest. Photographers are invited to submit their most compelling images. Open to all skill levels. Prizes include exhibition and more. Deadline: January 2010. Photographers should see website for more information.

- Center, the organization that sponsors this competition, was formerly known as The Santa Fe Center for Photography.

THE EDITOR'S CHOICE AWARDS

Center, P.O. Box 2483, Santa Fe NM 87504. (505)984-8353. E-mail: programs@visitcenter. org. Website: www.visitcenter.org. **Contact:** Laura Wzorek Pressley, executive director. Cost: $25/members, $35/non-members. Annual contest. Photographers are invited to submit their most compelling images. Open to all skill levels. Prizes include exhibition and more. **Deadline:** January 2010. Photographers should see website for more information.

- Center, the organization that sponsors this competition, was formerly known as The Santa Fe Center for Photography.

◪ ENERGY GALLERY ART CALL

Energy Gallery, Suite 333, 5863 Leslie St., Toronto ON Canada M2H 1J8. E-mail: info@ energygallery.com. Website: www.energygallery.com. Cost: $38 for 4 images; additional images $10/each. A jury selects artworks for the online exhibition at Energy Gallery's website for a period of 3 months and archived in Energy Gallery's Website permanently. Selected artists also qualify to participate in Energy Gallery's annual exhibit. Photographers should visit website for submission form and more information.

EXCELLENCE IN PHOTOGRAPHIC TEACHING AWARD

Santa Fe Center for Photography, P.O. Box 2483, Santa Fe NM 87504. (505)984-8353. E-mail: info@visitcenter.org. Website: www.visitcenter.org. **Contact:** Laura Wzorek, programs director. Cost: $20 members, $25 non-members. Annual contest. $2,500 cash award. Rewards educators for their dedication and passion for photographic teaching. Educators in all areas of photographic teaching are eligible. **Deadline:** October. Photographers should see website for more information.

FIFTYCROWS INTERNATIONAL FUND FOR DOCUMENTARY PHOTOGRAPHY

FiftyCrows, 49 Geary St., Suite 225, San Francisco CA 94108. E-mail: info@fiftycrows.org. Website: www.fiftycrows.org. Grants, career and distribution assistance to emerging and mid-career documentary photographers to help complete a long-term documentary project of social, political, ethical, environmental or economic importance. FiftyCrows maintains a by-appointment gallery and reference library, and creates short films about documentary photographers. To receive call-for-entry notification and updates, e-mail.

FIRELANDS ASSOCIATION FOR THE VISUAL ARTS (FAVA)

39 S. Main St., Oberlin OH 44074. (440)774-7158. E-mail: favagallery@oberlin.net. Website: www.favagallery.org. **Contact:** Betsy Manderen, executive director. Cost: $15/ photographer; $12 for FAVA members. Biennial juried photography contest (odd-numbered years) for residents of Ohio, Kentucky, Indiana, Michigan, Pennsylvania and West Virginia. Both traditional and experimental techniques welcome. Photographers may submit up to 3 works completed in the last 3 years. **Annual entry deadline: March-April (date varies).** Photographers should call or e-mail for entry form.

⊕ HUMANITY PHOTO AWARD (HPA)

P.O. Box 8006, Beijing 100082 PRC. (86)(106)225-2175. E-mail: hpa@china-fpa.org. Website: www.china-fpa.org. Contact: Organizing Committee HPA. Cost: free. Biennial contest. Open to all skill levels. See website for more information and entry forms.

INFOCUS

Palm Beach Photographic Centre, 415 Clematis Street, West Palm Beach, FL 33401. (561)276-9797. E-mail:cs@workshop.or. Website: www.workshop.org. **Contact**: Fatima NeJame, CEO. Cost: $25 nonrefundable entry fee. Annual contest. Best of Show: $950. Merit awards of free tuition for a PBPC photography workshop of choice. Open to members of the Palm Beach Photographic Centre. Interested parties can obtain an individual membership for $95. Photographers should write or call for more information.

LAKE CHAMPLAIN MARITIME MUSEUM'S SPRING JURIED PHOTOGRAPHY EXHIBIT

4472 Basin Harbor Rd., Vergennes VT 05491. (802)475-2022, ext. 107. E-mail: eloiseb@lcmm. org. Website: www.lcmm.org. **Contact:** Eloise Beil. Annual exhibition, Lake Champlain Through the Lens, images of Lake Champlain. "Amateur and professional photographers are invited to submit framed prints in color or black & white. Professional photographers will judge and comment on the work." Call for entries begins in June, photograph delivery in August, on view September and October. Photographers should call, e-mail, or visit website for registration form.

LAKE CHAMPLAIN THROUGH THE LENS: JURIED PHOTOGRAPHY EXHIBIT

4472 Basin Harbor Rd., Vergennes VT 05491. (802)475-2022, ext. 107. E-mail: eloiseb@lcmm. org. Website: www.lcmm.org. **Contact:** Eloise Beil. Annual exhibition, Lake Champlain Through the Lens, images of Lake Champlain. "Amateur and professional photographers are invited to submit framed prints in color or black and white. Professional photographers will judge and comment on the work." Call for entries begins in June; photo delivery in August, on view September and October. Photographers should call, e-mail, or visit website for registration form.

◼ LAKE SUPERIOR MAGAZINE AMATEUR PHOTO CONTEST

P.O. Box 16417, Duluth MN 55816-0417. (218)722-5002. Fax: (218)722-4096. E-mail: edit@ lakesuperior.com. Website: www.lakesuperior.com. **Contact:** Konnie LeMay, editor. Annual contest. Photos must be taken in the Lake Superior region and should be labeled for categories: lake/landscapes, nature, people/humor. Accepts up to 10 b&w and/or color images—prints no larger than 8x10, and transparencies. Digital images can be submitted as prints with accompanying CD. Grand Prize: $200 prize package, plus a 1-year subscription and calendar. Other prizes include subscriptions and calendars. **October deadline**. Photographers should write, e-mail or see website for more information.

LARSON GALLERY JURIED BIENNUAL PHOTOGRAPHY EXHIBITION

Yakima Valley Community College, P.O. Box 22520, Yakima WA 98907. (509)574-4875. Fax: (509)574-6826. E-mail: gallery@yvcc.edu. Website: www.larsongallery.org. **Contact:** Denise Olsen, assistant gallery director. Cost: $12/entry (limit 4 entries). National juried competition with approximately $3,500 in prize money. Held every other year in April. **First jurying held in February.** Photographers should write, fax, e-mail or visit the website for prospectus.

LOS ANGELES CENTER FOR DIGITAL JURIED COMPETITION

107 W. Fifth St., Los Angeles CA 90013. (323)646-9427. E-mail: lacda@lacda.com, rexbruce@ lacda.com. Website: www.lacda.com. **Contact:** Rex Bruce, gallery director and principal curator. LACDA is dedicated to the propagation of all forms of digital art, supporting local, international, emerging and established artists in our gallery. Its Juried Competition is open to digital artists around the world. It also sponsors other competitions throughout the year. Photographers should visit Web site, e-mail, call for more information.

MERCURY AWARDS

500 Executive Blvd., Ossining-on-Hudson NY 10562. (914)923-9400. Fax: (914)923-9484. E-mail: rwitt@mercommawards.com. Website: www.mercommawards.com. **Contact:** Ms. Reni L. Witt, president. Cost: $190-250/entry (depending on category). Annual contest. The purpose of the contest is to honor outstanding achievement in public relations and corporate communications. Major category for photography, including ads, brochures, magazines, etc. "Best of Show" receives a personalized trophy. Grand Award winners receive award plaques (personalized). Gold, silver, bronze and finalists receive a personalized award certificate. All nominators receive complete judge score sheets and evaluation comments. **November 11 deadline.** Photographers should write, call or e-mail for more information.

◩ THE MOBIUS ADVERTISING AWARDS

713 S. Pacific Coast Hwy., Suite A, Redondo Beach CA 90277-4233. (310)540-0959. Fax: (310)316-8905. E-mail: mobiusinfo@mobiusawards.com. Website: www.mobiusawards. com. Annual international awards competition founded in 1971 for TV and radio commercials, print advertising, outdoor, specialty advertising, online, mixed media campaigns and package design. Student/spec work welcome. **October 1 deadline.** Late entries accepted. Entry packages postmarked after deadline will be charged a 425 late fee. Awards presented in February each year in Los Angeles.

MYRON THE CAMERA BUG

c/o Educational Dept., 2106 Hoffnagle St., Philadelphia PA 19152-2409. E-mail: cambug8480@ aol.com. Website: www.shutterbugstv.com. **Contact:** Len Friedman, director. Open to all photography students and educators. Photographers should e-mail for details and/or questions.

NEW YORK STATE FAIR PHOTOGRAPHY COMPETITION AND SHOW

581 State Fair Blvd., Syracuse NY 13209. (315)487-7711, ext. 1264 or 12. Fax: (315)487-9260. Website: www.nysfair.org. See website for entry forms and submission guidelines. **Deadline:** July.

THE GORDON PARKS PHOTOGRAPHY COMPETITION

Fort Scott Community College, 2108 S. Horton, Fort Scott KS 66701-3140. (620)223-2700. Fax: (620)223-6530. E-mail: photocontest@fortscott.edu. Website: www.gordonparkscenter.org. **Contact:** Jill Warford. Cost: $15 for each photo up to 4 entries. Photos should reflect the important themes in the life and works of Gordon Parks. Awards: $800 1st Place, $400 2nd Place, $200 3rd Place and up to 3 honorable mentions with prizes of $100 each. Open to all skill levels. Winners will be announced during annual Gordon Parks celebration held each October. Photographers should see website for more information.

PHOTOGRAPHY NOW

c/o The Center for Photography at Woodstock, 59 Tinker St., Woodstock NY 12498. (845)679-9957. Fax: (845)679-6337. E-mail: info@cpw.org. Website: www.cpw.org. **Contact:** CPW program associate. Two annual contests: 1 for exhibitions, 1 for publication. Juried annually

by renowned photographers, critics, museum and gallery curators. Deadlines vary. General submission is ongoing. Photographers must call or write for guidelines.

▣ THE PHOTO REVIEW ANNUAL PHOTOGRAPHY COMPETITION

140 E. Richardson Ave., Suite 301, Langhorne PA 19047. (215)891-0214. E-mail: info@ photoreview.org. Website: www.photoreview.org. **Contact:** Stephen Perloff, editor. Cost: $30 for up to 3 images; $5 each for up to 2 additional images. National annual contest. All types of photographs are eligible—b&w, color, nonsilver, computer-manipulated, etc. Submit slides or prints (unmatted, unframed, 16 × 20 or smaller), or images on CD. All entries must be labeled. Awards include SilverFast HDR Studio digital camera RAW conversion software from LaserSoft Imaging ($499), a $270 gift certificate from Lensbabies for a Composer lens or other items on the Lensbaby.com webstore, a $250 gift certificate from Calumet Photographic, a 24"x50" role of Museo Silver Rag ($240), a 20"x24" silver gelatin fiber print from Digital Silver Imaging ($215), camera bags from Lowepro, and $250 in cash prizes. All winners reproduced in summer issue of Photo Review magazine and exhibited at photography gallery of the University of Arts/Philadelphia. Open to all skill levels. **May 15 deadline**. Photographers should send SASE or see website for more information.

▣ PHOTOSPIVA

Spiva Center for the Arts, 222 W. Third St., Joplin MO 64801. (417)623-0183. E-mail: jmueller@spivaarts.org. Website: www.spivaarts.org. **Contact:** Executive director. Annual national fine art photography competition. Over $2,000 cash awards. Open to all photographers in the U.S. and its territories; any photographic process welcome. Enter online at www.photospiva.org beginning December 4, 2009. Juror: TBA. **Deadline:** January 8, 2010. Exhibition: March 6-April 25, 2010.

PICTURES OF THE YEAR INTERNATIONAL

315 Reynolds Journalism Institute, Columbia MO 65211. (573)884-7351. Fax: (573)884-4999. E-mail: info@poyi.org. Website: www.poyi.org. **Contact:** Rick Shaw, director. Cost: $50/ entrant. Annual contest to reward and recognize excellence in photojournalism, sponsored by the Missouri School of Journalism and the Donald W. Reynolds Journalism Institute. Over $20,000 in cash and product awards. Open to all skill levels. **January deadline.** Photographers should write, call or e-mail for more information.

- The Missouri School of Journalism also sponsors College Photographer of the Year. See website for details.

THE PROJECT COMPETITION

Center, P.O. Box 2483, Santa Fe NM 87504. E-mail: info@visitcenter.org. Website: www. visitcenter.org. **Contact:** Laura Wzorek Pressley, executive director. Cost: $35. Annual contest. The Project Competition honors committed photographers working on documentary projects and fine-art series. Three respected jurors choose 1st Prize, 3 Juror's Choice Awards, and 3 Honorable Mentions. The Director also selects a Director's Award for a total of 8 award winners. Additionally, up to 25 finalists are also listed on the website. Prizes include a $5,000 cash award, full-tuition scholarship for a weeklong workshop of winner's

choice at the Santa Fe workshops, and a complimentary participation in Review Santa Fe, exhibition and more. Open to all skill levels. **Deadline:** January, 2010. Photographers should see website for more information.

RHODE ISLAND STATE COUNCIL ON THE ARTS FELLOWSHIPS

One Capitol Hill, 3rd Floor, Providence RI 02908. (401)222-3880. Fax: (401)222-3018. E-mail: Cristina@arts.ri.gov. Website: www.arts.ri.gov. **RI residents only.** Cost: free. Annual contest "to encourage the creative development of Rhode Island artists by enabling them to set aside time to pursue their work and achieve specific career goals." Awards $5,000 fellowship; $1,000 merit award. Open to advanced photographers. **April 1 deadline.** Photographers should go to www.arts.ri.gov/grants/guidelines/fellow.php for more information.

W. EUGENE SMITH MEMORIAL FUND, INC.

c/o ICP, 1133 Avenue of the Americas, New York NY 10036. (212)857-0038. Fax: (212)768-4688. Website: www.smithfund.org. Annual contest. Promotes humanistic traditions of W. Eugene Smith. Grant of $30,000; secondary grant of $5,000. Open to photographers with a project in the tradition of W. Eugene Smith. Photographers should send SASE (60¢) for application information.

TEXAS PHOTOGRAPHIC SOCIETY, THE NATIONAL COMPETITION

6338 N. New Braunfels #174, San Antonio TX 78209. (210)824-4123. E-mail: clarke@ texasphoto.org. Website: www.texasphoto.org. **Contact:** D. Clarke Evans, TPS president. Cost: $35 for 5 images, plus $5 for each image over 5, and membership fee if joining Texas Photographic Society. You do not have to be a member to enter. See website or call for information on membership fees. TPS has a membership of 1,300 from 49 states and 12 countries. Contest held annually. Cash awards: 1st Place: $750; 2nd Place: $350; 3rd Place: $200; 5 honorable mentions at $100 each. The exhibition will open in Austin, TX and be exhibited at galleries in Odessa, Abilene, and San Antonio. Open to all skill levels. See website or call Clarke for more information.

N TEXAS PHOTOGRAPHIC SOCIETY ANNUAL MEMBERS' ONLY SHOW

6338 N. New Braunfels #174, San Antonio TX 78209.(210)824-4123. E-mail: clarke@ texasphoto.org. Website: www.texasphoto.org. **Contact:** D. Clarke Evans, TPS President. Photographers should call, see website for more information for more information. Cost: $35 for 5 images, plus $5 for each image over 5, and membership fee if joining Texas Photographic Society. You must be a member to enter. TPS has a membership of 1,300 from 49 states and 12 countries. Contest held annually. Cash awards: 1st place: $750; 2nd place: $200; 5 honorable mentions at $100 each. The show will open at the Martin Museum of Art on June 8, 2010. The Members' Only show opens in different cities with a juror from that city and has opened in Austin, Beaumont, Longview, Lubbock, El Paso, Dallas, Galveston, San Marcos, San Antonio, and San Francisco, CA. Open to all skill levels. See website or call Clarke for more information.

UNLIMITED EDITIONS INTERNATIONAL JURIED PHOTOGRAPHY COMPETITIONS

c/o Competition Chairman, 319 E. Shay Circle, Hendersonville NC 28791. (828)489-9609. E-mail: UltdEditionsIntl@aol.com. **Contact:** Gregory Hugh Leng, president/owner. Sponsors juried photography competitions several times yearly offering cash, award certificates and prizes. Photography accepted from amateurs and professionals. Open to all skill levels and ages. Prizes awarded in different categories or divisions such as commercial, portraiture, journalism, landscape, digital imaging, and retouching. We accept formats in print film, transparencies and digital images. Black and white, color, and digital imaging CD's or DVD's may be submitted for consideration. Prints and large transparencies may be in mats, no frames. All entries must be delivered in a reusable container with prepaid postage to insure photography is returned. Unlimited Editions International also offers the unique opportunity to purchase photography from those photographers who wish to sell their work. All images submitted in competition remain the property of the photographer/entrants unless an offer to purchase their work is accepted by the photographer. All photographers must send SASE (.92 USA and $2.25 international) for entry forms, contest dates, and detailed information on how to participate in our International juried photography competitions.

U.S. INTERNATIONAL FILM AND VIDEO FESTIVAL

713 S. Pacific Coast Hwy., Suite A, Redondo Beach CA 90277-4233. (310)540-0959. Fax: (310)316-8905. E-mail: filmfestinfo@filmfestawards.com. Website: www.filmfestawards. com. **Contact:** Lee W. Gluckman, Jr., chairman. Annual international awards competition founded in 1968 for business, television, industrial, entertainment, documentary and informational film and video. Entry fee: Up to 30 minutes, $200; over 30 minutes, $300; student entries $25. **March 1 deadline.** Entries received after deadline will have $25 late fee. Awards presented in early June each year in Los Angeles.

WRITERS' JOURNAL PHOTO CONTEST

Val-Tech Media, P.O. Box 394, Perham MN 56573. (218)346-7921. Fax: (218)346-7924. E-mail: writersjournal@writersjournal.com. Website: www.writersjournal.com. **Contact:** Leon Ogroske. Cost: $3/entry. No limit on number of entries. Photos can be of any subject matter, with or without people. Model releases must accompany all photos of people. 1st Prize: $25; 2nd Prize: $15; 3rd Prize: $10; winners will be published in *WRITERS' Journal* magazine. **May 30/November 30 deadlines**. Photographers should send SASE for guidelines.

YOUR BEST SHOT

Popular Photography. E-mail: yourbestshot@bonniercorp.com. Website: www.PopPhoto. com. Monthly contest; submit up to 5 entries/month. Cash awards: 1st Place: $300; 2nd Place: $200; 3rd Place: $100; Honorable Mentions: $50. Photographers should see website for more information on how to enter.

Photo Representatives

Many photographers are good at promoting themselves and seeking out new clients, and they actually enjoy that part of the business. Other photographers are not comfortable promoting themselves and would rather dedicate their time and energy solely to producing their photographs. Regardless of which camp you're in, you may need a photo rep.

Finding the rep who is right for you is vitally important. Think of your relationship with a rep as a partnership. Your goals should mesh. Treat your search for a rep much as you would your search for a client. Try to understand the rep's business, who they already represent, etc., before you approach them. Show you've done your homework.

When you sign with a photo rep, you basically hire someone to get your portfolio in front of art directors, make cold calls in search of new clients, and develop promotional ideas to market your talents. The main goal is to find assignment work for you with corporations, advertising firms, or design studios. And, unlike stock agencies or galleries, a photo rep is interested in marketing your talents rather than your images.

Most reps charge a 20-to 30-percent commission. They handle more than one photographer at a time, usually making certain that each shooter specializes in a different area. For example, a rep may have contracts to promote three different photographers—one who handles product shots, another who shoots interiors, and a third who photographs food.

DO YOU NEED A REP?

Before you decide to seek out a photo representative, consider these questions:

- Do you already have enough work, but want to expand your client base?
- Are you motivated to maximize your profits? Remember that a rep is interested in working with photographers who can do what is necessary to expand their businesses.
- Do you have a tightly edited portfolio with pieces showing the kind of work you want to do?

- Are you willing to do what it takes to help the rep promote you, including having a budget to help pay for self-promotional materials?
- Do you have a clear idea of where you want your career to go, but need assistance in getting there?
- Do you have a specialty or a unique style that makes you stand out?

If you answered yes to most of these questions, perhaps you would profit from the expertise of a rep. If you feel you are not ready for a rep or that you don't need one, but you still want some help, you might consider a consultation with an expert in marketing and/or self-promotion.

As you search for a rep, there are numerous points to consider. First, how established is the rep you plan to approach? Established reps have an edge over newcomers in that they know the territory. They've built up contacts in ad agencies, magazines and elsewhere. This is essential since most art directors and picture editors do not stay in their positions for long periods of time. Therefore, established reps will have an easier time helping you penetrate new markets.

If you decide to go with a new rep, consider paying an advance against commission in order to help the rep financially during an equitable trial period. Usually it takes a year to see returns on portfolio reviews and other marketing efforts, and a rep who is relying on income from sales might go hungry if he doesn't have a base income from which to live.

Whatever you agree upon, always have a written contract. Handshake deals won't cut it. You must know the tasks that each of you is required to complete, and having your roles discussed in a contract will guarantee there are no misunderstandings. For example, spell out in your contract what happens with clients that you had before hiring the rep. Most photographers refuse to pay commissions for these "house" accounts, unless the rep handles them completely and continues to bring in new clients.

Also, it's likely that some costs, such as promotional fees, will be shared. For example, photographers often pay 75 percent of any advertising fees (such as sourcebook ads and direct mail pieces).

If you want to know more about a specific rep, or how reps operate, contact the Society of Photographers and Artists Representatives, 60 E. 42nd St., Suite 1166, New York NY 10165, (212)779-7464, www.spar.org. SPAR sponsors educational programs and maintains a code of ethics to which all members must adhere.

ROBERT BACALL REPRESENTATIVES INC.

4 Springwood Dr., Princeton Junction NJ 08550. (212)695-1729. E-mail: rob@bacall.com. Website: www.bacall.com. **Contact**: Robert Bacall. Commercial photography and artist representative. Estab. 1988. Represents 12 photographers. Agency specializes in digital, food, still life, fashion, beauty, kids, corporate, environmental, portrait, lifestyle, location, landscape. Markets include advertising agencies, corporations/clients direct, design firms, editorial/magazines, publishing/books, sales/promotion firms.

Terms Rep receives 30% commission. Exclusive area representation required. For promotional purposes, talent must provide portfolios, cases, tearsheets, prints, etc. Advertises in *Creative Black Book, Workbook, Le Book, Alternative Pick, PDN-Photoserve, At-Edge.*

How to Contact Send query letter/e-mail, direct mail flier/brochure. Responds only if interested. After initial contact, drop off or mail materials for review.

Tips "Seek representation when you feel your portfolio is unique and can bring in new business."

CONSULTANT/PHOTOGRAPHER'S REPRESENTATIVE

11977 Kiowa Ave., Los Angeles CA 90049-6119. E-mail: rhoni@phototherapists.com. Website: www.phototherapists.com. **Contact**: Rhoni Epstein. Commercial and fine art photography consultants. Expert in imagery/portfolio development, design, branding/ marketing and business plans. Estab. 1983. "We show you how to differentiate yourself from the myriad of other photographers. Customized portfolios, marketing programs, branding materials and website design are developed to be compatible with you and your photography. Your imagery will be focused and tell memorable stories that will last in the viewer's mind long after your portfolio has been seen. We'll guide you to recognize and embrace your own personal style, which will fulfill you and your market." Rhoni Epstein is a photography panel moderator, portfolio reviewer, lecturer and contest judge.

How to Contact Via e-mail.

Tips "Consulting with a knowledgeable and well-respected industry insider is a valuable way to get focused and advance your career in a creative and cost-efficient manner. Always be true to your own personal vision! When researching a representative's agency, research their photographers to understand if they prefer to rep similar styles or experts in a specific area. Remain persistent and enthusiastic; there is always a market for creative and talented people."

LINDA DE MORETA REPRESENTS

1511 Union Street, Alameda CA 94501. (510)769-1421. Fax: (419)710-8298. E-mail: linda@lindareps.com. Website: www.lindareps.com. **Contact:** Linda de Moreta. Commercial photography and illustration representative. Estab. 1988. Member of Graphic Artists Guild. Represents 1 photographer and 10 illustrators. Markets include advertising agencies, design firms, corporations/client direct, editorial/magazines, paper products/greeting cards, publishing/books, sales/promotion firms.

Handles Photography, illustration, lettering.

Terms Exclusive representation requirements and commission arrangements vary. Advertising costs are handled by individual agreement. Materials for promotional purposes vary with each artist. Advertises in *Workbook, Directory of Illustration.*

How to Contact E-mail or send direct mail flier/brochure. "Please do not send original art. Include SASE for any items you wish returned." Responds to any inquiry in which there is an interest. Portfolios are individually developed for each artist.

Tips Obtains new talent primarily through client and artist referrals, some solicitation. "I look for a personal vision and style of photography, and exceptional creativity combined with professionalism, maturity, and commitment to career advancement."

BARBARA GORDON

165 E. 32nd St., New York NY 10016. (212)686-3514. Fax: (212)532-4302. **Contact:** Barbara Gordon. Commercial illustration and photography representative. Estab. 1969. Member of SPAR, Society of Illustrators, Graphic Artists Guild. Represents illustrators and photographers. "I represent only a small select group of people and therefore give a great deal of personal time and attention to each." Also does coaching and consulting.

Terms Rep receives 25% commission. No geographic restrictions in continental US.

How to Contact Send direct mail flier/brochure. Responds in 2 weeks. After initial contact, drop off or mail appropriate materials for review. Portfolio should include tearsheets, slides, photographs; "if you want materials or promotion piece returned, include SASE."

Tips Obtains new talent through recommendations from others, solicitation, art conferences, etc. "I have obtained talent from all of the above. I do not care if an artist or photographer has been published or is experienced. I am essentially interested in people with a good, commercial style. Don't send résumés and don't call to give me a verbal description of your work. Send promotion pieces. *Never* send original art. If you want something back, include a SASE. Always label your slides in case they get separated from your cover letter. And always include a phone number where you can be reached."

CAROL GUENZI AGENTS, INC.

865 Delaware, Denver CO 80204-4533. (303)820-2599 or (800)417-5120. Fax: (303)820-2598. E-mail: art@artagent.com. Website: www.artagent.com. **Contact:** Carol Guenzi. Commercial illustration, photography, new media, film/animation representative. Estab. 1984. Member of Art Directors Club of Denver, AIGA and ASMP. Represents 30 illustrators, 8 photographers, 6 computer multimedia designers, 3 copywriters, 2 film/video production companies. Agency specializes in a "worldwide selection of talent in all areas of visual communications." Markets include advertising agencies, corporations/clients direct, design firms, editorial/magazine, paper products/greeting cards, sales/promotions firms.

Handles Illustration, photography, new media, film and animation. Looking for unique styles and applications and digital imaging.

Terms Rep receives 25-30% commission. Exclusive area representation required. Advertising costs are split: 70-75% paid by talent; 25-30% paid by representative. For promotional purposes, talent must provide "promotional material after 6 months, some restrictions on portfolios." Advertises in *Directory of Illustration* and *Workbook*.

How to Contact E-mail JPEGs or send direct mail piece, tearsheets. Responds in 2-3 weeks, only if interested. After initial contact, call or e-mail for appointment or to drop off or ship materials for review. Portfolio should include tearsheets, prints, samples and a list of current clients.

Tips Obtains new talent through solicitation, art directors' referrals and active pursuit by

individual. "Show your strongest style and have at least 12 samples of that style before introducing all your capabilities. Be prepared to add additional work to your portfolio to help round out your style. We do a large percentage of computer manipulation and accessing on network. All our portfolios are both electronic and prints."

PAT HACKETT/ARTIST REPRESENTATIVE

7014 N. Mercer Way, Mercer Island WA 98040. (206)447-1600. Fax: (206)447-0739. Email: pat@pathackett.com. Website: www.pathackett.com. **Contact:** Pat Hackett. Commercial illustration and photography representative. Estab. 1979. Member of Graphic Artists Guild. Represents 12 illustrators and 1 photographer. Markets include advertising agencies, corporations/client direct, design firms, editorial/magazines.

Handles Illustration, photography.

Terms Rep receives 25-33% commission. Exclusive area representation required. No geographic restrictions. Advertising costs are split: 75% paid by talent; 25% paid by representative. For promotional purposes, talent must provide "standardized portfolio, i.e., all pieces within the book are the same format." Advertises in *Showcase* and *Workbook*(www. portfolios.com and www.theispot.com).

How to Contact Send direct mail flier/brochure or e-mail. Responds within 3 weeks if interested.

N JG + A

444 N. Larchmont Blvd., Suite 207, Los Angeles CA 90004. (323)464-2492. Fax: (323)465-7013. E-mail: sherwin@jgaonline.com. Website: www.jgaonline.com. **Contact:** Sherwin Taghdiri. Commercial photography representative. Estab. 1985. Member of APA. Represents 12 photographers. Staff includes Dominique Cole (sales rep) and Sherwin Taghdiri (sales rep). Agency specializes in photography. Markets include advertising agencies, design firms.

Handles Photography.

Terms Rep receives 25% commission. Charges shipping expenses. Exclusive representation required. No geographic restrictions. Advertising costs are paid by talent. For promotional purposes, talent must provide promos, advertising and a quality portfolio. Advertises in various source books.

How to Contact Send direct mail flier/brochure.

TRICIA JOYCE INC.

79 Chambers St., New York NY 10007. (212)962-0728. E-mail: info@triciajoyce.com. Website: www.triciajoyce.com. **Contact**: Tricia Joyce, Amy Fraher, or Jann Johnson. Commercial photography representative. Estab. 1988. Represents photographers and stylists. Agency specializes in fashion, advertising, lifestyle, still life, travel, cosmetics/beauty, interiors, portraiture. Markets include advertising agencies, corporations/clients direct, design firms, editorial/magazines and sales/promotion firms.

Handles Photography, stylists, hair and makeup artists, and fine art.

Terms Agent receives 25% commission for photography; 20% for stylists, 50% for stock.

How to Contact Send query letter, resume, direct mail flier/brochure and photocopies. Responds only if interested. After initial contact, "wait to hear—please don't call."

LEE + LOU PRODUCTIONS INC.

211 N. Dianthus St., Manhattan Beach CA 90266. (310)374-1918. Fax: (310)374-1918. E-mail: leelou@earthlink.net. Website: www.leelou.com. Commercial illustration and photography representative, digital and traditional photo retouching. Estab. 1981. Represents 2 retouchers, 5 photographers, 5 film directors, 2 visual effects com, 1CGI com. Specializes in automotive. Markets include advertising agencies.

Handles Photography, commercial film, CGI, visual effects.

Terms Rep receives 25% commission. Charges for shipping, entertainment. Exclusive area representation required. Advertising costs are paid by talent. For promotional purposes, talent must provide direct mail advertising material. Advertises in *Creative Black Book*, *Workbook* and *Single Image, Shoot, Boards*.

How to Contact Send direct mail flier/brochure, tearsheets. Responds in 1 week. After initial contact, call for appointment to show portfolio of photographs.

Tips Obtains new talent through recommendations from others, some solicitation.

THE BRUCE LEVIN GROUP

305 Seventh Ave., Suite 1101, New York NY 10001. (212)627-2281. Fax: (212)627-0095. E-mail: brucelevin@mac.com. Website: www.brucelevingroup.com. **Contact:** Bruce Levin, president. Commercial photography representative. Estab. 1983. Member of SPAR and ASMP. Represents 10 photographers. Agency specializes in advertising, editorial and catalog; heavy emphasis on fashion, lifestyle and computer graphics.

Handles Photography.

Terms Rep receives 25% commission. Exclusive area representation required. Advertising costs are paid by talent. Advertises in *Workbook* and other sourcebooks.

How to Contact Send brochure, photos; call. Portfolios may be dropped off every Monday through Friday.

Tips Obtains new talent through recommendations, research, word of mouth, solicitation.

MUNRO GOODMAN ARTISTS REPRESENTATIVES

630 N. State St., #2109, Chicago IL 60610. (312)335-8925. E-mail: steve@munrocampagna. com. Website: www.munrocampagna.com. **Contact:** Steve Munro, president. Commercial photography and illustration representative. Estab. 1987. Member of SPAR, CAR (Chicago Artist Representatives). Represents 4 photographers, 30 illustrators. Markets include advertising agencies, corporations/clients direct, design firms, publishing/books.

Handles Illustration, photography.

Terms Rep receives 25% commission. Exclusive area representation required. Advertising costs are split: 75% paid by talent; 25% paid by representative. For promotional purposes, talent must provide 2 portfolios, leave-behinds, several promos. Advertises in *Workbook*, other sourcebooks.

How to Contact Send query letter, bio, tearsheets, SASE. Responds within 2 weeks, only if interested. After initial contact, write to schedule an appointment.

Tips Obtains new talent through recommendations, periodicals. "Do a little homework and target appropriate rep. Try to get a referral from an art buyer or art director."

NPN WORLDWIDE

The Roland Group, Inc., 4948 St. Elmo Ave., Suite 201, Bethesda MD 20814. (301)718-7955. Fax: (301)718-7958. Email: info@npnworldwide.com. Website: www.npnworldwide.com. Photography broker. Member of SPAR. Markets include advertising agencies, corporate/client direct, design firms.

Handles Photography.

Terms Rep receives 35% commission.

How to Contact "Go to our Web site. The 'contact us' section has a special talent recruitment form with further instructions on how to submit your work." Rep will contact photographer for portfolio review if interested.

Tips Finds new talent through submissions. "Go to our website and take a look around to see what we are all about."

PHOTOKUNST

725 Argyle Ave., Friday Harbor WA 98250. (360)378-1028. Fax: (360)370-5061. E-mail: info@photokunst.com. Website: www.photokunst.com. **Contact:** Barbara Cox, principal. Consulting and marketing of photography archives and fine art photography, nationally and internationally. Estab. 1998. "Accepting select number of photographers on our new website. Works with artists on Licensing, Photo Sales, Curating and traveling exhibitions, book projects."

Handles Emphasis on photojournalism, documentary and ethnographic photography. Vintage and contemporary photography.

Terms Charges for consultation, hourly/daily rate; for representation, website fee and percentage of sales.

How to Contact Send website information. Responds in 2 months.

Tips Finds new talent through submissions, recommendations from other artists, publications, art fairs, portfolio reviews. "In order to be placed in major galleries, a book or catalog must be either in place or in serious planning stage."

MARIA PISCOPO

2973 Harbor Blvd., #341, Costa Mesa CA 92626-3912. Phone/fax: (888)713-0705. E-mail: maria@mpiscopo.com. Website: www.mpiscopo.com. **Contact:** Maria Piscopo. Commercial photography representative. Estab. 1978. Member of SPAR, Women in Photography, Society of Illustrative Photographers. Markets include advertising agencies, design firms, corporations.

Handles Photography. Looking for "unique, unusual styles; established photographers only."

Terms Rep receives 25% commission. Exclusive area representation required. No geographic restrictions. Advertising costs are split: 50% paid by talent; 50% paid by representative. For promotional purposes, talent must have a website and provide 3 traveling portfolios, leave-behinds and at least 6 new promo pieces per year. Plans web, advertising and direct mail campaigns.

How to Contact Send query letter, bio, promo piece and SASE. Responds within 2 weeks, only if interested.

Tips Obtains new talent through personal referral and photo magazine articles. "Do

Photo Representatives

lots of research. Be very businesslike, organized, professional and follow the above instructions!"

ALYSSA PIZER

13121 Garden Land Rd., Los Angeles CA 90049. (310)440-3930. Fax: (310)440-3830. E-mail: alyssapizer@earthlink.net. Website: www.alyssapizer.com. **Contact:** Alyssa Pizer. Commercial photography representative. Estab. 1990. Member of APCA. Represents 10 photographers. Agency specializes in fashion, beauty and lifestyle (catalog, image campaign, department store, beauty and lifestyle awards). Markets include advertising agencies, corporations/clients direct, design firms, editorial/magazines.

Handles Photography. Established photographers only.

Terms Rep receives 25% commission. Photographer pays for FedEx and messenger charges. Talent pays 100% of advertising costs. For promotional purposes, talent must provide 10 portfolios, leave-behinds and quarterly promotional pieces.

How to Contact Send query letter or direct mail flier/brochure or e-mail website address. Responds in a couple of days. After initial contact, call to schedule an appointment or drop off or mail materials for review.

Tips Obtains new talent through recommendations from clients.

THE ROLAND GROUP, INC.

4948 St. Elmo Ave., Suite 201, Bethesda MD 20814. (301)718-7955. Fax: (301)718-7958. Email: info@therolandgroup.com. Website: www.therolandgroup.com. **Contact:** Rochel Roland. Commercial photography and illustration representatives and brokers. Estab. 1988. Member of SPAR, Art Directors Club and Ad Club. Represents 300 photographers, 10 illustrators. Markets include advertising agencies, corporations/clients direct, design firms and sales/promotion firms.

Handles Illustration, photography.

Terms Agent receives 35% commission. For promotional purposes, talent must provide transparencies, slides, tearsheets and a digital portfolio.

How to Contact Go to www.npnworldwide.com and complete talent recruitment form on contact page. Responds only if interested.

Tips "The Roland Group provides the NPN Worldwide Service, a global network of advertising and corporate photographers." (See separate listing in this section.)

VICKI SANDER/FOLIO FORUMS

48 Gramercy Park N., New York NY 10010. (212)420-1333. E-mail: vicki@vickisander. com. Website: www.vickisander.com. Commercial photography representative. Estab. 1985. Member of SPAR, The One Club for Art and Copy, The New York Art Directors Club. Represents photographers. Markets include advertising agencies, corporate/client direct, design firms, editorial/magazines, paper products/greeting cards. "Folio Forums is a company that promotes photographers by presenting portfolios at agency conference rooms in catered breakfast reviews. Accepting submissions for consideration on a monthly basis."

Handles Photography, fine art. Looking for lifestyle, fashion, food.

Terms Rep receives 30% commission. Exclusive representation required. Advertising

costs are paid by talent. For promotional purposes, talent must provide direct mail and sourcebook advertising. Advertises in *Workbook*.

How to Contact Send tearsheets. Responds in 1 month. To show portfolio, photographer should follow up with a call and/or letter after initial query.

Tips Finds new talent through recommendation from other artists, referrals. Have a portfolio put together and have promo cards to leave behind, as well as mailing out to rep prior to appointment.

TM ENTERPRISES

P.O. Box 18644, Beverly Hills CA 90209. E-mail: tmarques1@hotmail.com. **Contact:** Tony Marques. Commercial photography representative and photography broker. Estab. 1985. Member of Beverly Hills Chamber of Commerce. Represents 50 photographers. Agency specializes in photography of women only: high fashion, swimsuit, lingerie, glamour and fine (good taste) Playboy -style pictures, erotic. Markets include advertising agencies, corporations/clients direct, editorial/magazines, paper products/greeting cards, publishing/ books, sales/promotion firms, medical magazines.

Handles Photography.

Terms Rep receives 50% commission. Advertising costs are paid by representative. "We promote the standard material the photographer has available, unless our clients request something else." Advertises in Europe, South and Central America, and magazines not known in the U.S.

How to Contact Send everything available. Responds in 2 days. After initial contact, drop off or mail appropriate materials for review. Portfolio should include slides, photographs, transparencies, printed work.

Tips Obtains new talent through worldwide famous fashion shows in Paris, Rome, London and Tokyo; by participating in well-known international beauty contests; recommendations from others. "Send your material clean and organized (neat). Do not borrow other photographers' work in order to get representation. Always protect yourself by copyrighting your material. Get releases from everybody who is in the picture (or who owns something in the picture)."

DOUG TRUPPE

121 E. 31st St., New York NY 10016. (212)685-1223. E-mail: doug@dougtruppe.com. Website: www.dougtruppe.com. **Contact:** Doug Truppe, president. Commercial photography representative. Estab. 1998. Member of SPAR, Art Directors Club. Represents 8 photographers. Agency specializes in lifestyle, food, still life, portrait and children's photography. Markets include advertising agencies, corporate, design firms, editorial/magazines, publishing/ books, direct mail firms.

Handles Photography. "Always looking for great commercial work." Established, working photographers only.

Terms Rep receives 25% commission. Exclusive area representation required. Advertising costs are paid by talent. For promotional purposes, talent must provide directory ad (at least 1 directory per year), direct mail promo cards every 3 months, website. Advertises in *Workbook*.

How to Contact Send e-mail with website address. Responds within 1 month, only if

interested. To show portfolio, photographer should follow up with call.

Tips Finds artists through recommendations from other artists, source books, art buyers. "Please be willing to show some new work every 6 months. Have 4-6 portfolios available for representative. Have website and be willing to do direct mail every 3 months. Be professional and organized."

THE WILEY GROUP

1535 Green St., # 301, San Francisco CA 94123. (415)441-3055. Fax: (415)520-0999. E-mail: dw@thewileygroup.com. Website: www.thewileygroup.com. **Contact:** David Wiley. Commercial artist representative. Estab. 1984 "as an artist agency that promotes and sells the work of illustrators for commercial use worldwide. He has over 25 years of experience in the industry, and extensive knowledge about the usage, pricing, and marketing of commercial art. Currently represents 13 illustrators. The artists' work ranges from traditional to digital. The agency services accounts in advertising, design, and publishing as well as corporate accounts." Clients include Disney, Coca Cola, Smithsonian, Microsoft, Nike, Oracle, Google, Random House, Eli Lilly Pharmaceuticals, National Geographic, Super Bowl XLII, FedEx, Nestle Corp., and Apple Computers.

Terms Rep receives 25% commission with a bonus structure. No geographical restriction. Artist pays 75% of online agencies (Workbook.com or Theispot.com), postcards. Agent will reimburse artist for 25% of costs. Each year the artists are promoted using online agencies, monthly postcard mailings, and weekly eMailers from Adbase.com.

How to Contact For first contact, e-mail URL and one visual image representing your style. If interested, agent will e-mail or call back to discuss representation.

Tips "The bottom line is that a good agent will get you more work at better rates of pay."

Workshops & Photo Tours

Taking a photography workshop or photo tour is one of the best ways to improve your photographic skills. There is no substitute for the hands-on experience and one-on-one instruction you can receive at a workshop. Besides, where else can you go and spend several days with people who share your passion for photography?

Photography is headed in a new direction. Digital imaging is here to stay and is becoming part of every photographer's life. Even if you haven't invested a lot of money into digital cameras, computers or software, you should understand what you're up against if you plan to succeed as a professional photographer. Taking a digital imaging workshop can help you on your way.

Outdoor and nature photography are perennial workshop favorites. Creativity is another popular workshop topic. You'll also find highly specialized workshops, such as underwater photography. Many photo tours specialize in a specific location and the great photo opportunities that location affords.

As you peruse these pages, take a good look at the quality of workshops and the skill level of photographers the sponsors want to attract. It is important to know if a workshop is for beginners, advanced amateurs or professionals. Information from a workshop organizer can help you make that determination.

These workshop listings contain only the basic information needed to make contact with sponsors, and a brief description of the styles or media covered in the programs. We also include information on costs when possible. Write, call or e-mail the workshop/photo tour sponsors for complete information. Most have websites with extensive information about their programs, when they're offered, and how much they cost.

A workshop or photo tour can be whatever the photographer wishes—a holiday from the normal working routine, or an exciting introduction to new skills and perspectives on the craft. Whatever you desire, you're sure to find in these pages a workshop or tour that fulfills your expectations.

EDDIE ADAMS WORKSHOP

P.O. Box 75, Hackensack, NJ 07602-9192. E-mail: eawproducer@gmail.com. Website: www.eddieadamsworkshop.com. **Contact:** Mirjam Evers, workshop producer. Annual tuition-free photojournalism workshop. The Eddie Adams Workshop brings together 100 promising young photographers with over 150 of the most influential picture journalists, picture editors, managing editors and writers from prestigious organizations such as the Associated Press, CNN, The White House, *Life, National Geographic, Newsweek, Time, Parade, Entertainment Weekly, Sports Illustrated, The New York Times, The Los Angeles Times* and *The Washington Post*. Pulitzer-prize winning photographer Eddie Adams created this program to allow young photographers to learn from experienced professionals about the story-telling power and social importance of photography. Participants are divided into 10 teams, each headed by a photographer, editor, producer, or multimedia person. Daily editing and critiquing help each student to hone skills and learn about the visual, technical, and emotional components of creating strong journalistic images. Open to photography students and professional photographers with 3 years or less of experience. Photographers should e-mail for more information.

ALASKA'S SEAWOLF ADVENTURES

P.O. Box 312, Gustavus AK 99826. (907)957-1438. E-mail: kimber@seawolfadventures.net. Website: www.seawolfadventures.net. **Contact:** Kimber Owen. Cost: $3,180/6 days. "Photograph glaciers, whales, bears, wolves, incredible scenics, etc., while using the Seawolf, a 97-foot, 12-passenger expedition ship, as your base camp in the Glacier Bay area."

ANCHELL PHOTOGRAPHY WORKSHOPS

879 Cottage Street NE, Salem OR 97301. (503)375-2163. Fax: (503)588-4003. E-mail: info@anchellworkshops.com. Website: www.anchellworkshops.com. **Contact:** Steve Anchell. Cost: $250-2,500. Film or digital, group or private workshops held throughout the year, including large-format, 35mm, studio lighting, figure, darkroom, both color and b&w. Open to all skill levels. Photographers should write, call or e-mail for more information.

ANDERSON RANCH ARTS CENTER

P.O. Box 5598, Snowmass Village CO 81615. (970)923-3181. Fax: (970)923-3871. E-mail: reg@andersonranch.org. Website: www.andersonranch.org. Digital media and photography workshops, June through September, feature distinguished artists and educators from around the world. Classes range from traditional silver and alternative photographic processes to digital formats and use of the computer as a tool for time-based and interactive works of art. Program is diversifying into video, animation, sound and installations.

Ⓝ ◯ ANIMALS OF MONTANA, INC.

14752 Brackett Creek Road, Bozeman MT 59715. (406)686-4224. E-mail: animals@animalsofmontana.com. Website: www.animalsofmontana.com. **Contact:** Tracy Hyde, secretary. See website for pricing information. Held annually. Workshops held year round. "Whether you're a professional photographer or amateur or just looking for a Montana Wildlife experience, grab your camera and leave the rest to us! Please visit our tour page for a complete listing of our tours." Open to all skill levels. Photographers should call, e-mail, see website for more information.

ARIZONA HIGHWAYS PHOTO WORKSHOPS

Friends of Arizona Highways, 2039 W. Lewis Ave., Phoenix AZ 85009. (602)256-2873. E-mail: friends@friendsofazhighways.com. Website: www.friendsofazhighways.com. **Contact:** Robyn Noll, director. Offers photo adventures to the American West's most spectacular locations with top professional photographers whose work routinely appears in Arizona Highways magazine.

ARROWMONT SCHOOL OF ARTS AND CRAFTS

556 Parkway, P.O. Box 567, Gatlinburg TN 37738. (865)436-5860. Email: info@arrowmont. org. Website: www.arrowmont.org. Offers weekend, 1- and 2-week spring, summer and fall workshops in photography, drawing, painting, clay, metals/enamels, kiln glass, fibers, surface design, wood turning and furniture. Residencies, studio assistantships, work study, and scholarships are available. Application fees: $75 annual non-refundable application fee assessed for spring, summer, and fall classes; $35 for a weekend class. See individual course descriptions for pricing.

ART NEW ENGLAND SUMMER WORKSHOPS @ BENNINGTON VT

Massachusetts College of Art, 621 Huntington Avenue, 2nd Floor, Tower Building, Boston MA 02115. (617)879-7200. Fax: (617)879-7171. E-mail: ce@massart.edu. Website: www. massartplus.org. **Contact:** Nancy McCarthy, coordinator. Weeklong workshops in August, run by Massachusetts College of Art. Areas of concentration include b&w, alternative processes, digital printing and many more. Photographers should call, e-mail or see website for more information.

ART OF NATURE PHOTOGRAPHY WORKSHOPS

6401 Lake Washington Blvd., #407, Kirkland WA 98033-6853. (770)752-8566. E-mail: charles@charlesneedlephoto.com. Website: www.charlesneedlephoto.com. **Contact:** Charles Needle, founder/instructor. Cost: $125-1,5000 depending on the workshop; U.S. and international locations such as Monet's Garden (France); includes personalized one-on-one field and classroom instruction and supportive image evaluations. Emphasis on creative camera techniques in the field and digital darkroom, allowing students to express "the art of nature" with unique personal vision. Topics include creative macro, flower/garden photography, multiple-exposures, intimate landscapes and scenics, dynamic composition and lighting, etc. Open to all skill levels. Photographers should call, e-mail, see website for more information.

ART WORKSHOPS IN GUATEMALA

4758 Lyndale Ave. S., Minneapolis MN 55419-5304. (612)825-0747. E-mail: info@artguat. org. Website: www.artguat.org. **Contact:** Liza Fourre, director. Cost: $1,895; includes tuition, lodging, breakfast, ground transport. Annual workshops held in Antigua, Guatemala. Workshops include Adventure Travel Photo with Steve Northup, Portraiture/Photographing the Soul of Indigenous Guatemala with Nance Ackerman, Photography/Capturing Guatemala's Light and Contrasts with David Wells, Travel Photography/Indigenous Peoples, and Spirit of Place with Doug Beasley.

BACHMANN TOUR OVERDRIVE

P.O. Box 950833, Lake Mary FL 32746. (407)333-9988. E-mail: bill@billbachmann.com. Website: www.billbachmann.com.

NOELLA BALLENGER & ASSOCIATES PHOTO WORKSHOPS

P.O. Box 457, La Canada CA 91012. (818)954-0933. Fax: (818)954-0910. E-mail: Noella1B@ aol.com. Website: www.noellaballenger.com. **Contact:** Noella Ballenger. Travel and nature workshops/tours, West Coast locations. Individual instruction in small groups emphasizes visual awareness, composition, and problem-solving in the field. All formats and levels of expertise welcome. Also offers online photo classes and articles at www.apogeephoto. com.

BIRDS AS ART/INSTRUCTIONAL PHOTO-TOURS

P.O. Box 7245, 4041 Granada Dr., Indian Lake Estates FL 33855. (863)692-0906. E-mail: birdsasart@verizon.net. Website: www.birdsasart.com. **Contact:** Arthur Morris, instructor. Cost: varies, approximately $300/day. The tours, which visit the top bird photography hot spots in North America, feature evening in-classroom lectures, breakfast and lunch, in-the-field instruction, 6 or more hours of photography, and most importantly, easily approachable yet free and wild subjects.

BLUE PLANET PHOTOGRAPHY WORKSHOPS AND TOURS

1526 W. Charlotte Ct., Suite 107, Nampa ID 83687. (208)466-9340. Website: www. blueplanetphoto.com. **Contact**: Mike Shipman, owner/photographer. Cost: varies depending on type and length of workshop ($250-5,000; average: $1,900). Award-winning professional photographer and former wildlife biologist Mike Shipman conducts small group workshops/tours emphasizing individual expression and "vision-finding" by Breaking the Barriers to Creative Vision™. Workshops held in beautiful locations away from crowds and the more-often-photographed sites. Some workshops are semi-adventure-travel style, using alternative transportation such as hot air balloons, horseback, llama, and camping in remote areas. Group feedback sessions, digital presentations and film processing whenever possible. Workshops and tours held in western U.S., Alaska, Canada and overseas. Onsite transportation and lodging during workshop usually included; meals included on some trips. Specific fees, optional activities and gear list outlined in tour materials. Digital photographers welcome. Workshops and tours range from 2 to 12 days, sometimes longer; average is 9 days. Custom tours and workshops available upon request. Open to all skill levels. Photographers should write, call, e-mail or see website for more information.

NANCY BROWN HANDS-ON WORKSHOPS

381 Mohawk Lane, Boca Raton FL 33487. (561)988-8992. Fax: (561)988-1791. E-mail: nbrown50@bellsouth.net. Website: www.nancybrown.com. **Contact:** Nancy. Cost: $2,000. Offers one-on-one intensive workshops all year long in studio and on location in Florida. You work with Nancy, the models and the crew to create your images. Photographers should call, fax, e-mail or see website for more information.

⊕ BURREN COLLEGE OF ART WORKSHOPS

Burren College of Art, Newton Castle, Ballyvaughan, County Clare, Ireland. (353)(65)707-7200. Fax: (353)(65)707-7201. E-mail: anna@burrencollege.ie. Website: www.burrencollege.ie. **Contact:** Admissions Officer. "These workshops present unique opportunities to capture the qualities of Ireland's western landscape. The flora, prehistoric tombs, ancient abbeys and castles that abound in the Burren provide an unending wealth of subjects in an ever-changing light." Photographers should e-mail for more information.

CALIFORNIA PHOTOGRAPHIC WORKSHOPS

2500 N. Texas St., Fairfield CA 94533. (888)422-6606. E-mail: cpwschool@sbcglobal.net. Website: www.CPWschool.com. **Contact:** James Inks. 3 and 5 day workshops in professional photography.

⊕ CAMARGO FOUNDATION VISUAL ARTS FELLOWSHIP

1, Avenue Jermini, 13260 Cassis, France. E-mail: apply@camargofoundation.org. Website: www.camargofoundation.org. Residencies awarded to visual artists, creative writers, composers, and academics. Artists may work on a specific project, develop a body of work, etc. Fellows must live on-site at foundation headquarters for the duration of the Fellowship. Self-catering accommodation provided. Open to advanced photographers. **January 12 deadline.** Photographers should visit website to apply.

JOHN C. CAMPBELL FOLK SCHOOL

One Folk School Rd., Brasstown NC 28902. (800)365-5724 or (828)837-2775. Fax: (828)837-8637 Website: www.folkschool.org. Cost: $250-442 tuition; room and board available for additional fee. The Folk School offers weekend and weeklong courses in photography year-round. "Please call for free catalog."

CAPE COD PHOTO WORKSHOPS

46 Main St., P.O. Box 1687, Orleans MA 02653. (508)255-5202. E-mail: bob@bobkornimaging.com. Website: www.bobkornimaging.com. **Contact**: Bob Korn, director. Cost: $365-575. Photography workshops for the digital photographer. All skill levels. Workshops run year round. Photographers should call, e-mail or see website for more information.

THE CENTER FOR FINE ART PHOTOGRAPHY

400 N. College Ave., Fort Collins CO 80524. (907)224-1010. Website: www.c4fap.org/workshops_intro.asp. Cost: varies depending on workshop, $10-195. Offers workshops and forums by photographers who have skills in the subject they present, including Photoshop; photography basics with film and digital; studio lighting. Open to all skill levels. Photographers should write, call, see website for more information.

CENTER FOR PHOTOGRAPHY AT WOODSTOCK

59 Tinker St., Woodstock NY 12498. (845)679-9957. Fax: (845)679-6337. E-mail: info@cpw.org. Website: www.cpw.org. **Contact**: Ariel Shanberg, executive director. A not-for-profit arts and education organization dedicated to contemporary creative photography, founded in 1977. Programs in education, exhibition, publication, and services for artists. This includes

year-round exhibitions, summer/fall Woodstock Photography Workshop and Lecture Series, artist residencies, PHOTOGRAPHY Quarterly magazine, annual call for entries, permanent print collection, slide registry, library, darkroom, fellowship, membership, portfolio review, film/video screenings, internships, gallery talks and more.

⊕ CATHY CHURCH PERSONAL UNDERWATER PHOTOGRAPHY COURSES

P.O. Box 479, Grand Cayman, KY1-1106 Cayman Islands. (345)949-7415. Fax: (345)949-9770. E-mail: cathy@cathychurch.com. Website: www.cathychurch.com. **Contact:** Cathy Church. Cost: $125/hour. Hotel/dive package available at Sunset House Hotel. Private and group lessons available for all levels throughout the year; classroom and shore diving can be arranged. Lessons available for professional photographers expanding to underwater work. Photographers should e-mail for more information.

CLICKERS & FLICKERS PHOTOGRAPHY NETWORK—LECTURES & WORKSHOPS

P.O. Box 6094, Malibu CA 90264-6094 and P.O. Box 60508, Pasadena CA 91116-6508. (626)794-7447. E-mail: photographer@ClickersAndFlickers.com. Website: www.ClickersAndFlickers. com. **Contact:** Dawn Stevens, organizer. Estab. 1985. Cost: depends on particular event. Monthly networking dinners with outstanding guest speakers (many award winners, including the Pulitzer Prize), events and free activities for members. "Clickers & Flickers Photography Network, Inc., was created to provide people with an interest and passion for photography (cinematography, filmmaking, image making) the opportunity to meet others with similar interests for networking and camaraderie. It creates an environment in which photography issues, styles, techniques, enjoyment and appreciation can be discussed and viewed as well as experienced with people from many fields and levels of expertise (beginners, students, amateur, hobbyist, or professionals, gallery owners and museum curators). We publish a bimonthly color magazine listing thousands of activities for photographers and lovers of images." Most of its content is not on our website for a reason. Membership and magazine subscriptions help support this organization. Clickers & Flickers Photography Network, Inc., is a 21-year-old professional photography network association that promotes information and offers promotional marketing opportunities for photographers, cinematographers, individuals, organizations, businesses, and events. "C&F also provides referrals for photographers. Our membership includes photographers, videographers, and cinematographers who are skilled in the following types of photography: outdoor and nature, wedding, headshots, fine art, sports, events, products, news, glamour, fashion, macro, commercial, landscape, advertising, architectural, wildlife, candid, photojournalism, marquis gothic—fetish, aerial and underwater; using the following types of equipment: motion picture cameras (Imax, 70mm, 65mm, 35mm, 16mm, 8mm), steadicam systems, video, high-definition, digital, still photography—large format, medium format and 35mm." Open to all skill levels. Photographers should call or e-mail for more information.

COMMUNITY DARKROOM

713 Monroe Ave., Rochester NY 14607. (585)271-5920. E-mail: darkroom@geneseearts.

org. Website: www.geneseearts.org. **Contact:** Sharon Turner, director. Associate Director: Marianne Pojman and Karlie Cary Lanni, program assistant. Costs $65-210, depending on type and length of class. "We offer 30 different photography and digital classes for all ages on a quarterly basis utilizing digital and vintage processes. Classes include 35mm and digital camera techniques; black & white darkroom techniques; composition; studio lighting and available light; Photoshop, Dreamweaver, InDesign, and Illustrator; wet plate collodion, cyanotype, salt printing, liquid emulsion, and gum biochromate, and many special topics including nature, sports, architecture, night photography, photojournalism, and portraiture." Gallery Hours: Monday 9 a.m - 9:30 p.m; Tuesday-Thursday 9 am - 6:30 p.m; Friday closed; Saturday 10 a.m - 5:30 p.m; Sunday 11 a.m - 3:30 p.m.

THE CORPORATION OF YADDO RESIDENCIES

P.O. Box 395, Saratoga Springs NY 12866-0395. (518)584-0746. Fax: (518)584-1312. E-mail: chwait@yaddo.org. Website: www.yaddo.org. **Contact:** Candace Wait, program director. No fee; room, board, and studio space are provided. Deadlines to apply are January 1 and August 1—residencies are offered year round. Yaddo is a working artists' community on a 400-acre estate in Saratoga Springs, New York. It offers residencies of 2 weeks to 2 months to creative artists in a variety of fields. The mission of Yaddo is to encourage artists to challenge themselves by offering a supportive environment and good working conditions. Open to advanced photographers. Photographers should write, send SASE (63¢ postage), call or e-mail for more information.

THE CORTONA CENTER OF PHOTOGRAPHY, ITALY

665 Cooledge Ave. N.E., Atlanta GA 30306 or Vicolo del Fosso 9, 52044 Cortona (AR) Italy. (404)872-3264. Email: allen@cortonacenter.com. Website: www.cortonacenter.com. **Contact**: Allen Matthews, director. Robin Davis and Allen Matthews lead a personal, small-group photography workshop in the ancient city of Cortona, Italy, centrally located in Tuscany, once the heart of the Renaissance. Dramatic landscapes; Etruscan relics; Roman, Medieval and Renaissance architecture; and the wonderful and photogenic people of Tuscany await. Photographers should write, e-mail or see website for more information.

CORY PHOTOGRAPHY WORKSHOPS

P.O. Box 42, Signal Mountain TN 37377. (423)886-1004. E-mail: tompatcory@aol.com. Website: www.tomandpatcory.com. **Contact:** Tom or Pat Cory. Small workshops/field trips (8-12 maximum participants) with some formal instruction, but mostly one-on-one instruction in the field. "Since we tailor this instruction to each individual's interests, our workshops are suitable for all experience levels. Participants are welcome to use film or digital cameras or even video. Our emphasis is on nature and travel photography. We spend the majority of our time in the field, exploring our location. Cost and length vary by workshop. Many of our workshop fees include single-occupancy lodging, and some also include home-cooked meals and snacks. We offer special prices for 2 people sharing the same room, and, in some cases, special non-participant prices. Workshop locations vary from year to year but include the Eastern Sierra of California, Colorado and Arches National Park, Olympic National Park, Acadia National Park, the Upper Peninsula of Michigan, Death Valley National Park, Smoky Mountain National Park, and Glacier National Park. We offer

international workshops in Ireland, Scotland, Provence, Brittany, Tuscany, New Zealand, Newfoundland, Wales, Iceland, Morocco, Costa Rica and Panama. We also offer a number of short workshops throughout the year in and around Chattanooga, Tennessee—individual instruction and custom-designed workshops for groups." Photographers should write, call, e-mail or see website for more information.

CREALDE SCHOOL OF ART

600 St. Andrews Blvd., Winter Park FL 32792. (407)671-1886. Website: www.crealde.org. **Contact:** Peter Schreyer, executive director. Director of Photography: Rick Lang. Cost: Membership fee begins at $35/individual. Offers classes covering traditional and digital photography; b&w darkroom techniques; landscape, portrait, documentary, travel, wildlife and abstract photography; and educational tours.

CREATIVE ARTS WORKSHOP

80 Audubon St., New Haven CT 06511. (203)562-4927. E-mail: hshapiro8@aol.com. Website: www.creativeartsworkshop.org. **Contact**: Harold Shapiro, photography department head. Offers exciting classes and advanced workshops. Digital and traditions, b&w darkroom.

⚜ 🖼 DAWSON COLLEGE CENTRE FOR TRAINING AND DEVLOPMENT

4001 de Maisonneuve Blvd. W., Suite 2G.1, Montreal QC H3Z 3G4 Canada. (514)933-0047. Fax: (514)937-3832. E-mail: ctd@dawsoncollege.qc.ca. Website: www.dawsoncollege.qc.ca/ctd. **Contact**: Roula Koutsoumbas. Cost: $90-595. Workshop subjects include imaging arts and technologies, computer animation, photography, digital imaging, desktop publishing, multimedia, and web publishing and design.

THE JULIA DEAN PHOTO WORKSHOPS

801 Ocean Front Walk, Studio 8, Venice CA 90291. (310)392-0909. Fax: (310)664-0809. E-mail: workshops@juliadean.com. Website: www.juliadean.com. **Contact:** Brandon Gannon, general manager. The Julia Dean Photo Workshops (JDPW) is a practical education school of photography devoted to advancing the skills and increasing the personal enrichment of photographers of all experience levels and ages. Photography workshops of all kinds held throughout the year, including alternative and fine art, photography & digital camera fundamentals, lighting & portraiture, specialized photography, Photoshop and printing, photo safaris, and travel workshops. Open to all skill levels. Photographers should call, e-mail or see website for more information.

CYNTHIA DELANEY PHOTO WORKSHOPS

168 Maple St., Elko NV 89801. (775)753-5833. E-mail: cynthia@cynthiadelaney.com. Website: www.cynthiadelaney.com.

DIGITAL WILDLIFE PHOTOGRAPHY FIELD SCHOOL

P.O. Box 236, South Wellfleet MA 02663. (508)349-2615. E-mail: mlowe@massaudubon.org. **Contact:** Melissa Lowe, program coordinator. Cost: $325-350. Four-day course on Cape Cod focusing on wildlife photography using digital technology. Course covers fundamentals of

shooting wildlife in a natural setting and an introduction to editing images using photoshop. Taught by Shawn Carey and Eric Smith. Sponsored by Massachusetts Audubon Society.

ELOQUENT LIGHT PHOTOGRAPHY WORKSHOPS

W. Alameda Street, No. 115, Santa Fe, NM 87501. (505) 983-2934. E-mail: cindylane@ eloquentlight.com. Website: www.eloquentlight.com. **Contact**: Cindy Lane, managing director. "While our name is new, we have been offering photography workshops in the southwest for over 22 years. What was once the prestigious New Mexico Photography Field School has become the exciting new Eloquent Light Photography Workshops. We absolutely know the southwest. We know how to guide you to the best locations - to capture that special atmosphere at just the right moment. We're experts and enjoy sharing our passion for making photographs. We offer small groups with lots of individual attention. A photography workshop should be about helping you become a better photographer and helping you make great photographs. It should be about you and how photography fits into your world." Executive director, instructor and working fine art photographer Craig Varjabedian has been teaching photography for over 25 years. His photographs are known for their interpretation of light and place in the Southwest. His works are widely exhibited and collected.

JOE ENGLANDER PHOTOGRAPHY WORKSHOPS & TOURS

P.O. Box 1261, Manchaca TX 78652. (512)922-8686. E-mail: info@englander-workshops. com. Website: www.englander-workshops.com. **Contact:** Joe Englander. Cost: $275-8,000. Instruction in beautiful locations throughout the world, all formats and media, color/b&w/ digital, photoshop instruction. Locations include Europe, Asia with special emphasis on Bhutan and the Himalayas and the US. See website for more information.

EUROPA PHOTOGENICA PHOTO TOURS TO EUROPE

(formerly France Photogenique/Europa Photogenica Photo Tours to Europe), 3920 W. 231st Place, Torrance CA 90505. Phone/fax: (310)378-2821. E-mail: FraPhoto@aol.com. Website: www.europaphotogenica.com. **Contact:** Barbara Van Zanten-Stolarski, owner. Cost: $2,700-3,900; includes some meals, transportation, hotel accommodation. Tuition provided for beginners/intermediate and advanced level. Workshops held in spring (3-5) and fall (1-3). Five- to 11-day photo tours of the most beautiful regions of Europe. Shoot landscapes, villages, churches, cathedrals, vineyards, outdoor markets, cafes and people in Paris, Provence, southwest France, England, Italy, Greece, etc. Tours change every year. Open to all skill levels. Photographers should call or e-mail for more information.

EXPOSURE36 PHOTOGRAPHY

805 SE 17th Place, Portland OR 97233. (866)368-6736. E-mail: info@exposure36.com. Website: www.exposure36.com.Cost: varies, depending on workshop. Open to all skill levels. Workshops offered at prime locations in the U.S. and Canada, including Yosemite, Smoky Mountains, Bryce Canyon, the Oregon coast. Also offers classes on the basics of photography in Portland, Oregon (through the Experimental College or Mt. Hood Community College) and Seattle, Washington (through the Experimental College of the University of Washington). Photographers should write, call, e-mail, see website for more information.

FINDING & KEEPING CLIENTS

2973 Harbor Blvd., Suite 341, Costa Mesa CA 92626-3912. Phone/fax: (888)713-0705. E-mail: maria@mpiscopo.com. Website: www.mpiscopo.com. **Contact:** Maria Piscopo, instructor. "How to find new photo assignment clients and get paid what you're worth! See website for schedule or send query via e-mail." Maria Piscopo is the author of The Photographer's Guide to Marketing & Self Promotion, 3rd edition (Allworth Press).

FINE ARTS WORK CENTER

24 Pearl St., Provincetown MA 02657. (508)487-9960, ext. 103. Fax: (508)487-8873. E-mail: general@fawc.org. Website: www.fawc.org. **Contact:** Dorothy Antczak, summer program director. Cost: $700/week, $625/week (housing). Faculty includes Constantine Manos, David Graham, Amy Arbus, Marian Roth, Gabe Greenburg, Joanne Dugan, David Hilliard, and Connie Imboden. Write, call or e-mail for more information.

FIRST LIGHT PHOTOGRAPHIC WORKSHOPS AND SAFARIS

10 Roslyn St., Islip Terrace NY 11752. (631)581-0400. Website: www.firstlightphotography. com. **Contact**: Bill Rudock, president. Photo workshops and photo safaris for all skill levels held on Long Island, NY, and specializing in national parks, domestic and international; also presents workshops for portrait and wedding photographers.

FIRST LIGHT PHOTOGRAPHY WORKSHOP TOURS

P.O. Box 6921, Tyler TX 75711. (903)526-5466. E-mail: andy@firstlighttours.com. Website: www.firstlighttours.com. **Contact:** Andy Long, owner. Cost: $1,095-4,395, depending on tour; hotels, meals and ground transportation included. Tours are held in a variety of locations, including Penguins of Falkland Islands, Tasmania, Oregon coast, southwest Alaska, Alaskan northern lights, Florida, south Texas birds, Glacier National Park, historic Taos and Santa Fe, Bosque del Apache Wildlife Preserve, and more. See website for more information on locations, dates and prices. Open to all skill levels. Photographers should call, e-mail, see website for more information.

FOCUS ADVENTURES

P.O. Box 771640, Steamboat Springs CO 80477. (970)879-2244. E-mail: karen@ focusadventures.com. Website: www.focusadventures.com. **Contact**: Karen Gordon Schulman, owner. Photo workshops and tours emphasize photography and the creative spirit and self-discovery through photography. Summer photo workshops in Steamboat Springs, Colorado. Other workshops offered at Focus Ranch, a private guest ranch in NW Colorado. Customized private and small-group lessons available year-round. International photo tours run with Strabo Tours to various destinations including Ecuador, Bali, Morocco, and Western Ireland.

FOTOFUSION

415 Clematis Street, West Palm Beach FL 33401. (561)276-9797. E-mail: cs@workshop.org Website: www.fotofusion.org. **Contact:** Fatima NeJame, CEO. America's foremost festival of photography and digital imaging is held each January. Learn from more than 90 master photographers, picture editors, picture agencies, gallery directors, and technical experts,

over 5 days of field trips, seminars, lectures and Adobe Photoshop workshops. January 19-23, 2009. Open to all skill levels, interested in nature, landscape, documentary, portraiture, photojournalism, digital, fine art, commercial, etc. Photographers should write, call or e-mail for more information.

GALAPAGOS TRAVEL

783 Rio Del Mar Blvd., Suite 49, Aptos CA 95003. (800)969-9014. E-mail: info@galapagostravel.com. Website: www.galapagostravel.com. Cost: $4,500 plus fuel surcharges; includes lodging and most meals. Landscape and wildlife photography tour of the islands with an emphasis on natural history. Three nights in a first-class hotel in Quito, Ecuador, and 11 or 14 nights aboard a yacht in the Galápagos. See website for more information.

☒ ANDRE GALLANT/FREEMAN PATTERSON PHOTO WORKSHOPS

Shampers Bluff NB Canada. (506)763-2189. E-mail: freepatt@nbnet.nb.ca. Website: www.freemanpatterson.com. Cost: $1900 plus13% HST (Canadian) for 6-day course including accommodations and meals. All workshops are for anybody interested in photography and visual design, from the novice to the experienced amateur or professional. "Our experience has consistently been that a mixed group functions best and learns the most."

GERLACH NATURE PHOTOGRAPHY WORKSHOPS & TOURS

P.O. Box 642, Ashton ID 83420. (208)652-4444. E-mail: michele@gerlachnaturephoto.com. Website: www.gerlachnaturephoto.com. **Contact**: Michele Smith, office manager. Costs vary. Professional nature photographers John and Barbara Gerlach conduct intensive field workshops in the beautiful Upper Peninsula of Michigan in August and during October's fall color period. They lead a photo safari to the best game parks in Kenya during late-August/early-September every year. They also lead winter, summer and fall photo tours of Yellowstone National Park and conduct high-speed flash hummingbird photo workshops in British Columbia in late May. Barbara and John work for an outfitter a couple weeks a year leading photo tours into Yellowstone Back Country with the use of horses. This is a wonderful way to experience Yellowstone. Photographers should see website for more information.

GLOBAL PRESERVATION PROJECTS

P.O. Box 30866, Santa Barbara CA 93130. (805)682-3398 or (805)455-2790. E-mail: TIMorse@aol.com. Website: www.GlobalPreservationProjects.com. **Contact:** Thomas I. Morse, director. Offers photographic workshops and expeditions promoting the preservation of environmental and historic treasures. Produces international photographic exhibitions and publications. GPP workshops include the ghost town of Bodie, CA; Digital Basics for Photographers held in Santa Barbara, CA; expeditions to Arches and Canyonlands; Durango Fall and Winter, Big Sur; Slot Canyons; White Sands; Death Valley and other places. GPP uses a 34-ft. motor home with state-of-the art digital imaging and printer systems for participants use. Photographers should call, e-mail or see website for more information.

GOLDEN GATE SCHOOL OF PROFESSIONAL PHOTOGRAPHY

P.O. Box F, San Mateo CA 94402-0018. (650)367-1265. E-mail: goldengateschool@yahoo.

com. Website: www.goldengateschool.org. **Contact:** Martha Bruce, director. Offers 1-3 day workshops in traditional and digital photography for professional and aspiring photographers in the San Francisco Bay Area.

ROB GOLDMAN CREATIVE WORKSHOPS

55 West Main St., Oyster Bay NY 11771. (631)424-1650. Fax: (631)424-1650. E-mail: rob@rgoldman.com. Website: www.rgoldman.com. **Contact**: Rob Goldman, photographer. Cost varies depending on type and length of workshop. 1-on-1 customized photography lessons for all levels, plus intensive workshops held 2-3 times/year. Purpose is artistic and personal growth for photographers. Open to all skill levels. Photographers should call or e-mail for more information.

HALLMARK INSTITUTE OF PHOTOGRAPHY

P.O. Box 308, Turners Falls MA 01376. (413)863-2478. E-mail: info@hallmark.edu. Website: www.hallmark.edu. **Contact:** George J. Rosa III, president. Director of Admissions: Lindsay O'Neil. Tuition: $49,600. Offers an intensive 10-month resident program teaching the technical, artistic and business aspects of traditional and digital professional photography for the career-minded individual.

JOHN HART PORTRAIT SEMINARS

344 W. 72nd St., New York NY 10023. (212)873-6585. E-mail: johnhartstudio1@mac.com; johnharth@aol.com. Website: www.johnhartpics.com. One-on-one advanced portraiture seminars covering lighting and other techniques. John Hart is a New York University faculty member and author of 50 Portrait Lighting Techniques, Professional Headshots, Lighting For Action and Art of the Storyboard.

HAWAII PHOTO SEMINARS

Changing Image Workshops, P.O. Box 280, Kualapuu, Molokai HI 96757. (808)567-6430. E-mail: hui@aloha.net. Website: www.huiho.org. **Contact:** Rik Cooke. Cost: $2,150; includes lodging, meals and ground transportation. Seven-day landscape photography workshop for beginners to advanced photographers. Workshops taught by 2 National Geographic photographers.

HAWAII PHOTO TOURS, POLAROID, FUJI & DIGITAL TRANSFERS, DIGITAL INFRARED, DIGITAL PHOTOGRAPHY, PHOTOSHOP WORKSHOPS & PRIVATE TOURS AND SESSIONS

P.O. Box 335, Honaunau HI 96726. (808)328-2162. E-mail: kcarr@kathleencarr.com. Website: www.kathleencarr.com. **Contact:** Kathleen T. Carr. Cost: $85-100/day plus $30 for materials. Carr, author of Polaroid Transfers and Polaroid Manipulations: A Complete Visual Guide to Creating SX-70, Transfer and Digital Prints (Amphoto Books), and To Honor the Earth, offers her expertise on the subjects for photographers of all skill levels. Programs last 1-7 days in various locations in Hawaii, California, Montana and other locales.

HEART OF NATURE PHOTOGRAPHY WORKSHOPS

P.O. Box 1214, Volcano HI 96785. (808)345-7179. E-mail: info@heartofnature.net. Website:

www.heartofnature.net. **Contact**: Robert Frutos or Jenny Thompson. Cost: $345-2,695, depending on workshop/tours. "Photograph nature in the magnificent wonder of Hawaii, capture compelling and dynamic images that convey the beauty and spirit of the islands." Photographers should call or see website for more information.

HORIZONS: ARTISTIC TRAVEL

P.O. Box 634, Leverett MA 01054. (413)367-9200. Fax: (413)367-9522. E-mail: horizons@ horizons-art.com. Website: www.horizons-art.com. **Contact:** Jane Sinauer, director. One-of-a-kind small-group travel adventures: 1- and 2-week programs in the American Southwest, Italy, Amsterdam, Prague, Scandinavia, Mexico, Ecuador, Laos, Vietnam, Cambodia, Southern Africa, Northern India.

INFINITY WORKSHOPS

P.O. Box 27555, Seattle WA 98165. (206)367-6864. Fax: (206)367-8102. E-mail: mark@ infinityworkshops.com. Website: www.infinityworkshops.com. **Contact:** Mark Griffith, director. Cost: $850. Lodging and food are not included in any workshop fee. Location workshops on the Oregon coast and Southern Utah. Open to all digital and film users, color or black and white. Call, e-mail, or see website for information.

IN FOCUS WITH MICHELE BURGESS

20741 Catamaran Lane, Huntington Beach CA 92646. (714)536-6104. E-mail: maburg5820@ aol.com. Website: www.infocustravel.com. **Contact:** Michele Burgess, president. Cost: $4,500-8,000. Offers overseas tours to photogenic areas with expert photography consultation at a leisurely pace and in small groups (maximum group size: 20).

INTERNATIONAL CENTER OF PHOTOGRAPHY

1114 Avenue of the Americas, New York NY 10036. (212)857-0001. Email: education@ icp.org. Website: www.icp.org. **Contact:** Donna Ruskin, education associate. "The cost of our weekend workshops range from $255 to $720 plus registration and lab fees. Our 5- and 10-week courses range from $360 to $770 plus registration and lab fees." ICP offers photography courses, lectures and workshops for all levels of experience—from intensive beginner classes to rigorous professional workshops.

INTERNATIONAL EXPEDITIONS

One Environs Park, Helena AL 35080. (800)633-4734 (US/Canada); (205)428-1700 (worldwide). Fax: (205)428-1714. E-mail: nature@ietravel.com. Website: www.ietravel. com. **Contact:** Ralph Hammelbacher, president. Cost: $1,800-$4,898; includes scheduled transportation during expeditions unless otherwise specified; services of experienced English-speaking local guides; all accommodations; meals as specified in the respective itineraries; transfer and luggage handling when taking group flights. Guided nature expeditions all over the world: Costa Rica, Machu Picchu, Galapagos, Kenya, Patagonia and many more. Open to all skill levels. Photographers should write, call, e-mail, see website for more information.

JIVIDEN'S "NATURALLY WILD" PHOTO ADVENTURES

P.O. Box 333, Chillicothe OH 45601. (800)866-8655 or (740)774-6243. E-mail: mail@ naturallywhild.net. Website: www.naturallywild.net. **Contact:** Jerry or Barbara Jividen. Cost: $149 and up depending on length and location. Workshops held throughout the year; please inquire. All workshops and photo tours feature comprehensive instruction, technical advice, pro tips and hands-on photography. Many workshops include lodging, meals, ground transportation, special permits and special guest rates. Group sizes are small for more personal assistance and are normally led by 2 photography guides/certified instructors. Subject emphasis is on photographing nature, wildlife and natural history. Supporting emphasis is on proper techniques, composition, exposure, lens and accessory use. Workshops range from 1-7 days in a variety of diverse North American locations. Open to all skill levels. Free information available upon request. Free quarterly journal by e-mail upon request. Photographers should write, call or e-mail for more information.

WELDON LEE'S ROCKY MOUNTAIN PHOTO ADVENTURES

P.O. Box 487, Allenspark CO 80510-0487. Phone/fax: (303)747-2074. E-mail: wlee@ RockyMountainPhotoAdventures.com. Website: www.RockyMountainPhotoAdventures. com. **Contact:** Weldon Lee. Cost: $695-5,995; includes transportation and lodging. Workshops held monthly year round. Wildlife and landscape photography workshops featuring hands-on instruction with an emphasis on exposure, composition, and digital imaging. Participants are invited to bring a selection of images to be critiqued during the workshops. Photographers should write, call or e-mail for more information.

LEPP INSTITUTE OF DIGITAL IMAGING

1062 Los Osos Valley Rd., Los Osos CA 93402. (805)528-7385. Fax: (805)528-7387. E-mail: info@LeppPhoto.com. Website: www.LeppPhoto.com. **Contact**: Mary Sylvester, registrar. Offers small groups. "New focus on digital tools to optimize photography, make the most of your images and improve your photography skills at the premier digital imaging school on the West Coast."

◩ LLEWELLYN PHOTOGRAPHY WORKSHOPS & FIELD TOURS, PETER

645 Rollo Road, Gabriola BC VOR 1X3 Canada. (250)247-9109. E-mail: peter@peterllewellyn. com. Website: www.peterllewellyn.com. **Contact**: Peter Llewellyn. Cost varies. "All workshops and field trips feature small groups, maximum 6 for workshops and 12 for field trips to allow maximum personal attention. Workshops include basic Photoshop skills, digital photography and digital workflow. Field trips are designed to provide maximum photographic opportunities to participants with the assistance of a professional photographer. Trips include several South American destinations, including Brazil, Guatemala, and Peru, and various venues in Canada and U.S." Open to all skill levels. For further information, e-mail or see Web site.

C.C. LOCKWOOD WILDLIFE PHOTOGRAPHY WORKSHOP

P.O. Box 14876, Baton Rouge LA 70898. (225)769-4766. Fax: (225)767-3726. E-mail: cactusclyd@aol.com. Website: www.cclockwood.com. **Contact:** C.C. Lockwood, photographer. Cost: Lake Martin Spoonbill Rookery, $800; Atchafalaya Swamp, $290;

Yellowstone, $3,775; Grand Canyon, $2,450. Workshop at Lake Martin is 3 days plus side trip into Atchafalaya, February and April. Each April and October, C.C. conducts a 2-day Atchafalaya Basin Swamp Wildlife Workshop. It includes lecture, canoe trip into the swamp, and critique session. Every other year, C.C. does a 7-day winter wildlife workshop in August. Eagle Expo is a lecture and 1/2 day field trip to see nesting bald eagles. "At Lake Clark we work on Brown Bears and Landscapes around the Lake Clark and Katmai areas."

THE MACDOWELL COLONY

100 High St., Peterborough NH 03458. (603)924-3886. Fax: (603)924-9142. E-mail: admissions@macdowellcolony.org. Website: www.macdowellcolony.org. Founded in 1907 to provide creative artists with uninterrupted time and seclusion to work and enjoy the experience of living in a community of gifted artists. Residencies of up to 8 weeks for writers, playwrights, composers, film/video makers, visual artists, architects and interdisciplinary artists. Artists in residence receive room, board and exclusive use of a studio. Average length of residency is 5 weeks. Ability to pay for residency is not a factor. There are no residency fees. Limited funds available for travel reimbursement and artist grants based on need. Application deadlines: January 15: summer (June-September); April 15: fall/winter (October-January); September 15: winter/spring (February-May). Photographers should see website for application and guidelines. Questions should be directed to the admissions director.

MAINE MEDIA WORKSHOPS

(877)577-7700 or (207)236-8581. Fax: (207)236-2558. E-mail: info@TheWorkshops.com. Website: www.TheWorkshops.com. For over 34 years this international school has been offering hundreds of one- and two- week workshops for photographers, filmmakers, and media artists in Rockport, Maine. Programs are available for working professionals, serious amateurs, and high school and college students. Destination workshop locations include Venice, Paris, Rome, Istanbul, Greece, and India. Professional Certificate and MFA programs are also available through Maine Media College (www.mainemedia.edu).

WILLIAM MANNING PHOTOGRAPHY

6396 Birchdale Court, Cincinnati OH 45230. (513)624-8148. E-mail: william@williammanning.com. Website: www.williammanning.com. **Contact:** William Manning, director. Cost: $1,200-4,000. Digital photography workshops worldwide with emphasis on travel, nature, and architecture. Offers small group tours. Four programs worldwide, with emphasis on landscapes, wildlife and culture. Please see website for locations and fees.

JOE & MARY ANN MCDONALD WILDLIFE PHOTOGRAPHY WORKSHOPS AND TOURS

73 Loht Rd., McClure PA 17841-9340. (717)543-6423. Fax: (717)543-6423. E-mail: info@hoothollow.com. Website: www.hoothollow.com. **Contact**: Joe McDonald, owner. Cost: $1,200-8,500. Offers small groups, quality instruction with emphasis on nature and wildlife photography.

MEXICO PHOTOGRAPHY WORKSHOPS

Otter Creek Photography, Hendricks WV 26271. (304)478-3586. E-mail: OtterCreekPhotography@yahoo.com. **Contact:** John Warner, instructor. Cost: $1,400. Intensive weeklong, hands-on workshops held throughout the year in the most visually rich regions of Mexico. Photograph snow-capped volcanoes, thundering waterfalls, pre-Columbian ruins, botanical gardens, fascinating people, markets and colonial churches in jungle, mountain, desert and alpine environments.

MID-ATLANTIC REGIONAL SCHOOL OF PHOTOGRAPHY

666 Franklin Ave., Nutley NJ 07110. (888)267-MARS (6277). E-mail: marschool@nac.net. Website: www.photoschools.com. Contact: Jim Bastinck, director. Cost: $985; includes lodging and most meals. Annual 5-day workshop covering many aspects of professional photography from digital to portrait to wedding. Open to photographers of all skill levels.

MIDWEST PHOTOGRAPHIC WORKSHOPS

28830 W. Eight Mile Rd., Farmington Hills MI 48336. (248)471-7299. E-mail: bryce@mpw. com. Website: www.mpw.com. **Contact:** Bryce Denison, owner. Cost: varies per workshop. "One-day weekend and weeklong photo workshops, small group sizes and hands-on shooting seminars by professional photographers/instructors on topics such as portraiture, landscapes, nudes, digital, nature, weddings, product advertising and photojournalism. We offer Landscape/nature workshops to Italy, Alaska, Maine, Florida, California, and Canada."

MISSOURI PHOTOJOURNALISM WORKSHOP

109 Lee Hills Hall, Columbia MO 65211. (573)882-4882. Fax: (573)884-4999. E-mail: reesd@missouri.edu. Website: www.mophotoworkshop.org. **Contact:** photojournalism department. Cost: $600. Workshop for photojournalists. Participants learn the fundamentals of documentary photo research, shooting, and editing. Held in a different Missouri town each year, the last week of September.

MOUNTAIN WORKSHOPS

Western Kentucky University, 1906 College Heights Blvd., 11070, Bowling Green KY 42101-1070. (270)745-8927. E-mail: mountainworkshops@wku.edu. Website: www. mountainworkshops.org. **Contact:** Jim Bye, workshops coordinator. Cost: Photojournalism and Picture editing: $595 plus expenses, Multimedia: $750 plus expenses. Annual documentary photojournalism workshop held in October. Open to intermediate and advanced shooters.

NATURAL HABITAT ADVENTURES

P.O. Box 3065, Boulder CO 80307. (800)543-8917. E-mail: info@nathab.com. Website: www.nathab.com. Cost: $2,195-20,000; includes lodging, meals, ground transportation and expert expedition leaders. Guided photo tours for wildlife photographers. Tours last 5-27 days. Destinations include North America, Latin America, Canada, the Arctic, Galápagos Islands, Africa, the Pacific and Antarctica.

Workshops

NATURAL TAPESTRIES

1208 State Rt. 18, Aliquippa PA 15001. (724)495-7493. E-mail: nancyrotenberg@aol.com or kris@naturaltapestries.com. Website: www.naturaltapestries.com. **Contact:** Nancy Rotenberg, owner. Cost: varies by workshop. Workshops for 2010 will be held in Mexico, Tanzania, Baja, Skagit Valley, Costa Rica, St. Augustine, Blue Ridge Mountains, Oregon Coast, Crested Butte, New Hampshire, and India. Open to all skill levels. Photographers should e-mail or check website for more information.

NEVERSINK PHOTO WORKSHOP

P.O. Box 641, Woodbourne NY 12788. (212)929-0009 or (845)434-0575. E-mail: lou@loujawitz.com. Website: www.loujawitz.com/neversink.html. **Contact:** Louis Jawitz, owner. Offers weekend workshops in digital and film, teaching scenic, travel, location and stock photography during the last 2 weeks of August in the Catskill Mountains. See website for more information.

NEW JERSEY HERITAGE PHOTOGRAPHY WORKSHOPS

124 Diamond Hill Rd., Berkeley Heights NJ 07922. (908)790-8820. Fax: (908)790-0074. E-mail: nancyori@comcast.net. Website: www.nancyoriphotography.com. **Contact:** Nancy Ori, director. Estab. 1990. Cost: $295-450. Workshops held every spring. Nancy Ori, well-known instructor, freelance photographer and fine art exhibitor of landscape and architecture photography, teaches how to use available light and proper metering techniques to document the man-made and natural environments of Cape May. A variety of film and digital workshops taught by guest instructors are available each year and are open to all skill levels, especially beginners. Topics include hand coloring of photographs, creative camera techniques with Polaroid materials, intermediate and advanced digital, landscape and architecture with alternative cameras, environmental portraits with lighting techniques, street photography; as well as pastel, watercolor and oil painting workshops. All workshops include an historic walking tour of town, location shooting or painting, demonstrations and critiques. Scholarships available annually.

NEW JERSEY MEDIA CENTER LLC WORKSHOPS AND PRIVATE TUTORING

124 Diamond Hill Rd., Berkeley Heights NJ 07922. (908)790-8820. Fax: (908)790-0074. E-mail: nancyori@comcast.net. Website: www.nancyoriworkshops.com. **Contact:** Nancy Ori, director. **1. Tuscany Photography Workshop** by Nancy Ori. Explore the Tuscan countryside, cities and small villages, with emphasis on architecture, documentary, portrait and landscape photography. The group will venture in non-tourist areas. Cost: call for this year's price; includes tuition, accommodations at a private estate, breakfasts and some dinners. Open to all skill levels. Held September 13-20, 2008. **2. Private Photography and Darkroom Tutoring** with Nancy Ori in Berkeley Heights, New Jersey. This unique and personalized approach to learning photography is designed for the beginning or intermediate student who wants to expand his/her understanding of the craft and work more creatively with the camera, develop a portfolio, create an exhibit or learn darkroom techniques. The goal is to refine individual style while exploring the skills necessary to make expressive photographs. The content will be tailored to individual needs and interests. Cost: $350 for a

total of 8 hours; $450 for the darkroom sessions. **3. Capturing the Light of the Southwest**, a painting, sketching and photography workshop with Nancy Ori and a different painting instructor each year, held every other year in October, will focus on the natural landscape and man-made structures of the area around Santa Fe and Taos. Participants can be at any level in their media. All will be encouraged to produce a substantial body of work worthy of portfolio or gallery presentation. Features special evening guest lecturers from the photography and painting community in the Santa Fe area. Artists should e-mail for more information. **4. Cape May Photography Workshops** are held annually in April and May. Also, a variety of subjects such as photojournalism, environmental portraiture, landscape, alternative cameras, Polaroid techniques, creative digital techniques, on-location wedding photography, large-format, and how to photograph birds in the landscape are offered by several well-known East-Coast instructors. Open to all skill levels. Includes critiques, demonstrations, location shooting of Victorian architecture, gardens, seascapes, and, in some cases, models in either film or digital. E-mail for dates, fees and more information. Workshops are either 3 or 4 days. 5: **Costa Rica** in February 2011.

NIKON SCHOOL DIGITAL SLR PHOTOGRAPHY

1300 Walt Whitman Rd., Melville NY 11747. (631)547-8666. Fax: (631)547-0309. Website: www.nikonschool.com. Weekend seminars traveling to 30 major U.S. cities 9:30 am-4:30 pm; lunch is included; no camera equipment is required. Intro to Digital SLR Photography— Cost: $119; for those new to digital SLR photography or those coming back after many years away. Expect a good understanding of the basics of photography, terminology, techniques and solutions for specific challenges allowing you to unleash your creative potential. Next Steps—4159; for experienced digital SLR photographers and those comfortable with the basics of digital photography. This seminar will take your digital SLR photography to the next level.

NORTHERN EXPOSURES

4917 Evergreen Way #383, Everett WA 98203. (425)347-7650. Email: abenteuerbc@yahoo. com. **Contact**: Linda Moore, director. Cost: $450-1200 for 3- to 8-day workshops (U.S. and Canada); $200-450/day for tours in Canada. Offers 3- to 8-day intermediate to advanced nature photography workshops in several locations in Pacific Northwest and western Canada; spectacular settings including coast, alpine, badlands, desert and rain forest. Also, 1- to 2-week Canadian Wildlife and Wildlands Photo Adventures and nature photo tours to extraordinary remote wildlands of British Columbia, Alberta, Saskatchewan, and Yukon.

⊕ STEVE OUTRAM'S TRAVEL PHOTOGRAPHY WORKSHOPS

D. Katsifarakis St., Galatas, Chania 73100 Crete, Greece. E-mail: mail@steveoutram.com. Website: www.steveoutram.com. **Contact:** Steve Outram, workshop photographer. **Brazil:** 13 days every March and October. **Western Crete:** 9 days in the Venetian town of Chania, every May and October. **Lesvos:** 14 days on Greece's 3rd-largest island, every October. **Slovenia:** 11 days exploring the charming towns of Ljubjana and Piran, every June. **Zanzibar:** 14 days on this fascinating Indian Ocean island, every February and September. Learn how to take more than just picture postcard-type images on your travels. Workshops are limited to 8 people.

Workshops

PACIFIC NORTHWEST ART SCHOOL/PHOTOGRAPHY

15 NW Birch St., Coupeville WA 98239. (360)678-3396. Tollfree: (866)678-3396. E-mail: info@pacificnorthwestartsschool.org. Website: www.pacificnorthwestartsschool.org. **Contact:** Registrar. Cost: varies. Workshops are held on Whidbey Island and at various other locations. Topics are new and varied every year.

PALM BEACH PHOTOGRAPHIC CENTRE

415 Clematis St., West Palm Beach FL 33401. (561)276-9797. Fax: (561)276-1932. E-mail: cs@workshop.org. Website: www.workshop.org. **Contact:** Fatima NeJame, executive director. Cost: $75-1,100 depending on class. The center is an innovative learning facility offering 1- to 5-day seminars in photography and digital imaging year round. Also offered are travel workshops to cultural destinations such as South Africa, Bhutan, Myanmar, Peru, and India. Emphasis is on photographing the indigenous cultures of each country. Also hosts the annual Fotofusion event (see separate listing in this section). Photographers should call for details.

⊕ PAN HORAMA

Puskurinkatu 2, FIN-33730, Tampere Finland. Fax: 011-358-3-364-5382. Email: info@panhorama.net. Website: www.panhorama.net. **Contact:** Rainer K. Lampinen, chairman. Annual panorama photography workshops. International Panorama Photo Exhibition held annually in autumn in Finland and retrospective exhibitions abroad. Awards: Master of Panorama Art, opportunity to exhibit at Underground Photo Gallery (http://www.iisalmi.fi/?deptid+12149), other awards.

RALPH PAONESSA PHOTOGRAPHY WORKSHOPS

509 W. Ward Ave., Suite B-108, Ridgecrest CA 93555-2542. (800)527-3455. E-mail: ralph@rpphoto.com. Website: www.rpphoto.com. **Contact:** Ralph Paonessa, director. Cost: starting at $1,675; includes 1 week or more of lodging, meals and ground transport. Various workshops repeated annually. Nature, bird and landscape trips to Death Valley, Falkland Islands, Alaska, Costa Rica, Ecuador, and many other locations. Open to all skill levels. Photographers should write, call or e-mail for more information.

PETERS VALLEY CRAFT CENTER

19 Kuhn Rd., Layton NJ 07851. (973)948-5200. Fax: (973)948-0011. E-mail: photography@petersvalley.org. Website: www.petersvalley.org. Offers workshops May, June, July, August and September; 3-6 days long. Offers instruction by talented photographers in a wide range of photographic disciplines—from daguerrotypes to digital and everything in between. Also offers classes in blacksmithing/metals, ceramics, fibers, fine metals, weaving and woodworking. Located in northwest New Jersey in the Delaware Water Gap National Recreation Area, 70 miles west of New York City. Photographers should call for catalog or visit website or more information.

PHOTO CENTER NORTHWEST

900 12th Ave., Seattle WA 98122. (206)720-7222. E-mail: pcnw@pcnw.org. Website: www.pcnw.org. **Contact:** Annie Van Avery, executive director. Day and evening classes and

workshops in fine art photography (b&w, color, digital) for photographers of all skill levels; accredited certificate program.

PHOTO EXPLORER TOURS

2506 Country Village, Ann Arbor MI 48103-6500. (800)315-4462 or (734)996-1440. E-mail: decoxphoto@aol.com. Website: www.PhotoExplorerTours.com. **Contact:** Dennis Cox, director. Cost: $3,195; all-inclusive. Photographic explorations of China, southern Africa, India, Turkey, Burma, Iceland, Croatia, Bhutan, and Vietnam. "Founded in 1981 as China Photo Workshop Tours by award-winning travel photographer and China specialist Dennis Cox, Photo Explorer Tours has expanded its tours program since 1996. Working directly with carefully selected tour companies at each destination who understand the special needs of photographers, we keep our groups small, usually from 5 to 16 photographers, to ensure maximum flexibility for both planned and spontaneous photo opportunities." On most tours, individual instruction is available from professional photographer leading tour. Open to all skill levels. Photographers should write, call or e-mail for more information.

PHOTOGRAPHERS' FORMULARY

P.O. Box 950, 7079 Hwy. 83 N, Condon MT 59826-0950. (800)922-5255. Fax: (406)754-2896. E-mail: lynnw@blackfoot.net; formulary@blackfoot.net. Website: www.photoformulary. com. **Contact:** Lynn Wilson, workshops program director. Photographers' Formulary workshops include a wide variety of alternative processes, and many focus on the traditional darkroom. Located in Montana's Swan Valley, some of the best wilderness lands in the Rocky Mountains. See website for details on costs and lodging. Open to all skill levels.

PHOTOGRAPHIC ARTS CENTER

Fresh Meadows, Queens NY. Phone/Fax: (718)969-7924. E-mail: photocenter48@yahoo. com. **Contact:** Beatriz Arenas, president. Offers workshops on basics to advanced, b&w and color; Mac computers, Photoshop, Pagemaker, Canvas, CD recording and digital photography. Gives lessons in English and Spanish.

PHOTOGRAPHIC ARTS WORKSHOPS

Offers a wide range of workshops across the US, Latin America and Europe. Instructors include masters of both traditional and digital imagery. Workshops feature instruction in the understanding and use of light, composition, exposure, development, printing, photographic goals and philosophy. All workshops include reviews of student portfolios. Sessions are intense but highly enjoyable, held in field, darkroom and classroom with outstanding photographer/ instructors. Ratio of students to instructors is always 8:1 or fewer, with detailed attention to problems students want solved. All camera formats, color and b&w.

PHOTOGRAPHY AT THE SUMMIT: JACKSON HOLE

Rich Clarkson & Associates LLC, 1099 18th St., Suite 2840, Denver CO 80202. (303)295-7770 or (800)745-3211. E-mail: info@richclarkson.com. Website: www.photographyatthesummit. com. **Contact:** Brett Wilhelm, administrator. Annual workshops held in spring (May) and fall (October). Weeklong workshops with top journalistic, nature and illustrative photographers and editors. See website for more information.

⊕ PHOTOGRAPHY IN PROVENCE

La Chambre Claire, Rue du Buis, Ansouis 84240 France. E-mail: andrew.squires@ photography-provence.com. Website: www.photographie.-provence.com. **Contact:** Mr. Andrew Squires, M.A. Cost: €540-620; accommodations €255-315. Workshops May to October. Theme: What to Photograph and Why? Designed for people who are looking for a subject and an approach they can call their own. Explore photography of the real world, the universe of human imagination, or simply let yourself discover what touches you. Explore Provence and photograph on location. Possibility to extend your stay and explore Provence if arranged in advance. Open to all skill levels. Photographers should send SASE, call or e-mail for more information.

PHOTO WORKSHOPS BY COMMERCIAL PHOTOGRAPHER SEAN ARBABI

San Francisco Bay Area, California. Phone/fax: (925)855-8060. E-mail: workshops@ seanarbabi.com. Website: www.seanarbabi.com/workshops.html. **Contact:** Sean Arbabi, photographer/instructor. Cost: $85-3,000 for workshops only; some meals, lodging included - airfare and other services may be included, depending on workshop. Online and seasonal workshops held in spring, summer, fall, winter. Taught around the world via online, and in locations including Art Wolfe's Digital Photography Center, Betterphoto.com, PT Reyes Field Seminars, Santa Fe Photographic Workshops, as well as locations around the U.S. Sean Arbabi teaches through computer presentations, software demonstrations, slide shows, field shoots and hands-on instruction. All levels of workshops are offered from beginner to advanced; subjects include exposure, digital photography, composition, technical aspects of photography, lighting, fine-tuning your personal vision, utilizing equipment, a philosophical approach to the art, as well as how to run a photography business.

PRAGUE SUMMER SEMINARS

Metropolitan College, ED 118, University of New Orleans, 2000 Lakeshore Dr., New Orleans LA 70148. (504)280-7318. E-mail: prague@uno.edu. Website: http://inst.uno.edu/prague. **Contact:** Irene Ziegler, program coordinator. Cost: $3,795; includes lodging. Challenging seminars, studio visits, excursions within Prague; field trips to Vienna, Austria, Brno, Moravia, and Berlin, Germany; film and lecture series. Open to beginners and intermediate photographers. Photographers should call, e-mail or see website for more information.

⊕ PYRENEES EXPOSURES

E-mail: explorerimages@yahoo.com. Website: www.explorerimages.com. **Contact:** Martin N. Johansen, director. Cost: varies by workshop; starts at $150 for tuition; housing and meals extra. Workshops held year round. Offers 2- to 4-day workshops and photo expeditions in the French and Spanish Pyrenees, including the Andorra, with emphasis on landscapes, wildlife and culture. Workshops and tours are limited to small groups. Open to all skill levels. Photographers should e-mail or see website for more information.

JEFFREY RICH WILDLIFE PHOTOGRAPHY TOURS

P.O. Box 66, Millville CA 96062. (530)410-8428. E-mail: jrich@jeffrichphoto.com. Website: www.jeffrichphoto.com. **Contact**: Jeffrey Rich, owner. Leading wildlife photo tours in Alaska and western U.S. since 1990: bald eagles, whales, birds, Montana babies and predators, Brazil's Pantanal, Borneo, and Japan's winter wildlife. Photographers should call or e-mail for brochure.

ROCKY MOUNTAIN SCHOOL OF PHOTOGRAPHY

216 N. Higgins, Suite 101, Missoula MT 59802. (800)394-7677. Fax: (406) 721-9133. E-mail: rmsp@rmsp.com. Website: www.rmsp.com. **Contact:** Jeanne Chaput de Saintonge, co-director. Cost: $90-7,000. "RMSP offers three types of photography programs: Career Training, Workshops and Weekend events. There are varied learning opportunities for students according to their individual goals and educational needs. In a non-competitive learning environment we strive to instill confidence, foster creativity and build technical skills."

SANTA FE PHOTOGRAPHIC WORKSHOPS

P.O. Box 9916, Santa Fe NM 87504-5916. (505)983-1400. E-mail: info@santafeworkshops. com. Website: www.santafeworkshops.com. **Contact:** Registrar. Cost: $850-1,150 for tuition; lab fees, housing and meals extra; package prices for workshops in Mexico start at $2,250 and include ground transportation, most meals and accommodations. Over 120 weeklong workshops encompassing all levels of photography and more than 35 digital lab workshops and 12 weeklong workshops in Mexico—all led by top professional photographers. The Workshops campus is located near the historic center of Santa Fe. Call or e-mail to request a free catalog.

SELLING YOUR PHOTOGRAPHY

2973 Harbor Blvd., #341, Costa Mesa CA 92626-3912. (888)713-0705. E-mail: maria@ mpiscopo.com. Website: www.mpiscopo.com. **Contact:** Maria Piscopo. Cost: $25-100. One-day workshops cover techniques for marketing and selling photography services. Open to photographers of all skill levels. See website for dates and locations. Maria Piscopo is the author of *Photographer's Guide to Marketing & Self-Promotion*, 4th edition (Allworth Press).

SELLPHOTOS.COM

Pine Lake Farm, 1910 35th Rd., Osceola WI 54020. Phone/fax: (715)248-3800. E-mail: info@photosource.com. Website: www.sellphotos.com. **Contact:** Rohn Engh. Offers half-day workshops in major cities. Marketing critique of attendees' slides follows seminar.

JOHN SEXTON PHOTOGRAPHY WORKSHOPS

P.O. Box 30, Carmel Valley CA 93924. (831)659-3130. Fax: (831)659-5509. E-mail: info@ johnsexton.com. Website: www.johnsexton.com. **Contact:** Laura Bayless, administrative assistant. Director: John Sexton. Cost: $800-900. Offers a selection of intensive workshops with master photographers in scenic locations throughout the US. All workshops offer a combination of instruction in the aesthetic and technical considerations involved in making expressive black and white prints.

THE SHOWCASE SCHOOL OF PHOTOGRAPHY

1135 Sheridan Rd. NE, Atlanta GA 30324. (404)965-2205. E-mail: staff@theshowcaseschool.com. Website: www.theshowcaseschool.com. **Contact:** Jan Fields, director. Cost: $30-330 depending on class. Offers photography classes to the general public, including beginning digital camera, people photography, nature photography, and Adobe Photoshop. Open to beginner and intermediate amateur photographers. Photographers should see website for more information.

SOUTHEAST PHOTO ADVENTURE SERIES WORKSHOPS

1143 Blakeway Street, Daniel Island SC 29492. (518)432-9913. E-mail: images@peterfinger.com. Website: www.peterfinger.com/photoworkshops.html. **Contact:** Peter Finger, president. Cost: ranges from $150 for a weekend to $895 for a weeklong workshop. Offers over 20 weekend and weeklong photo workshops, held in various locations. Workshops planned include Charleston, Savannah, Carolina Coast, Outer Banks, and the Islands of Georgia. "Group instruction from dawn till dusk." Write for additional information.

SOUTH SHORE ART CENTER

119 Ripley Rd., Cohasset MA 02025. (781)383-2787. Fax: (781)383-2964. E-mail: info@ssac.org. Website: www.ssac.org. Cost: $50-175. Offers workshops and classes in introductory and advanced digital photography, landscape photography, travel photography, portrait photography, and darkroom. Photographers should call, e-mail, or visit website for more information.

SPORTS PHOTOGRAPHY WORKSHOP: COLORADO SPRINGS, CO

Rich Clarkson & Associates LLC, 1099 18th St., Suite 2840, Denver CO 80202. (303)295-7770 or (800)745-3211. E-mail: info@richclarkson.com. Website: www.sportsphotographyworkshop.com. **Contact:** Brett Wilhelm, administrator. Annual workshop held in June. Weeklong workshop in sports photography at the U.S. Olympic Training Center with Sports Illustrated and Associated Press photographers and editors. See website for more information.

STRABO PHOTO TOUR COLLECTION

P.O. Box 580, Dryden NY 13053. (607)756-8676. Fax: (208)545-4119. E-mail: info@stabotours.com. Website: www.phototc.com.

SUMMIT PHOTOGRAPHIC WORKSHOPS

P.O. Box 67459, Scotts Valley CA 95067. (831)440-0124. E-mail: b-and-k@pacbell.net. Website: www.summitphotographic.com. **Contact:** Barbara Brundege, owner. Cost: $99-200 for workshops; $1,500-6,000 for tours. Offers several workshops per year, including nature and landscape photography; wildlife photography classes; photo tours from 5 days to 3 weeks. Open to all skill levels. Photographers should see website for more information.

SYNERGISTIC VISIONS WORKSHOPS

P.O. Box 2585, Grand Junction CO 81502. Phone/fax: (970)245-6700. E-mail: steve@synvis.com. Website: www.synvis.com. **Contact:** Steve Traudt, director. Offers a variety of digital

photography and Photoshop classes at various venues in Grand Junction, Moab, Ouray, and others. "Steve is also available to present day-long photo seminars to your group." Visit website for more information.

TOM MURPHY PHOTOGRAPHY

402 S. Fifth, Livingston MT 59047. (406)222-2986 or (406)222-2302. E-mail: tom@tmurphywild.com. Website: www.tmurphywild.com. **Contact:** Tom Murphy, president. Offers programs in wildlife and landscape photography in Yellowstone National Park and special destinations.

TRAVEL IMAGES

P.O. Box 2434, Eagle ID 83616. (800)325-8320. E-mail: phototours@travelimages.com. Website: www.travelimages.com. **Contact:** John Baker, owner/guide. Small-group photo tours. Locations include U.S, Canada, Wales, Scotland, Ireland, England, New Zealand, Tasmania, Galapagos Islands, Machu Picchu, Patagonia, Provence, Tuscany, Cinque Terre, Venice, Austria, Switzerland, Germany, and Greece.

JOSEPH VAN OS PHOTO SAFARIS, INC.

P.O. Box 655, Vashon Island WA 98070. (206)463-5383. Fax: (206)463-5484. E-mail: info@photosafaris.com. Website: www.photosafaris.com. **Contact:** Joseph Van Os, director. Offers over 50 different photo tours and workshops worldwide.

VIRGINIA CENTER FOR THE CREATIVE ARTS

154 San Angelo Dr., Amherst VA 24521. (434)946-7236. Fax: (434)946-7239. E-mail: vcca@vcca.com. Website: www.vcca.com. **Contact:** Sheila Gulley Pleasants, artists services director. The Virginia Center for the Creative Arts (VCCA) is an international working retreat for writers, visual artists and composers. Located on 450 acres in the foothills of the Blue Ridge Mountains in central Virginia, the VCCA provides residential fellowships ranging from 2 weeks to 2 months. The VCCA can accommodate 22 fellows at a time and provides separate working and living quarters and all meals. There is 1 fully equipped black & white darkroom at the VCCA. Artists provide their own materials. Cost: "There is no fee to attend, but a daily contribution of $45-90 is suggested." VCCA application and work samples required. Photographers should call or see website for more information. Application deadlines are January 15, May 15, and September 15 each year.

VISION QUEST PHOTO WORKSHOP CENTER

2370 Hendon Ave., St. Paul MN 55108-1453. (651)644-1400. Fax: (651)644-2122. E-mail: info@douglasbeasley.com. Website: www.douglasbeasley.com. **Contact:** Doug Beasley, director. Cost: $495-1,995; includes food and lodging. Annual workshops held February through November. Hands-on photo workshops that emphasize content, vision and creativity over technique or gimmicks. Workshops are held in a variety of locations such as The Badlands of South Dakota, Oregon, Hawaii, Ireland, China, Japan, Africa, and Guatemala. Open to all skill levels. Photographers should call or e-mail for more information.

VISUAL ARTISTRY & FIELD MENTORSHIP PHOTOGRAPHY WORKSHOP SERIES

P.O. Box 963, Eldersburg MD 21784. (410)552-4664. Fax: (410)552-3332. E-mail: tony@tonysweet.com. Website: http://tonysweet.com. **Contact:** Tony Sweet or Susan Milestone, susan@tonysweet.com. Cost: $795-$1,000 for instruction; all other costs are the responsibility of participant. Five-day workshops, limit 8-10 participants. Formats: 35mm film; digital; xpan. Extensive personal attention and instructional slide shows. Post-workshop support and image critiques for 6 months after the workshop (for an additional fee). Frequent attendees discounts and inclement weather discounts on subsequent workshops. Dealer discounts available from major vendors. "The emphasis is to create in the participant a greater awareness of composition, subject selection, and artistic rendering of the natural world using the raw materials of nature: color, form and line." Open to intermediate and advanced photographers.

WILDERNESS ALASKA

P.O. Box 113063, Anchorage AK 99511. (907)345-3567. Fax: (907)345-3967. E-mail: macgill@alaska.net. Website: www.wildernessalaska.com. **Contact:** MacGill Adams. Offers custom photography trips featuring natural history and wildlife to small groups.

ℕ WILDLIFE PHOTOGRAPHY WORKSHOPS AND LECTURES

Leonard Rue Enterprises, 138 Millbrook Rd., Blairstown NJ 07825. (908)362-6616. Email: rue@rue.com. Website: www.rue.com. **Contact:** Len Rue, Jr. Taught by Len Rue, Jr., who has over 35 years experience in outdoor photography by shooting photographic stock for the publishing industry. Also leads tours and teaches photography.

WILD WINGS PHOTO ADVENTURES

2035 Buchanan Rd. Manning SC 29102. (803)473-3414. E-mail: doug@totallyoutdoorspublishing.com. Website: www.douggardner.com. **Contact:** Doug Gardner, founder/instructor. Cost: $200-$450 (some adventures include meals and lodging). Annual workshops held various times throughout the year in North and South Carolina: Waterfowl (Ducks, Snow Geese, Tundra Swan), Osprey & Swamp Critters. "The purpose of Wild Wings Photo Adventures is to offer one on one instruction and great opportunities to photograph 'wild' animals up close. Students will learn valuable techniques in the field with internationally recognized wildlife photographer Doug Gardner. Be sure to view the all new TV series, 'Wild Photo Adventures' online at www.wildphotoadventures.com."

ROBERT WINSLOW PHOTO, INC.

P.O. Box 334, Durango CO 81302-0334. (970)259-4143. Fax: (970)259-7748. E-mail: rwinslow@mydurango.net. Website: www.robertwinslowphoto.com. **Contact:** Robert Winslow, president. Cost: varies depending on workshop or tour. "We arrange and lead custom wildlife and natural history photo tours to East Africa and other destinations around the world."

WOODSTOCK PHOTOGRAPHY WORKSHOPS

The Center for Photography at Woodstock, 59 Tinker St., Woodstock NY 12498. (845)679-

9957. E-mail: info@cpw.org. Website: www.cpw.org. **Contact:** Liz Unterman, CPW Education Coordinator. Cost: $120-625. Offers annual lectures and workshops in all topics in photography from June through October. Faculty includes numerous top professionals in fine art, documentary and commercial photography. Topics include still life, landscape, portraiture, lighting, alternative processes and digital. Offers 1-, 2- and 4-day events. Free catalog available by request.

WORKING WITH ARTISTS

445 S. Saulsbury, Studios C-D/Main Gallery, Lakewood CO 80226. (303)837-1341. E-mail: info@workingwithartists.org. Website: www.workingwithartists.org. Cost: varies, depending on workshop, $95-995. Offers workshops on Photoshop, digital, alternative process, portraiture, landscape, creativity, studio lighting and more. Travels with Artists Workshops are held in Bali; Tuscany, Italy; San Miquel de Allende, Mexico; Spain. Open to all skill levels. They also have a gallery with changing juried photo exhibits. Photographers should call, e-mail, see website for more information.

THE HELENE WURLITZER FOUNDATION OF NEW MEXICO

218 Los Pandos Rd., P.O. Box 1891, Taos NM 87571. (575)758-2413. E-mail: hwf@taosnet. com. Website: www.wurlitzerfoundation.org. **Contact:** Michael A. Knight, executive director. The foundation offers residencies to artists in the creative fields-visual, literary, and music composition. There are three thirteen week sessions from mid-January through November annually. Application deadline: January 18 for following year. For application, request by e-mail or visit website to download.

YELLOWSTONE ASSOCIATION INSTITUTE

P.O. Box 117, Yellowstone National Park WY 82190. (406)848-2400. Fax: (406)848-2847. E-mail: registrar@YellowstoneAssociation.org. Website: www.YellowstoneAssociation. org. **Contact:** Information Specialist. Offers workshops in nature and wildlife photography during the summer, fall and winter. Custom courses can be arranged. Photographers should see website for more information.

YOSEMITE OUTDOOR ADVENTURES

P.O. Box 230, El Portal CA 95318. (209)379-2321. E-mail: pdevine@yosemite.org. Website: www.yosemite.org. **Contact:** Pete Devine, educational programs director. Cost: more than $200. Offers small (8-15 people) workshops in Yosemite National Park in outdoor field photography and natural history year-round. Photographers should see website for more information.

Stock Photography Portals

These sites market and distribute images from multiple agencies and photographers.

AGPix www.agpix.com

Alamy www.alamy.com

Digital Railroad www.digitalrailroad.net

Find a Photographer www.asmp.org/findaphotographer

Independent Photography Network (IPNStock) www.ipnstock.com

PhotoServe www.photoserve.com

PhotoSource International www.photosource.com

Portfolios.com www.portfolios.com

Shutterpoint Photography www.shutterpoint.com

Veer www.veer.com

Workbook Stock www.workbook.com

RESOURCES

Portfolio Review Events

Portfolio review events provide photographers the opportunity to show their work to a variety of photo buyers, including photo editors, publishers, art directors, gallery representatives, curators and collectors.

Art Director's Club, International Annual Awards Exhibition, New York City, www. adcglobal.org

Atlanta Celebrates Photography, held annually in October, Atlanta GA, www. acpinfo.org

Center for Photography at Woodstock, New York City, www.cpw.org

Festival of Light International Directory of Photography Festivals, an international collaboration of 16 countries and 22 photography festivals, www.festivaloflight. net

Fotofest, March, Houston TX, www.fotofest.org. Biennial—held in even-numbered years.

Fotofusion, January, Delray Beach FL, www.fotofusion.org

North American Nature Photographers Association, annual summit held in January. Location varies. www.nanpa.org

Photo LA, January, Los Angeles CA, www.photola.com

Photo Miami, held annually in December, Miami FL, http://artfairsinc.com

Photo San Francisco, July, San Francisco CA, www.photosanfrancisco.net

Photolucida, March, Portland OR, www.photolucida.org. Biennial—held in odd-numbered years.

The Print Center, events held throughout the year, Philadelphia PA, www.printcenter. org

Review Santa Fe, July, Santa Fe NM, www.sfcp.org. The only juried portfolio review event.

Rhubarb-Rhubarb, July, Birmingham UK, www.rhubarb-rhubarb.net

Society for Photographic Education National Conference, March, different location each year, www.spenational.org

Grants

State, Provincial & Regional

rts councils in the United States and Canada provide assistance to artists (including photographers) in the form of fellowships or grants. These grants can be substantial and confer prestige upon recipients; however, **only state or province residents are eligible.** Because deadlines and available support vary annually, query first (with a SASE) or check websites for guidelines.

UNITED STATES ARTS AGENCIES

Alabama State Council on the Arts, 201 Monroe St., Montgomery AL 36130-1800. (334)242-4076. E-mail: staff@arts.alabama.gov. Website: www.arts.state.al.us

Alaska State Council on the Arts, 411 W. Fourth Ave., Suite 1-E, Anchorage AK 99501-2343. (907)269-6610 or (888)278-7424. E-mail: aksca_info@eed.state.ak.us. Website: www.eed.state.ak.us/aksca

Arizona Commission on the Arts, 417 W. Roosevelt St., Phoenix AZ 85003-1326. (602)771-6501. E-mail: info@azarts.gov. Website: www.azarts.gov

Arkansas Arts Council, 1500 Tower Bldg., 323 Center St., Little Rock AR 72201. (501)324-9766. E-mail: info@arkansasarts.com. Website: www.arkansasarts.com

California Arts Council, 1300 I St., Suite 930, Sacramento CA 95814. (916)322-6555. E-mail: info@caartscouncil.com. Website: www.cac.ca.gov

Colorado Council on the Arts, 1625 Broadway, Suite 2700, Denver CO 80202. (303)892-3802. E-mail: online form. Website: www.coloarts.state.co.us

Connecticut Commission on Culture & Tourism, Arts Division, One Financial Plaza, 755 Main St., Hartford CT 06103. (860)256-2800. Website: www.cultureandtourism.org

Delaware Division of the Arts, Carvel State Office Bldg., 4th Floor, 820 N. French St., Wilmington DE 19801. (302)577-8278 (New Castle Co.) or (302)739-5304 (Kent or Sussex Counties). E-mail: delarts@state.de.us. Website: www.artsdel.org

District of Columbia Commission on the Arts & Humanities, 410 Eighth St. NW, 5th Floor, Washington DC 20004. (202)724-5613. E-mail: cah@dc.gov. Website: http://dcarts.dc.gov

Florida Arts Council, Division of Cultural Affairs, R.A. Gray Building, Third Floor, 500 S. Bronough St., Tallahassee FL 32399-0250. (850)245-6470. E-mail: info@florida-arts.org. Website: www.florida-arts.org

Georgia Council for the Arts, 260 14th St., Suite 401, Atlanta GA 30318. (404)685-2787. E-mail: gaarts@gaarts.org. Website: www.gaarts.org

Guam Council on the Arts & Humanities Agency, P.O. Box 2950, Hagatna GU 96932. (671)646-2781. Website: www.guam.net

Hawaii State Foundation on Culture & the Arts, 2500 S. Hotel St., 2nd Floor, Honolulu HI 96813. (808)586-0300. E-mail: ken.hamilton@hawaii.gov. Website: www.state.hi.us/sfca

Idaho Commission on the Arts, 2410 N. Old Penitentiary Rd., Boise ID 83712. (208)334-2119 or (800)278-3863. E-mail: info@arts.idaho.gov. Website: www.arts.idaho.gov

Illinois Arts Council, James R. Thompson Center, 100 W. Randolph, Suite 10-500, Chicago IL 60601. (312)814-6750. E-mail: iac.info@illinois.gov. Website: www.state.il.us/agency/iac

Indiana Arts Commission, 150 W. Market St., Suite 618, Indianapolis IN 46204. (317)232-1268. E-mail: IndianaArtsCommission@iac.in.gov. Website: www.in.gov/arts

Iowa Arts Council, 600 E. Locust, Des Moines IA 50319-0290. (515)281-6412. Website: www.iowaartscouncil.org

Kansas Arts Commission, 700 SW Jackson, Suite 1004, Topeka KS 66603-3761. (785)296-3335. E-mail: KAC@arts.state.ks.us. Website: http://arts.state.ks.us

Kentucky Arts Council, 21st Floor, Capital Plaza Tower, 500 Mero St., Frankfort KY 40601-1987. (502)564-3757 or (888)833-2787. E-mail: kyarts@ky.gov. Website: http://artscouncil.ky.gov

Louisiana Division of the Arts, Capitol Annex Bldg., 1051 N. 3rd St., 4th Floor, Room #420, Baton Rouge LA 70804. (225)342-8180. Website: www.crt.state.la.us/arts

Maine Arts Commission, 193 State St., 25 State House Station, Augusta ME 04333-0025. (207)287-2724. E-mail: MaineArts.info@maine.gov. Website: www.mainearts.com

Maryland State Arts Council, 175 W. Ostend St., Suite E, Baltimore MD 21230. (410)767-6555. E-mail: msac@msac.org. Website: www.msac.org

Massachusetts Cultural Council, 10 St. James Ave., 3rd Floor, Boston MA 02116-3803. (617)727-3668. E-mail: mcc@art.state.ma.us. Website: www.massculturalcouncil.org

Michigan Council for Arts & Cultural Affairs, 702 W. Kalamazoo St., P.O. Box 30705, Lansing MI 48909-8205. (517)241-4011. E-mail: artsinfo@michigan.gov. Website: www.michigan.gov/hal/0,1607,7-160-17445_19272---,00.html

Minnesota State Arts Board, Park Square Court, 400 Sibley St., Suite 200, St. Paul MN 55101-1928. (651)215-1600 or (800)866-2787. E-mail: msab@arts.state.mn.us. Website: www.arts.state.mn.us

Mississippi Arts Commission, 501 N. West St., Suite 701B, Woolfolk Bldg., Jackson MS 39201. (601)359-6030. Website: www.arts.state.ms.us

Missouri Arts Council, 815 Olive St., Suite 16, St. Louis MO 63101-1503. (314)340-6845 or (866)407-4752. E-mail: moarts@ded.mo.gov. Website: www.missouriartscouncil.org

Montana Arts Council, 316 N. Park Ave., Suite 252, Helena MT 59620-2201. (406)444-6430. E-mail: mac@mt.gov. Website: www.art.state.mt.us

National Assembly of State Arts Agencies, 1029 Vermont Ave. NW, 2nd Floor, Washington DC 20005. (202)347-6352. E-mail: nasaa@nasaa-arts.org. Website: www.nasaa-arts.org

Nebraska Arts Council, 1004 Farnam St., Plaza Level, Omaha NE 68102. (402)595-2122 or (800)341-4067. Website: www.nebraskaartscouncil.org

Nevada Arts Council, 716 N. Carson St., Suite A, Carson City NV 89701. (775)687-6680. E-mail: online form. Website: http://dmla.clan.lib.nv.us/docs/arts

New Hampshire State Council on the Arts, 21/2 Beacon St., 2nd Floor, Concord NH 03301-4974. (603)271-2789. Website: www.nh.gov/nharts

New Jersey State Council on the Arts, 225 W. State St., P.O. Box 306, Trenton NJ 08625. (609)292-6130. Website: www.njartscouncil.org

New Mexico Arts, Dept. of Cultural Affairs, P.O. Box 1450, Santa Fe NM 87504-1450. (505)827-6490 or (800)879-4278. Website: www.nmarts.org

New York State Council on the Arts, 175 Varick St., New York NY 10014. (212)627-4455. Website: www.nysca.org

North Carolina Arts Council, 109 East Jones St., Cultural Resources Building, Raleigh NC 27601. (919)807-6500. E-mail: ncarts@ncmail.net. Website: www.ncarts.org

North Dakota Council on the Arts, 1600 E. Century Ave., Suite 6, Bismarck ND 58503. (701)328-7590. E-mail: comserv@state.nd.us. Website: www.state.nd.us/arts

Commonwealth Council for Arts and Culture (Northern Mariana Islands), P.O. Box 5553, CHRB, Saipan MP 96950. (670)322-9982 or (670)322-9983. E-mail: galaidi@vzpacifica.net. Website: www.geocities.com/ccacarts/ccacwebsite.html

Ohio Arts Council, 727 E. Main St., Columbus OH 43205-1796. (614)466-2613. Website: www.oac.state.oh.us

Oklahoma Arts Council, Jim Thorpe Building, 2101 N. Lincoln Blvd., Suite 640, Oklahoma City OK 73105. (405)521-2931. E-mail: okarts@arts.ok.gov. Website: www.arts.state.ok.us

Oregon Arts Commission, 775 Summer St. NE, Suite 200, Salem OR 97301-1280. (503)986-0082. E-mail: oregon.artscomm@state.or.us. Website: www.oregonartscommission.org

Pennsylvania Council on the Arts, 216 Finance Bldg., Harrisburg PA 17120. (717)787-6883. Website: www.pacouncilonthearts.org

Institute of Puerto Rican Culture, P.O. Box 9024184, San Juan PR 00902-4184. (787)724-0700. E-mail: www@icp.gobierno.pr. Website: www.icp.gobierno.pr

Rhode Island State Council on the Arts, One Capitol Hill, Third Floor, Providence RI 02908. (401)222-3880. E-mail: info@arts.ri.gov. Website: www.arts.ri.gov

American Samoa Council on Culture, Arts and Humanities, P.O. Box 1540, Office of the Governor, Pago Pago AS 96799. (684)633-4347. Website: www.prel.org/programs/pcahe/PTG/terr-asamoa1.html

South Carolina Arts Commission, 1800 Gervais St., Columbia SC 29201. (803)734-8696. E-mail: info@arts.state.sc.us. Website: www.southcarolinaarts.com

South Dakota Arts Council, 711 E. Wells Ave., Pierre SD 57501-3369. (605)773-3301. E-mail: sdac@state.sd.us. Website: www.artscouncil.sd.gov

Tennessee Arts Commission, 401 Charlotte Ave., Nashville TN 37243-0780. (615)741-1701. Website: www.arts.state.tn.us

Texas Commission on the Arts, E.O. Thompson Office Building, 920 Colorado, Suite 501, Austin TX 78701. (512)463-5535. E-mail: front.desk@arts.state.tx.us. Website: www.arts.state.tx.us

Utah Arts Council, 617 E. South Temple, Salt Lake City UT 84102-1177. (801)236-7555. Website: http://arts.utah.gov

Vermont Arts Council, 136 State St., Drawer 33, Montpelier VT 05633-6001. (802)828-3291. E-mail: online form. Website: www.vermontartscouncil.org

Virgin Islands Council on the Arts, 5070 Norre Gade, St. Thomas VI 00802-6872. (340)774-5984. Website: http://vicouncilonarts.org

Virginia Commission for the Arts, Lewis House, 223 Governor St., 2nd Floor, Richmond VA 23219. (804)225-3132. E-mail: arts@arts.virginia.gov. Website: www.arts.state. va.us

Washington State Arts Commission, 711 Capitol Way S., Suite 600, P.O. Box 42675, Olympia WA 98504-2675. (360)753-3860. E-mail: info@arts.wa.gov. Website: www. arts.wa.gov

West Virginia Commission on the Arts, The Cultural Center, Capitol Complex, 1900 Kanawha Blvd. E., Charleston WV 25305-0300. (304)558-0220. Website: www. wvculture.org/arts

Wisconsin Arts Board, 101 E. Wilson St., 1st Floor, Madison WI 53702. (608)266-0190. E-mail: artsboard@arts.state.wi.us. Website: www.arts.state.wi.us

Wyoming Arts Council, 2320 Capitol Ave., Cheyenne WY 82002. (307)777-7742. E-mail: ebratt@state.wy.us. Website: http://wyoarts.state.wy.us

CANADIAN PROVINCES ARTS AGENCIES

Alberta Foundation for the Arts, 10708 - 105 Ave., Edmonton AB T5H 0A1. (780)427-9968. Website: www.cd.gov.ab.ca/all_about_us/commissions/arts

British Columbia Arts Council, P.O. Box 9819, Stn. Prov. Govt., Victoria BC V8W 9W3. (250)356-1718. E-mail: BCArtsCouncil@gov.bc.ca. Website: www.bcartscouncil.ca

The Canada Council for the Arts, 350 Albert St., P.O. Box 1047, Ottawa ON K1P 5V8. (613)566-4414 or (800)263-5588 (within Canada). Website: www.canadacouncil.ca

Manitoba Arts Council, 525-93 Lombard Ave., Winnipeg MB R3B 3B1. (204)945-2237 or (866)994-2787 (in Manitoba). E-mail: info@artscouncil.mb.ca. Website: www. artscouncil.mb.ca

New Brunswick Arts Board (NBAB), 634 Queen St., Suite 300, Fredericton NB E3B 1C2. (506)444-4444 or (866)460-2787. Website: www.artsnb.ca

Newfoundland & Labrador Arts Council, P.O. Box 98, St. John's NL A1C 5H5. (709)726-2212 or (866)726-2212. E-mail: nlacmail@nfld.net. Website: www.nlac.nf.ca

Nova Scotia Department of Tourism, Culture, and Heritage, Culture Division, 1800 Argyle St., Suite 601, P.O. Box 456, Halifax NS B3J 2R5. (902)424-4510. E-mail: cultaffs@gov.ns.ca. Website: www.gov.ns.ca/dtc/culture

Ontario Arts Council, 151 Bloor St. W., 5th Floor, Toronto ON M5S 1T6. (416)961-1660 or (800)387-0058 (in Ontario). E-mail: info@arts.on.ca. Website: www.arts.on.ca

Resources

Prince Edward Island Council of the Arts, 115 Richmond St., Charlottetown PE C1A 1H7. (902)368-4410 or (888)734-2784. E-mail: info@peiartscouncil.com. Website: www.peiartscouncil.com

Quebec Council for Arts & Literature, 79 boul. Rene-Levesque Est, 3e etage, Quebec QC G1R 5N5. (418)643-1707 or (800)897-1707. E-mail: info@calq.gouv.qc.ca. Website: www.calq.gouv.qc.ca

The Saskatchewan Arts Board, 2135 Broad St., Regina SK S4P 1Y6. (306)787-4056 or (800)667-7526 (Saskatchewan only). E-mail: sab@artsboard.sk.ca. Website: www. artsboard.sk.ca

Yukon Arts Section, Cultural Services Branch, Dept. of Tourism & Culture, Government of Yukon, Box 2703 (L-3), Whitehorse YT Y1A 2C6. (867)667-8589 or (800)661-0408 (in Yukon). E-mail: arts@gov.yk.ca. Website: www.btc.gov.yk.ca/cultural/arts

STATE AND REGIONAL GRANTS AND AWARDS

The following opportunities are arranged by state since most of them grant money to artists in a particular geographic region. Because deadlines vary annually, check Websites or call for the most up-to-date information. Note: not all states are listed; see the list of state and provincial arts agencies on page 457 for state-sponsored arts councils.

California

Flintridge Foundation Awards for Visual Artists, 1040 Lincoln Ave., Suite 100, Pasadena CA 91103. (626)449-0839 or (800)303-2139. Fax: (626)585-0011. Website: www.flintridgefoundation.org. For artists in California, Oregon and Washington only.

James D. Phelan Award in Photography, Kala Art Institute, Don Porcella, 1060 Heinz Ave., Berkeley CA 94710. (510)549-6914. Website: www.kala.org. For artists born in California only.

Connecticut

Martha Boschen Porter Fund, Inc., 145 White Hallow Rd., Sharon CT 06064. For artists in northwestern Connecticut, western Massachusetts and adjacent areas of New York (except New York City).

Idaho

Betty Bowen Memorial Award, Seattle Art Museum, 100 University St., Seattle WA 98101. (206)654-3131. Website: www.seattleartmuseum.org/bettybowen/. For artists in Washington, Oregon and Idaho only.

Illinois

Illinois Arts Council, Artists Fellowship Program, James R. Thompson Center, 100 W. Randolph, Suite 10-500, Chicago IL 60601. (312)814-6750. Website: www.state.il.us/agency/iac/Guidelines/guidelines.htm. For Illinois artists only.

Kentucky

Kentucky Foundation for Women Grants Program, 1215 Heyburn Bldg., 332 W. Broadway, Louisville KY 40202. (502)562-0045. Website: www.kfw.org/grants.html. For female artists living in Kentucky only.

Massachusetts

See Martha Boschen Porter Fund, Inc., under Connecticut.

Minnesota

McKnight Photography Fellowships Program, University of Minnesota Dept. of Art, Regis Center for Art, E-201, 405 21st Ave. S., Minneapolis MN 55455. (612)626-9640. Website: www.mcknightphoto.umn.edu. For Minnesota artists only.

New York

A.I.R. Gallery Fellowship Program, 511 W. 25th St., Suite 301, New York NY 10001. (212)255-6651. E-mail: info@airnyc.org. Website: www.airnyc.org. For female artists from New York City metro area only.

Arts & Cultural Council for Greater Rochester, 277 N. Goodman St., Rochester NY 14607. (585)473-4000. Website: www.artsrochester.org

Constance Saltonstall Foundation for the Arts Grants and Fellowships, P.O. Box 6607, Ithaca NY 14851 (include SASE). (607)277-4933. E-mail: info@saltonstall.org. Website: www.saltonstall.org. For artists in the central and western counties of New York.

New York Foundation for the Arts: Artists' Fellowships, 155 Avenue of the Americas, 14th Floor, New York NY 10013-1507. (212)366-6900, ext. 217. E-mail: nyfaafp@nyfa.org. Website: www.nyfa.org. For New York artists only.

Oregon

See Flintridge Foundation Awards for Visual Artists, under California.

Resources

Pennsylvania

Leeway Foundation—Philadelphia, Pennsylvania Region, 123 S. Broad St., Suite 2040, Philadelphia PA 19109. (215)545-4078. E-mail: info@leeway.org. Website: www. leeway.org. For female artists in Philadelphia only.

Texas

Individual Artist Grant Program—Houston, Texas, Cultural Arts Council of Houston and Harris County, 3201 Allen Pkwy., Suite 250, Houston TX 77019-1800. (713)527-9330. E-mail: info@cachh.org. Website: www.cachh.org. For Houston artists only.

Washington

See Flintridge Foundation Awards for Visual Artists, under California.

Professional Organizations

Advertising Photographers of America, National, 28 E. Jackson, Bldg. #10-A855, Chicago IL 60604-2263. (800)272-6264. E-mail: office@apanational.com. Website: www.apanational.com

Advertising Photographers of America, Atlanta, P.O. Box 20471, Atlanta GA 30325. (888)889-7190, ext. 50. E-mail: info@apaatlanta.com. Website: www.apaatlanta.com

Advertising Photographers of America, Los Angeles, 5455 Wilshire Blvd., Suite 1709, Los Angeles CA 90036. (323)933-1631. Fax: (323)933-9209. E-mail: office@apa-la.org. Website: www.apa-la.org

Advertising Photographers of America, Midwest, 28 E. Jackson, Bldg. #10-A855, Chicago IL 60604. (877)890-7375. E-mail: ceo@apa-m.com. Website: www.apamidwest.com

Advertising Photographers of America, New York, 27 W. 20th St., Suite 601, New York NY 10011. (212)807-0399. Fax: (212)727-8120. E-mail: info@apany.com. Website: www.apany.com

Advertising Photographers of America, San Diego, P.O. Box 84241, San Diego CA 92138. (619)417-2150. E-mail: membership@apasd.org. Website: www.apasd.org

Advertising Photographers of America, San Francisco, 560 Fourth St., San Francisco CA 94107. (415)882-9780. Fax: (415)882-9781. E-mail: info@apasf.com. Website: www.apasf.com

American Society of Media Photographers (ASMP), 150 N. Second St., Philadelphia PA 19106. (215)451-2767. Fax: (215)451-0880. Website: www.asmp.org

American Society of Picture Professionals (ASPP), 117 S. St. Asaph St., Alexandria VA 22314. Phone/fax: (703)299-0219. Website: www.aspp.com

The Association of Photographers, 81 Leonard St., London EC2A 4QS United Kingdom. (44)(207)739-6669. Fax: (44)(207)739-8707. E-mail: general@aophoto.co.uk. Website: www.the-aop.org

British Association of Picture Libraries and Agencies, 18 Vine Hill, London EC1R 5DZ United Kingdom. (44)(207)713-1780. Fax: (44)(207)713-1211. E-mail: enquiries@bapla.org.uk. Website: www.bapla.org.uk

British Institute of Professional Photography (BIPP), Fox Talbot House, Amwell End, Ware, Hertsfordshire SG12 9HN United Kingdom. (44)(192)046-4011. Fax: (44)(192)0487056. E-mail: info@bipp.com. Website: www.bipp.com

Canadian Association of Journalists, Algonquin College, 1385 Woodroffe Ave., B224, Ottawa ON K2G 1V8 Canada. (613)526-8061. Fax: (613)521-3904. E-mail: caj@igs.net. Website: www.caj.ca

Canadian Association of Photographers & Illustrators in Communications, The Case Goods Building, Suite 302, 55 Mill St., Toronto ON M5A 3C4 Canada. (416)462-3677. Fax: (416)462-9570. E-mail: info@capic.org. Website: www.capic.org

Canadian Association for Photographic Art, 31858 Hopedale Ave., Clearbrook BC V2T 2G7 Canada. (604)855-4848. Fax: (604)855-4824. E-mail: capa@capacanada.ca. Website: www.capacanada.ca

The Center for Photography at Woodstock (CPW), 59 Tinker St., Woodstock NY 12498. (845)679-9957. Fax: (845)679-6337. E-mail: info@cpw.org. Website: www.cpw.org

Evidence Photographers International Council (EPIC), 229 Peachtree St. NE, Suite 2200, Atlanta GA 30303. (886)868-3742. E-mail: EPICheadquarters@verizon.net. Website: www.epic-photo.org

International Association of Panoramic Photographers, 8855 Redwood St., Las Vegas NV 89139. (702)260-4608. E-mail: iappsecretary@aol.com. Website: www.panoramicassociation.org

International Center of Photography (ICP), 1133 Avenue of the Americas at 43rd St., New York NY 10036. (212)857-0000. E-mail: info@icp.org. Website: www.icp.org

The Light Factory (TLF), Spirit Square, Suite 211, 345 N. College St., Charlotte NC 28202. (704)333-9755. E-mail: info@lightfactory.org. Website: www.lightfactory.org

National Association of Photoshop Professionals (NAPP), 333 Douglas Rd. E., Oldsmar FL 34677. (813)433-5006. Fax: (813)433-5015. Website: www.photoshopuser.com

National Press Photographers Association (NPPA), 3200 Croasdaile Dr., Suite 306, Durham NC 27705. (919)383-7246. Fax: (919)383-7261. E-mail: info@nppa.org. Website: www.nppa.org

North American Nature Photography Association (NANPA), 10200 W. 44th Ave., Suite 304, Wheat Ridge CO 80033-2840. (303)422-8527. Fax: (303)422-8894. E-mail: info@nanpa.org. Website: www.nanpa.org

Photo Marketing Association International, 3000 Picture Place, Jackson MI 49201. (517)788-8100. Fax: (517)788-8371. E-mail: PMA_Information_Central@pmai.org. Website: www.pmai.org

Photographic Society of America (PSA), 3000 United Founders Blvd., Suite 103, Oklahoma City OK 73112-3940. (405)843-1437. Fax: (405)843-1438. E-mail: hq@psa-photo.org. Website: www.psa-photo.org

Picture Archive Council of America (PACA). (949)460-4531. Fax: (949)460-4532. E-mail: pacnews@pacoffice.org. Website: www.stockindustry.org

Professional Photographers of America (PPA), 229 Peachtree St. NE, Suite 2200, Atlanta GA 30303. (404)522-8600. Fax: (404)614-6400. E-mail: csc@ppa.com. Website: www.ppa.com

Professional Photographers of Canada (PPOC), 371 Dundas St., Woodstock ON N4S 1B6 Canada. (519)537-2555. Fax: (519)537-5573. E-mail: ppoc@rogers.com. Website: www.ppoc.ca

The Royal Photographic Society, Fenton House, 122 Wells Rd., Bath BA2 3AH United Kingdom. (44)(122)546-2841. Fax: (44)(122)544-8688. E-mail: reception@rps.org. Website: www.rps.org

Society for Photographic Education, 126 Peabody, The School of Interdisciplinary Studies, Miami University, Oxford OH 45056. (513)529-8328. Fax: (513)529-9301. E-mail: speoffice@spenational.org. Website: www.spenational.org

Society of Photographers and Artists Representatives (SPAR), 60 E. 42nd St., Suite 1166, New York NY 10165. E-mail: info@spar.org. Website: www.spar.org

Volunteer Lawyers for the Arts, 1 E. 53rd St., 6th Floor, New York NY 10022. (212)319-2787, ext. 1. Fax: (212)752-6575. Website: www.vlany.org

Wedding & Portrait Photographers International (WPPI), P.O. Box 2003, 1312 Lincoln Blvd., Santa Monica CA 90406. (310)451-0090. Fax: (310)395-9058. Website: www.wppionline.com

White House News Photographers' Association (WHNPA), 7119 Ben Franklin Station, Washington DC 20044-7119. Website: www.whnpa.org

Resources

Publications

PERIODICALS

Advertising Age, Crain Communications, 711 Third Ave., New York NY 10017-4036. (212)210-0100. Website: www.adage.com. Weekly magazine covering marketing, media and advertising.

Adweek, VNU Business Publications, 770 Broadway, New York NY 10003. (646)654-5421. Fax: (646)654-5365. E-mail: info@adweek.com. Website: www.adweek.com. Weekly magazine covering advertising agencies.

American Photo, 1633 Broadway, 43rd Floor, New York NY 10019. (212)767-6000. Website: www.americanphotomag.com. Monthly magazine emphasizing the craft and philosophy of photography.

Art Calendar, 1500 Park Center Dr., Orlando FL 32835. (877)415-3955. Fax: (407)563-7099. E-mail: info@ArtCalendar.com. Website: www.artcalendar.com. Monthly magazine listing galleries reviewing portfolios, juried shows, percent-for-art programs, scholarships and art colonies.

ASMP Bulletin, 150 N. Second St., Philadelphia PA 19106. (215)451-2767. Fax: (215)451-0880. Website: www.asmp.org. Newsletter of the American Society of Media Photographers published 5 times/year. Subscription with membership.

Communication Arts, 110 Constitution Dr., Menlo Park CA 94025. (650)326-6040. Fax: (650)326-1648. Website: www.commarts.com. Trade journal for visual communications.

Editor & Publisher, VNU Business Publications, 770 Broadway, New York NY 10003-9595. (800)336-4380 or (646)654-5270. Fax: (646)654-5370. Website: www.editorandpublisher.com. Monthly magazine covering latest developments in journalism and newspaper production. Publishes an annual directory issue listing syndicates and another directory listing newspapers.

Folio, Red 7 Media, LLC, 33 S. Main St., Norwalk CT 06854. (203)854-6730. Fax: (203)854-6735. Website: www.foliomag.com. Monthly magazine featuring trends in magazine circulation, production and editorial.

Graphis, 307 Fifth Ave., 10th Floor, New York NY 10016. (212)532-9387. Fax: (212)213-3229. E-mail: info@graphis.com. Website: www.graphis.com. Magazine for the visual arts.

HOW, F + W Media, Inc., 4700 E. Galbraith Rd., Cincinnati OH 45236. (513)531-2690. Website: www.howdesign.com. Bimonthly magazine for the design industry.

News Photographer, 6677 Whitemarsh Valley Walk, Austin TX 78746-6367. (919)383-7246. Fax: (919)383-7261. E-mail: magazine@nppa.org. Website: www.nppa.org. Monthly news tabloid published by the National Press Photographers Association. Subscription with membership.

Outdoor Photographer, Werner Publishing, 12121 Wilshire Blvd., 12th Floor, Los Angeles CA 90025-1176. (310)820-1500. Fax: (310)826-5008. Website: www. outdoorphotographer.com. Monthly magazine emphasizing equipment and techniques for shooting in outdoor conditions.

Photo District News, VNU Business Publications, 770 Broadway, 7th Floor, New York NY 10003. (646)654-5780. Fax: (646)654-5813. Website: www.pdn-pix.com. Monthly magazine for the professional photographer.

Photosource International, Pine Lake Farm, 1910 35th Rd., Osceola WI 54020-5602. (800)624-0266, ext. 21. E-mail: info@photosource.com. Website: www.photosource. com. This company publishes several helpful newsletters, including *PhotoLetter*, *PhotoDaily* and *PhotoStockNotes*.

Popular Photography & Imaging, 1633 Broadway, New York NY 10019. (212)767-6000. Fax: (212)767-5602. Website: www.popphoto.com. Monthly magazine specializing in technical information for photography.

Print, F + W Media, Inc., 4700 E. Galbraith Rd., Cincinnati OH 45236. (513)531-2690. E-mail: info@printmag.com. Website: www.printmag.com. Bimonthly magazine focusing on creative trends and technological advances in illustration, design, photography and printing.

Professional Photographer, Professional Photographers of America (PPA), 229 Peachtree St. NE, Suite 2200, Atlanta GA 30303. (404)522-8600. Fax: (404)614-6400. Website: www.ppa.com. Monthly magazine emphasizing technique and equipment for working photographers.

Publishers Weekly, 360 Park Ave. S., New York NY 10010. (646)746-6758. Fax: (646)746-6631. Website: www.publishersweekly.com. Weekly magazine covering industry trends and news in book publishing; includes book reviews and interviews.

Resources

Rangefinder, P.O. Box 1703, 1312 Lincoln Blvd., Santa Monica CA 90406. (310)451-8506. Fax: (310)395-9058. Website: www.rangefindermag.com. Monthly magazine covering photography technique, products and business practices.

Selling Stock, 110 Frederick Ave., Suite A, Rockville MD 20850. (301)251-0720. Fax: (301)309-0941. E-mail: sellingstock@chd.com. Website: www.pickphoto.com. Newsletter for stock photographers; includes coverage of trends in business practices such as pricing and contract terms.

Shutterbug, Primedia, 1419 Chaffee Dr., Suite 1, Titusville FL 32780. (321)269-3212. Fax: (321)225-3149. Website: www.shutterbug.net. Monthly magazine of photography news and equipment reviews.

Studio Photography, Cygnus Business Media, 3 Huntington Quadrangle, Suite 301N, Melville NY 11747. (631)845-2700. Fax: (631)845-7109. Website: www.imaginginfo. com/spd/. Monthly magazine showcasing professional photographers. Also provides guides, tips and tutorials.

BOOKS & DIRECTORIES

Adweek Agency Directory, VNU Business Publications, 770 Broadway, New York NY 10003. (646)654-5421. E-mail: info@adweek.com. Website: www.adweek.com. Annual directory of advertising agencies in the U.S.

Adweek Brand Directory, VNU Business Publications, 770 Broadway, New York NY 10003. (646)654-5421. E-mail: info@adweek.com. Website: www.adweek.com. Directory listing top 2,000 brands, ranked by media spending.

ASMP Copyright Guide for Photographers, American Society of Media Photographers, 150 N. Second St., Philadelphia PA 19106. (215)451-2767. Fax: (215)451-0880. Website: www.asmp.org

ASMP Professional Business Practices in Photography, 6th Edition, American Society of Media Photographers, 150 N. Second St., Philadelphia PA 19106. (215)451-2767. Fax: (215)451-0880. Website: www.asmp.org. Handbook covering all aspects of running a photography business.

Bacon's Media Directories, Cision, 332 S. Michigan Ave., Suite 900, Chicago IL 60604. (866)639-5087. Website: www.cision.com/media-directories.asp

The Big Picture: The Professional Photographer's Guide to Rights, Rates & Negotiation, by Lou Jacobs, Writer's Digest Books, FfiplW Media, Inc., 4700 E. Galbraith Rd., Cincinnati OH 45236. (513)531-2690. Website: www.writersdigest.com. Essential information on understanding contracts, copyrights, pricing, licensing and negotiation.

Resources

Business and Legal Forms for Photographers, 3rd Edition, by Tad Crawford, Allworth Press, 10 E. 23 St., Suite 510, New York NY 10010. (212)777-8395. Fax: (212)777-8261. E-mail: PUB@allworth.com. Website: www.allworth.com. Negotiation book with 28 forms for photographers.

The Business of Commercial Photography, by Ira Wexler, Amphoto Books, Watson-Guptill Publications, 770 Broadway, New York NY 10003. (800)278-8477. E-mail: info@watsonguptill.com. Website: http://amphotobooks.com. Comprehensive career guide including interviews with 30 leading commercial photographers.

The Business of Photography: Principles and Practices, by Mary Virginia Swanson, available through her Website (www.mvswanson.com) or by calling (520)742-6311.

The Business of Studio Photography, Revised Edition, by Edward R. Lilley, Allworth Press, 10 E. 23 St., Suite 510, New York NY 10010. (212)777-8395. Fax: (212)777-8261. E-mail: PUB@allworth.com. Website: www.allworth.com. A complete guide to starting and running a successful photography studio.

Children's Writers & Illustrator's Market, Writer's Digest Books, F + W Media, Inc., 4700 E. Galbraith Rd., Cincinnati OH 45236. (513)531-2690. Website: www.writersmarket.com. Annual directory including photo needs of book publishers, magazines and multimedia producers in the children's publishing industry.

Color Confidence: The Digital Photographer's Guide to Color Management, by Tim Grey, Sybex, 10475 Crosspoint Blvd., Indianapolis IN 46256. Website: www.sybex.com

Color Management for Photographers: Hands-On Techniques for Photoshop Users, by Andrew Rodney, Focal Press. Website: www.focalpress.com

Creative Black Book, 740 Broadway, 2nd Floor, New York NY 10003. (800)841-1246. Fax: (212)673-4321. Website: www.blackbook.com. Sourcebook used by photo buyers to find photographers.

How to Shoot Stock Photos That Sell, 3rd Edition, by Michal Heron, Allworth Press, 10 E. 23 St., Suite 510, New York NY 10010. (212)777-8395. Fax: (212)777-8261. E-mail: PUB@allworth.com. Website: www.allworth.com. Comprehensive guide to producing, marketing and selling sock photos.

How You Can Make $25,000 a Year With Your Camera, by Larry Cribb, Writer's Digest Books, F + W Media, Inc., 4700 E. Galbraith Rd., Cincinnati OH 45236. (513)531-2690. Website: www.writersdigest.com. Newly revised edition of the popular book on finding photo opportunities in your own hometown.

LA 411, 411 Publishing, 5700 Wilshire Blvd., Suite 120, Los Angeles CA 90036. (800)545-2411. Fax: (323)965-2052. Website: www.la411.com. Music industry guide, including record labels.

Resources

Legal Guide for the Visual Artist, 4th Edition, by Tad Crawford, Allworth Press, 10 E. 23 St., Suite 510, New York NY 10010. (212)777-8395. Fax: (212)777-8261. E-mail: PUB@allworth.com. Website: www.allworth.com. The author, an attorney, offers legal advice for artists and includes forms dealing with copyright, sales, taxes, etc.

Literary Market Place, Information Today, 143 Old Marlton Pike, Medford NJ 08055-8750. (800)300-9868. Fax: (609)654-4309. E-mail: custserv@infotoday.com. Website: www.infotoday.com or www.literarymarketplace.com. Directory that lists book publishers and other book publishing industry contacts.

Negotiating Stock Photo Prices, by Jim Pickerell and Cheryl Pickerell DiFrank, 110 Frederick Ave., Suite A, Rockville MD 20850. (301)251-0720. Fax: (301)309-0941. E-mail: sellingstock@chd.com. Website: www.pickphoto.com. Hardbound book that offers pricing guidelines for selling photos through stock photo agencies.

Newsletters in Print, Thomson Gale, 27500 Drake Rd., Farmington Hills MI 48331. (248)699-4253 or (800)877-GALE. Fax: (800)414-5043. E-mail: gale.galeord@thomson.com. Website: www.gale.com. Annual directory listing newsletters.

O'Dwyer's Directory of Public Relations Firms, J.R. O'Dwyer Company, 271 Madison Ave., #600, New York NY 10016. (212)679-2471. Fax: (212)683-2750. E-mail: john@odwyerpr.com. Website: www.odwyerpr.com. Annual directory listing public relations firms, indexed by specialties.

Photo Portfolio Success, by John Kaplan, Writer's Digest Books, F + W Media, Inc., 4700 E. Galbraith Rd., Cincinnati OH 45236. (513)531-2690. Website: www.writersdigest.com

The Photographer's Guide to Marketing & Self-Promotion, 3rd Edition, by Maria Piscopo, Allworth Press, 10 E. 23 St., Suite 510, New York NY 10010. (212)777-8395. Fax: (212)777-8261. E-mail: PUB@allworth.com. Website: www.allworth.com. Marketing guide for photographers.

The Photographer's Internet Handbook, Revised Edition, by Joe Farace, Allworth Press, 10 E. 23 St., Suite 510, New York NY 10010. (212)777-8395. Fax: (212)777-8261. E-mail: PUB@allworth.com. Website: www.allworth.com. Covers the many ways photographers can use the Internet as a marketing and informational resource.

Photographer's Market Guide to Building Your Photography Business, by Vic Orenstein, Writer's Digest Books, F + W Media, Inc., 4700 E. Galbraith Rd., Cincinnati OH 45236. (513)531-2690. Website: www.writersdigest.com. Practical advice for running a profitable photography business.

Pricing Photography: The Complete Guide to Assignment & Stock Prices, 3rd Edition, by Michal Heron and David MacTavish, Allworth Press, 10 E. 23 St., Suite 510, New York NY 10010. (212)777-8395. Fax: (212)777-8261. E-mail: PUB@allworth.com. Website: www.allworth.com

Real World Color Management: Industrial-Strength Production Techniques, by Bruce Fraser, Chris Murphy and Fred Bunting, Peachpit Press, 1248 8th St., Berkeley CA 94710. Website: www.peachpit.com

Sell & Resell Your Photos, 5th Edition, by Rohn Engh, Writer's Digest Books, F + W Media, Inc., 4700 E. Galbraith Rd., Cincinnati OH 45236. (513)531-2690. Website: www.writersdigest.com. Revised edition of the classic volume on marketing your own stock.

SellPhotos.com, by Rohn Engh, Writer's Digest Books, F + W Media, Inc., 4700 E. Galbraith Rd., Cincinnati OH 45236. (513)531-2690. Website: www.writersdigest.com. A guide to establishing a stock photography business on the Internet.

Shooting & Selling Your Photos, by Jim Zuckerman, Writer's Digest Books, F + W Media, Inc., 4700 E. Galbraith Rd., Cincinnati OH 45236. (513)531-2690. Website: www.writersdigest.com

Songwriter's Market, Writer's Digest Books, F + W Media, Inc., 4700 E. Galbraith Rd., Cincinnati OH 45236. (513)531-2690. Website: www.writersdigest.com. Annual directory listing record labels.

Standard Rate and Data Service (SRDS), 1700 Higgins Rd., Des Plains IL 60018-5605. (847)375-5000. Fax: (847)375-5001. Website: www.srds.com. Directory listing magazines and their advertising rates.

Workbook, Scott & Daughter Publishing, 940 N. Highland Ave., Los Angeles CA 90038. (800)547-2688. Fax: (323)856-4368. E-mail: press@workbook.com. Website: www.workbook.com. Numerous resources for the graphic arts industry.

Writer's Market, Writer's Digest Books, F + W Media, Inc., 4700 E. Galbraith Rd., Cincinnati OH 45236. (513)531-2690. Website: www.writersmarket.com. Annual directory listing markets for freelance writers. Many listings include photo needs and payment rates.

Resources

Websites

PHOTOGRAPHY BUSINESS

The Alternative Pick www.altpick.com

Black Book www.blackbook.com

Copyright Website www.benedict.com

EP: Editorial Photographers www.editorialphoto.com

MacTribe www.mactribe.com

ShootSMARTER.com www.shootsmarter.com

Small Business Administration www.sba.gov

MAGAZINE AND BOOK PUBLISHING

American Journalism Review's News Links http://newslink.org

Bookwire www.bookwire.com

STOCK PHOTOGRAPHY

Global Photographers Search www.photographers.com

PhotoSource International www.photosource.com

Stock Photo Price Calculator www.photographersindex.com/stockprice.htm

Selling Stock www.pickphoto.com

Stock Artists Alliance www.stockartistsalliance.org

The STOCKPHOTO Network www.stockphoto.net

ADVERTISING PHOTOGRAPHY

Advertising Age www.adage.com

Adweek, Mediaweek and Brandweek www.adweek.com

Communication Arts Magazine www.commarts.com

FINE ART PHOTOGRAPHY

The Art List www.theartlist.com

Art Support www.art-support.com

Art DEADLINES List www.artdeadlineslist.com

Photography in New York International www.photography-guide.com

Mary Virginia Swanson www.mvswanson.com

PHOTOJOURNALISM

The Digital Journalist www.digitaljournalist.org

Foto8 www.foto8.com

National Press Photographers Association www.nppa.org

MAGAZINES

Afterimage www.vsw.org

Aperture www.aperture.org

Art Calendar www.artcalendar.com

Art on Paper www.artonpaper.com

Black and White Photography www.bandwmag.com

Blind Spot www.blindspot.com

British Journal of Photography www.bjphoto.co.uk

Camera Arts www.cameraarts.com

Resources

Lens Work www.lenswork.com

Photo District News www.pdnonline.com

Photograph Magazine www.photography-guide.com

Photo Insider www.photoinsider.com

The Photo Review, The Photography Collector, and The Photographic Art Market Magazines www.photoreview.org

Shots Magazine www.shotsmag.com

View Camera www.viewcamera.com

E-ZINES

The following publications exist online only. Some offer opportunities for photographers to post their personal work.

Apogee Photo www.apogeephoto.com

American Photo Magazine www.americanphotomag.com

American Photography Museum www.photographymuseum.com

Art in Context www.artincontext.org

Art Business News www.artbusinessnews.com

Art Support www.art-support.com

Artist Register http://artistsregister.com

Digital Journalist www.digitaljournalist.org

En Foco www.enfoco.org

Fotophile www.fotophile.com

Handheld Magazine www.handheldmagazine.com/index.html

Musarium www.musarium.com

Fabfotos www.fabfotos.com

Foto8 www.foto8.com

One World Journeys www.oneworldjourneys.com

PhotoArts www.photoarts.com

Pixel Press www.pixelpress.org

Photo Imaging Information Council www.takegreatpictures.com

Photo Links www.photolinks.com

Online Photo Workshops www.photoworkshop.com

Picture Projects www.pictureprojects.com

Sight Photo www.sightphoto.com

Zone Zero www.zonezero.com

TECHNICAL

About.com www.photography.about.com

FocalFix.com www.focalfix.com

Photo.net www.photo.net

The Pixel Foundry www.thepixelfoundry.com

Shoot Smarter www.shootsmarter.com

Wilhelm Imaging Research www.wilhelm-research.com

HOW TO

Adobe Tutorials www.adobe.com.designcenter/tutorials/

Digital Photographers www.digitalphotographers.net

Digital Photography Review www.dpreview.com

Fred Miranda www.fredmiranda.com/forum/index.php

Imaging Resource www.imaging-resource.com

Lone Star Digital www.lonestardigital.com

The National Association of Photoshop Professionals www.photoshopuser.com

PC Photo Review www.pcphotoreview.com

Steve's Digicams www.steves-digicams.com

Glossary

Absolute-released images. Any images for which signed model or property releases are on file and immediately available. For working with stock photo agencies that deal with advertising agencies, corporations and other commercial clients, such images are absolutely necessary to sell usage of images. Also see Model release, Property release.

Acceptance (payment on). The buyer pays for certain rights to publish a picture at the time it is accepted, prior to its publication.

Agency promotion rights. Stock agencies request these rights in order to reproduce a photographer's images in promotional materials such as catalogs, brochures and advertising.

Agent. A person who calls on potential buyers to present and sell existing work or obtain assignments for a client. A commission is usually charged. Such a person may also be called a *photographer's rep*.

All rights. A form of rights often confused with work for hire. Identical to a buyout, this typically applies when the client buys all rights or claim to ownership of copyright, usually for a lump sum payment. This entitles the client to unlimited, exclusive usage and usually with no further compensation to the creator. Unlike work for hire, the transfer of copyright is not permanent. A time limit can be negotiated, or the copyright ownership can run to the maximum of 35 years.

Alternative Processes. Printing processes that do not depend on the sensitivity of silver to form an image. These processes include cyanotype and platinum printing.

Archival. The storage and display of photographic negatives and prints in materials that are harmless to them and prevent fading and deterioration.

Artist's statement. A short essay, no more than a paragraph or two, describing a photographer's mission and creative process. Most galleries require photographers to provide an artist's statement.

Assign (designated recipient). A third-party person or business to which a client assigns or designates ownership of copyrights that the client purchased originally from a creator such as a photographer. This term commonly appears on model and property releases.

Assignment. A definite OK to take photos for a specific client with mutual understanding as to the provisions and terms involved.

Assignment of copyright, rights. The photographer transfers claim to ownership of copyright over to another party in a written contract signed by both parties.

Audiovisual (AV). Materials such as filmstrips, motion pictures and overhead transparencies which use audio backup for visual material.

Automatic renewal clause. In contracts with stock photo agencies, this clause works on the concept that every time the photographer delivers an image, the contract is automatically renewed for a specified number of years. The drawback is that a photographer can be bound by the contract terms beyond the contract's termination and be blocked from marketing the same images to other clients for an extended period of time.

Avant garde. Photography that is innovative in form, style or subject matter.

Biannual. Occurring twice a year. Also see Semiannual.

Biennial. Occurring once every two years.

Bimonthly. Occurring once every two months.

Bio. A sentence or brief paragraph about a photographer's life and work, sometimes published along with photos.

Biweekly. Occurring once every two weeks.

Blurb. Written material appearing on a magazine's cover describing its contents.

Buyout. A form of work for hire where the client buys all rights or claim to ownership of copyright, usually for a lump sum payment. Also see All rights, Work for hire.

Caption. The words printed with a photo (usually directly beneath it), describing the scene or action.

CCD. Charged Coupled Device. A type of light detection device, made up of pixels, that generates an electrical signal in direct relation to how much light strikes the sensor.

CD-ROM. Compact disc read-only memory; non-erasable electronic medium used for digitized image and document storage and retrieval on computers.

Chrome. A color transparency, usually called a slide.

Cibachrome. A photo printing process that produces fade-resistant color prints directly from color slides.

Clips. See Tearsheet.

CMYK. Cyan, magenta, yellow and black—refers to four-color process printing.

Color Correction. Adjusting an image to compensate for digital input and output characteristics.

Commission. The fee (usually a percentage of the total price received for a picture) charged by a photo agency, agent or gallery for finding a buyer and attending to the details of billing, collecting, etc.

Composition. The visual arrangement of all elements in a photograph.

Compression. The process of reducing the size of a digital file, usually through software. This speeds processing, transmission times and reduces storage requirements.

Consumer publications. Magazines sold on newsstands and by subscription that cover information of general interest to the public, as opposed to trade magazines, which cover information specific to a particular trade or profession. See Trade magazine.

Contact Sheet. A sheet of negative-size images made by placing negatives in direct contact with the printing paper during exposure. They are used to view an entire roll of film on one piece of paper.

Contributor's copies. Copies of the issue of a magazine sent to photographers in which their work appears.

Copyright. The exclusive legal right to reproduce, publish and sell the matter and form of an artistic work.

Cover letter. A brief business letter introducing a photographer to a potential buyer. A cover letter may be used to sell stock images or solicit a portfolio review. Do not confuse cover letter with query letter.

C-print. Any enlargement printed from a negative.

Credit line. The byline of a photographer or organization that appears below or beside a published photo.

Cutline. See Caption.

Day rate. A minimum fee that many photographers charge for a day's work, whether a full day is spent on a shoot or not. Some photographers offer a half-day rate for projects involving up to a half-day of work.

Demo(s). A sample reel of film or sample videocassette that includes excerpts of a filmmaker's or videographer's production work for clients.

Density. The blackness of an image area on a negative or print. On a negative, the denser the black, the less light that can pass through.

Digital Camera. A filmless camera system that converts an image into a digital signal or file.

DPI. Dots per inch. The unit of measure used to describe the resolution of image files, scanners and output devices. How many pixels a device can produce in one inch.

Electronic Submission. A submission made by modem or on computer disk, CD-ROM or other removable media.

Emulsion. The light-sensitive layer of film or photographic paper.

Enlargement. An image that is larger than its negative, made by projecting the image of the negative onto sensitized paper.

Exclusive property rights. A type of exclusive rights in which the client owns the physical image, such as a print, slide, film reel or videotape. A good example is when a portrait is shot for a person to keep, while the photographer retains the copyright.

Exclusive rights. A type of rights in which the client purchases exclusive usage of the image for a negotiated time period, such as one, three or five years. May also be permanent. Also see All rights, Work for hire.

Fee-plus basis. An arrangement whereby a photographer is given a certain fee for an assignment—plus reimbursement for travel costs, model fees, props and other related expenses incurred in completing the assignment.

File Format. The particular way digital information is recorded. Common formats are TIFF and JPEG.

First rights. The photographer gives the purchaser the right to reproduce the work for the first time. The photographer agrees not to permit any publication of the work for a specified amount of time.

Format. The size or shape of a negative or print.

Four-color printing, four-color process. A printing process in which four primary printing inks are run in four separate passes on the press to create the visual effect of a full-color photo, as in magazines, posters and various other print media. Four separate negatives of the color photo—shot through filters—are placed identically (stripped) and exposed onto printing plates, and the images are printed from the plates in four ink colors.

GIF. Graphics Interchange Format. A graphics file format common to the Internet.

Glossy. Printing paper with a great deal of surface sheen. The opposite of matte.

Hard Copy. Any kind of printed output, as opposed to display on a monitor.

Honorarium. Token payment—small amount of money and/or a credit line and copies of the publication.

Image Resolution. An indication of the amount of detail an image holds. Usually expressed as the dimension of the image in pixels and the color depth each pixel has. Example: a 640 × 480, 24-bit image has higher resolution than a 640 × 480, 16-bit image.

IRC. International Reply Coupon. IRCs are used with self-addressed envelopes instead of stamps when submitting material to buyers located outside a photographer's home country.

JPEG. Joint Photographic Experts Group. One of the more common digital compression methods that reduces file size without a great loss of detail.

Licensing/Leasing. A term used in reference to the repeated selling of one-time rights to a photo.

Manuscript. A typewritten document to be published in a magazine or book.

Matte. Printing paper with a dull, nonreflective surface. The opposite of glossy.

Model release. Written permission to use a person's photo in publications or for commercial use.

Multi-image. A type of slide show that uses more than one projector to create greater visual impact with the subject. In more sophisticated multi-image shows, the projectors can be programmed to run by computer for split-second timing and animated effects.

Multimedia. A generic term used by advertising, public relations and audiovisual firms to describe productions using more than one medium together—such as slides and full-motion, color video—to create a variety of visual effects.

News release. See Press release.

No right of reversion. A term in business contracts that specifies once a photographer sells the copyright to an image, a claim of ownership is surrendered. This may be unenforceable, though, in light of the 1989 Supreme Court decision on copyright law. Also see All rights, Work for hire.

On spec. Abbreviation for "on speculation." Also see Speculation.

One-time rights. The photographer sells the right to use a photo one time only in any medium. The rights transfer back to the photographer on request after the photo's use.

Page rate. An arrangement in which a photographer is paid at a standard rate per page in a publication.

Photo CD. A trademarked, Eastman Kodak-designed digital storage system for photographic images on a CD.

PICT. The saving format for bit-mapped and object-oriented images.

Picture Library. See Stock photo agency.

Pixels. The individual light-sensitive elements that make up a CCD array. Pixels respond in a linear fashion. Doubling the light intensity doubles the electrical output of the pixel.

Point-of-purchase, point-of-sale (P-O-P, P-O-S). A term used in the advertising industry to describe in-store marketing displays that promote a product. Typically, these highly-illustrated displays are placed near checkout lanes or counters, and offer tear-off discount coupons or trial samples of the product.

Portfolio. A group of photographs assembled to demonstrate a photographer's talent and abilities, often presented to buyers.

PPI. Pixels per inch. Often used interchangeably with DPI, PPI refers to the number of pixels per inch in an image. See DPI.

Press release. A form of publicity announcement that public relations agencies and corporate communications staff people send out to newspapers and TV stations to generate news coverage. Usually this is sent with accompanying photos or videotape materials.

Property release. Written permission to use a photo of private property or public or government facilities in publications or for commercial use.

Public domain. A photograph whose copyright term has expired is considered to be "in the public domain" and can be used for any purpose without payment.

Publication (payment on). The buyer does not pay for rights to publish a photo until it is actually published, as opposed to payment on acceptance.

Query. A letter of inquiry to a potential buyer soliciting interest in a possible photo assignment.

Rep. Trade jargon for sales representative. Also see Agent.

Resolution. The particular pixel density of an image, or the number of dots per inch a device is capable of recognizing or reproducing.

Résumé. A short written account of one's career, qualifications and accomplishments.

Royalty. A percentage payment made to a photographer/filmmaker for each copy of work sold.

R-print. Any enlargement made from a transparency.

SAE. Self-addressed envelope.

SASE. Self-addressed, stamped envelope. (Most buyers require a SASE if a photographer wishes unused photos returned to him, especially unsolicited materials.)

Self-assignment. Any project photographers shoot to show their abilities to prospective clients. This can be used by beginning photographers who want to build a portfolio or by photographers wanting to make a transition into a new market.

Self-promotion piece. A printed piece photographers use for advertising and promoting their businesses. These pieces generally use one or more examples of the photographer's best work, and are professionally designed and printed to make the best impression.

Semiannual. Occurring twice a year. Also see Biannual.

Semigloss. A paper surface with a texture between glossy and matte, but closer to glossy.

Semimonthly. Occurring twice a month.

Serial rights. The photographer sells the right to use a photo in a periodical. Rights usually transfer back to the photographer on request after the photo's use.

Simultaneous submissions. Submission of the same photo or group of photos to more than one potential buyer at the same time.

Speculation. The photographer takes photos with no assurance that the buyer will either purchase them or reimburse expenses in any way, as opposed to taking photos on assignment.

Stock photo agency. A business that maintains a large collection of photos it makes available to a variety of clients such as advertising agencies, calendar firms and periodicals. Agencies usually retain 40-60 percent of the sales price they collect, and remit the balance to the photographers whose photo rights they've sold.

Stock photography. Primarily the selling of reprint rights to existing photographs rather than shooting on assignment for a client. Some stock photos are sold outright, but most are rented for a limited time period. Individuals can market and sell stock images to individual clients from their personal inventory, or stock photo agencies can market photographers' work for them. Many stock agencies hire photographers to shoot new work on assignment, which then becomes the inventory of the stock agency.

Subsidiary agent. In stock photography, this is a stock photo agency that handles marketing of stock images for a primary stock agency in certain US or foreign markets. These are usually affiliated with the primary agency by a contractual agreement rather than by direct ownership, as in the case of an agency that has its own branch offices.

SVHS. Abbreviation for Super VHS. Videotape that is a step above regular VHS tape. The number of lines of resolution in a SVHS picture is greater, thereby producing a sharper picture.

Tabloid. A newspaper about half the page size of an ordinary newspaper that contains many photos and news in condensed form.

Tearsheet. An actual sample of a published work from a publication.

TIFF. Tagged Image File Format. A common bitmap image format developed by Aldus.

Trade magazine. A publication devoted strictly to the interests of readers involved in a specific trade or profession, such as beekeepers, pilots or manicurists, and generally available only by subscription.

Transparency. Color film with a positive image, also referred to as a slide.

Unlimited use. A type of rights in which the client has total control over both how and how many times an image will be used. Also see All rights, Exclusive rights, Work for hire.

Unsolicited submission. A photograph or photographs sent through the mail that a buyer did not specifically ask to see.

Work for hire. Any work that is assigned by an employer who becomes the owner of the copyright. Stock images cannot be purchased under work-for-hire terms.

World rights. A type of rights in which the client buys usage of an image in the international marketplace. Also see All rights.

Worldwide exclusive rights. A form of world rights in which the client buys exclusive usage of an image in the international marketplace. Also see All rights.

Resources

Geographic Index

This index lists photo markets by the state in which they are located. It is often easier to begin marketing your work to companies close to home. You can also determine with which companies you can make appointments to show your portfolio, near home or when traveling.

North Carolina

International Index

This index lists photo markets outside the United States. Most of the markets are located in Canada and the United Kingdom. To work with markets located outside your home country, you will have to be especially professional and patient.

Subject Index

This index can help you find buyers who are searching for the kinds of images you are producing. Consisting of markets from the Publications, Book Publishers, Greeting Cards, Posters & Related Products, Stock Photo Agencies, Advertising, Design & Related Markets, and Galleries sections, this index is broken down into 48 different subjects. If, for example, you shoot outdoor scenes and want to find out which markets purchase this material, turn to the categories Landscapes/Scenics and Environmental.

Agriculture

Subject Index

Alternative Process

Anthology/Annual/Best Of

Architecture

Automobiles

Subject Index

Babies/Children/Teens

Business Concepts

Celebrities

Christian

Cities/Urban

Subject Index

Couples

Documentary

Education

Entertainment

Environmental

Erotic

Events

Families

Subject Index

Fashion/Glamour

Fine Art

Subject Index

Gardening

Health/Fitness/Beauty

Subject Index

Historical/Vintage

Hobbies

Humor

Humor/Satire

Industry

Interiors/Decorating

Subject Index

Lifestyle

Subject Index

Medicine

Native American

Parents

Performing Arts

Subject Index

Pets

Political

Product Shots/Still Life

Subject Index

Rural

Subject Index

Seasonal

Senior Citizens

Spirituality/Inspirational

Sports

Sports/Recreation

Students

Technology/Computers

Subject Index

Subject Index

Wildlife

General Index

This index lists every market appearing in the book; use it to find specific companies you wish to approach.

B

G

General Index

General Index

General Index

General Index

NOTES

NOTES

NOTES

NOTES

NOTES

NOTES

NOTES

NOTES

NOTES

NOTES

NOTES

NOTES

NOTES

NOTES

NOTES